GIUSEPPE PANZA

Memories of a Collector

GIUSEPPE PANZA

Memories of a Collector

TRANSLATION FROM
THE ITALIAN
BY MICHAEL HAGGERTY

ABBEVILLE PRESS PUBLISHERS
NEW YORK LONDON

Cover: David Simpson, *Dear to Saturn*, 1994

FOR THE ORIGINAL EDITION
Draft by: Alessandro Panza, Francesca Guicciardi, Giuseppina Panza, Cristiana Caccia
Editing and layout: Gioanola Elisabetta, San Salvatore Monferrato (Al) Italy

FOR THE ENGLISH-LANGUAGE EDITION
Editor: Walton Rawls
Production Editor: Megan Malta
Production Manager: Louise Kurtz
Jacket Design and Typographic Layout: Misha Beletsky
Composition: Robert Weisberg

First published in Italy in 2006 by Editoriale Jaca Book S.p.A.,
Via Frua 11, 20146, Milano.

First published in the United States of America in 2007 by Abbeville Press,
137 Varick Street, New York, NY 10013.

The text of this book was set in ITC Legacy.
Printed and bound in China.
First edition

1 3 5 7 9 10 8 6 4 2

Paperback:
ISBN-13: 978-0-7892-0944-3
ISBN-10: 0-7892-0944-6

Hardcover:
ISBN-13: 978-0-7892-0943-6
ISBN-10: 0-7892-0943-8

Library of Congress Cataloging-in-Publication Data

Panza, Giuseppe.
[Ricordi di un collezionista. English]
Giuseppe Panza : memories of a collector / translation from the Italian by
Michael Haggerty. — 1st ed.
p. cm.
Summary: "A collector and advocate of contemporary art since the late 1940s, Giuseppe Panza
has played a fundamental role in the artistic culture of his time, introducing
American phenomena such as Minimalism to the museums of Europe. In this book,
Panza shares philosophical insights and personal reflections that bridge a half-century
of his discovery of new artists and movements"—Provided by publisher.
Includes index.
ISBN-13: 978-0-7892-0943-6 (hardcover : alk. paper)
ISBN-10: 0-7892-0943-8 (hardcover : alk. paper)
ISBN-13: 978-0-7892-0944-3 (pbk. : alk. paper)
ISBN-10: 0-7892-0944-6 (pbk. : alk. paper)
1. Panza, Giuseppe. 2. Art—Collectors and collecting—Italy—Biography.
3. Art, Modern--20th century—Collectors and collecting—Italy. I. Title.

N5273.2.P36A3 2007
709.2—dc22
[B]
2007022824

For bulk and premium sales and for text adoption procedures, write to Customer Service Manager,
Abbeville Press, 137 Varick Street, New York, NY 10013, or call 1-800-ARTBOOK.

Visit Abbeville online at www.abbeville.com.

CONTENTS

CONTENTS

THIRD PART

THE THIRD COLLECTION

CONTENTS

These memories are dedicated to my parents,

Ernesto Panza Count of Biumo and Maria Panza Mantegazza,

who made all of this possible;

my wife Rosa Giovanna,

with whom I have shared my life, family, and art;

our children Alessandro, Giuseppina, Federico, Giovanni, and Giulio,

together with their families, for their help and understanding.

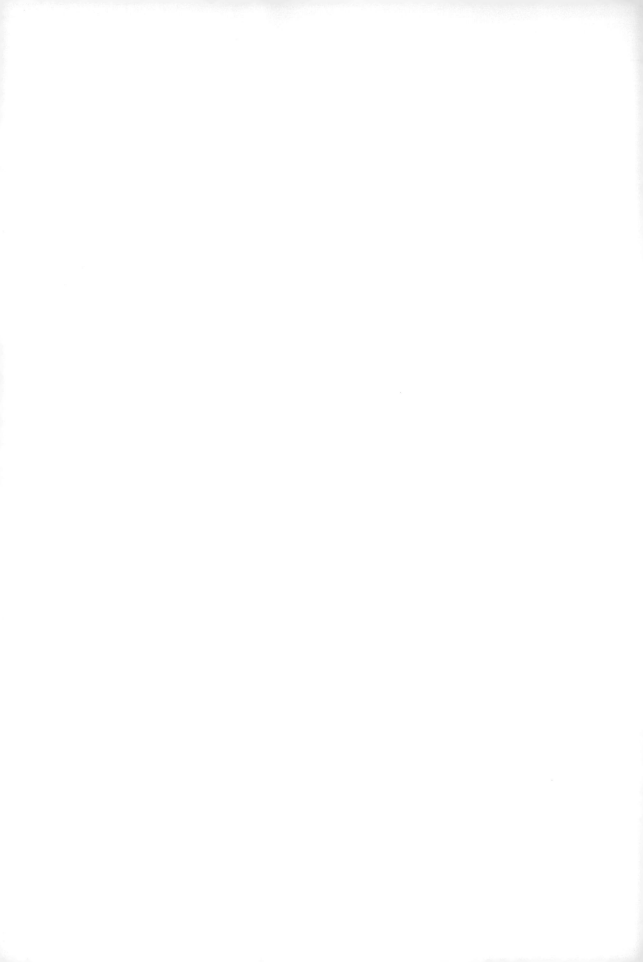

PART ONE

THE EARLY YEARS

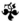

INTRODUCTION

The relationships I have had with art and artists during my life have been quite singular and would be difficult to repeat. Perhaps it might be useful if I describe this experience. It might be a way for a better understanding of my collection and explain the reasons why I bought some artists rather than others. A collection is also the history of the person who created it, step by step, and at least in my case over a long period, some fifty years in all. It is also the projection of one's own personality onto the artists and the works chosen. A personality is formed slowly and is realized through thoughts, feelings, instincts, hopes, and desires that in the course of a life give rise to actions, choices, and obligations. We are what we are because of what we think and what we aim for; I believe that in order to understand what I have done it is also necessary to explain what I wanted and thought. I still collect, and I still choose artists. But always in relation to my thoughts. And I think it is necessary to describe these in order to understand all the rest. A collector lives in a particular situation, one that has consequences on his possibilities for working in the field of art, and it is indispensable to understand this interdependence. Sadly we cannot do everything we would like to do. We also make errors that are difficult to avoid, and it is difficult to repair the damage they cause.

These memories were written down during my days off, Saturdays and Sundays, and during my holidays, and this is why they do not follow a linear pattern. I jump from the past to the present without bothering much about chronology. I describe the thoughts that come to mind through an association of ideas. This is why the time sequence has a less important role. I am not an outsider talking to another outsider. I am not writing about someone I've become familiar with through documents. I am talking about myself. It is the occasion for talking about my life. When you are aged eighty your perception of time changes: you do not know how long it will last, though doubtless not for all that long. I have so much to do, time speeds by quickly, so very quickly. Tomorrow could be the last day, and it certainly will arrive sooner than I thought; so for this very reason I have no time to lose. I began to write in March 1997 and I finished in March 2005. I have tried to be objective, to tell the truth, but that is not always possible. For others, if not for me, the truth can hurt. I must avoid or keep quiet about many details. But I have tried to be honest with myself, and this is the most difficult thing. I have been very lucky: I have done things that are rarely possible to do, which even once seemed impossible for me, and yet they have happened, almost without my being aware of them or wanting them to happen. I must thank those who have given me

this possibility. These are things apart from me, things I have been given. When you arrive at the end you realize that everything was a gift. Everything passes, and only good ideas remain alive in the life that follows.

The great—the very greatest—event: from being nothing to being conscious. To open your eyes, to see, to feel. To feel emotions, pain and pleasure, to discover the world, feel the great need for happiness: total, faultless, perfect. We know happiness exists because at times we experience it, though it disappears at once.

The beginning is so far off, wrapped in a luminous mist from which a few memories of my first years of life emerge only with difficulty. My mother, father, brothers, our home. My strongest memories, those most imprinted in my mind, are the vision of nature, the landscape in spring or in the autumn. I often stayed with my grandmother in Varese, in Via Veratti. The house still exists, but it has been rebuilt. I loved staying with her and Uncle Angelo at the end of the 'twenties. She would drive me around in her car, an open-top FIAT 501, when she went off for business or when she went to check on her land. The surroundings of Varese were beautiful then, with far fewer inhabitants than now. I remember a spring morning with the sight of Monte Rosa whitened with snow; the sky was blue, the lake was blue, and its banks were green.

When I was about to fall asleep, the bells of the tower of San Vittore filled my room with slow, solemn tolls, with long pauses, and I felt transported to another world. I was happy to hear them. A precise date can be figured out from a distant memory: the seventieth birthday of my grandmother, Giulia Mantegazza. She died in 1952 at the age of ninety-four, so this must have been in 1928, when I was five years old. I remember my older sister reciting poetry, the meal, my grandmother happy to see us all together. But I see I am no longer talking about birth, the most important thing. There is no such real and total void as the time before we open our eyes and become capable of understanding and desiring. None of the things that surround us, from those we can touch to the stars, have this capacity, so strange yet so closely linked to our physical nature. Our body has a long history, begun millions of years ago with the appearance of the first unicellular being.

The first link of the DNA chain, the genetic message, is exclusive to each of us and is made of chemical compounds, four bases and twenty-one amino acids, which are present in cosmic space, and these in turn are made up of heavy elements—carbon, oxygen, nitrogen—created during the collapse and successive explosion of huge stars. A very strange event, marvelously intelligent, but without any awareness of its own existence. The instructions for creating our body are placed inside a microscopic space.

About twenty volumes of a huge encyclopedia would be necessary to describe all this. The program developed over millions and millions of years,

without making mistakes. Due to this precision in copying with variants, I have a body that at eighty years of age still keeps me active and in good health. Those variants are appropriate for giving everyone a physical and intellectual personality that is different, though not too much. But I did not exist before, otherwise I would remember something from a previous life. Instead I learned everything fairly quickly, with the help of my parents and others. My awareness of existing came from nothing, and is unique and irreplaceable, and only mine. I feel joy and pain. And an endless wish for happiness. Life gives me happiness. Death is the end, and for me the end of everything. My children, who are a part of me, will continue to live after my death, but I will no longer be with them. Only with the passing of time do we ask ourselves what we are. When we are young we live, and that is enough. We live in the present and only later does the future become so very important. We wish always to have what is good and avoid the bad.

I was extremely fortunate when I came into the world. I could have become aware of myself only to realize I was someone gravely disabled, or born into a family with moral or financial problems, or else born in a distant region of Africa where even physical survival is menaced by war, revolution, deportations, and famine. But I was spared all these risks.

My parents were morally sound and gave me a sound body and a financial situation that was more than sound, in a society that, despite its defects, also has many good qualities.

But mine, and only mine, is the great love I feel for beauty in all its forms, and my greatest wish is to search for it always. To obtain it is my greatest happiness.

I am also extremely lucky to have this desire. Those who do not have it cannot experience the happiness I experience. When I compare myself to others I realize I have had so many privileges. I must be grateful to the Father who made all this possible; He does not live in this world, but He created it and recreates it in every moment, from the time He began to exist and afterward, in the unforeseeable journey of our—of my—existence.

He is the one who is hidden, but the only one who really exists.

All this came about on the day of my birth, March 23, 1923, in 15 Viale Montenero, Milan, at home since children then were not born in pediatric clinics. The house no longer exists; it was destroyed by Allied bombing in August 1943. It was on the bypass to the south of Milan, next to the seventeenth-century Spanish walls that were demolished after the war.

My father, Ernesto, was born in 1878 in San Salvatore Monferrato, a town of some ten thousand inhabitants among the hills between Alessandria and Casale, a pleasant place on the borders of the Po River Valley. On clear days—

above all in October after the grape harvest—you could see Monte Rosa, the Piedmont Alps, and the Ligurian Apennines. His family was part of the local lower middle classes, and he earned his living from trade. As the years passed, and at the cost of hard work and a great deal of thrift, his fortune had grown. A rigorous respect for moral values was at the heart of the life of grandfather Alessandro and his numerous family members.

My father had four sisters and three brothers. The family's origins were in San Salvatore Monferrato. They had been subjects of the marquises of Monferrato, an ancient state founded by the Lombards and taken over by the Savoy dynasty in 1713.

My grandmother, Luisa Giuseppina, had died young a long time before I was born, and grandfather Alessandro died in 1922, a year before my birth. This is all information I have found on the tombstones in the family chapel. Built in the 'twenties in the Romantic style, it was the largest chapel in the cemetery, in a period when the cult of the dead and the continuation of the family were still strongly felt, though these values have almost disappeared today.

My father's feelings for his links to the family and his country were extremely strong. In the 'thirties he was the *Podestà*, or mayor, of San Salvatore for quite some time. He owned a part of the old family home. This was a villa constructed on top of a hill at the beginning of the century; it had a garden, vineyards descended toward the valley, and it had a splendid view in every direction. When I was young we lived there for a month every year during the grape harvest. I have really lovely memories of the fall. I rarely go back there now except for funerals or mass in the cemetery during celebrations for the dead in November. The few times I pass nearby in the car the thought of when I lived in the house grips my heart, I feel a great sense of emptiness, of nostalgia for good times in the past that can never be recaptured. But I also feel for things that live on in the memory. Mysterious ties to my origins are born again. I am one of the last survivors of the family that lived in the house and for a long time in the town. These memories, beautiful as they are, will die with me.

The way of life of my grandfather Alessandro and of my father Ernesto can be summed up in three words: honesty, work, and family; my father was true to these principles for the whole of his life. He worked a lot and used his great intelligence to create something lasting, to construct something real—this was his aim: to build up his assets slowly by making few errors but many correct decisions, though he had begun with only modest financial possibilities. So this was his aim, and he reached it after many years of hard work. This was his way of creating something concrete but also something very difficult, and very few people manage to do this. It is very easy to drain your assets rather them increase them, even if you work with the best of intentions. There is no lack of examples; on the contrary there are a lot of them. The modern age is characterized by rapid changes in the financial situation. Activities that just a few years back were a source of gain are no longer so; in fact they produce a loss, and those who don't take care to sell their firm at the right moment—something difficult to do—lose their assets.

The town where he was born, San Salvatore, stands on the edges of the Monferrato hills, an area where the production of wine was the main resource. Most of the population lived from the production and sale of wine, which a hundred years ago was widely consumed. But now things have changed, and wine has been substituted for by other drinks and has become something for the elite, and so only high quality wines are drunk.

A town in the Monferrato region was a restricted area for commerce. After the unification of Italy, industries began to grow up in various large centers. In Milan the financial transformation had begun in 1880 with the development of mechanized production. Mass consumption quickly spread, increasing employment and income. At the time Italy was governed by wise politicians for whom paper money was worth more than gold. Financial systems backed by rational and traditional laws created development and well-being.

My father wanted to work and felt in himself a great energy that had to be expressed by undertaking something that just was not possible in his hometown.

He was obliged to go to those centers where economic activity was more intense. Growth was underway, and Milan was the most active center: its transformation from a static economy to an industrial one was only beginning, but its development was rapid. So at sixteen Father decided not to continue with his studies but to go to work in Milan. This was in 1894, more than a hundred years ago, and a century is a long time: deep changes and great events can happen, as in fact they did.

With its science, industry, market economy, and democracy, Europe was expanding throughout the world and dominated it with the financial power generated by its intellectual capacities and its wish for the new and the risky. Great eastern countries, China and Japan, which until the eighteenth century had had a similar development to that of Europe, turned in on themselves and refused to compete. My father wanted to experience this change and development, but at the same time he was deeply aware of traditional values that are always valid, even if today widely ignored.

Family, fidelity in marriage, respect for social values, public authority, and the motherland. This last value was deeply shaken at the end of the First World War as millions of useless deaths had been brought about in its name. The motherland was the pride of all the nation, but in reality it was the will for supremacy over others, and history as well as good sense have shown how it can lead to disaster. But then it was an extremely strong feeling.

New possibilities were being developed in the south as a result of the unification of Italy and the growth of a railway system that permitted low-cost transport from such distant parts as Apulia. The cultivation of grapes began to be extended throughout the regions in the south as a result of this increase in demand. New possibilities for earning in poorer regions were opened up. The firm of Alessandro Panza and Sons was among the first to develop this commercial integration. This possibility had been explored some years earlier by my grandfather on my mother's side, Aquilino Mantegazza, who was also a wine seller, greatly admired by my father because he was a person of great integrity as well as being extremely shrewd financially. In just a few years the firm quickly developed, and in the 'twenties it was second in importance only after the Folonari firm in Brescia.

One of my father's particular abilities was his sensitivity to market trends. He knew when the right moment was to buy and when to sell. He was highly attentive to the signs of any change in tendency. This was the result of a careful evaluation of both large and small phenomena that are determinant for an economy. This situation allowed my father to get through the Depression in the 'thirties without damage. He invested his income in property, houses, building and agricultural land: he trusted in what stood in the sun. He did not invest in stocks and shares. Stock exchange values are often ephemeral, but property, if chosen carefully in view of probable future revaluation, will undergo a lesser devaluation or, more often in fact, an increase.

My father was not a collector and was wary of contemporary art: he remembered a famous Milanese industrialist who in the 'twenties bought many works by De Nittis when that artist's fame was at its height, but, when they were sent to auction in the 'thirties due to their owner's bankruptcy were left unsold.

However, the great crisis allowed my father to buy the Biumo house in Varese at a convenient price. Henry David Prior, nephew of the Duchess Litta and the last of the Litta heirs, had died without leaving any descendents. There were some distant relatives in Geneva who wanted to settle things up, and the house was put up for auction, but no one even offered the minimum price. At the time there was no one who wanted to buy a property that was beautiful but that would cost a lot to run without giving any return. My father, though, fell in love with the Biumo house and, as my mother was from Varese and my grandmother lived in the same city, there were many reasons to put down roots there.

My mother Maria, who died suddenly of a heart attack in 1956 at sixty-eight years old, was born in Varese in 1889; her parents were Aquilino Mantegazza and Giulia Floriani, who had been born in Milan in 1858. Grandfather Aquilino had been born in Varese in 1851 and had died of a heart attack during a business trip to Apulia in 1922, at the age of seventy-one years. My grandmother was ninety-four when she died. My mother had two sisters: Aunt Pina, the eldest, and a brother, Uncle Angelo. Two people who have a place in my memories. My mother, Maria, was the third.

I never knew grandfather Aquilino since he died a year before I was born. From portraits I have seen and stories I have been told, he must have been a big, tall man, extremely strong with an extroverted character, and unconcerned with formalities; he dressed in whatever was to hand, had a cheerful face, vivacious eyes, and altogether had the rustic look of a man from the Lombard pre-Alpine mountains, but with an intelligent head on his shoulders. As I have said, my father greatly admired him for his financial acumen. Grandmother Giulia's character was quite the opposite, as she was introverted, reserved, spoke few words, and was very affectionate toward her grandchildren: I loved staying with her in Varese when I was a child.

Maria, my mother, was tall, upright, rather shy, very sweet, but also severe when necessary for educating us children. Her business was the family: father, her children, the home. She loved art and before getting married used to paint. Some of her paintings are still in the house, landscapes that show a certain sensitivity and have their own fascination. On Sunday afternoons she would take me to visit museums and art galleries together with Aunt Pina who had also painted when she was a young girl. My mother was sweet but strong, and she was an optimist who accepted negative things while hoping for better days. I never heard her complain about things going badly. She had very good health, and I never remember her being in bed for any kind of illness, not even a simple cold, but despite all this she died young after the death of my father in 1949. Her heart no longer functioned very well.

My father worked a lot and didn't have the time to attend to the household. He was very severe and we were afraid of his scolding, which was rare but left its mark. He had great authority because he was severe with himself and so could allow himself to be the same with others. His moral integrity was never in doubt, and he could not be criticized. When he made a judgment he always hit the mark. He understood the person in front of him and his psychological condition in a flash. If the person was hiding something, he guessed it straight

away, and with just a little probing would have his hunch confirmed. He was like this too in his business dealings and understood when a contractor was not telling the truth as well as knowing how far to push a request. In an argument he always had the right reply for demolishing his opponent's point of view. He had so much experience in life that it was impossible to make him believe something that was not true: he realized what was up straight away. My mother smiled at everyone without distinction, for her everybody was the same, whether rich or poor, important or not. She trusted in the good faith of whomever she met and had no ambitions for herself. She hated show-offs and loved the simple life, the humble yet genuine things of everyday life. She loved her children, her husband, the home. She was extremely close to grandmother and her sister, Aunt Pina.

Aunt Pina was the relative who, together with grandmother and Uncle Angelo, we saw most often and, given we were the only grandchildren, she loved us a lot. Aunt Pina liked art and painted both when she was young and when she grew old, but she was also a woman of action. When her husband Felice Comi died in 1933 she took over his firm, which was tottering because of the Depression. It produced equipment for neighborhood laundries, and she knew how to overcome its difficulties and put the firm back on its feet.

She lived in Milan in Via Piacenza at the corner of Via Verona in a villa belonging to the Comi family that had been built in Art Nouveau style by the architect Sommaruga at the beginning of the twentieth century. He was the best architect of the period: in Milan there still exists the façade of his Castiglini Building in Corso Venezia, though sadly the interior was destroyed when it became the head offices of the Italian Automobile Club. Anyway, hers was a beautiful house with large living rooms on the mezzanine overlooking the gardens and with an imposing staircase. It had been built by Uncle Felice's father who was the manager and shareholder of the Amiani & Silvestri firm, a large concern that made steam trains and railway wagons. This business was in Via Pietrasanta, in the same road as the wine cellars and offices of the Panza firm. My office used to be in the house I had built in 1962 at the corner of the same road. Amiani & Silvestri went through difficult times after 1918 since there was less need of trains, and Mussolini's policy for protecting the lira resulted in the firm's bankruptcy. For reasons of political prestige Mussolini wanted the sterling-lira exchange rate to be at quota 90, while in fact the rate was 120 lire for one pound sterling. This prestige policy caused great damage that only aggravated the problems caused by the crisis of 1930. Amiani & Silvestri was one of the first victims of this policy. There were enough trains in Italy, so it was necessary to export, but with a disadvantageous and artificial exchange rate Italian prices could not be competitive.

The very large area of land occupied by Amiani & Silvestri was bought by OM, a car and truck manufacturer from Brescia. When this was taken over by FIAT it became a forklift-truck firm. It is now, and has been for some time, a waste area. It should become a residential district. This is a testimonial of the great and unexpected economic and social changes of this century. From industrial concerns, each employing thousands of workers, to a service and exchange economy. Production has disappeared, has been relocated, or grouped into more efficient and automated units. We have gone from a society based mainly on laborers to one of clerks sitting in front of the computer monitor.

Aunt Pina's house was also the accidental victim of one of the first air raids in 1917 on a city that was far from the front line. The breakthrough on the Italian front at Caporetto had pushed the front back to the Piave River and had enabled the Austrians to move their airports closer to Milan. A low-power bomb fell on the steps of the staircase leading down to the garden, breaking them. In 1943, twenty-five years later, the raids were quite different, and about a third of the buildings in Milan were destroyed or damaged, our house among them.

I must mention an episode that is interesting because it is about art and is a record of changing taste and fashion, not about anything serious. In the living room of the house of Aunt Pina in Milan, there was an enormous picture with an imposing gilded frame that covered the whole wall: it was so huge that it reached the floor. The subject was a slave market in an Arabian city with nude women: a highly popular theme then as much as today. The painter, Ferdinando Brambilla, taught at the Brera Academy. He was a highly appreciated artist in Milan at the beginning of the century. He interpreted the taste of the burgeoning middle classes, who were not much different from those today. It is interesting to describe the history of this painting because it tells us a lot. The picture dominated the living room and was the first thing that guests saw; it was something that conferred prestige, the work of an artist who, if not famous, was at least highly regarded in the Milan area. My aunt died in 1970 at eighty-three years old, and this was a great sadness for me as she was the last survivor of my mother's family to leave us. When her inheritance was shared out between my two sisters and my brother, no one wanted this picture by an artist who had been so famous in the past; it ended up in the waiting room of my brother's office where there was a bare wall. The huge golden frame has disappeared: it was too large, and I think it was sold by my sister Giulia. Probably the shareholders of my brother's firm will change and the office will be moved: the picture's latest risk.

This is an example of the destiny of a once-successful work of art, which I believe cost quite a lot and had won a prize at an important show. Thousands

of pupils attended this academy and painted tens of thousands of paintings just as their teachers did. Where have these pictures all finished up? It is quite likely they all had the same fate as the *Slave Market*. Perhaps not. Today in our Postmodern times there is a revival of interest in this kind of art that I find extremely silly, but then there are a lot of people who like stupid art, especially if they can see beautiful half-naked women. In auctions in New York pictures that I consider the negation of art and culture change hands at elevated prices even though the only quality they have is of being painted in an agreeable manner and with a good technique.

Uncle Angelo Mantegazza, my mother's brother, was an important person in my childhood memories. He was a big strong man but with a completely different character. He never married and genuinely loved his nephews. When I went to stay for months with my grandmother in Varese he would take me around in his car almost every day. On beautiful spring days I would see the lakes, the Prealps, distant Monte Rosa, intensely green hills, and farm workers' houses. These are unforgettable memories. My uncle was very generous with me, and every so often when I saw a toy I liked he would buy it for me at once. He had not gone into the paternal firm since he did not have a dealer's temperament, but he lived on his income and spent his time looking after his affairs and following politics. He was very brave and in the face of danger never lost his head. During the First World War he was turned down by the forces because of his bad eyesight, but he asked to be enrolled as a volunteer and became an ambulance driver. He was awarded a silver medal. During an Austrian bombardment he picked up the wounded at the front, despite the danger of being shot. He was a great patriot and a fine bourgeois who quite properly considered that the right to own private property was one of the basic requirements of individual freedom and dignity.

At the end of the 1914–1918 war extremist socialism made the most of the critical situation to expand rapidly and threaten the basis of liberal and democratic society. Sadly only Mussolini's Fascist movement had an active program for fighting the violent and aggressive extremism of the nascent Communist party and radical left-wing Socialists. The other parties were divided: they were quite rightly pacifist, but they took no precautions against those who wanted to destroy the existing system, which despite the errors and the horrors of war had led the country forward. The Russian Revolution was a sinister threat that had systematically destroyed the middle classes, and even the intellectuals who had not shared the extremism of Lenin and Stalin were deported to Siberia where they either died or fled to the West. The middle classes did not want to lose everything, their lives included, and if they could they left Russia clandestinely. Many historians when talking about the origins of Fas-

cism forget just what the situation in Italy was like between 1918 and 1922, the year of the so-called Fascist Revolution. The state seemed incapable of stopping the violence of the left, which was not simply verbal. The fear of ending up like Russia frightened many people. So it was natural that, especially among the young who did not want Communism, there was a reaction to a situation that seemed to lead inevitably to toppling the system. The idea of saving one's country from a political action aimed at overthrowing it in the name of the international proletariat was a need felt by many. The unity of Italy had been the main political aspiration for the whole of the nineteenth century. The glory of our nation seemed a far superior aim to any other.

Europe still consisted of small nations fighting amongst themselves. To be the first and therefore the strongest nation was the objective even at the cost of great sacrifices. Pride in a large and powerful country excited the people quite apart from their social class.

Mussolini knew how to make the most of these feelings: fear of Communism on the one hand and nationalism on the other. He knew how to talk to the crowd, choosing popular themes, and slowly yet forcefully pronouncing the words as though sculpting them.

After 1922 Uncle Angelo had many political appointments in Varese and was for many years the president of the chamber of commerce. He undertook these duties with complete neutrality, until one day there arrived a prefect from Rome with whom my uncle did not get along. I do not know the reasons for their clash but I think he saw ambitions in the prefect's plans that were not consistent with public duties. The prefect had good connections in Rome and so, after an extremely tough meeting, my uncle decided to stand down from all public appointments.

In this period he bought a castle in Masnago, near Varese, a medieval building enlarged in the seventeenth century. The oldest part had become a farmhouse used for raising silkworms, a widespread and important activity in upper Lombardy, where it had been introduced at the end of the fifteenth century with the encouragement of Lodovico il Moro. The walls of the ancient castle, devoted to the breeding of the silkworms, had been painted white to cover over what was underneath. In certain places you could just about see the vaguest hint of some figures. My uncle, who was interested in art, realized that the white walls hid something that should be uncovered.

When the new wing had been built in the seventeenth century to become the patrician, residential part of the edifice, the old part was déclassé and given over to agricultural uses. We always think the new is better than the old. Usually you create something new in order to eliminate the defects of the old in the illusion of bettering it. But often it is only an illusion. Vasari in his *Lives*,

written in 1560, speaks adversely about medieval art and Gothic architecture, which arrived in Italy from the north. In fact, during the Renaissance old frescoes, even by great painters, were covered up to give place to the new. Uncle Angelo realized there were many things to discover and, infatuated by the idea, bought the castle, which did not cost much because it brought in nothing but was, on the contrary, a burden. I was twelve then and had begun to become interested in art, so I was excited when I saw old buildings. My imagination was stirred by a past life that could still live through the forms it left behind; I live through my own emotions and thoughts. Someone who had no identity had perhaps, so long ago, experienced the same things. So uncle set to work straight away and called in an expert, Mario Rossi the restorer.

I spent hours helping him, and it was an enormous pleasure to scrape away with a razor blade the crust of plaster that covered the frescoes: slowly there emerged the figures and the composition. This was a life returning to the world, coming back into existence. Representations of the Virtues and Vices appeared in the oldest rooms, the pleasures of the hunt in those of the fifteenth century, landscapes and symbolic objects in those from the beginning of the sixteenth. They had been painted by good but unidentified artists, followers of Bembo, Masolino da Panicale, and of Luini. This was my first contact with art; previously I had begun to love it by looking at books, but I really discovered it in that moment. Then too you could see a change in moral values: Virtues and Vices in the Middle Ages, semi-nude nymphs during the Renaissance.

Uncle Angelo fell ill with a slowly developing heart disease, one now easily cured with antibiotics but fatal in the 'thirties. When he understood there was no longer any hope—and I think he realized this quite soon—the sensation of the rapidity of passing time must have been horribly strong. What has been has been; there is no future to be built, no situation that can still be changed. Everything is by now fixed for eternity, but only for us. Outside of ourselves the world continues to change and be renewed in an incessant transition from life to death.

I had my sixth birthday in 1929, and so I had to go to school. My mother was worried about infectious diseases you could so easily catch in the public schools. The doctor said I was a little delicate; I was pale, and he looked into my eyes saying a word that he would keep repeating: lymphatic. The results of this could be very unpleasant, and so I would have to take a spoonful of cod-liver oil, a slimy, nasty-smelling, repellent liquid that made me sick. I cried desperately when they forced me to take it, so desperately in fact that the authoritative and severe intervention of my father was necessary—but I resisted so strongly that they had to give up.

Signorina Viganò was employed to teach the first two years of primary school lessons to me and my sister Marisa, who was two years younger. I remember having filled in notebook after notebook of "pothooks," capital and lowercase letters of the alphabet, and numbers.

My studies were carrying on with great difficulty, mathematics just wouldn't stick in my mind, and anyway I was interested in other subjects: geography, history, literature. After the fifth grade I began my yearly exams in October, except that now, in high school, Latin was added to math. This always ruined the end of my summer vacation. In September I would have to review and study. High school was far more demanding, and I needed a more competent teacher to help with my after-school lessons. I was extremely lucky because the job was given to the teacher Leandro De Stefani, though I don't know how my mother came across him. He taught in a primary school but was someone with a very wide culture, mainly in history and literature, and he was deeply read in contemporary literature, French above all. He was in love with knowledge, and this love he passed on to me. He arrived every day at five, but often he stayed on longer than necessary when I had to study history and literature, and I listened intently when he explained things to me. This was real happiness for me, and these were the best moments of my day. I would barrage him with questions about the things that interested me, and his answers were always exhaustive. Often our discussions would wander away from the theme of our lesson and we would talk about philosophy, French, German, Russian, and English literature, all things that either didn't exist or were overlooked in our nationalist, Fascist schools.

If since then I have always had a great love for culture, art, philosophy, and knowledge in general, then I owe it to Leandro De Stefani. He was one of the most important people in my life. He made me love and believe in something immensely great. I have an infinite debt of gratitude toward him. He helped me from high school to when I got my graduation certificate: eight years from

1933 to 1941. He lived in Viale Gian Galeazzo, at number 9, in front of the house belonging to my father that I reconstructed in the 'sixties. After the war I never saw him again, nor did I hear any word about him, and I'm sorry about this as I still remember him a lot. He had two sons, one called Ariele. I would like to meet him to reminisce about his father. But fifty-five years have passed, over half a century. He lived modestly on his wages as a primary school teacher and his lessons with me, which were often longer than had been planned. He read and explained to me the poetry of Valery, Mallarmé, Verlaine, Paul Claudel, excerpts from the great Russian masters Dostoyevsky and Tolstoy. He lived on the top floor in a small apartment, and his study, furnished with antique furniture bought in an auction from the house of a nobleman in Milan, was full of books. He attended a philological club where he could read the latest books. He didn't have money for vacations, but sometimes he took the train to Brianza or the lakes so he could see some greenery. With him I experienced the all-important moments in my life: I discovered the marvelous world of culture, art, poetry, a world that makes us free; poor in money perhaps, but wealthy with inexhaustible riches. A fundamental decision developed in me: art and poetry were more important than anything else, even at the cost of giving up money. Fifty-five years have passed, but my memory of him is still sharp: he was tall and thin, dressed in dark clothes, his cheeks hollow, his eyes large, and he always had a book under his arm, probably to read on the tram. Men disappear, but the love for knowledge is reborn; what I love, others will love after me. This is a great thing, a small kind of immortality that is permitted to us mortals.

So this was the situation with my schooldays. The teachers decided I was a mediocre pupil, and I had bad marks in the important subjects, though good ones in the secondary ones that for me were the most important, but my family was worried about my bad marks. My sister and brother, older by ten and seven years, found studying easy and got good marks. My sister said that if I carried on in that way I would become an incompetent in life and a burden for the family. My father expected his two sons to be active men dedicated to their work, as was the Panza family tradition, not intellectuals thinking about useless things.

My first year in high school was with the Barnabite Brothers in Via Commenda, and here my introduction to Latin was negative and I flunked the exams. In order not to lose the whole year I had to change schools and go to a private one. I don't have any good memories at all about that year; I didn't like the teachers or the other pupils. They were all the sons of noble families who thought they were more important than the others. The lessons were taught in the afternoons too, so at midday there was school lunch, which I

didn't like and didn't eat. The teachers told me off because I didn't follow the lessons: they were boring and I lost interest. I was forced to do things I didn't enjoy, and those that I did were not exam subjects. From the second to the fifth grade I studied at the De Amicis School, which was private and secular; it was in Via Curtatone, near home. I had a friend with whom I talked about art and literature. His name was Ferdinando Giolli, the son of a well-known art critic, and he died in the Val d'Aosta in 1944 during the partisan war. He was a sensitive and intelligent young man.

For two years my younger sister and I went for the summer to my Aunt Zelmira, my father's sister, who had a house in Borgio-Verezzi at the seaside. It was 1935 and I was twelve. When we were young all the family went to the sea where we would rent an apartment in Liguria for a month or else we would go to a hotel: I remember two periods in Viareggio in the Hotel Esplanade. In the afternoon we would go for trips nearby, to Lucca, Pisa, or Massa Carrara. I always enjoyed these visits to ancient towns. Life that had disappeared was still present in the ancient walls that testified to a past that had known how to create monuments that connected with my sensibility and attracted me intensely.

In Borgio-Verezzi my uncle and aunt didn't have the habit of traveling around the neighborhood, but in the morning and afternoon we went to the beach to bathe: it was good for our health and that was the main reason for going to the sea. While the others were resting I liked to go around and see the countryside; the villa was some distance from the center of town, near the railway, and trains would pass with a great roar. At night the noise would slowly lessen as the trains went farther away, and I would lie in bed and listen to the rhythmic sound that filled the nighttime solitude. When the railway had been constructed it had cut across an old upward-winding road that had since remained unused. It was very well built from cobbles, steep, and farther up it curved and the road finished against the sky: you couldn't see anything else, just the blue sky. It was a sharp division: here the earth, there nothing except the intense blue color of the Mediterranean sky. I was extremely struck by this vision and would stop and stare at it for ages. It attracted me irresistibly, and I would feel a sense of happiness that I'd never felt before. I could not understand why I felt such a strong emotion in front of a vision that was virtually made of nothing, only the infinite color blue. It was something quite beyond reach, something that could not be defined. I had discovered something quite new and felt it would have a great influence on my future life, that I would always want to relive that feeling. And I became aware that when walking along the beach and looking at the horizon of the sea, in the afternoon before the sun set, I could see the infinite above the horizon. I would stand a long time looking at the horizon and never tire of it. My uncle and aunt, though, were worried about this strange behavior, because people who were used to doing something all the time could not understand why I would spend hours looking at nothing: they thought it an illness to be treated. They told my parents about their worries, but that was the only thing to worry about since,

apart from that, I was quite normal and completely calm. When we went back to Milan only my older sister seemed worried; perhaps she understood the reason for my behavior and foresaw that I would become someone unable to cope with practical life and a burden on our family.

I do not remember exactly when my father bought the Biumo villa, though I think it was in 1935. The consequences of the 1930 crisis were still to be felt: houses could not be sold since their maintenance was expensive and they didn't pay their way, especially enormous ones built two hundred years before, when the way of life was completely different. Important families lived in an absolutely impossible way. Certainly it is a good thing that riches are no longer concentrated in so few hands, but it is also true that such beautiful, private buildings as Biumo cannot be undertaken nowadays. The man who caused the villa to be built halfway through the eighteenth century, Paolo Antonio Menafoglio, had been made a marquis by Empress Maria Teresa of Austria. He was a banker, so he too was a merchant, a merchant of money. Probably, as was the custom then, he had forked out a huge sum to become a nobleman. Certainly he was an extremely intelligent person. The choice of site was a piece of level ground on top of a hill, above the city, with open horizons on every side. It is a Baroque edifice, moderately proportioned, without useless decorations but with harmoniously realized rhythms of forms and refined architectural solutions that become visible only on close examination. The architect's name is unknown. The Marquis of Menafoglio, even if not the planner, certainly made his ideas felt. The roadside elevation shows nothing attractive, but when you enter everything changes and opens out to nature, light, space, Monte Rosa, the distant Alps.

I would like to know more about the life of the marquis because I have loved and still greatly love this work that has been passed on to me and in which I live. I own a copy of his extremely long will, full of bequests to people he felt grateful to and to religious orders for saying many masses for the salvation of his soul. A rare preoccupation today. He had friendly relations with the Duke of Modena and with the city. He was a tax contractor. In the Modena state archives there is a Menafoglio collection that would be interesting to study.

Francesco III, the duke of Este, was often the guest of the marquis, and the villa was a center of activity during the summer. Menafoglio died early in 1768 having been born in 1700. He had married one of the Beria family from Alessandria and they had had just one son. Then too the wheel of fortune was unpredictable, and after a few years the property was sold, until, in 1823, after having had many owners, it was bought by Duke Pompeo Litta who belonged to one of the richest families in Milan. He amplified the outbuildings, added the banqueting hall, and made some modification for the use of the

house and garden following plans made by Canonica, together with Cagnola one of the best architects working in Lombardy.

Pompeo Litta had been made a duke by Napoleon for his political merits. He was a liberal and democratic man open to the ideas of the French revolution that Napoleon had brought to Europe. The Litta family background was in commerce: their fortune had begun in the late sixteenth century with the spice trade. They opened a branch in Cadice where they bought merchandise arriving from America and the East at a lower price than that arriving in Venice from the Middle East. In the eighteenth century the family devoted itself to agriculture. Its patrimony grew through marriage, and the name Litta had Arese and Visconti added to it. During the 1848 revolution for independence from Austria the Littas financed the weapons for a regiment fighting the Austrians. In 1849 the war was lost. General Joseph Radetzky returned to Milan and confiscated the goods of all those who had fought against the victors. The Littas had to escape to Piedmont. These facts made the family's situation worse. The Littas had undertaken major irrigation works on their land and had incurred heavy debts. Napoleon had abolished the rights of the first-born son to the greater part of the inheritance. This had been a system for conserving a heredity down the generations and enriching it through marrying well. The younger sons had to devote themselves to the law, the army, or the church. Under the new system, the legacy of a family with many children was divided up with each inheritance, and in a short time, it was pulverized.

All these things slowly hit the family hard, and it lost all its previous splendor. The Biumo villa was inherited by the son Antonio who, in Paris, had married one of the Prior family from Geneva. She was of modest origins and, on his premature death in 1866, became the owner of the villa. When she died in 1901, the house was inherited by one of the Prior nephews who in turn died in 1934. He lived by himself and ate his meals at the Hotel Europa in the center of Varese. He loved books and had a large library that, sadly, was dispersed before my father bought the villa. Uncle Angelo had found out that the villa was for sale and that the auction had drawn a blank. He knew the property and thought it would be possible to buy it at a decent price. This was in 1935 when I was twelve years of age, and I was struck when, during the sales negotiations, I saw the garden and the interior façade of the building, a place with a dreamlike beauty. The property was in a bad state of preservation since Prior had lived by running through his assets. The restoration was undertaken along the lines planned by Portaluppi, one of the most highly esteemed architects in 1930s Milan. The property had gone through an ascending and descending cycle. It had shared in the destiny of its people and

families. The founder, an exceptional person, had created the estate; decline set in with the second generation and became more rapid with the third. Only rarely can we avoid this inevitable destiny. A hundred years of history is a long time. My father was extremely happy with his purchase, as was my mother who could once again put down roots in the city where she was born. From the garden balcony you could see the roof of the house she had been born in and where my grandmother lived. But I was the happiest of all. The place was for me something ideal. A setting where nature was united to art. The garden had been constructed in the best way for seeing the sky: light surrounded it, the horizon was visible in all directions. The solitude was complete: even though the city was nearby, it was lower down. The only human presence was the sound of the bells that, at sunset above all, seemed to fill the heavens and come in all directions from the parish churches of the various neighborhoods of Varese. It wasn't just a human presence, but also something different, the present and the past, the land and the sky, the living and the dead, a prayer that rose on high. The sounds united everything, living men and those who had lived there, a sound full of memories of a vanished time, one of expectation and hope for the future. A pause in the day's life, a moment for listening to the voice rising from within our being.

Another particular opportunity was to appreciate nature by looking at her, to contemplate, without obstacles or interference, her beauty, the colors of the flowers in the bushes and the grass of the fields. By concentrating I would discover things I hadn't noticed at first sight, and it was like penetrating her essence, becoming a part of her, dissolving myself in something that was extremely beautiful. I read the poems of D'Annunzio. Even though in no way did I agree with his way of living or thinking, there was one poem that gave me the same feelings when, along the beach in Versilia, he felt himself become part of the sea, the sky, the stars, the mountains, and the pines in the forest, as though all these things entered into him. A mystic kind of pantheism where nature was the supreme being. The heart of creation. The Biumo garden is the place most adapted for such an experience. It is a huge artificial square constructed by flattening the hill; the land is held up by weighty walls that raise the level of the garden within their perimeter and isolate it from the surroundings. It is a green space between the earth and the sky, and now, after all these years, I still feel the same emotions. Whenever possible, as soon as the light is clear my greatest pleasure is to return to Biumo. At sunset the light slowly fades, the day is about to end, the white clouds are tinged with gray and pink; later they become red and the sky changes from azure to pale blue; the distant mountains, a dark shadow, seem to retreat and the sky broadens. The sun is life; it sinks behind the horizon to illuminate other

worlds. I feel the wish to be drawn down with it; the wish for life lessens. The night is good and serene; there is a desire for something that must return. When the first star becomes visible this sweet sadness disappears and hope returns again together with the infinite sky full of distant lights.

SCARLET FEVER

carlet fever is an illness that is not dangerous, but it is highly contagious and affects the young above all. Now it is easily cured with antibiotics, but in Milan in 1935 this was not possible. The only precaution was isolation for forty days, because otherwise my school friends would have caught the disease. It was the beginning of May and I was studying for the end of semester exams that would decide whether I would fail or pass in Latin and math. Then boring exams again in October. When the doctor diagnosed the first symptoms of scarlet fever and ordered the most rigorous isolation, he also let the school know in the event of other cases. The rules were very strict. Only my mother could come into my room, wearing a white gown and rubber gloves to bring me food. For me this was all a great relief since I didn't have the big problem of the final exams; they couldn't fail me because, had I been able to study I might perhaps have been able to better my past results. And anyway I didn't have to study any more as by now school was about to end. So my first concern was to bring into my room the books necessary for learning what I liked, above all the history of art.

Recently there had arrived at home an important tool for learning, the *Treccani Encyclopedia* in twenty-six heavy volumes. This was a monument to knowledge begun by Giovanni Treccani, an enlightened Milanese industrialist. The encyclopedia was full of information, above all about history, art, and literature, and still today it is unbeatable in these subjects. The suggestion for buying it came from my Uncle Vincenzo Vago who had married one of my father's younger sisters, Aunt Carla, a delightful woman. Uncle Vincenzo was widely read in Italian and French history. He loved France and went there often to see the monuments and the sites of important events. He was also a refined gourmet. When he traveled he stopped off at famous restaurants and chatted about wines and cooking with the owner and the chef. He was a handsome and distinguished man who dressed with quiet elegance and was also our family lawyer. He had studied law at the Ghisleri College in Pavia and told us many funny stories about his student life there. Aunt Carla was the complete opposite, always happy, optimistic, expansive, and affectionate to her nephews and nieces. She had no children but adored her husband and lived only for him. My uncle died at age seventy-five in 1955. My aunt couldn't live without him and died just a few years later. She would often come to our house because she wanted to be surrounded by youngsters and our children. This is a dear memory of a dear person.

I recovered from scarlet fever in three days; while still contagious I was kept in isolation, but I could also devote myself to my great interests without any

hindrance. I began to examine the artists with the most reproductions and to memorize the formal and expressive characteristics of each of them. But flicking through an encyclopedia was also a way of getting to know a great many other things: Roman and Greek history, the Middle Ages, astronomy, biology. When I opened a volume to look something up I took a great deal of time to get there because I always came across many other interesting things before I could read about Michelangelo or Titian. The same thing still happens today when I look something up in the encyclopedia. I have to force myself to close the book and go to bed because otherwise, without my realizing it, it gets very late. Anyway, after thirty days I had learned a lot of art history. I would set myself an exam by covering up the captions to the images of works by various artists and almost always managed to identify the century, the school, and the artist. My artistic education had made a definite improvement.

With my savings I bought books about art. I was fascinated to read the letters of Vincent Van Gogh to his brother Theo. He was one of the artists I was most attracted to: I experienced his torments, his anxieties, I understood the reasons for his desperate end. I saved the money for the tram to go to Latin review with Professor Alcide Malagugini, and with the money I would buy good color reproductions of famous artists, Van Gogh, Manet, Renoir, Titian, Hals, and many others. This was my imaginary museum: the prints were sold separately by a shop that still exists today in the Galleria Vittorio Emanuele in Milan, and its name is Centenari.

Death was something that I recognized without there having been one in the family or among my friends; it was something without a specific cause but that suddenly began to torment me. I couldn't get it out of my mind. It always came back, and I couldn't do anything to repress it. I needed to find a way of regaining my serenity, but it wasn't easy. Before that particular day it hadn't yet come to mind, it was something that concerned others, and so I was not interested in it. But when I realized that I too would die, it was sudden and frightening. It was something inevitable and final. Everything I loved would disappear and me with it. The things I loved, I loved a great deal, and this increased my anxiety, and it made no difference that I was young and the likelihood was remote. It was the discovery of time, that life was not eternal, that everything passes, ends, and necessarily runs toward a conclusion in which I saw only nothing. Nothing is a terrible word, and there is no answer to this distressing problem. It was definitive, inevitable. In all of life's situations there are remedies: if you lose something important you can find another that helps you to live. Nothing is definitive; even though the new solution might be less beautiful or good than the earlier one, it can be lived with, but there are no compromises with death.

I searched for an answer among the wise, those who reasoned about what life was, who were dedicated to finding answers, the philosophers. But I found no answer. Strangely it was a problem they did not deal with and did not try to resolve, even though it was obviously the most important one. I remembered the words I would hear at Sunday mass. The words life and death were often near to each other, they came into the same arguments. Perhaps this was the only solution.

I also read about certain philosophers who dealt with the problem by eliminating it. When you are dead you feel nothing, you do not feel pleasure and you can't even dream because the brain no longer exists. It is a far deeper and final sleep than our sleep at night. It was sleep I hated; I wanted to live, not sleep. And then there was the problem of the soul. Are we only a body or does there exist something more important that allows us to live with awareness? Where do our strongest and most beautiful emotions come from? They are so different from the others connected to our physical existence, to eating, drinking, sleeping, fearing danger, sexual desire. Obviously the physical and the spiritual are mixed together and cannot be separated. The body dies and disappears, but conscious activity is not the same thing. This was a thought that gave me some hope.

We live in a universe. We did not create it, we do not know where it came from. Nothing is created from nothing, nothing is created from itself. Everything that exists exists because there existed before something that generated it. Time passes and everything changes, but things can change only because there existed before some possibility that caused present existence. This relationship between facts that happen in time, what philosophers call the causal principle, seems a certainty to me, an indubitable truth that gives rise to other certainties. So philosophy was becoming an extremely interesting argument for me, even more important than art. To test the exact meaning of a word, to follow all the consequences of reasoning: this was a mental activity that needed great concentration on my behalf. I suddenly discovered contradictions in many lines of reasoning that had once seemed convincing to me and that might have led to a satisfactory conclusion. I would have to begin again, but with my doubts my own anxiety increased.

The philosophy of Nietzsche was topical in the 'thirties. This was philosophy expressed through poetic images and was very seductive to read. The logical reasoning was contained by a metaphor. This was an attractive language that hid basic mistakes. The theory of the Superman was certainly outside my attainments, and the theory of the eternal return had no basis whatsoever: he was a philosopher who condemned metaphysics. His theories had a great success because they were imaginative rather than philosophical. I read *Thus Spoke Zarathustra* with the greatest confusion; its language was attractive, the ideas were completely deceptive. A dictator was embodying them: the prophet had found the person to carry them out. The blood of millions of innocent people was the price Germany had to pay for the false prophecy. I remembered what I had felt some years earlier. I opened the Gospel according to St. John and some phrases struck me with a blinding light.

After the September 8 armistice in 1943 I decided to escape and hide in Switzerland, which was not too far away. Had I stayed I would have been drafted and would have had to fight the war alongside the Germans and Fascists against the Allies, something I refused to do. The other choice was to remain in Italy in hiding as a clandestine, with all the risks this involved: a dangerous illegal situation. The partisan groups had not yet been formed.

I remember that it was, I think, on September 23 that I crossed the border at Ligornetto, some ten kilometers (6.2 miles) from home, after having made the journey in a gig pulled by a horse from our stable in Biumo, which was used by my father to go to the station. Once at the border I realized a lot of others had had the same idea. This wasn't a clandestine escape: the Swiss frontier guards had pulled down the wire fence to make the crossing easier. The crowd of fugitives was sent on to the Mendrisio sports grounds where we stayed until being sent to various refugee camps. Swiss organization was highly efficient: the same evening we were put on a special train for the Swiss interior. On the train during the night I slept deeply, and I woke up on the other side of the Alps. The train had stopped at a minor station. I had a dream-like vision: everything was in perfect order and condition, everything was whitewashed and painted like new. Even the old station, the roads, and the sidewalks were as clean as though they had just been swept. The few people I saw were dressed decently. I had arrived from a bombed city, just a few days before, and I had seen the house where I was born burn down. The setting of my childhood memories had disappeared. For many days Milan was covered by a cloud of smoke rising from the fires, many roads were blocked by the rubble, everywhere there was debris caused by the explosions of bombs. The city was half deserted and people cried at the loss of their homes. Many monuments to Milan's culture were badly damaged. The cathedral, miraculously, was intact, but the royal palace was half destroyed by fire, with only its outer walls left standing, as was the case with the other buildings around the square. The human victims were few: the air raids had been expected, the population had mostly left the city. The situation was most dramatic in the poorer areas where everything had been lost, above all in Porta Ticinese, the dockland area along the Naviglio River. Thousands of people were camped out in the streets.

Our train journey ended at Münchenbuchsee, a name meaning "Munich-books-lake." It was the birthplace of the greatest Swiss artist. This was almost a prophetic coincidence, for I only discovered a long time later when studying Paul Klee that this was where he was born. I was lodged, together with a group of

some hundred other refugees, in the town's schools. The first few nights I slept on a straw mattress, but later it was possible to rent a small room at a low cost. There was reasonable freedom of movement in the town, and I had a few francs so I could even eat in restaurants: for a refugee the situation wasn't at all bad.

It is lucky we have a country like Switzerland in the center of Europe, a country that has always been keenly aware of the misfortunes of others. It has always been hospitable to those who, for various reasons, had to leave their country of origin. It is the most democratic country in the world, where the rights of the individual are respected; it has an administrative system where bureaucracy is at a minimum and which works to help the private citizen and not to bully him for its own advantage. The greatest merit of a genuine democracy is a community where trust is at the heart of civil life. It maintains political stability; it is aware of rights and duties—a great quality that creates this trust—and for two hundred years it has not been involved in the wars that have caused Europe to lose its world primacy. This favorable situation has not closed Switzerland in on itself. It has a social and political system that other countries ought to imitate. The confederation has had for many years one of the highest per capita incomes in the world, and it continues to have it, though its differences from the surrounding countries have been much reduced despite the terrible destruction caused by so many wars. When man is allowed to work freely he has a great capacity for creating riches. The will to create and produce is far stronger than inertia or living from hand to mouth. Of course, these are not changes that can come about in a few years but in the life of a generation. In this evolutionary process what is decisive is the entrepreneurial spirit, the ability to change activity in order to adapt to new conditions, the will to accept risks for dealing with changing circumstances: in other words, to think and act for the future and not for the present or past. I am here portraying the real middle class. This is the social class that makes the world progress, and all the others follow after, unless they are busy creating obstacles. It is an open class where all those can enter who want to work and get ahead according to the rules of the economy and the market: competition, the refusal of political interference in the world of work and productivity, respect for the moral and legal codes of rights and duties. The middle class has in the past been bitterly criticized by the left because, obviously, it was incompatible with a Marxist system, but the judgment of history is clear. All the states that eliminated the bourgeoisie must now recreate it if they want to emerge from repression and misery. Obviously the bourgeoisie is not a perfect form of society, but it is certainly far better than a bureaucratic and political society. The risk of the middle class is the temptation to use fi-

nancial power in order to have political privileges, and it is the task of a democratic government to avoid these dangers.

My stay in Münchenbuchsee was brief. The refugees were all soldiers and I was the only civilian, so I had to change camps. I was sent to another village on top of a hill, a place with not many inhabitants and surrounded by woods. The camp was fairly big with many wooden huts and had existed for quite some time: there were whole families of Jews who had come from central Europe. Life in the camp was fairly severely controlled, and we could leave it only occasionally; the food was frugal, with lots of potatoes and carrots but little else. Our lives were well ordered. We had to do the cleaning ourselves: I was often charged with cleaning the toilets, an undertaking I did with the greatest diligence. There was only one other Italian, a doctor, who asked me to act as a nurse, which I thought was for me a more elegant job than cleaning the toilets. I helped for a few days, but then I pleaded with him to let me leave since seeing people suffer from diseases made me feel ill too. I preferred to go back to cleaning the toilets.

In the meantime my father had asked the Swiss representative of the Panza firm to contact me and see what he could do to help. I was twenty years old, and this was the first time that events had separated me from home for a time that promised to be long since the war showed no signs of ending. Still, it was far better than being in Russia or Libya where you died on the battlefield. I was lucky, thanks to Switzerland. There was a possibility of leaving the internment camp if a family asked to host a refugee. The representative of the Panza firm, Antonio De Simoni, came along to see me. He was my savior: I felt all alone in an alien world, and to meet a person who spoke Italian and had a pleasant look about him was a way of leaving my isolation.

I could never have imagined that the solution suggested would go far beyond my greatest hopes and that he would have asked the authorities if they would allow me to be a guest in the house of his parents: the father had died a few months back, the brothers were almost all married, and so there was a room free in Lucerne. Of course I accepted the offer with enthusiasm; it was the best possible solution, and I couldn't imagine anything better. The bureaucratic side of things was taken care of very quickly and, fifteen days later, I took the train to Lucerne.

It was a great fortune for me to have the possibility of knowing and living together for such a long time with a family like the De Simonis. It revealed a different way of living to me. Here I found a rigorous moral behavior undertaken with simplicity and generosity, and these ideal values were exerted in everyday life. There was a complete unity between having to be and being. We think that morally perfect conduct, if such a thing is to be found in this world, is something to be arrived at at the cost of sacrifices and tough struggles with oneself. In this family it existed naturally because that way of behaving was the best way, and being the best was the easiest, or at least it ought to have been. I arrived in Lucerne in the fall of 1943. The city is on the banks of the lake of the Four Cantons at the foot of the Alps.

The rocky pinnacles of Mount Pilatus were at the bottom of the garden. It often rained, but when it was clear the mountains were an intense green and the blue sky was reflected in the water of the lake, which was divided into various branches, each different from the other. The father, Alberto De Simoni, as I mentioned, had died a few months earlier. My father had known him because of business connections and thought a lot of him for his honesty. His death had left a big gap in the family. He had been born in Stradella, on the Pavia side of the Po River in Lombardy, as had his wife Elettra too, an angelic woman. She resembled my mother a lot. The mother of five children, she accepted her husband's death with serenity. She must once have been extremely beautiful, and she still was even now that she was old. Alberto De Simoni had emigrated to Switzerland as a young man and was a salesman for Italian foodstuffs, among them the wine of the Panza company. The work was being carried on by two sons, Tonino and Mario, both married with children. Still at home were Erminia, engaged to a young man from Rome whom she never saw because, as a result of the war, communications with southern Italy had broken down, and Vittorio, a medical student in Bern who came home every weekend. It was a family in which the Creator of all things and of ourselves was experienced as something alive, real, not simply as a hypothetical thought.

I was a stranger when I arrived in the house, but immediately felt I was not an outsider; in fact I was almost another son to Elettra. People predisposed to think well of others find at once the possibility of communicating with others of a similar disposition. Expressing yourself becomes a spontaneous fact, something you do with pleasure because communicating and living together with others is, in fact, a fundamental pleasure: the sadness of solitude, the feeling of being shut out of other people's lives disappears and allows you to

participate in the feelings of those who have a similar way of living. I am sure that Erminia understood straight away who I was, what I was looking for, and what I stood in need of.

Probably she saw that I was a young man who loved culture and who studied philosophy, art, and science, and who knew literature and poetry, who read Tolstoy, Dostoyevsky, Flaubert, and all those other writers it was necessary to read in order to know what culture was about. And in fact I also read newspapers and magazines about these subjects. All these things gave pleasure but could not completely satisfy me, because they could not replace a basic problem: what to do with my own life.

Culture was a great pleasure but it was also a passive one, and I was consuming the things that others had made. Great things, but not mine. I was greatly attracted to art, as it was the most immediate way of communicating an idea, an emotion, a feeling for the great wealth of ideal values: but it was a possibility to be excluded. I had enrolled in law school, the exams had gone well, and I had had good grades; it was an interesting humanistic activity, but only while I was studying it, and I had no intention of becoming a lawyer. Finance and economy were to be excluded as I had none of the capacities that my father had in aces: intuition and experience about the movement of the economy and its possible developments. When I had finished my exams my father sent me to work in the office of the Panza firm where I was concerned with accountancy, something I didn't understand, and I spent my time thumbing through the ledgers with their columns of debits and credits, which only confused me. It was torture. He wanted me to become a good accountant and follow a solid and concrete activity for which income was the yardstick of its usefulness. Unfortunately I was only interested in things that created no income, such as art and poetry. They cost almost nothing, and I thought I would always have the small amounts of money that were necessary.

I did not like the luxuries of life and far preferred simplicity in all things; I hated people who wanted to show that they were rich and, therefore, more important than the others. I hated appearances, and I didn't care much if the real underlying person was not easy to make out: I can see from people's eyes whether they exist or not.

For all these reasons the De Simonis were a family quite different from my own: the moral values were the same but they had another way of experiencing them. In my home, religion was respected and became extremely important when someone was about to die, but it was not part of everyday life. We went to mass every Sunday, we children had to say our prayers every evening, but that was as far as our relationship with it went. It was the way of life of the middle-classes who were busy creating businesses and the wealth of society.

This was the main purpose in life, carried out through hard work and commitment because the aim was so important: accumulating riches was not only useful for the person who was enriched but it also created activity and work for the others. Work was my father's religion. His strong personality dominated family life. He was a creator and had constructed a lot during his life; his assets were the proof of assiduous and farsighted labor in which making intelligent decisions was of the greatest importance in order to create favorable situations. The sheer intensity of involvement in work didn't leave much space for other considerations and other aspects of life, all of which were considered unnecessary luxuries.

I was interested in intellectual activities, and at home they considered me a kind of deviant from the right path: which was work. Things were different in the De Simoni household; for them unnecessary things were necessary. In this I found myself at home, but there was one crucial difference: I had been brought up to think of religion as an important but marginal aspect of life. My background was basically secular, one in which religion did not exist, for there only existed literature: Manzoni, Dante, Dostoevsky, Tolstoy, the poetry of Paul Claudel, the novels of François Mauriac, undoubtedly examples of great literature but not of life.

The basically atheistic and nebulously spiritualist mentality of Benedetto Croce was the dominant philosophy. In order to follow the rules of a free thinker an intellectual had to be free from any kind of conditioning, the master of his possibilities for thought. And proud of his freedom. In his politics he was a left-wing liberal, obviously anti-Fascist, and this was the thing that was most just. In Italy under Fascism, Marx's *Capital* was forbidden but Communist ideas were discussed, though of course in private among friends. The long ears of Ovra, the organization for suppressing anti-Fascist propaganda, were very highly attuned, but Ovra only intervened when activity became organized; otherwise the principle was live and let live, outbursts against repression were considered a safety valve.

There were also a number of jokes about the Fascist leaders that spread without any kind of hindrance. Everyone enjoyed them without problems. The free thinker was the model of the real intellectual and so it was necessary to know the philosophy of Kant, Hegel, Nietzsche, Croce, as well as the operas of Wagner, French and Russian literature, Impressionist and Modern French art, Braque and Picasso. These, more or less, were the foundations of the culture of the times.

This was the continuation of the French Enlightenment tradition of the eighteenth century. The goddess of reason was placed above all other gods. Only what was reasonable, understandable by reason, was true. There were no rea-

sonable explanations for death, evil, and suffering, nor for some people's search for the absolute.

This was a decisive period: my time in Lucerne after the armistice in Italy; Italy becoming a conquered nation; the Milanese bombardments; the German army imposing martial law; the need to evacuate to Switzerland; and, above all, the crisis of my difficult twenty years. I had had a tormented adolescence. My mind was torn between opposing forces, but above all I had an intense wish for happiness. Looking at nature I felt great joy. Reading poetry was a constant pleasure.

I didn't feel up to facing reality. We must live, and to live we must consume. To be efficient like those who were active and productive. With my slow way of thinking I had the impression of always being late. This situation created an inferiority complex in me. I was also worried by other contradictions. The certainty that everything came to an end, that one day I too would disappear, swallowed up by nothingness; all this frightened me. When I looked at the blue sky, the beauty of nature and art, I regained hope, but only for a short time; then my fears returned. I thought I could find a solution, some sure hope, but I didn't find it. I looked for an answer in philosophy, but so many contrasting ideas only increased my confusion.

In Lucerne I had the good luck to be the guest of a Christian family who experienced their values spontaneously. The serenity of the place and the time I had available were for me an opportunity for deep thought, even though I was preoccupied at the time. The war never ended: it was to last more than a year longer, and news kept arriving of death and destruction. What would the political situation be in Italy and Europe after the war? An unknown quantity. The Russian army menacingly advanced toward the heart of Europe, the communist parties made the most of their new power, and in Italy too they were strong. The middle classes could lose everything, and with them the hope for a new democracy might be lost too. A proletarian future rather than a wealthy one.

I had long discussions about philosophy and religion with some philosophers and priests among the friends of Erminia and Vittorio De Simoni. These were serious conversations in which everyone expressed their own ideas and criticisms energetically. Often a Jesuit father came along, a professor of philosophy who, I believe, was in Lucerne because his ideas were not quite orthodox. These were lively discussions with a person of greater culture than mine, but my questions, rather than embarrassing him, engrossed him. I studied philosophy enthusiastically and knew a little about it. His name was Father Otto Karrer. It sometimes happens in life that the solutions to pressing and worrying problems do not come as you expect, but at times come unexpect-

edly. I continued to think about the basic problems of life and death, of pleasure and pain, of nothingness and the hope for an eternal life, but I never came to a conclusion; for each assertion there was its reverse, reasoning led to a contradiction, so it was necessary to start again and follow a different path. I was at a crossroads, everything was doubtful, certain hope was not to be found.

I was envious of those for whom it was enough to hope, who did not ask for explanations that can be given, certainties that cannot be had. Logic was a yardstick too short for something that cannot be measured. This assertion touched me deeply. We cannot understand an entity beyond all understanding; my education that gave unlimited trust to "reason" would not permit it. As I was a lover of art I should have been able to understand that there are many things without a logical explanation, amongst which are beauty itself and, more important than all, life itself. Scientists fool themselves that they have discovered it because they have discovered its mechanisms, but a mechanism is only a "means;" our will to live is the experimentation we undertake within ourselves. It is an energy that dominates nature and the universe and makes it evolve; the things that can be observed are only the tools.

Understanding that this ascertainment was true resolved things. The goddess of "reason" could no longer be an absolute power; it was necessary to know her limits. This was certainly a powerful instrument, but the instrument has a "Creator" who is infinitely more powerful. This is the "Creator" who shows what the created must do through his free choice. Understanding these "indications" is either anguish or salvation; the middle way is that of the useless, the non-living.

The eventual end necessarily had to be good; it was not possible that the Creator wanted to fool, delude, destroy, and cause suffering only to disappear at the end. It would be an inconceivable monstrosity to create in order to cause suffering and deceive with the promise of happiness only to take it away definitively. In fact there exist evil, pain, and death: happiness cannot reside in the things that we see and touch, for these can only give an imperfect and brief happiness. There can only be a promise that is realized in another way that we can neither think of nor imagine. We must only trust in "His Goodness," in the goodness of "He who is Hidden"; it is an enigma. We must adapt ourselves to the existence of this enigma and have faith. Many times the "enigma" is generous: it shows us the way, it gives us proof, it gives us anticipation, even though partial, of our final end.

My inferiority complex disappeared; I serenely accepted my limits without pointless moaning and tried to reduce them by paying more attention, but even if I weren't able to manage this it did not have much importance; what

was important was to do everything possible to attempt it. My hope did not reside in corruptible things but in an infinite "entity."

From that day on the aim of my life was evident: to search, to find, to see "the invisible" within the visible.

VITTORIO DE SIMONI
LUCERNE, SWITZERLAND, 1917–
SOLOTHURN, SWITZERLAND, 1993

In 1993 my dear friend Vittorio De Simoni died. For many years he had been ill with cancer, which he bore serenely, looking after himself and working normally as a doctor. The previous year the illness had worsened. We got to know each other in Lucerne in 1943 when I was a guest in his house during the war. Together with his sister Erminia he had helped me out of the bitter mood of a twenty-year-old. His help was most valuable through his words and, above all, with his exemplary Christian life. Every year my wife and I went to visit him in Solothurn where he lived with his family. It was always a great pleasure to stay with him and speak about so many fascinating things, talks you can only have with your most intimate friends. Our last visit was the final visit. His health was rapidly worsening, but his spirit and will were extremely lively. He was far thinner but could still lead an almost normal life.

He spoke serenely of death as an event close at hand, and he was always coherent in his Christian principles. His death would not be the end, but the beginning of his real life. His illness caused him great suffering, but there was no trace of it on his face. His eyes looked at me with unusual intensity, a luminous gaze that saw afar. A goodbye for a new meeting, a completely different one. He was the one leaving for a journey to a new continent, and we were the ones who were waiting for another departure. Total trust in the goodness of our Father. As he had lived, so he prepared himself for the end.

There were few like him who, both as a doctor and in his everyday life, were completely generous. His account with the past was positive, and this could be seen from his eyes. After a short while we heard of his death. The definitive departure that he had waited for, not the end but a beginning. This happened forty years after the story I am telling. A long period, enough time to make good things better and mediocre things mediocre. At eighty years old you can consider the parabola from the beginning to the end. It is important to end well: all the rest is of very little import.

FATHER DAVIDE MARIA TUROLDO
CODERNO, UDINE, ITALY, 1916–MILAN, ITALY, 1992

I often saw a monk, Father Davide Turoldo, and these were occasions for discussing my doubts about my faith; he always had the right answer. The force and beauty of his vision were as convincing as his reasoning. He was a great poet: he wrote poetry, but above all his poetry was revealed in his words and his way of living. He would rouse people. Faith was an invitation to accept sacrifices, a means of resurrection for a greater life, a higher one, where the splendor of its beauty became an irresistible attraction. He revealed the true face of Christian faith: to be men in the fullest sense, not as children of nature but as the Creator's children in whom are concentrated all the possibilities for good to be shared with Him.

My friendship with Father Turoldo lasted all his life: he died some years ago of cancer. He officiated at our wedding and baptized our children. His ceremonies were solemn, and he repeated the ritual words at the top of his voice, one by one, and their meaning penetrated the mind. His sermons were never generic but were about the real problems of life.

VITTORIO TAVERNARI
MILAN, ITALY, 1919–VARESE, ITALY, 1987

In 1946 I met the sculptor Vittorio Tavernari, and he was the one to show me the world of art. He had many artist friends, among whom were Radice, Morlotti, and Guttuso. He was an artist who welcomed influences, was culturally sympathetic, and who was not enclosed in a single-minded vision. His best works were those that most directly expressed his nature and had a corporeal, vital physicality. His female busts are his most expressive works: the female body as a generating force, the creator of life, the flesh that creates man and where the wonder of birth is realized. We would meet in the evening to talk about art, above all contemporary art, and these were long and fascinating discussions. We would speak of Picasso, who was in those postwar years highly topical. In fact he influenced many artists of the times. Guttuso too painted canvases inspired by Picasso: the weakest ones. He freed himself from this by returning to a more traditional figuration. One of Tavernari's great merits was that of introducing me to my first abstract artist, Mario Radice, who lived in Como. Abstraction was a rarity in the 'forties. But in Como there was a group among whom were Soldati, Rho, and Reggiani. Licini was also part of the group, but he lived in the Marche, in Monte Vidon Corrado, and I met him later in the 'fifties. Radice was an intelligent man, the best of the group, and

his talk was extremely interesting. I remember a line of reasoning about what a masterpiece was, something that stands out from the ordinary, that happens by instinct almost without wishing for it, and perhaps each one of us in our life could create one, but only once. Tavernari suggested I buy some pictures by Radice, but sadly I did not have the money: this was my first chance to become a collector but I was not able to. My brother had some money, and so I thought it might perhaps be possible to convince him to buy something. We went to the artist's studio in Como, and my brother bought three pictures. The cost was some tens of thousands of lire. The cost of living in 1946 was 1,000 lire a day, and 30,000 lire was a month's salary. I think Radice at the time needed the money. My friendship with Tavernari lasted until his early illness and death, at the young age of sixty-eight (the word "young" should be understood as being used by someone who is eighty years old). I remember some pleasurable and interesting invitations to dine at Varese where I would find a Jesuit father, a professor of philosophy in Gallarate and a person of great culture. The conversation was extremely interesting, ranging from philosophy to art and problems of the moment. The organization of these dinners was due to Tavernari's wife, Piera, a violin player and a woman of great qualities. At times there would also be Guttuso who had become the cultural representative of the Communist party, though over time he came nearer to a democratic position, as happened with many Italian intellectuals who had been Communists only because this was the strongest opposition party. Occasionally the writer Piovene, who lived in the outskirts of Varese, would come along. He was a great writer with exceptional gifts of psychological penetration. In the 'thirties and 'forties he was famous but he is not spoken of nowadays. What strange cultural behavior or, rather, what errors are committed by intellectuals. *Gazzetta nera* and *Lettere di una novizia* are masterpieces. He was an introverted person and in his conversation did not reveal much about himself. This kind of behavior is common to great people who reveal themselves only when they paint or write. Art is their real freedom. Eugenio Montale, the greatest Italian poet of the twentieth century, was somewhat similar. At times he was invited to Varese by our friends the Bortoluzzi; he would stay in a corner, spoke very little, mostly generic phrases, and it seemed he was only there because he had been obliged to come, and that his thoughts were elsewhere. On the other hand, how else can a great poet behave in everyday reality? A man who is searching for the most intimate and hidden sensations that only silence and interior peace can reveal? I had a similar impression when I met another of the great poets of the twentieth century, Giuseppe Ungaretti, whom I came to know through Guido Le Noci, of the Apollinaire Gallery. The one of his poems that most struck me when I read it for the first time at sixteen con-

tained only four words, yet they expressed everything that could be expressed: *Mi illumino di immenso*, "I am illuminated by immensity." This made me think of the sun rising over the sea and of everything great that we can perceive. I have always been fascinated by the ability to say a lot with little. This poem is a typical example. Ungaretti doubtless had his moment of intuition, but finding the right words must have caused him immense labor, discarding many less efficacious alternatives. It is always like this, and Giacomo Leopardi's greatest poem, *L'infinito*, is very short, but there we find all his life and his unsatisfied search for an infinite happiness. This is the condition of all those who search for genuine happiness: I don't like chatterers in art at all.

Immediately after the war I met another friend with a great passion for culture, Popi Chiesa, whose father Pietro also was a highly cultured person with a refined aesthetic taste. He had a magnificent library of books illustrated by famous artists, all French editions. It was a great pleasure to turn the pages of those books. At the time Popi was unsure whether to devote himself to the book business or to study Chinese art and language. After a long stay in France, which then was still the center of European and world culture as well as a center of publishing, he decided to devote himself to the former, above all to Italian Renaissance manuscripts. His was not the work of a merchant but of a humanist who bought books to keep them, study them, know them through various lines of intellectual research, and to discover the ignored or overlooked values of our most fruitful past. His conversation was always interesting and enjoyable. He was a man of great sensitivity, affectionate with his friends; it was a pleasure to go and see him in his studio and see the books he had in his hands at the moment: it was a great emotion to see the beauty of the illuminated manuscripts. His was a love for a culture that in the past revealed itself through enriching a text with images and colors, which demonstrated that a book was an extremely precious object meriting particular attention. We passed many splendid evenings together with Elena, his wife. He loved conversation with friends, but also good cuisine in the tradition of all real humanists. Sadly he died early leaving a great emptiness behind.

Life in Varese continued happily, with studying, meeting friends, and reading. The great moment for making choices was on its way. After graduation I would have to work and busy myself with family affairs, or else choose what I preferred: study, art, philosophy. Intellectuals were not highly regarded in my family, who preferred a job that gave visible results. The involvement in an intellectual activity might be accepted only if you could demonstrate having the evident ability; they would never accept it as only an expedient for avoiding duties and responsibilities. Duty worried me. Work's moral value must be shouldered even if you don't like it: you must work; this is the same obligation for everyone. We have enormous values as a result of living in the society that we do, and as a result we must pay the debt that results from this. I was studying law but the profession of lawyer didn't appeal to me at all. Among the subjects studied in law school there was one that attracted me more than the others because of its affinity to a subject I loved: the philosophy of law.

This was why I chose to devote my graduation thesis to this. I thought it would be the occasion for demonstrating my aptitude for philosophical studies. Had I been able to show that I could dominate the subject I would then have had the possibility of thinking of a profession. I asked my supervising professor to set me a thesis on the philosophy of law.

I chose the subject of justice in the philosophy of Antonio Rosmini. My choice seemed interesting: Rosmini was a good philosopher who had interpreted Kant in the light of the Catholic philosophical tradition; he had been a priest and had founded an order and a school at the beginning of the nineteenth century. I searched out the texts on the subject, which I found in an antiquarian bookshop in an edition from the beginning of the nineteenth century. There were five lengthy texts of about three hundred pages each, and I was amazed that so much had been written on such a narrow subject: it would be a heavy task just to read it all. My aim was different. I did not want to become a specialist in Rosmini, even though he merited it. He is a somewhat overlooked thinker who deserves more attention than he gets. My aim though was to write a treatise on justice expressing my own ideas, not those of Rosmini, and this was a daring project, something that a student should never undertake. A student must only show that he has understood what he has studied, not put himself in the place of the subject to be studied. I realized too late that I had set out along the wrong road and that the undertaking was bigger than my possibilities: it was a disaster.

The professor complained of how I had avoided doing what I should have done, but perhaps because of the good grades I had had for other exams he didn't fail my thesis but passed it with the minimum grade. This was a failure for my studies but also the end of my dream of becoming a philosopher. I had to face up to some sad decisions. My life of studying in the Biumo household had come to an end. I had to go to work in Milan and involve myself with administration and commerce. This was in June 1948. Another sad event was also happening: my father had been diagnosed as having an inoperable cancer of the liver, so he had no hope. By now it was the fall of 1948, and no longer involved in studies I went to the office to help my brother, who had already worked there for some years. For me it was like entering a completely different and strange world. I didn't know where to start in order to do something useful, and I did not have any particular task. I listened to what the others said, I opened letters, quite useless things. I did not manage to find my place, and this was a really uncomfortable position to be in, a kind of torture, and time never passed. When my father asked me about the things that had happened during the day I spoke only vaguely and didn't give him useful concrete facts, so obviously he became worried because he wasn't told what he wanted to know. But what could a philosopher manqué do, someone who was used to refining his spirit by looking at the beauty of flowers or reading poetry? The firm dealt in large consignments of wine that it bought, kept on deposit, and then sold to be freighted in tanks by railroad, as was the common way fifty years ago. My father's health was quickly worsening. In January 1949 he went into a clinic. I remember his last journey in the car from the house in Piazza Mercanti to the Città di Milano clinic in Via Lamarmora, two hundred meters (656 ft.) from where I have lived for the past forty-eight years. I looked in a different way at the city, the streets, the people, life, knowing that this was the last time.

He put up with the pain of his illness with dignity and without ever complaining. This was an inexorable fact, and he knew how to resign himself to it. In his seventy-one years of life he had done a lot, and his life has been well spent, in complete honesty with everyone; he was admired for his moral qualities and had also been severe with himself; no one could reprove him for anything. His conscience was clean, the first quality for dying in tranquility. A few days before the end he felt better: he was not in pain and had enough energy to talk for a long time. He wanted to see, one by one, all the people connected to the family and to work in order to give directions and recommendations for what to do after his death. He wanted the family to stay united and in harmony. He knew that my mother, with her angelic presence, would do ev-

erything she could. He had a very strong sense of continuity: our work has served something if it is of use afterward. What he left to his family was the continuation of his lifetime's work, which he wished continued in the hands of his sons. He had not had the joy of seeing grandchildren, as none of us was yet married.

He asked his sons to develop new activities because the firm would have to find its future in a new situation.

The funeral left from the house in Piazza Mercanti, one of his last purchases, the place where the Palatine schools had been and where, at the end of the Roman Empire, Saint Augustine had taught. The restoration of the house had been finished only a few months before he died. I remember a strange detail: the books about Rosmini's philosophy that I had read for my graduation thesis were used to raise my father's head from his deathbed. The circumstances, my mistakes, my father's wish to maintain the family's unity, the continuity of work were all conditions that weighed down my possibilities like an obligation without alternatives. My experiment with philosophy had ended badly, so there was no choice than to look around for other possible employment, something that could interest me and was as near as possible to my aspirations. In the meantime something new was beginning. The facts of death cross those of life.

Love was always something important for me: to meet a woman with whom to share my life, my ideas, feelings, basic values. A beautiful mind had to be the basic requisite, and this should also be reflected externally: bodily beauty is the most worthy place for beauty of the soul. Difficult traits to find together. Then there was another big problem: I wasn't particularly attractive. I was attracted to beautiful girls, but sadly they didn't feel the same way about me. I was worried but resigned myself to waiting. I despised my contemporaries who gave in to bad habits and did not know how to keep their sexual instincts under control. I thought of them as people without willpower, unable to choose a better way of living.

I wanted to find a kindred spirit, but there wasn't one. The girls who had a similar way of thinking to mine and who might have had similar feelings had other interests. I was worried and saddened by my inferior position.

Luckily this situation was not destined to last. In the years following the war I had met a friend, Federico Magnifico, who had similar intellectual interests to mine but a completely different character: he was an extrovert with a ready wit; he had no problems in company and could put even the most closed and taciturn people at ease. He loved company and was always surrounded by friends. His family had a house at Courmayeur, at the foot of Mont Blanc, the highest mountain in Europe, and at the bottom of the Aosta valley. I was invited to go there for a couple of days during the Easter vacation, together with his group of friends. I booked in at the old Royal Hotel, the best known in the vicinity, rustic and characteristic. It was just right for those who wanted to go and see the mountains, but not to stay in the hotel to pass the time. This was the spring of 1948, and the aim of the visit was to go skiing if we could find any decent snow. This was a sport I enjoyed, and after having skied in the morning and part of the afternoon, at about five I met up with my friends for tea. I then discovered that my friend had a young sister who was pretty and fun. She was sixteen and more than just pretty: she was the most beautiful of the whole group. She smiled all the time and was pleasant with everybody. She busied herself with bringing the tea and handing around huge slices of cake that, after hours of skiing, I ate heartily. She had long blond plaits pinned up round her head that gave her face a youthful, ingenuous expression; she had bright attentive eyes that were also thoughtful, those of someone who was not superficial.

This was something that really attracted me. She was not the usual girl who was only interested in being looked at: for her this didn't exist. She dressed simply and with natural elegance. I recognized the presence of something dif-

ferent, a world all of her own. I didn't know her; as this was the first time I had seen her, I simply intuited that this was how she was. In certain moments, when she was not busy doing something for the others, her thoughtful eyes expressed it. This was why I tried to sit down near her. Her talk was interesting, she played the piano and really enjoyed music, and she read a lot. I saw that she liked my company and was happy to be near me. The vacation was about to end, I had to study for my final exams and the graduation thesis, so I had to go back to Varese. I was twenty-five and my young friend sixteen.

At the end of May there was another occasion, another weekend, to go to Courmayeur. It was the beginning of spring, the fields were covered with flowers, and it was by now too late to ski, as the snow had melted even on the mountain heights. So we went for long walks through the valleys around Mont Blanc. I had a great need to move. To stay in the open air, look at the mountains, run through the fields gathering flowers, of which I made great bunches to give to my young friend. Courmayeur was very different from now, invaded as it is by mass tourism. There were a few houses around the old town center, the valleys were empty, and there were still farm workers mowing the hay, and barns full of cows, all of which have now disappeared. These were exciting, joyful days. My friend liked the flowers I gave her and would carefully arrange them in a vase. I returned at the beginning of August for a longer stay, but halfway through the month I had to leave again to start work, having finished my studies. I had to go a long way away to look after the affairs of the Panza firm in Apulia, where it had factories for wine-making. I was to be away from Milan for a couple of months. I had to take the bus, and some friends took me to the bus stop and left just before I had to go. She stayed behind, gave me a rapid look, a look she would never have dared give me before, and that pierced my heart. It said everything, it was what I had waited for. I was happy, and never would I forget it. It was something final. Its intensity was complete, unique, never seen before. She was wearing a multicolored kerchief around her face, which was young and full of grace and vitality. She had everything I didn't, but also something I had too: she loved the things I loved. She too liked to hear bells ringing, to look at flowers, and to feel the solitude of nature where you are never alone. To meditate on the life we live.

I left for a distant place but with new hope: I felt reborn. At last there was somebody who loved me, and I was no longer alone. The aching, overpowering wish to share my being, my whole self, with another person could be satisfied, total harmony, the extension of one's own being into another person. A multiplication of my own existence. The life of another person also became mine.

After my father died it was up to me to choose what to do. A difficult decision. There were many alternatives. I was a shareholder in my brother's firm so I could work there. Our father's firm, the Ditta Panza, was being closed down: the wine trade was virtually blocked by a state system aimed at guaranteeing the income of the producers, but my father had left us some property and some building land that had to be invested in to keep its value up. There were also possibilities in other fields of work. So it was necessary to have more information to find the best solution.

Italy in the 'fifties was a fine country for tourism, art, and history, but was otherwise worse off than the country that had won the war, in other words, America. I had a great wish to leave the places I knew and discover the world. I needed to find out as much as I could, not just intellectually but on a real, concrete level.

It was necessary to travel and remain a long time in the most interesting places in order to make genuine and responsible choices based on deep rather than superficial information. Europe had been badly damaged by a terrible war and its democratic ideals destroyed by Nazism and Communism. Reconstruction was underway, but the outcome still was not certain. The boom in the 'sixties was still in the future, but American progress had gone ahead and continued to increase, leaving Europe far behind. In the postwar period many Italians saw distinct possibilities in Latin America, obviously due to cultural affinities. Brazil and Argentina were the most attractive areas. It was necessary for me to begin there.

But my journey to the Americas in long ago 1954 was to arrive at its high point when I left South America for North America. New York was the entrance to the new world, the real new world, because Brazil and Argentina were only an extension of old Latin Europe into different territory. The United States had won the war. They had demonstrated their superiority in all fields, in politics, economy, and organizational efficiency. Their faith in the democratic principles of their constitution was made concrete in respect for the liberty of the individual and personal abilities.

It was at the end of March 1954 that I arrived in New York, the twenty-third I think, the day of my thirty-first birthday. It was a great day, a great discovery, a vision of the future. The sky was dull, the clouds low, the light was lead-colored but sharp; things in fact were dark gray, but there was an aggressive look to them in the calm air. This is typical of New York light in spring and fall. The plane landed at La Guardia Airport; it had flown over the harbor, and in the background I saw the majestic line of skyscrapers: an imposing vision,

an expression of great energy. I had difficulties in explaining the address to the taxi driver and eventually had to write it down. I had imagined I could speak a little English learned from a book, and in fact I could read a magazine or newspaper, but understanding and making myself understood was another thing. I felt a sense of displacement; no one spoke Spanish or French, the only other languages I knew. Along the road I looked back and was amazed to see so many cars in four lanes. In Italy we went by bicycle.

As we neared Manhattan my amazement continued to grow—it was a city quite beyond my imagination. The highest buildings touched the clouds, you couldn't see where they ended, it was as though they continued to go ever higher. This was a challenge to the heavens. This was how man's power should be expressed, not horizontally but vertically to conquer gravity, the force that pulls us down. And the sky is the home of the Divinity. To use the power of the mind, creative capacity, to get closer to Him. It seemed to me a city of cathedral towers trying to rise above all things, rather than the center of the world's capital, where money was accumulated; it was a mystical rather than materialistic vision. It expressed the anxious search for something ever greater and necessarily higher, an inexorable will never to end, the essence of human beings. The will to search and discover, to continue to grow. Ulysses searched for the edges of the earth; the modern Ulysses knows this world and wants to reach others.

Money is never enough, and whoever stops to enjoy the results of his labors risks being brought to a halt because the competition will take over his position: he must continue to struggle so as not to be superceded by someone more active, aggressive, more efficient. The laws of competition are inflexible: the weakest die or are absorbed by the strongest. This is the law of nature, of evolution, the strongest must win until another overcomes him. In New York this law is visible, and the whole city is a demonstration of it, in the enormous towers of the skyscrapers, the areas where the social outcasts live, people who do not know how or are unable to compete. This is also the city of those who let themselves die from drugs or alcohol, of those who have no more hope and await the end of the vanquished. In Europe the aim of social life is the reverse: everyone must be equal, and the principle of solidarity is fundamental. Competition must be limited; we defend ourselves with the help of the state. And so we do not construct skyscrapers, or at least we build fewer of them. It is a city of oppositions, of creative energy and sacrifice. These two extremes generate extreme riches and the saddest misery, the tough triumph of the victor and the suffering of the vanquished.

I had been booked into a room at the Plaza, one of the most luxurious hotels in New York, and when I realized how much it would cost me I became

frightened and began to look for cheaper accommodation. I had no reason at all for seeming important, and I have always refused expenditures for luxury. I have always preferred a decent but modest appearance to seeming more important than I am, as I've never felt myself important and never want to. The only thing that interests me is to be able to offer something that others like and appreciate, and if this is not possible then that is fine too since I know my ultimate aim doesn't depend on riches or what others consider success in life. My wish not to waste money is not a wish to accumulate it, but respect for a precious commodity that has to be used with the greatest caution for something that is not only personal.

It was obvious that New York was the future, and so too was the continent on which it was situated. The energy, the desire to create, was the guarantee of its destiny. The future concerned me, since I might not be able to compete with others in facing up to and resolving everyday problems: people with a quicker and sharper mind than mine could have more success. My only possibility lay in my ability to reflect, to evaluate possibilities for development, compare how certain relatively recent situations had changed and how they might change in the future. America was thirty years ahead of Europe. Its present was the future of countries that had lagged behind but could become like America in a few decades. Its way of life and its technology would be imitated the world over. It was only a question of time; it had to happen if other countries wanted to equal America's affluence. This was obviously the only prediction possible, to expect anything else would have been naïve.

Only God knows the future; man cannot. Often thinking people are extremely innocent and fall in love with their own ideas. I too was ingenuous and thought that many of the developments in America could be transferred to Europe, above all to Italy. The unrestrained wish to become richer would have overcome any obstacle. This was ingenuousness but not obviously so, and so it was possible to believe in it, above all for a young man of thirty-one years. I read the financial history of America, about the fortunes that had been made by the great entrepreneurs in all fields of the economy. I admired the ability of those who had understood that the economic boom leading up to 1929 could not last and had, therefore, sold everything in order to buy it all back again at a lower price a few years later. A quick fortune is rare but possible. What is difficult is to keep it; we fool ourselves that it will continue, that fortune is our due, whereas in fact it is only a gift dropped from on high. We think we own it without realizing it is a gift that can be lost just as quickly as it was found. This is the history of many financiers who became rich in a period of development by investing courageously but did not understand that it was necessary to stop, not to go on, and so lost all their earlier gains. My father too had

known how to make the most of the favorable moment created by the First World War, but he also knew how to construct his fortune brick by brick, calculating that he would have to take a lot of time and avoid creating large debts for big investments, but every day make something small and useful. At the end of life many small things will have built up to create something big, but only at the end of life. In 1954, when I was about to start my lifetime's work, I still had not understood history's lesson, a lesson that is always true but that you only understand later, because when you are young you do not want to understand, working step by step seems too boring and slow: just one step at a time to climb high up.

I remember a car trip from New York to Toronto with my contemporary Pietro Castiglioni who worked in the New York branch of the Banca del Lavoro. He was a very pleasant character who was quite different from me, but we got on very well with each other and exchanged our opinions about America. This was the first time I had left Manhattan and at last was seeing the real America, the one created by the pioneers, by those who lived in the midst of nature, who tilled the soil. The real new world, full of traditions brought over from old Europe, from northern Europe, to the heart of the continent, to a territory that was still virgin soil, and where nature was still strong in all its beauty.

I could now go in search of America since I spoke English and understood what the others said. I prepared a program of trips to various cities, from the Midwest to the far west and the Pacific coast in order to see industrial plants and city planning and construction industries. I never came across any kind of hindrance to these activities of mine; everyone I met gave me all the information I asked for, in detail and with great politeness even though they were wasting time with me, and often they would take me to see the plant. It was spectacular seeing the size of American productive capacity. Evidently Mussolini and Hitler had never traveled to the States, for if they had they never would have made war against the most powerful country in the world: they would have realized they had lost even before beginning. My inquiries were interesting for getting to know the American economy, but not of much use. Later on, when I got down to work, I became busy with other activities, with city planning and construction. I fooled myself that American experience in this field could be exported to Italy, and this was a big mistake that I realized only when it was too late. I did not, though, involve myself with the activity that was to save me from my sad delusions and that turned out to be a wholly positive event, something that it would have been better to have known then. But the need to prepare me for a working life was predominant. Art was a pleasure but not a job.

Spring passed between one journey and another getting to know various industrial activities. The weeks passed quickly since I was so absorbed in these occupations. The weekends, when everyone left for the countryside during the fine weather, were sad days in which I really felt lonely. I wrote to my mother and, at more length, to my future wife who was patiently waiting for me in Milan. I really wanted to see her and embrace her again, to join our lives into one. I believed that what I was doing was important for my future and that of the family we were to start. Still, this was a necessary sacrifice in order to start in the best possible way a life of work.

In August I decided to go to the Pacific coast and cross the whole continent by train in order to get to know the territory. It was a marvelous journey, beginning on the north side of Lake Superior, along an endless sheet of water in the silvery-blue, limpid, luminous atmosphere of the north, past forests that were still virgin, small and huge lakes surrounded by mighty rocks eroded and flattened by the last glaciations. Here was land that was semi-deserted, with a few rare townships, fascinating just for this, and then there was nature in all her beauty and grandeur, the mother of all, the image of creation, the beginning and future of all things, immutable and always different. After the forests and the water, which the train passed over many hours' journeying, there came the plains of Manitoba, huge yellow expanses of ripe wheat, a limitless sea of gold-colored grain below a great blue, intensely blue, dome. Immense prairies, softly swept by mild waves, the world's bread. Unlike in Europe I couldn't see the farm workers or their houses. After miles and miles there would be a station with a few houses nearby, a wooden church with roofs like those of a Russian church, similar to an upturned bulb. I was on the way to Banff at the foot of the Rocky Mountains, but I had misunderstood the timetable and discovered the journey took a day longer than I had thought. I could have stopped for an afternoon at one of the little stations, walked at sunset along a side-road in the middle of the wheat, lengthened my sight of all that gold under the blue sky, the red clouds of sunset, in the heart of a yellow desert, resplendent in the sweet northern summer.

In New York in 1954 the fall was about to end, and you could walk along Fifth Avenue immersed in the warm light of a November that was cooling softly. My freedom to spend my time as I chose was about to finish, and I had to get ready for a near future of concrete and possible things, no longer more-or-less theoretical plans. I knew a part of the American economy, but the problems I would have to face up to and resolve on my return to Milan were genuine and different.

One thing was certain: I would marry Rosa Giovanna Magnifico. The American venture and my uncertainties about how to deal with practical life had delayed the date of our wedding, but not the choice I had made years before. I had found a woman with my same ideals, who shared my way of living and who loved me and whom I loved, and what's more, she was beautiful and desirable in every way. Obviously there could be no more waiting.

Italy had been very lucky after the 1948 elections. There was a will to be free of Fascism's state-imposed restrictions and the desire for personal freedom. The work of two great politicians was decisive, Luigi Einaudi, president of the republic and a liberal economist, and Alcide De Gasperi, head of the government, born in Trento in northern Italy when under Austrian domination, and who had learned what good government consisted of. These were men who believed in liberty and respect for the basic values of life that make freedom a reality. They were men who made the rebirth of Italy possible as well as its development in the years to come and its transformation into a modern country. The political situation on my return was positive, and I held that there were all the conditions for its continuation.

Our wedding was fixed for July 9, 1955. Now it was April and there was little time. My future mother-in-law, Giuditta, had bought two apartments in a new building in Corso di Porta Romana, at number 78/1. The third-floor flat looked onto a fairly large and very green garden, something rare in Milan. The houses in front were fairly distant, and we could see lots of sky. Noise was blocked by the houses at the back, so the silence was complete, something else that was rare. Previously I had only ever lived in very noisy buildings, and only in the dead of night could I experience the beauty of total silence. When I was young I lived in Viale Montenero, at number 15, a tree-lined avenue that was also a beltway, on the other side of the Spanish Walls: the quiet at night freed my imagination; at times a tram would slowly pass by and its sound would slowly disappear. There were few cars in the 'thirties. That was the time I would read the poetry of Leopardi, Ungaretti, and Montale. I would stop, undisturbed, and live again at length the enchantment these poets had aroused in me. So

the new house was ideal for us, and it became the definitive one. I really must be thankful to my mother-in-law for having decided to buy it and to give it to us. Another important thing was the choice of furnishings. This was always a worry to me, to stay in an environment that did not offend my aesthetic sensibility. The place where I lived had to be in harmony with me. This is why I am so disturbed when I enter a museum and see some jarring note that shatters the harmony of the whole. This was also the first step toward the construction of a collection. The first need was furniture, then we would take care of the walls that were still empty.

The marriage was celebrated in the church of San Paolo Converso in Corso Italia, next to the parish church of Santa Eufemia, a beautiful place built at the end of the sixteenth century and planned by a great painter, Cerano; inside there are some very beautiful frescoes. It was strangely divided in two because it was joined to a convent. Sadly, for a long time it has not been used for services: today it hosts art exhibitions.

It was a day we had waited for with great anxiety. I had had a tough battle with myself not to compromise the beauty and integrity of the moment, and I was sure the feelings of "Pupa" (as I lovingly called her) were the same. She too was waiting for this moment, hopefully but also with trepidation.

The house was ready and we could move in; the furniture was in place, but the walls were still empty and it was necessary to fill them. So there was a new problem: what to fill them with? We had bought some Romantic paintings from the first half of the nineteenth century, and we hung them in the bedroom. These pictures were adapted to pleasurably decorating a room used for sleeping, but they were not the expression of a serious personal involvement. I was still greatly interested in modern and contemporary art: I bought many books about Picasso, Matisse, and other famous artists. One of my first and most riveting books on art was the letters of Vincent Van Gogh to his brother Theo. When I was sixteen, his painting, full of violent and overwhelming desire for an unfulfilled happiness, was like a mirror of the feelings that vibrated in me. Now I was happily married, I looked on my life calmly, but my interest in having more information grew.

THE PLATES

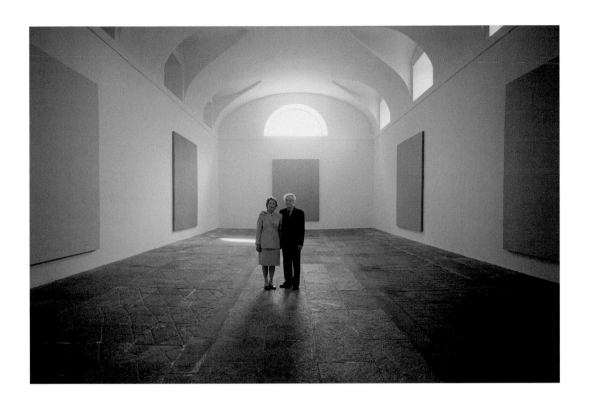

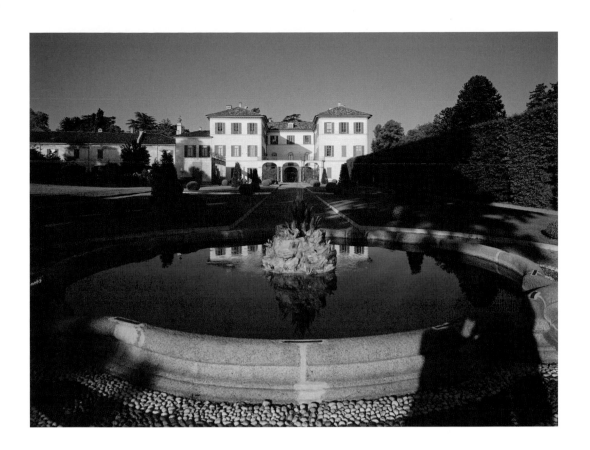

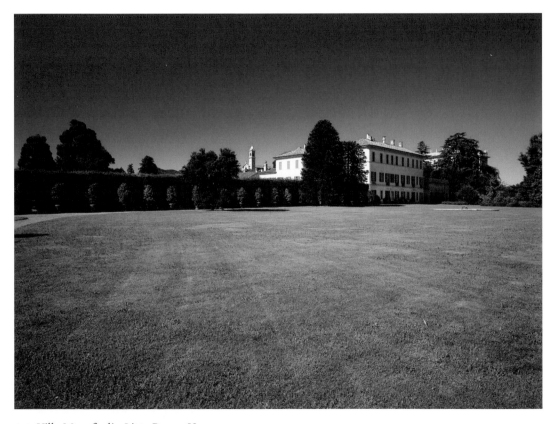

2, 3. Villa Menafoglio Litta Panza, Varese

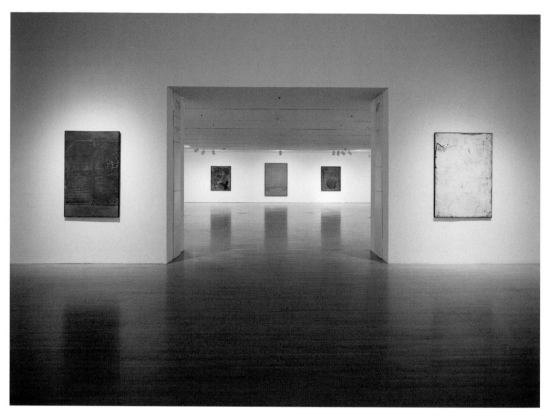

4. Antoni Tàpies

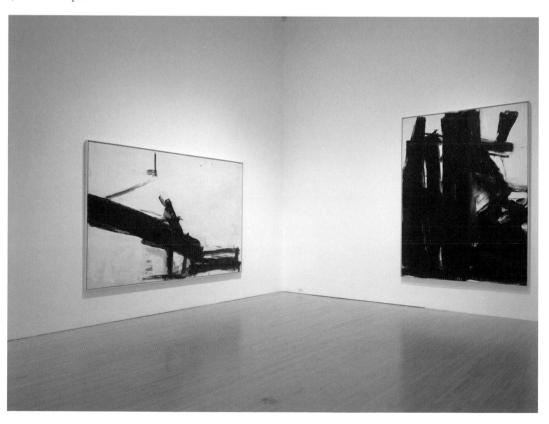

5. Franz Kline

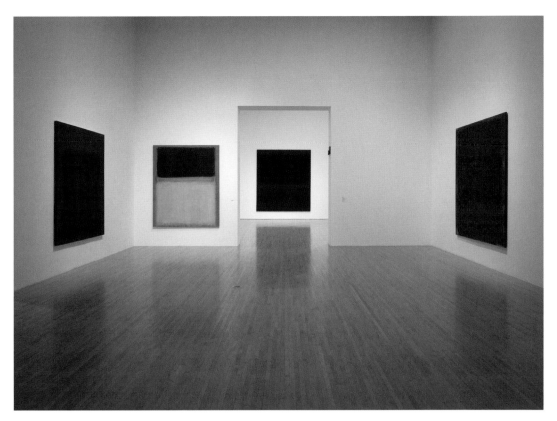

6. Mark Rothko

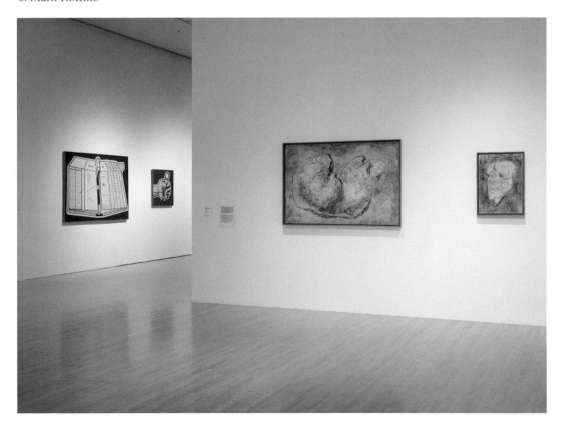

7. Roy Lichtenstein, Jean Fautrier

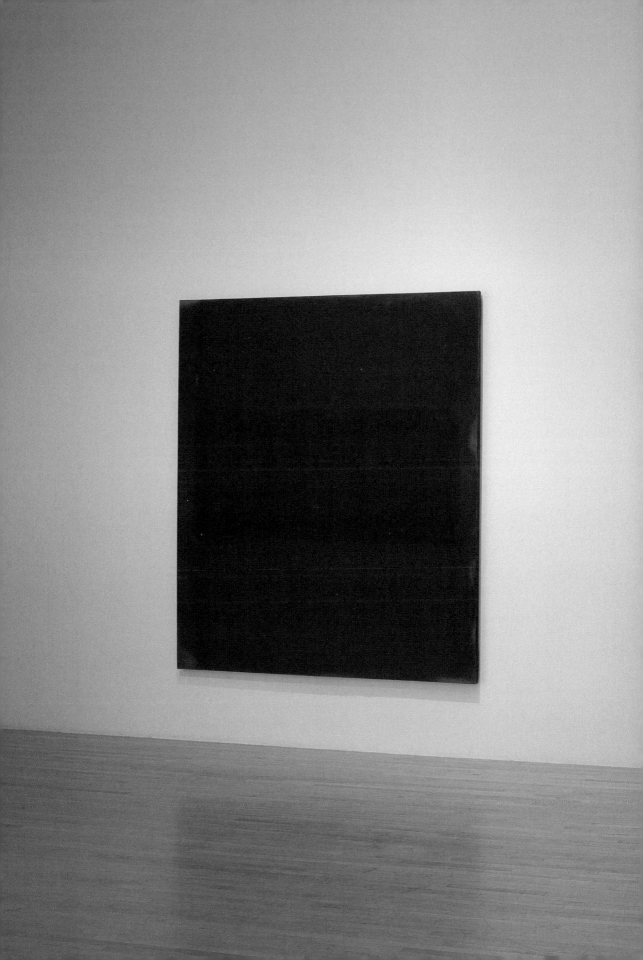

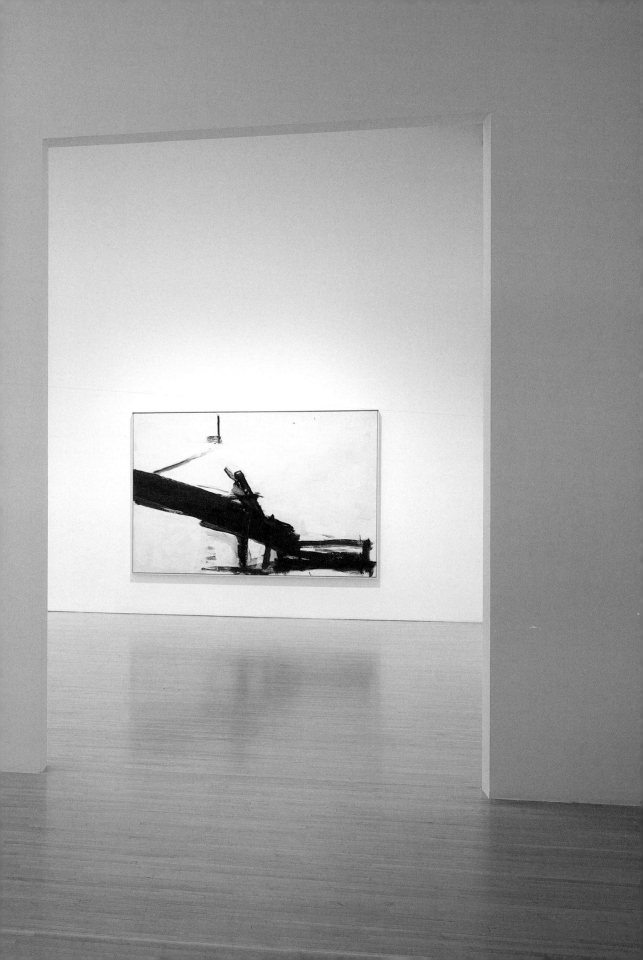

9. Robert Rauschenberg

10. Claes Oldenburg

11. James Rosenquist

12. George Segal

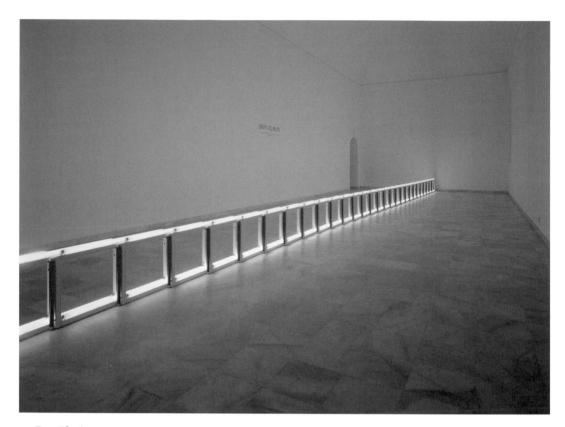

13. Dan Flavin

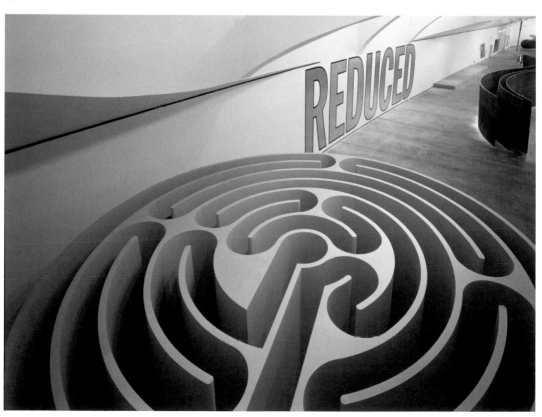

14. Robert Morris, Lawrence Weiner

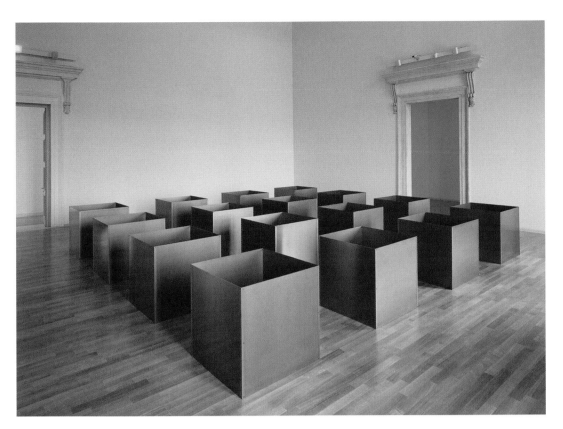

15. Robert Morris

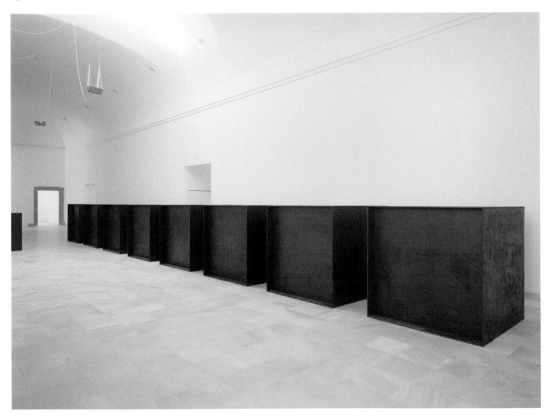

16. Donald Judd

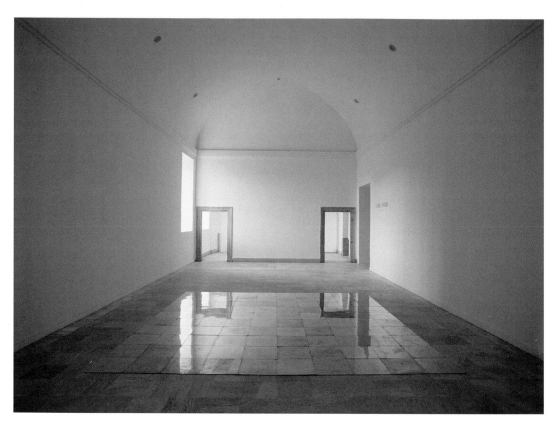

17. Carl Andre

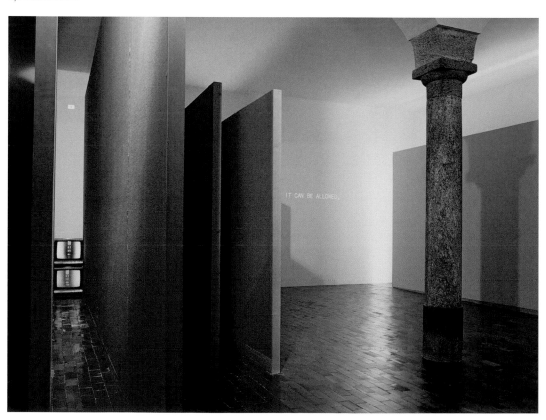

18. Bruce Nauman, Robert Barry

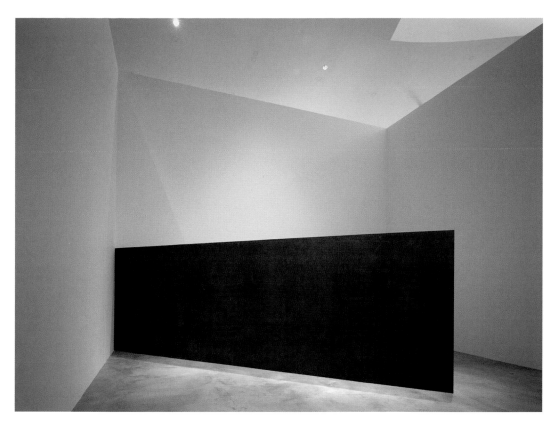

19. Richard Serra

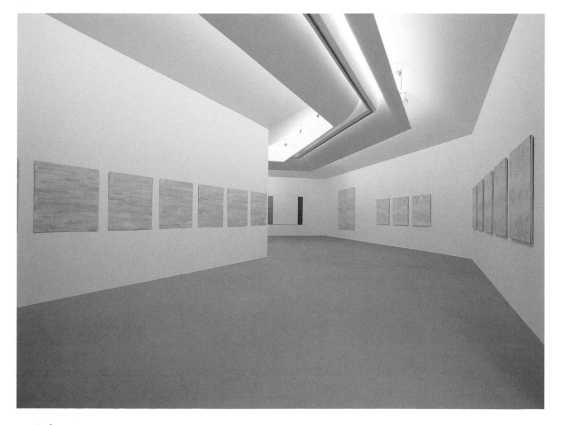

20. Robert Ryman

21. Brice Marden

22. Robert Mangold

23. Joseph Beuys

24. Sol LeWitt

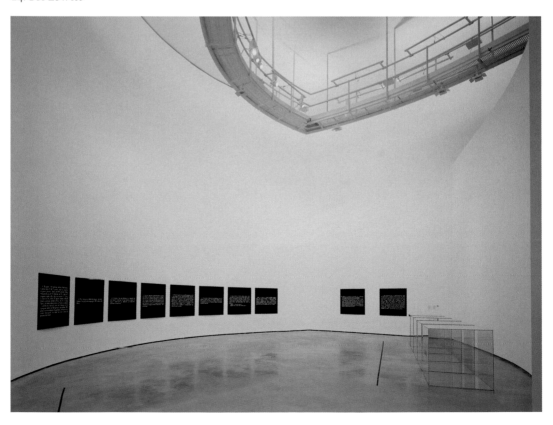

25. Joseph Kosuth

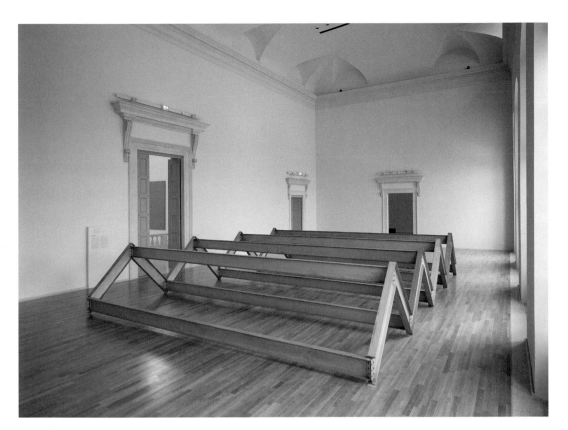

26. Robert Morris

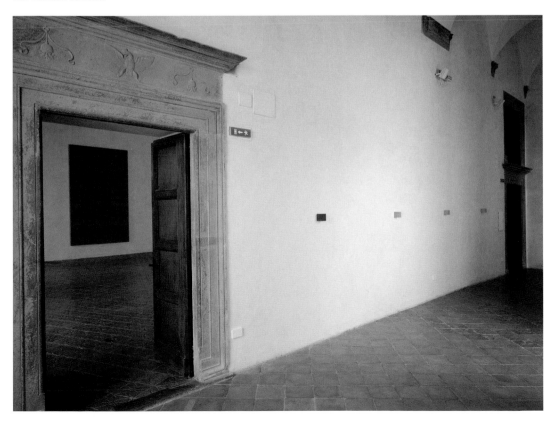

27. Phil Sims, Stuart Arends

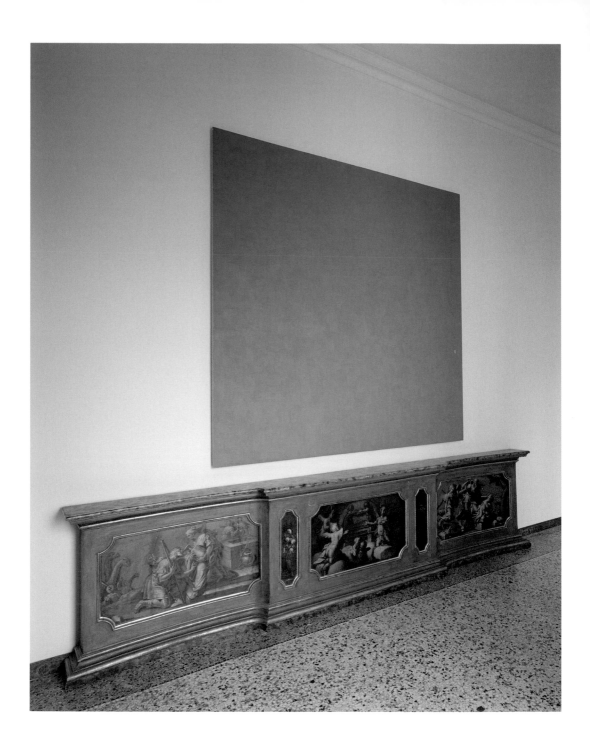

28. Phil Sims

29. Lawrence Weiner

30. Douglas Huebler

31. Hanne Darboven

32. Larry Bell

33. Carl Andre

34. James Turrell

35. Robert Irwin

36. James Turrell

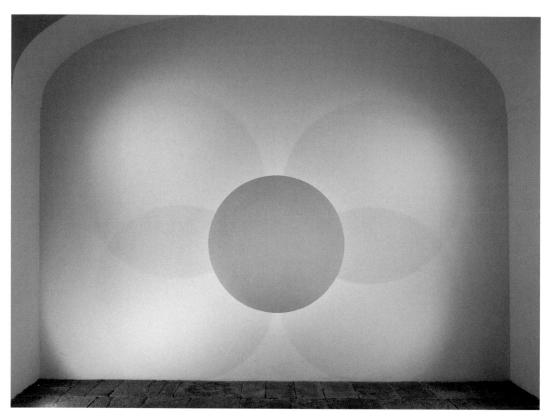

37. Robert Irwin

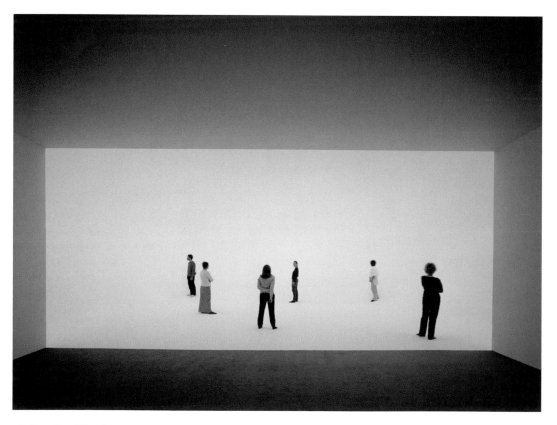

38. Douglas Wheeler

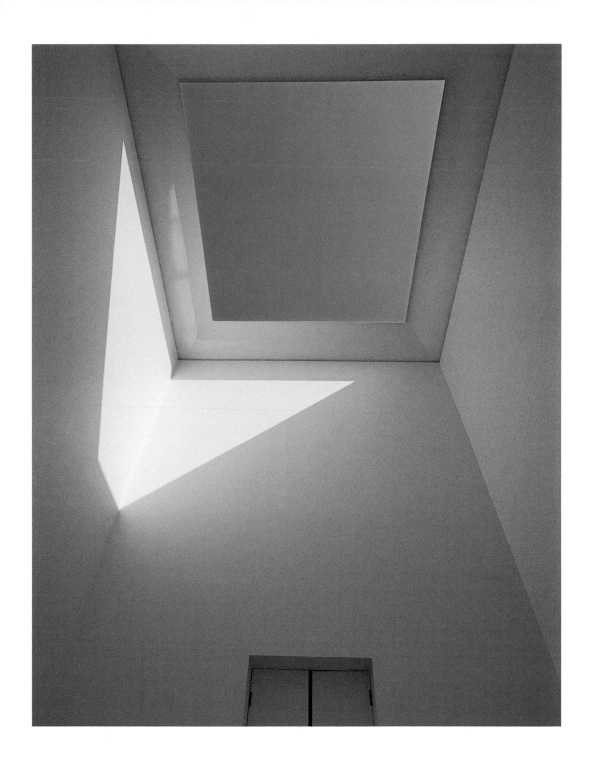

39. James Turrell

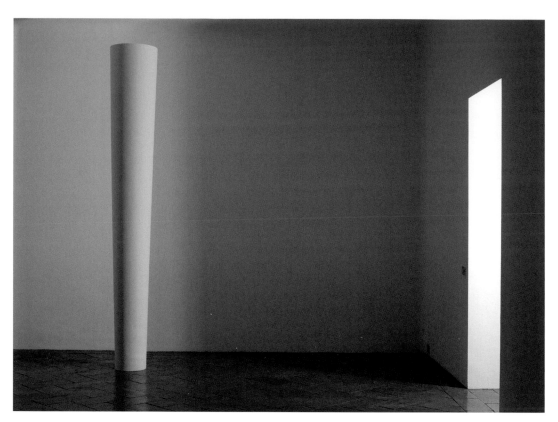

40. Ettore Spalletti

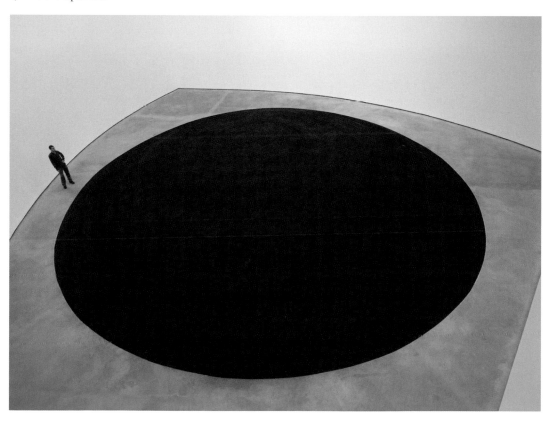

41. Jene Highstein

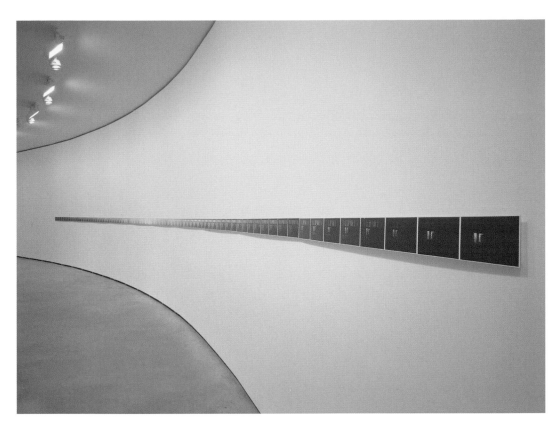

42. Jean Dibbets

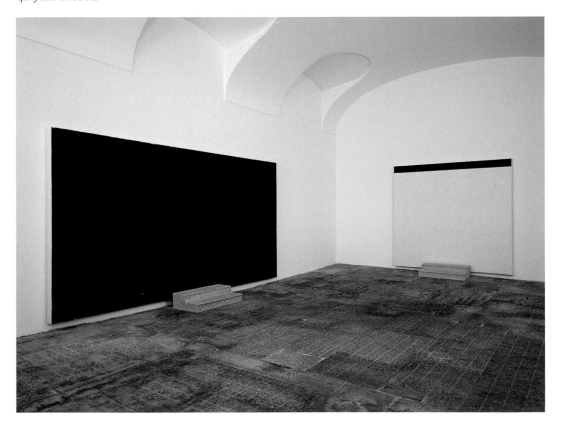

43. Allan Graham

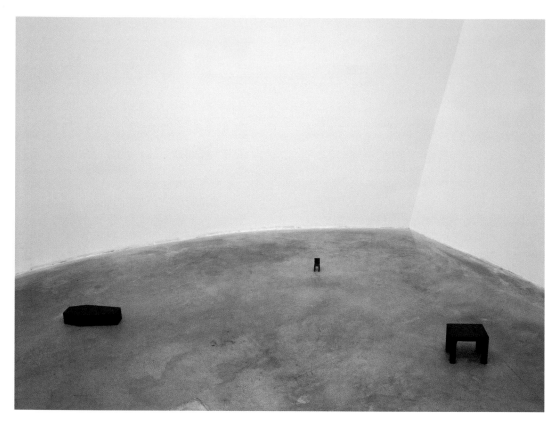

44. Joel Shapiro

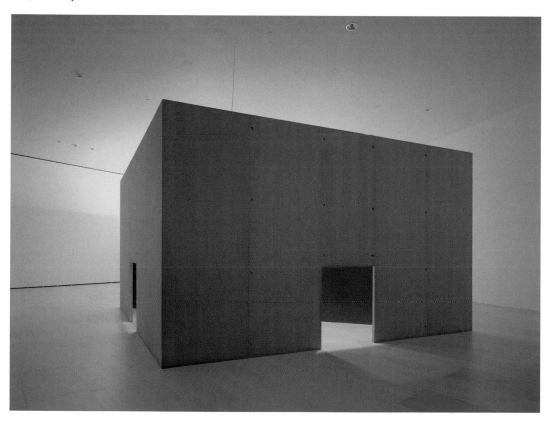

45. Bruce Nauman

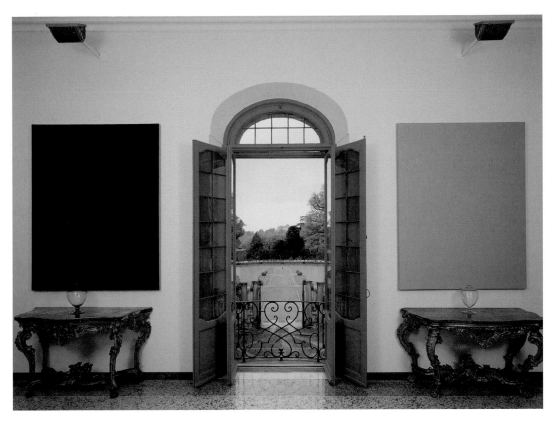

46. Phil Sims

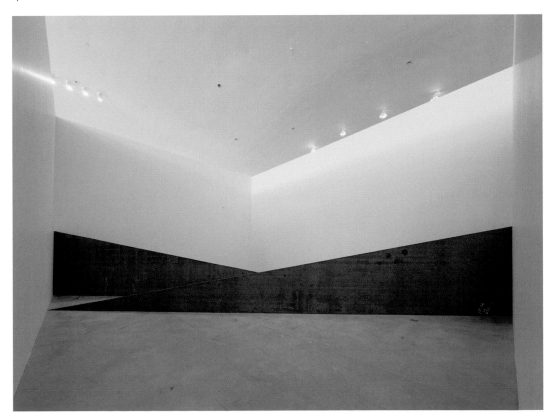

47. Richard Serra

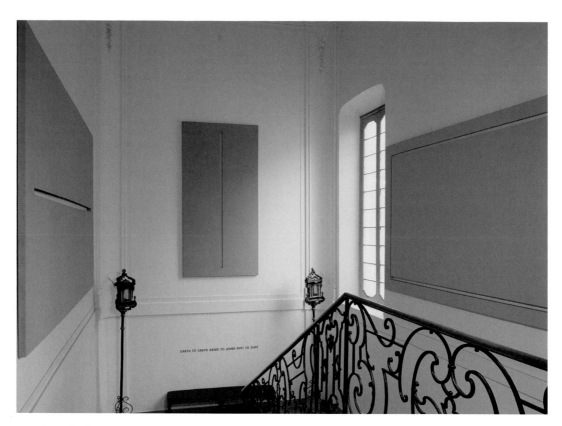

48. Alan Charlton

49. Peter Joseph

50. Richard Long

51. Claes Oldenburg

52. Ruth Ann Fredenthal

53. Max Cole

54. Ford Beckman

55. Stuart Arends

56. Barry X Ball

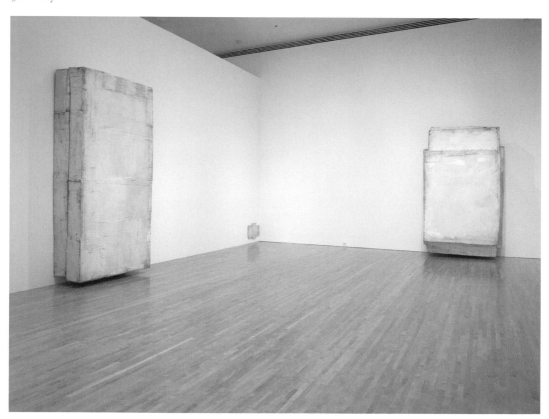

57. Lawrence Carroll

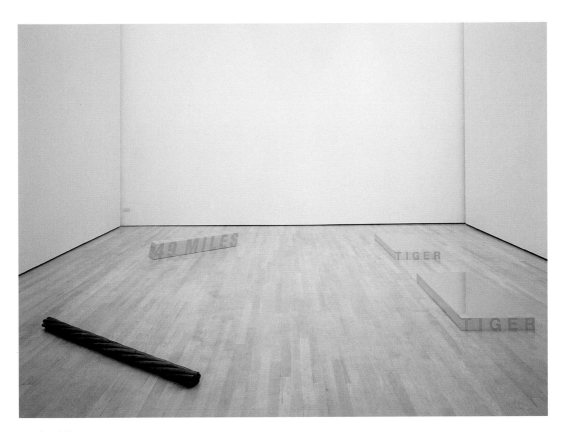

58. Roni Horn

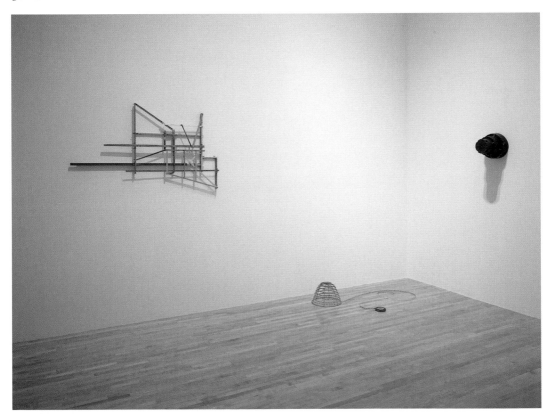

59. Greg Colson

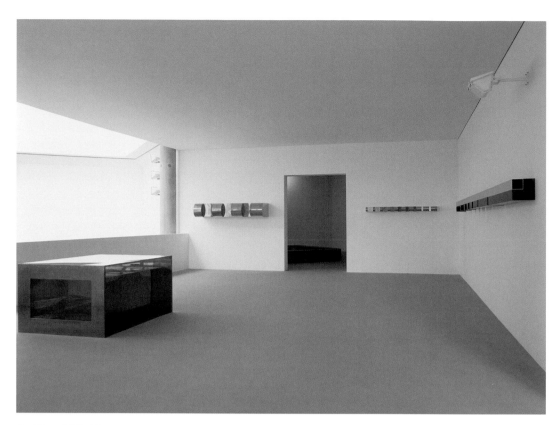

60. Donald Judd

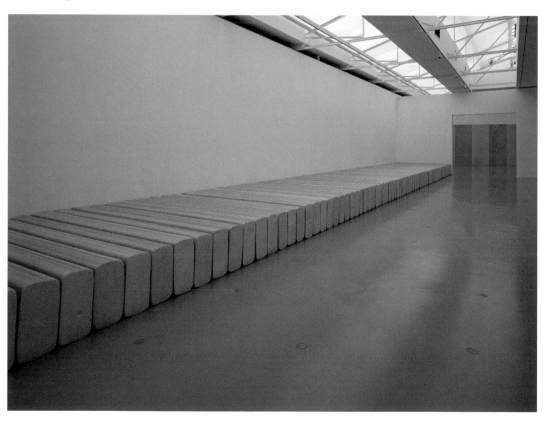

61. Carl Andre

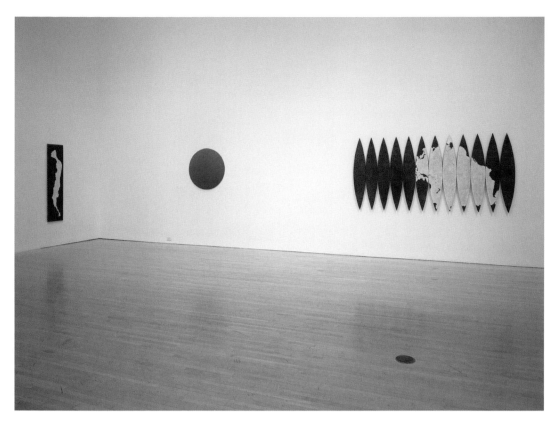

62. Gregory Mahoney

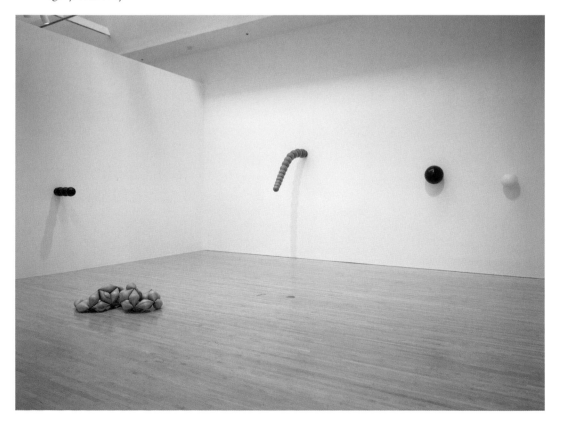

63. Ross Rudel

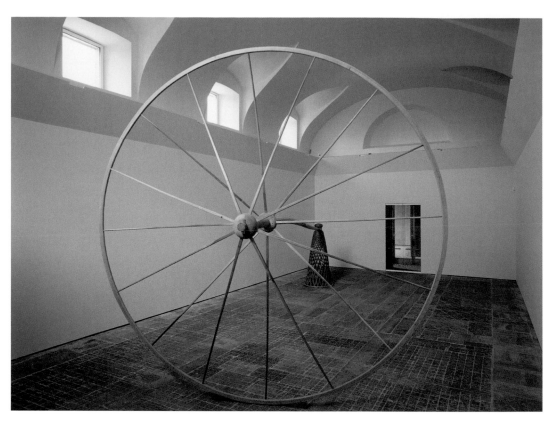

64. Martin Puryear

65. David Simpson

66. Jonathan Seliger

67. Palazzo Ducale, Gubbio

68. Peter Shelton

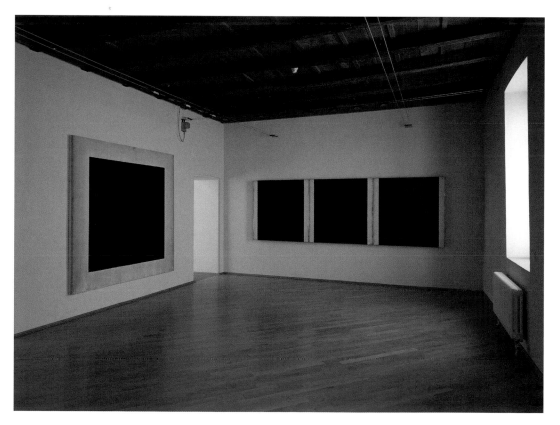

69. Ford Beckman

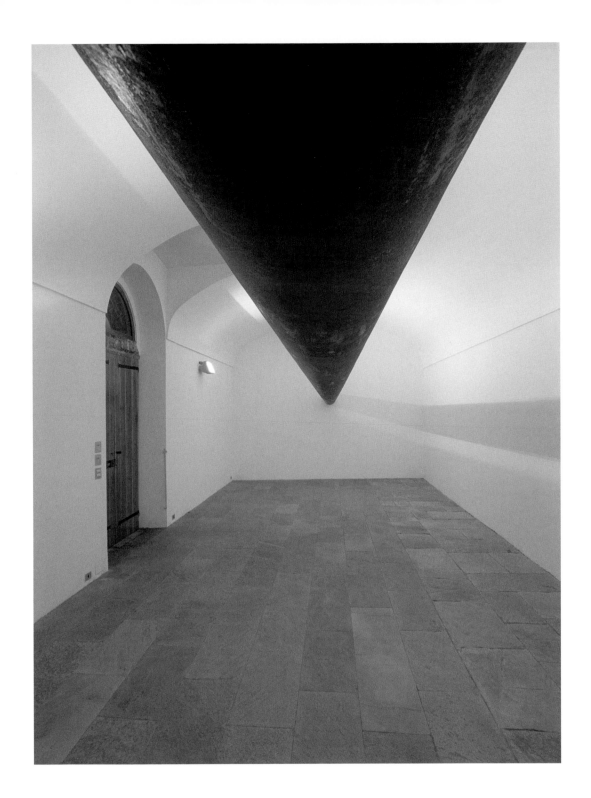

70. Jene Highstein

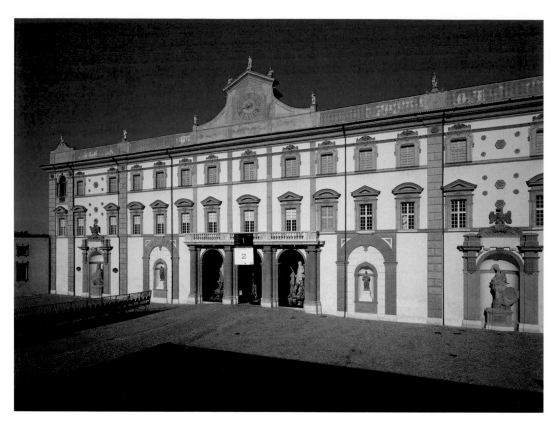

71. Palazzo Ducale, Sassuolo

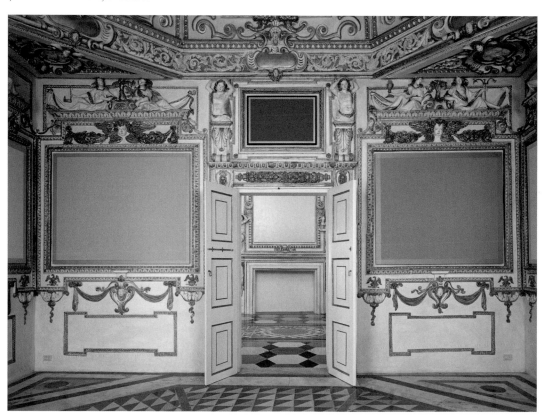

72. Winston Roeth

73. Robert Tiemann

74. Robert Therrien

75. Lawrence Carroll

76. Allan Graham

77. Meg Webster

78. Phil Sims

79. David Simpson

80. Timothy Litzmann

81. Ettore Spalletti

82. Hubert Kiecol

83. Anne Truitt

84. Grenville Davey

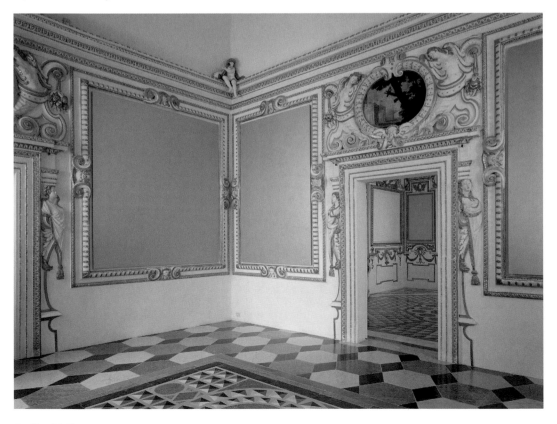

85. David Simpson

86. Dan Flavin

87. Joseph Kosuth

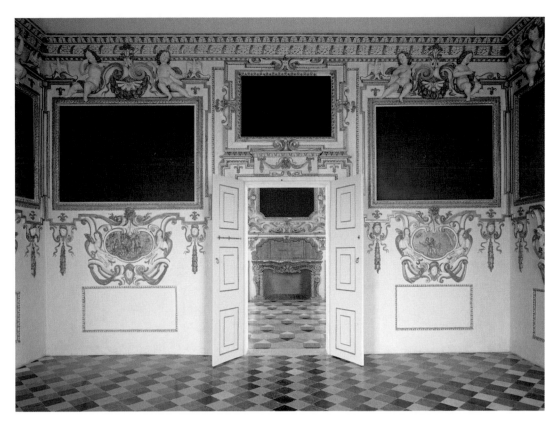

88. Anne Appleby

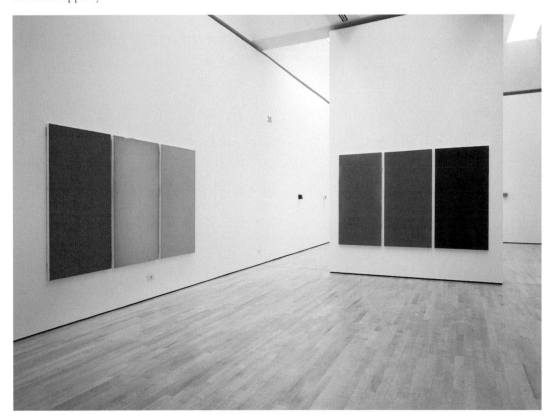

89. Anne Appleby

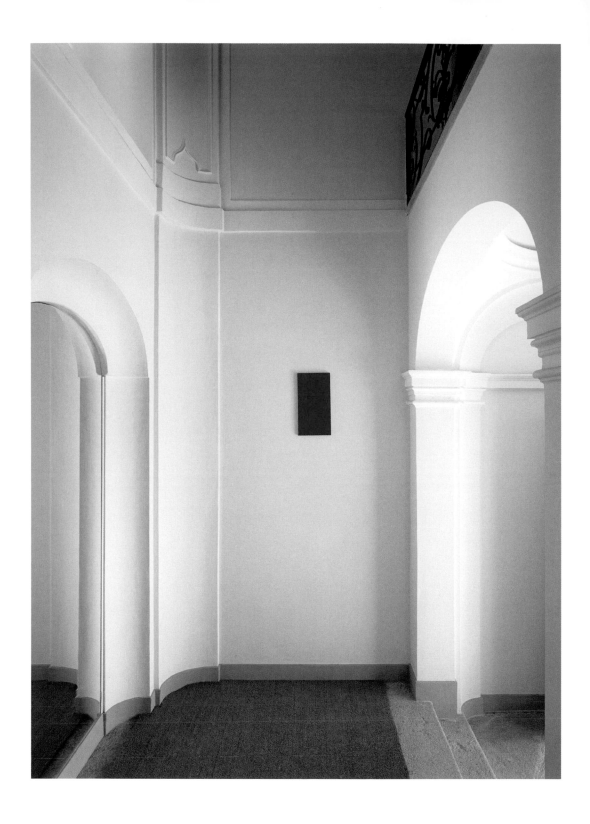

90. Alfonso Fratteggiani Bianchi

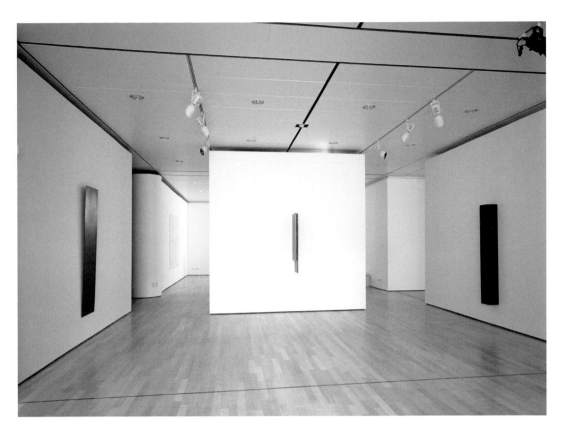

91. Julia Mangold

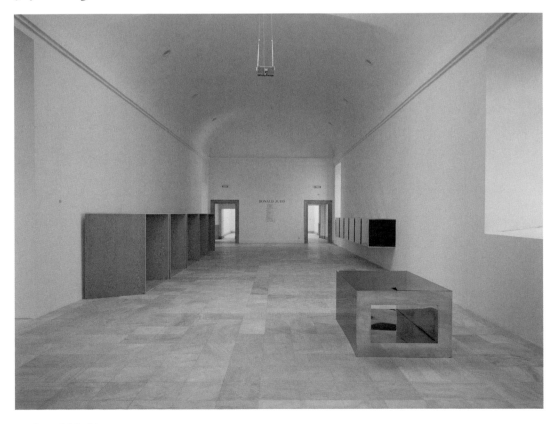

92. Donald Judd

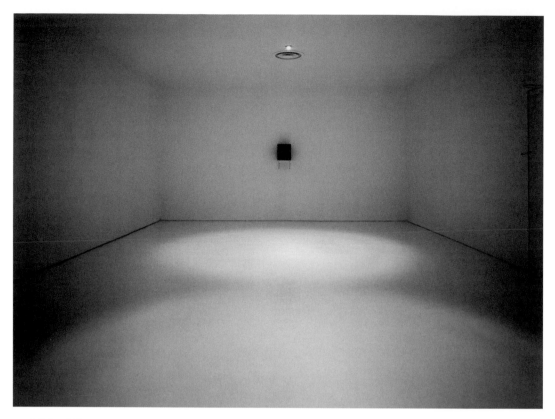

93. Michael Brewster

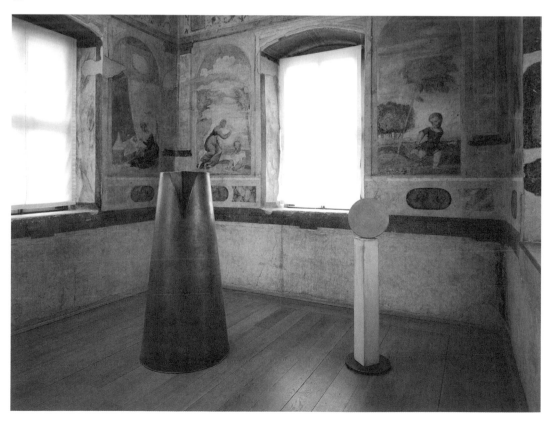

94. Robert Therrien

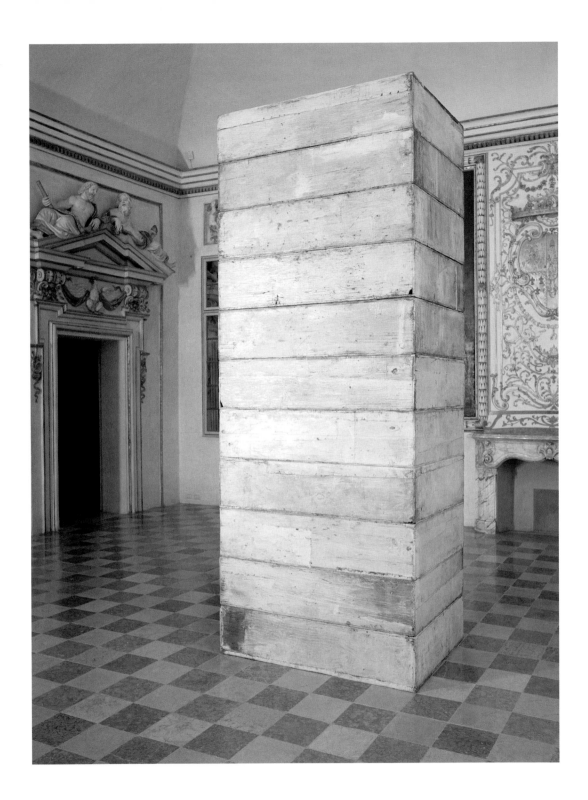

95. Lawrence Carroll

96. Sol LeWitt, Walter De Maria

97. Villa Menafoglio Litta Panza, Varese

98. Ron Griffin

99. Phil Sims, Lawrence Weiner

100. Franco Vimercati

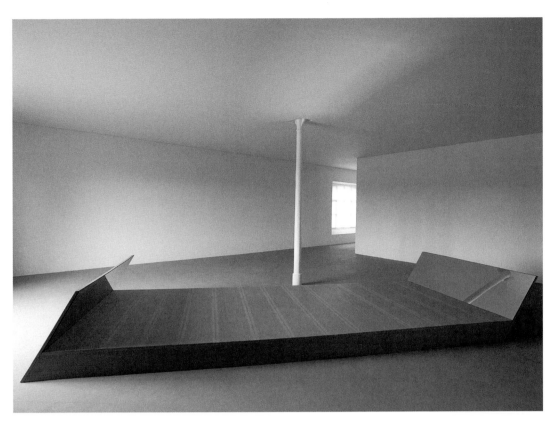

101. Bruce Nauman

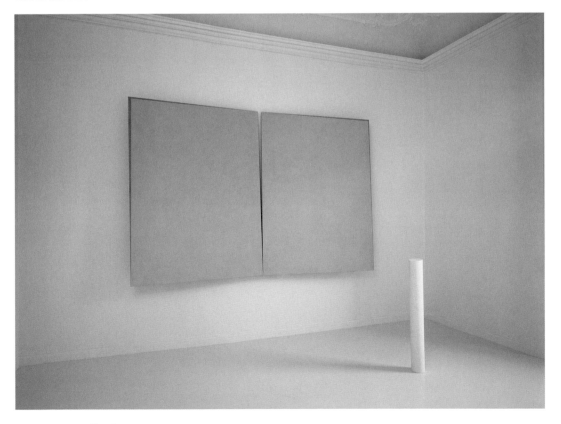

102. Ettore Spalletti

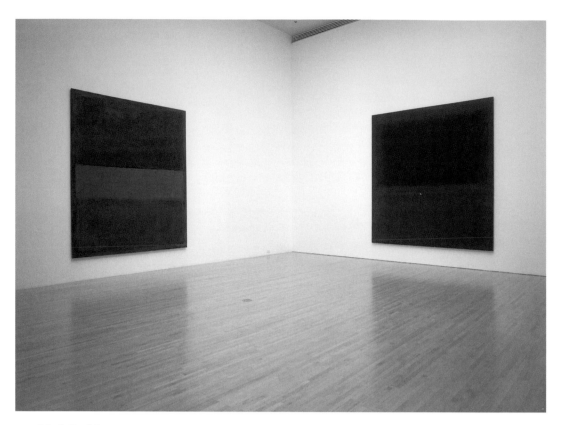

103. Mark Rothko

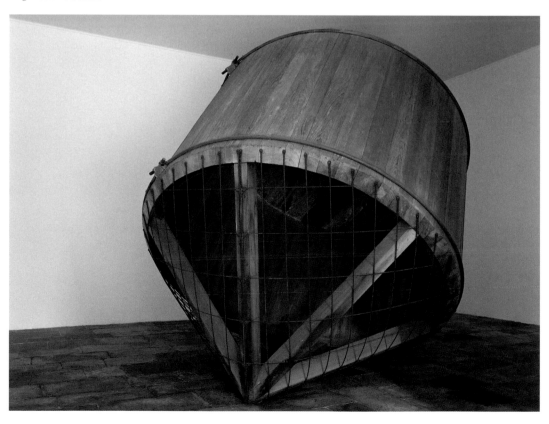

104. Martin Puryear

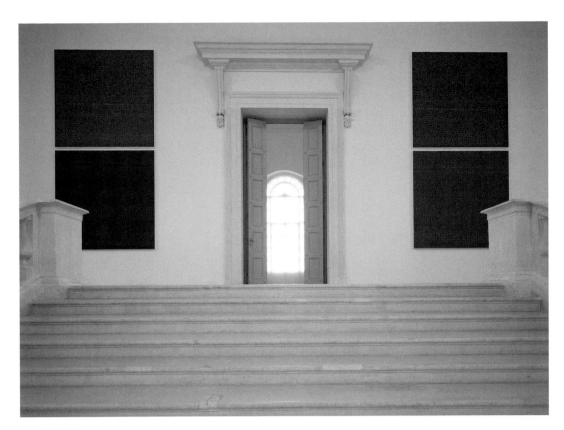

105. Phil Sims

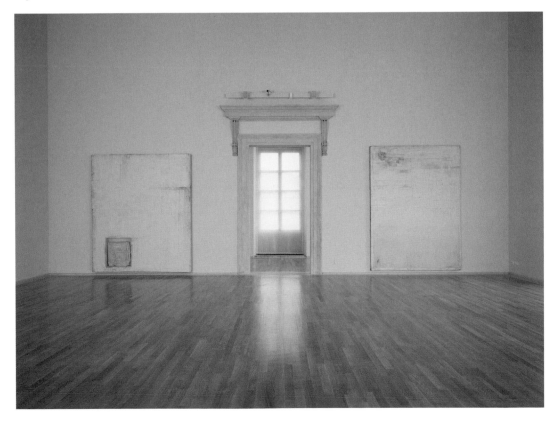

106. Lawrence Carroll

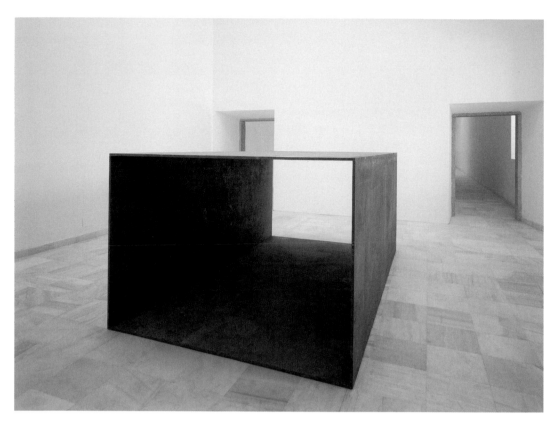

107. Donald Judd

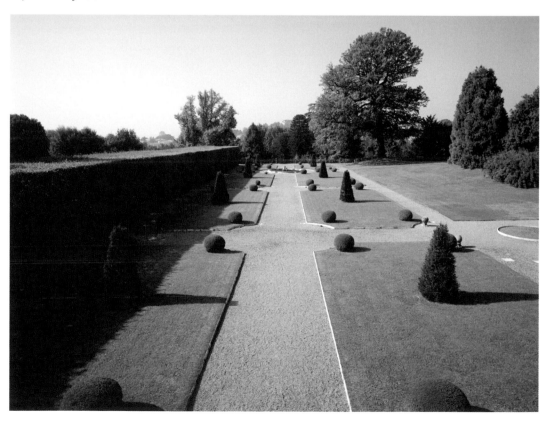

108. Villa Menafoglio Litta Panza, Varese

109. Dan Flavin

FROM THE 'FIFTIES TO THE 'SEVENTIES

During my time in America I didn't have the chance to concern myself with art, but now the moment had come. In my talks with friends and acquaintances about this I realized how little art was understood and that it was subject to irrational rejection. I saw that whoever was able to overcome such psychological obstacles could choose the best art before the others. The situation in which Van Gogh found himself was not very different from the present time. It was necessary to understand if there was true art behind forms different from those we were used to. But it was also necessary to have the widest information possible before making any decisions. The first step was to visit the art galleries in Milan. The best-known didn't have anything new; the most famous, the Milione, sold Morandi, Sironi, and Carrà, all the best artists of the Italian twentieth century, but all by now old and famous. There were no young artists. This was at the end of 1955, and Milan was undergoing postwar reconstruction; the situation was still that of the 'thirties: a society closed in on itself because of the Fascist nationalist policies that exalted the Italian Spirit and made relationships abroad difficult. There were also economic difficulties, the lira was undervalued in comparison to foreign currency, so buying from abroad cost more. There had been great collectors in Milan, Mattioli, Jesi, De Angeli Frua, all of whom were still active, but they had works from Futurism up to the 'thirties and were little interested in current art. Foreign art was hardly seen, except in the collection of De Angeli Frua, who bought in Paris. This was a collection that was to disappear a few years later due to his firm's financial difficulties. In the 'fifties he had bought Wols, Fautrier, Picasso, and Dubuffet. It was a collection of the highest quality and its dispersion was a loss for our culture. When I talk about things that happened fifty years ago I seem to enter into a shadowy land: a difficult period, a closed situation; I see the Milanese streets in the fall and winter, gray by day and suddenly dark in the evening, few lights along the roads and not much traffic, like the cityscapes by Sironi, a life oppressed by something imponderable.

Little light, long nights, but happily something of the good that existed then has been saved. The Mattioli Collection has been conserved and renewed by the intelligent and loving activity of the collector's daughter Laura, and a group of its top quality Futurists is on loan to the Venice Guggenheim Foundation. The Jucker was another important collection, and a nucleus has been bought by the Milan city council, with the help of the Cassa di Risparmio bank, and is now exhibited on the top floor of Palazzo Reale while awaiting construction of a museum of modern art. Another important collection was that of

Lamberto Vitali who specialized in Morandi: he was an enlightened connoisseur of art and, above all, of this great artist. There were also many other small- and medium-sized collections, and that of the tailor Tosi was not the least of them. In Milan there were tailors who collected, but now theirs is a profession that has virtually disappeared, and clothes are all machine made.

I have taken part in the same change too, as I wear clothes that are machine made. This is an inevitable evolution due to research into productivity, but something has been lost. The best tailors had artistic sensibility and were often collectors like, for example, Italo Magliano. It was a pleasure to go and try on a suit and, while it was being sewn, to talk about art.

Visiting gallery after gallery in Milan I discovered one with a greater interest in what was new: the Apollinaire Gallery run by Guido Le Noci, a friendly, helpful, and really enthusiastic and passionate person. He was one of the few dealers willing to talk about art with a young man who was only just starting and needed pointers, information from someone who was already an expert. The other dealers looked down their noses and didn't much take me into consideration even though they had to wait hours before a client might arrive to talk about buying. Le Noci sold fewer works than the others since his was not a long-established gallery with a stock of important pictures. His was a poor gallery but run by a competent person: he did not sell much and so had a lot of time to talk with whoever wanted to talk, and I was one of those: I needed those talks. I left the office at 6:30 in the evening and stayed in the gallery until a quarter to eight almost every day. I was forming my ideas about art and needed a person to react with. He was also one of the few who was interested in what was happening abroad, above all in Paris, then the undisputed capital of art.

I remember that the first time I bought an example of contemporary art, it was from Le Noci. I thought I had made a first appraisal of the situation, and so I felt up to buying something. It was a cold and rainy Sunday in January, and I had made an appointment with Le Noci at his home where he had other pictures to show me. There was an abstract by Atanasio Soldati, and a view of Venice by Gino Meloni that was, in fact, an ensemble of many colors in which the form disappeared. I think I paid 100,000 lire for each one. I remember looking out the window and seeing a beautiful winter sun shining. Today 100,000 lire seems ridiculously little, but if you think of the cost of living then it was quite a lot. The average wage of a working man was 120,000 lire a month, and a full-time domestic helper took home 25,000 lire a month, and there were many available, very different from today when they have to be invited over from the Philippines or India. A decent meal, without wine, cost 1,000 lire, and a dollar 700 lire. I was pleased with the first purchases I took

home. Pupa had not been able to come with me as she was not feeling well, but she too was pleased to see the works. At once we wanted to see where we could hang them, but the walls seemed too large for two rather small pictures; still, it was inevitable that the collection would grow, and there was a lot of space for it even though there was not much money for buying. Almost all the paintings I bought in the first year were then sold to buy others. I was overtaken by anxiety for having the best and had to obtain the maximum emotion from them. I continually juxtaposed one picture with another, one artist with another, in an unending search for the best. This is a necessary impulse for a good collection. At first it is almost inevitable that you will make mistakes, as with everything, but in collecting you learn by making mistakes. This is a risk you have to take. If buying art is not a momentary fad the experience you gain is extremely useful. You must continue to follow events and never abandon your interest in searching, otherwise you lose contact with topicality, you stay tied to the things of the past, to well-known things that in the meantime have increased in price, if they were the right choices, and so they can no longer be bought. Usually the amount of time for buying does not last long, and in a very few years the situation can change. This happened above all in the 'fifties, 'sixties, and 'seventies when the overall financial situation was expanding without much inflation, and critics were interested in the evolution of art. Today, in 2003, the situation is different. The art market went through a great crisis in the fall of 1990. Values were halved with respect to those of 1988, and for many artists the drop was extreme. Because of a general deflation policy, prices were stabilized at a low level. An increase toward the levels of ten years earlier only began in 1996. This was the longest crisis over the previous fifty years. The increase has been erratic, and many fashionable artists have been rewarded by conspicuous increases, but these are artists I would never buy since they have nothing to do with my sensibility or vision of life. For example Basquiat, who in 1984 cost 25,000 dollars, now costs over 500,000. Most of the artists I have bought recently have had stable prices, and they did not diminish during the crisis because they were already low, and they have not increased because the artists are outside current trends and critics do not concern themselves with them. In contemporary art there are extremely strong cyclic variations, and it is necessary to have the patience to wait for a change in trend. No one is a prophet, but high quality will perforce be recognized in time.

You come through only after a long wait. This certainty in waiting was my philosophy of life yesterday as it is today. I have never believed in luck, but I continue to believe in what is good. Probably when I am no longer here to talk about these things, the art of today that is overlooked by critics, by insti-

tutions, and by collectors, all of whom are on the lookout for novelty, will be appreciated differently; it does not matter that I won't be around: it is enough for me today to know that I am making the best choices my conscience will allow. In the past too I made difficult choices that were not accepted by everyone, or almost everyone.

PIERRE RESTANY
AMÉLIE-LES-BAINS, FRANCE, 1930–PARIS, FRANCE, 2003

An important moment during my acquaintance with Le Noci was when I met the young critic Pierre Restany, who was quite up-to-date with what was happening with the latest art in Paris. This was information I had been searching for, about the state of art in the world. Paris was the capital. Restany was French and a friend of Italy, still young, twenty-four at the time I think, and for this reason was more believable, not being compromised by links to galleries or artists. In just a short time I had become aware of the limits of the situation in Italy; I needed as much information as possible, and Restany was a way of having it. I hung on his every word. Paris was the capital of international culture. I had to go there.

He told me about such new artists as René Laubies, Claude Bellegarde, Luis Feito, all of whom Le Noci exhibited, and above all about the Spanish artist Antoni Tàpies who, when I saw photos of his works, seemed the most interesting. Other innovative artists were Wols, Jean Dubuffet, Hans Hartung, and Alfred Manessier, though all were by now well known and so difficult to buy. Finally, in May 1957, the long-awaited day arrived. This was the second time I had been to Paris, as I had gone there in August 1946, on my way back from a month in school at Angers in the Loire district to improve the French I had studied as a schoolboy. Restany's company was invaluable as he gave us all the necessary information for seeing the things that interested me. The first visit was to the Stadler Gallery where Tàpies was holding his second show in Paris.

ANTONI TÀPIES
BARCELONA, SPAIN, 1923–

This show made a great impression on me: a real revelation. It had been just over a year that Tàpies had reached his mature style, arrived at in 1955, and was seen in his first show at Stadler's. It was like meeting someone in whom, suddenly, you discover an identity of ideas, emotions, and experiences. His art expressed all the difficulties in generating a new world after the catastrophe of the war, which had destroyed not only men and things, but above all ideas,

hopes, and certainties. Since the Renaissance, European civilization had developed through its worship of the Goddess Reason, and she had been generous with her gifts: science and technology that had transformed the world and was allowing mankind to progress.

Between 1914 and 1945 this enormous progress seemed to have been transformed into a mortal poison. It seemed that at the end of the day the Goddess Reason had generated a monster that had devoured itself. Never in the history of humanity had there been so many dead in just half a century. Reason, no longer bowing before a higher law, could justify every crime. If Russian intellectuals did not agree to rigid ideological obedience, well then it was right to eliminate them; if the middle classes would not be collectivized, then they had to be destroyed. If the Jews could not be considered sincere nationalists, then they should be burnt in ovens. When there is no longer the expectation of another world but that only this one exists, the ends justify the means, and if happiness is only here on earth, then it must be arrived at at all costs.

Tàpies expressed this crisis, the disappearance of this way of thinking. More than ever it was necessary to get out of this destructive spiral in order to find other certainties, other hopes. His pictures had the colors of the desert where there is no life, of an earth tortured by convulsions that had been banished for some time, with just a few signs of some distant human presence, as though the living had given up existing while expecting an imminent apocalypse. The expectation of something extraordinary, perhaps terrible, perhaps salvation.

Tàpies used an *hautes pâtes* technique, one with thick impasto consisting of paint, sand, and a synthetic thickening, Vynavil. This technique had been invented by Fautrier in 1943 when he began to paint his *Otages*; this was an impasto of plaster and paint that created an effect similar to bas-relief sculpture; not only the form of the brushstrokes and the paint, but even the three-dimensional relief became a means of expression. A few years later Dubuffet used a similar technique. Tàpies, in order to obtain the colors of the desert used minerals, I believe, with earth colors: ochre, dark yellow, dark red, gray, gray-green. This was a new means of expression used by few other artists. It was a novelty, and nothing similar had previously existed in the history of painting. The Conformists judged it a daring extravagance, and for the greater part of art lovers it was a useless invention. My first acquisition from the Stadler Gallery was a picture with a brown background and at the center a gray-green rectangle (*Composition en marron grisaceo*, 1957). It seemed like a tombstone, immersed in a great dark space. It was a highly attractive image. Here was something that had disappeared for some time in a limitless space; there was the idea of a life lost forever, no longer recoverable. Over the next five years I bought many more works. I bought fourteen Tàpies while their

price gradually rose. I think that for the first I paid the equivalent of 250,000 lire, a low sum but one that should be multiplied by ten because of inflation; anyway, it was very little. He was a new artist who was then referred to as belonging to the avant-garde, a mistaken and over-used word: he was simply a creator in search of the best means for expressing himself. Giotto was avant-garde in comparison to the medieval artists who preceded him, and so was Masaccio compared to Giotto, and then Leonardo who discovered light's *chiaro e scuro*, light and shadow. It has always been like this in the history of Western art of all times. Creators invent new techniques, those most adapted to expressing a different vision of the world and life, and this is always the starting point of all art and of each work.

At the time a book by Michel Tapié, *Un Art Autre* (1952), was highly influential, and I too read it with great interest. He was the first critic in Europe to talk about Jackson Pollock and Clyfford Still with admiration. The artists he preferred were Wols, Jean Fautrier, and Jean Dubuffet, all of whom, in 1955, were still unknown and rejected artists. He was an aristocrat, the nephew of Henri de Toulouse-Lautrec, a relative of the counts of Toulouse, a very important figure for new art in France. He was an enthusiast for Tàpies. These were all certainly the best artists in Paris at the time. I wanted to buy some pieces by Wols; the pictures from the 'fifties, just before his death, were very beautiful—an explosion of vitality that destroyed itself because of the impossibility of becoming reality. This was in fact the situation immediately after the war: too much death had negated life; there was the threat of an atomic war; the continual road to death seemed to dominate. Some of Wols's pictures are highly relevant now. An overwhelming wish for life is never completely fulfilled. This is an artist who has never had the recognition that he merits. There are only a few beautiful paintings, since his creative period was brief. I would have liked to have bought some, but they cost ten times as much as works by Tàpies. I did not have much money; instead a great Italian collector, De Angeli Frua, bought them.

The other important artist in Paris at the time was Dubuffet. I liked him for his biting irony, the bitterness he expressed—the loss of happiness, the wish to find it again, the impossibility of having it. This was certainly an interpretation of the postwar period when so many ideals had been destroyed and when it was necessary to find others that were better. A difficult undertaking.

This situation was widespread in the world of intellectuals, and a writer such as Samuel Beckett expressed the same state of mind. His protagonists have a need for God but do not have the courage to recognize it; they are afraid of losing their freedom and prefer a desperate sadness to submission to another will, a proud affirmation of their own self. Pride is the greatest characteristic

of western European man, but also his limit, because when there is little trust then sadness has no hope: the void and nothingness are a weighty presence.

Perhaps *Waiting for Godot* best describes this situation. The person waited for does not arrive, yet he is the only reason for waiting. Without *Godot* everything is useless, and *Godot* can only be referred to in this way, the true name disguised. If it were "revelation," "resurrection," or "incarnation" it would be refused indignantly as an offensive intrusion. Perhaps for those who have suffered a Utopia that has died, even a long wait is a better thing—to prepare oneself slowly for the separation before a possible resurrection.

Fautrier's evolution was interesting. When I knew him in 1958, he was an angry man. He felt he had been unjustly snubbed and that his friend and rival Dubuffet was about to taste success and glory. The Informale Art movement with its *hautes pâtes* was having success, though Fautrier with his *Otages* had invented and realized marvelous works.

This merit was not awarded to him. His most creative period, between 1944 and 1947, had been brief but intense. His later works had been too beautiful, and there was less relationship with suffering, less pity for innocent humanity. The paintings lacked their particularity. Dubuffet's works, on the other hand, maintained their intense emotive burden until 1953. Fautrier's reaction to this was an exaggerated interest in sex. I remember a visit to his house, Chateau Malabry, with its living room hung with refined paper, the ideal environment for a French artist. In a building at the end of the garden were his ladies. Restany told me about Fautrier's quite different way of dying, with all the solace of religion, in 1968, after a long period suffering from cancer.

In 1957 these two artists were not yet famous; their prices were higher than those of others but still accessible. Other artists such as Alfred Manessier and Hans Hartung were more famous, and in fact the latter artist had done some very interesting pictures with black marks on a white background in the 'thirties. In the 'fifties he produced pictures with feathery black forms that were repetitive and less expressive. There were many artists who were active and famous: Serge Poliakoff, Jean Atlan, Roger Bissiere, Pierre Tal-Coat, and others I can't remember at the moment because they have disappeared from the scene. Atlan and, above all, Poliakoff are still well-known, and the latter obtains good prices. In 1965 geometric abstraction was out of favor. Many practiced this type of art but not very much has remained. It is difficult to be Mondrian; it is easy to draw lots of straight lines with all the enthusiasm of making a presumed discovery, but to draw a few that say a lot is managed by very few.

Less is far more difficult than *more*: with *more* it is easy to confuse the ideas of those who are less prepared. Now, this is what is happening at all levels: a great confusion of wrong and superficial ideas, or worse still, definitely negative and mistaken ones. This is what is successful, it is what people want. When I began to collect in the 'fifties, geometric abstraction was not considered bad but just useless. It could not express ideas forcefully.

Of course the important collectors did not buy these artists, they had Picasso, Braque, Matisse. Something strange happened with the Surrealists who in the 'twenties had been a culturally important phenomenon. There was little interest in them. After the great success in the 'thirties their prices had gone down, and you could buy Max Ernst and René Magritte for little because taste in the meantime had shifted to abstract art and the Informale movement.

There was also another reason. In the 'thirties the creative force of Surrealism had weakened, the quality was not the same as before. Many imitators had tried to exploit the movement's success and had filled the market with awful works, thus discrediting and damaging the image of the best artists. This crisis lasted a long time, and only in the 'sixties was there a renewal of interest. I remember that Arturo Schwarz in Milan was selling extremely beautiful and recent Magrittes—not from the 'twenties—for two million lire, pictures that today are worth 1,500,000 dollars. This is a classic example of a change in taste, of the cyclic fortune of art, above all contemporary art, and this goes through four phases: the beginning, creative but unknown; success, less creative; the continuation of success through the force of inertia and sustained by latecomers who become aware only after the others and who do not want to seem to be someone who does not understand. Then, lastly, there is the period in which the artist's creativity disappears and he works to satisfy demand; he earns a lot of money, and everyone is happy.

But when everyone begins to do the same thing there is a crisis. And it happens very quickly. Everyone stops buying, for by then another fashion has already started for a different product that is, or might seem, new. No one thinks of what had previously been bought even if the price had been high. It is necessary to buy what the others are buying because it is different, and little attention is paid to the ideal content of the picture and the efficiency of its form; when the others are buying the latest thing it is necessary to buy it too, even though no kind of inquiry has been made to discover the values that the artist has tried to express. Many people buy without having arrived at a reasoned and tested opinion, but only by having trusted in the surface: what you see at first sight. It has always been like this and it still is. Real cul-

ture is understood after a lapse of time, and we might say that people, even those considered intelligent, do not use their intelligence for judging contemporary work.

Mental inertia is very strong and only rarely do we use our head. The same things happen for antique art too, and forgotten artists are rediscovered. When a good critic begins to talk about them with conviction in papers or magazines, this can create an interest in a reader who is not superficial, and in this way the number of interested people grows until it becomes the general consensus. This is what happened with Lorenzo Lotto, an almost forgotten great artist who until forty years ago was not considered at all important. And then Flavio Caroli discovered the psychological complexity of the artist. Now he is famous again, far more so than he was in life some five hundred years ago. When there are exhibitions of his work, they are full of people and everyone has to see his pictures, whether they are educated people or not. When Lotto, at the end of his life, tried to sell off the paintings he had in his studio many were left unsold; he was not famous: Titian yes, Lotto no. Personally I prefer Lotto to Titian. He had to work for the bourgeois clients of a provincial town, Bergamo, or for the parish priests of the Marche region. Titian worked for kings and emperors. Only real quality stands up to such crises and will later regain its full value and a general recognition of its importance. Weak quality, without force and little content, is finally isolated. Time is ruthless in weeding out the weak, even if they seemed the strongest at the moment of their success.

Memory is necessarily selective; we cannot keep all our baggage because in our journey through history we must reduce the weight of useless things to a minimum. A tough task and one to be carried out pitilessly since good intentions are not enough. History only saves a few good ideas. Only ideas remain, and pleasurable accessories cannot be saved. And good ideas at times repel rather than attract.

Everyone must overcome the barriers to what is good. This asks for an involvement greater than usual: to select with the aim of understanding. My anxiety and torment has always been to fully understand the indestructible good within an artist and a work. The pleasure of discovery is great but it is not a certainty. It is always possible to make mistakes because enthusiasm often plays tricks on us: wishful thinking takes the place of what is actually there. Our interior life too undergoes moments of crisis, periods of optimism and depression, the desire to possess and to reject. These troubled moments are useful for developing a greater awareness and a truer judgment; in them we are obliged to think about the real values expressed by the work, without the enthusiasm that replaces reality with our desires. We must interpret the object in another way. Plurality of meanings is an indispensable requisite of

quality. To see if this plurality gets to the heart of things we must of course have already understood what the essential things are. If we do not have this predisposition we will never be able to understand what lies beyond the obvious. And this difference is a great difference. Many people have been condemned in advance not to understand, even though they have studied and have obtained their doctorates with the highest grades. The presumption of knowledge is the finish, it is the death of knowledge, especially when dealing with contemporary art. The quality of art is always an emotional phenomenon; it is an act of love, and the happiness of seeing and possessing art lies in this loving relationship. When we are in front of a picture in a moment of crisis, we have the idea that everything we have thought, felt, or loved was only a momentary subjective impression, not reality. We wonder if we were mistaken and why we were mistaken. We begin the work of analysis: an examination of motives; a critical meditation on the basis of interpretations; a test of whether the ideas we saw expressed in the work were real and not just our presumption; a reexamination of the link between idea and form, a difficult, even impossible link to define: it is the secret and mystery of art, it is its dark and potent heart, its great superior force teetering on the very edge of reason; it is the point of connection with the unknown, with the mystery of life and all things. It is like touching something that cannot even be imagined, it is like arriving at the source of life. This is not an intellectual act: it is a phenomenon that precedes our being and overcomes it. We can discuss every quality in all kinds of ways, explain how that yellow matched against that blue suggests an idea. How those forms run together harmoniously toward a central point, how the contrast between light and shade underlines another idea. All useful and correct things, but they are not the emotion felt when discovering beauty that is superior to any possible description. We can only feel and love, or else not feel it and reject the work, as happens with a lot of contemporary art distant from my own ideas. At this point a bias insinuates itself: the rejection of an idea because it is different from my own ideas. There is always an ideology, a philosophy, a particular world of values behind every emotion, even the most instinctive. We are cultured animals and culture is a part of existence; our ideas make us different from the other animals, for they only possess the instinct for physical life: we have something more. This "more" is the discovery of the sublime; it is the message of art. Sometimes we have the impression of having lost it. A verification is needed, and if the result is positive our future emotions will grow, our judgments will be reinforced. We will no longer be afraid of another confrontation.

We must be careful of our prejudices. They are a danger we must avoid. When a work of art does not reveal ideas, then there does not exist the neces-

sary condition for the existence of beauty: this is not a question of rejecting it in favor of something different, it simply does not exist as art.

When the rejection is motivated by the search for a higher value—one contrary to a society that does not see it—this rejection underlies the search for what is good; value exists even if it is apparently denied. German Expressionist art from the beginning of the last century seemed to deny the values of harmony and beauty, which were rejected in the name of higher values than the present could express. It is different when rejection is not about seeking what is good but is simply a refusal; in this case there only exists emptiness. Unfortunately much of the art being made today is a refusal without asking for anything else, without desiring a better state of things: it is only a condition of non-life, it is an illness of the psyche, a loss of reasons for living—the desire not to exist, to disappear from the world's scene.

This desire ought to find its logical conclusion in suicide, but this too requires a strong will in order to dominate and repress the atavistic instinct for survival, our basic attachment to life. A decision too powerful for those who reject everything. Existence is an inertial propulsion that is too tiring to stop. Suicide resulting from desperation is justified by its unbearable suffering.

This condition can produce great art: we suffer for the good we do not possess but that we would like to have. Indifference is the worst evil. Even the devil would vomit up those who do not feel, who have no soul, who do not hear and cannot produce art.

But these thoughts have carried me far from Paris in the 'fifties when the collection was at its start. Even then my enthusiasm for art was mingled with doubt. Often I felt the torment of not being sure I was choosing the best, that which would last in time, the certainty that I would not be deluded one day. This was a useful stimulus for reflecting on, and making comparisons with, the artists that others judged to be the best.

It is a test that forces you to evaluate differences and understand your choices better. But it must be an honest comparison: it is necessary to be ready to admit mistakes. It is necessary to overcome your pride, to admit you have not understood your error, to have used your mind improperly. This has happened to me many times I must admit. But it is useless to feel remorse; you just have to pay more attention in the future. There is no remedy for the errors of the past. The artists I did not understand at the right time I can no longer buy, they quickly went up in price and beyond my possibilities. Later I will point out my errors and the reasons why I made a mistake.

CAMILLE BRYEN
NANTES, FRANCE, 1907–PARIS, FRANCE, 1977

In Paris Restany introduced me to Bryen, whom he rated highly. He lived in an old house in the Latin Quarter. It was in a narrow street with little light. It was not far from the square where there was a café patronized by artists, Les Deux Magots, a fashionable meeting place at the time. It was almost necessary to go there to see the artists of the younger generation.

It was a house like many others in the Latin Quarter, where the upkeep left a lot to be desired. Everything was still as it had been a hundred years before, but with a century's wear. The surroundings were worn down by the many people who had lived there but who no longer existed. There was a vague presence of those who were absent. Bryen was by now almost an old man. He was introverted, shy, and was disturbed when an outsider became interested in his work and wanted to see his pictures. He would hold a handkerchief that he continued to twist around in his hands; he did not know how to start a conversation. He was helped out by his wife, she too was thin and old, but with a sweet and mild look. She was delicately attentive to her husband, who must have had a difficult character. The house consisted of three small rooms. There was all the order and cleanliness of dignified poverty, the kind of situation where it was a fight to put together the money to pay the rent. Everything was old and worn by time. There was no extra money. He painted beautiful pictures with multicolored patches crossed by nervous dark lines. I bought three. I think that at that particular moment this was something very unusual. Sadly I did not keep my Bryens but exchanged them for something else. This was a mistake because I saw similar works by him, all of high quality, exhibited at the Pompidou two years ago. I discovered later that in the 'thirties he created very aggressive Surrealist works. I have seen only a few examples from that period, and it would be interesting to make further researches. Bryen was in no way mediocre.

To go back to Milan after having seen so many galleries and artists, important or otherwise, was like returning to a provincial town, a small world instead of a great one. But there was, all the same, a more than dignified situation: the various Sironis, Carràs, Morandis, and Casoratis could stand up to the comparison. Also highly valued were the abstract paintings by Renato Birolli, though I didn't like them. His was an abstraction in which you could also make out a figure: a compromise, and perhaps this was why he was so popular. But at the end of the 'thirties he had created some excellent Expressionist-inspired paintings with acid and violent colors.

In the 'fifties abstract art was something scandalous, and those who bought it were madmen who didn't understand anything. They were also stupid since they threw away money on things without any value at all. Often when we had visitors at home they told me quite openly that I was stupid and didn't understand anything about art. The angriest were those who were interested in art. They just could not stand the idea that it might be considered something valid: the works were a negation of validity. I did not react to these criticisms or even insults as I knew how to conduct an argument and, anyway, I was confident in what I was doing. I tried to explain why abstraction interested me but without much reaction. I was in front of a solid and impenetrable wall. Whoever made some violent statement would have felt humiliated had he had to admit that his adversary, someone whom he had to destroy, might be even partly in the right: the pride of an intelligent, cultured, and expert person would have been wounded. The art critic of the *Corriere della Sera*, the most important newspaper in Milan, not to say Italy, Leonardo Borgese, made crushing criticisms about every show of abstract art. This was the newspaper that reflected the opinions of the managerial middle classes in Milan, the pulsating center of the Italian economy. To continue to collect in an aggressively hostile environment needed a great deal of tenacity.

FRANZ KLINE
WILKES-BARRE, PENNSYLVANIA, U.S.A., 1910–
NEW YORK, U.S.A., 1962

The most important event of 1957 happened in the fall. I was searching for all possible information about contemporary art, though there were very few books and magazines available. IRI, a state corporation for the production of steel, also promoted cultural activities for the spread of information about its

production and published a magazine, *La civiltà delle macchine*, which was run by some enlightened and competent intellectuals. In it I found an article about the relationship between industry and art, and among other things, a painting was reproduced that seemed to be a steel structure, one that had, though, been destroyed: its beams were twisted as though by an explosion. It did not seem to be a construction: it was evidently an abstract painting. With its vigorous black lines on a white background, it represented the energetic gestures of an artist who wished to convey a state of tension, the desire for something larger that had been cut off and could not be completed. It was the expression of an energy pushing toward something unobtainable. I was greatly struck by this image. I felt it was very American, and it gave me the same impression I had had when I looked up at the skyscrapers of Manhattan: the desire to reach the impossible.

The picture belonged to the Sidney Janis Gallery in New York. I had to try to have it; it represented myself and my will to reach some impossible perfection, the beauty of a superhuman desire, even though it is one that is destined never to be satisfied. I looked for the address and wrote saying that I wanted to buy a painting by Franz Kline and would they please send me some photos. They arrived some time after. I chose one of a painting called *Buttress, 1956*: a great horizontal line, a vertical one, and few other marks. There was both a great simplicity and a great force. The marks seemed heavy, painted with a big paintbrush. The only color was black on the white ground of the canvas. It was as though the artist had attacked the picture out of a creative fury that forced him to act with superhuman strength, as though he had lost control of his actions and was dominated by some outside power. This is a characteristic of all Kline works, and also their beauty. It was not a painting done with a brush held between the fingers, sitting down in front of the easel. It was evident that it had been painted standing up using all the movements of the arm and the whole person, a picture created in a short time, marking out a few lines, but with a Minimalist sobriety. I felt an instinctive preference for this kind of expression; there was a potent austerity, the ability to say a lot with a few gestures, eliminating all decoration and unnecessary incidentals. A little expressed a lot. This is the most difficult thing, and certainly the reverse practice is easier: to say very little with many unnecessary forms that hide a basic poverty. I have always had this instinctive preference. Even when looking at the masters of the past my preference is for this kind of art: Giotto, Masaccio, Fra Angelico, Piero della Francesca, and Michelangelo, above all his last sculptures. The list could continue, and actually this is the greatest art. Those who have the best ideas and the ability to give them their exact form have no need for the superfluous, in fact they despise it.

Kline was my first contact with American art. I awaited the arrival of the picture anxiously. When it was hung my excitement grew: it had greater force than I had realized from the photo. It was an overpowering picture. All the others I had been buying now seemed weaker. The price was 550 dollars, a reasonable figure in 1956, and even lower taking into account inflation. I asked Sidney Janis if I could have a discount, so I only paid 500 dollars. I had discovered a new world to be explored, and I could buy works by great artists that I could afford. They didn't cost any more than their equivalents in Europe or Italy. The system of buying by looking at photos also worked.

Photographs eliminate certain qualities from paintings but add nothing, so if a work was beautiful in reproduction then the original would be even better. If I managed to get enough photographic material I could avoid going as far as New York and save some money for more paintings. I was young, I didn't have much money, and my life was rather Spartan or, rather, simple. I avoided superfluous expenses, but my family was growing; our children began to arrive, and they were an absolute priority. But immediately after them there came the collection that had to be created. I had to have the images I loved in front of me; my wife followed me in this without ever complaining about some commodity that I couldn't let her have.

In one of the side rooms was a fine gold-framed mirror dating from halfway through the nineteenth century that we had bought in Turin while furnishing the house. Pupa used it when putting on her hat, as was the fashion at the time, before going out. The walls were filling with paintings, and the apartment was smaller than it is now, after having been enlarged in 1962. I really needed the wall taken up by the mirror to place my latest acquisitions. One Saturday Pupa went out shopping and I arranged for someone to come and move the mirror into a bedroom, where, admittedly, it would not be very convenient but at least the picture that replaced it could be seen very well. When Pupa returned home and saw the unannounced change she was surprised and perhaps rather offended, but she showed no reaction. She understood my motives—which she shared too. She remembers this episode, since it was the beginning of a continual and endless process of giving in. Anything for pictures.

In the meantime my study of American art continued, and I asked many galleries for photos of the works I saw reproduced in art magazines: *ARTnews*, *American Art*, and a few others.

The second American picture I bought was an abstract by Philip Guston; it had a fine range of colors applied in an Impressionist manner. When the painting arrived I was disillusioned: it had seemed beautiful but it had no force; the initial idea was weak and didn't impose itself. I had bought it from

Sidney Janis but don't remember for how much. After two years I sold it to the Ariete Gallery in Milan. The money was used to buy another Kline.

Guston's best paintings were his abstracts, but after a few years he began to do figurative works, evidently with the aim of making ugly pictures: to describe reality deformed by decay. A fully achieved aim. They have been a great success and they cost a lot. They can be seen in museums. I find them repellant, things that irritate me when they are in front of my eyes. It is like looking into the trash can, or at least that's my reaction. On the other hand a lot of people like them. One of the many phenomena today that I cannot understand. A strange behavior of human psychology, an unacknowledged and underground pull toward what is negative, toward evil. A deep emptiness in the unfathomable subconscious. We ridicule the identification of evil with the devil, but he is there within us. Guston, and many others, allows him to be seen in various forms. The devil is not a person, he is our own person and lives in us. If we are weak he can even take us over. If we insist on mistaken ideas, then he is strengthened within us. Nor is he at all an unattractive presence; on the contrary he is most inviting.

My third American picture was by the artist Richard Diebenkorn. This was a transitional work, between figuration and abstraction. There was a seated woman with her arm resting on the parapet of a terrace. I remember paying 800 dollars for it. When it arrived home I realized I had made a mistake. It was a hybrid result, the outcome of a lack of ideas. It was like putting both feet in one shoe: either a picture is abstract or it is figurative. I am not an opponent of figuration on principle. In fact all the Pop works I bought in 1962 were figurative, but they were so for a very precise reason. They created a dialog with such social phenomena as consumerism and transformed them into art. Diebenkorn's pictures were just a half-measure, beautiful, pleasurable, well made according to the rules of fine painting, but without ideas.

I bought them from the Borgenicht Gallery. A year later the gallery took them back, paying me slightly more. It was certainly a financial error to give up a Diebenkorn I had paid 800 dollars for. Today, after fifty years, I still hold to the opinion I had then: Diebenkorn was a good artist but not good enough to be part of history. There are hundreds of good artists, formally perfect, but they do not give me any strong feeling, which is the secret of beauty. This is a great difference, though there are no ways of demonstrating it, and it is the heart that makes the decision.

I would like, though, to make my thoughts about Guston clearer. I never had the occasion to meet him personally. From photos you can see he was a tranquil and well-disposed person, certainly not demoniacal. But when you create art you become the tool of a power that is not your own. Something

different arising from the subconscious takes over the activity and the will of our reasoning mind, a primordial instinct that existed before we did.

In the meantime I continued to buy Kline. I was just discovering Mark Rothko. I would have liked to buy works by Clyfford Still, but sadly they cost too much and I couldn't afford them. He was an artist whose policy was to buttress his own work by selling few at a high price. I do not think this is a good system. In order to be seen and appreciated works must circulate. But we must give him his due: he made donations to museums. The most important is the group in the Albright-Knox Art Gallery in Buffalo. They are all masterpieces, and many years ago I undertook a journey especially to see them. The director kindly showed them all, although they were all in the reserve collection. Marvelous masterpieces representing a great moment in American art. Sadly there were only a few hung in the rooms, so most were unseen by the public. It is a group of works of the highest quality that merit a museum to themselves. I don't know if the situation has got any better. They were all paintings of the 'fifties, his best period; those of the 'sixties are of a lesser quality. The room in the Metropolitan Museum devoted to Clyfford Still is different; there are paintings from the 'sixties. Evidently they were donated on the condition that they were all shown. This is an error often made by artists and collectors when they give works to a museum, that of insisting they all be shown together. We all make mistakes, and so do great artists who have creative periods and less creative or even negative periods. Artists easily become prey to the error of believing that it is their head that creates good art. This is not true: it is something else that we do not know but that we easily see by its results. This is why they are unable to understand the difference between beautiful things and those they made with their mind, which are, as a result, basically different and inferior, even if apparently similar. Another example of this kind of error is the Justin K. Tannhauser donation to the Guggenheim; here are masterpieces by Picasso and other artists side by side with pictures that have important signatures but are not great; in fact they are mediocre, and it would be better not to exhibit them. This would be good for the donor's reputation.

I was beginning to feel my way around the American continent and to discover the art up to the 'fifties. Europeans judged American art to be provincial and valueless. This judgment was also that of American collectors who bought in Old Europe, where good art was being made, not in New America. This was a deeply rooted opinion and justified until 1944. From then on things had begun to change, but few were able to see it. Some European collectors had begun to collect American art: in London Mr. E. J. Power had bought Kline, Barnett Newman, and other artists. I remember meeting him some years later, I think

at the end of the 'sixties, together with Nicholas Logsdail of the Lisson Gallery. He was an important and able collector. In Rome, Baron Giorgio Franchetti, in I think 1955, a year earlier than me, had bought Kline and Rothko. Two spot-on acquisitions. In 1961 I bought one of his Rothkos through Plinio De Martis, the proprietor of the La Tartaruga gallery. I met Franchetti many years later in Rome where the La Tartaruga was putting on shows of American art. This was an important job: De Martis was a pioneer and Franchetti was a supporter. His sister married Cy Twombly. He lived in Rome and was a link to the best American art. He did his utmost to promote this artist, above all in the 'fifties and 'sixties. Robert Rauschenberg and Jasper Johns became famous quite quickly; Twombly a little later, at the end of the 'sixties.

During this visit to Rome there was also Willem De Kooning, and I remember a crowded dinner in a restaurant. He was by now a famous artist and was treated with respect. He had become famous before the others. Today he is one of the most expensive artists, costing even more than Jackson Pollock or Jasper Johns. I don't believe the future will reserve such an important place for him. His art is derived from the German Expressionism of the beginning of the century, and in fact he was born in Amsterdam and his formation is European. His best works are the *Women* painted in the 'fifties; the abstract works from the 'sixties are good too. In the 'sixties his work began to become weaker. The pictures from the last ten years are only stripes of color without any meaning.

My first meeting with De Martis was in the La Tartaruga Gallery in 1958 for an exhibition of drawings by Kline. I bought four of them, which I still own, while the twelve large canvases have been in the Los Angeles Museum of Contemporary Art (MoCA) since 1984. This was the first show by Kline in Europe, and it was in Rome, not in Paris, the capital of art, nor in London, which had more relations with America. It is important to note that this interest occurred in Italy before other European countries.

Power and Franchetti were the first Europeans to buy American art. In 1957, however, I began a collection that explored this great cultural event in a systematic way, with many works by each artist, before it became a widespread phenomenon.

In 1958 the director of the Basle Kunsthalle, Arnold Rüdlinger, bought a group of American artists each represented by one work: Kline, Rothko, Newman, Tobey, and Still. This was the first European museum to do so, and it was a courageous and farsighted act.

The best art imposes itself for its qualities in a natural (I would even say inevitable) way. We all search for beauty and despise the mediocre. Diffusion is certainly useful for a rapid understanding of the best art. Europe was coming

out of a terrible period in its history, perhaps the worst since the fall of the Roman empire, and its ideals had been destroyed by the violence and wickedness of those in power. The ideology that should have made everybody happy and equal had destroyed its adversaries in their millions; the possibility of an atomic war could not be excluded, and a powerful army was at Europe's gates. America had won the war because of the positive forces in its society. It was a country full of life that believed in the future and that fought in the belief it could construct a better one.

Europe needed for hope to return. America was a return to life. This was one of the reasons that provoked a stronger interest in its new cultural message. At the end of the day it had superseded Europe in everything. Even the art market was managed in a different way.

When in Paris I asked to buy a picture in some gallery, I had to watch absurd maneuvers to raise the price. I knew they had lots of unsold paintings, but they would tell me there were only two left as the others were all unavailable. If another work was hung in the gallery, then it was reserved for a collector who was about to buy it. It was the same method of selling as practiced by an oriental rug salesman, where the sale is preceded by a pantomime between the buyer's low offer and the higher request of the seller. In America the laws of the market were respected, the prices were what they were, determined by the request and the availability of the objects. Everything on sale is visible. The French dealers feared the rise of American art. They tried to stop its diffusion, which was a great mistake since it would have been more intelligent to sell it in Europe. They behaved like decayed noblemen who, instead of selling their palace to pay their debts, sell their income-earning properties, and bring about their own ruin.

I was asked to lend a colored painting by Kline to a group show about color in Paris. It was a rare colored picture, *Alva*. Kline only did them after 1958, and the picture dated from that year. At the end of the show, when it was returned to me, an important dealer wrote to me saying that the American artist was not a good colorist. When I was in Paris in the 'sixties, after the prize awarded to Rauschenberg at the Venice Biennale, some dealers considered me a traitor to our glorious European culture, as though I had opened the gates to the Barbarians. These were the obstacles I had to overcome in order to collect in a systematic and ongoing manner. Building up a collection is a task that increases slowly and lasts a lifetime. This is the only way to have a positive result.

There are collections that have been created in a few years and over time have become famous. Then they stop. When you love art deeply it is not possible to stop; the impulse to search, see, and love is too strong. I had not been

married long, and our first son, Alessandro, had been born. My possibilities for collecting art were very limited since our paternal assets were held in common and their management was difficult because of the different interests of the proprietors.

It was a distressing decision to share out the assets that my father had wanted us to keep together. In unity there is strength, and four parts are less than a whole. But when aims differ then a division is not only necessary but for the good of all. It frees creative energies that would otherwise not be realized.

I had decided to devote myself to developing a real-estate operation. Constructing buildings was something real and was in the tradition of my father and my grandfathers, and it was also an activity I liked. It was work that took a long time and needed faith in the development of society and, as a result, the economy. My optimism was largely misplaced, and I realized this some years later when party politics began to become interested in city planning and in so-called property speculation, which in my case was not in the least speculation but, if anything, a loss rather than a gain. I have never really tried to uncover the truth, but without a doubt my assets never grew in over thirty years of work. Unfortunately Italy was not America. I discovered this at my own expense. After 1962 the country became more Socialist than Liberal. The times of De Gasperi and Einaudi were over. It would have been far better to have dedicated my energies, money, and abilities to art: I would have done far better than I did, which anyway was a lot, and so I have no regrets, and anyway I have been very lucky. Art is something you love not something you work with in order to gain a living. I had this respect for its inviolable freedom. In order to develop a real estate activity it is necessary to have capital tied up in very long operations—also because of the thorny and ambiguous Italian legislation, real estate became even more risky because of political interference. For this reason it was necessary to remain associated with my brother and his firm. The division with my sister was long and difficult, and we reached a conclusion by making sacrifices in her favor.

A sad event struck me in 1956: the sudden death of my mother. She was an angelic woman who lived only for her family. She was discreet and never meddled in the lives of other people, and she had a great respect for her fellow beings in whom she trusted; she was always smiling and calm, and disposed to helping others. The previous year I had been married, and I would often go to see her when I left the office in the evening. When I entered, her face would light up in a smile showing her great happiness. Maybe I was a son in whom she saw some good qualities. Perhaps I was even the son she loved most. My greatest memory is of her. The memory of her goodness is a great inheritance, indeed greater than any other. I hope to have merited it. I saw her for the last time half an hour before she died. Her heart was tired. Her death was sudden

and took place in the car at the beginning of Via della Passione. My sister had left her to collect a Christmas present from an antiques dealer. She was looking at a plaque on a house in front. Probably the best way to go, but far too soon: she was sixty-seven.

With the division of our assets I had earned my freedom, even though it was not quite complete as I was still associated with my brother. It was anyway a positive fact, and I could plan acquisitions for the collection according to the state of the real estate market on which my income wholly depended. This limit explains why I lost the chance of making certain purchases that would have been necessary, and why there were some empty periods, even years apart, when I bought nothing because of the cyclic crises of the real estate market. My mistake was to be involved with too many building sites between 1960 and 1962, the period of the economic and building boom. After 1963 there began a period of crisis that lasted until 1969. In order to pay my bank debts I had to sell the completed buildings that were bringing in an income, but in this way I began a parabola of necessary but negative operations. The length of the recession made my debts heavier, but I had to pay the high banking interests regularly. Because of the general crisis, the market was not in a condition to absorb the buildings still for sale. In this way my income disappeared while the costs rose.

Over-optimism during good periods is the cause of all economic crises: you think that demand will continue, and make big investments in the belief that the market will always be good. Then there is not enough money to pay the investments, and bank credit is needed. The banks are only too happy to lend because they have money to use that earns a good income. There inevitably comes the moment when debts are too big and their cost too heavy. Demand is becoming saturated, and so the recession begins, today as in the past, as always.

I have always been fascinated by cultures that have not been influenced by Europe, that have developed autonomously and have confronted the problem of interpreting existence outside Greek mythology, Judeo-Christian religion, and Western rationalist philosophy. It is interesting research to find points of contact and differences. Our interpretation is influenced by our habits of thought; rational reasoning is given more importance than intuition. Thought is an exclusively human process that is opposed to the experience of existence, which is an intuitive phenomenon. Thought distances us from nature, which evolves in a superior way to logic: nature creates, logic analyzes, discovers what creation consists of, what the relations are between one phenomenon and another, but it is incapable of imagining something different and new.

In the spring of 1958 Franco Monti organized a show of primitive art with pre-Columbian and African sculptures in the Ariete Gallery in Milan. This was a great event for me. I could research an idea that I considered important, in a real and concrete manner.

The art object expresses in the most complete way a vision of the world and life that can be communicated with the tool of intuition, not with logical arguments that impoverish the message the idea contains. To exhibit this art so different from the usual in a contemporary art gallery seemed a contradiction, but in fact there were many affinities. The gallery was run by Signora Beatrice Monti della Corte who had from the start developed an excellent program of contemporary art; she had been the first to show Tàpies and Rauschenberg. In Milan Franco Monti was, and still is, someone quite exceptional, with a great passion for sculpture and, in particular, for African art. In the period between the 'fifties and the end of the 'sixties he spent a lengthy time every year in Africa, traveling through almost all the equatorial zones where there had been great artistic activity. It was a hard and very adventurous life, traveling in a Jeep for months in inhospitable places with an oppressive climate and with the risk of catching tropical diseases. These were the last years for finding art, difficult years at the end of colonialism and before laws had been passed forbidding the exportation of artworks. Another important factor created a climate favorable to purchasing: the change of religion of the various peoples who converted from animism to Islam, which forbade the representation of the divinity and forced the faithful to destroy their images. American dealers had been buying African art for years through their agents, who lived in towns along the coast but had never set foot in the interior. They had created a market and a demand with prices that made sales more convenient than de-

struction. In this way a large part of African art was saved, because otherwise it would have disappeared. There would only have remained what was kept in European and American museums from the times of colonialism.

Many African countries, ex-European colonies, complain of having been deprived of their art, but they forget that if it had not arrived in Europe or America it would no longer exist. It was the interest of Western culture that saved it. A completely different social and ideological situation does not allow an adequate conservation in the places of origin. The museums created in Africa for safeguarding its heritage are in a disastrous condition. Often the best objects have disappeared, with the complicity of the people in charge. This was a brief period that only lasted a few years: a restrictive policy and the depletion of available works closed an era. By now collecting can continue only with the exchange of pieces already existing in the West; nothing more arrives from the countries of origin. A great art was created in Equatorial Africa that has only recently begun to be appreciated. It is an art created by anonymous and unknown artists, one in which the creator's personality is at one with his community. It was not an art created for aesthetic enjoyment but was, rather, an instrument for ritual, a means for communicating with the divinity, to placate or invoke the forces of nature.

Its supernatural power was its beauty, and that is exactly the beauty we appreciate. The distinction that we Westerners make between aesthetics and meaning is arbitrary. In fact this separation does not exist; real art is always a tool for communicating with the unknown that is within and around us. Franco Monti's work in this period was important. It was the last-moment salvage of a culture that has disappeared forever and that was part of a religious faith that cannot be recreated, one in complete contrast with Western influence, with its rational and intellectual culture that has broken all the instinctive links with nature. The illusion of the power of reason could be a great illusion indeed.

Thanks to Franco Monti I created a small collection of primitive, above all African, art, some sixty pieces both large and small that are conserved in the houses in Milan and Varese. These are a permanent part of the furnishing, objects I share my life with, and they match perfectly our Renaissance furniture that seems so distant culturally: they are placed on top of them. The best have been donated to FAI, together with the furniture, in order to preserve an environment that had lived together with its art in the Biumo house.

MARK ROTHKO

DVINSK, RUSSIA, 1903–NEW YORK, U.S.A., 1970

Kline represented my discovery of American art; he was the pathway to a new continent. Immediately afterward I began to concentrate on Rothko. I was fascinated by the mysticism of his colors. He was not only an artist who knew how to choose those that best matched together, he was much more; his was the vision of another world shown through a means that had an instinctive relationship with our emotions, with our way of being: the capacity of offering a vision that is inside us but also outside. And this was his great attraction. In some of his pictures I saw sunsets over the streets of Manhattan, when the sun sank between the skyscrapers toward the clear horizon, full of color, red, yellow, violet. The light that slowly faded. Life that was ending, the evening shadows lengthening, the rowdy traffic of the great city seemed to distance itself, the sensation of my own presence grew in the midst of a life that seemed extraneous to me. I immersed myself in the sunset, I felt my being dilate into an immense reality, distant, full of marvelous colors; I felt budding within me the possibility of a never-ending existence, an absolute beauty, the infinite beauty of nature. Our ego finds itself again in an existence from which there disappears the difference between the physical facts outside us and our conscience within. An identity between feeling and being in a true totality, not within a psychic situation, but in a reality similar to the marvelous colors of the sunset. In other pictures I saw a corner of my garden with many flowers blooming together to create a dense colored surface, radiating the sensation of a life full of joy. Rothko knew how to express with colors and simple, minimal compositions opposing emotions, vital and happy ones; or existence on the verge of extinction, not in order to die, but to be reborn in a new luminous life.

It was a shame that his paintings cost more than the others, so I had to find the money. The previous year I had bought some pictures by Emilio Vedova, an abstract artist who painted black and white pictures with marks demonstrating an aggressive attitude to painting: the brushstrokes were made rapidly and forcefully. His art was similar to that of Kline, but with a difference: Kline's art had very few marks. The underlying white background was dominant, the relationship with the black marks was strong, and they stood out visibly. There was a minimal quality, a certain thrift in using the brush unless there was an expressive, urgent need. Vedova covered all the surface with marks, the whole picture contributes to the final effect, not just a few marks isolated on white space. This was the difference that struck me. I had, and still have, a preference for economy of expression, when the meaning can be

understood through a few forms that show it in its entirety, and this not just in art but in literature: long poems tire me.

Hanging a Kline and a Vedova on the walls of home underlined the difference. I was disturbed, and so I decided to sell the Vedovas and buy Rothko. This was a mistake: I paid 500,000 lire for the Vedovas, and today they are worth 500 million lire. In order to buy Rothko I also sold a work by Alberto Burri, a "combustion" that, though it was not from his best period, was the only Burri in my collection. I admire this artist a lot, above all for the "sacks" he made in the 'fifties: high quality art and great masterpieces. I wanted to buy one but it cost more than I could afford. He had had great success in America and I remember these works cost 5 million lire, nothing in comparison to the billions they cost today. The most I had paid was 500,000 for a Vedova, ten times less. Values are always relative to the money you have available when it is necessary. I was also making another serious mistake: I knew of Lucio Fontana and often saw his pictures, which in 1956 cost 100,000 lire. It was only at the beginning of the 'sixties that they began to cost 500,000 lire. Fontana had a big output so there was a wide possibility of choice. He was a likable person, cordial and generous, someone who helped younger artists. I could have had tens of his pictures by spending a really small amount, which today would be worth a fortune, but I didn't. I knew him well and couldn't imagine that such a joyful, calm, and carefree person might have the character to create masterpieces. His works seemed too easy, too simple, created out of instinct without the necessary deep thought. I had convinced myself that to create great art it was necessary to suffer, be restless, unsatisfied, always on the lookout for something huge and unreachable, that those who are happy with everyday life could never create something exceptional. A romantic prejudice: the need for the sublime, for what was at the very edge of the possible.

Fontana had a collector, a Dr. Laurini, who did his utmost to create an international name for him, above all in Europe. Unfortunately, international success arrived after his early death. He was a simple man, without pride, and he knew how to accept life as it came: a rare virtue.

But in the meanwhile the first Rothkos were arriving home. I had bought two from a Milanese dealer, Peppino Palazzoli, who was also a collector who was very good at what he did. The pictures arrived from London, and I think I paid about ten million lire, 7,000 dollars, a huge sum for me but worth it for an artist I loved so much. My reference point was the 500 dollars I had paid for Kline. Abstract art was beginning to be accepted despite the outcry against it. The first Rothkos hung in the living room in Biumo were magnificent. The sober, elegant simplicity of the house was their ideal setting. Ancient and modern matched perfectly. I remember a long conversation with a Florentine

nobleman who just could not accept that the Rothkos were art. Despite my patient explanations he looked on them as swatches of color for painting the walls of the house.

JEAN FAUTRIER
PARIS, FRANCE, 1898–CHATENAY-MALABRY, FRANCE, 1964

The year 1958 was an important one for the collection: the quality and quantity of the works began to be consistent. I bought various pictures by Fautrier whom Le Noci was enthusiastic about and exhibited in his gallery. They were all recent pieces from the 'fifties and few from his earlier and far better period, for these were not for sale. I bought various works, and I was above all interested in those produced between 1944 and 1947, a brief but very fertile period. The *Otages* belong to this time, lacerating documents of an inhuman war. The rawness of the shattered bodies was veiled and sublimated by the refined preciousness of the colors and by the rhythm of the forms that brought harmony to where there was only horror and pain. Beauty managed to redeem the work of destruction of all human values. Pity and compassion are the only means for slowly recovering from suffering. Sophisticated and refined art could also express the possibility for redemption. Only a French artist who knew the beauty of colors and forms resulting from the aesthetic of art for art's sake, art only in itself, could transform this hedonistic sensibility into participation in a terrible tragedy. I wanted to have these paintings, which I believed to be really important. Some still belonged to the artist and his Parisian dealer, Samy Tarica, who was also an excellent salesman of Armenian carpets. Fautrier did not want to sell them, and I didn't have money to offer a higher sum. But due to my genuine interest it was possible to make an exchange: two recent pictures for one of the *Otages* period, a transaction that I considered convenient because of the great difference in quality, even though the recent paintings were bigger than the preceding ones. Fautrier was a strange person, never content and always angry. He considered himself a great but misunderstood artist, jealous of those who had more success than he had. He couldn't, though, complain about the success he had had in Italy. Palma Bucarelli gave him a show at the Rome National Gallery of Modern Art, and also published a catalogue raisonné of his work. Giulio Carlo Argan, and critics and newspapers in general, voted the show a success. Even one of the best Italian poets, Ungaretti, was favorable. The 1960 Venice Biennale devoted a room to him, and he was awarded the first prize.

As were all Frenchmen worthy of the name, he was an exacting gourmet. I remember a dinner in Varese with Tarica, the poet André Verdet, his friend

Restany, and Le Noci. The table had been laid in the imperial salon of the Biumo Villa, constructed by Duke Litta. My wife did her best to equal a French chef, the wines were excellent: they had been in the cellar since before the war and no one had tasted them before. Some of the bottles had not stood up to the passing of time but the few good ones had become excellent, comparable to the grand cru of Bourgogne or Bordeaux. Fautrier felt he was being treated like a great prince of art, and he was genuinely content.

Another important event of 1958 was the exhibition of new American art in the Basle Kunsthalle and then in the Galleria Civica d'Arte Moderna, Milan, organized by MoMA's International Council, a show that had a great influence in Europe. The major artists were all represented: Jackson Pollock, Arshile Gorky, Mark Rothko, Franz Kline, Barnett Newman, Clyfford Still, and Willem De Kooning, the postwar and 'fifties generation. This show was greeted with a lot of interest and great controversy. It was criticized by conservatives because it was abstract art, and by the extreme left because it was a manifestation of the culture of a capitalist country.

For me it was a great occasion to see works I had only previously seen in reproduction. Besides Kline and Rothko, whom I already knew well, I was very interested in Pollock, Newman, and Clyfford Still. These artists had a totally different vision from that of the Europeans. In Europe artists painted small paintings, usually about 60 x 100 cm (24 x 39 in.). Giorgio Morandi's format was the one most used. The Americans instead painted works 200 x 160 cm (79 x 63 in.). The former held their brush between their fingertips, the latter used the movement of the arm, standing up and using the whole of the body, which was not just a formal but a basic difference. It was art as an activity that penetrates reality in order to transform it, to give it a new direction, one that points to the future with the will to conquest. In Europe, art was an intellectual activity, closed within the artist's mind, without communication with reality, two separate worlds; and the artist was proudly isolated from his surrounding environment, which he despised as something incompatible with his ideal vision.

Another important even of 1958 was the birth of my daughter Maria Giuseppina, two years after that of Alessandro, our first child. So together with the collection my family was growing too, and in the following eight years was to be increased by Federico, Giovanni, and Giulio, four boys and a girl in all. One of the last large families, formed in a completely different social context from the present one. Other friends of my generation had large families. The second generation rarely has three children; most have none.

Tàpies was exhibited in the Spanish pavilion in the 1958 Venice Bien-
nale. I bought a picture from the sales office. In the section devoted to
younger artists there were present pictures by the Americans Jasper Johns
and Robert Rauschenberg, but I was not aware of their quality at the time. My
eyes passed over strange things that provoked no emotion in me, and today I
am ashamed of myself to think how stupid I was then. A lesson in life: never
think you know everything. I remember that in the fall of the same year the
Carlo Cardazzo Gallery was selling various pictures by Jasper Johns, proba-
bly arrived from the Venice Biennale. They were gray, medium-sized paintings
and cost 600,000 lire each, not much more than 1,000 dollars. They were without
color, and this was why they didn't sell. I have the photos together with the
prices: I was interested but I didn't understand. My stupidity was incredi-
ble. Sadly my relationship with Johns's art has been a series of mistakes. He
produced little, and so the New York collectors could buy them as soon as
they were finished, or at least reserve the next ones. I could have done the
same thing but didn't like the idea of buying without seeing the originals
to judge the result. Even later on, in 1970, I was about to buy a small and ex-
tremely beautiful picture, *Construction with Two Pianos*, 1954, that cost 4,000
dollars, but because I was so slow in making up my mind and because I didn't
have much money, the occasion vanished in favor of someone else. I saw the ex-
tremely beautiful pictures that Scull and Tremaine owned, and I admired them
a lot. I was not jealous, an emotion I have never felt, but I had to recognize
that they had been more clever than me. I have always appreciated the mer-
its of others. Luckily things went better with Rauschenberg. Cardazzo exhib-
ited Jasper Johns and he also had in the gallery a dripped painting by Pollock
that was large and beautiful, but it cost far more, I think about 6 million lire,
a price I just couldn't afford in 1958. It must also be kept in mind that because
of inflation the lira has revalued some ten to twelve times and the dollar five.

Pollock had just died and was already becoming a legendary figure.

In 1959 the second great Dokumenta show was held in Kassel. This cele-
brated the triumph of American art with all the great Abstract Expressionists.
There were some younger artists in the last rooms.

ROBERT RAUSCHENBERG
PORT ARTHUR, TEXAS, U.S.A., 1925-

Rauschenberg was thirty-four years old. His picture in Kassel was *Kickback*,
1959. It was fairly large and made a great impression on me because it had a

very expressive atmosphere, a representation of reality completely transfigured by memory and passion, momentary episodes: a newspaper cutting showing the *Nautilus*, the atomic submarine berthed at the North Pole, a pair of pants glued over it and covered with a dark paint that hid it; pieces of wood showing the word "King," and part of the painting was painted with rapid, energetic colored marks in an expressionist manner. I decided I would try to buy it. It came from the Galerie Rubin owned by the brother of the chief curator of MoMA who, at the time, had a space in Paris. I wrote to him, and the answer came straight away: the price was 2,000 dollars, and I bought it at once.

At last I had become appreciative of a new art completely different from that of Rothko, Kline, Tàpies, and Fautrier. Two thousand dollars for a picture that today would cost not less that 6 million dollars. I had been stupid at the Venice Biennale the year before, but then there were plenty of other stupid people. This was how I began my connection with Rauschenberg in the summer of 1959. I wanted to buy other paintings. I wrote to Leo Castelli, who I knew was his dealer, in order to have some photos, but they took a long time arriving. Then in September Castelli arrived in person with his wife Ileana, in order to see the collection in Biumo; it was a very cordial meeting and we became friends. He explained, though, why he had waited before sending me the photos: he just could not believe that in Italy there might be a collector interested in Rauschenberg. And when the pictures arrived in the house and some outsider saw them they created a violent reaction. "They are made from trash" was the common opinion.

Even those who admired Kline and Rothko could not believe that such an expressive form could exist side by side with artists who had tried to express the sublime, who had arrived at the highest, most immaterial condition of spirituality. The new arrival presented us with the dirtiest and worst kind of materiality juxtaposed with used and rejected materials. When *Gift for Apollo* arrived in my home in Varese, my wife became angry with the builders who had left a bucket full of cement in the gallery, and only very few people realized that it was a Rauschenberg. A friend who was fond of joking jumped up onto the work, which was supported by four wheels like a baby carriage, and pushed it around as though it were real. Luckily the wheels were robust enough not to bend. The pictures by Jasper Johns, with their vivacious Impressionist-like colors, were much more appreciated than pictures made by emptying the trash can. Even today there is a marked difference between the prices for the two artists, and I think the reason is always the same: the beautiful Impressionist-like colors. As far as I am concerned their artistic and cultural value is the same.

In 1960 I bought many works by Rothko. I was fully aware of his greatness. His was an interpretation of the world and of life that went quite beyond the

act of painting. It was an attempt to give an answer to the most urgent problems of existence. His paintings cost more than those of the others, so a great effort was needed to put together the necessary money. My work in the field of building needed huge investments, partly financed by banks using sources of credit guaranteed by my real estate. There was no revenue that I could spend, so I had to put together the money by eliminating those previous purchases I considered less important. My personal expenses were reduced to the indispensable minimum, but my family was growing and I would sacrifice nothing that might endanger their health or future. The only possibility, then, was to eliminate from the collection certain inessential artists and then concentrate on a few names that I held to represent the inalienable heart of the collection. I eliminated certain of my first years' purchases, those from the time when I was still finding my direction and considering various priorities.

I had bought various works by Emilio Vedova in the previous years; he was an artist with a high reputation in Germany. I appreciated his impetuous, almost violent style, the result of an interior, anguished and painful, expressive need. I felt part of his way of living. This was why I didn't want to part with any of his paintings.

On the other hand I had bought a lot of Klines, and my innate preference for simplicity, a sober language without adjectives and reduced to a minimum, was the most evident quality in his works. A single gesture had more content than many gestures. A single act could be the defining one. Just a few more were sufficient to say all. This was why my renunciation of Vedova was inevitable even though causing damage to the collection. To lose other Rothkos would have been even worse, and this was the problem, so the only solution was to choose the lesser of the evils. The dealer Peppino Palazzoli was only too happy to take works by Vedova in exchange for Rothko; the exchange rate was advantageous for him, so he still had a decent margin. He valued my Vedovas at less than their market price, though for more than I had paid years before. Of course it was a bad decision: now they cost a hundred times what I paid for them, but need had dictated my choice. I received a very sad letter from Vedova. I understood his disappointment since I had become his most important collector at the time. His fame and the value of his work had not taken a knock: he is rightly considered one of the best Italian artists of his generation and is internationally famous.

The most important event of 1960 was my return to New York after an absence of six years. It had been a fairly singular phenomenon putting together a collection of American art that was already one of the most important in existence, certainly the most important in Europe, and without having seen the pictures before buying them. This was a fact that went against all logic as well as being contrary to my present habit: I always want to see what I am buying before I decide, though of course there are always exceptions.

Despite this mistaken system I had not made any errors buying from photographs. The decision was always preceded by a great deal of thought based on the photographic evidence, in black-and-white since color photography still was not much used because of cost and outcomes not generally good: the information given was falsified. Black-and-white is reductive and the color, extremely important information, is lost, but if the technique is good it may cause a loss but at least does not make something seem better than it is. If a picture seems beautiful after losing 50 percent of its qualities then it really must be beautiful. It is an efficacious though difficult method, and it is impossible to use with monochrome art where color is everything and where understanding the way in which the paint has been laid on the surface leads to perceiving the meaning of the work. But when the eye has been trained, even in this extreme situation it is possible to understand the differences and therefore make a judgment. What is necessary is to have a good photographer who understands the problem, because this is a new and little understood or appreciated art.

To arrive in New York after so many years was a great event. The city had changed a lot; new big buildings had been constructed and others were underway. When I had first been in Manhattan, in 1954, it was still a city that had been constructed in the 'twenties, before the Great Depression started in 1929. About the only new modern building I saw then was on Park Avenue, Lever House; the later Seagram Building is now almost opposite it. Still today, after forty-two years, it is a city with a history and a past: most of the present buildings were constructed between 1818 and 1930, and in SoHo many are some 150 years' old. Despite its past it is full of energy and vitality, a quality you breath in the air, especially on clear, cold days when the wind comes from the sea and the north; it stimulates and keeps you awake. Perhaps Americans are like their climate, and it certainly must have its influence on them. At times, above all in spring and summer, everything changes, and when the wind comes from the south it is warm, humid, and depressing; you go about life laboriously: you really feel tired. Life becomes difficult and you are easily

infected by pessimism. Perhaps this explains the existence of such extreme attitudes: optimism, faith in the future, the will to construct, and its opposite, delusion and distrust, the conviction of many that they are beaten, unable to fight for life and survival. This often leads to alcoholism and drug-taking, a way of dying early but slowly.

Extreme conditions then, but ideal for stimulating creativity. An easy life and a sweet climate do not stimulate, but difficulties certainly do. This assertion, though, seems to be contradicted by Los Angeles where there exists an eternal spring without winter cold and summer heat; this ought to reduce creativity, but instead there are many artists no less creative than in New York. Perhaps there are other stimulating elements: the pure light when the desert winds clear the smog. The lack of seasons annuls the rhythms of time, the succession of warm and cold is a biological clock: in Los Angeles you feel lost in a time that does not exist and you lose perception of duration. The months and years melt together and perception of your own sense of existence becomes more acute and penetrating. You no longer know for how long you have lived and how much time is left. Existence levels out and has no history. You rush for hours along the highways every day together with an anonymous multitude hidden inside their cars. It seems a useless collective race, without an aim.

JOHN CAGE
LOS ANGELES, CALIFORNIA, U.S.A., 1912–
NEW YORK, U.S.A., 1992

When writing about Robert Rauschenberg and Jasper Johns I missed out something important: the year before, in 1958, John Cage, the now famous composer, came to Milan. He was not yet famous but already a curious experimenter with sounds. He was in Milan to work in the phonology department of the R.A.I., the state radio network, which was well equipped for creating electronic sound effects with instruments that interested Cage. He knew I collected American artists and called to meet me. He was invited to dinner, though without a dish of mushrooms, which later on I discovered to be one of his fields of expertise. He talked to my wife and me about his friendship with Johns and Rauschenberg and of his enthusiasm for their painting: this had intellectual affinities with his own music, which consisted of sounds and not harmonies. This was how we learned, from a qualified person, of the existence of these two great artists.

LEO CASTELLI
TRIESTE, ITALY, 1907–NEW YORK, U.S.A., 1999

In 1960 New York was full of life. Artistic activity was in full expansion. Artists who until recently had been considered provincial, without culture or roots in history, were about to receive international recognition and their revenge. Various people were waiting for my arrival, first of all Leo Castelli as well as Sidney Janis, from whom I had bought many Klines and Rothkos; William Rubin, from whose brother in Paris I had bought my first Rauschenberg; and many other dealers and artists with whom I had been corresponding.

One of the first persons I met on this trip was Rauschenberg, accompanied by Castelli, one evening at a restaurant. He was telling me about the art situation in New York when Castelli interrupted him: "He knows everything." Then the conversation began again in a more relaxed and friendly way. Jasper Johns and Rauschenberg had their studios in the same building, two huge lofts that overlooked the harbor at the end of Wall Street. Just a few meters away was concentrated the financial destiny of the world's riches, but nearby were artists still as yet unknown, with little or no money, who were probably at that moment creating one of the glories of culture; but at that moment no one knew or was even interested. It is fascinating that two extremes could live so near to each other. There were many people that evening, and I remember Johns's *White Flag* hung in the entrance, one of his masterpieces and recently bought by the Metropolitan, they say for millions, certainly between about ten and twenty million dollars. If that evening someone had imagined something of the kind he would have been considered crazy. Timidly, I thought that something of the kind might happen, in some far distant time: there was all the quality for a great future, but it did seem most improbable. A long time has passed, forty-three years, and the improbable had become reality. Some days later Castelli showed me the storeroom where he had put the unsold Rauschenbergs. There were so many, and they were so good, the great masterpieces of the 'fifties. They did not have the beautiful colors of his friend Johns, and this was why the sales were so slow. Pictures made from overturned trash bins enthused only very few people, and an art made with such traditional techniques as wax poured over a popular image like the flag was certainly more understandable.

The Castelli Gallery was on Seventy-seventh Street between Madison and Fifth Avenue, in an elegant building constructed, I believe, at the beginning of the century, a family house such as you see in London. The urban landscape of New York was beautiful as a result of these very contrasts: skyscrapers next-door to three-story houses. This is due to the possibility of selling the build-

ing without selling the space. I went there almost every day, and there were always interesting things to see. Conversation with Castelli was always a pleasure as well as being useful for knowing the New York art world. I was often invited to eat at the Pleiad, a French restaurant on Seventy-sixth. On my first trips I stayed at the Carlyle, a very beautiful hotel from the 'twenties, but it cost too much. I never went back there since I wanted to save money for pictures. Castelli thought that collectors were all rich and needed the best accommodation. This wasn't my case, as I have never loved luxury. I save less now that I am eighty years of age, and these are my final luxuries. I don't know for how long I can continue to enjoy them.

SIDNEY JANIS
BUFFALO, NEW YORK, U.S.A., 1896–
NEW YORK, U.S.A., 1989

Another important meeting was with Sidney Janis, New York's best collector and dealer in modern art. He was a distinguished person, well-mannered and extremely correct, and a real gentleman in his work, which he carried out with great ability. I believe he had opened his gallery in the 'forties and that before he had been an industrialist producing, I think, shirts. I have heard that his fortune came from the idea of making a new kind of shirt with pockets, and these had a great success. His real passion was for art. In the 'thirties he was one of the founders of the Museum of Modern Art. The splendid donation of masterpieces from Mondrian to Segal are the most luminous example of his generosity and intelligence. It enriched the MoMA. I always go to see the works he donated there. And I think of him with gratitude for allowing me and everyone else the privilege of admiring and loving beautiful pictures.

I had already bought many Klines and some Rothkos from photographs, but now I could see many originals. My brother had asked me to buy him a Rothko. I was shown an extremely beautiful one, black and red, which cost 6,000 dollars. I decided without hesitation to buy it: if he hadn't liked it then I would have kept it and been very happy with it too. The picture hung for many years in Biumo but I do not think it created much enthusiasm in the family. The picture had an unhappy life. In 1985 my brother decided to sell it through Sotheby's, but it did not reach the reserve price and was unsold. It was bought immediately afterward for 470,000 dollars. A very low price for a picture of such quality, but unfortunately there was a lot of black and not much red. In any case, there had been a big profit with an increase from 6,000 dollars to 470,000 dollars, even taking inflation and capital interest into account. I think this was my brother's best investment. The picture then returned to

Sotheby's in the nineties, where it had a good if not excellent result, and it will go to auction again in the next few days. I'll be interested to see what price it fetches. When I look at catalogues raisonnées or at auctioneer's catalogs it surprises me to see the number of hands artwork passes through: a median sale of every ten years, an amazing turnover. Of course death and economic crises are the main causes, but also whims, fashion, relish for change and for following the new, often exchanging the better for the worse, but profitably if the earlier work was good, which is not always the case. This is the opposite mentality to mine, even though I am also forced to make changes because of the great number of works I have bought. I always worry about the oldest works because I do not have the space to show all the ones that merit being seen.

I remember a meeting with William Rubin in, I think, the bar in the Hotel Plaza, and he spoke about the situation of art and his interest in the Color Field group, of whom Morris Louis, Kenneth Noland, and Jules Olitsky were the best known. I bought two pictures by Noland. I found Morris Louis less expressive. When the two Nolands arrived in Biumo I hung them in the dining room, and shortly afterward I was sorry I had bought them. They were beautiful paintings: concentric circles with different colors on a white ground. They were two of his best works. But sadly they conveyed no feeling to me. Nor could I find an intellectual process for revealing their complexity of thought or the result of purification after a painful process. The beauty was too evident and simple, and I couldn't find other motives, other possible interpretations. It was beautiful and that was all: too little to satisfy me. Noland was the all-too-faithful interpreter of a theory of the famous critic Clement Greenberg, whose great merit was to have discovered Pollock. According to his theory abstract art should be abstract and nothing more. It should represent nothing except itself and be a totality of forms and color. A representation of nothingness. And this was just what I felt. I resold the works to Beatrice Monti and recovered the money I had spent. I loved Kline, a cooled-down explosion of anxiety, a tormented wish for impossible happiness. That was what I felt and loved. Art can well be beautiful and nothing but beautiful, and this is a high aim; it is the search for the sublime, it is victory after torment, the conquest of serenity after painful inquiry. There was no trace of it in this art that only demonstrated a theory.

BARNETT NEWMAN
NEW YORK, U.S.A., 1905–NEW YORK, U.S.A., 1970

I knew Barnett Newman, a great artist. I remember my visit to his studio, which was dominated by a huge red picture. This was a great emotion. There

were other paintings of the same quality: large surfaces of a single color divided by a few, one or two, vertical white lines. Extreme simplicity. The simplicity of the sublime. The emptiness of the single color was filled by a vibration as though in adoration of something sacred. The simplicity of the Color Field paintings was cold and empty, this instead had the power to move me. I think the artist realized how much I loved his paintings because, while he descended the stairs, he offered them to me for 6,000 dollars each. I could not miss this occasion; otherwise it would be too late. But sadly I did not have 6,000 dollars, which today would be 30,000 dollars, a figure I had only exceptionally paid, and this was certainly a necessary exception—like so many lost occasions. A few days later Newman accompanied me to see the Ben Heller collection entirely devoted to the Abstract Expressionists. This was in a luxurious building on Central Park West. A house with high ceilings, the ideal space for exhibiting large-scale pictures, from Pollock to Rothko and Kline to Newman. They filled a huge room, and it was a superb collection: to see so many marvelous works all together was an emotion that took my breath away. The collection no longer exists, dispersed like so many others. This is how life goes: important groups disappear and new ones are created. We must accept the laws of death and rebirth. To try to impede things with protective laws would destroy the future, which is the essence of life and of the possibility to rebuild. Countries like Italy, which have laws that restrict the export of artwork, have just the reverse effect: the death of the possibility for creating new nuclei that, in time, become equally important and largely recompense previous losses. Laws intended to keep the existing cultural heritage within Italy can only worsen the situation and are dictated by distrust of society and its capacity to renew itself.

I never had the chance to get to know Franz Kline, the American artist I collected with the greatest enthusiasm. I remember being in his studio only once, in 1961. This was a chaotic room, a total mess, and on an easel was an almost completed painting with a black stripe crossing it horizontally. It was something definitive and solemn. After the Venice Biennale in the following year he died suddenly of a heart attack. In many pictures in my collection such an event is foreseen. A moment of life threatened by an imminent end.

MARK ROTHKO AGAIN

The most important event was my visit to Mark Rothko's studio, which was on the Bowery, one of the most infamous streets in New York. The situation has changed now but then, in 1960, a normal person just would not go there. The population consisted of alcoholics, drug-addicts, and bums who lived on the streets. The cab driver who took me back to the hotel after my visit asked me why I was in the area; in fact in order to enter the studio I had to give a quarter, the common tip then, to various people lying on the ground and blocking my way. The studio was in the building of a bank that lent money for retrieving items that had been pawned, and was a large room full of paintings piled one over the other; there were many unsold works. Despite this, Rothko was a tough salesman and didn't want to sell any more than five pictures a year. He managed to earn enough like this to live comfortably. He wanted to know who the buyer was, what the collection was like, and what the collector's aims were. To be authorized to visit his studio was a rare event. Only Sidney Janis's detailed information convinced him. It is always difficult to see into the heart of a person who has for so long inspired our admiration for the things he has created. Often there is a difference between what you expect and what you find. At times you have to overcome a sense of discomfort because there in front of you is someone quite different from what you imagined. When we love an idea we have the tendency to make a myth of the person behind it and put him on an altar, or at least on a pedestal. Even the person himself has to manifest what he expresses. Often this is not how it is. There might be a huge mind inside a puny body, beautiful thoughts in a modest presence. We have to capture the vivacity or intensity of a glance in order to understand what lies behind rather than what we do not see. This was not a risk with Rothko: he was tall and had an imposing and solemn personality. His deliberate way of speaking allowed me to intuit rich thoughts and feelings: his words were never banal. He wanted to know where and how his works would be displayed. He had heard about my house in Biumo and liked the idea that his works could find their setting in an aristocratic building erected in 1700 by the Marquis of Menafoglio. He liked the idea that his work would be seen in Europe in this way.

Certainly this possibility made it easier for me to make some acquisitions. For a couple of hours he showed me many paintings, and this was an emotion that shook my very being. I underwent something I had discerned but had never experienced: in those pictures I was seeing I rediscovered myself, the better part of myself. After seeing these works of art he wanted to talk while we walked and he led me to a ramp leading to a bridge over a river that, at the

time, was closed to traffic for repairs. We spoke of art and I found he admired Clyfford Still. We also spoke of philosophy, social problems, of his past, and how he had learned to use color from Milton Avery. He insisted I shouldn't use spot-lighting to illuminate his pictures since they should be seen with low lighting to invite the viewer to contemplate in silence. Thinking about him and his work after all these years, the significance of his personality and the nature of his sensibility becomes more explicit. He was a Jew born in Russia. The Jews are known for being active in business, in scientific research, in all those professions that need extraordinary people with uncommon capacities, but we know little of the spiritual life of Judaism. Christians read the New Testament, in other words, the "manifestation." The Jews read the Old Testament, the "promise," "expectation," two completely different things. The former is the "visible" the latter the "invisible." The life within us.

I believe that Rothko expressed in the fullest way this difference, and I believe this was the first time these values have been expressed so explicitly. The Jewish religion rejects representations of the Divinity, whereas abstract art, which does not define images but states of the soul, is the perfect means for expressing a spirituality that is part of an ancient tradition, one that is always alive because it lies within the heart and not in forms: a spirituality that survives destruction, massacres, diaspora, and persecution because it expresses the religion of life that is within us and that no one can destroy. Christians have salvation, Jews do not because they are waiting for it. Two completely different ways of looking at life. At times salvation seems lost, far from reality, and so expectation is truer than possession. Those who do not have it must search for it, and those who have it do not. For the Jews life must be active: they must search.

In 1962 I missed a great occasion with Rothko. I wanted to build up the number of his paintings; those that were already in Biumo just increased my wish to have more. A series of large paintings was available, I can't remember if they were the ones for the Four Seasons Restaurant in the Seagram Building or the same series the artist donated to the Tate Gallery in London. They were imposingly large and very beautiful. Rothko was anxious for a worthy setting and liked the idea of them being in an eighteenth-century building in Italy. I didn't have the money to buy so many works all together, but he was ready to accept payment over a number of years. So we concluded the deal.

It was a great risk for my family finances: in fact the boom in the 'sixties, the so-called Italian Miracle, was about to come to an end. Just a year later the economy was in ruins and my possibilities were reduced to nothing. I pleaded with Rothko to do me the favor of revoking the contract and to use the money I had already given him to provide another two works that were

not part of the series. He was very understanding and sent me two extremely beautiful paintings for the amount I had spent.

This episode was wrongly interpreted by a historian who wrote a biography of Rothko. According to him I had waived the purchase in order to buy Pop Art, which was just coming to the fore at the time. The idea is completely mistaken since I had bought examples of Pop Art the previous year and had no intention of buying more. So a mistaken interpretation has been repeated by others and has become part of history. This episode makes me doubtful of many facts that history gives for certain, because, even though they are wrong, they then become true just because they are repeated.

I had other meetings with Rothko, who would invite me and my wife to a Chinese restaurant where we ate excellent fish. He would drink lots of Bloody Marys.

We often went to his midtown studio near Forty-second Street, in the former stables of Cornelius Vanderbilt, founder of the railroad lines leaving from New York's Grand Central Station. Here were the paintings he was doing for the Ecumenical Chapel in Houston, paintings of an overwhelming beauty.

The last time we saw him, not long before his illness, he asked my wife to contact the Vatican for a chapel in Rome. We did nothing since we were very doubtful how such a suggestion would be received, knowing the difficulties of the Vatican in appreciating abstract art. The previous year we had gone to visit the Vatican's Collection of Modern Art, invited by Monsignor Pasquale Macchi, Pope Paul VI's secretary, a highly cultured man. Unfortunately works of great quality were very few among the many donations made to the museum by artists who were interested in having their name associated with a place visited by millions of pilgrims. It was an error not to have asked the pope's authorization for the chapel, even though the answer might have been negative. Trying costs nothing. Perhaps a sudden illumination might have changed the situation, and in fact the director asked me to donate a Rothko, a request that I didn't take into consideration because it would have been an isolated element in such a different context.

Some time later the artist had a stroke that reduced his ability to paint. The sad gray paintings of this period document a situation experienced in expectation of the end, which came about, as with the Stoics, when he cut the veins in his wrists.

In the last years before his illness, his paintings had become dark, like those in the Houston chapel. They presage the end; here was a darkness that was highly attractive, as though it hid another power, an unthinkable mystery, superior to everything. Very few artists in the history of civilization have been able to express this reality with such force.

My wife and I have often gone to Houston to see the Rothko chapel where we also have the occasion for meeting Mrs. Dominique De Menil, the donor of the chapel, a person with great moral qualities, intellectual and cultured. We admired her greatly both as a person and for her activity, something I believe was reciprocal. She was also donor of the De Menil Museum in Houston built by Renzo Piano. This is a museum not just of art from the 'fifties to the 'seventies, but also of African art, Surrealist art, Byzantine icons, and primitive arts that document a train of ideals in the search for content that goes beyond aesthetics: the means for communicating with a reality that is higher than everything and that can only be intuited.

There had been much discussion about the lighting of the chapel: visitors stupidly complained that they couldn't see the paintings. They did not understand that this was the artist's aim. It was a chapel for contemplation and thought, not for a quick visit. The visitor should remain there for at least five minutes, and then the eye adapts to the gloom and the colors can be seen quite clearly. These stupid criticisms led to a modification of the natural light, with the result that the excessive light damaged the paintings, which, some years later, had to be restored. I was among the stupid: I should have said more forcefully that to increase the light would have been a mistake.

The year 1962 was another important one. In 1960 I was at the Venice Biennale when Fautrier was awarded the prize. It was strange to see how, at the decisive moment before the prize was given, the artist, together with his dealers Tarica and Le Noci, went around trying to drum up support by contacting his friends and influential people. Fautrier well merited his prize. His work was appreciated in Italy, and I do not think there were other rivals to fear. The only one might have been Franz Kline, but he was American: the time was not yet ripe, and many thought his was not a culture worthy of such an important recognition.

Something else was also happening though. When in 1961 I went to the Castelli Gallery in New York, there was a work standing on the floor in the owner's studio that caught my attention. It represented a household appliance, though I don't remember if it was a kitchen range or a dishwasher. The subject was vulgar, but the way in which it had been painted showed artistic ability. A few days earlier I had been with Ileana Castelli to see the studio of a young artist who had painted a shoe and a necktie, and the forms and colors were so good as to make the viewer forget the poverty of the subject. The artist's name was Jim Dine. This was the summer of 1962. Castelli and Ileana were in Venice for the Biennale and they called for an appointment. We met in a hotel, I think the Londra, where Ileana was staying. They wanted me to have a preview of this discovery of theirs, which they were completely convinced by and wanted to back. They had a lot of photos of works by James Rosenquist, Jim Dine, Claes Oldenburg, and Roy Lichtenstein, which I had seen previously in Castelli's office.

This was Pop Art being born. These were no longer the mystic and heroic pictures of Abstract Expressionism, but quite the reverse: stupid and vulgar everyday life. Again in 1961, in the Martha Jackson Gallery, which in 1958 had put on a show by Tàpies (from which I had bought a painting after seeing a photo), there was a group show of young artists. One of them was very interesting. He made indefinable objects, neither painting nor sculpture, with brown corrugated cardboard cut into irregular shapes with black marks on them. The forms might just about resemble objects, and they had forms and colors similar to those of Dubuffet and seemed to be influenced by him: this was Oldenburg. The photographs that Castelli showed me were something different: objects painted with bright colors, not sad images but an art full of vitality, of the joys of life, with the vulgar subject strangely transformed.

The Rosenquists, instead, were precise and well-drawn images with nothing expressionist about them. They were similar to large advertising billboards for

consumer products or sportswear painted like metaphysical pictures: the expression was quite different from what it seemed to say. I was greatly struck by a photo that Castelli showed me. In October I had to go to New York, and the first thing I had to take care of was a visit to these artists.

ROY LICHTENSTEIN
NEW YORK CITY, U.S.A. 1923–NEW YORK CITY, U.S.A, 1997

Castelli had many Lichtensteins, in fact the very best, and I bought seven of them for 600 dollars each. The artist's creativity was at its highest, and he had found the right artistic balance, definite progress compared to the paintings I had seen the previous year. This was the mythical story of everyday America: full-color love stories with a happy ending taken from comics, or a pilot embracing his girlfriend at the end of the war. All the innocence and happy optimism of an America that had not only won the war but also the battle for prosperity. American industry produced millions of products for everyone, available to everyone; poverty was disappearing and the poor could have what the rich had too—the triumph of capitalist democracy. Another important fact was underway: the Russians had withdrawn their missiles from Cuba, the Third World War would not take place; the era of the Atom Bomb was over, so we could work serenely toward the future. Khrushchev's aggressive stance was only verbal, and Kennedy embodied the image of the American nation: strong, young, trusting in the future. A basic poetic content animated these images. Lichtenstein had freed them from the descriptive function of their sentimental and popular context. And he employed the expressive system of the art of all time; the harmony of forms and colors revealed the fundamental values of an image that had been worn by habit and by baleful overexposure. His paintings are not reproductions of images seen again and again, they are transformations even though they remain recognizable; above all they are images transformed in their very expressive substance. A popular image, one used in adverts of a beautiful woman presenting a product on the television, becomes in its expression a face similar to that of a Greek divinity with an enigmatic smile. What is popular transcends the myth. And this is his great ability.

JAMES ROSENQUIST
GRAND FORKS, NORTH DAKOTA, U.S.A., 1933–

Another great experience that October was my visit to the studio of Rosenquist, which was downtown near Wall Street and overlooking the central fish

market. At the time it was a very run-down area even though it was just a few hundred yards from the heart of world finance. The end of the room was completely taken up by a large painting that the artist was in the process of painting: it was the face of a smiling woman, the ideal American Beauty, and it looked like a huge billboard such as those you see in Times Square, the center of entertainment.

It was painted in the same perfunctory manner, and near-up it seemed colored fog, though from a distance the forms were precise. In fact, Rosenquist was a billboard painter, and only recently had he become an artist. The room was a many-colored mess, giving the impression of smiling vitality, in no way sad. His personality was much the same, and he moved nimbly among his sketched-out paintings describing what he was doing and inventing outrageous stories. His paintings struck me with their harmonious compositions of fragments of images that joined together coherently. The forms, reduced to their essential elements, transformed the everyday into the universal, the temporary into the permanent, and materiality into an idea. Here was the necessary simplification of advertisement images, a means for arriving unswervingly at a definition of the indefinable. The indefinable: the intrinsic property of beauty. The messengers bringing the mystery were no longer the gods of Olympus nor the Christian saints but the unknown authors of our daily life. This was the artist's magical period.

I had been taken to see Rosenquist by Dick Bellamy, one of the two Pop Art dealers together with Leo Castelli. His gallery, the Green Gallery, had a fundamental role in the promotion of Pop Art. He was a person with great intuition that he developed courageously, though perhaps he did not have the necessary practical ability for a dealer. Sadly his gallery only had a brief life, but at the time his was an important activity that ended too quickly. He continued to busy himself with art in the following years but no longer had the possibility of discovering a great creative moment as it was being born, even though in America there were artistic innovations of great creativity still to come. It is difficult to perceive a new proposal, and it is enough to do so once in a lifetime. He died in 1998 and is someone I remember with great admiration. He was extremely sensitive, too much so for the battle of life.

CLAES OLDENBURG
STOCKHOLM, SWEDEN, 1929–

There was a marvelous exhibition of work by Oldenburg in Dick Bellamy's gallery. I think it was his first solo show, probably the first with new works painted in shiny enamels, with strong, clear, and brilliant colors. These works

were completely different from those I had seen the previous year in a group show at the Martha Jackson Gallery. These instead were works taken from everyday life. *Breakfast Table*, 1962, set for breakfast with a red tablecloth, eggs, a box of cornflakes, a glass with tomato juice; the red tablecloth fluttered as though swept by a breeze, but at the same time it was solidified by the plaster mass necessary for modeling the sculpture, and by the red enamel, the color of fresh blood, as shiny as a mirror. On the tablecloth were other objects in the same bright color and, even though small, quite visible. There was everything for beginning to live, for the start of the day. Here was the participation in our life of the indispensable objects we use, and the extension of our own being to the things that live with us, things that record and bear witness to our existence.

This process of disorder and of union between ourselves and things was even more obvious in other sculptures shown in the gallery: *Blue Pants on a Chair*, 1962, dark-striped jeans hanging from a yellow chair. Thrown there casually after a heavy day when you want to go straight to bed. An image of tiredness, of exhausting work, of time passing, and solidified in colored plaster, shining blue, cerulean, and yellow. A monument of modest dimensions dedicated to an even more modest moment of our life.

Each of the objects on show had a similar history to tell. Because of their use, the things we throw into the trashcan incorporate something of ourselves, of our everyday life that is, in fact, real life and not the one our imagination would like us to live. It is not right to disdainfully throw away things that are part of our experience, for they are ourselves and worth the creation of a monument, even if only in painted plaster, with colors that make them live again. This is an attempt to recreate our history, which inexorable time has destroyed; it is a fight against death, a fight we know we are losing, but all the same we defend ourselves with this attempt at resurrection and try to lengthen the disappearing moment. To recreate it we must place our hope in other days. The vivacious colors of the gleaming enamels reconfirm it. Red, green, yellow, blue: all the colors of life.

The Oldenburg show did not end in the gallery but continued in another space that was also the studio where the artist made his objects; I do not call them sculptures because they are painted forms where color has the main role. Only particularly interested collectors could go to the studio since he could not be disturbed while he was working. It was known as the Store and in fact was a shop transformed into a studio, downtown in the poor area of New York. I remember that visit as something unreal, a place I have never seen again. It was in a narrow street where there were many other stores, which strangely enough did not sell things straight from the factory as usually hap-

pens, but only old things, above all clothes, hung in the windows. These were not the clothes you would usually wear but almost exclusively women's evening wear, formal clothes that are worn only on important occasions, and there were many wedding dresses.

These clothes had refined finishing in lace and embroidery; some were perhaps even made by famous tailors and had extremely beautifully colored fabrics. All were old and some could even be dated if you knew something about fashion; for others the age was uncertain but remote. These testified to a long-gone rich and happy life. Probably they were clothes pawned and never paid for, the final residue of a well-being ended in poverty. In fact, the street was in a Jewish neighborhood, and there were pawnshops that gave money on security or even for the contents of grandmother's wardrobe, which her grandchildren had to hock so as to share out some money or just to get rid of bulky material. Hanging there in the windows the clothes told a long story, many different stories, of happy expectations, of ambitions, of admired or envied successes, of a flourishing life that time had mercilessly cut short. It was easy to imagine the person who had worn an evening dress with a deep décolleté, or the girl who for the first time wore a beautiful dress with a flower. The dress for special occasions now sold for a few days' survival. The lost memory of a distant happy life. The crowd that time devours. There were thousands of these dresses, and from the street you could see these huge and dimly lit spaces full of them; they all specialized in the same kind of merchandise, strange commodities that seemed made of still-pulsating human life rather than old cloth.

Suddenly I saw Oldenburg's Store full of color and the joys of living, the reverse of what I had just seen. It was full of all the things that were in the other stores but here they were transformed. Colored-plaster clothes covered the walls or hung from the ceiling, like in the shops along the street. At the end there was a large sculpture of a white bride with a red arm and hand. The face seemed that of a mannequin but it was unrecognizable: it resembled a skull painted white rather than a happy bride. This was the only image to contradict the surrounding vitality. It had been a great emotion to see the items in the stores along the way and then enter the Store. These were the same objects that had passed from death to life.

I at once decided to buy almost all of the sixteen objects in the collection, and they are now in the Los Angeles MoCA. I bought another two a year later from the Dwan Gallery in Los Angeles: *Green Stocking*, 1961, and *A Brown Shoe*, 1961. I also bought the large *Bride*, 1961, with her death's-head and bloody hand. In 1962 the prices were really low. And they still are today: his works should cost far more than 400,000 dollars. He is a great sculptor, and an essential artist.

This quality of his work is similar to that of Lichtenstein. These are the mysteries, the unexplainable contradictions of the market. I think the future will remedy this though. Unfortunately the contemporary art market demonstrates human idiocy. There are artists without any quality who quickly reach exorbitant prices, and others who are far better who remain ignored. The highest prices are determined by the buyers with most money, but having more money does not mean being good at making choices: it is one justification but not the only one. Sadly, professionally qualified people make mistaken decisions in the field of contemporary art, errors they do not make when dealing with historicized modern art, which is art over thirty years old. Ideological prejudices are the main cause of these mistakes, but I do not want to dwell on this all too interesting topic now. The right moment will be when I come to describe the art of the 'nineties.

After visiting the Store I only had a few possibilities for meeting Oldenburg. He has a serious face and has difficulty in greeting people, as though he were offended by something.

Oldenburg's masterpieces I had the fortune to collect are all in MoCA, which looks after them with care and exhibits them well. I think his character has changed. His first wife, Patty, was very likable: she helped him sew the objects onto the canvas. He is highly active as the sculptor of large monuments that are always extremely beautiful. With Oldenburg I can end my account of my experiences with the beginnings of Pop Art. One other important artist has been left out, George Segal, whose work I bought some years later, after having interrupted my purchases from 1965 to 1969 due to the economic situation.

GEORGE SEGAL
NEW YORK, U.S.A., 1924–NEW YORK, U.S.A., 2000

In 1969 I visited Segal's studio, which was not in New York but outside in New Jersey, about an hour away on the bus. It was an interesting journey along the Atlantic coast where heavy industry is concentrated. It is not a landscape of houses or warehouses but a steel landscape. Enormous cranes for loading ships, chemical plants, steelworks, long bridges all of steel; it was an infernal and gigantic landscape. The power of technological man to construct an artificial world.

Segal had made his studio in a fairly grubby poultry farm that had been abandoned some time before. There were a lot of dark rooms, and in each of them there was a sculpture or a group: white in a dark setting, dimly lit. They were ghosts of people without bodies immersed in a timeless time where life had silently dissolved, leaving behind memories of living things.

It was easy for me to make good choices: the cast of the old German professor of philology, Helmut von Erffa, the two bathers taking the sun on a New York rooftop—similar to the casts of those surprised by the eruption of Vesuvius over Pompeii, or waiting for some catastrophic event, a nuclear explosion perhaps.

I went back to America in 1963 and saw that the success of Pop Art was growing rapidly and quite unexpectedly. It was a far easier art visually than the Abstract Expressionism of the 'fifties. Every American could find familiar images in the dignified context of art, even though this created suspicions and diffidence among the most hard-line intellectuals. Many people enjoyed Pop Art without understanding its artistic qualities.

Important collections were in the process of being formed, and I remember a visit to Robert and Ethel Scull in their Long Neck home on Long Island. It was a complicated journey with Leo Castelli, whose new wife Tuany was driving; he had just gotten divorced from Ileana. The car was a small FIAT 500 that was just right for New York City, where parking it was easy, but not for the outer freeways where it seemed an ant in a herd of elephants. I was sitting sideways in the cramped space in the back, and we arrived late because of the constant mistakes by the driver who didn't know the road. The collection was superb. Every work was of the highest quality, and there were no mistakes here: Abstract Expressionism, Rauschenberg, Johns, the best of the Pop artists. But the history of the Scull collection is a sad one.

Robert's wealth came from running a business of some two hundred cabs. The scarcity of licenses made this a very remunerative business. But when the New York City administration relaxed the rules for issuing licenses their value fell dramatically, and the two hundred cabs were sold off as scrap iron. The collection had the same fate and was auctioned off in 1974, a historic event that marked the success, in financial terms too, of American art in general and of Pop Art in particular. I remember Jasper Johns's resentment when his famous sculpture of beer cans was sold to the well-known German collector Peter Ludwig for 90,000 dollars, it having been bought twelve years earlier for 1,000 dollars. Even though Scull's affairs had gone badly, art had given some satisfaction; I remember that he was aware of the risks his investments faced and that they could disappear with the liberalization of licensing. He too died many years ago. By chance I met his widow in Los Angeles in, I think, 1986. She was not the most attractive woman I have ever met. She was worried because she had to sell her last Jasper Johns, which, in fact, was to fetch a good price at the Sotheby's auction: 4 million dollars, I believe, though if she had been able to wait another two years it could have been sold for double that amount. I think she needed to sell, and I have the idea it was one of her last resources. I remember what they did for art with a great deal of respect and admiration, and they were also very generous to museums in the good times. Recently at MoMA I saw a very beautiful Jasper Johns donated by them. If

they had kept it, it would have been an important financial prop when the going was tough, but by donating it they saved forever something of inestimable value. Everything disappears, even their physical presence, but the memory of their great activity as collectors will never disappear.

Other important collectors, above all of Pop Art, were Burton and Emily Tremaine: they had a marvelous collection from Delaunay to more recent art. I remember an Oldenburg hung in a passage when a more worthy place could not be found for it in a house already full of masterpieces. They were a very pleasant couple. They came to see us every year in Biumo on their way from Saint Moritz where they went skiing. The wife above all was very capable. They have both been dead for some years now and unfortunately almost nothing is left of their collection. I remember meeting Mr. Tremaine many years ago when his wife had already died; he wasn't very well and walked with difficulty. I asked him if he had plans for the future of the collection, and he answered, slightly irritated, that he did not, and he complained about the donation he had made to the National Gallery in Washington that was not on view, though in fact this was not the best part of his collection. I think that this bitterness toward museums was the main cause of the collection's dispersion. I was extremely sad when I saw the last paintings auctioned off at Sotheby's.

THE WORLD'S BEST COLLECTORS:
DOROTHY AND HERBERT VOGEL

Dorothy Vogel was working at the New York Public Library with a salary of 1,000 dollars a month. Herbert Vogel worked at the U.S. Post Office for a salary of one thousand dollars a month.

In the second half of the 'sixties, it was still possible to live in New York as a couple for just 1,000 dollars a month. Because of this, the Vogels had one thousand dollars a month left over to spend for art. It was what they did with their lives, putting aside every other kind of indulgence.

At the end of the 'sixties, I also had the possibility of buying many Conceptual works for 1,000 dollars each. It was possible to buy drawings by Pop artists and small but beautiful objects of Minimal Art, because so few people were interested at the time.

In their gradual way, the Vogels put together a collection that is unique. It was so unique that the National Gallery in Washington was happy to receive the collection as a gift. It was shown for a long time in a large room. When I saw the show, I was astonished to see so many beautiful works.

Today there are collectors with a capital of thousands of millions of dollars, who pay large sums for paintings that I don't like. When the fog made by Postmodernism clears, probably in the distant future, there will be no room for that kind of art in the National Gallery in Washington.

On December 1, 1962 our fourth son Giovanni was born, a year and a half after our third son, Federico, had been born on April 15. The family was growing and our optimism about life did not lessen despite the growing difficulties of work.

The year 1965 was one of crashes and enforced bankruptcies. Relatives of mine whose businesses were not in good condition were forced into costly closures. Even my father-in-law, Giacomo Magnifico, found himself in a similar situation, and it was necessary to help him out with his debts, which luckily were not great. The modest sums I contributed had been destined for enlarging the collection. Pop Art could still be bought for a thousand dollars a picture. I could have had tens of the best Lichtensteins, which today, after thirty-five years, would be worth at least 3 million dollars each. Among the victims of the crisis was also a beautiful Cycladic head dating from 1000 B.C. that I had bought from Franco Monti in 1962 for 2 million lire. In 1965 I was forced to sell it, luckily at a good price, for 6 million lire, once again through Franco Monti. I didn't know who the buyer was and, in fact, only found out two years ago when visiting a property donated to FAI by Guido Monzino: the Balbianello Villa on Lake Como, an enchanting place. In an exhibition case, together with some African sculptures, was the Cycladic head that had belonged to me. It had ended up in the same foundation to which I had donated the Biumo villa together with its collection, a happy channeling toward a common aim of works that must be conserved for the future.

Other victims of the crisis were two Rauschenbergs, beautiful though not particularly interesting: one was titled *Aenfloga*, 1961, and I have seen it reproduced occasionally; but the really hurtful loss was of three Lichtensteins, and one in particular, a large painting called *The Engagement Ring*, 1961, a great work. I had bought them for 600 dollars each and sold them for 1,000 dollars. Some years later I saw *Engagement* reproduced in an article about a collection in Rome, but no name was given. Then a few years ago I was invited to dinner to see the collection of Samuel Irwin Newhouse, a marvelous collection of masterpieces from Pollock to Ryman. On entering a room I saw *Engagement*; I was thunderstruck, a bolt of lightning shot through my heart: the joy of seeing a masterpiece, the sadness of having lost it. I do not think it is now still in the same collection, most of which was bought by David Geffen of Los Angeles, an important figure in the entertainment world, but I hope that *Engagement* belongs to him as I would like to know where it is at the moment. Had I kept it, it would have gone to MoCA together with the others, and so it

wouldn't have been mine anymore anyway. Pictures that once belonged to me, and which every so often I see exhibited in museums, still feel mine, as happens to all those who love art. It is interesting to see how works of art move about: the more important they are, the more they move.

Death is always one of the reasons for dispersing art. Inheritance taxes cause the destruction of collections; important pictures cost a lot, and you can often buy them only when you are old. This is one of the reasons for their rapid circulation, but economic crises are certainly not secondary either. Newhouse's sale of part of his collection is inexplicable, as he is extremely rich. The collection gave him far more standing than money. The speed that pictures circulate is an essential element of the freedom to have possessions: sooner or later they end up in a museum where their wanderings cease.

In the crisis years from 1964 to 1965 I was forced to stop buying. I had to look to the past instead of forward. It is a sad situation to have to deny yourself the possession of some new example of beauty, not for the brief pleasure of having what you want, but for being unable to feel the joy of researching, discovering, and of dialoguing with a work you love. The discovery of creation is the discovery of a new world, it means to become aware of the unknown. Once explorers went in search of distant lands, and this was the great passion of Europeans from the beginning of the Renaissance until some two hundred years ago. Now discoveries are over as there is nothing new to discover. We have, instead, an endless territory to explore within ourselves: it is our conscience, which art reveals and makes known.

An important event happened at the 1964 Venice Biennale: Rauschenberg was the prizewinner. It was the first time that the Biennale had awarded a prize to an American, to the great disgust of the French who felt themselves threatened by American cultural imperialism, though in fact Paris had by now lost its place as the capital of art. It had to accept a secondary role, but then its creativity seemed to have been worn out after the phenomenon of *Nouveau Réalisme*, which had been promoted by Pierre Restany. De Gaulle's Grandeur had had a negative effect, and French national pride had caused France to lose her international receptiveness. She had become a nation just like the others. This was one of the many evils caused by nationalism. America, instead, was a young giant full of drive and intellectual energy, and was happy to show its, evidently positive, results. Italy did not have the psychological complexes of France; it had nothing to lose by opening the doors to the Americans. Her art was not diffused internationally, and politically it wasn't important on the international scene. It was, like Germany, a country that had been beaten, while the French did not feel they had been beaten, only oc-

cupied. Of course the Parisian galleries were worried: commerce was shifting over to New York.

I must mention a Parisian dealer who in 1961 put on the first European show of work by Rauschenberg: Daniel Cordier, a courageous and intelligent man. The last work I bought was *Trophy III (for Jean Tinguely)*, 1961, a work painted by Rauschenberg in Paris for the show.

Many works had been sent to Venice from Biumo to be shown at the Biennale. Strangely they were not exhibited in the Biennale gardens themselves but in the American consulate, which, still today, is next door to the Peggy Guggenheim Collection. Perhaps Castelli did not think there was any possibility of winning the prize. A condition for it to be awarded was that it should be shown in one of the Biennale garden pavilions. When Castelli had the feeling that the prize jury was favorable he hurriedly moved all the Rauschenbergs from the consulate to the Biennale. They were not packed, and one of the works was damaged: the mirror at the bottom of *Untitled Combine*, 1955, which was there in order to reflect a part of the work that would otherwise be invisible, shifted and cut the material next to the mummified chicken. I asked for insurance compensation for the damage undergone by such an important work. I was paid a long time after with a decent sum, six thousand dollars I think. This I used to buy works by other artists who I thought were further developing Pop ideas. I realized my mistake at once, but it was too late, and I tried to sell them, which was possible for some, but only at a loss. I was helped in getting the insurance payment by the curator of the show in the American Consulate, Alan Solomon, an intelligent critic who died too young. The show's title was *Four Germinal Painters: Robert Rauschenberg, Jasper Johns, Morris Louis, Kenneth Noland.*

After the 1964–65 political and economic crisis in Italy where many shaky financial affairs with the banks had fallen apart, there was a period of calm. Aldo Moro and the Socialists governed with good sense and without causing any more traumas. The situation was quiet but the economy was stagnant. Established real estate activities like mine were without clients and so could not conclude business, and as a result, they could not pay their debts to the banks, debts that grew bigger with accrued interest. This was a heavy and worrying situation that completely blocked any possibility for enlarging my collection. I also had to put a stop to my usual trips to New York in search of new artists, and I ran the risk of losing contact with the latest developments; in fact, I didn't realize that in 1964 there had originated a group of artists creating what was called Cool Art. An abstract, highly intellectual art, at first sight quite lacking in emotion. The first people to mention it to me were the Tremaines during one of their stays in Biumo after Saint Moritz. The first dealer to show these artists was Dick Bellamy at the Green Gallery, the same man who in 1962 had been the first to exhibit Pop Art. The lack of direct on-the-spot information was a big hurdle.

DAN FLAVIN
JAMAICA, NEW YORK, U.S.A., 1933–
RIVERHEAD, NEW YORK, U.S.A., 1996

My eyes were opened two years later when, in 1967, Sperone opened a gallery in Via Manzoni, Milan, run by Tommaso Trini, with a show of neon pieces by Flavin. These works came from Cologne where Rudolf Zwirner had held a show of them in his gallery. It was a revelation. These fluorescent tubes seemed to me to be a new world made from light. This was a marvelous territory to be explored. They were works that needed mystical attention if they were to be understood. More than any other works of art they had to be contemplated in silence. Here was the apparition of a supernatural image. It was religious art, without symbols, without rites, and without intermediaries; it was the direct and immediate presence of the supernatural, the way to the absolute. Light was no longer an illuminating body but manifested its true nature as pure energy: the least physical thing in a physical world. It was the most direct path to the invisible. This was the art my subconscious mind had been waiting for. The neon lamps cost little, 260,000 lire, an expense I could manage despite my financial difficulties, and I bought as many of them as I

could straight away. The amount I spent might seem laughable now, but it should be multiplied by at least twelve; anyway, it was enough to allow the artist and his wife, an adorable person, to come to Europe.

This was how I came to know Flavin, whose character was unlike his work. Quite the opposite in fact. If his art led to serene and intense contemplation, his behavior was edgy: he was never content. Everything other artists did, as far as he was concerned, was wrong and should be changed. At the time I still had not received the certificates signed by the artist. They were indispensable: anyone could make a Flavin by buying their materials from the electrician downstairs. This was why Sperone had sold me drawings of the works I had bought, but Flavin did not agree and wanted them back at once. I tried to resist and said I would give them back as soon as I had their authentication certificates, which were slow in arriving. The hassle Flavin made for Sperone was so great that he pleaded with me to give him back the drawings without waiting for the certificates. I was worried about this, since I had discovered Flavin's unpredictable character. I had shown I loved his art more deeply than that of all the others, and in all I had bought twenty-seven works, just at the time his prices were at their lowest: in fact they only went up noticeably in 2000, sadly some four years after his death. I should have been appreciated for the interest I took in his art. In Biumo I had set space aside for his works, more than for any other artist. Each work is exhibited in the best possible way, better than in any museum where shows last such a short time: the installation is permanent in Biumo. The dispute over the certificates ended when they finally arrived, after a long time and a great deal of persistence. I never received the certificate for *Untitled (to Karin)*, 1966, formed by three diagonal neon lights: two long white tubes and a shorter central one of a warmer white. All the works had been paid for in full and at once, and I never knew why he didn't want to give me the certificate. The same thing happened for some works I bought from the Heiner Friedrich Gallery in 1974 at fifty times the price. I have never received the certificate for a work consisting of four squares in the four corners of a big room (*A Four Corner Installation*, 1973), an important work, just right for being installed permanently in a museum. It is damaging to his prestige not to be able to install it. I paid in advance, confident in the good relationship between Friedrich and the artist.

Flavin had a difficult childhood because of his relationship with his mother, and this had had an influence on his behavior, which consisted of refusing anything positive life might offer him. Certainly, I was the collector who most loved his work, which I have exhibited correctly and permanently in my home in Biumo. And despite this he was hostile toward me: when he met me he never greeted me with any kind of pleasure. With my wife things were dif-

ferent, and he was always very kind and well behaved. I remember a meeting many years ago in Los Angeles, during one of his shows, perhaps in the Ace Gallery, when he came up to us reciting the marriage lines in Latin: *Ego coniugo vos in nomine dominis*. Flavin knew Catholic liturgy very well since he had studied to become a Jesuit in a seminary, but he had given up the order. He did this, not as a joke, but quite seriously, crossing his fingers in benediction. He even had the physique of a monsignor, of some priest from the higher clergy. He must have thought his vocation had been betrayed. Every so often I would hear him say that he would have been a bad Jesuit. His conscience was always attracted by both transcendental needs and the pleasures of life. He was extremely gluttonous, and preferred French cooking and wines: when he traveled he always went to the best restaurants. His gluttony was bad for his health, since he suffered badly from diabetes and should have kept to a strict diet. His illness slowly worsened, and some years back he had to have one foot partially amputated and then had to use a wheelchair.

In 1990, during the inauguration of the restored Guggenheim Museum in New York, where a work of his occupied the spiral, he remarried, to what must have been the least suitable woman possible. I remember a chance meeting many years ago, when I was in a restaurant with Edi De Wilde, the director of the Stedelijk Museum in Amsterdam, and Flavin was childishly shy of him, overly friendly, fearful of putting on a show: the very reverse of the way he treated me, someone who had bought so many of his works, which he also knew I loved. When in 1988 I mounted a beautiful show of Minimal Art in the Reina Sofia Museum in Madrid, where the Flavins were the heart of the show, I made the mistake of being too liberal in the way I adapted the installation of the work to the dimensions of the room. Instead of asking me to change the installation of the work, he sent a really violent letter to the director, Carmen Gimenez. I have never invited an artist to the installation of a show, as I know from experience that they only create problems. Every one of them wants to have the rooms given to others; jealousy and envy abound, and there are endless arguments. This problem would have been particularly heavy with Flavin, who was never satisfied. Dealers and museum directors had spoken to me about the worries caused by the time he took to make decisions. His installations were wrong because he wanted to put too many works together. It was far better to put just one rather than a lot. If there was only a single work, light dominated instead of the form; if the light was more important, then the meaning of the work changed, and its mystic aspect emerged.

Flavin did not want this to be visible; he was a left-wing intellectual, a dissenter, and so his subconscious had to remain hidden; that was how it had to be. I think it was just because of this that he didn't like me, because I let oth-

ers see a truth that he wanted to keep hidden. The others were not aware of his fundamental mystical essence, and so they didn't bother him.

It is a widespread opinion among intellectuals that freedom of judgment and thought is the most important thing, and in this they are quite right. But those who search for basic truths risk losing this freedom. A mistaken idea, perhaps, but one that may be justified when opposed to individual choices. Flavin's background was one of constant clashes with his mother. He was the second, unexpected twin, and so everything his parents held to be important had to be rebutted. These were also the 1960s, the period of contestation.

He was a man torn by two opposing tendencies: the search for truth and the rejection of truth. Two opposite but equally strong directions, and as a result, destructive. His subconscious knew where good was to be found, but his reason wanted pleasure, success, the satisfaction of personal desires. Above all he had a great and unfulfilled need for love, which he had not had from his mother and that he didn't manage to have from any other person. I remember his first wife as a sweet, patient, and good woman. But he did not know how to keep her with him. And those who loved his work were almost as unwanted. Such extreme situations create enormous suffering. Freedom from contrasting forces lies in creation, which allows our conscience to escape from these constraints and to find its own autonomy and peace. Great suffering gives rise to great art. It leads to the roots of being, stripped of all contradictory elements.

Flavin died in 1996. He wanted to die. He did not take care of himself, knowing that by not doing so he was asking for death; he continued to eat and drink the things he had been forbidden.

In the last months of his life something new happened. The occasion resulted from a visit to the rooms in Biumo where the Flavins were on show, by Father Giulio Greco, the parish priest of Santa Maria Annunziata in Chiesa Rossa in Milan, and by his assistant Father Pier Luigi Lia, professor of theology at the Catholic University. Having been struck by the mystic meaning of his works they made the decision to ask Flavin to make a project for their church, so as to give the building a new look, one that was in line with its function. The church, of great architectural quality, was built in 1932 by one of the best Italian architects of the time, Giovanni Muzio, in a classical style that he had reinterpreted in a personal and original manner. The interior had been ruined by various pointless additions that were easy to eliminate. Through Michael Govan, the director of the Dia Art Foundation in New York and a friend of Flavin, the artist was asked to prepare a project. At the beginning he was fairly reluctant as it was something new for him, a permanent work in a Catholic church, a religion he had abandoned. He was almost constantly in a clinic, and it was very difficult for him to move. He had to plan his project

with the help of a model, drawings, and photographs. As time went on he became more interested and involved in the task. Meanwhile his illness was worsening, and the danger was that he would not manage to complete the work. In fact Flavin died, and it seemed that hope for the Chiesa Rossa installation was nil. Shortly after the artist's death I received a call from Michael Govan in New York who told me that Flavin had completed the project, *Untitled*, 1996, two days before he died, in a moment of clarity and serenity, and that there were therefore all the instructions for installing the work correctly. It could well be said this was a miraculous solution, the end of conflict, the reconciliation with his true destiny. Once the alternatives have been experimented with, the need for truth becomes a free choice. This is how his path returned to its origins. The transcendent is a wound that always festers, that is never healed until you follow its call.

The work was undertaken thanks to the generosity of some friends. Giovanni Rossi and Laura Mattioli Rossi, the daughter of the famous collector Gianni Mattioli, together with their son Giacomo, who is also an enthusiastic collector, restored the church to its original condition. Miuccia Prada and her husband Patrizio Bertelli donated the work. Apart from being internationally important in the fashion business, they are also generous and ardent collectors. It has made me extremely happy to see how the demand for Flavin's work has increased in the five years since his death. For thirty-six years their value was low. His work was admired by the few but not by collectors. Until a short while ago you could buy at very low prices, ten times lower than that of the other Minimalists. It is sad when this happens after the artist's death: life is often ungrateful to creators.

The great lesson of this tale is one of being untrammeled by money, but even more important is the assertion of an often repressed primordial impulse: the search for truth.

ROBERT MORRIS
KANSAS CITY, MISSOURI, U.S.A., 1931–

The second artist whose work I bought in 1967 was Robert Morris. I asked for photos from Leo Castelli and then made my first choice. It was easy to understand his sculptures, simple geometric forms painted in light gray: the photos clearly showed the volumes; there was no color, and the reproduction was close to the reality. What was evident was the intellectual and mental character of this new kind of sculpture with its light forms in painted plywood or fiberglass, empty on the inside but having extremely large, if weightless, volumes. They were the very reverse of the usual stone, marble, or steel sculptures. Their

forms were geometric: cubes, cylinders, wedges—the forms we see in school books for studying geometric theorems. For example, there were sheet steel cubes open at the top and bottom: *Untitled (16 Steel Boxes)*, 1967. Their cubic essence had to be completed by the imagination. The thin sheets outlined a form not just a volume: the inside was visible, not closed in, as it should have been to acquire its full identity as a cube. They were sculptures resulting from meditation on what reality is: only when stripped of all superfluous elements can it find its real, unchangeable essence, the essence common to all things, which to exist must have three dimensions. From this basic premise of reduction to the absolute minimum, there begins another process: the transformation of the simplest element into a generator of complexity. The relationships that create a volume are only three: height, depth, and width, but their reciprocal combination can create an infinite variety of constantly varied forms. The artist can make a choice from these theoretical yet also real, infinite possibilities. In order to humanize the infinity of possibilities the human mind can make choices unfettered by limits of weight or dimensions. The sculpture is at the same time the manifestation both of this research into the final irreducible essence, and of the limitless ability of the mind to create forms that are always new and different. This art represents the power of thought. To arrive at the greatest complexity from the greatest simplicity, as well as the reverse process: to arrive at the greatest simplicity from the greatest complexity. This is the research of philosophy and science: to discover an ultimate, definitive, permanent, and unalterable identity in various and changeable forms. The beginning of all things in order to understand all things that have always had a common starting point. The highest aim of knowledge. The basis of being a man, the need to know, is only possible through this mental process. The discovery of the starting point. This is not only an aspiration and an intellectual pleasure, but it is the understanding of natural phenomena in order to control and use them to our advantage; this is the enormous potential of our mind but also its infinite beauty: an enormous power given to us by nature—which created our mind—and thus given to us by heaven. A power that allows us to discover its secrets and to understand them in order to imitate its creation, an enormous power, almost terrible in its greatness, and that increases proportionately with our responsibility.

Everything that we discover increases our power, and this can be used for better or worse. Knowledge is certainly man's greatest aim, it is his dignity and his beauty. This constant and restless search, though, contains its own limits. Three entities are its starting point, and simplification can go no further. There is no way of explaining why there must be these three elements: they have been imposed on knowledge, and logic can only be constructed if

this state of things is accepted. As complexity increases, this limitation becomes more obvious. It makes impossible any understanding of other kinds of phenomena, those that are decisive for understanding the Whole and ourselves. This was what I understood looking at Morris's sculptures. My interest in philosophy, and my being used to meditating, allowed me to understand this art at once and instinctively, an art that sadly was rejected by those unused to thinking. For this reason Morris has only had a success among the few, among those with a solid education: his art is rejected by the ignorant.

The dissemination of Minimalism has been slow, and its important artists have still not had the recognition they deserve. Very few people have realized there has been a sudden evolution of culture: for the first time, philosophy and thought have been made visible through art, whereas before thought could only be communicated orally or in writing.

Twentieth-century sculpture began with Brancusi, the great poet of elementary forms, whose primary concern was to arrive at the essence of reality. His sculptures are not abstract but have a visible relationship with an object that is stripped of superfluity and rhetoric in order to rediscover its real worth. It is different from Rodin who was full of rhetoric. By rhetoric I mean feelings that are already known and are made visible by inflating them in an artificial manner.

Sculpture assimilated more slowly than painting the possibilities given by abstraction, forms that have no relation to the reality we see with our eyes. Julio Gonzales perforates his volumes, which then become virtual rather than real, their limits being indicated without filling them with material. In the 'sixties Anthony Caro made use of abstraction and the emptying of volumes; he used varnished steel and applied color in place of the material's natural one. Minimal Art was revolutionary in its way of making sculpture. The work is no longer the product of the artist's hand as it wields the chisel to carve wood or marble or models clay or plaster to be cast later on. The disappearance of manual work frees the sculptural dimensions, which no longer depend on the limits of the hands. The work is made in a workshop where there are the tools for cutting large sheets of steel or other metals, which are then put together following the plans laid down by the artist. The plan gives all the indications for constructing the work exactly.

When the work is complete nothing can be added or taken away. This guaranteed final appearance is the result of the plan. What is crucial is the experience of the artist who must mature a virtual vision of the final work in his mind.

The original work is no longer a three-dimensional object but a two-dimensional drawing. Possession of the plan is the owner's certificate: the object can actually exist or not, but this depends on whoever has possession. This

drawing must also have, apart from sufficient indications for the work's exact construction, a declaration that the plan is not a drawing but the authorization for constructing the work. This new concept of sculpture liberated it from the fetish of the object: art was no longer a material asset that could be exchanged, its price giving it its importance rather than its quality. Creation was freed from subservience to the market: what was important was the idea, creation, in all its original purity. All the Minimalists were enthusiastic about this way of considering art, one that challenged an ingrained habit: the possession of the real rather than the virtual object. It is only after forty years that this new concept has become part of the mindset of collecting, even though still hedged with difficulties.

The works of Dan Flavin, Carl Andre, and Donald Judd have high prices, even though far lower than their quality and artistic importance merit. When their prices were low all these artist were eager to use the new system. They felt freed from the limitations of the market and the covetousness of avid collectors. For some of them this enthusiasm wilted when demand rose together with the prices. For Judd and Andre the piece of iron used for the first time in carrying out an idea became the justification for the work's validity, but it was in fact only a piece of iron formed by the workers in the workshop. The artist's only action was that of checking there hadn't been mistakes in cutting the sheet metal, something that was almost impossible because the machines had a tolerance of just a few tenths of a millimeter. The fear of having difficulties in selling a plan instead of something physical to a traditional collector led them, simply for financial reasons, to give up the ideal purity of an art that exists only in the realms of ideas. I hope this ugly fact of giving importance again to the object instead of the plan might be abandoned and a return might be made to the origins: the truth and beauty of a new idea. Among other considerations, it is also more convenient for a collector to buy a project rather than a heavy and bulky object that can easily be stolen or faked. The plan, when accompanied by a contract clearly specifying the obligations of the artist and the owner, makes the work incorruptible and eternal. And the work is entrusted to the care of the one person who more than anyone else is interested in its scrupulous and exact execution. Collecting too is coming to understand these advantages, but it still continues to apply the concepts of earlier times. I must honor Morris, Nauman, and Serra who have remained faithful to the principles underlying the vision of this new situation.

The important thing is the contract where reciprocal rights and duties are laid down. Jerald Ordover, the lawyer of the Castelli Gallery, had drawn up a standard contract that took into consideration all possibilities and consider-

ations. This was a tool that protected the integrity of the work, the artist, and the collector. It was a tool that was extremely useful when an artist wanted to challenge the sale of his plans for constructing a work bought from the Castelli Gallery.

I later bought many more works by Morris, almost all large-scale. The show of them at the Reina Sofia Museum in Madrid in 1988 was marvelous. They could be seen in all their expressive richness. They illustrated a fundamental period in the development of the century's art. The creative capacities of the human mind reach a metaphysical level by using logical means that, working at the very limits of simplification, allow us to discern another range of values only accessible by going beyond reason.

The conquest of the work by Morris and Minimal Art is to place reason within a wider dimension. His preceding period is important too. These works are based on a conceptual vision where the idea is the most important thing; the objects themselves are small. They were made between 1960 and 1963. They anticipate Conceptualism, which, as a group of artists, was to be formed at the end of the 'sixties. Sadly I did not have the opportunity of buying works from this period, one I consider very important. My interest has always been in his large sculptures. The main nucleus was bought through Castelli, accompanied by the Ordover contract, in 1973, a period when my financial possibilities were better than they had been. The heaviest sculptures, consisting of thick steel slabs, were made in Italy in a workshop where there was the greatest attention given to the work, and the result was perfect. These works have been shown on various occasions and will be seen even more widely in the future now that they belong to the Guggenheim. They will be exhibited with the obligation of bearing the name "The Panza Collection" in consideration of the extremely favorable conditions of sale. All the Minimal sculptures were conceived in a rational and geometric manner, with flat surfaces, right-angles, and cylinders with a regular curvature. As a result of this simplification, thought has conceived things and makes them knowable.

A further requisite of Minimalism is the use of series. Some forms are repeated just as they are, and this repetition increases the size and gives the work added power, that of being integrated with the surrounding space so that even the architecture the work is installed in becomes part of it. It does not exist in isolation but as part of everything around it. The object is not observable as a single entity but as part of a whole. The artistic experience becomes the experience of a total reality, a unity with the environment that we enter in order to exist physically as well as mentally. This is art as an experience of life, something that the ancients were far more aware of than we are. Unfortunately a museum is often an accumulation of things we should look at and

not a place where we remain in order to experience a different condition, as when we enter a cathedral.

As a result of Minimalism's characteristic of being made from simple elements such as blocks that are put together and repeated, making them causes no problems of interpreting the original. Any workshop that uses precision systems can make them perfectly. I have always had an excellent rapport with Morris. In the Guggenheim Archives there is extensive documentation about how to mount some of his largest works, such as *War Memorial*, 1970, for which various materials could be used. There were no definitive plans because the works had never been made and there was no occasion for making them. When there arose the possibility of making donations to the castles of Rivoli and Vigevano, which had extremely large spaces, I asked Morris to give me more detailed information. Sadly these possibilities all faded, but the works could still be erected in the large museums created by the Guggenheim, such as in Bilbao and Mass MoCA in Massachusetts. In Bilbao the Philadelphia *Labyrinth*, 1974, was remade and was a great success with the public: there was always a queue of people at the doors.

BERND AND HILLA BECHER
BERND BECKER: SIEGEN, GERMANY, 1931-;
HILLA WOBESER: POTSDAM, GERMANY, 1934-

It is fascinating to compare the great Minimal compositions with an experience granted me many years ago by Bernd and Hilla Becker in Düsseldorf. I was very interested in their photographs recording large industrial plants. I was invited to travel in their Volkswagen pickup truck to see various steelworks along the Rhine, between Essen and Dortmund: a world of fascinating beauty. Gigantic Minimal structures, cylinders, spheres, rectangles, high chimneys like needles pointing skyward. Complex structures of huge steel beams and enormous pipes connected the cylinders and spheres, like arteries carrying life-giving blood, a crossover between the biological and the artificial. In the purity of their conception they had become enormous and imposing sculptures. The human mind's search for creating useful productivity through science and technology had become visible in forms of rare beauty. The Minimal artists had shown the mind's capacity to give form to itself; in this enormous artificial landscape this was visible on a gigantic scale. The image of the enormous power of the mind, for better or worse. Also for worse. These factories produced the steel for the cannons, bombs, and tanks that increased German pride and led to two catastrophic attempts to conquer the world.

Like many artists in the 'sixties, Morris was very involved in political debate. Art and politics in the 'sixties and 'seventies were two separate situations that did not interfere with each other. Art was art and was not contaminated by outside influences. It was not used for displaying any ideologies, except for the time artists refused to allow the Whitney Museum to open a show to the public as a protest against the war in Vietnam. It was a great surprise to me when, at the beginning of the 'eighties, I saw a catalog of Morris's new pictures, the subject of which was the atomic apocalypse. In one picture you could see flames in the dark night. The frame was huge and had casts of skulls and bones, rather like baroque mirrors from the seventeenth century where the decorative emphasis was more important than the content. This was a complete reversal of his values, from sublime research into the nature of thought to the wholly earthly reality of politics. The nuclear bomb is certainly a terrible risk, but the atomic holocaust never happened and the possibility is becoming less, for our fortune and that of the world.

If we had believed in that negative forecast, then it would have been better to disappear at once. Luckily, or as a result of the intrinsic logic of events, we are still alive and the bombs did not explode. Pessimism is a bad guide in life and even worse in art.

I remembered his athletic agility when I first met Morris in the 'sixties. I saw him again some fifteen years ago when he visited the site of the Massachusetts Museum of Contemporary Art (Mass MoCA), still in its planning stage. I had the impression he was depressed. I hope that situation was only a passing phase and that this vision of the beauty of thought might return to illuminate his mind.

Pessimism about the future is a widespread attitude in Western culture. In America in the 'sixties the situation was different, the new generation had youthful energy and looked to the future with optimism and the will to change it in order to better it. There was an active involvement with life; action to batter down resistance and to affirm new values was genuine; no idea was accepted just because it was imposed or had become a habit; everything could and had to be discussed. This attitude created the favorable conditions for an art that explored new forms of expression and new ideas. There was widespread faith in the future, a favorable condition for research and experimentation, an indispensable condition for creativity and an irreplaceable nourishment for art: if it dies art dies. This situation had made possible the birth of Abstraction and Informale painting in Europe, and Abstract Expressionism in America in the 'fifties. Later, in the 'sixties, there arrived Pop Art, Minimalism, Conceptualism, and Environmental Art in Los Angeles. It was a period full of changes and new ideas that at first were shared by few people but that quickly found a greater number of followers and imposed themselves on the attention of a greater public. This evolution was fuelled with energy and conviction by the whole art community, from critics to museums and the mass media. The years from 1945 until 1975 were a great period in the history of Western art. Almost thirty years full of innovations, changes, and intellectual growth. New ideas and new emotions were discovered and expressed through new forms and images. It was certainly one of the richest periods of art and culture of the past two thousand years, comparable to the Italian and European Renaissance of the fifteenth century, or to the years of Impressionism and Post-Impressionism in Paris between 1863 and 1890, another tremendous thirty years of great creativity. And another similar period was in Europe between 1907 and 1925 with Cubism, Abstraction, and Surrealism.

All these artistic innovations occurred at the same time as great scientific discoveries, which, with their technological applications, created various new possibilities for transforming society not only in the countries where they took place but throughout the world. Scientific, social, economic, and artistic creativity are all related phenomena. Creativity, inventiveness, and the discovery of new laws of nature are all expressions of a central point that is the propulsive power of everything that comes after it: the desire to know the unknown, which finds its most complete visualization in art. When this desire to search, discover, and create lessens, then art dies.

There is a lot of talk about what the Modern and the Postmodern might be. The best definition of Modernism is the wish to evolve and create a future; it is faith in progress, in the possibility for a better world, even though all the evidence is against this. This desire is the individual's reason for being, it is his task in life even in the face of all kinds of delusion.

Postmodernism is the negation of all this: it is a pessimistic vision with no hope for a better future. There is no belief in progress and so there is no belief in searching for something new. Everything that can be discovered already has been discovered, so it is useless to keep on trying. It is the end of research and the end of creativity. It is the end of art. In natural evolution, all those individuals who do not evolve are eliminated because they are not adapted to the struggle for existence. In the same way time will eliminate, as it has always done in the past, all those who do not answer to the needs of evolution. Museum basements are full of the debris of evolution, destined to be forgotten. The greater part of the objects in private hands end up in the garbage dump.

When I look through old numbers of contemporary art magazines, most of the artists are not even remembered any more. Their work might have been good or at least dignified, but it was repetitive: it followed the dominating trends, it played no part in evolution. In January 1999 I was at the Bologna art fair where there were exhibited some two thousand pictures, and I asked myself how many were fit to survive. Certainly in forty or fifty years' time the great majority of these artists will not be remembered.

The word Postmodern ought to be replaced with Anti-Modern because it is the negation of all the values of Modernism, which is not an invention of twentieth-century art but, in fact, has existed since the beginning of time, ever since man discovered how to make objects to express his conscience. The infinity of being. The Chinese jade circlet of five thousand years ago is a perfect example of Modernism and of Minimalism. The representation of Everything by the elimination of almost everything. The miracle of art.

DONALD JUDD
EXCELSIOR SPRINGS, MISSOURI, U.S.A., 1928– NEW YORK, U.S.A., 1994

My third Minimal artist was Donald Judd, whose work I bought some years later. His works were made from more precious materials: anodized aluminum, brass, Plexiglas, and they were therefore more expensive than Flavin's florescent tubes or Morris's fiberglass geometrical forms. But their underlying interests were similar. His work has a different attitude to forms, which

are more articulated. He did not use color. The sculptures were not painted. It was a basic tenet of his not to paint the works using the traditional means of paint applied manually with a brush. The work had to be made by machines in a workshop. The artist's action was purely intellectual: to invent an idea

This idea should then appear in all its beauty and uncontaminated by man's dirty hands, an almost ascetic concept. Despite this, in Judd's sculpture color has an important function, but it is the color of the material used and incorporated in its very substance, or applied, as in the case of anodized aluminum, through some industrial treatment without human intervention. The Minimalist artists were extremely proud of demonstrating their independence from their creations, from the financial and commercial fetishism of art as an object to be exchanged for money. This was in the 'sixties, the years of contestation when politics were important, but luckily it was not mixed up with art.

My involvement with Judd's work increased in 1973 when, having more money available, I decided to buy a lot of large works that had, in part, been made for shows at the Castelli Gallery and then destroyed because they had no buyers or were too big to be kept in store. Other works had been planned but there had never been the opportunity to construct them. My interest in this large-scale art was the result of a program I had set out on in search of large spaces available in abandoned industrial buildings or in ancient buildings such as villas, castles, and fortresses, which in Italy above all there are many. This might have seemed a utopian project, but it was not impossible. There was an intellectual interest in this art if not a financial one, because collectors were almost nonexistent. No one could put a sculpture some twelve to fourteen meters (39 to 50 ft.) long in their house. Museums could, but they didn't, since it was an art that was too new and too bulky, and so these beautiful but unsalable works lay heavy on the finances of the Castelli Gallery, which had also paid for making some of them.

At the time I had also purchased projects for large-scale works by Morris, Andre, Serra, LeWitt, the rooms by Turrell, Irwin, Wheeler, Orr, and Maria Nordman. All beautiful works but unsalable. They had been shut up in the drawers of the artist or the gallery. But there was a positive side. They were not objects. They were works of the intellect that could become a reality at any time, in the near or distant future, just like a plan for erecting a building or making a machine. They were works of intelligence in the real sense of the word. The artists were fully aware of this fact. They sold the certificate with all the instructions for making the work: they were not selling an existing sculpture made with their own hands from wood or stone, or cast in bronze from a model. The artists were not only conscious of this special trait of their work but, on the contrary, they were proud of having been the first to create a new approach to art, free from the slavery of the market or money. In a period when everything, above all the merchandizing of art, was being disputed, this characteristic was acclaimed as the beginning of a new freedom and a new age.

This way of thinking about art was in line with my aim of forming a collection of works for museums, even though this would probably mean waiting for many years, and in fact only now, after thirty years, are things coming together. Certainly this was not in any sense speculation. Being aware of the difficulties, I needed to define exactly how the works should be constructed, and I also needed the right to assemble them without having to rely on the assistance of the artist when I finally managed to undertake the project. This was a

very important clause in the case of the premature death of an artist, as sadly happened with Judd himself and also with Eric Orr. Jerald Ordover, the lawyer for the Castelli Gallery and of many artists, was asked to draft a standard contract to protect the artists' interests. I think this contract is thorough and meets the needs of everybody and, above all, of art. Artists and collectors die but genuine art lives on down the centuries. I am convinced that these works have all the requirements for overcoming the tough and inexorable challenge of time. This undertaking has proved to have taken longer than I thought, and though many exhibitions have been held they were all temporary, except for the one in my home in Biumo, which has been donated to FAI, the Italian cultural and environmental foundation, to serve as a museum. I am sure that in a not too distant future this part of my collection will almost wholly belong to museums, either as a result of sales with a discount or of donations. Public ownership ensures its survival if its administrators understand the need to care for it. This different financial relationship with the art object was the great innovation of the 'sixties. It revolutionized the centuries-old tradition that buying art was about having an object from the hands of the artist who had painted a surface with a brush or had carved wood or stone. There is a big difference between an individual, physical, and real presence and an idea described on a piece of paper, a virtual reality that can exist or not according to the will of its owner—a presence that can disappear and reappear over time. The work can be made, destroyed, and remade. A piece of paper becomes the guarantee of ownership of an object that might even be extremely large but today does not exist. This concept of ideal ownership did not previously exist in art but is extremely common in other economic sectors: patents for equipment or systems, for example, or for literary or musical works guaranteeing reproduction rights.

In the case of works of art, rights are transferred from the artist to the owner of the document who thus has the possibility of making and dismantling the work. This is both very important and very useful. A bulky work made from poor materials might be easier to construct from scratch every time a museum requests it rather than keeping it in storage and then incurring high transport costs, as in the case of Nauman or the rooms of Turrell, Irwin, and Wheeler.

In the case of damage, instead of restoration it might be more convenient to remake a work completely. The work cannot be stolen since the deeds are kept in a safe place and, as a result, there is no need for insurance against theft or damage.

Very large works filling a whole room can be kept, ready to be made, in a desk drawer or in the file of an archive, thus saving the often high costs of storage. The convenience of this new kind of possession is slowly becoming part

of our usage and habits, though in the 'sixties it was a novelty and looked on with reservation.

Another important consideration is that the curse of the art market has always been fakes. With this system the danger no longer exists. There is no longer a need for experts to authenticate a work. The piece of paper tells its own history and documents the various owners; it is a guarantee that cannot be questioned.

Someone might object that documents too can be faked, but this is very difficult. Documents create a web of relationships with other people who can easily confirm or refute information. They create a network of cross-checking that would rapidly indicate any eventual faking. The language used by Ordover was that of lawyers, traditional phrases not used in everyday speech but that, in law, have a specific meaning with only one interpretation. The scope of the law is to be categorical, and obviously it has no relationship with art. It is an important tool for avoiding conflict. This is its only aim and is very important, as will be seen later.

Some artists, like Nauman and Morris, thought the certificate was useful but others refused it for the difficulty they had in understanding the conventional language of contracts valid in law, a language that was too different and divergent from artistic ideals. Irwin and Flavin thought it a ridiculous idea.

Previously my lawyer in Milan, Carlo Maino, an exemplary and honest man with a great interest in culture, had drafted an extremely simple text that summed up everything in a few words, a solution that was useful, for instance, for the works by Bruce Nauman. Exact formulation is the great problem and difficulty. "Less is more" is an important principle as much for art as it is for contracts regularizing people's concerns, and it is also difficult to say everything in a few words. The occasion for arriving at a simple but sufficient text came not with Minimal Art but with Conceptual Art, which is even more intellectual. If for Minimalism the idea was made concrete through a project that could actually be made, for Conceptual Art the text was sufficient in itself; a work could either be made or not. Words are the main means of expression, and for this reason many Conceptual works just consist of words. Words: the means for communicating, for establishing a relationship with others, for externalizing what is within us and giving others the possibility of understanding us. I bought the words and phrases of Lawrence Weiner: *Marred, Beside Itself, Reduced, Earth to Earth Ashes to Ashes Dust to Dust,* (all dating from 1970), all common phrases for which I paid 1,000 dollars each. But when I asked Carlo Maino to draft a contract for buying the words of Weiner he nearly went mad: it isn't possible to buy something that is available to everyone and is to be found in a dictionary. I answered by explaining that the artist had made a

choice, that this act of choosing was his decision and his decision only, not of anyone else. Rules regulate the facts resulting from a decision. If they do not become a fact they are not something that can be regulated.

Weiner communicated his choice to others, therefore the act of communication was a fact that could be regulated. Following these lines the lawyer found the solution for a formula that worked and that still works. Over thirty years have passed, and I haven't yet sold a single word by Weiner; I gave various of them to the Guggenheim and so have never had the occasion for testing the system in a case of disagreement.

Weiner also has a very efficient additional system. Attorney Ordover has a register in which there are noted all changes of ownership. For every work I bought I have in my archive a declaration by Ordover informing me that he has registered the work in my name.

The acme of Conceptualism is the philosophical conversations with Ian Wilson. They last more or less an hour and are about the problem of problems, the basis of all philosophy and also of life: Truth. This is a discussion I have every year; it costs 5,000 dollars and I am happy to spend the money. It is the only time in a year when I can speak for an hour about this problem of problems, the origin of everything. The discussion is not recorded, and there only remains a piece of paper, signed by Ian Wilson, and with the date and the phrase "There Was a Discussion": not much for 5,000 dollars, but a lot for me. This is the most substantial way of still being alive. If these thoughts disappear from the mind then you begin to die.

Sadly I will never be able to exhibit the works of Ian Wilson. They are completely impalpable and have no corporeal existence, but a room would not be sufficient for them; they would need a temple like the Pantheon in Rome. The most important building in the world, it has in fact existed intact for two thousand years and has passed unharmed through wars, earthquakes, fires, invasions, and the stupidity of mankind, but it continues to exist. It is covered by a hemisphere with an opening in the center in order to see the infinite sky, the origin of truth. The Romans must really have been a great people if they wanted to construct this building, so rational: a sphere. The overall geometric image, all the power of reason, and above the circle the opening to the infinite, the unknowable, the entity that stands above reason and to which we are subordinate. The harmony of the eternal and the infinite. The recognition and acceptance of its power. A power that is our life and our ultimate happiness.

D onald Judd is a great artist and one of the most important Minimal-
ists, but he is the only one with whom I have had totally unjustified
problems. When, in 1973, I bought many of his large sculptures, per-
haps he thought that I wanted to give over the whole Biumo house to his work,
an impossibility as I would have had to eliminate the works by Morris, Andre,
Flavin, Turrell, and Irwin. Still on the main floor in my apartment were the
Rothkos, Klines, Rauschenbergs, Oldenburgs, and Rosenquists. He knew I was
buying his works in order to place them in museums and that this was cer-
tainly not about to happen soon. I too was not very pleased that this was not
taking place at once, but all the same something was happening. This group
of monumental works was among Judd's best, and certainly the works mer-
ited special attention, but their size made a solution difficult. I understand
that for the artist it was painful not to see them constructed.

THE SHOW IN ROME

In January 1980 there was an exhibition in Rome at the National Gallery of
Modern Art when the director was Giorgio De Marchis. The exhibition's com-
missioner was Ida Panicelli and on show were two large works made in Italy
according to the instructions of the contract stipulated in 1974. The show was
devoted to Minimal sculpture from the Panza Collection and there were also
works by Morris and Andre. Judd's *Eight Hot Rolled Steel Boxes*, 1974, was ex-
hibited in a room near the entrance, and also on show was *Large Steel Straight
Tube*, 1974, both works made in the Sant'Angelo Lodigiano workshop, which
specialized in working iron for the best architects in Milan. I remember that
for the second work, made from large sheets of steel, it was necessary to send
it to the only steelworks in Italy with a large enough press to undertake the
leveling. As a result of the thickness of the sheets, hundreds of tons of pres-
sure were necessary.

The show was a friendly occasion, and the director and commissioner were
interested in contemporary art. In 1980 Minimalism was still contemporary
even though its greatest moment had been in 1975. I am writing this in 2003
when almost thirty years have gone by, a long time, and what was contempo-
rary is now in the distant past.

The artist too has gone. Time goes by quickly, but good things are validated.
The National Gallery of Modern Art in Rome has had some excellent direc-
tors, but it has never been able to free itself from its original sin, the cele-
bration of the unity of Italy. This was a political not an artistic aim, and the

museum was created at the beginning of the century, forty years after Italy had tried with great difficulty to weld together the north and south, two completely different entities with regard to history, way of life, and civil behavior— a unity that after 140 years still does not seem a reality. History has its revenge for ideological force. Politicians wanted a single state that could compete with France, Spain, and Britain, under the illusion that a large state could be more powerful; but the outcome was a weaker state because of profound differences.

This original aim weighs heavily on the National Gallery, which cannot free itself from political interests. It is obliged to celebrate the nineteenth century, the Century of Unification, with some good quality works, and a lot of bad ones. As it is a state museum it has not had gifts from good collectors. The directors have never had enough funds for genuinely artistic choices. The money has been spent on useless acquisitions of the artist friends of influential politicians. The Italian nineteenth century is not well represented; even though it was a weak century for Italian art, a few good artists did exist.

The Italian twentieth century has been almost completely ignored, and only recently have the gaps begun to be filled, while the storerooms are full of canvases that are a denial of art. New art was too different to be credible for ignorant Fascist, Christian Democrat, or Socialist politicians.

THE SHOW IN DÜSSELDORF

In September of the same year, 1980, there was a large exhibition of Minimal Art from the Panza Collection in Düsseldorf, organized by the Kunsthalle and directed by Jürgen Harten. He was an extremely competent person who did an excellent job during his long directorship. The show occupied two buildings, the Kunsthalle and an old steel building for trade fairs that had fallen into disuse. It was very large and therefore well adapted to exhibiting large-scale sculptures, but sadly it was not the best setting for art. It was illuminated with cold fluorescent lighting with a ceiling of shabby steel, but there could be shown many of Judd's sculptures in steel and plywood that had been made in Milan following the instructions of the contract with the artist. We informed Judd about the works on show and he sent his assistant, Mrs. Dudley Del Balso, who carefully examined the works made in Italy and found them to be basically in line with the plan, apart from some secondary small imperfections, mainly due to the wear undergone by sculptures during transport and erection. Contrary to what is generally believed, works in steel are very fragile and, being heavy, are easily scratched by the lifting forks; it is difficult to keep the external surface in perfect condition even though the sculpture will last for centuries without change, unlike wood, canvas, and

paint that age and are worn away by time. Judd has never doubted Dudley Del Balso's work. She was an extremely correct and able person, and a basically favorable opinion was given to me in writing with a note on all the small imperfections that had to be eliminated.

THE SHOW IN MADRID

In 1988 the Reina Sofia Museum in Madrid devoted a large exhibition to Minimal sculpture from the Panza Collection. At the time the director of the museum was Carmen Gimenez, assisted by Mrs. Guadelupe Echevarría. It was a marvelous show in an ideal setting. Here too there were many works by Judd made in Italy, and he was one of the main artists in the exhibition. In 1988 the Rath Museum in Geneva also asked for a show of Minimalist works from the collection. Many pieces by Judd were shown, and some had never been constructed before. In this way works that had been bought as projects came concretely to light. It was a very costly operation, and it was also difficult to find the best workshops for high quality workmanship and high quality materials. But it had also been expensive to buy the projects too: if I work out how much I spent for them in 1974 and take into account the rate of inflation of the dollar, the value in 1999 was about one million dollars. Not all this money ended up in the artist's pocket, because he owed the Castelli Gallery money for many of the works that had been constructed but not yet sold. That's not a small sum for something that only existed on paper. The construction of these large-scale objects was entirely up to the buyer.

THE VALIDITY OF THE ORDOVER CONTRACT

These shows are programmed by the collector without asking the artist for his help unless it is necessary. Having perfectly clear instructions for the project, instructions that at times purposely leave very little room for interpretation, the artist's help is superfluous. When artists are consulted or are present during installation conflicts can easily result. A situation is created in which everyone is against everyone else and they in turn are against the organizers. The show really snarls up. When the person who has chosen the works makes decisions that are the result of an artistic idea, the artists understand and respect those decisions, perhaps with some comment under their breath, but nothing more. A show must be the outcome of an artistic project in order to be a real show: it must not seem to be a prize given to the best, which, in most cases, means that what costs the most is what most pleases an often ignorant public. The organizer must take into account the qualities and limits of the

available spaces in order to create a harmonious whole, one in which an idea, or various ideas, are visible and easily perceptible to the public. Some, even important, exclusions are necessary, but they can be justified when there is a logic behind the choices that have been made.

All too often choices are made in a hierarchical way that values the artist's fame for the market but not always the quality of the work. For this reason I have never asked others, not even Judd, which works to show, nor have I asked their thoughts in order to adapt to them. The artist, thinking of his own interests, might alter the overall program, which he does not necessarily know, and become opposed to the organizer. For example: he might prefer a new work to an old one: artists prefer to make known what they are currently working on rather than things from the past. Probably Judd was irked by not being involved in the shows, even though his works have always had a dominant position, perhaps even better than in the solo shows he himself held in galleries and museums. Being excluded from the preparations for a show might perhaps have prompted feelings of neglect in him, but this would have been totally unjustified and completely irrational. Often one's psyche is not governed by reason. If I had had to consult the artists about every exhibition I did, then it would no longer have been mine but someone else's, and there would also have cropped up the problems I mentioned earlier.

The works of art I had bought as a project to be made later were all constructed in Italy; according to the contract I had every right to act as I did. The estimate made for me by the artist's usual workshop in New York was double the one I had had in Italy for the same thing using the same materials. There might be a justification for a difference of 20 or 30 percent for the various costs of the work, but not a difference of one hundred percent. When this difference was multiplied for the nineteen works to be constructed, then it became extremely heavy.

A further phrase in the Ordover contract gave me complete freedom: the last but one paragraph on page two, says: "But it is clearly understood, and I reaffirm, that the written approval shall not be necessary if the work is realized in full compliance with the document." All the works were realized in full conformity to the projects and so the artist's written assent was not necessary, just as it will not be necessary for any of the still unrealized projects now belonging to the Guggenheim Museum. Sadly the artist has died in the meantime, and this phrase has turned out to be a very useful one. Otherwise there would have been a real problem. When a person transfers a prerogative to a third party, this prerogative no longer belongs to the original owner but to the new one who is free to do what he likes with it, though always respecting the conditions laid down in the contract of assignation. When a writer or mu-

sician sells the rights of his manuscript to a publisher, then the publisher will publish it when he can and when he finds it convenient, and his responsibility will be that of reproducing the text integrally and exactly. When the rights have been sold and fully paid for, the writer or musician can neither stop the book or music being published nor withdraw it from circulation. The same situation holds for the works by Judd sold with the Ordover contract; the artist was paid in full and so had no right to stop its being realized, because the work was not his and existed in a virtual state from the moment the contract of sale was signed.

Before the big shows of Judd's works our personal relations were excellent. He signed without hesitation the Ordover contracts that, in 1974, were consistent with Minimalist philosophy: art is not an object but an idea that becomes visible with the execution of the project. He and his young children were twice guests in my home in 1975, and he was enthusiastic when he saw a work erected in Biumo: *Galvanized Iron Wall*, 1974, (along three walls, eight inches apart, sixty inches high), a work that had been shown in the Castelli Gallery in a room with similar dimensions, but it had been galvanized with a different technique. The Biumo version was galvanized with an electrolytic process, one that gave the surface a gray-blue color and was more uniform. Furthermore, as the flooring was antique and could not be touched, and also sloped toward the outside, it was necessary to add a small wooden wedge, a few centimeters high, in order to keep the zinc-coated slabs perfectly horizontal. He fully agreed with these modifications and complimented me on the way they had been carried out. These were modifications meeting a specific need and were not something I would have wanted.

The second time he was a guest at Biumo I was away for work. It was a rainy fall, and my wife told me later that she often saw Judd looking thoughtfully out the window, though without seeing, absorbed in his thoughts; he was taciturn and had a sad expression.

MARFA, TEXAS

The Dia Art Foundation was developing a grand project under the enthusiastic direction of Heiner Friedrich, and with the generous financial help of the De Menil family and Mr. Friedrich's wife Philippa De Menil: *Lightning Field* by Walter De Maria, *Roden Crater* by Turrell, and Judd's large Marfa project. These were marvelous projects that I too was enthusiastic about. At the insistence of Friedrich, whom I had known since 1966 when he had an art gallery in Cologne, I decided to visit Marfa and see a project Judd wanted to undertake: to transform the old buildings of a disused military base into a

museum for him and his friends. One building was to be devoted to Flavin. The description I had been given of the site was very attractive. It was on a West Texas highland some two thousand meters (6,562 ft.) above sea level, near the Mexican border, in a semi-arid area with the most beautiful light. It was the fall of 1977 or 1979—I don't quite remember which—and the nearest airport was El Paso, three hundred kilometers (186 miles) from Marfa, on the Mexican border. The car journey was interesting: the highland, like all deserts, is a wonderful place, and every so often I would leave the highway for a secondary road without traffic in order to see the landscape, nature's great Minimalist masterpiece: just the horizon, the blue sky, the enlivening light of the sun, contact with the inexpressible. I arrived at Marfa toward midday, and Judd took me around the empty buildings: work hadn't yet been started. Having seen the project and heard Judd's explanations, and as there was nothing else to do, I decided to return the same evening and sleep in a motel at the crossroad by the highway.

West Texas nights are as beautiful as the days, perhaps even more so. I could see an enormous quantity of stars, the night was full of light, and reality expanded to infinity. The self disappears into a distant but multiplied life.

YET MORE PROBLEMS. FLAVIN, JUDD

Unfortunately, it could take years and even decades to mount shows by these artists, and if, as in the case of Judd, the artist dies before seeing his project realized, then this becomes the problem of the heirs. I am obliged to clarify this problem because the artist's unwarranted accusations have become history and can be read about in books written by uninformed people; for this reason I must state just how things stand and what the truth is. The only artist ever to accuse me of not respecting my pact was Judd, but this was for completely baseless reasons, as can be seen by reading the documentation.

To be precise, Flavin also accused me once of having changed a work of his: this was during the Minimal Art exhibition at the Reina Sofia Museum in Madrid in 1988. The work *Untitled (to Jan and Ron Greenberg)*, 1972–1973, could only be shown in a barrel-vaulted corridor, which to accommodate the work would have had to be lowered and narrowed, eliminating the sight of the beautiful vault. I decided not to modify the room, an arbitrary operation. The result was incredibly beautiful. On one side was a wall of yellow fluorescent lights two meters high (7 ft.) that divided the corridor into two equal parts; on the other side was the same wall of lights but green. Only on one side there was a small opening, and above the vault the intense green and yellow light mixed to create a marvelous effect, an overwhelming and glorious festival of color.

Flavin did not come to see the show, though had he seen it he would have approved, but unfortunately he only had a photo to judge from, the one printed on the poster, and this was another mistake as it would have been better to say that this was the collector's interpretation of the work, and then the artist would have had nothing to object to.

In his short work *Notes from Underground*, Fyodor Dostoyevsky described with great psychological accuracy the contradictory behavior of intellectuals who are always hostile to those having power because it is used without human considerations, and for this reason they would like to eliminate it; but when they themselves by some happy chance find themselves with power, they use it in the same way as those they criticized.

I remember the opening of a show by Judd in the 'eighties in Los Angeles in the excellent Margo Leavin Gallery, the best in the city. Judd made a long speech to the public, a kind of lecture delivered in a low voice that was difficult to understand, but I understood the sense of it: he was speaking against capitalism, which had betrayed the promises it had made to artists. The Dia Art Foundation had promised Judd it would finance the conversion of the Marfa military camp into a museum for Judd and his friends. Because of the financial problems of the Foundation the program had been suspended. Judd sued, and a couple of years later he managed to obtain five million dollars in damages, an enormous sum. And thanks to the De Menil family, always generous with art and artists.

When I went to Marfa with the CIMAM group (the International Committee for Modern Art Museums) in 1996, I saw Judd's marvelous works installed with great precision in these buildings that during the war had been military depots. In Marfa Judd had been able to make his dream come true and arrange his work with all the space it needed, a grand vision that required equally grand financial support. It is wonderful when a dream becomes reality, here in a place far from any important town and where very few people can visit it. It is seeming madness to imagine finding help for a place out of this world, but at times apparent madness becomes reality when someone is really determined, especially in America. Probably the artist was disappointed in no longer having available the large sculptures he had sold me in 1974 and that he could have exhibited in Marfa. Perhaps it was this impossibility that caused his resentment toward me.

His anger burst out when Douglas Chrismas asked Judd's secretary for permission to remake, just for the period of a show at the Ace Gallery, the work installed in Biumo made from galvanized panels: it could easily have been reconstructed in an equivalent space in Los Angeles. Chrismas believed he had Judd's approval because he had heard so from the secretary. And it was Mini-

mal Art's philosophy that it was possible to reconstruct works in other places without the intervention of the artist's hands, because they were made from industrial materials that are the same all over the world. This possibility was made clear and confirmed by the Ordover contract, signed by the artist of his own free will. The Ace Gallery space was very large, and Chrismas had installed some very beautiful shows of works by Minimalist artists, shows that not even museums had done better, and works that private collectors would buy only with difficulty because of their large dimensions. I have a great feeling of respect for Chrismas because of his courage in putting on expensive and difficult shows, though he has been criticized in the past for his financial difficulties with artists. I have bought a lot of art from his gallery and have never had problems. For Judd this was the occasion to let his anger blaze out and make his resentment of me public, even though his imagined reasons were without foundation.

If it had been true that my breaches of his rights were as bad as he had said, he should have proved it by taking me to court, but he did nothing, knowing full well that he would have been found guilty of defaming me. He confined himself to making a lot of fuss in the newspapers and magazines. I should have gone to my lawyers but I didn't want to increase a controversy that, when it came down to it, would only have blackened the character of an artist I admired and whose works were an important part of my collection. Judd also complained about Castelli who, as a result of his work as a dealer, had brought Judd fame.

He said he had not received all the money I had paid. Judd was greatly in debt to Castelli who had advanced him money in order to construct many works that were left unsold. Judd felt he had been swindled out of the important works he had sold me of his own free will and which, in 1974, he was happy to see in the Panza Collection as well as having received money for them. As far as the works are concerned, they are all in the greatest museums in the world, which exhibit and will continue to exhibit them once some stupid restrictions are lifted. As for the money, twenty-five years ago he received a sum that in 1999 would be the equivalent of a million dollars.

The scattering of the works, something that happens quite frequently, has been avoided, and they are now in the Guggenheim, a museum that has a building extension planned for housing large-scale Minimalist sculptures. This program is going ahead slowly because of the cost of new museums. His last wishes were that no more works by him should be realized after his death. The projects I had bought had already been constructed in 1975 and 1976 and had, in fact, been seen in shows in Düsseldorf in 1980 and in the Reina Sofia Museum in Madrid, as well as in the Rath Museum, Geneva, in 1988. There

still had to be realized the *Bern Kunsthalle Pieces*, 1976, which have dimensions variable according to the available space, and the *Large Tube With Parallelogram Inside*, 1974. The works exist since the time the artist sold the rights to realize them, even without his supervision, as long as they were constructed according to the plans. So his restrictions have no validity for the Panza Collection. The Guggenheim is still waiting patiently, as it wishes to avoid controversies; it is a problem only for the artist's reputation and, therefore, for his heirs, if his best works are not visible. When I sold the projects for the still unrealized works to the Guggenheim, the lawyers closely examined the documentation, which they held to be perfectly lawful, otherwise they would have refused to buy them, but they did, with a 50 percent discount. Unfortunately the inferiority complex that artists and intellectuals so often suffer from resembles the situation described by Dostoyevsky and psychological reactions are caused that have nothing to do with logic.

1968

This year was not only important for student unrest but for collecting too, and many new artists were bought. I was in Paris with my wife a few days before the revolution exploded, and we were staying in a small hotel near the Sorbonne: everything was quiet and normal.

The artists I bought in 1968 and 1969 were Robert Irwin, Larry Bell, Richard Serra, Bruce Nauman, Douglas Huebler, Lawrence Weiner, Joseph Kosuth, Robert Barry, and Sol LeWitt, a group of very high quality artists.

GERMANO CELANT
GENOA, ITALY, 1940–

At the end of the 'sixties and the beginning of the 'seventies Germano Celant, a young critic, undertook a very important work. He was the main promoter of Arte Povera, which had begun in the same period. He was actively interested in all the new ideas being born, not just in Italy but in the world. He was among the first Italian critics to know and divulge all the new trends from America: Minimalism, Conceptual Art, and Los Angeles Environmental Art. He traveled to America and came to know the artists personally and could immediately evaluate their work at firsthand rather than by hearsay or through some inadequate reproduction in one of the very few magazines able to understand new art.

I often saw Celant, and every time our talk was an intense exchange of opinions, judgments, and ideas about the meaning of an art as yet unknown, even among intellectuals. He was one of the few people from whom I could have information and exchange ideas in a country such as Italy where the most interesting news arrives late.

At the time Celant was important for confirming and widening my choices.

I never collected Arte Povera, and this was certainly a great deficiency. It was a big mistake not to buy these artists at a time when I could have chosen their best works at a reasonable price and create a great collection. I was a frequent visitor to the Sperone Gallery when it was in Turin and was showing Arte Povera artists, all of whom I saw and met during my visits.

I used to go to Turin for the American artists Sperone exhibited, important artists though new to Europe, and in fact they were seen in Turin before London, Paris, Cologne, or Düsseldorf, the cities most open to ideas. After almost forty years, errors become macroscopic. The money for buying is never enough: this is the hard truth. You cannot do what you would like to. Economic laws force you to make choices, and as a result, many sacrifices.

I was very involved with Minimal, Conceptual, and Environmental artists, and for each of them I have been able to build up the best collection in private hands, far better than museum collections, apart from that of the Dia Art Foundation, which is now splendidly and grandly exhibited in its own building in Beacon, New York.

I am glad that the collection from the 'sixties and 'seventies is now in an important museum, the Guggenheim, with 350 works partly donated and partly bought at an especially low cost. In 2000 a big show of a hundred of these works was held in the Bilbao Guggenheim, which gave over the whole building to their display. I hope that in the future the other 250 will also be seen. (From this period there are still another three hundred works in the collection that I hope to place in other museums.)

Germano Celant is still very active and is the Guggenheim consultant. I am grateful to him for the help he gave over the sale of this part of the collection.

BRUCE NAUMAN
FORT WAYNE, INDIANA, U.S.A., 1941–

Bruce Nauman's work was an important acquisition in the 'sixties. He had held a show at Castelli with works from his first period made from plastic and rubber. I bought various pieces. This was in 1968. He had not yet developed his most typical and important style, but there was already great promise for what he was about to involve himself in: the relationship between our physical presence and our awareness of reality. We try to possess reality and our body is the necessary means, but we are not used to considering it as such. We have an abstract concept of our physicality. We do not see how our being is immersed in our body.

Nauman's works underline the difference between our mental activity and the tools it uses. There is a separation between our thoughts and our head, our torso, our legs, all that which makes us appear what we are, as though we were seen by others. In Nauman's works the external viewer is not another individual but someone without a body, who though without eyes sees and judges everything. This is our awareness lifted to another, higher plane, and it becomes a universal entity, no longer individual. The separation between the physical and the mental underlines the presence of something that does not have the attributes of physicality but is completely distinct from the body, it is an indefinable entity but it is everything; it gives the possibility of saying: I am. It is a reality that we can feel but not think because it comes before thought, it is the entity that makes reality exist. We can only intuit its presence: it is everything, it is us. Without our ego nothing exists because nothing can be known.

I met Nauman for the first time in 1973 in Pasadena where he had his studio. He was a young man of few words, introverted, and it seemed that he was always thinking of the ideas he expressed in his work, that they completely absorbed his attention. I had the luck to buy forty works. I am sure this has been one of my most important purchases, and it showed me a new way of understanding what we are, the relationship and the separation between our body and our consciousness. I can see nothing to be compared to it in the history of art. It is something new.

Perhaps at the back of Nauman's art lay a philosophy that pushed to the very limits Descartes's principle *Cogito ergo sum*, and had lost the notion of the existence of our body as the indissoluble seat of the "cogito." When an idea is fully developed in a unilateral way, ignoring its relationships with other conditions and showing its limits, a reaction comes about that tries to re-establish a balance with reality.

The first works by Nauman that I saw were not the environments created from 1970 onward, but the *Shaped Canvases* he was still making in 1965, and the immediately successive works made from plastic, rubberized canvas, and neon lights. The artist had liberated himself from painting in order to create freely invented forms using the materials most adapted to the needs of his imagination. He had not yet created the environments in which the discovery of our physical presence in reality was to be the final point in the evolution of modern art. These objects are important because they mark the break with a traditional past and an acceptance of new experiences. As they were objects and not bulky environments taking up a whole room they were a great success with the market, which always prefers easily transported things. A typical example is a work from 1967, *My Last Name Exaggerated 14 Times Vertically*, a medium-sized neon piece that I bought for 2 thousand dollars in 1970 and that in July 2002 Sotheby's valued at some 2,600 times the value of thirty-two years earlier, while the environments are worth 160 times their original cost. The most artistically important works cost far less than those that are more easily salable. A typical contradiction of the market.

RICHARD SERRA
SAN FRANCISCO, U.S.A., 1939–

Serra is one of the greatest sculptors of the last fifty years, and I came to know him and buy his works for the first time in 1969. From the 'sixties to the end of the second millennium the quality of his work has always been extremely high and has never varied, a rare phenomenon among modern artists who are often uneven.

His work deals with the universal force that holds everything together, our body to the earth as much as to the most distant stars in the cosmos: the force of gravity that makes possible the aggregation of everything. In stars it causes hydrogen to change into a radiation that warms and illuminates us. We have to make an effort to stand up, and this is due to gravity. No other artist had ever thought about how to represent this primordial situation, one that is indispensable for our existence. In relatively recent times, at the beginnings of science, no one before Galileo and Newton had managed to define its laws, the first brick of our systematic knowledge. It is a phenomenon belonging to the sphere of science and technology, and only engineers, the builders of bridges, struggle to conquer it. Bridges are among the greatest achievements of mankind. The fight to overcome gravity needs a deep knowledge of the physics of materials and a search for the ones that are most resistant. A research that transforms bridges into a form of pure beauty.

Serra's sculptures have a menacing and disturbing look. They are made of very heavy slabs of steel balanced between stability and instability, and they could fall disastrously if this unstable equilibrium were to change. Their fixity seems to be destroyed by this inherent possibility of shifting suddenly and speedily from an intrinsically stable and immobile material to an active and destructive force. We are made from heavy elements and are the outcome of a great gravitational disaster that occurred in a star of hydrogen and helium far larger than the sun. Excessive gravity caused a collapse, crushing and transforming the atoms of helium into heavy elements, from carbon to uranium, necessary for the existence of the planet and of ourselves. Richard Serra uses this force for expressing its invisible nature and its potentiality.

I did not buy my first Serra sculptures in New York but in Cologne from the Ricke Gallery and in Paris from the Lambert Gallery. These works were prior to the monumental pieces: they were made from rubber or lead, but the presence of gravity was already in evidence. This was in 1969, and my first acquisition from Ricke was one of the most important works from this period, *Belts* (1966/1967, 84 x 28 in.). This consists of seven groups of rubber strips wrapped around each other in a disorderly way. Gravity makes them descend so they form harmonious curves in accordance with the nature of the rubber, which is heavy but flexible.

The first large-scale work I bought in 1972 from Castelli was *Strike*, 1969-1971, a slab of steel that seemed to project from a corner and take over the whole room. Seen from one side it seems an enormous, solid mass; seen from the front the thick steel slab seems thin, unstable, and dangerous. Its mass is transformed into a disturbing threat.

I met Serra many times in New York in order to discuss how to install the works. His build was massive like his sculptures but, at the same time, agile

and vigorous. He made rapid sketches on a sheet of paper to explain how to install the sculptures. His way of talking too was rapid and almost cutting. He seemed devoured by the wish to make large things. In fact his sculptures really were dangerous while they were being installed. An engineer had to be on hand to prevent accidents, which, nevertheless, would happen all the same. Once a heavy sculpture was being assembled in the auxiliary part of the Castelli Gallery, which was the house where the John Weber Gallery was situated and where the artist Lucio Pozzi lived. A slab of steel fell and seriously injured an assistant who had to have a leg amputated, and it also damaged the structure of the building.

I installed some of his very beautiful sculptures in the large space of Bilbao, and they were really awe-inspiring in their majesty. I must also say that, once they are in place, Serra's sculptures are quite safe: it is only during installation that they are dangerous, as this is a matter of lifting many tons.

Serra has created marvelous and imposing sculptures, all of them extremely beautiful, in public places. For the most part they were temporary installations, and after the planned time they were taken down, a great injury for both art and the urban environment. One case that made the artist suffer was the work installed in a square in front of a federal building in downtown New York. It was a large semicircle of steel that crossed the space diagonally. It was intended to be permanent and had, in fact, been bought by the city, but was then dismantled because of the opposition, for futile reasons, of the workers in the building: they had to go a few yards farther to go home or drink a coffee. New York has lost the possibility of having a work by a famous artist, one of the glories of American culture, who had always lived in New York. It often happens that you are rebuffed by the town you are born and live in.

In 1990 I was in Paris for a show at the Musée de la Ville de Paris. This was the occasion for seeing the new monumental center of the Défense, where there were many works of art placed in the squares and green areas. In one of these there had been installed an imposing vertical sculpture by Serra. I spoke with the person in charge who told me that the sculpture had to be removed because it was the nighttime refuge for down-and-outs. I was petrified to hear this kind of reasoning. At night the place is patrolled by the police, and undesirables could easily have been kept away.

Art runs such risks when in the hands of the ignorant.

BRIDGES

These are a marvelous manifestation of the human presence in nature. They are works of art carried out with most basic power nature has created: the human mind. Bridges fight against the force of gravity using all the possibilities offered by knowledge of natural phenomena. This is similar to nature's own work in growing a tree, which in the forest must conquer gravity in order not to fall and to reach light, the sun's energy that is transformed into cellulose fibers and into lignin to give solidity to the tree so it may continue to grow. The interweaving of cellulose fibers and lignin is an undertaking similar to that of an engineering plan for creating arches or pylons for overcoming gravity. This is why bridges are one of man's wonders in nature, when the engineer thinks he is doing the same thing as nature does with a tree. Bridges are always very beautiful and are always harmonized with nature.

Environmentalists make a mistake when they object to them. They do not understand the intimate relationship between thought and nature that creates it. The more we know nature, the more we know the intelligence that makes it exist. Human science has this basic task: to discover intelligence.

FAI too, which is allied with environmentalists in the fight against bridges, has not understood this fundamental truth. It is enough to look at them without prejudice in order to understand their beauty.

CARL ANDRE
QUINCY, MASSACHUSETTS, U.S.A., 1935-

The laws of nature are identified by their origins. Material is governed by unchangeable laws and its appearance is always different, but the laws that make it exist are always the same. Galileo said that the book of nature is written in numbers: law is to nature as the soul is to the body. They are two entities that are completely wedded and cannot be separated. But at the same time they are seen as two different realities.

Our mind's ability to abstract universal judgments from an infinity of particulars is the most evident proof of the existence of an activity not available to matter. Carl Andre's works are made from sheets of metal or other materials sectioned by following a rigorous mathematical formula of extreme simplicity, and then recomposed to create a larger entity, one controlled by the same laws. The metal sheets are laid straight on the floor as though to become part of nature. The aim is not to make them seem the result of a mental plan. In this way the artist highlights the existence of a law that is given by a supreme power that conditions all things, as well as highlighting it as part

of physical reality. Where does this law come from? This is the great question, and the artist gives no reply. He cannot give an answer because then he would step outside his role as the discoverer of a reality that each of us must try to know for ourselves. We cannot have certainties that are unreachable by our intelligence, and this is why the large sculptures of Carl Andre are so disquieting yet so attractive: they ask us to reflect on our presence.

I came to know the artist in 1968 in the John Weber Gallery. I remember a work consisting of a lot of small white cubes in a sack; in order to see them it was necessary to pour them onto the floor where their arrangement resulted from chance, without any preplanned order, but they were still all tiny identical cubes. This simple work related two of nature's basic phenomena, the first being the simplest and the second the more complex. The inherent unpredictability of the evolution of wholes in which many phenomena interact.

I cannot know if I will fall ill next year nor can I know the exchange rate of the dollar tomorrow, but it is possible to know the position of the moon at this time next year with great precision. Carl Andre's works too, like all Minimalist sculptures, are not made by the artist but are executed in a workshop. They are metal sheets cut into squares, or blocks of industrially produced cement, or geometrical forms of cedar wood, all the same, but composed in different ways. The certificates granting ownership of the work and its relocation are extremely beautiful. At the end of the 'eighties when commercial values were rising Andre too felt the need to give a concrete form to works that existed only on a sheet of paper. After having refused to agree to the Ordover contract legally specifying the rights and duties of both artist and collector, he, for preconceived and emotional reasons, considered authentic only the first example made.

In this way he mixed up the right given by the artist's signed declaration with the object, which, not having been made by the artist, was reproducible. It was one of Minimalism's conquests to free art from the fetish of the commercial use of the object. The written contract was invented by the Romans two thousand years ago, and it is still today the best means for regulating relationships between individuals in society. Artists and committed intellectuals often fall into contradictions when trying to use a means that is different from the traditional ones, which also include the marketplace, money, and capital—all things they dislike.

I never saw much of Carl Andre after my acquisitions in the period from 1960 to 1970. In 1990, after the sale to the Guggenheim, I still had some money to complete the historical section, and his works were central for me. The new works were still of high quality. I asked him for an appointment to examine the possibility of buying something, and we met in a very high building near Washington Square inhabited by intellectuals who worked at New York Uni-

versity. I think he lived on the twentieth floor, and there was an impressive view of downtown New York. We concluded nothing because his sculpture cost too much, far more than I could afford. We went to dinner together with his companion Ana Mendieta, a Cuban artist; their characters were completely different and there were deep tensions between the two of them, as is often the case when two artists live together and one is more successful than the other. However, I never would have imagined that their relationship would finish in such a tragic way, with Ana Mendieta's suicide.

RICHARD NONAS
NEW YORK, U.S.A., 1936–

Richard Nonas is the most radical of all the Minimalists I collected in the 'sixties and 'seventies.

In order to exist it is essential that a sculpture have three dimensions. Flat painting on a surface, in fact, must also have more than two dimensions. The paint must have its thickness, however shallow and almost invisible, because otherwise it couldn't be seen, it would not exist. Mathematical theories about a supposedly two-dimensional world are nothing more than a theoretical fiction. If something is to exist physically it must have three dimensions. A large or small, thick or thin, volume must always exist for there to be a thing because otherwise there would only be an idea.

Our civilization and culture are for the most part two-dimensional. We are surrounded by printed matter that gives us an enormous amount of information. Since a few years back the computer has become a common item and its monitor shows us images that are even more two-dimensional; as soon as we press a key they disappear at once. And in this way our very existence seems to become virtual too, but all the same we clash with the existence of the three dimensions that do not disappear.

When I met Nonas in 1975 his means for making art was mainly a steel bar sheered off at both ends and placed diagonally at forty-five degrees. This was the only difference with respect to a similar bar fresh from the foundry. The greatest possible simplicity for any physically existing object, the final phase of reduction beyond which it is impossible to go.

It was this realization that fascinated me and aroused my interest in his work. To arrive at the starting point and the end of all things. Scientists are arduously and anxiously searching for the origin of everything, the algorithm with which the universe is constructed.

Nonas's sculptures were not just a physical but also a philosophical verification. Kant's *Critique of Pure Reason* applied to everything: in place of the pri-

mary forms of thought, the primary forms of reality. Beyond this there is only the noumenon, the unknown, what cannot be described. This is the final point of visibility. Nonas's steel rod, what we call material, is the last visible, but not invisible, point. Scientists, with the right instruments, can in fact understand what is inside steel, and with an electronic eye they see the atoms that make it, and in this way start a process of reduction the end of which we do not know. But in any case it must be a substance that finally produces three dimensions: height, width, depth.

When I met Nonas he had only recently become an artist. Before he had been an anthropologist. He lived for long periods of time with the Indian tribes in Mexico, Arizona, and New Mexico, and among groups of hunters in the northwest of Canada. He lived with them because only in this way could he understand their character and their religion. He also saw the tragic consequences for these peoples when they came into contact with Western life. The enormous difference in productive capacity provokes a flight from reality in the form of drinking alcohol. I remember a description of a place where the Indians performed their ritual dances: simply a platform that aroused intense fascination in the artist. It was an extremely simple form with a magic power, as though the religious rites had conferred a different nature on him.

Nonas has transferred this anthropological search for the primordial nature of human beings into his sculptures.

JENE HIGHSTEIN
BALTIMORE, U.S.A., 1942−

I don't remember exactly when I met Jene Highstein. Perhaps it was when I went to see Nonas's studio, since they worked in the same building, a large loft full of materials and works in progress. This was downtown on a road running perpendicular to the river.

The impression his works gave me was of mass. This is the most brutal but also most potent expression of something that exists and that existed before all other things: it is like seeing their origins. It is a leap back into the past, a remote, unknowable, omnipotent past. Nothing can exist unless it has mass however small it might be. Even the mysterious neutrinos, which come from the depths of the universe, and pass through our body and the earth without any kind of resistance due to their smallness and lack of an electrical charge, have recently had their existence verified by complicated and enormous equipment. Every thing has mass. Only our awareness of existing, our will, thoughts, and beauty do not have mass, but they have need of mass to demonstrate their presence.

Highstein's interests are in some ways similar to those of Serra: both show the primordial forces that dominate nature, which for Serra is gravity, the force that holds all things together, and for Highstein is mass, the existence of all things.

These basic forces have never been represented in the history of Western art. We have to go back to the ancient Egyptians who some four thousand years ago constructed the pyramids and, above all, the obelisks weighing hundreds of tons that point to heaven's zenith from which all things come. What is the reason for this ignorance? Perhaps because we have had a mediator between us and everything. The Egyptians instead searched for it directly.

Highstein's tumuli, finished in cement covered with black paint similar to ink that penetrates the surface, are the works that express most strongly his research into mass. The first of his works I saw and collected was shown in the Salvatore Ala Gallery in Milan in 1974. The biggest and most impressive tumulus, *Human Scale Black*, 1975, was exhibited in 2000 in the Panza Collection show at the Guggenheim Museum designed by Frank Gehry in Bilbao. The room was huge, and rose two stories in height. The work had a maximum height of two meters (7 ft.), occupied the whole room, and could be viewed from above. It really was impressive. When you looked at it closely an unexpected thing occurred: the black, opaque surface absorbing the light diminished the volume. Instead of fullness you saw a void. In fact, when searching for the origin of everything we discover that we do not know what creates mass: perhaps it is only energy, but it is not a material entity, it is not matter, it is an enormous quantity of immobilized energy.

Highstein's work is also created in other forms and from other materials. An example of this diversity is the work in the Villa Panza in Biumo, *Untitled*, 1974, which I have given to the Guggenheim but that is, for the time being, on deposit with FAI. It is a heavy pipe, one of those used for carrying gasoline and methane gas and where the material has to flow in large quantities. It is placed in a room twelve meters long by four (39 x 13 ft.), just above a man's height. The room has no windows, and you see the mass of the pipe running along the length of the space; it is only suspended at the ends and could even fall and kill someone. If you look at it from the far wall, the impression it gives is dynamic rather than aggressive. It is a force that passes through walls. It comes from far off and goes far. I recently saw a show by Highstein in a New York gallery. On show were granite column-shaped works with spiral reliefs that rose up along the circumference. They had the same force and quality as the works I had collected thirty years ago, an evident confirmation of the artist's quality. He is well-known and highly esteemed, but not to the extent that he really merits. We live in a society that values appearances and not

substance. One day, of course, the truth will be recognized. When? We don't know, perhaps many years will have to pass. Knowing we have made the right choices, though, allows us to wait in peace.

In 1977 we traveled together to Tenerè in the Sahara Desert, a place where it rains once every five years. A real desert. He loves the emptiness also loved by my wife and me. A void that is full. The presence of Creation and the Creator. Highstein was searching for a great mass of black stone at least two meters in diameter. He didn't find one because, though there were circular blocks of black lava stone, they were not homogenous. He wanted to make a black sphere from a single block, a real mass. I believe that some years later he found a solution by using Swiss black granite; I've only seen the work in a photograph exhibited in the Ace Gallery in Los Angeles, the gallery directed by the courageous and competent Douglas Chrismas whom I've known since the 'seventies. He has put on shows of huge, and therefore virtually unsalable, works by the best artists. These are the kind of shows that museums should put on but do so only rarely. This is his great merit.

Conceptualism is another conquest by American culture from the end of the 'sixties. But its precursor was Marcel Duchamp, a European, born in France in 1887 but who lived almost always in America. Strangely he did not work in Paris in the 'twenties and 'thirties when it was the capital of culture. He discovered that young America, which, between the two wars, had a provincial culture in comparison with that of Europe, had a more favorable cultural climate for him, one more in line with an evolutionary situation. He felt that young America, the daughter of old Europe, had the energy that was the indispensable condition for a different future. It was the convergence point for the major European potentialities, a place where they could more easily become a reality.

MARCEL DUCHAMP
BLAINVILLE, FRANCE, 1887-
NEULLY-SUR-SEINE, FRANCE, 1968

Duchamp's art was a revolution. Here was the possibility of creating art without making it. Every moment of awareness of life is art. All manifestations of life are art. There are no limits to calling the most various manifestations art. This idea gave rise to his ready-mades, works created by putting together objects of daily use that are no longer utilized and have lost their purpose. As they are useless they can now serve another purpose.

Thought is the most complete manifestation of life. It is its highest form. The greatest art is created by thought. When thought uses objects that have been thrown away it can transform them into art. This change happens when two different things are united. A union that works against the possibility of use causes a surprised reaction and stimulates the wish to give an explanation of a contradictory situation. It is the contradictions of life that have forced man to think. Our brain developed as a result of this. It is a senseless act to stick a bicycle fork with its wheel into a bathroom stool. It is a gesture that needs an explanation. The wheel turns, moves, and is a symbol of life, the fork bearing the wheel and stuck in the stool is a symbol of the procreation that transmits life.

I was fortunate enough to meet Duchamp many times in New York and Milan. My first meeting was in New York, and I was with Rauschenberg who considered him his "master." I seem to remember he lived near Washington Square, and from the windows of his studio you could see the trees in a park; it was fall and the leaves were yellow. Duchamp was sitting in a high-backed

armchair sculpted with art nouveau figures. The chair seemed a throne, but the conversation was very amiable and "straightforward" as they say. He didn't condescend in any way and did not think he was one of the most important people of the twentieth century. This, I believe, was in 1961 or 1962, and his fame was limited to art specialists. The many books about him were written later, because he certainly wasn't well known then. I also remember seeing a photo of Max Ernst sitting in the same armchair. There were paintings by Matisse in his house, which I think belonged to his wife.

The conversation was very pleasant, but his replies to questions about his work were very evasive. In fact you must never ask an artist what he does and what his art means. The viewer must understand for himself since the artist expresses himself fully in what he does.

During a visit by him to Milan I stupidly asked him what was his preferred means for expressing himself. He answered that his aim was to create art without a paintbrush. This principle was adopted by the Minimalists and the Conceptualists.

Duchamp often came to Italy in the 'sixties accompanied by Arturo Schwarz, with whom he was working on a monumental catalog. I still have photos taken together with the artist in a restaurant on the Naviglio. Duchamp came to the Villa in Biumo together with Schwarz, and at the time there were also Rothko, Kline, and, above all, Rauschenberg, his disciple. I could not go with him as I was held up in Milan by work, and he was met by my wife who had not understood that this was one of the most important people of the century. She was kind toward him, as she is with everyone she meets. When she found out who he was she was extremely annoyed with me because I had not told her.

And this morning I made a great discovery: I had forgotten that Duchamp had written a dedication in Robert Leibel's book on Duchamp's art: *Pour Joseph Panza grand inventeur, pour sa passion de nombreux beaux tableaux, Marcel Duchamp 1962*. It is in his mother tongue, which we always spoke.

Thought is the very substance of art, its manifestations are not direct, obvious, and immediate. It hides behind metaphor, saying something that resembles something else that cannot be defined with adequate words and far less with a logical argument. You can only prowl around the subject and describe an aspect that, however, is never "It."

This way of conceiving art is not philosophy but uses the conclusions of philosophy with the aim of a logical development. This is an intensely emotional act because it is dialoguing with existence. And this way of conceiving art is one of the basic elements of Conceptualism, and Duchamp's influence was fundamental.

Another important factor was the philosophy of Ludwig Wittgenstein and his analysis of language, its capacity or incapacity to describe reality. Definitions of things created by our mind are always metaphors, elaborated by logic that uses symbols that, anyway, cannot give complete knowledge about the thing described but only an approximation.

We live in a virtual world, a world of ideas. But this is the only way we have of possessing things, or at least many of them. There is an insuperable division, but it is also our advantage not to be a thing among other things. If knowledge is virtual, reality is not virtual, and it acts in a determining manner on us, an inseparable mixture of body and soul.

Minimal art began in 1963 and Conceptualism in 1968: a few years difference and enough to establish a relationship between the two movements. Minimalism showed the way. Minimalist sculpture is not made by the artist's hands and is realized in a workshop following a project, which is the original work: it is the idea that is the work. Here we enter the world of concepts, and this was the urgent and necessary reason for later developments.

JOSEPH KOSUTH
TOLEDO, OHIO, U.S.A., 1945–

This is an artist who already in 1965 had studied the relationship between meaning, its representation, and communication. For him the way to demonstrate the difference between the object, its definition, and the image consists in showing the viewer these three phases of knowledge. Visualizing this operation becomes the work of art. The definition of a clock is often used when giving an example of Kosuth's work: *One and Five (Clock)*, 1965. The work consists of using a real clock, its definition from the relevant paragraph in a dictionary, and a photo of the clock corresponding to the idea we have in our memory: this is the process for describing a clock completely.

We remember things through images elaborated by our memory; these are the idea of a clock, not what we see. The reproduction of the text from the dictionary is the definition held to be most exact for identifying the thing described. From a comparison between the definition and the object it becomes evident that the definition uses other definitions that are never an exact description but only symbols that add together to other symbols, and being in agreement are true, but true only by approximation. We know exactly what the word clock means, but this has little to do with the mechanism measuring time. The dictionary definition that says it is an instrument for measuring time is precise, but generic: these mechanisms can be extremely diverse. From a physical point of view it is not real. This is so with all human knowledge: it has

the great power of transforming an abstract and generic idea into a real object, and a real object into an idea. This passage from the ideal to the real is possible insofar as the laws of logic are common both to our mind and to the physical world outside us. This is the problem of phenomenology: if only what our mind knows is true, how can what lies outside our mind be true? It is a problem that we resolve in every moment of our life but yet one that philosophers do not find a solution to when they think about it. This is what Kosuth explains to us by putting us in front of the definition of language and the object, mental knowledge and reality. Two different, radically different, worlds. The crisis began when mankind began to believe only in himself, when his own conscience became the center of the world, when his descent from and attachment to the Father was forgotten.

I came to know Kosuth many years ago, in 1968, when, I believe, he was twenty-four years old. He was amazed that someone could be interested in his work and buy many of them. I think that the money I spent in a short time allowed him to journey to Italy and buy a house for the summer in Spoleto. The gallery owner from Bari, Marilena Bonomo, also had a house there. She was interested in Conceptual artists and showed his works.

SETH SIEGELAUB
1941-

The first time I saw Conceptual Art was in 1968 in the home of Siegelaub, who had set apart some rooms to be used as an exhibition gallery and who was showing works on paper by the Conceptualists Sol LeWitt, Douglas Huebler, Lawrence Weiner, Robert Barry, and Kosuth. It was a show of words that offered little visual satisfaction but was, on the other hand, extremely stimulating culturally.

This was in complete contrast to the works I had bought a short time before: the great sculptures by Judd, the heavy iron and lead works by Serra. At Siegelaub's you saw only ideas, words written on paper, so I had traveled from the physical to the negation of physicality. He was the first to understand the revolutionary importance of communications and how they would have an impact on everyday life: we are increasingly immersed in symbolic messages. The world of information has been exploding in recent years and we pass much of the day saturated in a virtual world. With the monitor screen we can do almost anything and be everywhere at the touch of the mouse, but this is always virtual, never concrete and physical.

I have lost sight of Siegelaub and don't know what he is doing or where he is; many years back he said he was gathering together documentation about

protests. In the 'sixties this was an up-to-date concern, but by the end of the century it is something we have almost forgotten, although we can see the consequences. The way of life of the new generations has changed, and this change occurred after 1968, though it began in America in 1964 with the Vietnam war.

More recently Siegelaub offered me his collection of Conceptual art, which he wanted to sell, and I would have bought it had I more money. On the other hand I already had many works by the same artists, and there really was no need to have even more.

LAWRENCE WEINER
NEW YORK, U.S.A., 1940–

Weiner only uses words in his art. But his is the reverse of a work of literature: there is no discourse since the words are not placed one after the other to express an idea in a logical form. Nor even in a metaphorical form as with poetry. They are words and nothing more.

The word in itself calls to mind the many various meanings it has. We believe that the word means only the thing we are thinking of in that moment. If we open a dictionary we can see how many meanings it can have and that change according to the context it is in. When it is freed from the bonds of a discourse it gains complete freedom. Whoever sees it can decide which context to place it in. It becomes an instrument with possibilities because it has lost its exact function. Weiner uses it to compose small phrases without any precise meaning and without a literary function. He does not turn them into tiny poems such as Ungaretti's famous "I am illuminated with immensity." Typical is the phrase "The Joining of France Germany and Switzerland by Rope," 1969, which was written or invented in Basle where it might well be possible to join the three countries with a rope, because there exists a geographical point where this could occur. Obviously the value of that phrase does not end once we have ascertained this, because it also conjures up the idea of the different cultures that form Europe and also of the wars between neighboring states. It would be enough for an art like this to be printed on the pages of a book to make it known, but it is different when we read it on a wall where, if it is shown in the right way, it is an effective situation for reflecting on its meaning. It is an invitation to seeing any kind of art for what lies behind it, for searching the idea that brought it into existence. The real way for experiencing it.

Weiner is a very likable man: tall, thin, with a big beard. In the 'seventies he often came to Europe where he lived on a barge in the port of Amsterdam.

When we happen to meet we greet each other with great cordiality. He is an artist who has faced up to the rejection of intellectual art after 1975, a cri-

sis caused by the collapse of political utopias and the increased interest in the concrete, the real, and the social, all of which were its exact opposite. There is no reality without what precedes it: thought.

I remember a dinner with Weiner in an Italian restaurant in New York. He wrote a work on a menu that I have kept with great care in my archives. It was certainly the most easily available piece of art: it wasn't even necessary to go into a studio or gallery to see it.

ROMAN OPALKA
ABBEVILLE, FRANCE, 1931–

I discovered Opalka's work in 1973 when my interest in Conceptual Art was very strong. Since the beginning of the 'sixties he has always been doing the same work, *1965/1-∞*, a progressive list of numbers in gray on a gray background. The color becomes paler as the ink runs out. He then dips his pen in the ink and continues the sequence of numbers—for all his life. My picture *Détail 460.260–484.052*, 1965, has the initial number 460,260 and the last is 484,052.

Even today he continues to paint his series of numbers. I don't know what number he has arrived at, but it must be very high if forty years ago it was 484,052. Each work is supplied with a photograph of the artist's face taken during the execution of the work. This is the documentation of an existence. There are millions and millions of existences, and few will be remembered by those who come after us. There are many roads named after people we don't even know who they were.

Perhaps Opalka will not disappear into the shadows of the past. Art has a great force for survival.

I had reserved another two pictures by him that I wished to buy, but his dealer, and I've no idea why, only delivered one to me; it didn't cost very much so perhaps someone else had offered more.

ROBERT BARRY
NEW YORK, U.S.A., 1936–

Barry is an artist who attempts to define the unknown, obviously an impossible task, but useful all the same. The attempt greatly extends the limits of what is indefinite and shows how we are surrounded on every side by something we do not know.

This is not a metaphysical answer to the limits of knowledge but it is useful for defining its confines. We love science because it gives us knowledge that is real, or at least it seems to be, though we don't know if it really is or if it is

only an approximation. It can be very useful when applied to industry, and this is more than enough: it is the proof of a tendency toward a truth even if not to the truth. Barry's unknown is different from what we can eventually know when we have more information. It is a question of primary entities that are quite distinct from physical reality and that no new information can explain. These are ideal and primordial entities that precede everything. They are words detached from discourse and arouse in the mind generic ideas without a specific character. Often they contradict each other. In this way they underline the impossibility of defining what they would like to define.

The use of words and discourse gives us the impression of effectively representing reality: description and existence become one, but this is only an approximation.

Literature consists of words, as also do newspapers and all the information we receive. Robert Barry dematerializes them.

They do not become part of a discourse that would give them unity, they are deprived of a body, their function ends, they can represent a great many things but none at the same time. Our knowledge is stimulated by many and various visions of reality, all possible but suspended in a void. When we become aware of this fact the indefinite becomes an invisible, ungraspable but powerful reality.

Barry's work has various manifestations, always employing words, with brief phrases and individual words projected on a white wall. He projects drawings with words written in a circle onto a colored background. In this way a Conceptual work has a strong visual presence.

DOUGLAS HUEBLER
ANN ARBOR, MICHIGAN, U.S.A., 1924–
TRURO, MASSACHUSETTS, U.S.A., 1997

My house in Milan is quite near to where I was born, where I went to junior and high school and where my father had his office. The roads and houses of these places have not changed much in eighty years despite the destruction of war and redevelopment. When I go back on Sunday afternoons they are almost the same as when I was a child and adolescent with my marvelous rediscovery of the world and my youthful anxieties. My world and that of my parents and all those who were adults when I was young: all gone without leaving visible signs. The walls of the houses are still gray and regular. Today, just like then, the roads are thronged with people going to the office, doing the shopping, going to work in order to earn a living, and sometimes just walking around for pleasure. Probably there is no trace of these individual actions.

Huebler tries to remove these facts, which represent a large part of our existence, from the destruction of time. Our actions are always aimed at realizing a program, however unimportant. His works record actions that we undertake and that then disappear, even though they were intended for something.

To underline the intention of our actions, the conceptual element that directs all our behavior, is the scope of all his work. An example is a work from 1969, *Location Piece n.6*, describing a journey he made to Los Angeles with other people. Each day a spontaneous choice was made of a place where he would put a white label that was photographed together with its setting. The photographs all together constitute the work. The outcome of programmed actions, the trip to Los Angeles, and the casual choice of the place to be remembered through a photograph is a way of preserving the memory of an action that would otherwise be forgotten. A program conceived mentally and the reality of being there has, when judged by someone who did not take part, no meaning. The apparent difficulty lies in understanding the behavior.

He came to Varese in 1972 to see how his work was shown. Back in Milan we went to dine in the Riccione Restaurant, which was famous for its excellent seafood. This was the last time I saw him. In order to make a living he had to teach in colleges far from New York, and so it was difficult to meet up. Some time ago I received a letter in which he made his farewell to his friends. He had a terminal illness. I answered at once that I would take care of his works and would have them displayed in a museum. Shortly thereafter arrived the news of his death.

So many useless things, superfluous to our life, can become important and final things. The common and repeated actions of every day can become, suddenly and unexpectedly, singular. Huebler's work was not useless when it recorded what happens to us daily.

SOL LeWITT

HARTFORD, CONNECTICUT, U.S.A., 1928–
NEW YORK CITY, U.S.A., 2007

The bringing to fruition of a project is the basic element of his drawings and murals. Every detail is the visualization of the same idea. The plan, the intention, determines the form. This is also the way in which every intelligent being actually behaves. For Sol LeWitt, aims do not exist, only the plan that evolves, rather than in time, in two or three dimensions, and becomes wholly and immediately visible. The aim of the work is its manifestation, which becomes a value in itself, a pure product of the intelligence, without any emotional or romantic ends. Its beauty consists only in showing the capacities of

intelligence, and for this reason we perceive great—the greatest—beauty. When we look at the tiny flowers and blades of grass in a field we see the manifestation of an infinity of programs linked between themselves. This intricate system creates beauty freed from any kind of use or meaning. Different yet in a way similar is the beauty of a bridge, a mass suspended in emptiness defying the laws of gravity. A work made possible by a system that uses knowledge of materials, the tensions and pressures of forces, something that, being an elaboration of intelligence, becomes a work of art. This quality is more evident in his mural works since the two dimensions permit a greater freedom of invention: in the sculpture the physicality of the material becomes an obstacle.

In the drawings of the 'sixties and 'seventies the line drawn by the black or colored pencil freed the artist's imagination from all limitations, and he could develop a quantity of ideas without end. A phrase of just a few words is enough to define the plan to be carried out on the wall surface, even a very large one. Only rarely does the artist himself execute the project. This is done by good draftsmen who carry out his instructions exactly. The quality of the result is contained in the quality of its definition. For this reason the work is not bound to any specific place, and the first realization is not the definitive one. It might be the first of many. It can be wiped out and remade elsewhere according to need, as long as the new space has the necessary measurements. This is the freedom and force of ideas. We live in a society where most repetitive actions are carried out by electronically transmitted programs. The works by Sol LeWitt and by all Conceptual artists, at the end of the 'sixties, anticipated a technology that is now creating a revolution in methods of production and of living. I believe I was one of his first collectors and the one with the most works. I remember LeWitt's first work in the large stable in Biumo, *Wall Drawing n.146,* 1972.

I remember that it was long ago, in 1974, that I offered various walls of my house for the drawing, one of the many I had bought, but he said no as he wanted the large wall of the stable: five meters (16 ft.) high, twenty meters (66 ft.) long, plus the side at the end, which was another ten meters (33 ft.), and offering a really imposing possibility. Sol made this huge work by himself, helped by our gardener, the great Angioletto Soldati. Unfortunately there were a few errors, and so his assistants came and remade them perfectly.

CIONI CARPI
MILAN, ITALY, 1923–

I was introduced to Cioni Carpi by a friend of mine many years ago at the end of the war. We were both veterans of internment in Switzerland, a pleasant way of passing the war, though I had stayed in another part of the country. Cioni's father, Aldo Carpi, a well-known artist in Milan in the 'thirties, had for political reasons been put in an internment camp in Germany, and that was quite a different story. Cioni was a shy young man, sensitive and extremely cultured. Conversation with him was pleasant and interesting too. Afterward I only saw him a few times, and it was not until the 'seventies that I heard of his activities as an artist, concerned at the time with Conceptual and Minimalist interests. In this he was following a trait of his family, which tended to be involved in activities in which imagination, sensitivity, and expressive flair were basic. I bought various works of his, and he also generously gave me others. His creativity took various shapes and forms: sculpture, films, words. He had a great talent for mimicry and would move with harmony, expression, and naturalness.

He was married to a charming woman, Yve, who also took care of the necessary public relations for Cioni. His life as an artist was difficult and had its ups and downs; his income was low, and he was always in search of the indispensable minimum. This was the period in Milan when the economic boom had been followed by a period of calm when art was not much in request. I was also affected by the same sad situation.

His wife Yve became ill with cancer, and she died after many months of suffering, during which she was lovingly cared for by Cioni. I was away at the time of her funeral but I returned to Milan the following day. She had wanted to be cremated. I went to the main cemetery for a last farewell and saw the crematorium at the end of a wide tree-lined avenue: dense black smoke was coming from the chimney. It was a gray sunless day, as is often the case in Milan during the winter. The cemetery was almost deserted. In the black smoke pouring from the chimney I imagined I could see her poor remains turned into smoke and disappearing into the gray air. I went into the entrance hall where the doors of the crematory ovens were, but there was no one, neither friends nor relatives, so I had obviously mistaken the day or the time. The solitude and sense of death were terrible. She must have still been behind one of the doors. And yet I think it was better like this rather than being in a hermetically sealed casket in which the body would slowly disintegrate: far better to finish in smoke and give the one permanent thing we have, our atoms, back to nature.

After Yve's death Cioni decided to sell his few possessions and go back to the States, where he had previously lived for a few years. He stayed there just a short time; he had not found what he had hoped for in order to begin a new life. He came back to Milan, always a difficult city for art.

I have had very little news of him for a long time. He is still painting, though in a different way from before, creating a world of symbolic fantasies related in some way to his own father's art. I don't know if he exhibits his work, and I think he makes a living by translating from English, a language he knows very well.

I would very much like to see him again, but I have one worry: that of being blamed, however well disguised by nothing more than hints, for having abandoned him, for not having followed his art: a charge that sadly I think is true. When you are caught up in the world of art you tend to promote the artists you are currently collecting and not those you purchased forty years before. Those artists have found their path and go ahead on their own without need of help. There are also many who are not appreciated when they are at their best. They are left to one side and find themselves against the impenetrable wall of artistic insensitivity. People's indifference is the end. But a rebirth is always possible, even after a time so long that hope has been abandoned, even after the artist's death.

It is a great happiness to express your own thoughts and emotions completely freely and autonomously, and it doesn't much matter if others do not care. The pleasure of making the things we love is ours alone, and all the better if they can be useful to others. The artist's activity then takes on another dimension and has another responsibility. But this does not necessarily have to happen, the pleasure remains intact. Responsibility to art is a great one. We often forget the good or bad influence our choices, or even non-choices, can have as a result of our negligence or, even worse, of our superficiality in observing and judging.

Unfortunately there are many situations similar to that of Cioni Carpi; in fact they are the great majority, but, despite this, the unpredictable adventure of art is always highly attractive.

Like me, Cioni too is eighty-two years of age and by now his fate, like mine, is certain. Fate is a great and terrible thing. There is nothing more real. It is for the most part the great architect of our life. It is at work from the day we are born. And it is completely unpredictable. Only at eighty-two years old can we decipher it and see the strange coherence in the succession of events. Of course our will can ruin it or help it along; this is our freedom, another terrible thing. Fate can be good or less good, sad or painful. To accept or reject it depends entirely on our free will, and this represents freedom or death.

After Minimalism and Conceptualism the great novelty was my discovery of the art of Los Angeles, one consisting of light and space; immaterial entities but extremely striking and powerful. This was a high point in the evolution of modern art. The first time I came across it was in the Sonnabend Gallery in Paris with Larry Bell's cubes, and in the Pace Gallery in New York with Robert Irwin's discs. This was in 1968, and I had the great luck to meet Irwin and hear of his experiences at firsthand. I followed very closely the descriptions he gave about the activity of a group of artists, his friends, who were working in a similar way. This was a new world of experiences that were very close to my own ideas and sensibility. Other artists were giving a visible form to this possibility. The beauty of light is a reality that has always fascinated me, one of the marvels of nature.

LARRY BELL
CHICAGO, ILLINOIS, U.S.A., 1939–

I saw Bell's light-traversed crystal cubes for the first time in the Sonnabend Gallery in Paris. I was greatly impressed that he had found a way of imprisoning light. The supreme element in the universe and the most elusive: immaterial, bodiless, weightless, pure energy that comes from the interior of the stars, filling the skies day and night, reaching us from our own star, the sun. It gives us life because in its absence we would die at once of cold. The corn that feeds us grows as a result of its heat.

The cube is the simplest geometric form and contains all the others, it is an intellectual entity and exists in nature only in certain crystals in which the atoms group together to create the simplest form in the presence of pure elements without waste. The cubes, usually about forty centimeters (16 in.) each side, were placed on transparent plastic bases a meter and a half high, which increased the sensation of something halfway between the concrete and the unreal. Some of them threw shadows that filtered the light and created various effects. In the years following 1967–68 his work evolved into an environmental state. The cubes became large-scale crystal walls in the center of the room. The walls were partly transparent and partly mirroring.

The viewer became an active element in the work of art: the mirroring surface reflected the image of the person looking at it. It was a manifestation of the self, of the viewer's own physical presence that when it moved disappeared, leaving only the light visible among the faint reflections of the glass walls.

The sudden appearance of each person's image; when we face ourselves we have a different impression of our outside appearance, and this is almost always accompanied by a feeling of disappointment. This is the beginning of a process of self-criticism. Sadly we become aware of our deficiencies: of what we would have liked to have been like but are in fact not. For some this becomes the start of an examination of conscience, the search for our own errors so as not to repeat them and to better ourselves. There are many things we cannot change: like my nose, which seen up-close is too big, is not handsome; on the contrary it is ugly, though of course there are other things more important than an ugly nose. It is necessary to become aware of our defects and limits, for this makes us more humble, more ready to accept the defects of others; we live in an imperfect world in the midst of many imperfections. The wish for perfection is very strong. Perfection is happiness.

We can make two choices: rage against destiny and not accept it, or accept it in the hope of a better one. In the first case we become atheists, in the second we acquire faith in the ultimate goodness of existence. This is an eternal problem. We do not have what we would like to have and must accept what we can have by searching for the beauty of things that we have overlooked because we are used to seeing them.

So I urgently had to go to Los Angeles to discover the new art Irwin had described to me. This was a new world that could only be understood by experiencing it and having an encounter that was not simply mental but manifested through a relationship with a reality outside oneself.

My dream has always been to live in a situation that reproduced my wishes completely and in which the exterior was a continuation of my interior feelings; a situation in which the discrepancy between the beauty I desired and reality was abolished. This is why my house has always had such a great importance for me, so I could live in harmony with the things that surround me.

I had heard about the Land Art in the western deserts, where the earth, the sky, and the stars became one huge work of art. Here the artist had the possibility of appropriating nature in its totality because it was unpopulated and was where timeless phenomena, those that were the first and will be the last, become visible. These were places without the human presence.

Los Angeles lies at the end of the continent, where there is no land, where the ocean begins: the emptiness of the sea. It is far from Japan, another culture different from our own that developed autonomously, influenced by China and not the West.

In order to arrive in Los Angeles you have to cross the deserts of the Far West, traveling along the same roads followed with such great courage by the pioneers going to California some one hundred years back. The desert, for those who appreciate its fascination, is a particularly favored place that wafts your being up into another world, a world where life and death do not exist. This is the state that precedes all others. If our being consists of two elements, the mortal body and the soul with its different nature, in the desert a separation of the two seems possible. Just look at the earth, millions of years old, and at the limitless sky. This is a situation that does not die, and the possibility that our conscience is part of this eternity seems real.

Whoever experiences this cannot forget it.

Los Angeles is a growing city where everything changes and is on the move. Even the houses are not made to last; they are for the present; they are not fixtures as in Europe. Everybody uses the six-lane highways. It comes to mind automatically to ask the reason for all this movement. But even while asking the question, you too are on the move, so it seems to be an inevitable mutual destiny.

Another basic trait is the weather, a perpetual spring, a climate without seasons, always the same. The sequence of winter and summer, of heat and cold, ought to mark the passing of the months and years. Events are remembered

in relation to nature's periods. Where there is no rhythm of the seasons the past seems to be all the same. You lose the perception of its length and have the impression that the past shrinks, that you are living in a provisional world where certainties disappear.

One of the most important activities is entertainment: film, television, pop music, all produced for the moment, for a first or at most a second encounter, after which they no longer interest anybody. Something new and different then has to be offered. Products for a vast public without much critical sense. A medicine for the stressed millions of listeners, or a panacea for the boredom of those who do not know what to do. There are also many universities specializing in scientific research, in physics, biology. The journeys to the moon and genetic manipulation were initiated and studied here in California, as were the "star wars" during the years of the Cold War. Research is continually and rapidly expanding. After just a few years what once were important scientific discoveries seem distant and superceded by more recent ones.

In European cities there is a historic nucleus where the presence of the past can be seen, testified to by churches, patrician buildings, roads narrating a life experienced down through the centuries.

Los Angeles is on the coast of the Pacific, the great ocean separating the continents. Water should be an element that separates and impedes communications but, as it is without obstacles, even great distances can easily be covered. Japan's Buddhist culture has influenced those artists who were interested in it.

In the 'sixties there was a strong presence of Minimal and Conceptual Art, researches aimed at investigating the activities of thought and its visualization. This, something never previously attempted, was undertaken with a rigorous philosophical preparation and, therefore, had the possibility of arriving at precise results with a form that was exhaustive in its simplicity. All these conditions are necessary for understanding why Environmental Art, one based on the perception of light and space, began in this city before any other.

The starting point is the mobility of a rapidly changing situation, one without roots in the past that, with its brief duration, assists the future. Relationships between individuals are less easy because of the hours lost in car travel. The mobility of everything leads to a sense of a lack of identity; personality is watered-down in the flow of time, a time that is always the same and where the remote past is confused with the immediate past.

When you are in the middle of a situation in which everything changes, you feel more the need to find something stable, certain, and, therefore, true. More true than all the things that change and that for this reason are not truly true, they only have a temporary existence. In order to be true, truth can-

not change, it must always be identical to itself. If all we see and experience changes, where is truth to be found? Certainly not in the things we touch. We must search for it somewhere else; but there does not exist another place where it can exist physically, because everything that is physical changes, and it is an entity without weight or volume. It can only exist within ourselves, it is our awareness of being alive, it is the point where everything is born: this is the starting point of truth. Everything else follows after, in different forms. The moment of existence is the same for us all. The universe would not exist if we were not able to say: it exists.

It was the nearness of the desert and its powerful attraction for those searching for this starting point that suggested a solution. It is an immensity of light. Light is vision, it is knowledge. The individual's solitude becomes changed into participation in an entity that overcomes the division between life and death, time and permanence. We are placed within what is and what will continue to exist. So in what way could there be repeated such a radical and absolute experience in a room in the middle of a city where millions of people live and move? Strangely, the cinema techniques used by Hollywood studios suggested a solution.

Film, like all spectacle, consists of things that are not true but seem to be so. It is the illusion of truth in the place of truth. The one important thing is that the illusion is complete, that there is no suspicion that it is fiction.

The scenes in a film are shot in a studio even when they seem to take place in the open air. Continuous curved dioramas are used, and in this way a finite space can seem infinite; by changing the lighting the eye's ability to discriminate is lessened, and something nearby can seem to be distant. In Disneyland these systems for creating the illusion of spaces that do not exist are used in a highly efficient way.

The artists' aims were, of course, quite the reverse of the world of show business. They did not want to tell a story but to scrutinize themselves and look inside their own soul. See only their own life. The primal moment from which come all the episodes of our personal history: birth is the most important moment of our existence. In order to arrive at this point it is necessary to undertake an operation of depuration to eliminate the waste matter left by our passions and interests and find our self once more in all its untainted beauty. This is not a metaphysical idea beyond our possibilities. There is no need to be involved in a search with some kind of mystical aim. It is easy to accomplish by everybody. Only one condition is necessary: to forget oneself for a moment. To free the mind of all thought. This aim is common to all the artists of this group, though its implementation varies greatly according to the personality of each one.

ROBERT IRWIN
LONG BEACH, CALIFORNIA, U.S.A., 1928–

The first artist from the Environmental Art group that I came to know was Robert Irwin whom I met at the Pace Gallery in New York in 1968 where he was showing his discs, some of the first works giving the illusion of a body suspended in a void. These inquiries into perception had been preceded by pictures with tiny colored points that at first sight seemed fairly chaotic: *Dot Painting (One of a Series of Ten, Each Unique)*, 1963-1965. But, if you looked at them for some time, the chaos slowly assumed a form and was transformed into a red circle standing out from a blue background. If you continued to look at a certain point the mass seemed to vibrate and move: from a static state everything changed into movement, a complete reversal of the previous situation.

The discs, on the other hand, gave quite a different impression, that of a mass that dissolved into infinite space where it lost its weight and volume, as in *Plastic Disc (One of a Series of 18, Each Unique)*, 1968-1969. The disc *Disc Colored Pale Gray Green Pink Violet*, 1966-1967, about 150 centimeters (59 inches) in diameter, was slightly convex like a section of a far larger sphere. It was painted in a very light neutral color and toward the edge it slowly became tinted with red and green, but it was difficult to distinguish between one color and another.

The granulose surface was fundamental, as it had to absorb the light and eliminate reflections. The points of color had to be so small as to be invisible to the naked eye. They were created with a special technique, so special in fact that when the work was damaged during a show in Bologna a famous restorer was unable to repair it, and it had to be sent back to the artist who remade it completely: to repair just one part would have made it different from the rest and always visible.

Illumination was another important characteristic. I should point out that the work was not hung against the wall but held by a back-support that kept it some fifty centimeters (20 in.) away from the wall. Four lights were placed at both sides of the work throwing four superimposed shadows of the disc onto the wall, giving the illusion of something far larger suspended in space. And the final result was precisely this, a mass without mass moving in the empty spaces of the universe. The apparition of an entity without a body, suspended between the real and the unreal, an entity with an indefinable origin, an impossible way of existing, but imaginable as an ideal.

This was a completely new effect undertaken for the first time, and made possible by close study of new technical possibilities.

For testing the best materials and techniques, Irwin had a lot of help from an expert who made prototypes for the aeronautical and space industries. They were

unique pieces and the first obviously had to be made by hand. This expert also helped out other artists when they had difficult problems to resolve. He helped Robert Therrien to oxidize correctly the metal surfaces of his sculptures.

Irwin was and is a thinker, a deep connoisseur of philosophical problems, and it is fascinating to talk to him about these problems: this is a rare ability among artists who are generally more intuitive than rational. Certainly, this capacity of his has allowed him to create a new art. It is a pleasure to listen to him and easy to follow the thread of what he says.

He was one of the protagonists of Oral Communication: the possibility of creating art by discussing fundamental philosophical problems with the public. Ian Wilson was doing the same thing at the same time. He was an ascetic figure engaged in the search for truth.

For Irwin this was a highly interesting activity and he devoted a great deal of his time to it. Universities would invite him to hold conversations with their students. This was a period in which the interest in research was intense, and many people wanted to discuss this because they used their mind and wanted to resolve problems. Today, the beginning of the new millennium, this interest is almost extinguished. Many people consider problems far too difficult. You just need to think of the present and the problems of every day, which are almost always financial.

Irwin's help in introducing me to other artists who worked in a similar way was very useful. Through him we met Doug Wheeler, Eric Orr, Maria Nordman, and James Turrell.

JAMES TURRELL
LOS ANGELES, CALIFORNIA, U.S.A., 1943-

We were invited by James Turrell to visit his house in Santa Monica, a suburb of Los Angeles near the ocean where the light is clearer. It was a completely different house from all the others. All white, without furniture except for a table, some chairs, and a bed to sleep on. There were no doors since the light had to flood through the rooms without any hindrance. Whoever entered had to be able to see everything. In fact the light was the real inhabitant of the house and people an encumbrance. We drank tea made from herbs gathered in the desert, which was a place the artist loved. He went there whenever he could in his airplane.

We discovered that he was an enthusiastic pilot and his inspiration came not from art but from being a pilot. He bought wrecked planes, restored them, and then sold them back to vintage plane collectors, of whom there were many in California. He was an expert in technology and mechanics and

restored the old planes with his own hands. He knew how to restart engines that had not worked for years by finding or making the missing parts. He had also reconstructed his house with his own hands, making a lot of use of plaster wallboard, a material easily found in the States and very easy to erect. His conversation was very interesting, and we spoke of art, planes, and the desert, which was his main love. Sunset was nearing. It was already late afternoon.

Turrell asked us to go into another room and sit down on some cushions. It was a square room lit from below by a neon tube hidden in a fissure between the floor and the wall. The ceiling was very high, and just below it was an opening through which we could see the sky. It was not a window, there was no way of shutting or opening it: the opening was a slender line in the wall as though a continuation of it. It faced west: the sunset began. The sky seemed painted over this continuation of the wall. It was a deep almost physical blue. After a few moments we realized it was emptiness, the infinite void of the sky. It was a continuous alternation of two opposites, the physical and the void.

The most striking experience, though, was to happen just afterward when the opening began to be tinged with the colors of the sunset. This really was an incredible vision and a series of emotions each more intense than the last. It was as though we were seeing the sunset for the first time. I have always loved the sunset when I stand still and watch until the last colors disappear and night falls. But it was something different in Turrell's room: I had never before realized that the colors of dusk had such a deep intensity. A simple idea had completely transformed a common experience. The idea was to illuminate the room from inside in order to reduce the degree of intensity and cut down the dazzle. The second idea was the form of the opening: it was no longer a widow and seemed a continuation of the wall.

The emotions were not yet done with, and they continued throughout the evening, after a frugal meal. We entered a darkened room and sat on comfortable chairs. The room was fairly big, in the corner of the house near a crossroads with traffic lights. At the end of the room were two walls with tiny apertures that could be opened. We were sitting looking in the opposite direction. After a few minutes the room became completely dark. After another few minutes, perhaps in order to get our eyes used to the lack of light, Turrell opened one of the holes in the wall behind us.

The room was filled with a fragile, cool, silvery light, like that of the moon, and it gave the same sensation of an unreal reality, the vision of a dream world in which it was pleasant to be immersed. After some more time in complete darkness another aperture was opened and the room was filled with an intense, blinding light; it was something triumphal, transparent, clear, strong. After a few seconds it suddenly disappeared and the previous inky darkness

returned. Then, after another interval, there was something new again: a green light that filled the room, then briefly yellow, and finally pink and then darkness again. Gorgeous colors, completely unexpected.

The last spectacle was like a fireworks show: lights that at first were tenuous suddenly became strong and filled the room with blinding light only to disappear just as suddenly. This whole show was a great discovery. Turrell was the king of light, which he controlled in a completely new way. I don't know anybody who in the past has done anything like this. Painters have tried to create the illusion of light with light and shadow. Leonardo was the first, and then the Impressionists with color. But no one before had used real light, that of the sun or of electricity.

All these different experiences were easily explained. The room was at the corner where there was a crossing with a traffic light: red, amber, green. The intense light was that of a waiting car with its headlights on; the moonlight was the cool light of a street lamp; the tenuous light that then increased was that of the cars passing in a hurry when the lights were green. My wife and I were extremely impressed. We just had to experience this emotion again in our home in Biumo.

There were some unused rooms above the stables. The tenants who had been living there had left as we intended to use the space for art. We were also fascinated by this aviator artist and by his flights over the desert, a place of unreal enchantment, his interest in technique and his ability to make things: an artist who also knew how to be a laborer, an intelligent laborer. He spoke about a specialized research that to us seemed utopian though extremely stimulating. He flew over the deserts of Arizona and New Mexico in search of extinct volcano craters, and when he had found one he would, from its center, be able to see the sky in a special way: like the window in his home but multiplied a thousand times. He had found a crater in Arizona that had the right characteristics, an almost perfectly circular form and an upraised rim that created a sharp separation between earth and sky. He wanted to show it to us, and we were more than ever interested in seeing it.

Turrell had a four-seater airplane. The invitation was difficult to resist and we accepted enthusiastically. Oh, but I forgot to mention an important detail: the journey had been organized by Helen Winkler who accompanied us. She was the assistant of Heiner Friedrich, a gallery owner from Cologne who had moved to New York and from whom I had bought a lot of art: Ryman, Flavin, Judd, and Morris. She was a kind, intelligent, and able person. Helen organized all our appointments, something that I disliked doing.

While waiting to leave on the trip with Turrell I was able to visit other artists, and we saw the studios of Irwin and Wheeler, but at the time there were

no finished works available. Wheeler was experimenting with a space with rounded corners. When there was uniform lighting the differences between top and bottom, left and right disappeared and the space became continuous, as though there were no end to it.

They all lived in Venice, a fairly run-down area. It had been given this name because there was a canal with some dilapidated buildings in a bad imitation of the real Venice. A regretful memory of distant Europe. Los Angeles is full of these nostalgic memories. There are many houses in the middle of luxuriant gardens with trees and tropical flowers, all imitations of English, Spanish co-lonial, Renaissance Florence, and French Louis XV styles, all badly done and in extremely bad taste. The few beautiful houses are in Old American style or else modern and planned by good architects, but there are very few of them. A journey to Italy can be misleading: you cannot repeat something that no lon-ger exists. But the memory and regret for old Europe are still strong.

In 1973 Los Angeles was still a flat city. They were still building the downtown area with the first skyscrapers: the city hall was the only vertical building. In the west toward Beverly Hills the Mormon tabernacle with its trumpet-blowing angel on top could be seen for miles around. Now the urban landscape is greatly changed.

Finally the day for the air trip with Turrell arrived. I had only occasionally traveled in a small aircraft. Its maneuverability was amazing, with its sudden veering upward and its tight circling around something we had to be shown. Turrell said it only needed seventy meters (230 ft.) to land at a very low speed, and so it was a very safe plane. Our first stop was Las Vegas Airport, a brief halt to take on gas. Even in the airport there were hundreds of slot machines that took loose change, but there was no time to play. But then I have never been attracted to gambling. In fact it was something I particularly disliked. I am not attracted by risk. When you gamble all the time you inevitably end up with heavy debts as the bank keeps hold of a large percentage. In life there are many risky situations to be undergone, and this is inevitable: I don't see the pleasure in adding another risk. A strange pleasure.

The journey continued to Overton, a small airport near the great Lake Mead reservoir, which resulted from the construction of a huge dam on the Colorado River.

The idea of the trip was not just to find out about Turrell's project, but also to see the Land Art of Michael Heizer and Walter De Maria. The morning af-ter, we got up before dawn to see *Double Negative* by Heizer at first light. We had to climb to the top of a mesa. These are strange geological forms caused by the rising of the seabed to two thousands meters (6,562 ft.) above sea level, the result of the continental shift westward. Over millions of years it had been

eroded at the sides and was left isolated. In Spanish *mesa* means a table and, in fact, it is quite flat on top where you walk on land that has remained almost intact for millions of years. This one is called the Mormon Mesa after the sect that has colonized many places in the West.

It was difficult to discover where *Double Negative* was: we couldn't see it. But walking along the edge of the mesa we suddenly came across it, almost under our feet. It was just what its name said it was: a negative, almost invisible, but a very imposing place once you had found it. There are two vertical trenches excavated by imposing scrapers, some ten meters wide (33 ft.), some hundred meters (328 ft.) long, and separated by a deep canyon about three hundred meters (984 ft.) wide. It might have seemed a wound inflicted on nature, but instead it was integrated with the landscape. There are many landslides along the edges of the mesa but this was different from the others because of its geometry. One of the characteristics of Land Art is just this integration with nature, and here this aim was perfectly achieved. This is an art that confronts man with the beauty and grandiosity of nature in a religious manner.

Another experience of a similar quality was the visit to Walter De Maria's *Testing Lightning Field*. This was a tryout for the final work, which was to be created in New Mexico in 1977 with the very generous financing of the De Menil family. *Testing Field* consisted of some ten stainless steel rods instead of four hundred for the definitive version. It was installed in the ranch belonging to the Tremaines, famous New York collectors, both of whom are now dead and their wonderful collection dispersed.

We were accompanied by the artist in person who drove a four-wheeled vehicle best adapted for travel in the desert.

To see these almost invisible steel rods reflecting the light was a great experience, a foretaste of the beauty of the final work, which I was to see some years later.

RODEN CRATER (ARIZONA, U.S.A.)

The most important event was to take place the day after. Once again we took Turrell's plane at Overton and, after having flown over the Grand Canyon and the Painted Desert, certainly among the most beautiful places in the world, he made some sharp turns that rather frightened us, so we could see from above the Roden Crater, which he had recently discovered to be the best place for creating his great dream: that of transforming the crater with just the slightest of alterations into a gigantic work of art. This was really a tremendous dream, at the very limits of the imaginable and, above all, of the possible. We landed at the airport in Flagstaff, a small town but also a tourist center with one of

the branches of the University of Arizona some forty miles away. We stayed in a comfortable motel, typical of the Far West, where we ate excellent steaks. The place is fairly high up, about two thousand meters (6,562 ft.), like a large part of the West. There was no desert. Flagstaff was surrounded by forests of conifers. The program was that the following day we would go to Roden Crater, which was no more than about an hour away. We assumed we ought to get up at dawn the next morning. But Turrell dawdled, and he took us on some interesting but unnecessary trips. There are some two hundred extinct volcanoes between Flagstaff and Roden Crater with many different forms. Only one is very big, a real mountain, but the others are all small, like the one Turrell had chosen.

Only in late afternoon did we finally start out for the crater, and when we arrived there the sun was already going down toward the horizon. To say that these places are among the most beautiful in the world might seem an exaggeration, but when you see them you have to admit that this is true. Light fills everything. It is clear and seems to transform things that become more evident, things are no longer things, they are another entity and seem to come from some other world that is not of this earth. This is the desert where only a thick kind of grass grows, which is the same color as the land. Your eye sees far off to the very limits of the horizon from which rise great white clouds, and over all, everywhere, is the sky.

To get to the Crater you had to go along dirt roads; it was a solitary mass in the middle of a plain, and I was struck by its regular form, almost a perfect cone.

We began the climb uphill, slipping on the volcanic sand: we would make two steps forward and one back. At last we arrived at the edge of the volcano where the crater began.

We could see a marvelous panorama: a distant range of mountains, and the colors of the Painted Desert were unreal. We went down into the crater toward the center, along a smooth declivity. Then the decisive moment came and we raised our heads and looked around. After some moments of uncertainty our attention was captured and we stood motionless, staring at unexpected and unthought-of things. The blue sky was no longer at an infinite distance above us. It seemed to descend to earth and the earth to rise toward the sky, as though the two were united. It was the almost perfect circle of the crater's edge that created this effect. A unique phenomenon, impossible to perceive in conditions other than these special ones.

Every so often great white clouds crossed the sky, pushed along by the wind. The white was changing into another color, and almost suddenly the sky filled with red. The clouds seemed enormous mountains floating in the air: red.

Meanwhile the clouds became yellow, gold, then violet, pink. For some minutes the sky was shot across with green rays. We were not in front of a window that, as in Turrell's house, allowed us to see marvelous colors; in the crater, instead, everything became color, the color was everything, the earth disappeared in the shade of dusk. At last we understood why Turrell had made us wait to see something unimaginable. Meanwhile the sunset came to an end. The colors became paler and disappeared, from blue the sky became violet, and from violet black. The first luminous stars appeared, ever more luminous, ever more numerous.

The black sky once more shone with light, and the lack of humidity cleared the night sky. There was no moon but we could walk and see what was in front of us. Stars were everywhere. There wasn't a part of the sky that was not full of them. The darkness disappeared, and there was a festival of light. The night was our friend, we had no fears; quite the contrary, our little self seemed to dilate in that luminous immensity and take on a new life: the eternal life of the universe. A life that certainly was not eternal but infinitely longer than one's own.

There came on me a new certainty. Death did not exist and it was possible to have a different destiny, a destiny of infinite beauty that cannot die. A hope had become a tangible proof.

After that visit it was almost a necessity to go back and see the volcano. The nature of the Far West is a strong attraction: deserted places, without life but with another kind of life that stands apart from time, the light that uncovers everything, distant mountains, unreachable places. To look down into the Grand Canyon, to enter a furrow excavated by a million years of erosion, a time dimension where our life is but a brief episode.

Turrell's plan for making the crater into a work of art would have cost millions of dollars, it was a marvelous utopia, a genuine utopia for someone who had no money. But it had the very rare characteristic of being an amazing aim. Sometimes the most beautiful and therefore the most useless things, like all really beautiful things, can become reality. These are the dreams of those who believe in the silent force of beauty, and sometimes those who work toward her ends win the prize. And without thinking of anything but beauty.

It was necessary to buy the land where the crater was as well as that surrounding it so as to avoid the risk of contamination. This was an enormous area, not a matter of square meters but of square kilometers. Land in the Far West costs little because there is no agriculture. There are only grazing lands for cattle, though just a few of them, but even if costs are low they still have to be multiplied by the great spaces involved. It would be necessary to per-

fect the edges of the crater: there was, for example, a hole at one side that would have to be filled, an enormous amount of volcanic ash would have to be shifted.

The most expensive thing would have been the construction of a pedestrian underpass to bring the visitors to the center of the crater where suddenly they would see an absolutely unique spectacle: the conjunction of earth and sky, our participation in an endless existence. Turrell wanted to add further underground rooms, invisible from outside, from which you could view other unusual celestial phenomena. The volcano would become an astronomical observatory, and with a further enormous increase in costs. The millions of dollars in costs continued to grow.

In America there are foundations devoted to nonprofit cultural activities. At least in this case this was certainly true, but it was another thing to convince those responsible to fork out such a sum for a single project. It was a hope but probably an impossible one.

This was in 1973, and now we are in 2003: the first part has been completed and the second will be ready in 2005. The volcano will be inaugurated at the end of the works. Evidently miracles can come about if we have the will to continue working to make them happen, without losing heart in front of what seem insurmountable difficulties. Thirty years of work and waiting are a lot, almost a lifetime, but tenacity is about to be rewarded. It is interesting to see how this all came about.

The first help came from the Dia Art Foundation, which donated a first sum for buying the land. This foundation was created by the De Menil family. The most important person for this was Dominique De Menil—an extraordinary person who did marvelous things for art and culture throughout her life: the Rothko chapel in Houston, the De Menil Museum by Renzo Piano in the same city, numerous donations of masterpieces of modern art to the Pompidou and other museums. The Dia Art Foundation was directed by the daughter Philippa and her husband, Heiner Friedrich, both deeply involved in promoting new art forms, Minimalism and Land Art. Their courage and vision have produced great historically important works. Besides the initial money for the Roden Crater they completely financed Walter De Maria's *Lightning Field* and gave a substantial sum for Judd's complex in Marfa in West Texas. Their headquarters are in New York on West Twenty-second Street in a large industrial building where they exhibit the collection and put on shows of high quality. The foundation is now directed by Michael Govan, a first-rate person with great capacities. The museum will be enlarged and conserved in another big industrial building given them in Beacon, about an hour's drive north from New York City.

Turrell has continued to work on the crater these past thirty years, investing his earnings in buying the surrounding land. Small savings in the early years, since he did not earn much from his activity as an artist but by restoring old planes that as a result of his technical abilities flew once again. Only recently has his art work been appreciated and paid for, as it merits.

Such an audacious and, therefore, expensive project could only be financed by a foundation with considerable funds, but there are many of these in America that invest in art. Many influential people in the art world were invited to see the crater and, of course, they were much impressed by the place and by the idea. The best publicity is always seeing and then making other people see that the proposals are better than the others. An advertising campaign for promoting a show or a museum costs a great deal, not less, I think, than 250,000 dollars if immediate results are wanted. If there is a lot of time available, many years, you can arrive at a result with international and worldwide publicity without spending anything, only by making the thing accessible to those who are interested and when the information is qualitatively different from the rest. This is what happened in the case of the Panza Collection: I have not spent a lira, but millions of people know of its existence, from California to Japan. Hundreds of articles have been written in newspapers and magazines.

Turrell has had to wait for thirty years, but at last the result has been accomplished. The first part of the project was realized with the help of the Lannan Foundation, the second part with that of another foundation, and everything will be available in 2006. A great monument to the artist, and it will be the biggest work of art ever constructed, second only to the pyramids if we consider them sculptures. Such a long wait is proportionate to the impressiveness of the result.

An artist who had no money has created a grandiose work. The magical power of beauty that is far greater than millions of dollars.

The vision of the sunset and then the star-filled night sky is a memory etched on my mind and that of my wife. This was the beginning of a commitment to help Turrell realize his dream, a dream that was not just his but that of many people, and for this reason it came about. This commitment of mine concluded in 1993 with the gift of 200,000 dollars for an architect to prepare the executive drawings of the overall project, in order to make an evaluation of possible costs and, therefore, to be able to ask a building firm to carry out the work. Until then the foundations interested in financing the project had not made any decisions, as it was too difficult to evaluate the costs. My donation was able to convince the Lannan Foundation to undertake the first part of the program. At last the dream could become a reality because it was now possible to define the financial limits of the initiative.

Without money you can do almost nothing. Even beauty needs gold to exist: if money can be spent for beauty, after having taken care of prime necessities, then this use will certainly be more important than all the others. Only the beauty we find within ourselves has no need of money. But we cannot live on that alone. I remember the numerous meetings in Los Angeles with Mr. Patrick Lannan, Jr., the president of the foundation, to discuss the feasibility and the quality of the project. The institution was already undertaking various cultural and social tasks: the publication of literary texts, the study of Indian languages, as well as the purchase of contemporary works of art.

TURRELL IN BIUMO

I do not remember if Turrell came to Biumo in the fall of 1973 or in the following spring. He stayed a long time, over a month, to plan a work that required some alterations of the house. The empty rooms on the first floor, over the stables, allowed a great deal of freedom. The three rooms at the end of the corridor were the best adapted. The wall at the end of the corridor was easily adapted. The window could be closed off by a wall and the lunette of the vault could be opened up and an iron lock be put in place that would not be seen when the work was functioning (*Sky Window I, Varese*, 1976). The most important change consisted of hiding the neon light behind the frame between the wall and the vault, which would modify the existing light. All the walls and vaults were carefully smoothed over with plaster in order to eliminate any surface irregularities that would have been very evident under the radiant neon lighting. All the walls were painted white. The corridor was orientated northwest, a good direction for seeing the colors of the sunset.

It was more complicated to install the opening in the room to give a vision of the sky from straight above (*Sky Space I, Varese*, 1976). A large square hole had to be made in the roof, each side some three meters long. After a struggle the opening was made. It was then made smaller by about fifty centimeters (20 in.) along each side by installing a sheet of copper painted white in order to create a sharp division between the surface of the ceiling and the sky. At the bottom, just above the floor, the neon light was hidden. The first idea was to leave the zenith opening open all the time, but unfortunately the climate in Varese is not that of southern California: it is damp and it snows in the winter. We saw at once that the walls were crumbling as a result of the humidity, so it really was essential to install a mobile metal roof that was drawn back completely when visitors entered the room. At midday the light is blinding, and it changes each hour: sunset is magical, the clouds cross the sky, each season is different. In the fall when there is a rare foggy day, the

atmosphere in the whole room is silent and filled with an "extraterrestrial" enchantment.

The third room consisted of a mixture of daylight and artificial lighting, fairly complicated to arrange (*Virga, Varese,* 1976). In this case it was necessary to make a hole in the roof in order to put in a skylight that was then hidden by a plaster ceiling with two openings at the extremities, so as to allow the daylight to enter and mix with the artificial light. We had planned a fourth room with two projectors hidden above the ceiling in the attic (*Projections: Afrum 1,* 1976 and *Argus,* 1976), which would have created strongly illuminated rectangular or square forms that would make the wall disappear. The outlines of these forms had to be perfect, without blurring. I don't know why but it wasn't possible to obtain the desired effect, even though we tried for years, changing the projectors, the lenses, and the exact focusing. Finally I decided to donate the two works to the Guggenheim and let others have a go at finding solutions to the problem, and this was certainly possible as I had seen other similar works by Turrell in museums where they worked perfectly.

So for one thing and another Turrell had various reasons for coming to Biumo for long periods. He also made use of his time drawing beautiful projects that made use of natural light: I bought some of them, and in 1992 I gave them to the Guggenheim in the hope that in its ambitious expansion plans there might be space for Environmental works, a hope that so far has only partly been fulfilled with temporary shows. His project for the chapel was particularly beautiful: *Light Space Chapel,* 1974. Your gaze ended up looking toward the light, the sky, the infinite. A really religious condition and one that has been rare in the Catholic church since the great commissions by the nobility stopped after the French Revolution and with the beginning of industrialization.

Turrell was a marvelous guest, and it was a pleasure to meet and pass time with him. He has a vast culture: from astronomy to science, psychology, and literature. We always had lots to talk about.

Turrell, like all artists, is very imaginative. He would stay in Biumo to the end of fall when the nights are long and the silence is profound throughout the empty villa. He said he had seen the ghost of the Marquis Menafoglio in his sumptuous eighteenth-century clothes; he did not arouse fear, but on the contrary, he had an affable and friendly look about him. He was the father, the founder of that wonderful creation, the villa itself. It was natural that he should make himself known. When I too walk around the rooms of his house or through his garden I often think about him, the creator of this gift. At times I imagine him as he walked through these rooms, experiencing it as I experience it now, certainly with the same feelings I myself experience. His house is different from what it was, not as regards the building itself, which

is mainly the same, but for what I and my wife have put inside it. Given that for some time now he is pure spirit he will doubtless understand what the new things mean; I am sure he loves them too. Deep down they are not too different from the things that were there then; their form had changed but not the substance.

MARIA NORDMAN
GÖRLITZ, SAXONY, GERMANY, 1943-

I do not remember exactly if it was in 1973 or the following year that we saw Maria Nordman's work. Her environment was exhibited in the University of California art gallery in Irvine, Orange County, an hour's ride to the south of Los Angeles. The county has this name because there were great orange groves that stretched to the horizon. The university gallery did a great deal of good work for contemporary art by showing the best emergent artists.

The room was to one side of the campus and overlooked a wood. You entered it from a corridor that became narrower toward the end, where there was a mirror that reflected part of the outside light into the interior (*Irvine Room*, 1973). The interior was divided into two equal parts, one half weakly illuminated and the other in complete darkness. The room had to be visited alone, and it was necessary to stay there for a long time. It was fascinating to see the difference between the faintly illuminated part and the complete blackness that seemed to be an infinite void. It was like being at the very edge of the universe: on the one side was life and on the other the end of all things. But strangely enough this sensation did not create a sense of fear. It was nothing but it was still something. Creation comes from nothingness; we do not see the creator since he is hidden in the void. By remaining a long time the eye became adjusted to the semi-darkness, and the contrast between light and darkness became even stronger.

Every so often the murmur of the trees outside would be heard in the room. The funnel-like shape of the corridor increased the sound. It was a way of feeling yourself near to something living, no longer lost in a limitless desert. My wife and I were greatly moved by this experience. We thought it might be possible to do something similar in our home in Biumo, perhaps in the coach house in Casa Litta where there would be enough space.

We asked Maria Nordman to come to Varese and make us a project. She finally came in 1975 and stayed for a long time in Biumo. The work was simple but needed a lot of care in making it. The two rays of light that entered the room were extremely slender with sharp, focused edges; there was little light, which had to be aimed to the left and right but not the center.

The room is preceded by two small hallways that are needed to prepare you for the semi-obscurity of the large room. Once you are inside you have to move toward the center of the wall between the two blades of light, with your back toward the garden, and then you wait to see what happens even though at first sight the room seems completely dark. Obviously this is not recommended if you suffer from claustrophobia or fear of the dark. A few minutes have to pass before you become used to the darkness. This is the most difficult moment: waiting to see. We are always impatient for a variety of things that we then forget at once. To wait in the dark is the most boring thing for someone who is not used to thinking, but for those who have this habit it is a welcome occasion rather than otherwise. Your thoughts can be concentrated on something important. Anyway, those who wait are not disappointed, as their reward soon arrives. The darkness lessens, something appears to the right and left, a weak light, an entity without limits, which becomes more luminous: there are no limits but the center becomes darker, an infinite void in which one is suspended. You are alone with yourself and your own consciousness. The question of who we are becomes urgent and it is necessary to find an answer. We become aware that our existence lies between two points that are unknown to us: our entry and exit from this world.

Unfortunately, since the property has been donated to FAI the work is not much visited due to operational problems. In a museum open to the public and where there are hundreds of visitors the work makes them wait too long, so there has to be a booking system with a guide to explain things before the visitors enter.

It took six months to complete the work. Nordman felt comfortable in Biumo so she was not in a hurry. The outcome was completely satisfactory.

In June of the same year the Venice Biennale opened, and Nordman was invited by Celant and the Architect Gregotti, the director, to create a room. The result was not as good as in Biumo. It was done in a hurry, as always happens at the Biennale: the walls were not straight either, so the effect was spoiled. Nevertheless, the 1976 Biennale was interesting, one of the best. Many American artists had been invited and Irwin too had made a work, but it could not be seen at the opening because of organizational problems.

Maria Nordman was born in East Germany, but since the war she has always lived in Los Angeles where her background was formed. She has worked for the Austrian-born architect Richard Neutra who designed houses that gave much importance to light and the relationship with the outside.

I have bought many works in the form of projects to be realized at a later time. Particularly beautiful was the one she created for the Toselli Gallery in Via Melzo, Milan (*Toselli Room*, 1974). The problem with her work is always the

lack of space and the difficulty of finding spaces similar to the original, which is always difficult to repeat.

I bought the project created for a room in a disused gas station, *Room With 1½ in Opening to Skylight, Pasadena*, 1972. The light entered through a thin fissure in the ceiling, and it was extremely atmospheric. If I am not mistaken, the walls were painted black. Another extremely beautiful work, though not mine, was recently exhibited, in the fall of 2000, at the Peggy Guggenheim Museum in Venice as part of the show *Venice-Venezia* in which the artists who took part had lived in the Venice suburb of Los Angeles between 1960 and 1970. This piece reworked an idea from 1968. It consists of a black wooden box in which only one person can stand. There is a weak light coming from the sides; you leave from the opposite side and suddenly you see the amazing sight of the lagoon between the Ducal Palace and the Salute. Maria Nordman is always adamant that she must decide when and where to construct a work. And this is only right since there are many contingent facts that must be taken into consideration and that influence the outcome. The sounds coming from outside are very important in her work as well as the daylight, which depends on the orientation of the space in relation to the sun. There is also the problem of the ease of access, which might be in either a public or a private space. These are all things that the artist must take into consideration as they crop up in what is anyway an unpredictable situation.

But not all her works are so dependent on a particular situation as not to be realizable in other places, as long as they have the right requisites, such as the size of the space and the direction of the daylight. I do not understand why a work cannot be replicated if the presence of the artist is not necessary. No one, least of all an artist, is eternal, and the more time passes, the probability of losing control of your own work increases exponentially: sooner or later this eventuality will come about.

One permanent installation exists in the Panza Collection in Biumo, but I don't know how many there are in the rest of the world. I don't believe this situation will change much in the future. For thirteen years the Minimalist and Environmental works have been consigned to the Guggenheim in the hope that their expansion programs will offer a solution, but until now, the result has been zero. Of course we live in hopes, though in the meantime I might well disappear, and this is true for the artist as well. If the work cannot be replicated then it will die, definitively and forever, together with the artist. After years since the original was built and dismantled, even the memory of it will be lost: a second death.

One of the few artists of this group who will certainly become part of history is Turrell, because he does not interfere in the reconstruction of his

works, even though in practice they are all made under his supervision or that of his assistants in order to be sure no mistakes are made.

Museums replicate the easiest works for their temporary exhibitions; the ones that cause problems are left aside in the hope of better days, though you never know when these might arrive.

Some thirty years have passed since I bought Los Angeles Environmental Art. This is a long enough time to verify if any permanent result has been arrived at. The conclusion is a sad one since only Turrell has been able to impose himself as the most important protagonist of what was a basic event in American culture in the second half of the twentieth century.

Irwin too has been recognized as an important protagonist, though the works he made prior to his environmental pieces are more appreciated. The environments run the same risks as those of Maria Nordman, because the limitations imposed make it virtually impossible for others to reconstruct them, limitations that are often completely illogical. The problem could be resolved by stating that supervision is necessary as long as the artist is capable of traveling.

I have spent time and money in order to create a collection of this art that might be as complete as possible. I think I have succeeded since I do not see any museums or collectors that have done anything similar to preserve an important record, but the actual outcome has been very modest, mostly as a result of the lack of cooperation by the artists. I will continue to try to resolve this problem, but it is not possible to make previsions since I am in my eighties and have had two heart attacks.

ERIC ORR
COVINGTON, KENTUCKY, U.S.A., 1939–
LOS ANGELES, CALIFORNIA, U.S.A., 1999

I do not remember if I met Eric Orr in 1973 or on my trip the following year. I remember, though, the first work by him I saw at the Cirrus Gallery in Los Angeles, which made a great impression on me. This was the room called *Zero Mass*, 1974. You entered through a narrow corridor that stopped light entering from outside. The room seemed completely dark. The instructions were to sit on the floor on a cushion that had to be groped around for as the darkness was complete. Then you waited for what seemed a very long time. At last the gloom began to lighten and a few shadows could be made out, but only shadows: nothing identifiable. I thought that after the shadows something might be seen, and I looked for my wife. All quite useless: the shadows stayed shadows and nothing else could be seen. I looked around trying to see if something was happening, and I felt a little uneasy.

By sheer chance I looked down at my hands and was surprised to see they had become shadows too. It was as though they no longer belonged to me. I was surrounded by a faint light that came from all directions. I could see no one else, I was alone. I was disturbed but not afraid. I had become a shadow. My body no longer existed. It was something that had lost its materiality. This was a strange impression that I had never felt before. I had entered the unreal world of spirits and only my conscience remained: the only immaterial entity that distinguishes us from all other things. Evidently Eric Orr believed in the existence of the soul and wanted to show us, by way of a metaphor, just how much this conviction of his was true.

I must use the past tense when speaking about him because sadly he died prematurely in 1996. When I think again of this and other works they seem a premonition of what was to happen so prematurely. It is interesting to discover how the room functioned. It was a room within a room, separated on every side by a hollow space of about a meter. The small room was made from thick white paper that covered the floor as well. On the side opposite the entrance was a fluorescent white light hung on the outside wall, partly hidden to make it less visible and to diffuse the light in all directions. A very simple thing, but then great inventions are always simple; the difficulty is thinking of them before the others. He was an artist involved in searching for the invisible. The things that we see and touch and of which we too are made are just a small part of reality. Small signs and large signs that we do not understand but that are a distant manifestation of a greater reality. He was also interested in hypnosis and invited me to take part in an experiment to no effect, though it did work for my son Giovanni.

Sadly he died before there was a possibility of exhibiting the numerous projects I had bought from him, except for *Zero Mass*, which has been reconstructed for various shows. I hope the situation gets better in the future. But as long as the Postmodern mentality, with its lack of ideals, controls the market and the thoughts of so many people, there are few hopes for any improvement.

I remember the house of a Los Angeles collector that Eric Orr had arranged by creating rooms that in themselves were works of art. The first was a completely sound-proofed space with an awning stretched over it to hide the soundproofing material. This caused a strange sensation as though the visitor had suddenly become deaf. The glass of the windows in another room had been modified to change the illumination. There was a continual alteration of the spaces and a resultant series of surprises and emotions. I visited this house over twenty years ago and don't know if it still exists. I do not even remember the name of the collector. But it was a marvelous experience. I would like to have a house like that.

DOUGLAS WHEELER

GLOBE, ARIZONA, U.S.A., 1939–

When I visited Wheeler's studio in 1973 there was not a single finished work. He was trying out a new idea: to give the impression of an endless space by rounding off all the corners of a room: not, to be honest, a new idea, and one that is widely used in the film industry. Try going to Disneyland and visit the attraction known as "Pirates of the Caribbean" where, from a train, you can see a series of rooms with attacks on the open seas, naval battles, endless jungles: all in what are really quite small rooms, but they seem huge as a result of this kind of technique.

I got to know Wheeler's work some years later in an unexpected place far from Los Angeles. Irwin insisted he was a very good artist and that it was important to follow his career. I finally met him in Milan in, I think, 1976 in a show at Salvatore Ala's who, at the time, was showing interesting works of American art. The work on show, *SA MI DW SM 2 75 Continuum Atmospheric Environment*, 1975, was one that simulated day, dusk, dawn, and day again in a slow but continual succession. It was a wonderful work, and the illusion of finding yourself in a white desert was perfect: the walls disappeared as a result of the rounded corners.

The work was repeated in "Temporary Contemporary," MoCA's "The First Show" in 1983. This was the time when the museum had begun to use a temporary space in a downtown industrial building. This building was perfect for showing works requiring large areas of space and had been refurbished by one of the most famous American architects, Frank O. Gehry. This work was recently replicated in the fall of 2000 in the Bilbao Museum, another large and beautiful building by Gehry, for a show devoted to the Panza Collection of Minimal, Conceptual, and Environmental Art from 1960 to 1970, all belonging to the Guggenheim Foundation.

For the exhibition in Bilbao I had proposed showing four other works representative of Wheeler's development, all using projects from the collection. The artist instead suggested using the same work previously shown and increasing its dimensions in order to make the most of the space available. The work was a great success with the public, but a chance was lost to discover another aspect of his work.

Wheeler is a typical example of how difficult it is for artists creating this kind of art to have a continuous exhibition activity as well as possibly earning a living from it. In fact for many years he had been involved with the movies, writing dialog for sci-fi films.

He is reserved and does not have the same determination as Turrell, who faces up to and overcomes difficulties, coming out tops after many years thanks to his tenacity.

Wheeler came to Italy, if I remember rightly, at the end of the 'seventies or the beginning of the 'eighties, and he was our guest in the house in Biumo. I let him use my car for trips to Tuscany. He visited the stables of the villa in Poggio a Caiano, a Renaissance masterpiece by Giuliano da Sangallo built for the great art patron Lorenzo il Magnifico, the famous Sire of Florence.

Negotiations were already underway with the Tuscan region for a long-term loan exhibition and eventual donation of works from the Panza Collection by Flavin, Nauman, Wheeler, and other artists. But as happened so often in that period it all came to nothing. Wheeler's proposals were very beautiful, but they were never used, something that saddened me greatly. The public lost a great experience in its life. Millions of dollars are spent for stupid things that will be forgotten in a few years' time because they are representative of a moment of uncertainty in our understanding of the Western way of life, and so a few thousand dollars are saved on works that might have made us love life.

In the 'sixties and 'seventies the art life in London was extremely interesting. The Lisson Gallery run by Nicholas Logsdail had a series of shows of extremely high quality with new English and American artists. I bought many works from him in that period. I often went to London with my wife, and they were always interesting trips. I collected five artists: Richard Long, Robert Law, Peter Joseph, Alan Charlton, and Hamish Fulton. These artists' way of making art is different from that of the Americans. English sensibility is more private, delicate, and intimate. The Americans are, in a certain sense, more overbearing and show their thoughts more energetically.

RICHARD LONG
BRISTOL, UNITED KINGDOM, 1945–

I came to know Long's work at the end of the 'sixties, not in London but in the contemporary art museum in Mönchengladbach, Germany, a city near Düsseldorf. This museum was directed by Dr. Johannes Cladders, a person of great sensitivity and competence, and he was one of the first to show the new American and European art of the period. The town council would not give him money to travel but he still understood what the most interesting things were before the others.

My first purchase was not in London but in Milan in, I believe, the gallery run by Mrs. Françoise Lambert. It was an excellent gallery that in the 'sixties and 'seventies had a first-class program with, above all, European artists. I bought many works. Milan at the time was receptive to art from abroad. Many American artists had their first European show in Milan rather than in Paris or London. This was a culturally interesting activity undertaken wholly by private galleries and backed by collectors looking for the new and the best. The gallery was at the beginning of Via Borgonuovo in the center of Milan.

Unlike most of his works, this one by Long was not made of stones but with small pine needles laid on the floor and filling part of the room *(Sculpture at Galerie Lambert,* 1969). It reminded me of tree-filled forests, of the life of nature, of leaves falling at the end of the season, of the cycle of life.

The beauty of Long's work consists in the relations they create with nature. Usually they are made from stones: the material that contains the history of our planet, the first elements that condensed and solidified, as old as the earth itself, probably some 4.5 billion years ago. We see stones as solids, but this is only the end of their long history. Probably they have undergone many transformations. Continental shift has forced them below the fiery shell of the earth's

crust where they dissolved in order to reemerge and solidify again. Richard Long places the life of nature before us. He extracts its final element. Its presence in an enclosed space allows us thoughts on its past.

When we are in the mountains or in a wood we have other impressions: grandeur, impressiveness, the connection of the parts to the whole. The artist spends a great deal of time in long excursions to places where nature is still uncontaminated and where there is no human presence. These are among the most beautiful places on earth and he experiences them by walking, spending the night in a sleeping bag under the stars, either alone or with Hamish Fulton. The impulse behind his work is his love for this marvelous reality. The circles of stones, the configurations of fragments of wood found along the river banks are a demonstration of his love for the places he visits. It is an act of homage to the great mother who created us and who gives us life. We think we dominate her but in this we are presumptuous. In reality we should not betray her generosity if we want our neighbors or our descendants to continue living. Long's travels to lonely places and his placing the proofs of this relationship in a room is like a religious ritual, an homage and an act of love toward the greatest entity that exists and that lets us live within its own life.

The British landscape with its wide green fields over rolling hills surrounded by imposing trees, seemingly laid out by a masterly architect, suggests a vision of unpolluted nature. In Scotland where there are many places where the human presence is almost absent, the sky is crossed by great white clouds that stand out against the silvery blue sky in the clear northern air. Another invitation to this vision of nature, our gorgeous and ever young mother.

I remember on a trip to Scotland my visit to the garden created by the artist Ian Hamilton Finlay where each detail was the result of a human action, but one that was concealed and seemed spontaneous. This was a continual homage to the goddess Nature. It was a religion venerating her beauty and bounty. My wife and I were accompanied by Richard De Marco, a tireless and enthusiastic activist for art and culture, which he considered the supreme human activity. He was the secular priest of a genuinely ecumenical message. In Britain gardening is not a hobby but something far more important: it is part of a rite for thinking of a greater entity that we see in the colors and forms of flowers.

ALAN CHARLTON
SHEFFIELD, UNITED KINGDOM, 1948–

Here is an artist who has abolished color. He only uses lighter or darker gray. There are innumerable differences between the two extremes as grays are always different. The pictures' forms observe the same principle of rigorous simplic-

ity. They are composed of linear forms, just straight lines, squares or, prevalently, rectangular forms often with holes, symmetrically squared. The surface might be furrowed with straight lines that form a cavity in the picture's depth. The depth is of some centimeters in order to give profundity to the furrows and holes.

This is the result of a rigorous Minimalist philosophy followed through with absolute exactitude and method. His pictures are always part of a series: equal but with variations. The straight lines are either long or short and can be combined with other lines to create an infinite quantity of surfaces. This is the proof that everything can be articulated endlessly. Infinity enters into the finite. Human imagination transforms the inert into something living and always new.

Each picture is, as I say, part of a series, and this is why they cannot be shown one at a time but in groups, where the evolution is visible. A series fills a room and is, therefore, an example of Environmental Art. The evolution of a series and, therefore, the way it can be placed in a room, makes it similar to architecture.

The relationship between the environment and the pictures themselves is very important. The relationships of the series must always be respected. Museum curators who show a single picture are making a mistake. And this mistake goes right back to when they bought a single picture instead of a complete series.

Alan Charlton is very reserved and a man of few words. I remember that at the opening of his shows in the distant 'seventies he was always seated, in silence, on an armchair while all around was the chatter and noise of people moving around. He seemed like an iceberg in the midst of the waves. He was very young and a silent presence. A Minimalist attitude, coherent with the forms of his work.

The many works I bought are all in the Guggenheim but only rarely are they shown. I do hope that interest in his work grows because he really merits it. We have to hope in another crisis, that of Postmodernism, which is anyway inevitable but still far off, despite the time that has passed by now.

PETER JOSEPH
LONDON, UNITED KINGDOM, 1929–

I got to know the work of Peter Joseph at the end of the second period of the collection. This, I seem to remember, was in either 1974 or 1975. Logsdail was his dealer. He is an artist who has had little luck. He has created beautiful pictures but in a reductive and radically abstract spirit just when the Postmodern figuration was becoming fashionable.

His work is important because it is only seemingly Minimalist. In reality his is a completely different interest: he is not concerned with essential forms or with painting with marks or researching into color. His is a research into light. Light becomes color, and color is light. His canvases are spread over with a pale tint, though this is never white. The picture is painted with a thin layer of paint that never shows the sign of the gestures of his brushstrokes. His is a neutral surface without forms. The only thing that distinguishes one picture from another is the nuances of the color on the surface; slightly bluish, delicately gray, at times perhaps rather ochre.

At the edge is a strip of the underlying color, but accentuated and creating a visible difference. This is the only compositional element in a picture that is otherwise without a form. These are surfaces that enter into a relationship with daylight that changes all the time, at every hour, every day. These continuous but slow changes constitute the beauty of the works. Time is necessary to understand these works. They must be seen at different times of day. You have to have patience, a virtue that is very rare nowadays when we want to see everything at once, with the result that we see nothing.

In fact there is absolutely nothing to see, just a pale, almost indefinable color. This might seem the total negation of painting. But instead, for those who have the necessary time and patience, a great discovery lies in wait. Just as the light of the sun completely changes what we see, with each moment the surface becomes clear, dark, it radiates light, and each time it hints at different feelings. Here is light's infinity, the origin of everything. The origin and creation of life. Before Peter Joseph no other painter had penetrated its essence, though they had almost touched it: Vermeer, Caravaggio, Leonardo, and the Impressionists.

The English climate is the best adapted to this kind of painting. It changes continually during the day: there is a little sun, a little rain. The sky is gray and then luminous.

Only the artists of Los Angeles at the end of the 'sixties and the beginning of the 'seventies had understood the problem, though in a completely different way, but still making light as a physical reality their own.

Peter Joseph lived in the suburbs of London where the houses begin to mix with the countryside with its pleasant low hills. My wife and I passed a whole afternoon at his home looking and looking again at the same pictures as the light changed. We bought many of them. I believe this day was something completely unusual for the artist. Very few collectors remained for hours looking at these works without becoming bored, and certainly they did not buy so many. A few days later Logsdail told us that the artist had had an epileptic attack after our visit. Perhaps an emotion due to a meeting different from the others he had had.

All of Peter Joseph's paintings have been in the Guggenheim for the past fifteen years. They have only been exhibited rarely, and once I looked at one with horror. A painting had been hung in a room with artificial lighting, the same throughout the day. A complete misunderstanding of the work. Well, these things happen even in the best museums.

ROBERT (BOB) LAW
BRENTFORD, MIDDLESEX, UNITED KINGDOM, 1934– UNITED KINGDOM, APRIL 2004

Another excellent English artist was Bob Law. We met him in London in, I think, 1974. Most of his paintings were painted in dark ink: blue, dark rust, or violet. A single color covered the whole surface. At times different inks mixed together. The canvas had a homogenous surface but seemed covered in a kind of fleece that had absorbed the ink. It gave the impression of having penetrated right inside. Everything was opaque: the light was completely absorbed and there were no reflections. These were very allusive paintings, severe but not sad. Here was a strange limitless night, two contradictory aspects since one should have excluded the other.

The sense of emptiness seemed to cohabit with tranquil serenity.

After these works he painted a series of white paintings all of the same size. This was the opposite of black, but it did not convey the same rich impression.

Bob Law lived on the outskirts of London in a small dignified house, like many in England. The first time I met him he had an arm in a plaster cast since he fallen over and broken it while coming out of a pub. I have not heard of him for many years. After the black paintings he began to make Minimalist sculptures, strange but interesting. I do not know where he is, or what he is doing now. I have not heard anything about shows of his. My sad impression is that he has disappeared.

With regret I have the idea that a good artist is disappearing into the enormous crowd of the forgotten. Of course this is the destiny of all living people, but it is sad to think this is so while he is still alive, and I hope it is not true. He too was a pioneer in his researches into color as an excusive and unique entity, strangely enough by doing the opposite: eliminating it.

HAMISH FULTON
LONDON, UNITED KINGDOM, 1946-

Fulton is an English artist who is also a friend of Richard Long, and in fact together they go on long excursions to lonely places in various continents where nature still rules and is uncontaminated by the human presence. It is terrible to realize that the human presence contaminates. It was not like this before the beginning of industrialization and the scientific discoveries that have caused the population explosion and the unchecked increase of house building with its resulting production of pollution.

Luckily there are vast virgin areas, deserts, mountains, and icy regions that are still intact. These are the regions Fulton investigates, on foot, taking photos or else making great plans for wall compositions, using words that represent certain qualities of the territory or line-drawing the outline of mountains.

A love of nature is a characteristic of the artists of this generation born in the first half of the 'forties: Long, Fulton, Turrell, Webster, Highstein, Heizer, and De Maria. A love that disappeared with the triumphant artists of the 'eighties and 'nineties.

Today pleasure is taken in the destruction of the self, in being dragged down into the vortex of one's vices as though by inevitable destiny. Any possibility of resurrection has been completely lost. The experience of happiness, and thus of escaping from passive inertia, has disappeared.

American Minimalist Art of the 'sixties and 'seventies is mainly typified by sculpture. This kind of expression has completely changed the way of making sculpture. Artists no longer sculpt with the hammer and chisel in order to create by subtraction, as Michelangelo said. No longer does the artist toil away at a piece of stone and make drawings on a piece of paper: it is all done for him in a factory. He looks at the finished work, and checks to see that the assistants have not made any mistakes in interpreting the project: this is what his toil now consists of.

Sculpture also had had need of a base to lift it off the floor. Minimalism abolished this. It stands on the ground like everything else. And here it is without being in any way privileged, very democratically. One thing differentiates it drastically from traditional sculpture: its size. As it is made in a factory and with materials already roughly prepared industrially, there is no limit to its form. It only needs aesthetic coherence.

Different from sculpture, Minimalist painting remains faithful to the limits of the canvas. It is painted by hand and is not made by others on behalf of the artist. The three people who have most interested me in this have been Robert Ryman, Brice Marden, and Robert Mangold.

A basic principle distinguishes this kind of painting from traditional painting: it is radically abstract. Form almost completely disappears. The radical research is a characteristic of all twentieth century art. This is a research that leads to new worlds previously forbidden as a result of intellectual prejudice. Radical abstraction has been transformed into a universe of new possibilities that previously could only be sensed under specific conditions. This is a process similar to that of scientific research. A hundred years ago no one knew about the existence of the atom; it was invisible to the eye, but our thought processes have discovered its nature by way of indirect proofs. New instruments have made it, not visible, but comprehensible. Probably we are at the center of two infinites, that of the stars and that of the infinitely small. Physicists and mathematicians are inquiring into the existence of strange particles that would be as big as atoms in comparison to the solar system, a smallness quite beyond our imagination.

Minimal painting has the same function: to open up the mind and sensitivity to a new dimension. This possibility was explored in the 'eighties and 'nineties by artists using color as their only expressive element.

ROBERT RYMAN
NASHVILLE, TENNESSEE, U.S.A., 1930–

Ryman is fundamental to twentieth-century art. His importance consists in having shown the relationship between the creative feeling that runs through the cells of our brain and the nervous system that transmits this impulse to the hand and makes it visible through the gesture of laying the paint on the picture surface. This is the moment in which the work of art begins to exist.

This is the first intervention and one that will condition everything that comes after. In this gesture the artist expresses his whole personality. It is like handwriting: the expert observer can pinpoint the character of the writer by looking at the way each letter is formed. Without being aware of it each of us tells our own story as we write. To an even greater extent the artist writes his story too when he begins to use his brush to paint. The evidence of his personality is directly related to the mark he leaves on the canvas. This is something we can all directly observe in a museum where there are paintings by great people. Titian made kinds of marks different from Giorgione or Lotto. In this way it is possible to identify the artist. From a detail we can see what he wanted to express, whether a dramatic story, fear, an uneasy mind, a contemplative condition, or the pleasure of life.

The mystery of creation becomes evident. Each moment of our existence is the implementation of this mystery: understanding how our conscience experiences life, how, by way of this impulse, something new is born that is not an imitation but the fullness of our life. How this reality within us is translated into something visible and communicable is the mystery we experience and that we make concrete through our brain and our hands. We can, in relation to this observation, study art history in a different way and discover the most secret and intimate impulses of each artist.

Ryman's art is the most realistic: no one has been able to express like him in such a direct way how to formulate the ideas and emotions within our mind.

No scientific research has ever discovered how and when ideas are formed in the mind; they are translated into electric and chemical impulses that, through neurons, control the movements of the hand and then the laying of paint on the picture surface. The activity of the nervous system has been discovered, or at least is about to be, but the source of all this activity remains obscure, only existence and art reveal it.

I seem to remember I first met Ryman in 1968. I had been taken to see him by John Weber, the well-known gallery owner. Ryman was painting his famous

Standards, perfectly white pictures without any marks. The canvas, which was white too, could be seen along the edge. The paint was a kind of very thin, shiny enamel. The marks of painting could not be seen, as in his other pictures, with which they seemed in contradiction. But even a non-mark can be a way of painting. The paint becomes a colored fog where the gesture is absorbed by a smooth material.

I did not understand the real value of Ryman during this first visit.

The following year the Lambert Gallery in Milan held a group show in which there were some small pictures by Ryman painted on a plastic material; they cost 300,000 lire each and I bought them all: *Mylar Pieces*.

The year after, in 1970, the same gallery held a solo show by Ryman with some paintings that had been part of a traveling show in Europe and that previously had been shown in the Friedrich Gallery in Cologne.

I remember a picture that struck me like a sudden revelation, and in that moment I realized it was something huge, something that imposed itself powerfully on my mind without any obvious reason. This ignorance of mine about the cause of this sudden inspiration made the picture even more attractive. It was in white acrylic on various juxtaposed sheets of paper. The paint was smooth without any marks. This was *Murillo*, 1968. This was the beginning of a race to buy any available Rymans. They were all of the same high quality, and this was why I had to buy them all.

Ryman had had shows in various European cities, including Paris and Cologne, with very little commercial success. Most of the paintings were left unsold. People thought they were canvases prepared for being painted on and that the work was still to be done. I also bought from the Friedrich Gallery in Cologne twelve paintings part of a series, *Standard*, all painted in the same way on steel panels. They cost a great deal as there were many of them, all large. My raid had a successful outcome. I bought some twenty works: by now it was a collection in itself and had not cost all that much.

Over the following two years I bought other pictures to arrive at a total of thirty. The last was *Zenith*, 1974. I would have liked to have continued since my passion for Ryman was so great, but I had to stop as a result of the rise in prices. People had begun to understand that they were not canvases waiting to be painted on.

Together with my wife I went to Ryman's New York studio many times. It was in a strange tall narrow building. In the past it had been used to store the backdrops for the operas mounted at the Metropolitan. I remember that Ryman, on one of these visits, asked my wife why I was so interested in his work. He just didn't understand. His collectors were few and far between and so he felt isolated. His art did not interest anyone. He did not complain about this

exclusion. He believed in his work and continued with it without giving in to the demands of the art market. This is why his art is so coherent. Over many years his quality has remained of the highest without any weak periods. This is very rare because artists change: there is a high point for a period and then a decline. It is difficult that the gift of creation continues to be offered. Ryman is a simple man, humble, without ambitions, and he knows the basic things in life and is faithful to them. This explains his quality. To remain humble when you are famous is a very rare virtue. Those who remain so are rewarded. The result is there to be seen. Ambition is a vice that leads to blindness.

Since Ryman showed me the importance of how painting materials are laid on the canvas surface I have changed my way of looking at a picture of any kind or period, modern or ancient art, Raphael or Rothko, Piero della Francesca or Phil Sims. The act of putting on paint is the beginning of everything, the miraculous, mysterious, and sublime moment of creation. Composition, form, and color are all important, but less so than that first moment that determines all the rest.

Last spring I was in the Metropolitan Museum in New York where there was a show of many of the best works by Velázquez. This, in my view, is an artist who concentrates together all the possibilities of painting. There are no tensions, conflict, dramas, sadness, or desperation. Everything is calm and even. There is only the immense pleasure of beauty and harmony. A personality similar to Ryman's.

I looked at Velázquez's pictures from close up and saw how his way of painting changed: at times there was a colored mist consisting of light veils of paint, in other parts of the picture the colored material was thick, the brushstrokes wielded energetically but without violence and integrated perfectly with all the other parts of the picture.

When I go to a museum of art I always take a lens with me: it is a pleasure to see how a great artist expresses himself and in his gestures reveals all his personality. Often in works by Raphael the forms dissolve in what at first sight seems a uniform mixture of colors; in other parts the paint is applied in long brushstrokes with a visible thickness. In Titian's late pictures the brushstrokes are full with thick paint, laid down energetically with every gesture visible.

The differences between one person and another are innumerable: you could write a different art history: the history of the way of painting would be a fascinating tale.

BRICE MARDEN

BRONXVILLE, NEW YORK, U.S.A., 1938–

I met Marden in the same year that I met Ryman, and I was again accompanied by John Weber. During my first visit in, I think, 1968 or 1969, I did not understand his work. At the time I was buying Nauman, Andre, Serra, and Conceptual artists, artists who made a completely different kind of art: the former having a strong physical presence and the latter a philosophical intellectualism. This was why my first visit to Marden left me indifferent.

In 1971 Sperone put on a show in Turin with many works by him and I bought one: *Tour*, which cost me 2,000 dollars. I think this was his first show in Europe. At the time Sperone was doing an excellent job. I would go every month to Turin to see his shows, also coming across the Arte Povera artists whom I did not buy as I was concentrating on the Americans.

Marden's show was of dark paintings in various shades of gray; these were his best works but nobody liked them because there wasn't any color: it is well known that people prefer color. I was also rather perplexed since I still hadn't understood that I was seeing a great artist. In fact I hung my picture in the wrong place in Biumo, at the bottom of the staircase leading up to the second floor, a disgraceful place for a masterpiece. I do not remember when but, I think, a year later I suddenly realized that the Marden was marvelous.

Probably the presence of Ryman had helped me to understand Marden. His is a difficult art. Pictures painted with wax, a semi-transparent material. I had the sensation that the light entered the material and was absorbed. It was a material that seemed to take over the vision of the viewer. It was like the beginning of a journey into the unknown hidden in shadow and darkness. It was a vision of the power of material, an indefinable power.

We think of material as something definite and that we cannot go beyond it. Marden showed me possibilities without end.

This is precisely what is happening in the most advanced scientific research where, in its exploration of the infinitely small that is the basis of our world, there are no limits. We are between two infinites, an important central position. We know that there exist two extremes, but only we know this: the atoms, the stars, the hypothetical tiny Strings know nothing about it.

This discovery led me on a hunt for Mardens. The artist was an extremely slow worker and produced very few paintings a year. He was never satisfied and continued to repaint them. It was difficult to find them and, in fact, I only managed to purchase nine before the others realized he was an important artist. The last attempt was for a picture wanted both by me and the Grenoble Museum. As it was a museum I gave up the fight for it. The vendor

was the Lambert Gallery in Paris, which at the time was one of the best contemporary art galleries in Europe.

I remember my second visit to Marden's studio in the infamous Bowery. A lot of not-yet successful artists lived there as the rents were low. It was in a tall and very dilapidated house but a fine light entered from the windows. There was a pot on a burner to keep the wax warm in order to be mixed with the paint and laid on the canvas.

Marden was a man of few words: he wouldn't speak but kept on painting slowly. All the paintings I bought between 1971 and 1974 were dark or light grays, at times blue-grays, but always darkish. Only one triptych, *D'Après la Marquise de la Solana*, 1969, had a pink panel. Some years later he began more brightly colored works, though perhaps by doing so he diminished that descent into the unknown that I preferred.

I met Marden during a visit to the Metropolitan where there was an exhibition of their new acquisitions: he pointed out to me a Khmer sculpture of Buddha, very beautiful, and this was an indication of his preferences.

ROBERT MANGOLD
NORTH TONAWANDA, NEW YORK, U.S.A., 1937–

Mangold is one of the few Minimalists whose use of paint, applied not with a brush but with a roller, becomes a mechanical operation in which the personality of the artist seems to disappear but is, in fact, manifest in his choice of colors. These are not the primaries, red, yellow, and blue, nor are they those of flowers, but they give the impression of being artificial, the result of the inventions of the paint industry and giving a new direction to research. His pictures often seem to have geometric forms but in fact they are not. There is always an alteration of the intellectually perfect form. There are lines and circles drawn with a pencil where the ideal regularity of the form is negated.

The pictures I collected were from 1966 to 1974. I believe this was the artist's most creative period. The colors of the pictures from this period have a strong visual impact: they impose themselves powerfully. And underlying his works, though it is not highly visible, is a strong challenge to logic. But it is concealed by the imposing presence of the color, an invented color.

I bought many works by Mangold in the short period from 1973 to 1974. The circumstances were favorable. Someone has told me that because of these sales he managed to buy a house in the country that he calls Panza House.

I remember a visit to the Max Protetch Gallery in Washington in, I think, 1974, where there were five or six beautiful large paintings, and I bought them all. It was necessary to make the most of the situation while they still cost very little.

NEW EXPERIENCES

WALTER DE MARIA
ALBANY, CALIFORNIA, U.S.A., 1935-

De Maria was a great artist I came to know in New York at the end of the 'sixties.

Sadly I was only able to buy a few works, and not even his most important ones. He is a great artist with a limited output. The important things are very large, often made from expensive materials and so cannot be bought for a few dollars. If I had known about his work a few years earlier it would have been possible to have some small-scale pieces at a reasonable price. In the home of the great New York collectors of the 'sixties, the Sculls, I saw some splendid small objects by Walter De Maria. They were made from stainless steel, and various words were etched on them that could only be seen by looking very carefully. I do not remember what was written but I do remember the intense emotion they caused in me: a genuine poet.

These were the years in which various artists felt the need to leave New York in order to find something absolute and sublime in the deserts of the Far West. Walter De Maria was one of these.

When, together with Turrell, we went to the desert for the first time in 1973, one of our reasons was to see the *Testing Field for the Lightning Field*, slender stainless steel rods set in the endless spaces of the desert. There was a line of light that emerged from the earth: it wasn't the sun that shone light but the earth itself, an overturning of reality. They were almost invisible lines of light. From afar they could not be seen, so nature was not contaminated but maintained its original purity.

During the same trip we went to see Heizer's *Double Negative*. The center of all this activity was Flagstaff, a small town hosting one of Arizona's universities. You would see cowboys walking around just like in films of the Wild West, but these were real. I went back thirty years later and everything was changed. The town had become a city with new hotels: a new freeway had brought tourists. Evidently the Grand Canyon and the Painted Desert were liked by everybody and not just us. The natural beauty of Arizona cannot be compared to anything else. In thirty years many things can change, above all in America. In fact one of the mightiest powers in the world has fallen apart without being attacked by an enemy. Anyway, besides the numerous large and small volcanoes there was an interesting visit down into the Meteor Crater created by a huge meteor some fifty thousand years ago. A cavity with an almost perfect form. We are lucky that there are no longer any monstrous stones like

this still around, otherwise we would risk an ugly end as happened to the dinosaurs fifty million years ago. When you are in the desert you think about the history of the earth and the stars because they are there, visible. De Maria took us around in his jeep: in fact in 1973 there were only a few roads, so this kind of vehicle was useful for crossing the terrain adapted to his works.

LIGHTNING FIELD COMPLETED

I saw the real *Lightning Field* some years later when it had been completed with the help of the Dia Art Foundation, which then, as today, was doing amazing things. Some years earlier, when the project was being finalized, I had sent a fairly large sum of money to finance the work. However, the Dia Art Foundation reimbursed me, since it had itself sufficient means to further the project.

Walter De Maria had found the best adapted place in the New Mexico desert. It was surrounded by distant mountains and was some three hours' car journey distant from the nearest town, Albuquerque. I arrived there in Turrell's plane from Flagstaff where he settled in order to be nearer his great child, the Roden Crater. There was no airport so he had to land on a dirt track, the only surface smooth enough to avoid accidents. Turrell chose the best adapted place. His plane had an important advantage: it could land at a very low speed, about seventy kilometers per hour (43 mph), and it could come to a halt in just a few meters. Everything went well.

Although it was impossible to see *Lightning Field* from a distance, Turrell had already been there and was able to land without hesitation. Helen Winkler and the technician who had curated the installation gave us a warm welcome. Turrell left shortly after. But first he washed the plane, which had been dirtied after running through a puddle. Dusk was nearing, but the greatest work of art in the world, four hundred stainless steel rods, each six meters (20 ft.) high and occupying an area of a square mile, still could not be seen. But then looking into the light we could make out slender black lines rising from the land: the glaring sunlight hid them from our eyes. When we moved toward the east with the sun behind us the view changed completely. The black lines were transformed into a source of light. The whole square mile and all the four hundred rods became luminous.

The light now emerged from the earth, not from the sky, and it stood out against the land, which was becoming darker as the sun set behind the distant mountains. About an hour after dusk the rods continued to reflect the small amount of light that still hovered in the west before the sun set completely. This was a quite special, unforgettable moment. The light seemed to come from the earth and we could only see lines of light in the surrounding

blackness. I would have liked to have stayed even longer to see such a moving vision, but my hosts were looking for me; they were worried that they hadn't seen me come back.

The house was made from tree trunks sawn so as to fit together exactly. It was very comfortable, warm, and strangely silent: every sound was absorbed. I slept little due to the emotion and the height: the house was over two thousand meters (6,562 ft.) above sea level. Every so often a horse would press its muzzle against the window; the stars seemed lamps. I awoke the following morning before dawn and saw the triumphal arrival of the sun.

Life again shone in the desert where there was a clear light that filled everything. It was a huge, completely empty plain, surrounded by mountains so distant as to be almost invisible. The four hundred rods glittered in the light: this was the moment of greatest illumination. As the sun rose above the horizon the light lessened. When moving around within the rods you could see flashes every so often where the sun was reflected from the tip of a stainless steel rod that became a mirror.

The journey back to Albuquerque was fairly long, and we followed the Lava Flow, a solid black river of lava, for many miles.

Some years ago we had visited the *Las Vegas Piece*, 1969, in Nevada quite near Las Vegas. We were accompanied by Helen Winkler who knew just how to discover the work of art: it was in the middle of the desert, without reference points, and completely invisible from a distance. It consisted of two trenches opened up by a tractor, both about a mile long and they joined up to form an "L." The bottom of the trench opened up by the tractor was quite smooth and we could walk over it without looking where we were putting our feet. The desert floor was rough and covered with thorny bushes. We could walk by looking at the horizon, at the sky, at the colors of the earth. We heard the flutter of the breeze and the twittering of birds. We saw the infinite beauty of the desert.

Another extremely beautiful De Maria work is *Broken Kilometer*, 1979, installed in a New York loft on West Broadway. This consists of five hundred shining brass bars each two meters (6.6 ft.) long. They were placed in five parallel lines for a total of one thousand meters (3,281 ft.). The floor of this huge room seemed to emit light. It is a work of rigorous purity and sublime perfection. When a work is perfect it is separated from time, it is the presence of an immortal idea. If the deepest wish of humanity is to vanquish death then this work is its testimony. I do not think there are better words than these to define the work of Walter De Maria. This is the most a man can hope to express. His way of living, his personality are here. The need to express the inexpressible asks for a great concentration: he conceives his works slowly, making few of them, almost always on a large scale and of a high quality. They do not suf-

fer the wear of time. I remember a visit I made to his studio some years ago. It was dug from a large area with its cement walls visible. It was quite empty except for a desk in a corner covered with papers.

IAN WILSON
DURBAN, SOUTH AFRICA, 1940–

Together with my wife I have known many artists and collected their work over the past fifty years. All the artists whose work we have bought remain in our heart and mind for quite precise, carefully studied reasons, and this is why they are all loved equally. Ian Wilson has a place to himself. He is an artist who produces nothing.

You might think, apparently quite rightly, that he cannot be an artist. His work is an evolution of Conceptual Art: it is its logical conclusion. In order to understand life it is necessary to think, and seeing is a secondary fact: those who do not think cannot understand and cannot know. We are never in charge of our own destiny but, by thinking, we can accept and even change it. If the aim of art is knowledge of reality, thought is its indispensable instrument, which is why it too is art, above all art.

Art is the possibility of communicating: this is its main aim, and if it remains a single isolated episode, it disappears with the person who created it; it does not extend beyond that person. Art communicates through an object that expresses ideas and emotions, intuitively. Its aim is always the same: to communicate.

The object, the work of art, is the means. We also communicate through language, using words linked together by logic. The movement of the hands, eyes, and face, the tone of voice, are all elements that together form expression.

For Conceptual Art the main objective is the idea. The art object can even be superfluous when words and the argument can be the most efficient means for communicating the idea. If speaking is more useful than the material object, then it is no longer necessary to make art: it is better to speak, and the object becomes superfluous.

There is a basic idea from which all the others derive. We only have an approximate and confused awareness of it.

Often we are full of contradictions, even though we might deny this. This basic idea is the truth, a word that makes us tremble and that we feel is infinitely distant. We can only think about it and attempt to deal with it: this is painful. There are moments in life when this attempt is inevitable, even though we are unprepared: the pain increases proportionately. We can try to put this off but its presence becomes insistent and disturbing. An answer is necessary. This requires not only to think in the most logical way but to trans-

late this into a coherent behavior. Truth cannot only be thought of but must be experienced.

The object Ian Wilson works on is the search for truth. He does not create things with a form. He speaks and questions us about this idea; he forces us to reflect; we must involve ourselves with all our mental energies in order to reply to his questions. This is a great effort that cannot last more than an hour, but at the end we feel different, completely different. The discussion is not recorded or written down, there remains no visible trace, but it remains indelibly printed in the memory, even though we might forget the words or reasoning. It is the experience of something unforgettable. There remains a sheet of paper that states there was a discussion on that particular day, in that particular place, and this is signed by the artist and by the person who has participated.

Our first discussion was thirty years ago in 1974, a long time back. The conversation lasts an hour and costs 5,000 dollars. I do not believe there exists anywhere a professional who is so well paid for such a brief service. Despite this he has not become rich; in fact he is poor. Evidently there are only a few people who pay money in order to think of the truth. Perhaps this is why the ability to judge art is in such sharp decline.

I am happy to spend this money almost every time I go to New York, as I think this is money well spent.

Wilson is tall and thin like a secular ascetic. You always want to see him again. Unfortunately my illness has stopped me from traveling for some time, but I hope to return soon.

Our first discussion took place in my house in Milan. Ian was staying at the Hotel Rosa, a very humble hotel in the center where in 1974 a Conceptual artist could still afford to stay. It is now a luxury hotel. The discussion was very involving: I had to try to remember all the thoughts that over the years had been at the center of my mind. I have always been obsessed with the problem of truth. Can we know what it is? Our knowledge is so limited and full of contradictions and thus of doubts that to imagine arriving at the truth seemed an unreachable aim. But all the same it was necessary to reach it. If it was not possible there would remain only one certainty: disappearance, the terrible abyss of nothingness. In order to arrive at the truth it was necessary to think. And with the instrument of thought, logic, to eliminate contradictions. As thought was the only instrument that could be used it was necessary as a first step to see whether this was useful to my aim and could give a positive reply: what we have found is the truth. When we read books of philosophy doubts increase instead of diminishing.

The first question was always: what can we know, what can our thoughts tell us with certainty? This is where the discussion with Ian Wilson began: a

basic philosophical question that asked for all my possibilities of thought. After an hour of questions and answers I was exhausted, as was Wilson too. It was necessary to recover from the effort with a good meal. When the discussion took place in New York in the artist's house his wife took care of this; she was an angelic woman who made an excellent ice cream that I ate with gusto, as I am extremely greedy.

His wife was and is important in Ian Wilson's life. The profession of philosophy does not produce an income, and the earnings are chancy and occasional. To have the freedom to think is necessary, but so is the minimum security for living. His wife worked and so guaranteed a basic wage. She was devoted to her husband and extremely respectful of what he did: an example of that silent goodness that keeps the world going round.

The conclusion of the search for truth is always and only One. Our mind cannot discover it, and logic finds itself in front of an insuperable wall. We cannot know the unknowable. We are in the midst of it, surrounded on every side. We become aware of this only when we get down to serious thought or when we decide we will never know it; we can find the truth in another way, which is not a mathematical certainty but only a hope, a hope we can believe in. There are no other alternatives: either hope or the definitive sadness of a life that promises happiness but does not maintain the promise.

A recognition of the reality of this situation has slowly pushed the artist toward a mystic solution. I remember his interest in *The Little Flowers of Saint Francis* and afterward Indian mysticism.

By now thirty years have passed since I met him for the first time: a long time, a lifetime. We Italians are used to living in the same house, in fact I have lived in mine since I was married, in Corso di Porta Romana in Milan. I was born in the same area I live in and only ten years ago moved to Lugano because of problems over the collection, but I am not there all the time. I am often in Biumo, Varese, which is a place I love, but my home is always Porta Romana where our children were born and grew up. Ian Wilson, on the other hand, moved every so often. Some years ago I went to see him in an ashram in a distant area of New York where he was guided by an Indian mystic who would journey between America and India. I never met the man but he must have had a notable spiritual attraction. The ashram had been constructed in an old motel in a tourist area among forest-covered hills. Its function was in contrast to the reality of the building itself, which did not seem to me much adapted to a mystic life: it was completely different from ancient French or Italian monasteries where, once over the threshold, you find yourself suddenly in a different reality.

Ian Wilson continues as an artist who communicates through speech. Every so often he is invited to Europe for series of discussions; two years ago he

was in Biumo and once again we discussed with passion and concentration the usual problems, but in a more calm and detached manner: time, the experience of life, an invitation to resignation, but also to serenity.

JOSEPH BEUYS
CLEVES, GERMANY, 1921–DÜSSELDORF, GERMANY, 1986

I met Beuys many years ago, in 1968. I had gone to see the Eindhoven Museum in the Netherlands where there was a show of work by Robert Morris, the American artist I was then collecting. The museum was divided in two, half devoted to Morris, which I think was his first show in Europe, and the other devoted to Beuys. I knew neither his name nor his work. I was struck by a great emotion. I discovered an art that allowed the emergence of unknown forces hidden within our being. It seemed to make possible a medieval world of bodiless witches, magicians, and demons: they were only positive or negative energy. The artist knew how to dominate them and was able to give them a form through placing together objects we live with but do not notice. Suddenly they had the power to communicate emotions never previously experienced. This was the vision of a dark, shadowy, subterranean world that had become visible.

A short while after, I had the occasion of meeting the artist after seeing a performance by him in which he was transformed: he was no longer a man but had taken on the semblance of a witch doctor with supernatural powers. Obviously he did not have these powers, but he could have had them since his behavior made them quite possible.

The happening consisted of a very simple action. The artist had to hold up a long wooden plank with his hands and keep it vertical, something very difficult. It continually tended to become unbalanced and fall, so Beuys had to shift about rapidly in order to avoid letting the plank fall and so end the performance. I do not know why but the action at once became a metaphor for something different. It was no longer about balancing a plank, but about the fight by man to avoid being overcome by destiny and the unknown. A fight in which consciously or not we are continually involved. These are the imponderable forces that hang over us and dominate us. We run the risk of being overcome and have to use all our energies not to end up badly.

The artist always dressed in the same way, in jeans and a fur coat reaching down to his feet that he always wore: it covered his whole body. He seemed to have suddenly appeared in the present from some remote time. His most characteristic apparel was the hat he always wore, in the house or outside, in summer or winter. It was said that this was to hide a platinum plate that covered a serious war wound received when he had had to land his plane in east-

ern Russia. He was saved by the Tartars who covered him with their cloaks until he regained consciousness. Since then his life had changed.

This was another world made manifest. Rationalism has been imposed on us and has repressed our primitive instincts. In the north certain instincts have deep roots and it has not been possible to repress them completely. In the old civilizations washed by the Mediterranean, sunlight lasts longer than the night. In the sculptures from equatorial Africa there is an analogous situation. They manifest the mysterious and unpredictable forces of nature that are stronger than the will of man. The witch doctor has the task of questioning and interpreting them. Beuys was the witch doctor who reawakened instincts unknown even to ourselves.

This is a world that disappeared in the Middle Ages and that we call superstition.

I wanted to collect his works. I knew an excellent dealer from Düsseldorf who represented him: Alfred Schmela who died far too early. Sadly there were no works available; Karl Stroher, a great collector from Munich, bought almost everything he made. I could have commissioned a work to be installed in a room in Biumo. Beuys came to Varese to see it. He liked me and would have worked quite happily there, but it was a period in which I was without money and did not like the idea of buying something on spec. So I lost the opportunity of having an important work. Later on I bought two small but beautiful objects from the admirable *Schmela: Fontana Dose*, 1973, and *Untitled*, 1961.

It was a great experience when I went to see the Stroher Collection in the Darmstadt museum where various rooms were devoted to Beuys. A monument of historic importance for German art.

I remember the discussions that Beuys had with the public in Kassel during "Dokumenta 6" in 1977. The main theme was "Give Power to Creativity." If he were to reawake now he would be deluded by the situation of art, because stupidity has been given power. By that time he had become famous internationally, though today his fame has diminished. A new generation of artists with an easier kind of art has had great success, to Germany's great satisfaction. But the interest in easy art will diminish too: if it lasts too long it becomes a bore.

The presence of the artist was very important. After his death they put on shows of his work, but it is not the same thing. In installing his objects he really was a magician and knew how to release energies that, without him, are invisible. It was his personality that imparted a soul to things that did not have one. A tiny shift was enough to transform something inert. This is why the exhibitions installed by others rarely show the energy his works contain. The last work shown in Palazzo Regale, Naples, just before he died, has always deeply moved me: in a fairly large glass showcase were placed the fox-fur coat

and the hat he wore in every season. These were visible signs of his presence, but they were empty, without the body they used to contain. At the side were two large brass drums that, as we read in the Bible, were beaten to celebrate the arrival of the returning victor. Evidently Beuys believed in the victory of life over death when the soul departs from the body. This was his last message: a synthesis of what he had always believed. To reveal the presence of the invisible. Palazzo Regale was the most appropriate place for this celebration: the indefinable, the unknowable became real.

HANNE DARBOVEN
MUNICH, GERMANY, 1941–

I saw Darboven's work for the first time in Düsseldorf in the Konrad Fischer Gallery in 1972. I think it was her first show, and she was still an unknown artist. I was fascinated by her insistence on doing a repetitive task in which the changes were programmed: it was a logical development of a mathematical system. Her translation of this system into an image created a harmonious and ordered impression of great beauty. It was evident that numbers can be poetic. When I went to school I didn't like math, and even today I am blocked when I see a formula, as for me it is something abstruse. But Darboven's progressions were easy to understand, and with a little attention it was possible to understand the ideogram on which her numeric system was organized. Every so often the progression was interrupted and the logical development came across a gap or a contradiction: the system adapted to this and changed by introducing a variant, and then continued to develop again. It was like reading a book about biology where an error becomes a mutation that causes life to develop in another direction, enriching the system with greater complexity. You can find a similar experience when listening to a piece of music: the main theme is transformed while remaining faithful to the original. Life and the universe are complex systems where logic comes up against and integrates with accidents only to continue developing and living.

The beauty of Darboven's work consists in reproducing the work of nature. A reality that is not visible and that becomes understandable only when its development in time is observed. It resembles human DNA, a spiral held together by a logic that can be represented by numbers and that, as it develops, reveals the order in our life.

I have had the luck and the pleasure of knowing the artist personally. The first time, my wife and I were invited together with Konrad Fischer to her home in a Hamburg suburb, a large, beautiful house where she lived with her mother and two sisters. Her father had been dead for some years. The fam-

ily owned a business that produced Darboven coffee, an important firm in the sector, and the older sister looked after it. It was a family of women all very close: none of the daughters was married, and you felt the lack of a man about the house. The youngest sister was sweet and docile.

Darboven's studio was in a very large room that had an order similar to that of her work, with every so often a delicate feminine touch, like a rose in a thin glass vase. There were various thermos flasks of coffee, of which she obviously drank a lot. I like coffee too but can't drink too much as it ruins my stomach. Her drawings were grouped together in files, and it was a pleasure to look through them. Both the house and the family were very hospitable and time passed in an interesting way. We could choose the works we liked.

We went back many times. We stayed in a hotel in Hamburg, a very beautiful city with interesting museums. I remember a visit to the Kunsthalle accompanied by the director to see his marvelous Caspar David Friedrich, a great love of mine, and the German Expressionists. We had become great friends with Darboven, and she would send us messages written not in words but in numbers and marks. But the meaning was clear, one full of affection and friendship. This ideal relationship lasted until 1975 when, suddenly, it stopped. I don't know why. Perhaps because I had reserved a large work on show in the Castelli Gallery that I could not then buy when my real-estate problems suddenly worsened in that period. This is only an idea of mine. She wanted me to give her back all the works sold, quite regularly and fully paid for, by the Konrad Fischer Gallery. Of course I refused. Some of these works have been shown in various museums. At the moment they are on long-term loan to the Guggenheim and I hope they have their definitive home there. Her work was an important element in our lives as collectors, certainly the high point of our research. We are attached to her by great admiration for her work as well as for affectionate memories of the time we passed in her home where she sold us marvelous works that we continue to love as when we first saw them

JAN DIBBETS
WEERT, NETHERLANDS, 1941–

This is the artist who, unlike those of the Renaissance, suppressed perspective. In the fifteenth century nature had been discovered as a reality lying outside ourselves, but in our own time it has been interiorized. The self is the measure of all things: nature is within us, it exists only insofar as we exist, and without us the whole universe in all its immensity would not exist. The first works I saw by Dibbets were photographs where the arrangement of certain elements made the image flat: the third dimension had been eliminated. The record-

ing of time too is an important part of his art. Duration is broken down into moments, each slightly different from the other. Both for our awareness and our instincts, time is an uninterrupted continuum where everything is married together in our memory. But our knowledge tells us this is impossible. In order to understand reality we must stop time, break it down into different moments. This is an artificial and unnatural operation, but one that is indispensable for our knowledge. There is an evident difference between science and metaphysics, life cannot be part of an analytical process: these are two different and incompatible things, and if you have one you lose the other. In the science of particles there is a similar phenomenon: final reality is a wave of energy, and if you stop it to understand it, it loses its motion. Sunlight warms and lights us; in the void there is darkness.

The camera is the best means for demonstrating this truth. It can break the image up into distinct parts. In many of Dibbets's works the camera rotates slowly round in order to see reality from various angles. This difference between knowledge and perception has been demonstrated in an exemplary way by the great philosopher Henri Bergson, and even Saint Augustine in his *Confessions*, written in 401 A.D., had precisely understood the difference; time's rapid flow makes our life precarious and provisory.

The camera is an instrument that is without a personality. It sees things in an objective way, just as they are, without adding anything. Its eye is different from ours, it cannot perceive the reality of time.

I remember Dibbets's interest in two great seventeenth-century Dutch painters, Paulus Potter and Jan Saenredam, both meticulous observers of reality.

CY TWOMBLY
LEXINGTON, VIRGINIA, U.S.A., 1929–

The missed opportunity of buying five pictures by Twombly was one of my greatest mistakes. I had met the artist during a trip to Rome in, I think, 1959. I knew Plinio De Martis the owner of the La Tartaruga Gallery where the previous year I had bought four drawings by Franz Kline. He was an intelligent and sensitive dealer and one of the first in Europe to be interested in the right American artists. Rome at the time was the city most open to the new culture arriving from across the Atlantic. It required a lot of courage to overcome the old prejudice about the superiority of European art. America was considered a provincial phenomenon as regards culture.

American artists were only too happy to come to Rome where they had a warm welcome. Paris was too haughty: it was still at the center of the world's art and feared competition by others. Italy had lost everything during the war

and so had nothing else to lose. There was the strong wish to break through the tight confines of the nationalism forced on it by Fascism.

Through De Martis I met Baron Giorgio Franchetti. He was a great forward-looking collector who had bought works by American artists before the others. His sister had married Twombly, and they lived in Rome where he had a studio in the city center. This was why it was easy to get know him and his work, which was very difficult to sell. In fact I bought five works for a ridiculous price. Two were large-scale pieces painted with large strokes, one was a drawing from his most recent period, and then there was another canvas he had painted some years before in a quite different manner, with the superimposition of freely composed lines, a very beautiful picture.

I cannot manage to understand why, when I looked at the paintings hung in Biumo, that my interest in them did not increase. Probably it was due to the growing interest I found in Rothko, Kline, and Rauschenberg, who represented for me a different ideal and emotional world. I exchanged them for works by Rosenquist through Ileana Sonnabend who at the time wanted to move her gallery to Europe, to Rome or Paris. The Rosenquist paintings were beautiful, but I should not have taken them in place of the Twomblys. But that is how it was. They say that it is pointless to cry over spilt milk: I could say the same thing for the three Lichtensteins lost, the Warhols I never bought, the Barnett Newmans that I could have had for 6,000 dollars and so on: a sad list.

ON KAWARA
AICHI PREFECTURE, JAPAN, 1933–

Kawara was the Japanese Conceptual artist I collected at the beginning of the 'seventies. The center of his work is time, that ungraspable entity that allows us to exist and destroys us. Every day he painted a date on a small canvas. This was accompanied by a box in which there was a page from the newspaper with the important news of the day from the city where the artist was in that moment. Another very interesting work consisted of ten folders in which a million years were typewritten: *One Million Years*, 1970–1971. Funnily enough human history only takes up the last pages of the last book. This was visibly a tiny amount in comparison to the origins of the human species in its progression to Homo Sapiens, born some 100,000 years ago. This newest and most modern art has its roots in Buddhist Zen culture. When you go to the Buddhist monasteries in Kyoto you find yourself in a similar atmosphere with the same sensibility. This is a culture directed toward introspection. The "Self" is confronted with "Being" and "Existing." A way of arriving at the roots of life,

of leaving daily life in order to enter into the eternal and the infinite, which we feel is inside us but in a confused way. This is a culture completely different from ours with its Western activism. Our Christian roots are different. We have to submit to evil and at the end good will prevail, but only at the end. Suffering is the road to final happiness. It is not possible to avoid the fight against evil: we must live where it does its work.

Since opening its confines to Western influence Japanese culture has produced very few visual artists. Since the war Japan has produced great exponents of architecture, indeed these are probably the best in the world. They have discovered how to fuse the essentiality of Zen philosophy with Minimalist Modernism. When you look at Japanese temples you find the same search for Less is More: a poetic vision of life, light, and nature.

The history of Japan is interesting because it is an example of the possibilities and difficulties caused by the integration of different cultures where something is lost but other things are gained. Japan had said no to Western influence for some 250 years. Only halfway through the nineteenth century did the Japanese become aware that Europe and America were rapidly progressing thanks to new technology.

Western power would have become overwhelming if the Japanese had delayed adopting Western productive systems. The change was profound but it has not, all the same, changed the moral and civil principles that lie at the base of Japanese society.

In the first half of the twentieth century Japan had become the great power in the East. Its greater ambitions, though, were demolished during the Second World War. Since the 'fifties Japanese ambition has been concerned with finance in order to develop an industry that might conquer the world with its products. This policy led the country to a financial crisis that has lasted some ten years but that still has found no solution. Over the past twenty years China has been making rapid progress, and in the next thirty years it will be a world power.

My wife and I have been to Japan twice. The first time, in the 'eighties, we were invited by the Japan Foundation, and the second time It was for a meeting of CIMAM, when we stayed for twenty days. It was a particularly interesting experience to get to know ancient Japanese culture in Nara and Kyoto; a modern culture even though centuries old. The temples and gardens of the Buddhist monasteries were built following the intellectual principles of Minimalism, where the idea of Less is More is always followed.

The temples are constructed using modular and repetitive elements that give rise to new and original buildings. The way of considering nature is particularly interesting. In the monasteries there are openings for seeing just a

part of the garden, a window at floor level for looking at the snow falling, and a platform for observing the full moon. Incredible attention is given to every detail: to the way in which a particular type of stone is placed in a particular position in a context in which every part follows a project that, at first sight, seems natural and spontaneous. The gardens are small but seem large. The plants are kept small with knowledgeable continuous pruning. When you stand still in the garden you only need to turn ninety degrees to see each time a new landscape, and it always seems huge. Every detail is a carefully camouflaged work of art. This ability to discover the universal in a detail is the great value of this culture. The constant search for essential simplicity, Less is More, makes stylistic evolution superfluous: perfection cannot change, it is the truth, the eternal truth. This explains why changes in history are difficult to understand for the Japanese. Only errors change.

Over the past thirty years in Japan many beautiful museums have been built by the best architects: monuments of architecture. Their collections have not been so lucky and they have few important pictures. They are full of artistically mediocre things. This is something that must be taken care of, but it takes a long time to build a collection. A building can be constructed in say three years, but a collection takes fifty. When the crisis of the 'nineties is finished, then Japan can become an important place for collecting once again. But only by choosing quality and not names, which, often, is all they sometimes have to offer.

NOASHIMA ISLAND (BENESSE ART SITE, JAPAN)

Naoshima Island is a great accomplishment. It was created and financed by Soichiro Fukutake. Here he created a museum with rooms for guests planned by Tadao Ando, one of today's best architects. His architecture is not only amazing but is a work of great quality consisting of walls, light, and space. Through him Buddhist values live again: the search for interiority, the relationship with nature, sacred entities, and the expression of the sublime, something that he makes us find in everything, great or small. Light is the main element, the manifestation of supreme beauty.

The museum owns works that integrate with the meaning of Ando's architecture. This collection of Environmental works created in other parts of the island continues to grow.

We spent a night in one of the guest rooms on the island. It was empty. The end of the room was filled by crystal glass that gave us a highly spectacular view of Japan's Inland Sea, an unforgettable sight. The landscape entered and filled the room.

Mr. Soichiro Fukutake has a firm for the production of books for students: it is to his great credit that he uses in this way the earnings of his firm; an example to be copied.

I knew that in Kyoto Tadao Ando had constructed some small buildings. I asked our guide if it might be possible to visit some. He took me to a bar for a coffee and, when I raised my eyes from the cup I realized I was not in a bar but in a tiny Buddhist monastery. Wherever I looked I was moved. This was a tiny, huge work by Ando.

MAURIZIO MOCHETTI
ROME, ITALY, 1940–

Mochetti is an artist who creates kinetic art, objects that move. A motor gives them movement, something that belongs to life. This is not an unlimited movement but one that is rigidly programmed.

Machines can only make a few movements. But even within these limits the objects are highly evocative. The movement happens over time, which is necessary to exist and to think. If time stopped so would we. Immobility is absolute coldness, absolute death. The passing of time is permitted by the laws of entropy that pervade us and the universe: from a hot beginning all things tend toward a mortal chill. We can exist between these two extremes until heat is transformed into cold and every form of life will cease, whether animal, vegetable, or physical. Even the atoms will stop moving, absorbed in an enormous black hole or dissipated in infinite space in the form of radiation.

Entropy is the weak point of Mochetti's art. The machines wear down and stop as they run toward death, like all things. His mechanisms are the best representation of becoming. It is brilliant work, but the artist has not defended himself against the law of entropy that destroys everything. The machines break down and stop like all machines. There does not exist an organization for repairing them and getting them going again. In this kind of art the ingeniousness of the idea is not enough: technical help is needed in order to revive the idea of time.

I have collected beautiful works by him, some made from light, such as a point that moves in a circular space (*Punto di luce*, 1969–1970), or a line of light projected on the walls of a room that grows and diminishes ($o \rightarrow X \rightarrow o$, 1969); or acoustic works: an oscillating aluminum pipe containing a steel sphere that when it arrives at its destination emits a sudden bang (*Asse oscillante*, 1968–1969); or one aluminum cylinder that emits an illuminous impulse every fifteen seconds, causing an ensuing sound from the second one (*Cilindri Luce-Suono*, 1969), which stops when you pass through the light beam. This summary de-

scription is just that: a summary. But when the works are constructed they show their complete and complex meaning, which goes far beyond their apparent mechanisms. But sadly entropy is one of the universe's inexorable laws. No one has ever invented perpetual motion, for the simple reason that it cannot exist. In order to make something it is necessary to pass from heat to cold, and from cold there is no return.

Apart from entropy, the mechanisms wear out, are consumed, their actions change. It is necessary to have spare parts near at hand. Mochetti really is brilliant and creates new ideas, but he doesn't worry himself with their conservation. His work is not widely known as a result of this limitation. This is a pity as he merits far more. He completely believes in technical progress and thinks that soon there will be a point at which there will be instruments without any need of maintenance. I fear this is as much a utopia as perpetual motion.

I remember a journey of his from Rome to Milan in a car he had built with his own hands, putting together pieces from different sources. It was a small two-seater car.

Mochetti has his own niche among artists who make art that moves. In Italy I know Piero Fogliati whose work I have collected, and in France the most famous is Jean Tinguely. This artist's work is different in size and, above all, in its meaning. Mostly they are works made from used materials that he has found. His is an ironic look at machinery that is designed by engineers to be perfect for its eventual function. Tinguely's machines have no function; they are useless. They are built without any planning and put together in a home-made way from materials that might, and in fact do, work. Their only use is that of play, and it is fun to see them working despite their improvised construction. His intuition has the same value as an engineer's invention. The Hoffmann Sacher family in Basle has very generously devoted a museum to Tinguely, which is enthusiastically visited by children. It is in a marvelous building by Mario Botta.

Mochetti's vision is quite different. These are works created and made with an engineer's precision so that they work as the artist wanted, apart from the various times they break down: the light of the projector burns out; points of contact do not, in fact, make contact; the nylon thread that makes a sphere go up and down breaks, and if the thread is reeled badly the mechanism stops, though this is a marvelous work.

In a moment of despair I thought about getting in touch with my lawyer to force the artist to make the works function, but I realized at once that this would have been useless. All the works I collected thirty years ago have been lent to the Guggenheim for ten years, but nothing has happened to them. As we know, museums avoid difficult things; they put them to one side and wait

for the moment, if it comes, when the artist becomes famous and the effort of looking after the works is repaid. Sadly there is no generous patron ready to build a museum for Mochetti, so we have to do what we can in order to know and save for posterity work that is certainly important and not yet appreciated as it ought to be. The artist's collaboration is important: the artist is everything; his place cannot be taken.

DANIEL BUREN
BOULOGNE, FRANCE, 1938–

I saw Buren's work for the first time in 1968 at the Apollinaire Gallery owned by Guido Le Noci, the legendary Milanese merchant of the 'fifties and 'sixties. The gallery was hung with wallpaper with green and white vertical stripes. There was no intervention by the artist other than occupying the gallery with this completely anonymous object. I was interested to see an artist who abandoned himself, disappeared into anonymity, by the use of a message that was not a message: wallpaper for a modest house such as exist in their millions all over the world. The artist's personality emerged in his presentation of green and white striped wallpaper outside its usual setting where its transference became an act of force and broke down our habits. The work I bought (*White and Green Paper Collage, Varese*, 1968) was installed in the apartment on the second floor of the house in Biumo where it still is. It does not take up the whole room, only one end, and so it does not become wallpaper but something different, a very discrete presence halfway between a work of art and a part of the setting.

Unfortunately I did not buy any other works by Buren. They are all environmental works that need a lot of space, and they are also site-specific and unmovable. They need a great deal of space, and space is the most difficult and costly thing.

The pictures, instead, are easily transportable, and various ones can be placed in a room together; but the environments cannot. I have bought many environmental pieces, some very large, and I know from experience how difficult it is to show them. None of the environmental works given to the Guggenheim has been permanently placed in a museum, only in temporary shows.

JOEL SHAPIRO
NEW YORK, U.S.A., 1941–

I have collected Shapiro's work since the beginning of the 'seventies when he created tiny sculptures. I have always been fascinated by large-scale art, but

just as well by its opposite. At the time I had actively collected Minimal sculpture, always large-scale, often completely filling a room.

Shapiro's was a completely different alternative. Works on a tiny scale, when they are really beautiful, can actually take up as much space as a large piece. His works had this quality. They also had another characteristic: they were not abstract but idealized miniaturizations of real objects such as a chair, a house, or a table. It was a compromise between abstraction and figuration: because of its Minimalist simplicity the form lost most of its relationship with the visible. It stripped reality of its incidentals and returned to the idea behind the thing, a process of abstraction related to Plato's philosophy. It is ideas that create reality, and when they are identified with something they are debased, they become mixed with the relative, the casual, the perishable, and, therefore, they lose their main characteristic, which is that of being outside time. The small works by Shapiro in this period have this quality and were born to exist. They need a lot of empty space around them. The idea grows and fills it. Many artists, above all Americans, preferred large dimensions where the force of the idea might fill a whole wall. It had to be more real than reality. In the 'eighties and 'nineties some chose the opposite solution and demonstrated the force of their idea in the opposite way: what was small became large because the idea made it so.

DAVID TREMLETT
ST. AUSTELL, UNITED KINGDOM, 1945–

The works by Tremlett in the collection are from a very brief period, between 1974 and 1975. Above all in these works there was a particular attention paid to nature, a characteristic of various English artists from the 'sixties and 'seventies: Richard Long, Hamish Fulton, and Roger Ackling.

For Tremlett this took on a different dimension. He did not use stones like Richard Long, nor the photographs of nature as with Fulton, and not even the sun-burnt small pieces of wood created by Ackling. The work that most interests me, among the, sadly, very few I collected, is that in which the artist traces out the wavy outlines of the hills and mountains of Scotland, *Scotland (Lochness)*, 1975. In this case too Tremlett's images show a very simple form that is sufficient to represent the beauty of Scottish nature; he knows how to capture its best characteristics.

Our imagination then fills it with fields and flowers under a clear sky, with clouds bringing rain or revealing the sun. The hills come alive as though we too were in the same place, the evocative force of these simple lines is complete: the force of the ideas that have created reality. Exact form but abstract has this power.

PART THREE

THE THIRD COLLECTION

I was extremely late in writing the last chapter of my memoirs up to 1976, even though I began it in 1996; but I have only partly told the story of my life and the story of the collection for the first twenty years. I still have twenty-six years to describe, all full of unexpected events. Being just under eighty I don't know if I will have enough time to finish my task. I have not been able to do more because over the past years I have been busy exhibiting parts of the collection, either permanently or for lengthy period, in museums. This is the best thing that can happen to a collector while he is still alive. In fact it was only a remote possibility that it might have occurred after my death; but destiny instead has willed otherwise. Destiny has been very lenient with me and has provided me with gifts and has awarded my faithfulness to beauty, which I have always searched for with tireless tenacity, overcoming doubts and making a rigorous selection of works. I have had the luck to have a wife who has always followed, understood, and helped me, and who has shared in every choice so that we have a mutual vision of the aims of life. The year 1976 marks the end of the first and second periods. This was not an end but the beginning of a third period for the collection, and also of the development of a program for showing the works to the public, works that are by now numerous and of high enough quality for a museum setting.

Beauty is a strong but discrete force, generous to those who seek it out without other motives since it does not show itself to those who want something else. It is a direct expression of a goodness superior to any other; it doesn't die but is immortal, because it is not material even though it uses material to manifest itself. An instrument does not exist for measuring it but it is within everything, from the stones to the stars, from flowers to our own mind. And because it cannot be measured it escapes scientists who believe only in what can be measured. It is the invisible engine of the universe and of life.

The first twenty years of the collection were difficult as a result of all-around incomprehension, which at times became outright hostility. I have had to overcome many difficulties even in my work as a real estate developer, given that it was a mistake to have undertaken this activity. It would have been better to have let it alone and busied myself only with art: I could then have done more as a collector, above all in the early years. The right choices are rewarded only after many years. Often decades are necessary, and thirty years can be few. The choices we make when we are young become important and are widely recognized only when we are near the end. In fact, I am writing this at age eighty; my parents and a sister and a brother are dead, and they died at a younger age than mine.

My great happiness is to see others who love what I too have loved. I never tire of seeing the works I have collected, and I have placed them in the best possible settings. This work is now paying off and many others share in this pleasure of mine. And this sharing increases my own pleasure. I see that many people renew their spirit looking at what my wife and I have put together: this is the same experience I have every time. Beauty is immortal. It might suffer from changing intellectual fashions, though less than other cultural manifestations. I believe that good choices made in the past and in the present will be increasingly widely understood and can become a document of how much that is creative and affirmative has been created in a period that has been full of terrible yet also positive events, a relatively brief a period in which deep and incredible changes have happened. If the future is like the past when I lived together with works created by artists, then I have reason for hope.

The artists are the very substance of a collection, since without them nothing would exist. I have had the fortune to live in a period particularly full of great personalities who, with their creative force, have enlarged our awareness and knowledge. Without them life would be very sad: they allow us to believe and trust in goodness through beauty, which is the truth and image of goodness.

Artists with the qualities for entering history are rare, and it has been a great fortune, together with my wife, to have found them. I am infinitely grateful to the dealers, art critics, collectors, museum directors and curators who, with their information, helped me to find the best artists when they were still unknown.

THE THIRD COLLECTION FROM 1989:
BEGINNING WITH ORGANIC ART

The third collection began in 1989 after a long period of inactivity, the longest in my life in fact, and a situation completely contrary to my nature and desires. This was all due to various circumstances beyond my control. In the first place there was the crisis over my real-estate activity, with heavy debts to the banks and the slump in house buying and, as a result, the slowing down of debt repayments. When money is in short supply you have to cut down on unnecessary expenses in order to live. The purchase of pictures is certainly not necessary for physical life. It is necessary for another kind of life, that of the soul. It was also a terrible period for another reason: the insidious attacks of someone who wanted the end of my dreams of art and to see my humiliation. Luckily things went differently and my faith in beauty was rewarded despite the attempts to demolish my trust, or, as my critics called it, blind faith. In this appalling period my salvation was the complete solidarity with my wife. This was the proof of the real love that unites us and that has lasted fifty years. Real love for the person who is loved is like real love for art: it never has an end and is always new. Common ideals unite us indissolubly, because real ideals, those that we try to make real through difficulties and sacrifices, do not die, they are always alive.

I was able to begin collecting again because I had finally been freed of the debts for my sad business affairs. Whoever believes that real estate operators are just speculators is completely ignorant about it. I am not very good in business affairs and certainly there are others far better than me, but I do not think there are many of them. Another positive factor was the payment of the last installment for the eighty pictures I sold to MoCA in 1984. The final payment had been made a year in advance because an anonymous foundation had donated the money for completing the transaction. The MoCA trustee, Fred Nicholas, with whom I had always had friendly relations, asked me for a discount in the case of payment ahead of time. I suggested a further discount of 10 percent and he was amazed at my generosity, but I was only too happy that the museum's purchase was definite.

When I received the last payment from MoCA I had at last money to spend on art. I had finished all my other commitments and now I felt free. I no longer had money problems and could devote myself wholly to my passion, to my greatest pleasure.

My first idea was to fill a gap. I consider very important the Los Angeles artists who, in the second part of the 'sixties, developed researches into perception, light, and space. I had bought works by each of the most interesting

artists, but there were still not enough to give the complete picture. So this was why I bought various works by James Turrell, Robert Irwin, Doug Wheeler, Eric Orr, Maria Nordman, and Hap Tivey, a little known but interesting artist. The works by these artists are projects, drawings that will become visible and real when circumstances allow: difficult conditions to fulfill because of questions of space and the cost of recreating the works. These are museum pieces and difficult for the private collector. In my home in Biumo there are works by Flavin, Turrell, Irwin, and Nordman, but there is no space for other installations.

When I decided to donate 150 works to the Guggenheim I included these works under the impression that, with the museum's expansion program, there would be a greater possibility of constructing them. Unfortunately eleven years have passed since the donation and the results have not been very encouraging. Just one work, by Wheeler, was built during the exhibition of the Panza Collection in Bilbao.

We live in a period when Postmodernism rules, and this is exactly the opposite of an art of perception that requires thought, attention, and contemplation.

The life of a museum does not end with the present but continues through the centuries, and so I am sure that things will change, and it doesn't matter if I am not here to see the rebirth of interest in this kind of art.

Having completed documenting the art of perception I was free to make new choices. The artists I had bought in the 'sixties had had a fair success even though not yet the one they merited. However, they were already part of history. There were many of their works in the collection, so it was not necessary to buy more. Two artists were under-represented: Dan Flavin and Richard Long, so I bought various of their works imagining that in the future this would not be possible. But it was necessary to become interested in new artists who had just started their activity.

I was now in a situation completely different from that of the 'fifties, 'sixties, and 'seventies. Collectors then were violently anti-abstractionist. The intellectuals, or at least some of them, began to understand abstractionism and some critics were in favor of it; in fact there was a lively controversy between those favorable and those against. The few in favor made their opinions known forcibly, and some publications gave space to the new ideas. After seven or eight years the new ideas had become established and had found wider favor. Museums of modern art devoted important shows to new artists. The arguments with the opponents were still violent, but the best institutions made their choices courageously without bothering about the critics. There was an ideological affinity between my choices and those of the intellectual world involved with contemporary art.

This situation changed in the 'nineties. Most intellectuals have ideas different from mine, and it might be interesting to investigate the reasons. Intellectuals tend to be left-wing. There are fewer of them than on the right. Intellectuals write and talk but they have no power, because to be powerful you need money too. Power is in the hands of political organizations that generally are to the center-right, and money is in the hands of capitalists. This is why they are against both politics and capitalism.

This might seem an over-simplified generalization, which of course it is, and luckily the exceptions are numerous. Intellectuals are very jealous of their freedom of thought and do not want to be influenced, which is all well and good. It is fundamental to think by using your own mind and not that of others.

Intellectuals are often atheists. If you believe in God there is the risk of having to follow what the pope or priests say. A danger to be avoided. This is why the Church is looked on with suspicion. Automatic refusal is their prevailing attitude. Obviously the society we live in is not perfect and there are many things that could be improved. Sadly, there do not exist perfect societies on this earth. We just have to accept that ours is less imperfect than others and work toward its betterment. We are lucky to live in a society that is less imperfect than others. This quite commendable intolerance of imperfection is very strong in intellectuals. But intolerance, when it is overdone, can produce strange effects. The first is faith in utopias. Mankind, if it wants to, can be happy by eliminating evil. Evil is egoism and belongs to those who have, not to those who have nothing. By eliminating those who have, you automatically obtain happiness for everyone. This is important. There only exists one life and that is our own, so we ourselves must be happy now, not when we die, as Christians believe. Unfortunately the application of these principles has produced a result different from the one hoped for. Russia and China, among the most important countries in the world, have had to abandon their utopia. Not because of outside pressures but because of a natural crisis in the system. For many this was like the end of a religion. The disappearance of a basic aim in life. The death of hope. Ideology is a lighthouse in the night. It is something to be reached for. If ideology dies then everything else dies with it. Life no longer has an aim. This is the philosophy of Postmodernism. Everything has the same value as everything else, no ideas are better than others. This is a theory of emptiness. Truth does not exist. It is useless searching for it. What had to be said already has been said. The only true thing is survival. Money is necessary for this. In front of such a situation suicide would be the logical solution. In order to commit suicide a great energy is needed to overcome the atavistic instinct to survive: strong dedication, a great sadness, desperation.

Living in a wealthy society that supplies us with all we need and where there are few risks, it is difficult to become desperate since it is easy to find your own role in the power system and live in comfort. If we add all this up, then refusal, the end of the ideology of equality, widespread wealth, the lack of risks, and an easy life, results in Postmodernist art. This is very popular as it shares an attitude with the rest of society. The basic character of the current situation is a lack of fundamental values; those that there were had feet of clay and have died.

Art is always the expression of an idea; if one does not exist then art cannot be created, and if it is mistaken then good art cannot be made.

The philosophy of Postmodernism is the exact opposite of my own. I believe in God, and by believing in Him I believe in the existence of a truth that cannot be proved mathematically but only sensed. It cannot be possessed and has infinite possibilities of expression, all partial, and that we can see within ourselves and in nature. We may not be able to possess it but we can get near to it. The aim of life is toward a higher state. It does not matter if we cannot see it with our own eyes because we will see it completely when we no longer have eyes; we cannot know how it is, and so be it. We can only hope that it will exist because our life is for goodness and not for evil: death is the extreme evil. If life is a progress to an infinite goodness, then art is the representation of this slow progress and, like life, it is a slow progress from the simple to the more complex, from single-cell organisms to our brain. Art's task is to discover new possibilities for representing our being.

The art that came into favor after 1975 is Postmodern art and so is completely different from my way of looking at life. The art that has become popular is not all the art there is, but the art that is different from it has been marginalized.

I have bought works by a considerable number of artists that I think are of the highest quality, and I have been buying them for many years, from 1989 until today: fourteen years, a long time. In the past a good artist could become well-known in such a period of time. But, except for Martin Puryear, the others have had problems in making a name for themselves. I keep asking myself if I am the one making mistakes or if it is the others. It just doesn't seem possible to me that so many intelligent people continue to be mistaken. This doubt worries me at times, but when I make comparisons I no longer have any doubts. The best system for discovering the truth is to stand in front of two paintings and make comparisons to see which one is the best. Beauty cannot be defined by concepts but by feelings, and this makes the difference obvious. Probably my particular mindset does not let me appreciate different kinds of things. I am fully convinced that great art, at times even the very greatest, can be made from representations of negative things but only when this negativ-

ity is experienced to its very depths and to its inevitable consequences. Negativity becomes, as a reaction, the reflection of the positive. It is said that the society we live in is very tolerant toward art and different ideas. But is it tolerant because it is indifferent and avoids making choices. Everybody does the same as everyone else. Society is tolerant toward what in the past would have been scandalous. Many intellectuals are not aware that they are giving their approval to artists who are doing nothing really new, just variations on the same old subject. These are all figurative artists, while those I prefer are all abstractionists. Abstraction was a novelty invented a hundred years ago, while figurative art dates back some 2,500 years. Abstraction has a potential that has only just begun to be known since we are still at the beginnings. It has millennia in which to evolve. Its ability to change and express new ideas is infinite. Figurative art is easy to understand, it gives immediate satisfaction to the ignorant who then think they finally understand contemporary art. If so many people think they understand, then the works are sold more quickly and more money is made. So finally the age when artists die of hunger has come to an end. Abstract art represents the new discoveries of science over the past two hundred years, discoveries that have changed our life and will continue to change it. It is up to us to use these new means for the sake of the common good. Our conscience is always the arbiter of our fate. The choice between good and evil, beauty and ugliness will always be a challenging problem. The underlying aim of human life is ecstasy, infinite happiness, when being rises above itself. In the splendid immensity of creation our life should be a preparation for this rare and difficult state. But art, instead of being the best preparation for it, is usually only a surrogate.

This is the belief that has always guided my choices. Today as in the past, if every human being wishes for happiness, then art will be found to be a means that never fails. There is the possibility that the artists who have been marginalized by the fashion for a different kind of art will find themselves permanently in this situation. Sadly only the artists who are widely talked about exist, not the others. When one way of creating culture dominates, it will inevitably reach a saturation point, as happens with fashion, and in that moment everything can change, even quite rapidly, and then the values that have been shunned are retrieved.

In 1989 there were various lines of inquiry that I found interesting with rich possibilities for development. I thought there were basically three: the first was the art of living forms; the second, color research; the third, small-scale objects.

There is, though, something else to be taken into consideration for understanding the differences between the art of the 'sixties and 'seventies and that

235

of the 'eighties and 'nineties. This is the question of the date of birth. Minimal and Conceptual artists were born at the end of the 'twenties or during the 'thirties. The artists working in the 'eighties and 'nineties were born in the 'forties and 'fifties. As we all know, a new generation always rejects the preceding one. It has to be different in order to assert itself, which is just as it should be. It has to show new ideas, as long as they really are new, and give its contribution to the development of knowledge. An extremely difficult thing to do.

If what is "different" contains no new ideas, then it easily becomes the remaking of art already seen a hundred years before. Figurative art showing a situation and a society that was breaking up. A hundred years ago figurative art was used for historical subjects, for the battles won by Napoleon, for frivolous worldly scenes, for showing the poor and the workers. A seductive Venus about to bathe was always a great success too. Today the representation of similar subjects is heavily realistic. Completely different from that of the Impressionists who discovered the importance of color and nature. Now a plunge into society seems to be the aim, as well as to create an art that can be understood by everyone. The artist has to dirty his hands in the surrounding mud. But if you don't wash your hands they stink. This is what has happened with a lot of art that tries to involve itself with current problems.

It is very difficult to create an evolution in awareness; rapid success does not come about easily, and sadly there is also a preference for the ugly rather than the beautiful. Perhaps this is just a way of opposing a system that does not allow us to live better. It would be more useful to give people art involving the best instincts of a person rather than those rising from the gut. Luckily there are still many people who love beauty and do not want to dirty their hands. They have no way of making their voice heard: those who have dirty hands have dirtied them with power, even intellectual power.

MARTIN PURYEAR
WASHINGTON D.C., U.S.A., 1941–

I had seen the art of vital or "living" forms some years earlier, in, I think, 1979. I had seen Martin Puryear's sculptures, and they struck me a great deal. He was just at the beginning of his career then. He is an African American. For many years I had been collecting African art before it had become influenced by the West. The way it used wood made me feel the presence of the unknown forces existing in nature. The forms were not geometric and rational but followed the twisting of living and growing things. Puryear lived in Chicago, and in 1979 I had to go there to visit the museums, so I asked to meet him and see his work and studio. It was in the city outskirts; it was fairly gloomy and of

medium size but highly evocative. The sculptures seemed to revive the magical power of the witch doctors of the past. An unfathomable but benign power. These were the years I was having financial problems and could not buy art, so I was deeply upset not to purchase anything. I had to wait until 1990 in order to make up a part of what I had missed.

It is interesting to see just how I made my purchases, rather late but still just in time. I saw a very beautiful show by him in the Margo Leavin Gallery, Los Angeles, in the 'eighties, so I still wasn't free of my debts. There were about ten beautiful sculptures. I think they cost about 25,000 dollars each. I was obliged to look at them with enjoyment but not to buy them. This was a superb and moving show.

In 1988 I was finally free! My finances were in order, I was out of debt, and I could buy whatever I wanted within certain limits. My first thought was to buy something by Puryear. The works I had seen in the gallery had been sold, but the Donald Young Gallery, his main dealer, should have had some works still available. This was an excellent gallery doing a first-class job, and I had already bought some Flavins from them. They had but two very large works available: *Shrine* and *Desire*, dating from 1985 and 1981. I bought them at once since they were just perfect for Biumo. *Desire* was the perfect size for the big stables, but the price was also big: 60,000 dollars each, a figure I had never paid in my life. In 1960 I had spent 6,000 dollars each for works by Rothko, and it had been incredibly difficult to get hold of the money: in fact I paid in installments and also had to sell some less important works. The situation, though, would not crop up again and I couldn't lose the sculptures. I was lucky enough to have sufficient money, and my wife also wanted the works. This was in April 1988. The following June Donald Young offered me another important work, *Some Tales*, 1977, which was in six parts. This too was a large-scale work, very beautiful and important from his early period. Unfortunately this cost even more: 78,000 dollars. I bought it at once without asking for a discount.

Word then spread among the galleries that I was interested in Puryear, but as there were no other works on the market this led to nothing. Then, in April 1991, while we were in New York, I had a telephone call from Craig Cornelius who asked us to come and see something very interesting. In fact he had an amazing blue-painted circle, *Cerulean*, 1982, of medium size, far smaller than the ones I had bought before. It should then have cost less; instead the price was 70,000 dollars. My wife insisted I buy it, and so once again I broke my rules about how much I spent. The following year, once again through Craig Cornelius, I had further news: the Drysdale Gallery in Washington that in the past had sold works by Puryear now had something else by him. We went to see what was a small but high-quality work, *Untitled (Dyed Pine)*, 1975. A work

from the period when I had gone to see his studio, but the price had gone up: 75,000 dollars. This was the end of my hunt for things that were so difficult to find. The following year I was offered another work of the same size, though perhaps not so beautiful. It cost 90,000 dollars. I declined since I had by now gone well beyond anything I had ever paid in my life as a collector. I saw the same sculpture the following year in the house of a man from Washington who had a heterogeneous collection. The work really was something apart, quite distinct from the other pieces. What a loss; there are so few works by him on the market. In 2002 two were sold by Sotheby's and Christie's at ten times the price I had paid, after making huge sacrifices.

He is a great artist, and in the meantime others have realized this too. Unfortunately Puryear has never had a show in Europe and so is not well known here. I donated the two largest works to FAI and they are exhibited in Biumo. They should be the biggest attraction in the house, but people do not know it.

So I managed to buy five important works at a high price, but reasonable all the same. At current prices I couldn't buy anything, but what had been the biggest effort of my life has been amply repaid by the joy of having some masterpieces.

This was my first step in the search for the art of vital forms. Martin Puryear's art is of great importance. It is the first time that two such different and seemingly opposed cultures have been united to create works of the highest quality. He is, I am convinced, one of the greatest sculptors of the twentieth century. He shows the possibility of non-Western cultures to create art as they did in the past, before European influence ruined a traditional system.

Puryear is descended from Africans who have lived in America for generations. He demonstrates that what today seem unbridgeable differences can, in the future, be reduced and disappear, giving peoples passing through difficult periods of transition the hope of a renaissance.

DEALERS

Part of the works I bought by Puryear were obtained through Craig Cornelius, a highly competent and sensitive person, and very well informed about the New York art scene. He is interested in the thousands of new artists and knows which ones are worth following. At the end of the 'eighties he had a gallery on Fifth Avenue, near downtown, where rents were low. He sold young artists who had low prices but were difficult to sell. He had the courage not to sell commercial stuff, the Postmodern art that is so popular today. But, as he was not inclined to make compromises, he had to close and now works as a private dealer.

I bought from him, apart from Puryear, many works by Stuart Arends, his small cubes painted with tremendous imagination and sensitivity, and many works by Ford Beckman. He took me to see his studio, which had in the past belonged to Brice Marden, a house on the corner of the Bowery where many artists had worked before becoming famous.

Another of the artists whose work I bought from Cornelius was Jonathan Seliger: he creates exact imitations of objects that are used and thrown away, containers of all kinds, printed with advertising slogans. With just a light, almost imperceptible change, he can make them into extremely beautiful things.

When in the 'nineties we would stay in New York a month at a time, in spring or fall, Craig Cornelius would take us on long trips to artists' studios, though they were not all equally interesting, but at least it kept us up-to-date on what was happening on the New York art scene. Because of my illness and the commitments in Biumo, Gubbio, Verona, Sassuolo, and Rovereto, I have not been to the States since 2000, and this is a great loss.

My life has entered another phase, no longer the search for new artists but one for new spaces for showing other artists. I am eighty and so this is a difficult task, certainly one that will not be concluded by me; so my children will have to see to it.

Another important person I met at the end of the 'eighties and the beginning of the 'nineties was Mrs. Dudley Del Balso. She looked after the affairs of such artists as Therrien and Barry X Ball. I had met her when she came to see the works by Judd installed in the show in Düsseldorf, works that had all been constructed in that period. At the time she also followed Judd's interests, but later they parted. She gave her approval to the way the works had been constructed, apart from some details. She was a refined, kind, and competent person. She came to collect us to take us to Barry X Ball's studio on the other side of the river. In her company this was a very enjoyable trip, and visits to Barry's studio are always interesting.

Two dealers were very important for the collection: Eric Stark in New York, and David McAuliffe in Los Angeles. They have devoted their lives to promoting an art that was new but unfashionable. They accepted all the difficulties that such an art causes, with the resultant sacrifices in going ahead with a task that earns them little, at most their survival without glory. This is what anyone must accept if they are involved with an art that is widely rejected now but that, within a few decades, will be in the history books explaining the art and history of our times. What is successful now will be forgotten, as has always happened.

Eric Stark promoted the art of color with works by Winston Roeth, Phil Sims, Ruth Ann Fredenthal, and Michael Rouillard. His is a gallery that has

had to fight to survive, and recently he has had to give up in the face of diffi-
culties too great for him. At the end of 2002 he had to close his place in Chel-
sea and work as a private dealer. The crisis brought about by 9/11, 2001, has
reduced the possibilities of many collectors.

David McAuliffe's Angles Gallery in Santa Monica has shown many of the best
West Coast artists of the 'nineties: Robert Therrien, David Simpson, Ross Ru-
del, Gregory Mahoney, and Robert Tiemann. McAuliffe too has been damaged
by the crisis of recent years and has had to exhibit more salable artists, thus
changing the gallery's artistic program. I know about the problems of a large
family, as I have five children and also some problems with my health. In life
there are priorities and needs that oblige us to make certain justified choices.

It is a great blow for art when the most intelligent galleries, ones that do
not work for money but for the best in art, are obliged to close down their ac-
tivity, the most useful one for the future.

This is a demonstration of how grave and widespread is a negative vision of
life and, therefore, of art that is the direct expression of life.

PETER SHELTON
TROY, OHIO, U.S.A., 1951–

The second artist who creates sculpture with living forms is Peter Shelton,
whom I saw in the Louver Gallery in Los Angeles in 1989. Actually I had come
across him some years earlier on the advice of Julia Brown, a curator at MoCA
who is always on the lookout for what is new. I had discovered the Los Ange-
les artists who use light, space, and perception through Robert Irwin, while
Julia Brown was very useful in pointing out to me the most interesting artists
of the following generation.

Peter Shelton is involved with research into more organic forms. His work
gives the sensation of seeing something almost alive, a material in which
blood has just stopped flowing. Despite this they are not anatomical studies
of the human body; there is just the sensation that they might be. This am-
bivalence between carnal reality and living abstraction is what fascinates me
about his work. I bought many painted plastic works. This combination of
painting and sculpture is characteristic of many artists of the present gener-
ation. Once again sculpture is being painted as in the Middle Ages or in an-
cient Greece before Phidias. Sculpture from the Renaissance up to the present
day was left unpainted as the result of a misunderstanding: the very oldest
sculpture was unknown and Medieval sculpture was considered undeveloped.
So-called modern sculpture had to be made from perfectly white marble or
else bronze in order to stand outside without being ruined by the weather. It

had to represent the human figure. Our body was the most beautiful thing in the universe, the supreme model. The concept of beauty was not an idea but the imitation of a real model, and beauty was shown as a hypothetical reality. This was a restrictive concept of beauty. The forms of sculpture can be extremely beautiful in many other ways. So when you enter a room with works by Shelton you do not have the idea of entering a butcher's shop. Organic unity underlies these works, and the forms are not a realistic description. They are an image of life, not physical life.

Shelton has been successful since I first saw his work at the beginning of the 'eighties. He had a small studio smelling strongly of solvents for use on plastic. This was the material used for many of his sculptures.

In the 'nineties he was able to build himself a very large studio home above Malibu with a stunning view of the Pacific. He lived there with his beautiful Japanese wife who worked at the Los Angeles County Museum as curator of Oriental art. She mounted a beautiful show of marvelous Japanese kimonos. His seemed a completely happy life, but recently I received a sad letter from the artist telling me of his divorce and the sale of his house. I hope this bad news doesn't have an effect on his work. But then at times adversity can stimulate us to do better.

The development of this kind of sculpture is recent, and nothing similar exists in the history of art. At the end of the sixteenth, and more throughout the seventeenth century, great interest developed in still-life. This development had begun during the Renaissance when attention could be concentrated on nature. Until the end of the fourteenth century, art's function was mainly religious. The basic preoccupation was judging man's actions: he would be saved if he was good and eternally damned if he wasn't. If he died prematurely it was necessary to be ready.

A decreased interest in the future made possible a rediscovery of nature and all its gifts. In seventeenth-century still-lifes we can almost taste the fruit and the flavor of the meat, smell the flowers. Obviously no one feels hungry looking at Cézanne's apples. This comparison has its sense. In 1863, with the birth of Impressionism, there began a process of idealizing reality, and the way of considering and understanding it became more important than possessing it. This process continued with the Post-Impressionists, with Cubism, and finally with Abstraction, which opened up new fields of inquiry.

Rembrandt's famous carcass of beef, 1655, is not an image of living nature, as all still-lifes are by definition dead: you don't see any living animals. Only through this process of idealization is it possible to separate formal and life-like representation from its more substantial, energetic nature, which animates and gives life to representation.

241

ROSS RUDEL

BILLINGS, MONTANA, U.S.A., 1960–

Another interesting artist who develops living forms is Ross Rudel. Different from others following the same path, he creates small objects. The basic interests are the same but his forms are more abstract, more newly minted. He gives a craftsman's attention to detail. These are works that have to be looked at for a long time: they are small but as full of meaning as large-scale works. When installed each sculpture must have a lot of space: they take up more than you would think. They have a greater or lesser resemblance to human organs and at times are concerned with eroticism. Eroticism too is part of reality. If sexual attraction disappeared there would no longer be life on this earth; we would all be dead. When its aim is generation then its existence is indispensable: sexual pleasure is necessary for life. But this is quite different from sexual freedom, something the Postmodern generation has not understood.

This research into vital forms is an absolute novelty in the history of sculpture, as I see nothing similar in past art. This is an evolution that explores unknown aspects of the reality we experience. It means understanding the origin of life, perceiving the energy that gives life to the activity of our mind, the seat of awareness. We are animals living in the company of many other animals. Fate has willed that our front limbs lengthened and produced hands to cling onto branches; fate has willed that our thumbs could press against the other fingers to be able to create utensils. The art of vital forms represents the energy that created the world and ourselves. If at the bottom of things there is only energy, then vital energy is its most intelligent and, therefore, most important form. If geometric Minimalism explored the power and richness of intelligence, shown in a rational form created by our mind, then forms of vital art represent the energy that comes from our mind and makes possible the existence of the human intellect, and this is why it is such an extremely important art.

I have known Rudel for many years, since 1991. I always see him alone, but never sad, and at times he can be very entertaining. Recently, when installing his works in a room in the Rovereto museum, MART (Museum of Modern Art of Trento and Rovereto), he told me a funny story about a chicken, showing us a photo of it, while we were dining with other artists.

Art is work, a total involvement that does not need other people's affection. He has moved out of his small studio under a lean-to roof full of machinery for carving wood, but I haven't yet seen his bigger, more comfortable new studio.

I have also met his parents who live in a town far from Los Angeles: straightforward and friendly folk, but they could not understand why they had a son

who was an artist and made such strange things. They were reassured by my judgments on their son's work and of the future of his art.

Someone might say, though, that vital-form art is not really as new as I am making out. When Michelangelo sculpted a nude, underlining its musculature, articulation, and veins to create the Vatican *Pietà*, 1499, he was doing something similar. This was the form of a body but one that had once been alive. The difference between this and the recent artists is basic: it is not a case of studying anatomy, describing a human body inside out, but it is the representation of the energy that models life and that can have an infinity of forms, not only among animals but vegetable life too, and here the freedom of invention is even greater. This is the energy that every spring causes leaves to grow. So these artists invent and interpret: they do not copy.

ALLAN GRAHAM
SAN FRANCISCO, U.S.A., 1943–

Another artist who can be included among those interested in vital forms, Graham lives in New Mexico. This is a state in the American southwest where there are the most Native American reservations, and the indigenous communities have maintained their traditions, above all their interior life. We have the habit of considering cultures inferior that differ from ours and that have not developed scientific research and technology. This is a huge mistake. In some cases they are superior since they have a religious respect for nature, believe in her strengths, and know they have to submit to them. This is the very opposite of what we do. We are atheists for the most part and we ignore nature. We exploit it in our own interests and don't think for a moment that nature is our great mother. We must all die; in fact thanks to medicine we can live longer.

Allan Graham's pictures, above all those painted between 1984 and 1990, represent a complex reality that has a disturbing sense shown in contorted forms. Western man feels he has left his origins too far behind; he knows he has lost the truth and cannot be serene unless he finds it again. The pictures from the 'eighties express this anxious search for harmony. But many of his works are not just pictures with twisted forms, but sculptures with broken shapes as though destroyed by violent inner forces. To these destructive forces he opposes a base that holds together the parts in conflict, and so, on the point of destruction, they are held in harmony.

In order to describe the content of Graham's work it might be a help to describe what he had in his house when he was living in Albuquerque, New Mexico. He had built a cylindrical room some five meters below ground. It was

open to the sky. It was possible to sit at the bottom, and it was large enough to fit inside comfortably and look at the sky. It resembled one of the rooms the Indians used for prayer and meditation: it established a relationship between our mortal body, which finishes below ground, and our soul, which searches for the infinite life of heaven. The artist's work stands between these two extremes. He became more thoughtful and less torn by opposing forces in the 'nineties, and created forms that express a more conceptual and serene vision.

I venerate the act of painting, which is unique and unrepeatable: it is the presence of a state of grace lasting just that one moment and that will never ever be repeated. Allan Graham's painting *See of Dreams*, 1988, is very large and was painted on a canvas that had been stretched on a warped frame, and it had lost some paint in certain parts due to an error during its preparation. These losses continued to increase over other parts of the painting. I hoped that if these parts were restored, no further intervention might be necessary. It was necessary to invite the artist to Biumo to find out the causes of the damage. This decision greatly disturbed and worried me: I risked losing a work of art that was unique and unrepeatable. But my worries did not of course resolve a problem that continued to grow. I have always had a reverential respect for the work of art as an object. When I hear about some breakage or accident I always anxiously rush to see what has happened. Luckily these problems do not crop up too often. Very few works have been damaged in the past fifty years, though there are hundreds of them on show around the world, and those few have been perfectly restored.

The artist came to Biumo with all the necessary tools, he quickly scraped away the painted surface as it had not adhered to the canvas in the technically correct way. He completely repainted the picture in a relatively short time. *See of Dreams* went back on the wall as beautiful as before. I couldn't make out any differences: it had been repainted in exactly the same way.

This makes me understand how Leonardo da Vinci, together with Ambrogio de Predis, painted the London National Gallery version of the original *The Virgin of the Rocks*, 1483, now in the Louvre, without second thoughts. They are two marvelous works, and it is difficult to see a difference in quality between the London version and the one in the Louvre. Obviously what is important is not only the act of painting but also the picture's conception: a concept that is to be represented can exist independently of the physical act. As Conceptual Art teaches us, the idea is the most important thing.

Allan Graham, because of his way of thinking, is a fully involved ecologist. He built his house with his own hands, taking a year to do so and interrupting his art for a fairly long time. Occasionally helped by his wife Gloria, who is also a good artist, the work was made easier by employing a new technique.

The walls are made of bales of hay plastered with untreated clay. These form an ideal isolation against the heat and cold. I have not seen the new house. The artist is a complete ecologist and drives a hybrid kind of car that he uses to cover miles and miles on just a gallon of gas. It is made of aluminum, as it had to be very light, but this is why it costs more than other cars. But this is an example of what can be done to save the world from pollution and to respect nature.

EMIL LUKAS
PITTSBURGH, PENNSYLVANIA, U.S.A., 1964–

In my collection there are some artists who have an affinity with the living form group. Perhaps the most similar is Emil Lukas. His is an art that dialogues with nature. Not the nature we see when looking at a view, but the one that almost always escapes us as it is small and hidden. When we see it, perhaps it irritates us, and we tread it underfoot. This is the world of insects, these also living creatures. If we overcome our distaste and look through a magnifying glass we discover another world. At first sight it might be repugnant, but once we get used to it we see the beauty of organisms adapted to their own form of life. The female beauty that we so admire has, in fact, precise functional characteristics: procreation, nutrition for children, and the energy to bring them up. Another aspect of Emil Lukas's art is his attention to what we consider "dirt." Wine marks on a tablecloth, stains of tomato sauce on napkins, mud on shoes. We despise so many aspects of the small world immediately around us and think they are of no importance, and this is why they annoy us. If we look at marks of wine on a tablecloth we actually find beautiful colors: dark red, lighter red, and around the mark spread beautiful shades. The same can be said for an infinity of things that we do not look at. The artist does not use dirty tablecloths or unwashed clothes. But he transforms this humble and hidden reality into something noble in order for us to understand. Perhaps this is why he wants us to have difficulties in viewing his work. Marvelous drawings are hidden under separate layers of painted plaster that have to be removed any time you want to see what is underneath. I have no idea how to show them in a museum for the public to see. It is impossible to remove objects from those underneath a hundred times a day. These layers form columns that can be dismantled, but they are heavy and easily damaged. This is part of his way of thinking, to hide what is already hidden. You have to make an effort to see it.

I met the artist through Craig Cornelius, the tireless searcher for new things. He had a studio in what was once the infamous ghetto of Harlem. I

had seen it for the first time in 1954 by mistake: I had taken a wrong direction on the subway. I should have gone to Wall Street but found myself at the opposite end of town where everything was black, including the inhabitants. They looked at me sourly: the only white man in a hostile place. I immediately took the train in the right direction.

By 1993 things had changed. Many houses had been restored, the uglier ones demolished, the streets were clean, and it was a sunny day. I had no impression of hostility or latent violence. Emil Lukas's studio was fairly large, kept in order, and the works could easily be seen. It was interesting to hear his explanations of what he was doing. In one corner of the room was a pile of things to be thrown away: cloth, paint, paper, all soft things that could then be welded to other similar materials with plaster. An unusual operation. When he had finished his layers he would then cut them into slices, and it was fascinating to see the result of all these things together. This was the record of a day, the residue, the life of a day. The stratifications were undoubtedly beautiful.

For some time now Lukas no longer lives in New York but in Pennsylvania with his family. He works there at about two hours' distance from New York. He lives in a perfectly old American house in an old American town. It is near the countryside in the middle of nature. The house is surrounded by a large garden necessary for both his temperament and his art.

When I met him some ten years ago, he was a young artist. But time passes quickly: he was once the youngest artist represented in the collection. He is still very youthful looking, tall and thin, and moves about nimbly. His eyes are clear, ingenuous, and thoughtful. He has a wonderful wife and a son who is just as attractive, though he must have grown a lot since I last saw him. When I first arrived in the house Lukas referred to me as "Doctor," and his son ran away shouting. The day before he had been to the doctor, who had hurt him.

It is characteristic of all the artists whose work I have collected over recent years to pass a simple domestic life, and to have a sociable and relaxed character without apparent neuroses. They are quite different from the artists of the 'fifties who were big drinkers, as alcohol was necessary to stimulate their creativity, with the result that they often died before getting old. They knew they had something new and important to say, and they had to break down the barriers put up by American intellectuals who preferred to take an interest in Europe. They had to overcome isolation and a sense of inferiority. But at the same time they felt they were the harbingers of a new message.

The generation of the 'sixties was very politically orientated. There was the war in Vietnam, and they were in revolt against everything at all levels, above all the system handed on to them by the previous generation, resulting from the 1929 financial crash and the Second World War in which they had risked dying. So

there were hard times that imposed a hard moral discipline. It was necessary to win the war and overcome a powerful and imposing enemy. In the 'sixties less alcohol was consumed but on the other hand more drugs were taken.

In the 'fifties sexuality was curbed, but in the 'sixties there was sexual freedom. Many marriages instead of lasting broke up. Artists were engaged in politics but, luckily, this was not translated into their art, which remained sacred. They had more important ideas to express. Politics were something related to the makeup of society. Marxism had dominated politics for a century. In a post-industrial society it was no longer relevant, no one spoke about it, not even in developing countries that, in fact, would have had good reasons for making use of it.

The artists from the 'nineties collected by my wife and me do not follow Postmodern philosophy. They are not protestors and are interested in politics just enough to keep themselves aware of what is happening around them. Above all they do not involve their art with it, since when that occurs art disappears. They follow moral rules, have a family, work where and when it is necessary to work, for art doesn't pay much. They do all this quite naturally, as they consider we are all workers even when we use our head instead of our hands. They work keeping their mind on their work, which, after all, is work and not some condition that ought to be looked up to. I have no idea how Postmodernists behave, since I do not know any of them and do not collect them. This, as I have said, is a philosophy that rejects universal and absolute moral laws. Their basic law is that of self-interest, their norms of life are established by the social and political context, so if you do not like the society you live in, then it is right to reject it. Protest is something important, as is not knowing better ideas: this becomes the main theme of art, which in turn it destroys.

LAWRENCE CARROLL
MELBOURNE, AUSTRALIA, 1954-

Lawrence Carroll is quite a different artist. His aim is to share in the life of man, of humanity, and of its sufferings. The individual lost in the metropolitan crowd. The sadness of solitude. The need for love. The existence of those rejected by society and who do not have the strength to compete with others in order to exist. On the edges of the cities in America are districts as large as cities, inhabited by society's rejects: drug addicts, alcoholics, the mentally afflicted, blacks who are unable to be part of the system. This is a part of humanity that lives by the force of inertia. These are people who are humbled by adverse circumstances and have lost everything, but they have not lost their soul. I of-

ten have to pass through these areas on the way to the studios of artists who have yet to become successful and who do not have the money to live in the more expensive quarters. It wrings my heart. I am moved and at the same time feel the greatest sympathy for them. Perhaps our affluence and well-being, our tranquility are paid by them. We are happy as a result of their suffering.

Many people have a miserable life through no fault of their own. And whose fault is it anyway, even for those who have made mistakes? There is no justice to make up for such sufferings that lie hidden in the unforeseen destiny of each of us. Where is there some hope for salvation? Lawrence Carroll is not a photographer, he does not describe the reality we see with our own eyes. He represents it in a more substantial way and arrives at the essence of reality where good and evil are hidden. Pleasure and suffering. To explore the invisible world of the soul, the unique and unrepeatable moment of existence. The metaphor for what we see before what is real becomes reality.

His colors—whites, grays, and yellow, more or less dark but even more often light—become marks and surfaces painted on canvas that is then attached to a wooden support, perhaps a crate found in the streets that is then turned into a three-dimensional picture. The colors and forms of poverty.

This is an art that has to be looked at carefully to discover its refined beauty hidden in among gaunt colors, flat, pale, and sad. Once it has been discovered you undergo a deep emotion; this hidden and unobvious beauty, a beauty without aggressiveness, throws out roots that enter into our being. It shows us an underground reality that is the primordial condition of our existence. It relates us to the others, to humanity, through what we do not see but experience.

I could compare them to the *Otages* by Fautrier that were painted during the war over a period of just a few years. Using elegant forms he represented the terrible suffering of those times when violence was destroying everything. In Carroll's work there is none of the elegant suffering of Fautrier, who changed his way of painting and living as soon as the war was over. Carroll's participation in the life of others continues: it is his life. And this is why the quality of his work is always of the highest.

Perhaps Carroll's work has an affinity with that of Rauschenberg's paintings of the 'fifties. For this artist the presence of reality transformed through memory is the main element. There are fragments of photos, writing, and newspapers. The difference lies in the preponderance of personal memories linked to his adolescent experiences when he opened his eyes in amazement at a life that already belonged to his past. A great value that had been lost could no longer be recovered.

Carroll has a great liking for the famous Italian painter Giorgio Morandi, who is not widely appreciated in America, an artist who passed his life from

the 'twenties until the 'fifties, painting a single thing: bottles. This is a modest even insignificant subject. But in spite of this he was a great painter. I share Carroll's interest in him. Here there are no heroes or overwhelming sadness, only domestic images of daily life. He was not interested in the great dramas but in the life of the many who disappear without leaving a trace but who continue to live. Carroll is a great friend, and it is pleasant to pass time with him and his wife Lucy, and they both enjoy good cooking.

When we meet to install his works in a museum he finds the best restaurants where we spend hours eating well and conversing enjoyably. In Italy there are still cities where food is still tasty, produced in a fertile soil with the best climate, and it can be enjoyed without damaging your health.

I first met Lawrence Carroll in 1992 when he was living in New York. It is interesting to describe his home, as this helps us understand his work. It was downtown near the huge bulk of Brooklyn Bridge, a few hundred meters from the skyscrapers of Wall Street, the center of world trade. Almost inexplicably a group of small houses had remained standing: probably the owner had not yet received permission to rebuild. In the meantime it was occupied by artists' studios. The rent was low as they were only being used temporarily. In order to reach Carroll's rooms we had to go through the studio of an artist who used wood, along a corridor between the planks. Carroll's rooms had no windows and were full of works in progress that took up all the space; only one room was empty, and he used this to store his finished sculptures. You couldn't see the sky, you couldn't see the city, even though skyscrapers towered way above. There was a strange sense of isolation and compression, as in certain nearby poverty-stricken areas. The works of art were in the right place, in their own environment.

When Carroll sends me a fax he always ends with three words: God Bless You. In my fifty years of collecting, he is the only artist ever to say goodbye in this manner. I think these three words explain better than a long disquisition who Lawrence Carroll is. To describe pain and suffering is difficult since you can easily become rhetorical and overemphatic, and feelings are exaggerated in the attempt to make them more evident.

This was a characteristic of social art a hundred years ago. There were pictures that described the toil of the farm workers, of miners laboring below ground, of children dying of tuberculosis, of shipwrecks in tempestuous seas with drowning sailors. The favorite theme was battles, usually during the Napoleonic wars where the heroic but wounded general died surrounded by his faithful men. A fine example for the young who had to learn to love their country. Artists and pictures now completely forgotten, though you can still see them reproduced in old history books where they were intended to remind

you of what you had just read. There still exist some museums of a hundred years ago that have remained mummified in the fashion of the time as their donors had willed.

The artists of the past who best expressed suffering were the German Expressionists between 1908 and 1920. Ernst Ludwig Kirchner, Max Beckmann, Otto Dix, Emil Nolde, and Oskar Kokoschka were great artists then, one of the most important moments in modern art. They sensed and experienced the tragedy of Germany and Europe between the two wars. They understood how the will to power was destroying all moral values and would destroy the people too. When the terrible will to power takes over those who think they possess it, then terrible wars come about. Nietzsche's Superman was about to be incarnated. The personality cult and its dictators was to destroy Europe. The Superman needs this cult in order to exert his power. This was the future these German artists intuited.

Carroll's work expresses intensely and efficiently the reality of pain because it sublimates it in a metaphoric representation of a situation that otherwise would be aggressive, wounding, and too violent to be shown. Today this task falls to newspaper and television photographers who are generous in informing us about so many things it would be better not to see. Carroll's subjects are not violent events, they are those of the sad life of people who cannot live like others for many reasons: vices, mental illness, character deformations, physical weakness, and often poverty from the sudden loss of an income and the difficulty of rebuilding a life. Misery has apparently disordered colors and forms that the artist makes use of, and art then imbues them with a new harmony that is amazing in its beauty. At least it is amazing for those who are able to strip away their own prejudices.

MAX COLE
HODGEMAN COUNTY, KANSAS, U.S.A., 1937–

Another artist who cannot be categorized is Max Cole. In her pictures there is almost nothing to be seen, there is no color, and they are without form.

There is an incredible amount of tiny vertical black lines, each painted next to the other, and all aligned horizontally. This is a work of great precision since corrections cannot be made, and if a mistake is made, the whole thing has to be done again from scratch. This operation is repeated thousands of times in each picture, a completely senseless job and unthinkably monotonous. In the past in enclosed convents, the nuns sewed marvelous and complicated embroidery, and it would take a year to create an altar cloth. The product of all this labor gave pleasure to those who saw it, it was useful, and

each was different from the others. Max Cole's pictures seem to be something useless, almost crazy if, that is, the mentally ill had the energy to undertake a boring, laborious, long task, always using the same gestures. Despite this her pictures are fascinating, and it is difficult to explain why. Evidently this cannot be an aesthetic pleasure as they are not beautiful. I believe an answer can be found by leaving aside usual schemes and by making use of metaphysical ideas that have an indirect connection with aesthetics. This tireless obstinacy in repeating the same gesture could be compared to a prayer, an invocation to our Creator for eternal joy: a condition we would like to arrive at and that, at times, we seem to grasp for a moment, but just for a moment. The sense of the absence of such a moment is so strong that we have to keep asking heaven for it.

When looking at Max Cole's pictures Art Brut comes to mind, an art produced by the alienated and mentally ill.

But when we make a comparison the difference is obvious. There is a rigorous rationality and a method running through all the artist's work. She has done the same thing all her life. It is not a labor that has lasted years but decades. And yet her paintings are always different and their power never lessens. At times the lines are close together, one almost placed against the other; in other works they are more distanced. They can be long or short. The horizontal lines consisting of the tiny vertical marks can also be nearer or more separated. Sometimes the background is white or dark red. And with this vocabulary of a few elements her language is practically infinite. The combination of these few elements creates ever different results: here we see the human mind's unlimited capacity for inventing new things. This intellectual attitude might make her work seem similar to that of the Conceptualists. These are certainly things in common, but Max Cole has something more. Her basic aim is not the exaltation of the power of thought, but a mystic and contemplative attitude.

Her scope is to prepare herself for something we do not have but that must arrive and that we hope to have. This distant hope is the justification for her work, and if it wasn't there she would have given up some time ago this senseless labor, maybe she would not even have begun. To do something so difficult, painful, and without aesthetic attraction, to create images that cannot give pleasure because they are without form and color, it is necessary to believe utterly in the existence of the unknowable from which everything derives, that cannot betray Hope; the expectation of infinite happiness that for her too is unknowable. In order to make these pictures you cannot be an atheist and believe that everything comes from original chaos, that the order we see in ourselves and in nature has no reason, no aim. Whoever thinks in this

way cannot be aware of the infinity of the blue sky or of the stars, and cannot put an infinity of lines one behind the other.

Max Cole's pictures remind me of another artist with a similar spiritual attitude. I am referring to Agnes Martin, an artist who painted with lines, grids, and with just a few pale colors. She painted with a Minimalist sensibility. She has nothing in common with such Minimalist painters as Ryman, Marden, and Mangold who make great use of gesture, material, and color. Her mind is concerned with the rarefied atmosphere of pure spirituality, and, this being genuine spirituality, her pictures have a powerfully expressive force. When looking at them you are deeply fascinated. You discover the beauty of something that cannot be reached. Something both distant and near. There is a precise formal order that creates a celestial harmony, and the viewer is reminded of that great fifteenth-century Italian painter Fra Angelico in whose work reality is transformed into an angelic presence, a heavenly reflection.

Sadly I was never able to buy any pictures by Agnes Martin. I saw them for the first time in the Elkon Gallery in 1967. They were marvelous. I was greatly struck by them: they represented her best period. These were difficult years for my work so I had no money and was forced to pass them by. They cost 700 dollars and now are worth 500,000 dollars. Obviously I can no longer afford them, but this is a great void.

It is amazing that in a period so desirous of success, money, and power, there are still people like Max Cole and Agnes Martin who think only of spiritual things.

GREGORY MAHONEY
LOS ANGELES, CALIFORNIA, U.S.A., 1955–

Gregory Mahoney lives and works in Los Angeles, but he is not a city dweller. He spends a lot of time in his van in the desert, and his favorite place is Death Valley, a deep depression in the center of California between two mountain ranges and on the border with Nevada.

It almost never rains. It is a complete desert. The air is quite clear, and at night the sky is filled with myriad stars and gives the impression of being at the center of the universe. The light is a radiation of our own star and is a beautiful thing. Perhaps it is the most beautiful thing in the universe and, in fact, is the source of life. Light creates vegetable life with the photosynthesis of carbon and oxygen: we eat the products of light. Gregory Mahoney's work is about the contemplation of the universe. It is impossible to represent the universe, but it is possible to discover a fragment of it that demonstrates its presence. In Death Valley there are, for example, the remains of machines used

150 years ago by gold miners who departed many years back. These scraps are worn by the sun's ultraviolet rays and are corroded with rust. They are a testimony to the slow process of time that raised the mountains and causes the erosion that has laid bare ancient strata that were once at the bottom of the sea. Millions of years of history are visible. The ground is composed of colors difficult to imagine when looking at our familiar nature covered with one color: green. In this desert the ground is black, white, yellow, ocher, red, and green.

The most interesting bits of wreckage are ball bearings, which, made of good steel, have resisted time best. The artist often uses them in his work where they allude to time, to the movement of all things, to the history of mother earth who seems immobile but actually always slowly changes.

At 230 meters below sea level, the lowest point of Death Valley, there is a lake of perfectly white salt. In the fall, storms from the nearby mountains fill it with water that then disappears during the summer due to the intense heat. This is another material used by the artist for its perfect whiteness.

Mahoney is a poet of nature, the nature that precedes life and that seems eternal. Another element that interests him is the Ocean. *Five Gallons/Five Oceans*, 1995, is about the immensity of the sea, which he represents by five little steel cubes containing samples of the water of each ocean and brought home from his travels.

The object of many of his works is the Continents represented by their outlines taken from a map and placed on a disk representing the form of the earth: the continents are white and the oceans the color of the material he often uses: steel rusted and corroded by the sun. Here is the presence of light, the sun, the air, water, and rain, which, in geological time, wears away and changes everything, and where the human presence has no importance. Nature is far greater and more powerful than we are. Its beauty is even greater.

Love for nature is the impulse behind Gregory Mahoney's art. This is a love he shares with other artists such as Walter De Maria, James Turrell, Michael Heizer, Richard Long, and Hamish Fulton whose work consists of the contemplation of its beauty and communicating this experience to us. This is a vision that is only possible when your own being becomes aware of the existence of a reality far greater than us, one that gives us life.

This is why we feel a link like that between father and son, mother and child. Nature is both mother and father, loving yet severe; it does not forget the offenses we inflict on its virginity, and one day it will make us pay for our sins and offenses, perhaps after generations, but the chastisement will arrive and will be severe. Those who love nature also love humanity and respect others. They love and respect all that is living because it comes from nature. This is

the message given to us by artists such as Gregory Mahoney. Never as in the 'eighties and 'nineties have so many artists forgotten their mother and interested themselves in aspects of life dominated by evil. These artists are successful, are admired by the public, critics, and of course the market, which is a demonstration of a deeply sick collectivity. One that has lost all ideals and has no high aim in life. If this situation is not rejected then our future will be ruinous.

FORD BECKMAN
COLUMBUS, OHIO, U.S.A., 1952–

The works Beckman created between 1985 and 1991 seem, though only apparently, to use a Minimalist language. His pictures have geometrical shapes. This reductive simplicity might make us think of a culture related to that of the 'sixties, but in fact the content is highly expressionist. The meaning is represented with violent force, even though this is held within a rigid form. This contrast increases the intensity of the result. Only after 1991 did his language change to a more informal manner.

I consider that the most expressive part of his work was produced between 1985 and 1991. In this period his works often have a standard format, four feet by four feet, or a multiple of it. The composition is usually a black square, at times white, around which is a slightly larger space painted in yellows, whites, brown-yellows, either lighter or darker. The dominating surface is the black in the center. It is a dense, tar-like black, without reflections and seeming to absorb the light. This is the darkness of starless night. It is what will be found not just at the end of life but at the end of the universe, an end without return, definitive.

The contour of the square is the color of the skin of the elderly, of things yellowed by time, things that have lived and still live and have not yet been sucked into the infinite womb of the void. The paint runs down the edges of the canvas. Dark yellow on light yellow, as though representing the act of painting. The presence of a living protagonist. The presence of the single, individual, and personal self in front of the great unknown of existence. At times the larger surface is white and shines with light: this is the return of hope, the expectation of salvation, final happiness.

In other pictures the part painted in yellow predominates: the yellow of time that passes, that consumes, that tires. A humble and humiliated existence hidden among the rest of the multitude with a common destiny. Beckman's pictures are painted on canvas glued to a heavy plywood panel stiffened by a wooden structure. The picture thus acquires mass: it is heavy and seems to

want to impose itself physically too. At times, beside the painted panel there is another, exactly the same size, of unpainted wood: this is matter, inert and lifeless, the passive acceptance of fate. His works are intensely evocative and their abstract language becomes a concrete message about our destiny.

The remote metaphor of abstraction becomes an eloquent representation that is difficult to express with other images that would easily become the chronicle of an event rather than a synthesis of reality.

I bought many paintings by \ between 1988 and 1991; since that period, when I followed his activity with great interest, I have rather lost contact with him.

His work has entered a new and different phase from the previous one. He exhibits less than before, but every so often I have news of him. I believe he has family problems. His wife is an extremely nice person who will help him out of his problems. Many artists have sudden and unexpected developments in their work. The collector who is interested in particular inquiries will be surprised to see different images from the ones he loved. A period full of emotion creating strong interior tensions does not last long but does use up a person's energies. Ford Beckman is a big man, as massive as his pictures. He moves energetically and nimbly. This gives me faith in a new springtime in his life and art.

ROBERT THERRIEN
CHICAGO, ILLINOIS, U.S.A., 1947-

Therrien lives and works in Los Angeles and is a sculptor who makes painted sculptures. His art is abstract, but the forms bring real objects to mind. These are transformations that an image undergoes when it is remembered after a long time. The details and physical characteristics are lost, but a memory of a concept, an idea stripped of its concreteness, remains. When we try to remember it we add more concrete details, at times adding something that was not there. This often happens with our childhood memories. We remember only the beautiful things, and luckily we forget the ugly ones. The beautiful ones are immensely beautiful saturated in colored light. It was the dawn of our life, the start of existence, the expectation of happiness. These memories are like the images in a dream, but only a few basic things remain in our mind, and we think of them with great regret. We are not able to relive that happiness. Therrien uses the instrument of memory, which alters reality while maintaining a connection with the real. These are the images of his childhood. A barn painted blue in the Midwestern prairies where he lived as a boy. Λ snowman, three superimposed bronze volumes were oxidized gold by the artist in order

to make snow into something precious. I could mention many other examples of how he makes an abstract form into a real-life object.

The inspiration for making sculptures is not only found in his distant childhood memories but also in objects of daily use or ones that are at least present in our daily life. The artist simplifies these by subtracting all that is unnecessary in order to give the object a symbolic value. He seems to return to the ideas that make things exist. It would be legitimate to refer back to Plato's philosophy where the reason for the existence of all things is the presence of a universal ideal that does not depend on contingency. This is an operation similar to that of the vision of some great artists of the fifteenth century who saw in reality the presence of a transcendent idea.

Therrien often uses the form of a great stone placed at the center of an arch. A form that disappeared some hundred years ago, since we no longer use stone to build with but reinforced concrete and steel. Arches no longer exist, but the keystone that holds that whole construction together has taken over this artist's interest: it is the symbol of a necessary reality. He makes this image in many ways with different materials, though they are always colored, painted or oxidized with new chromatic effects if they are made from metal. At other times the images are of an object of common use, such as the milk bowl used in the morning or in the afternoon for drinking tea. Milk is a primordial nutrient that gives us life when we are born. It is white, the color of purity: the slightest alteration of it is immediately visible. The object containing it can communicate the same idea as the things it contains. The bowl might be larger or smaller, spherical or as flat as a bas-relief, made from zinc, red or green wood, or it might be as gray as metal. At other times there is the image of a church with a sharp vertical form beside it pointing to the sky. Often he used the form of a casket, an obvious reference to death, but the colors are in no way sad. Paolo Uccello, the great Renaissance artist, translated Plato's philosophy into his images of battles; Therrien does something similar with images without heroism or blood but with the humble objects of daily life.

Some lovers of art history will feel betrayed and almost insulted by this comparison between a cavalry battle and a bowl for milk. But what is more true, the battle or the milk? Battles kill; milk gives life.

Therrien is a shy and reserved person with something childlike in his face, his movements, and way of speaking. His life is immersed in a reality quite opposed to a brutal and vulgar one. I went to his studio for the first time many years ago, I think at the beginning of the 'eighties. It was on Pico Boulevard, a poor and degraded area of Los Angeles. He still had very few collectors. The rooms were full of machinery for woodworking that created a lot of

dust, but everything was quite clean. A steep staircase led to a small room where he slept. It was painted white, but it was empty. There was a small crucifix on one wall. This represented his personality, his memories, his art.

MEG WEBSTER
SAN FRANCISCO, CALIFORNIA, U.S.A., 1944–

Meg Webster is a woman who lives and works in New York. She is an Environmental artist but she also makes sculptures out of copper, steel, and other materials. Rather than defining her as an Environmental artist it would be better to say that she makes large sculptures from earth, which, being very big, fill a whole place. Her real originality and uniqueness is to be found in the earthworks. Her constructions have a Minimalist simplicity. Earth is not a compactable material, so you cannot handle it to give it the shape you want. It is necessary to accept its limitations and its nature as an incoherent material. Ancient peoples created tumuli for burying the chiefs of their communities, and this is the basic form used by the artist. Her tumuli though do not make us think of sepulchers and death but, rather, of our mother—nature that feeds us with her fruits and who will then accept us in its depths when we have ceased to exist. This is an homage to its silent and humble presence. It has always existed. It has provided the nutrition for the generations that have lived and died. We forget its importance, but without it we could not live. It is the silent witness of this strange, almost incomprehensible, event of being born, living, and dying.

Meg Webster uses earth to create her art. This is something unique, and I do not remember anything similar in the past. The forms are simple of necessity because of the nature of the material; they have some kind of relationship with the large-scale sculptures of the 'sixties Minimalists. There is also some affinity with the Land Art of the same period, which discovered the beauty of nature and sought a way of appropriating its power through interventions that were an almost invisible presence that respected its sacredness. Her work is almost always placed inside, not outside; it is to be found in cities, in the middle of an artificial life, far from nature, and this is why it bears such a significant message in comparison to the environment in which it is placed.

The artist also creates some outdoor works that are covered with vegetation, grass and flowers. The earth's presence is hidden by living vegetable life; the form becomes the main element. It is the transition of life's potential to the actual presence of life.

Some years ago I saw a marvelous work by her in the garden of a collector from Houston where there were already other works of the highest quality,

works similar in taste to mine. It was in the form of a great funnel covered by a special grass only to be found in Texas. I seem to remember that the collector's name was Klein.

In the house in Biumo she created a work in the form of a cone with the top part cut off, *Slipped Cone with Flat Top*, 1993. It is a work I really like, but visitors to the house are not used to seeing earth art: it is something new, and the new always provokes suspicion before it is understood. The work took a long time to make as we had to find the right kind of earth. A sample was sent to the States for the artist's approval. It was constructed in successive layers, each one damped down with water and then stamped on in order to make it compact. The huge mass then had to dry: six months were needed, but at the end the result was outstanding. The artist approved the photo, and I hope she will come to see it. It is a permanent installation in a museum.

An interesting development in the 'eighties and 'nineties was the attention paid by some artists to small-scale objects, and the rediscovery of making things with the hands and, above all, the fingers. This was the reverse of the principal interest in the 'sixties and 'seventies with Minimalist sculpture and Environmental Art. Of course this is nothing new. The illuminated books in the Middle Ages and the Renaissance were marvelous examples of love for books, the means for transmitting culture and knowledge. Creating on a small scale was aimed at exalting the beauty of knowledge. Obviously an interest in what is small expresses an attitude based on intimacy, the private, the individual: there can be no statements of a general or collective kind. It is the small world on our table that keeps us company when we write, read, or think. It is a silent witness to our life.

This is an art with very distant roots, above all in northern Europe. The "Wonder Room" was the pride of princes, full of tiny precious things. Articles that needed a long time to be made. The artist had to work with a lens and sophisticated tools for miniaturizing the work to the utmost. When you see these tiny objects you are overcome with wonder. A large collection could be placed in a bag: it was an easily transportable art. Perhaps the long cold northern nights favored a work that had to be carried out in the house, on the workman's own table, and had no need of princely dwellings in order to be appreciated. It demonstrated a preference for the private, the individual, and personal to the visible and public. This art has become relevant especially in comparison to the large installations of debatable taste that are now fashionable and that are also quite different from those of the 'sixties.

STUART ARENDS
WATERLOO, OHIO, U.S.A., 1950–

Stuart Arends belongs to this group. He paints tiny cubes of wood or steel, no bigger than twenty centimeters (8 in.) per side. He uses all kinds of materials: oil, acrylic, wax. The only limits to these compositions are those of the imagination, which is infinite. Each cube is painted with all the care needed for something huge. Each piece has its own individuality and is complete in itself. Strangely enough, when they are hung on the wall they need a great deal of space. Their presence is highly visible. His work has no particular aim; there is no ideology behind it, nor the need to express any personal situation. The only aim is the beauty of the composition and the colors. It is a search for pure harmony, something similar to the song of angels; it is about living happily

in serenity, without torments and anxieties, which, of course, can also lead to great art if the antitheses are resolved through the clarity of contemplation.

Stuart Arends has no need to go through torments to arrive at happiness. This is his fortunate disposition. This is paralleled by the place where he lives in a deserted region of New Mexico, far from important towns, and where the light is clear and the sky limpid the whole year round.

It is a rare virtue to have the will and the ability to live in the desert in order to be separated from devious influences and the temptations of the market, above all at the present time when many artists are more interested in success and money rather than art. They study strategies for reaching this aim as soon as possible. They don't want to be an artist who has to do without almost everything in order to survive. Art must be a well-paid profession, but how might his be possible? Well, the only condition is to follow public taste, which, for the most part, has no cultural interest.

Stuart Arends does not belong to this category. He lives with very little. He creates small-scale objects that have a corresponding price. Every so often he goes to some big city to meet dealers or collectors who love his solitary work. He doesn't stay there long: the call of the desert is irresistible. His creativity can only flower and flourish in silence and solitude.

He is very tall and dresses like a cowboy. No one thinks he is an artist. He is not interested in the impression he gives. His art comes alive in his face and eyes.

RON GRIFFIN
POMONA, CALIFORNIA, U.S.A., 1954 –

Ron Griffin too works on a small scale, not just regarding the dimensions of his pictures but also their subjects. He is a figurative artist who treats the image as though it were abstract. There is an analogy with Pop Art in the 'sixties but his subject is different. Pop Art dealt with so-called popular culture: cartoon drawings, advertising imagery, posters with images of famous film stars. Ron Griffin's subjects instead are the small objects of everyday use that are on our office or home table. Labels sewn to clothes, envelopes, headed writing-paper, everything that is flat and on the table. The fact of using flat objects is important for the artist, since he works in two not three dimensions. Reproductions of real objects are painted onto thin sheets of paper glued in layers to a support in order to simulate reality more faithfully. And the imitation is completely useless because their aesthetic quality has nothing to do with the subjects. The thing in itself is only the artist's starting point for discovering the quality of the common object: he certainly betters the graphics of the

written word and the overall harmony in an almost invisible way. The colors are certainly better too, though they are no different from the originals. When Ron Griffin reproduces kitchen towels with colored stripes they become marvelous Mondrian abstractions.

The artist has a great feeling for the beauty of wood. He loves the desert as much as the other artists my wife and I collect, and for him wood is a way of representing this. He will use a long and narrow piece of wood in which you can see a sunset in the desert or the sun rising. In this case the work is of medium size. He lives modestly in a small studio in Venice, a Los Angeles suburb. His work has not yet had the recognition it deserves. But success in art is an unpredictable thing. Artists I consider mediocre have become famous, and many I consider far better are not appreciated. We must wait, be coherent, and hope in the future.

His pictures always have a white background, so the composition and colors can be better appreciated and reflect a serene and happy life. His relative poverty allows him to live modestly.

His studio is small, just a few square meters, and it is also where he lives; everything is reduced to a minimum. The pictures are placed on shelves above head-level. But recently there has been a complete change. His pictures no longer have a white background but a black one. The reproductions of the objects on our tables have been replaced by geometric forms in white semi-transparent paper that stands out from the black background. This contrast between black and white, where the forms have lost their familiar aspect, causes a disturbing sensation as though something sad has happened in the artist's life. In fact it has in his affections and feelings. I hope this is a situation that might be quickly and positively resolved and that he might regain his serenity.

JONATHAN SELIGER
NEW YORK, U.S.A., 1955–

Seliger's work has some points of resemblance to that of Ron Griffin as he too imitates the things we use every day. But the basic difference is that Seliger works in three dimensions: shoe boxes, matches, the bags used for the things we buy. The things we buy are inside containers, and the artist recreates their forms almost exactly like the original in both color and design. But the operative word is "almost." The original is not beautiful or at least we do not consider it to be so, but the imitation is delicious. The miracle of art: to transform reality through an almost invisible act.

This is a difference we also find in painting. Copyists once worked in museums. The good ones made good copies, the less good made ugly ones. You

could see that the good copies were, in fact, copies. They were almost the same as the original, but not quite since they lacked that indefinable and invisible substance that transforms the inert into art. Here in Biumo where I am trying to finish this long story, I have a work by him on my studio table, *Future Archeology, Met*, 2000. I began these memories in 1996, and was interrupted by more important business for art and also by my body: an abdominal aneurysm and two heart attacks, all happening just a few months apart, with the relative risk of leaving this world for good. In front of me there is a bag from the New York Metropolitan Museum bookshop. It is a bright, warm yellow and the letters are white. It is the same size as the original but is made from painted canvas rather than paper. I have been buying books from the bookshop for many years but never realized that the bag was beautiful. It looks very good on my table.

The artist works in New York and has his studio downtown in a shabby house with many floors where there are workshops and stores. He has a small room some six meters by four (20 x 13 ft.). It is high up and there is a good view of distant skyscrapers. When you enter there is a riot of color of the many things to be looked at closely. They are small and there are a lot of them. Even if you shift just slightly you discover something marvelous. Containers of all kinds, cartons of orange juice, and all remade, of course, from brightly painted canvas. A bag with the word "Prada"; a fan with the colors of the American flag; an evening newspaper with the latest news, which has become an object in heavy canvas, in black and white, little color. This is a strange resurrection of disposable objects that come back to life, triumphant and glorious.

ROBERT TIEMANN
AUSTIN, TEXAS, U.S.A., 1936–

Tiemann is another artist who creates small-scale objects. His are completely invented objects with no relation to reality. They are made from industrially processed wood, ground down and glued together under great pressure at a high temperature, making use of the leftovers of other works. The life of the tree that grows in the sun to feed on light, water, and air has disappeared. It is used for those products that wood contains such as cellulose and lignin. By cutting, sawing, and gluing the artist can make all the forms his imagination suggests. His work is the product of pure imagination. Imagination is the faculty that allows us to create marvelous things when it is kept in check by the rules of harmony, which the artist creates and recreates each time.

The artist lives and works in Austin, Texas. I have been various times to Dallas, Fort Worth, and Houston where there are splendid museums and excellent collectors, but Austin is an isolated town and cut off from more active centers.

In my collection I have many of his works bought years ago from the Angles Gallery, first-class pieces that are well worth seeing. He is an artist who is comparable to the best of those working in a similar way. In no way is he provincial, but he risks being ignored. His would not be the first case, since the development of Postmodernism has been quite efficient in excluding those who are not part of its system.

DAVID GOERK
NEW JERSEY, U.S.A., 1952-

Another artist who creates small works is David Goerk, who lives and works in New York. His art is difficult to describe. His objects are even smaller than those of the others. They are abstract and have no connection to other things. He uses little color: white or black, or else dark brown; at times the pieces are covered in wax. The surfaces are smooth. They do not have a startling visual presence with bright colors. They look good on small walls in almost hidden places where you can see them if you want to look them out. His is a discrete research with a humble aspect, one that does not want to be impressive. The white objects are difficult to see on a white wall. But when you look at them their quality is impressive, and over time they do not disappoint but always surprise. This is the best proof of their quality.

Obviously an art of this kind does not pay. In fact he works for the Pace Gallery in New York, one of the most important galleries of contemporary art. Here you will find artists who have become famous and are sold on the international market at correspondingly high prices. In fact I do not buy from this gallery even though they have various artists I bought when they were not yet famous.

Only many years ago, in 1968, did I buy a disk by Irwin that I had seen in the same gallery in 1966. The director is Arne Glimcher who has always done an excellent job with a careful choice of shows. Goerk has to be satisfied with hanging other people's pictures: this is his job. I hope one day he will be hanging his own works in an equally prestigious gallery.

BARRY X BALL
PASADENA, CALIFORNIA, U.S.A., 1955-

When I got to know Barry X Ball he was creating small but precious objects covered in gold, placed on an equally rare material and all finished with great care. He uses the best material in order to be certain that they will last. This work takes a lot of time. To find the longest-lasting materials also requires a

long search, but the result of this effort can be seen. They are small jewels, precious and extremely beautiful. The emblematic work from this period is *Twelve Identical Units*, 1987–1988. These are a series of twelve small objects, about twenty centimeters long each side, which are gilded and hung from two thin steel wires between the ceiling and the floor. In the 'nineties he developed a different kind of work, making larger objects though always finished with the same obsessive care, using a special extremely hard plastic that is only made by DuPont. In these works a part of the composition consists of a special crystal container, quite transparent, like those astronomers use for telescopes, and this container is full of pure pigment. In this way the color has greater importance than when used in painting a canvas. It has an unimaginable chromatic strength. The colors we usually see are always mixed with a binder, because otherwise they would float away since they are a very fine powder. But the binder greatly reduces the intensity of the color. Even the packaging of these works is made by the artist. Each thing has its exact place from which it cannot move, and there are white gloves for handling the work, as well as detailed instructions.

The packaging resists the strongest knocks. For the larger pieces the packaging is inside another very light plastic crate so it can float in the eventuality of shipwreck or of a plane falling into the ocean. These are works that must last for centuries without alterations. Often he talks to me about the gold backgrounds used by Medieval Italian artists. They are eight hundred years old, and his own works must last that long too.

His studio is full of sophisticated machinery for working with precision, and it is so clean you could eat off the floor. To spend time making a small object that is not easy to see is in total contradiction to what happens in our so-called modern times where the opposite is expected: to do a lot in the shortest possible time. We live in a wealthy society where everything is done for a comfortable life. Time is money. It is certainly a basic thing, and there is nothing more important. But it also has another basic characteristic: it doesn't last. This is a certainty for all of us without exception. We are lucky if time lasts an average span.

We quickly pass from childhood to adolescence, to youth, maturity, old age, and then the end. When you are eighty you see just how true this is. All philosophers are searching for truth, a definitive truth, but there can be no mistake in the face of these facts. They must start from here in order to build a true interpretation of the world, but instead they begin from things that do not count or that are less important.

An explanation of this phenomenon would explain everything, but they do not try: in fact, to explain the unknowable is impossible, and at this point philosophy stops.

But to get back to Barry X Ball, the time necessary for making things, and the fact that for modern society to do better it must produce more and quicker sucks us into a vortex together with our freedom. If we do not have more time for thinking and judging then we are finished. We are no longer people. Time, a lot of time, is necessary for thinking. It is also a lot of effort: we must have doubts and run the risk of having to start all over again. We must question ideas we love, those that reflect our desires but that often are dangerous. We would like to change the world but without knowing where to start from, because it is the others who must change and not us.

It is important and unusual that Barry X Ball has the courage to say no to this way of life, with all the risks this involves. Whoever goes against economic laws, Time is Money, cannot expect to make money. Luckily not everyone applies these laws and understands that time spent on thinking and doing things well is time well spent and the best way of spending it.

A contradiction of this system is the rapidity of change: when you produce a lot it then has to be used up, otherwise you must slow down and change things and, as a result, create a widespread wish for this change. In a rich society this desire is very strong, and production must make the most of it. A person who courageously contradicts this perverse trend is my wife who will throw nothing away, and consumes whatever there is to be consumed until nothing is left. At times she exaggerates, but I too feel myself involved in this virtuous principle. I never throw crumbs of bread away but eat them.

Barry X Ball is not nostalgic for some lost past; he doesn't exclude the use of up-to-date methods, in fact his drawings for his works are created with a computer, and have all the cold precision of mechanical things, but they serve their purpose. This is a work of collaboration with industries that produce materials, and with other people who undertake special tasks; for example, the artist's mother-in-law carries out the long and painstaking job of applying gold leaf to the works. The beauty of this art is to be innovative and antique at the same time.

RONI HORN
NEW YORK, U.S.A., 1955–

Horn is another female artist whose work is in the collection. In the 'fifties there were no women; in the 'sixties and 'seventies only two, Hanne Darboven and Maria Nordman, but in the 'nineties, even though men are still in the majority, there are many women, all excellent. It would be interesting to discover the causes of this evolution that has given women the same artistic dignity as men. Women are more intuitive and are quicker to understand emotive

factors; the male mind is more analytical and searches out causes. Art is essentially intuitive, so in this field women can supersede the men. In the past there were few women artists of high quality. Artemisia Gentileschi was an exception, but she was not a great artist. In wealthy Western society, where individualism has reached its greatest development, the family has lost its importance. The number of births in the world must be reduced. Women are more free from the heavy commitment to bringing up a family. A more expensive way of life forces women out to work in order to earn money. This evolution has also produced some negative results, and each individual must discover how to avoid them. In art this change has brought about a new situation, one that is very positive for culture.

Roni Horn's work can be classified as Reductionism. As a mental process this is similar to Minimalism, but her work is quite different from that produced by other artists in the 'sixties. She belongs to a younger generation. Her objects are generally medium-sized or small.

She uses copper, lead, stainless steel. At times she inserts a phrase using plastic letters in her steel sheets. All her works are heavy, the material is solid and without cavities for making it lighter. This insistence on material presence is characteristic of her work. But the weight and mass lose their brutality because they are dignified by the artist's rationality that creates mental geometry. Her copper cones, the lead forms, the imperfect spheres of steel always have a rigorous concept behind them. Her work could be described as the power of thought over material.

During the summer Roni Horn lives in Iceland in an abandoned lighthouse. Iceland is the land of fire and cold, volcanoes and glaciers. There is a northern light, and in the summer, dawn and dusk flow into one. This is the ideal place for an artist seeking the ultimate meaning of forms

Since I have known her, many years by now, her work and her fame have both increased significantly.

The artist's presence reflects that of her work: she speaks clearly and precisely, decidedly, without doubts and hesitations. She is aware of her ability and of the things she wants to make. Her sculptures are not big but, being made from solid metal, are heavy. Installation has to be done with care and with the help of many people. These heavy things have a fragile surface that can easily be damaged; there is a disproportion between the inertia of the mass and the delicacy of a surface that, through accurate finishing, is perfectly smooth and reflecting. She is an artist who works in a coherent way. Work that follows a specific aim is appreciated and rewarded in the long run.

MICHAEL BREWSTER
EUGENE, OREGON, U.S.A., 1946–

Michael Brewster is an artist in sound. But he uses sound without becoming a musician; he does not make musical compositions. Sound is interpreted for what it is. When we see a color we associate it with certain emotions and impressions; even if they are not clearly defined they awaken latent memories. The same thing happens with sound. A sound, even the simplest, creates a great many possible relationships and makes real a whole series of possibilities. Brewster transforms this confusion of imprecise emotions in a highly attractive manner. It is like the sound of bells. It is simple. Each bell has a single sound that is always the same and can only be varied in intensity. But its simplicity is its attraction, for it can bring to mind an infinity of sensations, whether sad, melancholy, serene or happy. Bells ring in the distance, the sound travels in space, it is like time and makes us think of distant lives, the world of the living is linked to that of those who died centuries ago. The sound of bells propagates over large distances. It is like looking at the blue sky; it is the presence of something infinite within us. It is the image of something that is a substance but is also not a substance. Michael Brewster's sounds have the same function: to awake emotions that have no apparent relationship to what we are hearing, and by listening more new sensations can come about.

There is a work of his in Biumo that consists of a sound that seems to come nearer as it slowly intensifies, only then to diminish in the same way, slowly; after a moment's silence it begins the same cycle again (*Aerosplane, an Acoustic Sculpture*, 1993). When I hear this work I think of some indefinable thing that comes nearer and then draws away again. Something that might bring happiness but is then taken away. This causes nostalgia and the wish to have it back again. Or else it can seem the sound of a bomber-plane coming near to destroy us, a memory of the war when planes flew over Varese on their way to bomb Milan. When I am in America I miss the sound of bells and lose a link to the undefined, to infinity. Brewster's sounds have the same effect: they make us dream and awaken our drowsy imagination. These sounds are also a physical presence. In one of Brewster's rooms strange things occur: in certain points the sound decreases and in others it grows even when the source is the same because the reflected waves are added to the original ones or mix with them.

He is an artist who has difficulties in becoming known, a difficulty common to all artists who use space, which is something rare and expensive. Furthermore he creates work where there is nothing to see, one that is the maxi-

mum of immateriality. You have to stand in the room for a long time and listen. This is another problem in a society where everything must be done in a hurry. There is no time to waste, especially for enjoyment. But art too must be enjoyment.

SUZANNE KAISER VOGEL
1947-

An interesting but almost completely unknown artist is Suzanne Kaiser Vogel. I discovered her work in the Malinda Wyat Gallery in Venice, Los Angeles, in 1982. *Plum Blossom Domain, This Side and Beyond* was an environmental piece with a wall of cement blocks that had been hand-smoothed in order to obtain a patina. The wall didn't reach the ceiling, and at its center was a small hole from which was emitted a diffused light. It was a very evocative environment. I bought some projects to be constructed from various materials, even some with tiny parallelograms in colored chalk such as children use for writing on the blackboard. These were very beautiful projects made some years ago in the art galleries of some universities.

Unfortunately I have not had the possibility of constructing any of them yet, and I feel guilty about this. I have heard nothing more about her and think she is no longer involved with art. Hers are complex works needing a lot of attention and special conditions. Sadly artists who have created Environmental Art have been excluded from the art world. They do not produce pictures that can easily be put on the wall and taken down again and do not take up much space. Our culture has lost a great asset. But even professionals in the art field, who ought to have the task of preserving the best things produced by a generation, to make them known after us, not only do nothing about them but do not even know they exist. Even for me it would be easiest not to discuss Kaiser Vogel's work in this book and forget she ever existed as an artist—which is actually what risks happening—but I do not want to and cannot allow it to happen. She had family problems and could not promote her art: she did not fight for shows in museums or galleries. Selling such works is difficult, and there are no private collectors with large enough houses to install a work that takes up a whole room. Museums could buy them but do not for the same reasons. As I have the projects and the rights to recreating them, I just hope there might be a future occasion. Perhaps I might come across an enlightened museum curator who appreciates the beauty of this work; this might not happen either today or tomorrow but perhaps in a hundred years when there will be renewed interest in this art. Never lose hope.

JOHN MEYER

LOUISVILLE, KENTUCKY, U.S.A., 1943–
SAN FRANCISCO, CALIFORNIA, U.S.A., 2002

I saw John Meyer's work in San Francisco in 1992 when he was showing in the Paule Anglim Gallery. He painted pictures where the painterly gesture could hardly be seen. His later work was more radical. The picture would have a colored surface, but now the gesture disappeared completely as did the composition. What was visible was a colored panel covered with a smooth and shiny varnish. Usually they were diptychs with two equal panels. Sadly I could not follow his development as he was an artist who merited more attention. In the meanwhile he has died all too young of a heart attack. I do not think he lived from his art. He made excellent crates for packing art works that seemed works of art in themselves.

It is sad to talk about someone who no longer exists and who could still be working. We could have met him again on our next trip to San Francisco. Even today, just as in the past, people can die too early, suddenly and without warning.

CLAUDIA MATZKO

PROVIDENCE, RHODE ISLAND, U.S.A., 1956–

Claudia Matzko is an artist I greatly admire. I do not remember if I know her personally, and sadly I only bought a few of her works, which is the reason I did not visit her studio and get to know her. She is a woman with the romantic sensibility that only a woman can have. At the same time she is strong, precise, and expresses what she feels clearly, originally, and quite personally. The originality of her expressive language is the best proof of her authenticity. We often think we are being authentic because we say what we feel and think without being aware that we are using forms and images already used by others. Such titles as *Untitled (Tears)*, 1995, or *Untitled (Theory of Angels)*, 1995, are a message in themselves.

The first of these two works consists of small half-spheres of variously colored glass glued randomly on the wall. The second is made from empty white glass tubes, just like the ones used for neon lamps. Their white verticality has something mystical about it. Another work, *Untitled*, 1995, consists of a line of concave glass discs hung against the wall; when illuminated correctly, the saline solution that covers them reflects fractured light onto the wall.

The works I own were bought from David McAuliffe's Angles Gallery in Los Angeles. He is a first-rate person who has done an excellent job in courageously

showing art that is difficult to sell in a market only interested in things produced by a completely different kind of culture.

I would like to have more works by this artist and find the possibility of exhibiting them.

Some years ago I was in New York, in the Chelsea district where the art galleries had emigrated. This was an interesting phenomenon. In the 'fifties they were all uptown on Fifth Avenue or on Madison to the north. In the 'sixties the emigration downtown was underway toward SoHo where rents were lower and the spaces larger, in buildings that 150 years ago were warehouses and factories. The Leo Castelli Gallery was the first to move, and this was a courageous choice because at the time the area was the haunt of shady characters. It was not at all pleasant to find yourself alone there in the evening. Now it is fashionable, and clothing stores have taken the place of art with a resultant rise in rents. Chelsea was for many years the headquarters of the Dia Art Foundation, which was the pole of attraction for new developments. The big difference of this district, which was once next to the port, lies in the availability of single-storied warehouses that can easily be transformed into galleries, having overhead lighting and large amounts of space. In just a few years there has been a huge transformation, another example of American flexibility that rapidly adapts to new needs.

So during a visit to Chelsea I entered a gallery I did not know, which, to my surprise, was exhibiting Claudia Matzko. One work in particular struck me. It was a steel table with an electronic apparatus and a headphone for listening to music. But instead of music you heard an amazingly beautiful sound. Better music than any other music. Celestial sounds. The best place to hear these is in the house in Biumo above the parish churches of Varese. You can hear the bells from a German city that were re-cast after their destruction in the war. The sound of these bells rises above the city, above the souls of the living, of those who have lived, and of those who are still to come. It is a call to immortality. This is an example of the world in which Claudia Matzko lives, an extremely beautiful world.

CAROLE SEBOROVSKI
SAN DIEGO, CALIFORNIA, U.S.A., 1960–

Another woman whose works I actively bought at the end of the 'eighties is Carole Seborovski. These are small-scale works made from various materials; they are often drawings where the graphite covers most of the surface with geometric forms that are highly imaginative but controlled by a Minimalist rigor. This is the period of her work that I most prefer.

I met the artist in 1988 through Mrs. Del Balso. I bought many pencil draw-ings by her. I continued to buy them until 1993 when her work changed to become small objects showing a concern with a kind of situation completely different from the previous one. The first works were dominated by a severely expressive order. She paid great attention to values of a higher kind, and there was a strongly transcendent, almost mystical idea behind them. They were beau-tiful for this very reason. The use of black and white, the gray shading of the graphite, and the linearity of the forms, suggested the presence of some ideal message. In the later works she showed an interest in the body, a widely preva-lent interest in the art that predominates today. The body gives us life, but at the end and in a very short time, it changes into something that rots, is ap-palling to see, and finally becomes simply a little dust or a few bones that have chanced to be preserved. The body is a limit, and whoever is trapped inside this limit loses contact with ideas that have no limits and do not die. This is what happens in the art that dominates today. It is destined to die because it is concerned with something mortal. There is no way of avoiding this fate.

I donated the first twelve works, the best, to the Lugano Cantonal Museum. This was out of a total of two hundred works by various other artists. In ten years only a few have been shown, since despite attempts by the director Marco Franciolli the museum has not been enlarged, so I do not know when it will be possible to see the others.

When I came to know Seborovski she worked in a downtown basement where the rent was very low. In 1991 she held a show in Paris in the Karsten Greve Gallery, directed at the time by an excellent person, Hans van Vliet, who did various shows by such American artists as Greg Mahoney and Lawrence Carroll, then unknown in Europe, unfashionable, and not very marketable. Sadly he left the gallery some years later, but Seborovski continued to show in Cologne and in other branches of the gallery. So she no longer needs to live in a basement.

Some days ago I received an invitation to her wedding with the kind of for-mal wording used by the best families.

GREG COLSON
SEATTLE, WASHINGTON, U.S.A., 1956–

Another artist I bought in Los Angeles at the beginning of the 'nineties was Greg Colson. His theme is the city and the social life of conurbations. Ameri-can cities are very different from European ones that grew up around an ur-ban nucleus with the cathedral at its heart and closed off at the outskirts by imposing walls that could withstand long sieges. The streets follow no kind

of order and are narrow to house all the population inside the walls. Only religious orders have over the centuries created buildings with lots of space, the land left to them by those who died childless. American cities represent a wholly different social life where the dwellings spread out across the territory and the streets form a geometric network interrupted by a few diagonals.

So the interest of this artist is concentrated on the urban and social aspects of these places. Unlike Lawrence Carroll and Ford Beckman he is not interested in the life of the individuals who live in it and who are often excluded from the life of the luckier people. The stadium (*Memorial Coliseum*, 1991) is the place for the most imposing social meetings. It did not exist in the Middle Ages, though it did in Roman times; the arenas are the only buildings constructed some two thousand years ago to come down to us almost intact. Greg Colson represents the form of the city in his compositions. In the 'nineties he developed another theme: the makeup of social life. He is an artist having a great success.

JEFF COLSON
LONG BEACH, CALIFORNIA, U.S.A., 1967–

Greg's brother Jeff is also a good artist, but his interest is completely different and is based on the values of painting and form. I collected his pictures between 1991 and 1994. They mostly consisted of marks of paint that give a positive resolution to the harmonic form and the expressive content. This is what gives coherence to an apparently disorderly composition of forms and colors. He illustrates books that, being painted by hand and not printed, are unique pieces of great quality.

ROY THURSTON
LONG ISLAND, NEW YORK, U.S.A., 1949–

Roy Thurston is an artist who had developed a different kind of interest from all the others, so much so that he cannot be placed in any category. At first sight he seems a monochromatic Minimalist painter. He does not use a paintbrush, he does not use paint, he does not use his hands in painting, so he is not a painter. He does not work with the forms of the materials he uses, so he is not a sculptor. He always uses the same material.

This strange work consists of tracing vertical parallel lines with a steel point on a lacquered panel. In his early work the panel was almost always black. He ruined a beautiful smooth and shiny surface with a sharp steel point. The results were always different, for it is difficult to scratch vertical lines very close

to each other. They were fascinating. They needed close attention and time. The slight imperfections of the lines made the artist's manual intervention obvious. In a society where everything has to be made in a hurry by a machine, in order to save on expensive human work, this is a rarity. We are drowning in a mass of products all the same, or at least similar, in order to cut down costs. This is a kind of logic that destroys the pleasure of single objects made to be beautiful and to be appreciated by those who want to own them.

It is also a rejection of the "disposable" system where things are useful for the moment but are then destroyed in order to increase the mountains of rubbish dumps that surround all large cities. In two thousand years these will be the only record of our existence. When excavating, archeologists will discover cans of Coca-Cola and will ask themselves just why there were so many. They will not find marvelous sculptures as in Greek or pre-Columbian necropolises, for with us the cult of the dead has disappeared.

Roy Thurston's work has continually evolved, making use of panels with different colors, different instruments for cutting and shaping the groove, in order to create new effects of light. These are inquiries that have a great variety of solutions developed by the artist with notable results. This is a kind of work that cannot be appreciated by a superficial observer, and in our "disposable" society this is something rare. It is fairly obvious that this kind of art does not make enough money for living and having a studio. In fact Roy does not live by his art. He has to have another job and creates his art in his free time, giving other things up. He has a small firm that makes installations in galleries, does interior decoration on commission, and builds architectural models. He created scale models for an exhibition about skyscrapers that reproduced the most famous ones.

Some years ago he had a relationship with a Chinese lady that lasted quite some time. They decided to marry, but after six months they divorced. Quite rightly his wife could not put up with him using the time he wasn't working to go into his studio to make panels with many lines drawn with a steel point. An example of the sacrifices art demands. His work shows his total dedication to art, and this is why it is so fascinating. The artist's studio is in an area of industrial buildings in Los Angeles, mostly warehouses. There are few people around in the evening, and those few there are not very reassuring. These risks do not worry Roy Thurston. He works mostly in the evening and at times he sleeps there. It is a large studio just right for seeing the pictures. The space outside is full of old trucks from the 'thirties: his specialty is repairing these huge vehicles. Evidently people who collect them exist; they are certainly not used for going for a drive.

MARK LERE
LAMOURE, NORTH DAKOTA, U.S.A., 1950–

Mark Lere is an artist I collected between 1988 and 1991 with works dating from 1983 to 1990. His sculptures are interesting because they represent a new interpretation of Minimalism through forms; they demonstrate his search for simplification by freely articulating these forms. They refer to nothing and, like Minimalism in the 'sixties, are geometrically arranged. The end result of these interests was the art of vital or living forms. In this the artist could find a way of giving form to an activity, not by following preexisting laws but by creating forms dictated by instincts and incidents in a constant relationship with indefinable inner energies on the one hand, and the influence and conditioning of the external environment on the other. This is precisely the history of the evolution of life on our planet. In the works I collected at this time this process is visible. Lere efficiently demonstrates a kind of pursuit that also concerns other artists and that I consider one of the most interesting and important events in the years following the period of Minimalism, Conceptualism, and Environmental Art.

In recent years, as a result of my long absence from Los Angeles due to my health problems, I have not had the possibility of following his most recent work. I hope to do so when I start embarking on longer trips.

Almost all the sculptures I bought by Lere have been donated to two museums, the Cantonal Museum in Lugano, and the Los Angeles MoCA. In Lugano they have been seen in various shows, and MoCA devoted a room to his work in the winter of 1999–2000. It is now up to the two museums to make the work as well known as it merits.

We feel great pleasure when we see flowers, just as when we look at the blue of the sky on a clear morning. It is also a pleasure to look for a long time at the sunset and see the white clouds color with red, yellow, and pink. There are innumerable feelings that color can give, and it is impossible to list them all. When I walk in a field I see tiny blue, yellow, and white flowers in the midst of the green grass, and I stop to look at them. Color is the means for attracting insects that, while they suck the nectar, become covered with pollen for fertilizing other plants; it is a way of making life grow. Flowers are bright with color above all in the spring, when life is reborn after its fall and winter sleep. In the winter green becomes brown, yellow, deep red, and the earth almost black. When I dream I remember events together with the colors of the place where they took place; they exist in our subconscious and are part of our innermost nature. Our strongest feelings are continually related to them, and it is obvious how dark colors represent sad feelings while bright colors express pleasure, happiness, and the joy of living.

In painting, the colors have always had great importance but were always subordinate to form. It was necessary to narrate or describe something: religious matters, metaphors describing the glories of princes using episodes from ancient mythology; in the Middle Ages the Passion or the image of the Virgin Mary were represented using colors adapted to expressing completely different situations. This impossibility of giving color an autonomous function lasted until the beginning of the twentieth century when abstraction did away with landscapes, portraits, bathers, more or less beautiful nudes, Napoleonic battles, and other historical subjects. This was a revolution, the beginning of a new expressive age, complete freedom for creativity and imagination. This possibility had begun to be used in the last century, but developments are unlimited just as our ability to create and think is unlimited.

This revolution parallels that in science since the atom was discovered; our awareness of reality has changed and so has our life.

The first seventy years of twentieth-century art history saw a gradual acceptance of the freedom of color use. For Kandinsky and Mondrian it was still subject to the composition. Only after 1950 did it have new possibilities. Rothko's works express their emotional content through color; composition has a secondary role. This reversal of the relationship marks the beginning of different possibilities. Rothko demonstrated that everything can be expressed through color, from the immanent to the transcendent. There was still a residue of composition, the need to balance a picture with two or more colors.

In the 'sixties Marden and Ryman studied the problem in greater depth. Ryman completely abolished composition, and what became important was the marks, the contact of colored material with the surface and with the nervous system that moves the fingers. They reveal the phenomena of the mind. The biochemistry of the brain does not show the origins of the creative act.

Ryman only used white, which is the absence of all colors. Real white is never really white: the material, the binding agent, and the support are not really white, so he had begun a subtle research into what color and its differences might be. It seems our eye can distinguish an incredible amount. There are only three primary colors, but their combinations produce an unlimited quantity of different sensations.

This is the starting point for a group of artists who in the 'eighties and 'nineties have gone ahead with new pursuits never before attempted. These are pioneers out to discover a new continent that, strangely enough, is near at hand though an intellectual prejudice blocked it from view.

It is interesting to examine how this interest was born and developed. The gold backgrounds of medieval painting are the first signs of this sensibility. Gold is precious and so gave greater value to a sacred image. Saints had to be surrounded by the luminous reflection of this rare and precious metal. It was the world's tribute to the supreme good, to what was unreachable. The clothes are a mass of compact color to underline the impressiveness of the figures. There comes to mind Mantegna's polyptych *Saint Luke*, 1457, now in the Brera Museum in Milan, where the color and forms serve to show the personality of the saint. We are by now in the Renaissance, the springtime of Western culture where the harmony between the creator and creation had to be demonstrated by generating the greatest happiness.

But already in Giotto's frescoes in the fourteenth century the figures are shown through the use of compact colors, imposing forms that are further underlined by chromatic masses. Color has the function of creating a two-way dialog that distinguishes the people in a composition while, at the same time, uniting them. Its expressive usefulness is strictly linked to the meaning of the scene. And this is humanity before the immense power of divinity that is rejected, accepted, and adored. A presence hidden from those who refuse it but salvation for those who recognize it.

In fifteenth-century Italian and Flemish art it was the manifestation of the transcendent presence within the immanent. This fusion of two extremes produces happiness and is the supreme condition of human beings, the nearest point to perfection and truth. Happiness is expressed through light, and colors are the sign of its presence. This condition makes nature a part of this ecstatic contemplation that has its common and unique origin in mankind.

In the paintings of the artists of the fifteenth century, landscape appears behind the figures of the saints, filled by the light of the sun.

Color is not yet the protagonist of the painting, but it represents the presence of the divine in creation. The humanists' Neo-Platonic philosophy was the intellectual tool for completing this evolution. The idea comes from the Supreme Mind, and this is the condition for the existence of every thing. Its origin unites the All, in other words nature and its thinking beings. Even the dress of the enthroned Virgin, the saints, and the donors is an occasion for showing the triumphant presence of color in order to exalt the Glory of the Creator. In the pictures by Jan van Eyck, Hugo van der Goes, Rogier van der Weyden, and Piero della Francesca this sublime ceremony is celebrated.

In the seventeenth century color seems to retreat into darkness, and only the figures of the protagonists are illuminated: behind them is blackness and dark. The individual is alone in the face of the unknown, and nature does not comfort him with its beauty.

Descartes's *Cogito ergo sum* exalted the power of the human mind, but this was also the beginning of its isolation. Lutheran reform placed individual conscience before the supreme judgment without any intermediaries, without the possibility of being regenerated through pardoning. A person stands alone before his conscience. Perhaps this is why there is black and no light behind the people in Baroque pictures. The best example for describing this situation is the last painting by Titian, which he left incomplete at his death and which was then finished by Palma the Younger: *La Pietà*, 1576. It is one of Titian's darkest paintings, and in it the artist pleads for the Virgin's pity. The artist, who had always tasted success, whose patrons were kings and emperors, was alone at the end. His only companions were the mute caryatids who seem to emerge from the darkness, the undecipherable images of what cannot be known.

One of his contemporaries, Lorenzo Lotto, perhaps an even greater artist than Titian, also had a completely different kind of character. He was timid, introverted, solitary, ambitionless, uneasy, and uncertain of himself. He worked in a provincial city for the bourgeoisie and the local nobility; he was meditative. His pictures are full of color and the landscapes that can be glimpsed shine with light.

A typical example of seventeenth-century culture is Caravaggio's painting where the light illuminates the protagonists, behind whom there is nothing. Only man is of interest, and his origin is ignored. He is alone with his goodness or evil. These were the years Europe had been broken up by religious wars and the separation between north and south.

An exception to this situation is the art of Vermeer where light, and therefore color, is the protagonist. Light enters through a window and illuminates

the room where the person lives who is transformed by its presence. We can easily see a Vermeer in our own home in the morning or at sunset when a ray of sun enters obliquely and illuminates some objects, transforming them. They are returned to another world, the world of origins where everything is new.

With Romanticism at the end of the eighteenth century the love of nature was rediscovered, not as an extraneous entity but as a reflection of our deepest and hidden being. Our common origins were rediscovered, our conscience relived them. A condition that had been ignored and rejected was now experienced in all its marvelous beauty. No longer was it an unknown entity that we had to understand in order to possess it by discovering its laws through the newly developed human sciences. A Romantic painter, Caspar David Friedrich, shows this change. Nature is a mother and a friend; it is great, powerful, yet humble. It is happy and sad; it gives us infinite joy yet frightens us with its power. Above all it gives us the strongest and most secret aim: to reach the unreachable. Friedrich painted its endless horizons with delicate glazes that show this force of attraction. The light and the beauty of nature is represented through a knowledgeable use of color and glazes.

Impressionism began in France in about 1863. These were artists who painted in the open air and who immersed themselves in the colors and light of the landscape. This was a deep renewal of our way of observing and interpreting what we saw. There was no longer any need to take great care over the details, as the Academy had taught. When we look at Reality what is most important is the sensation of color and light: this is the most important thing and what we must represent. For the first time in the history of art color became the most important if not the only factor.

With Van Gogh's and Gauguin's Post-Impressionism the importance of color evolved even further: it formed large, compact surfaces and replaced real colors in order to express forcibly some great emotional experience. Color was no longer a means for completing a composition but became more important than the form: it was the most direct means for expressing some particular expression of awareness.

At the beginning of the twentieth century, the abstract art of Kandinsky and then Mondrian liberated painting from the need to describe the reality that we see. Reality was interiorized. So we could look within ourselves rather than outward. Color could express its potentiality freely without need to refer back to what our eyes saw. And the artist was in complete control of this expressive means.

But the great change came in the second half of the twentieth century with the work of such painters as Mark Rothko, Barnett Newman, and Ellsworth Kelly. Form now had a secondary place, and it was the colors that conveyed

the meaning of the work. This was a revolution in the relationship between form and color, but it was not yet the end. The revolution was to be completed only toward the end of the 'eighties: form disappeared.

DAVID SIMPSON
PASADENA, CALIFORNIA, U.S.A., 1928–

David Simpson is the oldest of these color painters: he was in fact born in California in 1928, and he used to teach art in Berkeley at the university. He has always created monochrome abstract paintings, but his art only changed and became really important after he stopped teaching. At the end of the 'eighties he discovered a new possibility: metallic colors mixed with a mineral that reflected light from particular positions. When you move in front of the painting and change viewpoint the color changes completely: gray becomes a light-saturated silver, pale yellow becomes a rich gold, gray-green becomes a luminous green. There is always in these works the passage from an inert opacity to light.

This is something that has never been seen before, something surprising and unexpected: resurrection in light. Color is light and the picture glows with this essential possession. Metal has different colors from those of flowers: they do not have their origins in life and so we do not see them in organic matter. Their origins are distant in time, within cosmic activity. They are formed during the collapse of a star greater than the sun due to its enormous force of gravity, which transforms helium and hydrogen into heavy elements such as gold, silver, copper, zinc, iron, and uranium.

This is the recovery of the memory of a remote and primordial event. It is also the fascination of this art that lives through color and light; it is an episode of cosmic life that gives us too the possibility for living.

I saw this artist's work for the first time in the Angles Gallery in Santa Monica. Various paintings had been hung on one wall: they were well lit with natural light, and I could see at once the differences of the colors. I didn't even have to move in front of the pictures. It was something really amazing, something completely new. Here was something coming from another world and no longer of this earth. What an emotion. Yet my wife and I were among the few who found them beautiful, and other collectors were not even aware of them. This was why they cost so little and why David McAuliffe had difficulty in selling them. I really don't think we are two crazy fanatics who get excited over nothing. In fact our enthusiasm has lasted exactly the same for some thirteen years. If we really are mistaken, then we are as pigheaded as they come.

I have hung many of these works in Biumo, Gubbio, and Verona. People see them but do not look at them and behave as though they do not exist.

Some years ago there was a conference of art critics, museum directors, and curators at Biumo, but no one asked me about this artist who, without a doubt, they did not know. What is generally said now is that, given I was a collector highly involved in the 'sixties and 'seventies, I can no longer separate myself from the past, and being eighty I am far too old to change. So, as I am an old prisoner of the past, I am not capable of following new developments in art but only want to continue with dead things. The logic then is that the artists I have collected in recent years are not worth looking at, and so they are all ignored without a moment's thought and without anyone asking themselves if they are making a mistake. This is the current view of the art world and of those intellectuals who get excited about what they consider to be contemporary art. Manzoni, the great Italian writer, asked of Napoleon's victories, "Is this real glory? Posterity will make this tough judgment." If young school children become enthusiastic when they see Simpson's paintings, it means that this "judgment" is only a question of intellectual flexibility.

Our culture always has this myth of the young artist who dies young too. Raphael is the typical example, painting masterpieces at eighteen and dying at thirty-seven. But there are so many contrary examples, artists who created masterpieces when old or even extremely old, like Titian and Michelangelo. In ancient times old artists who were good had also been so when they were young. Nowadays the reverse seems to happen. Creativity seems to last for only a short time, perhaps for four or five years, and then to diminish worryingly. This is quite frequent, and it is difficult to find an explanation for it. It may be that since the beginning of the twentieth century time passes by ever more quickly. Scientific discoveries and their applications create revolutions in our way of life that influence artists a great deal.

In 1962 Pop Art was born; it celebrated the triumphs of industry producing consumer goods for all, a real social revolution that coincided with the end of the fear of the Cold War, the end of a nightmare. Consumerism rapidly increased, with its rush for status symbols instead of a search for something useful. A perversion of social conquest. But the realization of this has caused a loss of faith in Pop Art and its golden aura, and artists have become disenchanted.

In 1963, the following year, Minimal Art began with Flavin, Judd, and Morris. Theirs was a different kind of interest, in fact one that was completely opposed to Pop Art. While Pop transformed the vulgarity of cartoons, popular literature, and advertising into art, Minimalism instead interested itself in the

activity of thought, an interest limited to philosophers, scientists, and intellectuals. The Minimalists considered the technology of steelworks, great industrial constructions, and bridges to be something that only thought can inquire into and undertake, and this was intimately consonant with their art. Land Art began in 1965 with its rediscovery of the beauty and power of nature as seen in the deserts in the Far West and in the works of Walter De Maria, Michael Heizer, and Robert Smithson.

In Los Angeles in 1968 Environmental Art was begun, rooms in which there was only space and light. The viewer became the protagonist who discovered the perception of his own being and arrived at the source of existence. It is an art that requires concentration, time, and a predisposition to contemplate. These are all difficult requirements and quite unlike today's way of thinking. In the same year Conceptual Art began in New York. This investigated the place of philosophy in daily life and elaborated the creative abilities of thought. It examined the problems of expression, of the connections between meaning and the object, a relationship that cannot be explained by rational logic but only by transcendent intuition. In eight years an incredible number of events changed our way of feeling and thinking, ones that offered new horizons to knowledge and life. Such a concentration of events had never happened in the millennial history of culture. It is perhaps understandable that such a dense creative and intellectual activity might seem too heavy for the younger generations to continue. When something is too difficult it is easier to reject it. And this was what happened after 1975. It would be very interesting indeed to examine the causes of this phenomenon.

There is no doubt that Simpson is old; having been born in 1928, he is only five years younger than me. But despite this he has created some incredible pictures over the past fifteen years and continues to produce them.

Many of the works my wife and I collected in the 'nineties are by artists who are no longer young. Max Cole was born in 1937, Ruth Ann Fredenthal in 1938, and Robert Tiemann in 1936. Many were born in the 'forties and so are no longer young, but all the same, their creative energy is as fresh as ever or even more so. Why is this? I believe it is due to society's weakened critical activity. It is as though intellectuals had contracted in on themselves in a kind of implosion. There is less willingness to try to understand, the principal reason for culture and art. This cultural defeat has only acted as a stimulant to those who do not accept it, who believe in the vitality of life, and who continue to pose themselves the questions that make life interesting and worth being lived.

PHIL SIMS

RICHMOND, CALIFORNIA, U.S.A., 1940-

Another protagonist of the art of color is Phil Sims. He paints pictures that have an enormous force of attraction. This is something intuitive that precedes any kind of reasoning and is an indispensable element for any work of art. It must be present, because if not, there is no art: it is its power. It can be overlooked or remain hidden, and usually it is not felt due to ignorance on the part of the viewer. But when its nature is discovered its power is never exhausted, it continues to renew itself, and the observer never tires. This hidden secret is the permanent power of ideas. It is an innate power and permeates Sims's pictures. The instrument of this power is color, and when its nature is represented with immediacy, then its power is completely revealed, but it must be represented without deviations, in its integrity. Painting with color seems the easiest thing in the world, and this is why it is an art despised by intellectuals. But it only seems easy for those who do not look, for those who do not have the habit of looking at flowers. If you pay attention to them you discover that their great beauty is due not to their form, but to their color; if you pay even more attention to the nature of the color you will see that every flower invents its own technique to exalt it and reveal its attractive force. If you then look at its surface with a lens you can see how each time it uses a different system to make the color more evident. Each artist does the same and develops his own system. It we think of the millions of cells that make up our organism, that are continually renewed, and that work together without a mistake, then we can only marvel. If at times there is a mistake then there are big problems. Evolutionists say that this is a matter of chance and that slowly, over time, something simple becomes more complex. How intelligent chance is! It really is unbelievable that something stupid can make such intelligent things—without even mentioning our brain, the intelligent complexity of which is beyond imagination. So, for many intelligent people, stupidity is necessary to produce intelligence: a more complicated entity is created from nothing.

This is not the case with Phil Sims: his simplicity is evident; anyone could paint one of his paintings. But in spite of that they have their own, absolute, specificity that makes them quite distinguishable from all the others. He has a very special sensitivity toward color and arrives at a result that can only be his.

I have often asked myself how he achieves this miracle. Perhaps it consists in the numerous veils of paint he places over each other: there are about forty to sixty successive layers of almost identical colors. This is a slow, gradual process toward the final objective: the particular color the artist has in mind, one of his own invention that is discovered only through this long evolutionary

process. The artist stops when the miracle has occurred. The material has been transformed into an idea; it has become another thing. For this reason, as with all color art, the pictures are virtually irreproducible. How can a mechanical means capture something immaterial? This is something that cannot be grasped either by scientists who are used to measuring facts with instruments or by people who understand only by following logic. This might be its limit, but it is also its secret force: it asks for an interior cleansing. We must eliminate useless superstructures, go back to being a child, and this is the most difficult thing. Our consciousness is covered in so many encrustations.

Perhaps Sims's origins have some influence on all this. He was born into a family of agricultural workers in California. California has a climate similar to that of the Mediterranean, and there are the same colors that give a specific character to the landscape. There is little humidity, and light illuminates without diminishing visibility, and because the air is pristine, things can be clearly seen: where there is light there is color.

The quantities of color are innumerable and those that Sims chooses are his and his alone. The pictures, above all the large-scale ones, are like a land without end that you enter and are immersed in, becoming another being, just as when on a clear day if you look at the blue sky you are absorbed by an infinite reality. With regard to the power of his pictures, I remember a conversation we once had while on the way to Trento for a show about the influence of Indian spirituality on his art. Buddhism and Hinduism might have had points of contact with it. Sims told me he had great respect for Indian spirituality but had never deeply investigated this interpretation of reality. He felt his relationship with things as something concrete, not an evasion to some transcendent state. I think this is the best interpretation of his work: to transform reality into an idea where physical incidentals disappear and there remains only what is essential. This is a kind of painting that lives and is transformed by light according to its intensity, and when the color changes so does the picture. This is why the pictures must be seen in daylight, which as it changes hour by hour changes the pictures.

When they are hung it is necessary to take great care over the light source and how they are illuminated during the day. This is an art that comes from nature and must be seen with natural lighting.

I have bought many paintings by Phil Sims. I just cannot stop myself when I see new ones. I have also done my best to show them to others. Many are on show in the house in Biumo that I have given to FAI: a fair number of people visit it.

A room has been devoted to his work in the Ducal Palace in Sassuolo where his pictures fill the stucco frames left empty for centuries because of the po-

litical problems of the dukes of Este. The Gran Guardia in Verona, the biggest building in the city, dating from the early seventeenth century, contains many works by Sims. I asked the artist to create paintings adapted to the building's imposing, eleven-meter-high (36 ft.) walls. The works are exhibited in the largest room and over the imposingly large staircase. In the new museum in Rovereto there is a room containing four pictures by Sims. A room was devoted to his work in the Ducal Palace in Gubbio, but sadly the loan period ends soon.

I hope to find other large old buildings in which to show these very beautiful paintings. I am always on the lookout and hope to find something, but this needs a lot of time. Beautiful and available buildings are in short supply, though in Italy they still exist. Placing the ancient and modern side by side has always been my passion, something that began many years ago in the house in Biumo, which dates from halfway through the eighteenth century.

ANNE APPLEBY
HARRISBURG, PENNSYLVANIA, U.S.A., 1954–

Anne Appleby lives and works in Montana, an almost uninhabited area of the Far West, in the midst of forest-covered mountains. Appleby too paints works in a single color: often they are triptychs where each panel has a different color, thus creating harmony in diversity. She uses a special technique: oil paint mixed with wax, which gives depth to the surface, and it seems that some kind of hidden entity is about to emerge from the surface. This is a quality of nature, an unknown reality that reveals its colors but hides its deepest being. Its mystery is fascinating, and Ann Appleby manages to represent it, something that is almost impossible. Her paintings are the landscapes of a nature that is invisible to our eyes but not to our conscience, which goes beyond the visible. Landscape is a genre much used by figurative painters. There are very few really good ones who go beyond a mere reproduction of what we see.

Perhaps the greatest was Caspar David Friedrich whom no one has bettered in reproducing the sense of the horizon. His superimposition of thin glazes gives us an idea of limitless space. In Friedrich's work nature is an immense cathedral where man is alone in front of the mystery of his existence, but he does not despair as he feels the presence of the Creator above all things. Seeing his pictures again recently in the Alte Galerie in Berlin I felt the same emotions I always have. Even in the pictures by Lorenzo Lotto and Giovanni Bellini you can see beautiful landscapes, fragments of nature, behind the figures of the saints. The Impressionists were among the first to paint from life in the middle of the landscape. They described the immense pleasure of light

and color. They saw the beauty of the unknown but did not to enter within it. Appleby goes further or, rather, digs further inside, inside and beyond the visible.

The choice of living in a solitary place among the forests demonstrates that the life of nature is her life too. Abstract art does not distract us with the sight of trees, mountains, and flowers, because abstraction goes beyond that and reveals what is hidden from our eyes.

She is a middle-aged woman full of youthful vigor. Her face reminds me of the Indians of the West as they are shown in the photos of a hundred years ago, the last survivors of a great civilization. When the president of the United States asked an Indian chief to sell his territory to the government, he answered that land cannot be bought or sold since it is sacred and divine.

I envy those who manage to live in the isolation of nature, to live within her beauty and become a single thing with her: then you are no longer alone but part of a life that never dies.

I remember a journey many years ago, in 1954, to the Canadian Rocky Mountains; Montana is just to the south, so I imagine the landscape is the same. It was a marvelous experience! The Alps are dwarves in comparison. Everything is grand and solemn in America. But the grandiosity is not aggressive: it is like an immense altar that rises toward the heavens, a deep blue with the silvery reflections of northern light. Just how right was that Indian chief when he said that nature is something sacred! The valleys are wide, swathed in intensely green conifer forests. The glaciers are overwhelming and plunge right to the bottom. The mountains have rocky walls but are not oppressive as they are full of light. I was just one among many tourists and stayed in the Grand Hotel; our trips were well-organized. In the evening there were dinner-dances, but I never participated as it was sad to see such mediocrity in the midst of the splendor of nature. This experience allowed me to understand Anne Appleby's choices: this is the best way to live, in a marvelous place creating paintings that are just as marvelous.

I see I have spoken a lot about nature in this story of my life. Certainly I repeat myself. I have mentioned the deserts of the West that have inspired the Los Angeles artists of light and perception; Turrell's Roden Crater in Arizona, one of the most beautiful places in the world; De Maria's *Lightning Field*, one of the greatest emotions I have experienced in my life; and now the Montana mountains. These may well be repetitions, but I don't think I am boring the reader: these are all such different things!

Anne Appleby's pictures attract like the Rocky Mountains. The colors of her works hide something within, something that is both near and far at the same time. When I think of traveling in those mountains I feel nostalgic. At age eighty

I will never have the time to go back. This is a vision of the "Great Mother" who creates everything; we come from her, we were generated in her womb, and we will return to her. The unknown wheel of life that is always turning. Being the "Great Mother" is nature's fascination and irresistible power.

ANNE TRUITT
BALTIMORE, MARYLAND, U.S.A., 1921–
WASHINGTON, D.C., U.S.A., 2004

Another female artist of great quality, but who was underrated throughout her life, was Anne Truitt. Her work began with the Minimalism of the 'sixties. She always made painted sculpture, a fusion of form and color.

The reductive rigor of her work was the exact reproduction of her character, as can be understood when reading her diaries, which tell of her interesting interior life and her family. This was a life of complete moral coherence, a way of existing that ought to be that of us all, or at least of many of us. It is exactly the opposite of what we see today; there are some people who live like this, but sadly not all that many, and I think they are becoming fewer. However, the majority does not behave in this way and does not follow this way of life but challenges and rejects it. This was the strange behavior of the generation of the 'sixties who accused their parents of presumed corruption.

She really should have had the same fame as Judd, Andre, and Ryman, since her work was not in any way inferior and was shown by the famous Andre Emmerich Gallery in New York. But this was not enough.

The sculptures are made from painted wood. The paint is laid on carefully, layer after layer over a perfectly smooth surface. I think her most interesting works were the columns she made over the past fifteen years. They are about two meters tall and about twenty to thirty centimeters each side. They have to be seen in an empty white space where their verticality becomes the dominant quality. The color is an immaterial element that empties the object of its physicality. The column seems to disappear, absorbed into an existence that has no physical identity. This is a direct manifestation of the artist's personality, and is similar to those people painted by Piero della Francesca in the fifteenth century who also became a manifestation of an entity that exists before all things. It is the discovery and manifestation of the invisible, of that substance that is not a substance and so cannot die; it exists always and that saves us from desperation when we think of the end. I hope to have this possibility in the future.

I was greatly moved when I read parts of her books and must find the time to read them all to the end.

I bought nine works; three are on loan to MART in Rovereto and were exhibited from December 14, 2002, to March 3, 2003. They will be shown again in the future, depending on the museum's program of shows that have to change periodically. In fact only three of the nine works are exhibited. I hope to buy other works by her. Their price has increased, as is only right, and I am sure it will increase even more.

At eighty I cannot buy with the same freedom as some years back, my advanced age obliges me to keep my finances in balance. If I die, as will necessarily happen sooner or later, I cannot leave my five children with financial problems; they must be able to live in serenity without economic problems, otherwise the integrity of the collection would be endangered, and this integrity must be aimed for by a progressive and gradual collocation in museums.

Just a few days ago came bad news. Anne Truitt had died on December 23, 2004, just before Christmas.

On November 5 we were in Washington to see the Flavin show at the National Gallery, and this was an occasion for meeting and getting to know her, a meeting we had hoped for a long time, and at last it was possible. Renato Danese, her dealer, organized the appointment for us in the Four Seasons Restaurant in Washington.

We were, and still are, fervent admirers of her art. I knew about her life from her books, written in the form of diaries narrating the large and small events of her daily life.

She leaned on a walking stick but her health seemed excellent. I had bought sculptures and drawings created over the previous months. She was at the height of her creative energy despite her eighty-three years. I never would have believed that that would be the last time we would see her.

Her slender, distinct, still vigorous form did not betray her age. She was elegant and simple, her limpid and sincere gaze was unusual, something rare in an elderly person. She gave me the idea of the person I had imagined when I looked at her sculptures or read her books.

It is not always like this. Sometimes imagination and reality part company. Our conversation during the meal was not all that simple though. My hearing has diminished recently and my eighty-two years are beginning to make themselves felt; my English has worsened as I have fewer occasions for speaking it. Truitt spoke softly, sounding her words in her throat and making it difficult for me to distinguish them, something that often happens to me in America. Because of all this our conversation did not flow easily; I only understood a part of what she said and, no doubt, the same happened to her too. It was, though, an important experience. We had met a person we greatly admired.

Time destroys everything, but beauty does not die. Appreciation of it grows over the years and can suddenly revive interest. This is what happened with the work by Lee Bontecou from 1960 to 1963. At first it was not greatly appreciated and was forgotten for some forty years. Recently interest has been rekindled by a series of shows. The value of the works from that period has, in less than two years, risen from 70,000 dollars to 700,000 dollars. Commercial values are not a guide to real value but they are an indication. Now we have the responsibility as well as the pleasure to work for Anne Truitt's art, which has within it the strength and power to make itself appreciated. The amount of time necessary for this task cannot be known, but working to shorten it should be the mission of those still alive.

Certainly history's judgment will be highly positive, different from today's.

RUTH ANN FREDENTHAL
DETROIT, MICHIGAN, U.S.A., 1938-

Ruth Ann Fredenthal is an artist who at first sight seems to paint pictures with just one color, but when you look at them with attention you discover this is not so. This is, though, only of secondary value as what is more important is the technique the artist uses for obtaining the desired effect. The interest of her pictures lies in the impression they produce when you look at them. The painted surface seems to disappear and opens up a vision of indefinite space. This is the same effect as when looking at the horizons of the great Caspar David Friedrich with their numerous delicate glazes. Fredenthal's pictures are also painted with various glazes: fifty or sixty. But there is a difference: they are completely abstract and are not monochrome. There are three or four colors disseminated over the surface. Their differences are minimal and can be seen only by looking carefully when you also see the boundaries between one area and another, similar to an undulating line. Friedrich also used slight variations of color in order to emphasize the effect off depth.

In Fredenthal's pictures there is also a further factor of instability. The tiny differences in color are not strong enough to interest our mind and catch our attention. Our eye continually moves when we look and probably sees something different before we do, something that it is not able to identify because the mind's attention has not yet been brought into action. This is a problem of perception, at the very limits of our possibilities; perhaps it is some remote hereditary factor written in our genomes when we were wild animals that had to save themselves from predators. The gift of conscience had not yet been given us and only instincts existed.

The basic characteristic of her pictures remains the delicacy of their surfaces.

The colors are both strong and tenuous at the same time; they give the sensation of dilating space. They seem to be windows opening toward the sky at twilight, at the moment when there is still light but it is fading; when the colors of sunset have disappeared, then the presence of the infinite becomes stronger.

Fredenthal began to create extremely beautiful pictures halfway through the 'seventies, just when Postmodern philosophy was beginning to impose itself, rejecting all the values of Modernism. Her work is an evolution of Modernism and uncovers a new dimension that orthodox Modernism, when it became incorporated in Minimalist Art, never developed.

Postmodernism is the exact opposite. This is why she was excluded from the art world in the 'seventies, 'eighties, and 'nineties. She has been marginalized by critics, museums, and the market. She only sold a few paintings and so could not live from her activity as an artist. She worked for a firm that made shoes and designed the new models, a job that left free time for painting. This was her one pleasure, because admiration, so important for artists, was certainly in very short supply.

Each picture takes a long time, and she produces just a few in a year. She has to allow many days to pass between putting on one layer of paint and adding the next, and many layers are needed. She is no longer young but is always in good health. She keeps herself active by taking part in the New York marathon every year: a long journey around Manhattan, and she always arrives with a good placing.

In the house in Biumo there are three rooms with works by Fredenthal. In each of these rooms there are three pictures. They all have similar colors, a light blue like the sky at sunset, and they are very evocative. When FAI, which administers the place, receives donations, as a gesture of thanks it puts the donor's name in a room. An association had its name written in one of Fredenthal's rooms. One day a lady, the president of the association I believe, came to see it, and when I showed her the beautiful room she was very disappointed and said, "There's nothing here," and left. She had expected to see a fine landscape, which was not there, except that it was: had she looked out the window—the sky had the same color—she would have seen a beautiful view just like the three pictures in the room.

ETTORE SPALLETTI

CAPPELLE SUL TAVO, PESCARA, ITALY, 1940–

Ettore Spalletti is one of the few Italian artists in the collection. He works in the field of reductionism and single colors. He creates sculptures and pictures coated in a layer of colored plaster. They seem the colors of Florentine frescoes of the Renaissance at the beginning of the fifteenth century. His work is completely abstract but has an intimate relationship with the environment where the artist lives and ancient Mediterranean culture. This is a culture of balance, proportions, and harmonies; only rarely are there the anxieties and tensions of the north. Nothing is hidden, everything is displayed and visible. The sun that illuminates these regions also illuminates the soul. The forms Spalletti uses are of elementary simplicity. Often they are columns that enlarge toward the top: the variations on this are many and the possibilities inherent in it are endless. At times the pictures are detached from the wall at one side, and the thick edge of the picture is painted. He uses pink, light blues, and grays. These are the colors that can be seen from his home, which is on a hilltop: beyond are the distant sea and silvery olive groves, and the wide valley surrounding the hill takes on their colors. The distant mountains of the Gran Sasso and the Maiella are seen through a pink, gray, and light-blue atmosphere. I see his two rooms in Biumo every day, and each time I feel the same emotion. These are colors and forms that seem to rise from the earth, suspended like something weightless. Many shows have been held with such titles as Spirituality in Art, but very few works in them manage to rid themselves of their material nature and gain another. This is a miracle caused by the presence of the spirit, a very rare phenomenon and one that very few artist achieve. Often they have the best of intentions, but they do not manage to transform the material into a different and unworldly entity. So-called spiritual works of art often have religious subjects, but the only spiritual thing about them is their aim. There is no transformation into another entity. This would be a very interesting subject to examine: to understand why religious art doesn't manage to be spiritual.

I found out about Spalletti through the photographer Giorgio Colombo who had done his military service with him. We went to visit him in his home and studio in Cappelle sul Tavo after a long journey from Milan to Pescara along the Adriatic coast, a memory now tinged with pink, blue, azure, and clear gray dissolved in a springtime light. When I look at contemporary religious art I see a lot of heavy material. I do not know what Spalletti thinks about this as I have never had the chance of talking with him about it. I think that, rather than being about some precise idea, this is a question of a way of feeling. When an artist experiences something completely, he necessarily finds within

himself emotions originating from something else, not from his own self. In that moment he feels he belongs to a greater reality, one that is higher than him. He feels within himself an intangible entity, one that has no body but is the reason for the existence of everything.

Spalletti lives in a place where the light and colors are typically Mediterranean, though without the harshness of the more southerly regions such as Sicily.

Many years ago I was in Athens and went to see the Acropolis. I was greatly struck by certain sculptures in the museum, the *kouroi*, which had remained buried under the ruins left by the destruction of the earlier Parthenon during the Persian invasion in 480 B.C. They have a strong human presence and are absorbed in a solemnity that transcends physical existence. This is the presence of the divine in the human. It is the exaltation of humanity because it expresses a dimension without limits. The union between the sacred and the real: a characteristic that sculpture was to lose in later centuries by becoming the expression of a hedonistic reality without the values it once had.

When I look at the sculptures and pictures by Spalletti I have a similar impression: I breath in an atmosphere where the real is absorbed by the unreal and is surpassed by its invisible and indefinable power.

ALFONSO FRATTEGGIANI BIANCHI
PERUGIA, ITALY, 1952–

I met Fratteggiani some years ago through Phil Sims, who was his guest in his house in the country. He was involved not only with agriculture but also music and art, organizing exhibitions and concerts; his wife, Ulrike Brand, is an internationally known cellist.

He had asked me to lend a picture by Sims to a show of abstract art at the Perugia National Art Gallery, on the advice of Caterina Bon Valsassina who was at the time working for the art superintendency. This was my opportunity to get to know Fratteggiani, who was not an artist but someone interested in art and culture. We had long and enjoyable discussions.

Perugia is a splendid Medieval and Renaissance city with a gallery full of masterpieces from the thirteenth century to the time of Piero della Francesca, an artist I love deeply. We were about to conclude plans for using the Ducal Palace in Gubbio for a long-term loan of works from the collection, again thanks to the help of Caterina Bon Valsassina who was also the director of the building.

In 2000 my wife had arranged a trip to Umbria with a group of friends, and the last stop was in Perugia at the Villa del Cardinale, a building by Alessi from the second half of the sixteenth century, which also has a large garden.

I was unable to go on this trip as Fratteggiani wanted me to visit his home in order to show me "something," but he didn't say what. In a room of his old house, which had been built in about the eleventh century, there were a lot of small paintings hung on the walls. His friendship with Phil Sims, an artist involved with the color art, had given him the stimulus for trying it out himself, but the paintings I saw were different from those of Sims. The best were painted on a heavy stone support. The color was laid on without any kind of binder. The impalpable pigment dust penetrated into the microscopic cavities of the stone. This is a property that other kinds of stone do not have, only a particular stone found in Tuscany and Umbria, known as Pietra Serena, and used by Brunelleschi in the fifteenth century for the churches in Florence. This is the only existing means for seeing color on a surface in its absolute perfection. If there is no binder then inevitably the pigment blows away at even the slightest breath. The binder is an inert agent that changes the color, and this is unavoidable. You can use oil instead of tempera, acrylic instead of Vynavil, but the result is always the same: a color that is less beautiful than the original pigment.

Fratteggiani's discovery is quite simple, and anyone could have taken a piece of this stone and used it. Piero della Francesca, Perugino, and many other great artists had it under their eyes but they did not use it. It has taken two thousand years of art history to be able to see color in all its purity. But it was not possible before Abstractionism. The duty of painting was to describe and represent what was in front of our eyes. Rothko had to teach us that with color you can express everything better, even the inexpressible. Duchamp too changed our ideas about art by making a simple gesture, that of putting a bicycle fork and a wheel into a hole in a bathroom stool. This gesture contains in itself an infinity of metaphors and interpretations. Anyone can take a Flavin home just by going to the store downstairs and buying florescent tubes. But no one, in fact, thinks of imitating him. Flavin was the first to have the idea of creating art with light.

Fratteggiani continues to work with color, occasionally worried that bad weather might damage his vines, at times journeying to the Apennines to choose sheep for his flock.

After my visit to his studio my interest in his work grew considerably. I bought various pictures to hang on the wall of my studio in Biumo. They looked good, very good. The more I looked at them the more I liked them. To enter the room and see colors so ample in their authentic simplicity was a continual pleasure. In the collection there are many artists who use the expressive element of color. It has, after all, been one of the main areas of artistic research over the past fifteen years. Fratteggiani does different work, which has an unusual kind of visibility. Because of the weight of the stone he only

makes small pictures, but they have all the imposing presence of large works. His is a strange way of painting, without canvas or a wood or metal surface, without paintbrushes or a palette knife or a spray gun to apply the paint, and using a material that has no solid consistency, just a fine dust that could disappear at a breath. The paint is applied in an even more unusual way, with the movement of his fingers over the stone's surface, just sufficient to make the pigment penetrate into the minute cavities of the material. This is a property exclusive to Pietra Serena, which is firm, quite homogenous, without impurities, and with a neutral clear gray color that does not alter the look of the pigment that is added to it. There are other sandstones that could be used but they do not have a neutral color without impurities.

The only problem is the weight that makes larger surfaces impossible. So far his largest works have been 56 x 37 cm (22 x 15 in.). Another limit is the delicacy of the surfaces, which cannot be touched since the color comes off on your fingertips. The experiment in my studio in Biumo was completely positive, so I just had to buy other works, lots of them. But Fratteggiani has also been very generous with gifts. And not just pictures: when he comes to Biumo he brings tomatoes, bottles of wine, capons, geese, and eggs that have all the full tasty flavor of his native soil. He loves the land, though he is not a farmer. He knows all the latest things about music throughout the world, for music is a great passion of his too. Some years ago he constructed a cello that every so often he plays, and he plays it well too. His house is often visited by intellectuals and musicians. This is an enthusiasm he shares with his wife Ulrike. I have donated many of his pictures to FAI. Many people are struck by the colors and ask me for more information, for this is an art that strikes straight at our instincts. This is why many intellectuals are still not aware of his work. Many others know about it though.

A lot of people ask me how they can meet a good artist: Fratteggiani is one, and I met him through another artist, an acquaintanceship that came about for various reasons. It is important to discover the right occasion for finding what you are looking for.

His work has another important characteristic: you only see color. The artist's action is passive, it is only a way of allowing us to see the color without any kind of manipulation or gesture to show his own personality. Apparently the artist need not exist and could be substituted by a craftsman. But this is not so. To lay on color with your fingers is not a mechanical movement: you need a lot of experience to apply it well and obtain the effects you want. What is fundamental is the choice of pigments for they do not all work well. Certainly here color is more important than the artist. Fratteggiani knows how to indulge it.

PATRICIA MOISAN
TAKOMA PARK CITY, MARYLAND, U.S.A., 1951–
BETHESDA, MARYLAND, U.S.A., 2007

Patricia Moisan was another artist fascinated by the beauty of color when it is not polluted by a binding agent. She lived in Los Angeles. She attempted to make extremely fine colored powder adhere to a surface. This is an almost impossible undertaking that, however, those who love color cannot stop attempting. Los Angeles is a semi-tropical city with a temperate climate that doesn't change throughout the year: the ideal environment for having beautiful flowers all the time. There you can see flowers quite unknown in our part of the world and which create masses of compact color. For an artist it is irresistible to imitate nature and possess this supreme beauty.

In the 'sixties Yves Klein had tried to achieve this aim with blue, the color of the sky. He obtained his best results by blowing the pigment onto a sponge that he then placed in his work: the honeycombed surface absorbed the color but the form of the sponge was not adapted to being part of a picture. Remembering this artist upsets me since I knew him well, and he often came to Milan when he exhibited at Le Noci's. But I never realized his importance, and this was a big mistake. Patricia Moisan has found another material with the physical characteristics of sponge. This is a plastic with a rough surface well adapted to absorbing color. In this case too the pigment has to be blown on. I think that first of all she lays down a layer of binder. The result is very positive: the color is pure and dense.

Like those of Fratteggiani, her pictures cannot be touched since the paint sticks to the fingers. But I am understating the case when I say that Moisan's pictures are extremely beautiful. When colors are visible in all their purity there is nothing more to add as the utmost limit has been reached. You can of course discuss what feelings are caused by red, blue, or yellow, and the allusions might well be many, each different from the other. Here we are in the area of individual impressions, we are dealing with opinions and interpretations. But over and above subjectivism there is an objective reality where the individual self disappears. When color is pure we see something definite beyond which we cannot go. We are in the domain of the sublime, the *sub limes*, below the limit. This is the maximum of the perceptible and the knowable. We become aware that all other colors are more or less contaminated and do not give us the impression of having reached this limit. I think that this perception of the sublime is due to color's luminous nature. Color is light, light reflected by the atomic structure of the material. Light results from various wave-lengths: it is the smaller or greater distance between one flow of

visible energy and a successive one. Black absorbs all visible energy while white reflects it. When this absorption is only partial the result is different colors, the waves of electrons spinning around the nucleus that absorb or reject the various energy frequencies. Energy: something that behaves in a strange way and that is not material but can become something with enormous power. The beauty of color, probably, consists in this enormous power of energy.

TIMOTHY LITZMAN
VICTORIA, TEXAS, U.S.A., 1963–

Timothy Litzman is yet another artist whose aim is to research the expressive possibilities of color. His technique for doing so is completely different from the others. The painted surface is a transparent acrylic plastic panel with one side sanded in order to make it opaque. The great difference is that he does not apply color on the surface but on the other side. The color filters through the thickness of the plastic. This filtering creates new and unusual chromatic effects.

The color loses its substance and becomes something light but at the same time clearly present. These are not colors diluted with white to make them clearer. They are completely different and mix with light, and though they lose their physical presence, they acquire another one that is even more present. All the sides of the panel are painted with a thin layer of a different color that seems to penetrate inside it. It is extremely interesting to see how each artist reaches his or her aim through different techniques. Each technique is exactly right for each individual artist. The two things seem to become a unity. Litzman is young, married to a delightful wife, and with a baby just as delightful though, not having seen him in some time, he will have grown up by now. A short time back Litzman's success increased, though I don't know for how long, when he began to exhibit with Mary Boone, the famous dealer, an extremely able saleswoman with an important clientele. The gallery is on Fifth Avenue in New York, between Fifty-seventh and Fifty-eighth Streets, in the most central part of the city. I have known Ms. Boone for many years now, since when, in the 'seventies, she was the secretary in the Bykert Gallery run by Mr. Klaus Kertess, which I often visited when it represented Brice Marden. At the time I was greedily buying all his available works. Over thirty years have passed, but she is still a highly attractive person and her business has continued to grow. Sadly, when my artists arrive in her gallery their prices go up and I can no longer buy them.

In Los Angeles in 1988 and 1989 I bought many pieces by Roni Horn. In 1990 I went to Mary Boone's gallery with my wife and saw an amazing stain-

less steel sphere, and even though it cost far more than the preceding works, we bought it all the same. However, it was the last work we bought, as the prices were just too high for us.

Luckily I don't think Timothy Litzman has been sucked into the vortex of the market. His art is a reflection of his personality, an art of someone who leads a quiet life and, therefore, a morally balanced one, without ambitions that might change his behavior and hence his art. He has always shown understanding for my plans. When I asked seven artists to makes pictures with the precise measurements for the preexisting frames in the Sassuolo Ducal Palace, he helped me finalize what was a very high-level project. I have faith in his character and am sure he will not be attracted by the market's blandishments.

But on the other hand it is only right that the best artists have a financial recognition as well. Unfortunately even those who do not merit it have it too. But then if fate wants to be generous there is no way of stopping it.

MICHAEL ROUILLARD
VALPARAISO, FLORIDA, U.S.A., 1955-

Michael Rouillard is another artist who works with color. The first pictures I bought from the Eric Stark Gallery between 1994 and 1995 were painted with a special color, "Japan Paint," that had a particular luminosity. It was as though the material had absorbed light and then slowly emitted it again, with a gradual lowering of its intensity. The works had varying dimensions, some very large. The pieces created using that paint were really beautiful. Now Rouillard paints thin panels of aluminum that are superimposed with a very positive aesthetic result.

One of the last times I visited his studio, in a dilapidated building that was about to be demolished—though in a great location on the other side of the river with a spectacular view of the Manhattan skyscrapers—he was complaining to Eric Stark that he kept bringing him visitors who would ask "What does it mean?" when they saw pictures that only showed color.

This is the question that has haunted me since I began collecting fifty years ago, above all in the early years when people would enter the house and see my Klines. They would laugh and say that a child could do the same thing by pouring black paint on a white canvas. The Tàpies works were old scraped-down plaster. It was impossible to convince anyone by saying that the Klines expressed the wish to reach an impossible destination, that Tàpies represented the search for a new kind of truth after the moral and physical destruction of the war. In front of the Rothkos, "a wall-painter's color samples," I uselessly tried to explain that in the paintings there was the sensation of limitless space, the vision of a supernatural reality. They just couldn't see it. And what laughter there was at the sight of the Rauschenbergs: these were things made by tipping over a trashcan. I would explain that they were images and objects that reminded him of his past. Only on seeing the Pop Art pictures did they understand what the pictures meant. "How vulgar," they would say. But my further attempts to explain that they were painted like classical pictures and idealized the subject were not convincing.

When Minimalism arrived the comment was that this was not art; they were not things made by an artist. Ryman's white paintings were canvases that still had to be painted on. My explanation was that the marks created when laying paint down on a canvas revealed the artist's feelings and personality like a kind of handwriting. Conceptual Art revealed my madness in buying words that could be found in any dictionary. It was quite useless for me to explain that this was a philosophical inquiry into the connection between what was signified and the signifying object. Los Angeles Environmental Art, rooms containing light and space, was boring, just a waste of time looking at nothing at all. It should have been an occasion for perceiving what we are, the beginning of life, but, no, it was boring. The same thing happens today. The negative comments in the past were pronounced by art professionals, not by people without any education: museum directors, curators, art critics. Today there is a difference and the situation has changed, as was shown when the first part of the collection was bought by the Los Angeles Museum of Contemporary Art, and even more so when the Guggenheim bought the collection's Minimal Art: everybody knows that there is no questioning the quality of choices made fifty, forty, or thirty years ago. They are in museums, even though for many people they are still difficult. There is now a reverential nervousness; it is dangerous to say you do not understand or to criticize openly, as there is always the risk you will say something stupid and make a fool of

yourself. The visitors to Biumo become enthusiastic in the Flavin rooms, works of some forty years ago; and the same thing happens with the Turrells and Irwins that only date back thirty years. This is no longer contemporary art but is part of history and has a considerable commercial value. The judgment of art professionals on the art of color is usually negative, with exceptions of course. It is thought of as a continuation of Minimalism, something from the past and therefore boring. We live in a period of so-called Postmodernist philosophy that rejects Modernism and so cannot admit that Modernism could evolve and build something even more complete on the basis of past experience. I have in front of me paintings by Simpson, Sims, and Fredenthal in the rooms where previously there had been Rothkos, Klines, and Rauschenbergs from the 'fifties, Pop Art from 1961 to 1962, now considered among the most important works of art of the second half of the twentieth century, one of the most creative periods of modern culture. But I feel no important difference: my feelings have the same intensity. I have been looking at these paintings for many years by now, and if there were any weaknesses I would have discovered them, just as I discover that every so often I commit errors. At times I ask myself, if so many educated people do not understand, then am I the one who is mistaken? But when I look again my doubts vanish. The same errors committed fifty, forty, or thirty years ago are being committed now: we must be patient. I have within myself a thermometer for measuring beauty. I realize quite quickly when this is not functioning; but when this measurement of vision is repeated, then—if you will allow me to say so—it proves itself to be infallible. Fifty years of history demonstrate the truth of this. The thermometer has become even more refined over time. It measures the temperature of my feelings. It is something I also feel when looking at antique art. The need to answer the question "What does it mean" in just a few words has been very useful and has forced me to give a cogent and simple definition. Interpretations can be many, so I have to choose the ones that say the most. This has also been a help in my own understanding of art. It is necessary in all things to arrive at a central meaning from which the others derive. This is the best way of understanding even the most difficult things. In philosophy and for scientific problems it is a necessary system. When knowledge is dispensed in pills, the more pills there are the more you can know, from the simplest to the most complicated things. This is science's method and the one nature is built from.

WINSTON ROETH
CHICAGO, ILLINOIS, U.S.A., 1945–

Roeth works with color and was the first artist of this kind my wife and I collected, in 1990. His is a very different technique. He uses a binding agent that is extremely ancient and was used by Piero della Francesca and almost all the artists before him: egg tempera. Oil painting was disseminated in the sixteenth century, but tempera has its own particular quality: it spreads uniformly on the surface without creating thickness, and so the artist's intervention disappears together with that of the paintbrush. The painted surface stays smooth, as in the paintings by Piero della Francesca. The paint seems a colored mist. These are Roeth's characteristics. The luminosity of his colors is his most important quality. Roeth inserts an elementary form into his compositions. He most often uses a stripe a few centimeters wide that runs along the edge in a darker color than the picture itself; at other times it is an almost invisible grid that covers the whole surface. At other times the painting is divided into two equal parts, though with different yet harmonizing colors.

Roeth lives and works in New York and has his studio downtown, near SoHo, which, until a few years ago, was the center of the art world, though it has now moved to Chelsea on the West Side. His house abuts Little Italy; in fact the Café Roma is on the ground floor. This is an area full of nostalgia for its lost origins. He lives together with Susan, a beautiful, likable woman, and also a very good dancer. Part of Roeth's work also involves theater scenery with projected colored light.

He spends summer and fall in Maine, a North Atlantic area of astounding beauty. It is cold but the sky is almost always clear and blue and is reflected in the waters of various lakes and in hollows where the sea penetrates beneath the land. There are hills covered in great forests. A bewitching place for an artist.

Color artists are disliked because of their simplicity. They are considered the tired followers of something from the past and unrelated to reality. Minimalism is considered an empty intellectual exercise by its opponents. It is necessary to communicate with people and use a language understood by everybody in order to create an art of importance to society. It is necessary to choose subjects that interest everyone so everyone can be involved in some way or another. The artist's aim is to communicate with the greatest number of people. Art must not be the privilege of those few with enough education to understand. This was precisely the agenda of the artists active in Paris between the end of the 1800s until 1929. These are the artists illustrated in the *Larousse Encyclopedia*, all now forgotten though famous at the time, while

many artists, the ones we consider fundamental for the history of our century, were misunderstood. The situation began to change after the crisis of 1929; the contemporary artists seen in Larousse disappeared, and even the artists of the distant past began to be reconsidered. There was an increased interest in modern art that did not aim at pleasing people. Here was a search for a new vision of reality opposed to the usual one. People did not understand because they did not want to make the effort needed for understanding. Modern art seemed a transgression, a provocation in order to draw attention to the artist. Those who did not understand Picasso, who put eyes where the nose should have been, did not see the inhuman tragedy that was spreading throughout Europe, a bloody war that began in Picasso's own country: a million people died in the Spanish Civil War. After 1939, millions of dead, torn apart by explosions and executions, had eyes in the place of their nose. Those who drank their coffee on the Champs Elysées in Paris never thought this might happen.

De Chirico, in the second decade, painted Metaphysical pictures in which the perspective was wrong and all the rules discovered in the Renaissance were broken. Dreaming, imagining a reality that looked toward an infinite horizon, was his only way of withdrawing from the violence of the present.

In the 'eighties and 'nineties of the twentieth century too many artists engaged in provocative themes, often with the help of sexual images. These images aim at being challenging but no longer are; there are so many of them that everyone has become used to them. It's about time they changed argument; so-called provocation's only result is to provoke. It is a protest against the political system or social injustice. All quite admirable aims that cannot be resolved by artists alone. But as there is no higher aim the work becomes a useless protest. There are just not the conditions for a desperate and despairing vision of the world, since after all we have a far better life than there was in the 'thirties; we do not have the threat of terrible tragedies hanging over us.

Rejection only destroys, it does not construct. It is necessary to have hopes for positive outcomes, hopes based on convictions that can resist all adversities because they are independent of personal aims and external circumstances. Such convictions need constant commitment, an unprejudiced mind, and, above all, the courage and tenacity not to do what others are doing. To go against the current means sacrifices, giving things up, and economic poverty, but moral victory that sharpens our capacity for working better is the real aim of life.

CAROLEE TOON
1947–

Carolee Toon is an artist who creates delicate monochrome pictures. Their basic quality is their light color, yet despite this they are not pale, vaporous, and almost nonexistent but are real colors: substantial and real. She merits more attention than I have been able to give her. Her work is original and quite different from that of others with her same interests.

I saw her pictures in the gallery run by Mrs. Kiyo Higashi, one of the best galleries in Los Angeles and specialized in this kind of art. She devotes herself to this activity fully and competently. I have come to know and buy works by many of her artists. As she is Japanese she knows the restaurants that prepare the best sushi, the food my wife and I prefer. She takes us to Katsuo First near the Beverly Center where the owner is also the cook. He greets us with typically Japanese etiquette and attention.

I have only bought a few works by Carolee Toon. I discovered her work on one of my last trips to Los Angeles, before I fell ill, and I have not yet had the possibility of going back. She is an artist who is worth seeing again. I have only once visited her studio, though I don't remember if it was in Pasadena or the San Fernando Valley. It was a small room in an agreeable little house in the countryside showing a delicate sensitivity, where everything conveys a feeling of serenity and peace. It exactly mirrors her art. I believe that she supports herself by teaching, certainly not by her art. I hope that since that time her situation has improved as much as her work merits.

These are all courageous artists who create an art where there is nothing but color to be seen. Very few people are able to judge the different qualities between one artist and another. This art is rejected by the great majority. It needs a refined sensibility, and not many people have either the will or the disposition to be receptive to the origins of existence. Because this is what we are dealing with: understanding existence. These artists have understood what is important while others do not and chase after easy success.

PETER WEGNER
SIOUX FALLS, NORTH DAKOTA, U.S.A., 1963–

We came across this artist some years ago, in 1997, in San Francisco in the Hosfelt Gallery, which does excellent work with artists who may still be unknown but are of top quality.

The works we have collected by him are a combination of words of a conceptual nature and a delicate use of color on small panels that are then aligned

along the wall. The work develops from an extremely physical and utilitarian object: a firm's color catalog. Each color has an identification mark and a title. These elements are the excuse for making alterations to the color and title. They are always variations on a theme: blue, azure, pink, and yellow. The words, which are never more than two, change according to the tone of the color. The result is the transformation into poetry of something with an exclusively commercial use.

It is a fascinating transformation, the union between the meaning of the two words and its intensification by the color. The artist obtains poetry from something insignificant.

Various galleries have interested themselves in this work, even the famous Mary Boone Gallery in New York. But when a lot of interest is shown in an artist, even though quite justified, it becomes difficult to follow him. Even his work has changed. But let's hope the enchantment of his delicate poetry remains unchanged.

JOHN McCRACKEN
BERKELEY, CALIFORNIA, U.S.A., 1934–

McCracken is one of the most radical of artists. His reductionism reaches the maximum simplicity of form and color. He has, in fact, almost always used panels similar to the wooden planks used by builders for scaffolding. Usually these are about two meters (7 ft.) long, thirty centimeters (12 in.) wide, and three centimeters (1 in.) thick, the barest minimum for the existence of a form. He has even given up the last resource of Minimalism, the possibility of changing dimensions to give variety. But despite this basic limitation his work is in no way monotonous. It always avoids being boring.

The paint he uses is a shiny enamel, perfectly uniform and homogenous over all the surfaces of the object, which transforms it into something else. He uses primary colors, but they are always different as he varies their intensity. One of the dogmas of Minimalism was never to use paint but only the natural color of the material employed. McCracken does not follow this rule but invents another: non-painting. In fact there is no visible sign of the gesture of laying paint on the surface. His colored panels are very beautiful. Another demonstration of how simplicity is the endless source of aesthetic possibilities and of positive feelings.

My collection of works by McCracken is also minimal: I have only two, and even these I was slow in buying. I missed the occasion in the 'sixties when there was a wide choice. I managed to purchase the two I have in 1993 when the artist needed money to buy a house in New Mexico so he could leave Los

Angeles, a city he considered too big, with too much smog, and no longer having the limpid light it had forty years earlier.

CARTER POTTER
LOS ANGELES, CALIFORNIA, U.S.A., 1961–

Carter Potter's work is outstanding for its rigorous reductionism. His pictures are always square and are made from the celluloid frames left over from film editing, something easy to find in Los Angeles, the world capital of film-making. I must also say that the movies produced in Los Angeles are popular, but I don't like them; they are a commercial product, and I never go to see them.

These frames are used frugally, no more than four horizontal strips for each picture, not much at all. The strips are laid on a semi-transparent canvas permitting the stretcher behind it to be seen. This consists of four vertical bars instead of making use of horizontal ones. The result is a composition of elementary forms reminding me of Mondrian's black lines on a white background where the presence of the color is marginal. The maximum of simplicity and compositional rigor. It is difficult to go any further than this, the very limit of expressive possibility. I realize the dangers of this situation; on the other hand I am fascinated by the search for extreme limits. When you are near the limits, the presence of the unknown, the mystery of existence, whether ours or of everything, becomes evident. This unknown and mysterious presence is everywhere and in all things, the difficult thing is to know how to see it. It can even be found in the leftovers of Hollywood films where insensibility to the unknown is total, and for this reason they are quickly forgotten. Art's greatest results are on the rare occasions when this presence becomes evident. This explains my preference for fifteenth-century Italian and Flemish art. Another example would be the sculptures of Richard Nonas that are similar corrugated geometric forms, like the folds caused by the shifting of the earth's crust.

ROGER ACKLING
ISLEWORTH, LONDON, UNITED KINGDOM, 1947–

Ackling is a romantic lover of nature, a poet of its beauty as English and German painters captured it two hundred years ago. He respects it so much that he does not try to imitate it by painting it, as this would be a rude attempt to discover the secret it keeps hidden. The artist is aware of this impossibility, so he rejects any kind of imitation and embarks on a passive rather than active operation. He uses sunlight and pieces of wood. Our eye has a lens that

concentrates light onto nerves sensitive to the sun's radiation, allowing us to see. An artificial lens has been invented that concentrates the sun's rays onto a single point, which burns as a result. This is how the artist traces out parallel lines onto wood. This work is slow and needs a great amount of time, patience, and love. This is what nature asks of us mortals. It is a way of living together with our Mother.

I first saw his works many years ago in the Lisson Gallery in London, but I didn't buy anything. I was more interested in Richard Long, Hamish Fulton, and Peter Joseph, all artists who interpret light and nature.

I saw his work again in the Annely Juda Gallery, London, in 1990, and then in the Laage-Salamon Gallery in Paris. Strangely the prices were still low. I bought eleven small works, which in 1995 I gave to the Cantonal Museum in Lugano where they have never been shown due to the lack of space. Sometimes museums become the graves of art instead of a display case for it.

LUCIO POZZI
MILAN, ITALY, 1935–

I share with Lucio Pozzi an enthusiasm for New York as well as for art. For many years he too has been seduced by its vitality, its energy, its lack of class distinctions and social conditioning, a place where people are valued for what they are and do. There is a constant acceptance of the new in a society that looks toward tomorrow and not back to yesterday. Lucio Pozzi's art developed in this context, but with a difference: he has kept his identity as an emigrant Italian. A characteristic of Latin culture is its clarity of thought, which is a factor common to its various artistic manifestations, where instincts, intuition, and the primordial energies that erupt from the depths are guided by a clear logic. In his work Pozzi has managed to balance impulse and reflection, allowing a continual renewal of the image. The wish to emigrate is inborn for Italians and for Europeans in general. It is not necessity that pushes us to leave our native country but the irrepressible wish to discover new knowledge, to have different experiences, to try to be what we want and forge our own destiny.

When I was young I left for a long trip to America. I felt the need to leave my shell and discover the world; I felt an overwhelming desire for boundless deserted lands, cities that arose in just a few years, created by men who wanted to work and live a different life, one in which you were the creator and not the inheritor. And this is the basic difference, to create rather than accept. New York was the synthesis of all these impulses, the place where they could take shape. This is the main reason for its attraction: it is the ideal place for an artist.

Despite all this our links to our origins are unbreakable and remain intense. When I go from Varese to Liguria the freeway passes by my father's village, San Salvatore Monferrato, where I stayed every fall as a child and a place my father loved. From a distance you can see church towers and, on top of the hill, the house of my father and grandparents, and the vineyards where the grapes ripened. And my heart beats quicker as I feel a visceral link to this land. I ask myself why I don't come back, even though I know this is impossible. The wish to emigrate is evidently written in our genomes, it is part of our being.

In fact I have five children and three of them live abroad: they didn't remain in Milan where they were born. One is in Arizona at the very edge of town where the desert begins.

Lucio Pozzi too experiences these instincts as well as the other side of the coin; in fact he often comes back to Italy.

In my life as a collector I have seen a revolution. In the 'fifties Paris was still the world's art capital. It was necessary to go there to find out was going on, and it was there that the events that made art history took place.

Since 1960 everything has changed. Then it was necessary to go to New York; Paris by now had to take a back seat: it was haunted by local artists and was no longer the center of the art market. This was a reversal of events that took place in a short time, just a few years, though Paris's situation had seemed untouchable. I do not think the financial power of America was a determining factor, but other factors I have described certainly were.

In my own small way I too am an emigrant. In fact I only budge some forty kilometers (25 miles) from Milan or Varese to Lugano, not because I have a visceral craving for the new but in order to escape the suffocating Italian bureaucracy in matters of art.

FRANCO VIMERCATI
MILAN, ITALY, 1940–MILAN, ITALY, 2001

I remember with great emotion and regret a friend who died. He was a photographer who during his life never had the success he merited, though he was appreciated and loved by the few people who knew him. His work was not understood by a public misled by appearances, perhaps now more than ever in the past. His photos are anything but spectacular. This is why he is so little known. His art could be defined as the ability to give a soul to objects that do not have one, and he did this by reproducing them exactly with rigorous realism. He managed to capture for a moment the very idea of their existence as objects of use that are thrown away because, being no longer useful, they must disappear. It is very difficult to capture the ideal within reality, but Vimercati

was one of the few who managed this almost impossible thing. A soup bowl, a glass, an iron, an old alarm clock: how can they have a soul? Certainly, when we use them and make them live we pass a little of our own life onto them.

Perhaps there is something even more important. The animistic religions in Africa attribute a soul to everything. Even the smallest and most unassuming thing possesses this incredible, enormous, immeasurable privilege of existing, of having come from nothing. Vimercati was able to capture this moment. This moment is the same for everything, big or small.

I often used to meet Franco Vimercati, and it was always a great pleasure to speak with him, as we had ideas in common and believed in certain important things. I remember going to his home to have my portrait taken. He lived in an area of Milan near Corso Buenos Aires where the streets are wide but the tall buildings make them seem narrower. This is a cement environment where people live because they have to, certainly not for pleasure. This was the Milan that, as a child after the vacations in the country, used to overwhelm me with suffocating sadness on my return to the city.

Vimercati's apartment was on the seventh floor, far from the noise of traffic, which was muffled at that distance. For each pose I had to sit in front of the camera for a long time. Between one shot and another there was time to think and absorb the milieu. We were in a city full of people, noise, traffic, but in his home there was almost complete silence. Down on the street it was not possible to see the sky, but here the pale Milanese sun entered through the windows. We were above and outside the city, in another world where it was possible to meditate and think of things that were not of every day, not those born of necessity but those that are more important, the only really important ones. This was his refuge, a place of real freedom.

Vimercati was almost obsessive about the way his photos should be shown to the public. They are works of art that penetrate reality and do not stay on the surface, so they need the right presentation. He complained that in commercial galleries this attention was not given. Often photography is considered a record of something rather than a work of art in itself.

Vimercati's photos have just this quality, and this is why they cannot be mistaken for anyone else's. In recent years there has developed a deformed and deforming interest that does not distinguish between a real work of art, which is something very rare, and that which only seems to be so.

Successful photographers have very steep prices. Franco Vimercati's research into the soul of objects is something common to other artists in the collection, such as Jonathan Seliger who makes them, or rather re-makes them, exactly or almost the same by reconstructing them in canvas and painting them perfectly. Ron Griffin also does something similar, remaking such objects

of common use as letter-paper, office documents, labels, and other useless things produced in industrial quantities and that the artist changes imperceptibly into works of art.

FRANCO MONTI
MILAN, ITALY, 1931–

I knew Franco Monti many years ago, in 1958. At the time he did not make sculpture but was concerned with African and primitive art. He had put on a very beautiful show in the Ariete Gallery in Milan, a first-class gallery that did a courageous and difficult job and was directed by a very skilled person, Beatrice Monti della Corte. This show of African art was an important event. Here was the possibility to get to know a different culture where the various layers of civilization had been eliminated. Here the individual was faced with nature and destiny, with existence without deformations or deviations, without pretences for provisionally distancing him from reality. This became a part of my own research for genuine humanity that could still be found in that culture while Western humanity had become infected by civilization. We have become too powerful, and with our science and technology we fool ourselves that we can do everything and change our destiny. Perhaps one day we will become immortal, or almost so, with the right program for changing organs and with good medicines for avoiding their rejection. Perhaps, even better, there will be medicines against aging, or the injection of new cells produced in the laboratory, and the modification of our genomes. These are all hopes that, inevitably, nature will prove groundless. Nature: this great powerful mystery that we do not want to recognize and venerate. Nature that created us and allows us to continue living according to laws that we only discover afterward through our knowledge of the past, but that do not allow us to know the future, which will always be different from what we imagine and want, because of nature's intrinsic structure.

Franco Monti is a genial person, as is also his wife Laura, and we share many intellectual ideas and interests. So our friendship and my collection of African art began and grew together.

Monti taught me all I know about this art. In the 'fifties and 'sixties he went on long and certainly uncomfortable journeys into the heart of Equatorial Africa, crossing long distances in his Jeep in search of the real Africa still unadulterated by Western influence. He discovered antique sculptures that the old people sold from financial need, though with an aching heart. He discovered cultures unknown or little known by the Western market. These possibilities did not last long, and at the end of the 'sixties, new states arising

after colonialism passed new laws to protect their cultural heritage, though the larger part of the sculptures had already been exported to the West.

The activity of Franco Monti and other Western dealers has saved the heredity of Equatorial Africa. The peoples have changed religion and have become in large part Muslim or Christian, religions that forbid the adoration of idols. We think of their idols as sculptures and do not understand their meaning. For them sculpture was a tool for establishing a relationship with the unknown that dominates us all. By having this power ourselves we find them beautiful, though from another point of view. Probably the reason for their beauty is the same.

After this experience Monti moved with his family to Ibiza in a place far from the noise and turmoil of city life, just like the Africans. During a visit to Ibiza some years later I discovered to my surprise that Franco had become a sculptor. He uses cement mixed with colored earth. The material is not worked on with tools but is poured into a mold where it slowly solidifies. The wooden mold that contains the fluid cement becomes the form of the sculpture. These sculptures show a relationship to African art.

The forms have a similar solemnity and essentiality. They are a meditation on the basic values of life. The compact mass of cement relates to these ideas.

The masses are compact and heavy when seen from one side but become light and airy from another viewpoint, the mass seems to take on fluidity and movement. This is an art that needs the right space for each work as they have a notable weight and bulk, and this is why they are not seen.

There are three sculptures in the Biumo garden in a secluded spot that is not easy to find. My wife complains because I do not treat the works of a friend better. But there is an objective reason for this choice. The Biumo garden was planned in the eighteenth century as architecture where the presence of the sky and the horizon is dominant and must not be disturbed by the human presence. In fact, in all my fifty years of collecting, and after having bought hundreds of sculptures, I haven't placed any of them there. They would have interrupted a harmony reflecting the controlled union between nature and architecture. This was the aim of Marquis Menafoglio and his unknown architect, an aim that was achieved by building mighty walls in order to create a flat space suspended between heaven and earth. Though there was a different function, there are points of contact with the vegetal avenues that the great Le Nôtre created in France leading to the infinite horizon.

JULIA MANGOLD
MUNICH, GERMANY, 1966–

I began to buy works by Julia Mangold in 1997; at the time she was the youngest artist in the collection. It was surprising to see an artist from the younger generation whose work was influenced by Minimalism, something most of her contemporaries considered old-fashioned and superseded.

She needed a remarkable personality and a strongly independent mind to oppose a dominant trend. She is an artist in search of truth. Only by using a language reduced to its essentials can she express her thoughts. But her affinities with American Minimal Art are only apparent. If you compare her work with that of Judd, Andre, Morris, or Serra you see that she has, in fact, not been influenced by them at all. Julia Mangold is German. Her works are black, the color of steel when it is waxed. This is also a color you frequently see in Germany but not in Italy. Steel is a rigid material, and to bend it you must use great force, but Julia Mangold is a delicate, sweet, kind girl who seems fragile. German is a precise language, and it expresses ideas exactly. Her sculptures are formed from straight lines, and her steel panels are bent into right angles: they are without curves or roundness. Everything has to be clear and linear. The composition of the volumes though is not decided mathematically. Free imagination and intuition express the personality of an artist who goes beyond the rules and limits of logic.

The ultimate truth is an aim that our society abandoned some time ago. A contemporary philosopher has said that if the search for truth is abandoned then beauty is lost. A genuinely true truth. Never in the past was so much ugly art produced as in recent years; only the few who continue to believe in the search for truth are saved.

GUNTHER UMBERG
BONN, GERMANY, 1942–

Umberg is one of the very few artists who have always and only created art in a single color: black. I bought some of his pictures from the Stark Gallery in New York. Only many years ago did he ever use other colors, and only for a brief period. He has always remained faithful to this color, which is not a color but the sum total of them all. And despite this his pictures are never the same but always different in form, size, the nearness or distance from the wall, the kind of support, whether made from metal, wood, canvas, or synthetic material. Obviously the black also changes in relation to the material used to

obtain it. This allegiance to a theme and aim is what creates the work's fasci-
nation, beauty, and emotive capacity.

Perhaps this preference for black is a German characteristic, and it is also a
symbol of death. Wagner's gods die: their twilight is inevitable; even the un-
conquerable hero Sigfried dies; Tristan and Isolde can only satisfy their infi-
nite desire for love in death. In Thomas Mann's novels the real protagonist is
death, the end of every story.

FRANK GERRITZ
BAD OLDESLOE, GERMANY, 1964–

I have purchased some paintings by this artist and they are all black, painted
with a single material that is always the same: graphite, which is the black-
est material that exists. It is pure carbon. It is what I am using at the moment
to express my thoughts. But graphite has a very particular way of being black
since it creates a smooth surface that reflects the light, and this is why his pic-
tures seem to shine with a hidden light. The pictures are painted with a pencil
that draws horizontal or vertical lines very close together to create a homog-
enous surface. By making the most of the reflection and absorption of light
the artist obtains elementary and ever different compositions.

I recently saw a painting by him at the Basle art fair, and it stood out from
the others, the best indication of high quality. Perhaps it is worth my while to
buy others. In the past my wish to buy other pieces has been checked by the
delicacy of the surfaces, which if touched even lightly leaves a mark, and your
finger is blackened. The artist says, though, that the works can be repaired by
doing the black lines again with a pencil.

I already have a lot of delicate pictures, but all the same, I keep on buying
them. But maybe it's best not to overdo things.

But to get back to the theme of black being a characteristic of German art,
this is something that can be tested when passing the Rhine from the left
bank in Cologne to the right bank in Düsseldorf: the colors become darker.
The Romans arrived as far as the Rhine, but being unable to cross it they were
defeated. What a tragic history was the fight for supremacy in Europe begun
in 9 A.D. and ending in 1945. If the laws of evolution are true, and fighting im-
proves the contenders, this may provide one reason for the domination of Eu-
rope over the rest of the world from the nineteenth century until 1945.

LIES KRAAL
ROTTERDAM, NETHERLANDS, 1937–

Kraal is an artist who works with color, and I came across her work in the Kiyo Higashi Gallery in the early 'nineties. She is a first-class painter who has not had the recognition she is due, just like the other artists who work in this way. What is attractive about her work is the nature of the surfaces, which consist of layers of chalk superimposed to create depth and then finished so as to make them perfectly smooth and hard. When you touch them you have strange sensation. The surfaces seem to lose their concreteness and become an immaterial entity. If you softly run your finger over the surface there is no resistance to it. This is the same sensation you have when looking at them. The colors seem to flow over the surface and lose their materiality, even when they are strong and intense, full of pigment. Yet another experience with color that shows its infinite possibilities. And this is one of the many manifestations of what the most sensitive artists undertake with success, but only the success for art, not for the art world that ignores them instead of helping them.

Lies Kraal has lived for many years in Los Angeles, but her origins are European: she was born in the Netherlands. She lives with a friend in a small house like many others in Los Angeles, with a little garden full of flowers tended with care.

PERRY ARAEIPOUR
LOS ANGELES, CALIFORNIA, U.S.A., 1959–

Araeipour is an artist who creates compositions from mass. He is not interested in color. This is Minimalist culture transferred from sculpture to painting. Araeipour's masses are of the greatest simplicity, purely geometric rectangles that are juxtaposed, two or three elements at a time, to create a composition. If you can imagine a limit to artistic creation, then that is where Araeipour has arrived. The rectangle is the simplest possible form that can be imagined, there is no possible further reduction. One of the aims of modern art is to arrive at the ultimate form, which is why it is always condemned by conservatives. The enemies of Impressionism began this 150 years ago when they accused them of destroying the precision of good drawing and representing reality. Kandinsky and Mondrian began abstraction; Rothko painted the first monochrome pictures, and Ryman the first pictures consisting only of marks. In each case art arrived at a point beyond which it could not go. But at each ending of a simplification process art does not finish, and artists continue to discover new expressive possibilities. The history of art is the history

of the point of arrival of a determinate research, only to begin again in other new, previously unseen, different directions where the inventiveness of each authentically original person develops. Araeipour represents this continuous process of completion, consumption, and renewal with new ideas.

HUBERT KIECOL
BREMEN-BLUMENTHAL, GERMANY, 1950–

Kiecol is a German artist who creates cement sculptures. They consist of geometrically rigid forms. The cement is mixed with earth, and the pieces have mainly dark colors. In some works there are linear cavities that cross the form vertically. In this case the forms are vertical parallelograms. At times they remind me of stela for commemorating the dead, and the dark color increases this impression. At other times there are steps at the top of the parallelogram, like something for climbing higher up it. At other times Kiecol superimposes two volumes, one very large and the other small.

A typical sculpture by him consists of three blocks of cement 75 centimeters (30 in.) high, 60 centimeters (24 in.) wide, and 140 centimeters (55 in.) long. It is titled *Wir Metaphisiker*, 1992. In fact it resembles a sarcophagus that we might see in a cemetery to indicate a burial place. It is typical of today's society that the image of the dead has been eliminated. We try to pretend it doesn't exist, we try not to think about it, but this is a reality we absolutely cannot avoid. This is the final truth, with no possible doubt. In the face of this fact all philosophies denying the existence of truth are given the lie. To find a solution to this reality is a difficult problem. A problem that the philosophies preached today will certainly never find an answer to.

THOMAS SCHÜTTE
OLDENBURG, GERMANY, 1954–

I purchased many of Schütte's works in 1990, but they are all earlier than this date. I do not know him personally, as I only saw him in passing in the Musée de la Ville de Paris when there was a show of his. I have never had another opportunity of meeting him. At the time he was already an admired and well-known artist, and his fame has continued to spread and grow. The 'eighties were an interesting period. This is a German artist who experienced the crisis of Postmodernism in a constructive way and without falling into the easy figurative and expressionist trap, as many other artists of that generation did, though Schütte too has expressionist aspects. This is characteristic of German culture from the Middle Ages to Cranach and Grünewald and up to Kirchner,

Otto Dix, Max Beckmann, and the great Beuys. Dürer and Boecklin are less representative than Schütte in this. I have collected many large-scale works such as *Galeeren*, 1990, *Laundry*, 1988, *Big Building*, 1989, *Melony*, 1986: they are all environmental pieces that take up a lot of space. This is why I have not been able to exhibit them in the right places, even though their quality merits it. I am always on the lookout for large spaces for the collection, and I hope to manage it one day. *Galeeren* is in the form of two upturned boat keels. Here we find the idea of motion, of navigation toward distant places; but given that the work is overturned it also reminds us of a shipwreck, the idea of the impossibility of reaching a destination, the harbor of some continent. Galleys were rowing boats propelled by delinquents condemned to hard labor. Perhaps we too are condemned to unhappiness! Could this be our own fault?

Laundry: we have to wash ourselves and put on clean clothes, but in fact we do not have a clean conscience. In *Laundry*, clean and brightly colored clothes are lined up on hangers, with a word at the center to indicate why they had to be washed: these are the sins of those who wore dirty linen.

Big Building consists of large model skyscrapers under construction and showing only their skeletons. Or else buildings with many windows falling against each other as though hit by a sudden earthquake. Big buildings are the symbol of our power, and we know how fragile that can be.

My Eye, Your Eye–Controllo, 1988, consists of six cabins painted blue, similar to ticket booths in stations or theaters. When you take a flight, the police check your documents: you can, you can't. Judgment. The cabins are painted light blue because they are those of the sky, and they look us in the eye to read our soul.

Schütte's work consists of metaphors and brings to attention those who want to meditate on situations hidden within us.

JAN VERCRUYSSE
OSTEND, BELGIUM, 1948–

Vercruysse is a French-speaking Belgian artist. His works too develop around a metaphor. They are images of our domestic life that the artist makes us experience again by using forms that resemble the furnishings of home: a fireplace, empty frames whose pictures no longer exist, though perhaps they did once.

When you see the walls of a house under demolition, the only indication of earlier habitation is the wallpaper, still sticking to the walls but in tatters, with colored flowers or stripes. The last proof of a life lived in that place. It is like looking at an archeological excavation: from the remains that still can be seen we can imagine the life of people who have been gone for centuries. We

are deeply moved when we think of life that no longer exists. The inhabitants were men and women just like us, with the same thoughts and feelings. All destroyed by the inexorable flow of time. We too are part of this fatal chain, and the present moment will pass into oblivion, an endless stream with no possibility of return. We are part of this story of life that will continue even without us, even though there will be different eyes, though similar to ours, to see what happens. Vercruysse often uses mirrors in his compositions. They are a severe judge of us, and when we see our face and body reflected we see a negative verdict: we always hope to be better than what, in fact, we are. This is a wounding discovery, but there is nothing to be done about it, it is the truth. We have to be intelligent enough to know our defects and limits; we have also to be so with regard to our thoughts and actions. This is a useful way for making an effective confession.

I have always had difficulty in exhibiting the works by Vercruysse since they cannot be installed like other pieces: they cannot be used for decoration. These are private, completely private, objects that once belonged to a person, even though unknown and nonexistent. This person's virtual presence becomes even more burdensome. So the corner of a room has to be reconstructed where the objects can tell their tale of someone who has lived and of the many who might still live, a tale that must be told in silence in a secluded corner.

This is one of the few artists I have never met personally. Even though I have bought many works by him from galleries I have never been in his studio. Clearly he is a reserved and private person, just like the objects he creates.

GRENVILLE DAVEY
LAUNCESTON, UNITED KINGDOM, 1961–

Grenville Davey's inquiries are of a reductive kind. He is a sculptor with affinities to American Minimalism, but his view is less intellectual and abstract. The starting point for Davey's sculpture is objects of daily use having a form that if enlarged to become voluminous become beautiful sculptures. This is the case of two similar objects called *Trommel*, 1989, diameter 131.5 cm (52 in.), which seem to be two bottle-tops for Coca-Cola or mineral water. The artist often uses forms originating in things we see around us. This is a type of minimalism that, through its formal relationships, is part of the reality of our everyday life. Perhaps to maintain a connection with something that can be tested and used is related to Anglo-Saxon pragmatism, a way of avoiding high-flown intellectual speculation that can only lead us away from our needs as human beings. An example of how the artist refines the surface of his sculpture is the two-part work titled *Idiot Wind*, 1991, each part having a height of

225 cm (89 in.) by a diameter of 131 cm (52 in.). These are two cylinders with a rusted surface, the natural result of steel left to the effects of time.

I met the artist in his studio in, I think, July 1990, a primitive place under a corrugated iron roof in South Bend, London, a disreputable district where you can easily have your wallet stolen. He had not yet won the Turner prize, which a few years later was to bring him success.

PIERO FOGLIATI
CANELLI, ASTI, ITALY, 1930–

Like Maurizio Mocchetti, Fogliati is a kinetic artist who creates pieces that move. I find them particularly interesting, but despite his quality, he has not been successful and has remained unknown. He has an amazing ability to make little moving machines from components of various origins. The concept of the Machine is tied to its usefulness: they are the servants of humanity, created to save effort and time. Above all time. This is the most important asset since the lack of other things can be remedied but time cannot: once lost it is lost forever and cannot be regained. When you are young you do not realize that its loss is final because you seem to have so much time available, and the moment currently being experienced will be replaced by others in the future.

When, as in my case, you are eighty you realize this is no longer true. The present moment has far more importance, and the fact that it cannot be replaced forces us to think in another way. When machines move without any purpose they blame us and ask us what we are doing with time. Do you know it will never come back, it is gone forever? The word "Forever" has a terrible meaning. Useless machines that move, that seem so innocent, and appear to be nothing more than toys larger and more complex than others, can have other meanings that may even be more than their creator intended and can ask very disturbing questions.

Sadly I have heard nothing more about Fogliati for years. I exhibited his machines in Biumo only a few times, but since the house was given to FAI there have not been other opportunities. To show machines that need maintenance and continuous assistance in a museum is a very complicated matter. There does not exist a toolbox with spare parts to repair each work as soon as it breaks down. This is an important problem that has to be resolved. It is the same problem with Mochetti, and if it isn't solved, then this art will be neglected in favor of paintings and sculptures that once installed need no more work.

VITTORE FRATTINI
VARESE, ITALY, 1937–

Frattini is an artist who makes abstract pictures characterized by painted stripes along the longest side of the composition. This gives many possibilities that can be explored differently each time. To concentrate on a means of expression is a positive starting point that in the long run allows you to arrive at the best results. It also, though, needs strength of character and commitment to the choice that has been made, because it is an obligation that lasts forever and also shows a participation in universal values. With a minimal mark you can say a lot, in fact everything. This is a refusal of the kind of overemphasis where the aims are higher than the possibilities. Once the first impression has passed—which also can be very impressive—then time reveals all the work's limits and weaknesses.

Frattini is also a generous person who enthusiastically takes part in any initiative he considers positive. Frequently artists drip with jealousy and create obstacles when they have nothing to gain from other people's initiatives. Frattini helped me when, in the 'seventies, I thought about transforming my house in Biumo into a museum that I would then donate, together with its contents, to an institution that could preserve it all. The most logical candidate was the city of Varese, which would have received a donation of international importance, useful for educating the public, for the prestige of the city, and for creating tourism that would also be healthy for the local economy. All Frattini's efforts to convince the local administrators were useless, but generous. The problem was then immediately solved by FAI, which understood at once the need to do something. Relations with the city council are now quite cordial, but the financial problems for the museum's upkeep have to be resolved by FAI, which it does with a great commitment.

Frattini is also a sculptor, and the work he created over the entrance road to Malpensa Airport is particularly successful.

GIORGIO COLOMBO
MILAN, ITALY, 1945–

Colombo is the collection's photographer, and he administers an archive of thousands of photos. I have always given the greatest importance to the images of works of art. Sadly the spread of information about art is through reproductions. I say sadly because the information a reproduction gives is extremely limited. Obviously we must see art with our own eyes, as otherwise we lose a lot of information that cannot be reproduced. This problem is even

greater for art that pushes our perceptive abilities to their limits. This difficulty is particularly serious for art in color where differences that seem minimal can instead be substantial. I have always thought that art, good art, is not a private but a public experience, and to this end photography is an indispensable means of diffusion. Obviously there are good reproductions and less good ones. The quality must be almost as good as that of the original. The photographer must understand and love the object he has to reproduce, otherwise he will only make mistakes. Every reproduction is also an interpretation, and interpreting art is difficult—interpreting contemporary art is even more difficult. For all these reasons I chose Giorgio Colombo. He understands contemporary art, in fact he is also a collector, and he pays an almost obsessive attention to quality. He is also meticulous in putting in order and conserving his material. I consider him an artist and not a technician; he is a great photographer.

His qualities can be particularly appreciated in his black-and-white prints. His use of grays and shadows transforms the photos and turns them into art. Unfortunately black-and-white is no longer used in books on art, but that is real photography, not color, which greatly reduces our interpretative capacities. Giorgio Colombo really is an artist in his use of grays.

It has been, and still is, highly expensive to conserve these images of the collection. But this is a heritage that will become more important with the passing of time. It is an investment in the future and not just in the past and present. I hope it will continue to be conserved and be even more useful.

Color photography is a material that deteriorates over time, so all the important images must be digitalized and saved on a CD, which then ought to last a long time. Colombo's wife Piera should also be considered an artist. She makes beautiful ceramics with marvelous colors and drawings. She is also an excellent cook, and in this too she demonstrates her artistic nature. My wife and I are really pleased when we are invited to one of her appetizing and fascinating dinners with friends.

ANGELO SOLDATI
VARESE, ITALY, 1919–

Angelo Soldati was the gardener and custodian of the Biumo villa from 1945 until 1990. I consider him an artist because he lives with an artist's sensitivity. He was of great help for the collection. He helped me to hang the pictures, which when I was young we used to do together.

He has handled all the collection: Rothko, Kline, Tàpies, Rauschenberg, Lichtenstein, Oldenburg, Rosenquist, Ryman, Marden, Serra, Nauman, and all

the others. He knows all the artists who have come to work in Biumo or to see their work installed. He had friendly relations with them all, even though he knew only a few words in English. He accompanied the numerous visitors; he explained the artists in such a way that even foreign visitors could understand. In fact, many of them remember him, and when I meet someone in America who has been to Biumo I am always asked for news about Angioletto. He has a religious respect for nature and everything that is natural. Flowers, the grass of the lawn, the trees, and, of course, animals, are all his friends. Dogs follow him around while he is working; he does not use insecticides, which poison the earth; he does not use machinery of any kind as machines are unnatural. He uses a scythe, as in the past, in order not to harm the grass. In the spring he would call me in Milan to let me know when the swallows arrived. He was saddened by the disappearance from the little paradise of the garden in Biumo of the red squirrels, the glowworms, the frogs, toads, and grass snakes, resulting from the increasing pollution of the environment. I too can only rarely see the starry sky I used to see, because of the polluted night sky.

This story ends in 2000. Today, in January 2005, I am nearly eighty-two years old. Time has not stood still these past five years; other things worthy of notice have happened. I prefer to put off their description to another day when my tale can be more complete, though when your age is eighty-two it is certainly risky to put things off until later. When you feel well, and your head is functioning as well, you make long-term plans, even though in all probability they will never be accomplished. I place my faith in beautiful things that can last even after having gone through difficulties and risks. Life is like this, and we can't change it but only trust and hope: this is our duty and, when it comes to it, our happiness.

Artists are more important than all the others, and I am writing this for them, not for myself. I am somebody only because I appreciate their work: these I loved, chose, and bought because otherwise I would have remained a negligible entity in a crowd whose only future is to disappear. It is amazing, but when you look at the history of the more or less remote past you only speak about people who have come to the fore; the masses, the true builders of history, almost do not exist.

Among these emergent people are "Color Artists." A growing number of artists in all parts of the world devote themselves to this investigation, which causes no particular interest or attention in intellectual circles. They are lone wolves living in a hostile and indifferent society. But you cannot *not* love beauty: its power is irresistible, and whoever discovers it would be making a great sacrifice by abandoning it.

SONIA COSTANTINI
MANTUA, ITALY, 1956–

I saw Costantini's first picture in the home of Giorgio Colombo, the collection's photographer. A gallery in Cologne exhibits her works from different periods. In the past it was possible to discern a figure that crossed her pictures, but I then had the impression her work had still not fully matured. Her evolution has been completed in recent years: the forms have disappeared, leaving only a slightly paler border at the four edges of her pictures.

The paintings of Sonia Costantini have a particularity. There is a background surface painted in acrylics, and on it there are small marks of oil paint. Of course both are of the same color, but there is a difference. Acrylic is a material that absorbs light while oil reflects it. This contrary behavior of the two materials gives the color a particular vivacity: it is not too reflecting, thus

robbing the color of its force, and it is not weakened by the opacity of the acrylic. A knowing balance of two opposites underlines the beauty of the color.

This is another proof of how inquiries into color are correlated to the invention of different ways of highlighting it. We are dealing with solutions that are apparently elementary, but to find the right balance needs a lot of experience, which is often arrived at only after years of trials.

The artist lives in Mantua, a splendid city that has managed to preserve its past almost intact. It was the small principality of the Gonzagas, great art collectors and protectors of culture, painting, sculpture, music, and literature. Despite the political disasters of the dynasty, the city still safeguards the beautiful monuments they commissioned.

RUDOLF DE CRIGNIS
WINTERTHUR, SWITZERLAND, 1948–
NEW YORK CITY, U.S.A., 2006

I discovered the work of De Crignis at the beginning of the 'nineties. I saw blue pictures with strange, extremely smooth surfaces. Fascinating paintings without a doubt. In 1995 the Stark Gallery suggested I buy some of his paintings, but I was doubtful about the opportunity of enlarging the number of artists I had who worked with color: I was in the middle of buying many works by Sims, Simpson, and Fredenthal, as well as others who worked along the same lines. But after some insistence I bought one, although I didn't take much notice of the work, which had not struck me.

De Crignis had a studio in New York next door to that of Fredenthal so I had another occasion to see his work. In 2004, during a trip to Germany to visit the Rhineland museums, I went to the Bonn Kunstmuseum where the director was Dr. Dieter Ronte, someone I have known for years and who has always done excellent work. There I saw a room with four works by De Crignis, beautiful without a doubt, and they stood out from the other pictures in the show. This visit had been organized to see if there was still interest in our artists, the museum having two years before devoted a room to the work of Phil Sims for some months, but it had had to change its program as a result of the German economic crisis.

Some months ago, while photographs were being taken of some works in storage in Punto Franco di Chiasso, I came across the work by De Crignis that I had bought in 1995. Why hadn't I bought others? It was a very dark blue that sucked everything into it and was really superb. It gave a strange impression, being a different blue from all the others. The surface was hard, as

though it had been compressed, but at the same time it was soft and delicate. If you touched the side where it was not painted your finger seemed not to be in contact with the material.

When I went back to New York in 2004 for the reopening of MoMA, my first stop was at the gallery of Peter Blum, who represented the artist and whom I have known for many years. In the 'seventies he had come to Biumo for a photo session about the collection, which was then published in *du*, a photographic magazine. It was one of the best photo services of the period.

There were three pictures in the gallery, one large and two medium sized. The big one was not blue but gray with a blue background, but just as beautiful. My wife too was enthusiastic, and she never makes mistakes. There and then we decided to buy all three. I think I will buy others.

SÉAN SHANAHAN
DUBLIN, IRELAND, 1960–

I saw Shanahan's pictures for the first time in the home of my daughter Giuseppina and her husband Gabriele Caccia, both enthusiastic collectors. I was drawn by the surfaces' lack of reflections. The material seemed to absorb the light. An effect of material density; the color was inside, not on the surface. In fact the artist does not make use of a traditional support for his painting but a partly synthetic material, ground-up wood that is then mixed with glue and compressed. He uses medium density paneling that is very heavy but not very dense, and in this way the material can absorb the fluids that are layered over it. This layering is carried out with a palette knife and has to be repeated many times, as the color has to penetrate deep inside. And this is precisely the impression you have when you look at the works, and this is a substantial difference when compared to the work of other artists.

Pictures made from wax can also give this impression, but with Shanahan the effect is stronger. Color is reflected light and a property of the surfaces, but in this artist's pictures it becomes a substance too.

Here we might begin a philosophical discussion along the lines of Spinoza. It is substance: not just matter but everything that is knowable. In this sense the pictures of Shanahan are substance.

CHRISTIANE LÖHR
WEISBADEN, GERMANY, 1965–

Löhr's work has little to do with paint. Its singularity consists in her use of dried, small-scale vegetable matter. These are fragile things that might crum-

ble into dust if you touch them. Instead when they are kept in glass boxes they can last forever.

In Löhr's work we find all the poetry of the small things of nature that we overlook just because they are small, but instead, they are just as beautiful as large things. With these small compositions made by joining up tiny blades of grass, the artist shows us the beauty of a small world that is still beautiful even when deprived of life.

The material she uses is small, and so, therefore, are the works she creates. They reveal the patient labor of those who love tiny things seen when walking through fields, far from the artificial life of the city that is so often sad and oppressive. Here we rediscover our real nature. We are alive just like the grass in the fields. We find once again our distant origins, which today also nourish us.

It is right to end this book of memories by speaking about Christiane Löhr. She is someone who is involved with blades of grass, with the small things of nature that only last a season, that flower in the spring and die soon after or are mown down to be fed to cattle. Things that enjoy a brief, modest existence in the inexorable recycling of all things. It is just as enjoyable to look at tiny flowers as large ones when they bloom, since they are no less beautiful. The blades of grass that support them have harmonious shapes, each different from the others: some long and simple, others complicated with voids and spaces, angles and curves. They are works by an artist with an inexhaustible and sagacious imagination and who never makes mistakes. They are beautiful things that last a brief time. When you are eighty-two years of age you apply such a discovery to your own experience: the passing of so many people, changes, years that flow by so quickly. The question is inevitable: what will follow? Will there be something?

When I am in Biumo on tranquil nights I see so many stars. Tiny luminous pinpoints in the infinite vastness of the universe. I do not feel lost in the immensity of night but feel the presence of someone calling to me and whom I trust. From this infinite emptiness comes life. A powerful life that attracts and absorbs everything within itself. I do not know why this call is so inviting. There is no theory to justify it, no theory that I can test. I can only be certain that this call is stronger than any other. I too am a blade of grass that lasts a season like those gathered by Löhr. I know I will disappear, but I have had the possibility to exist, which is the only important thing. My physical presence will not last, but existence will always exist.

I was in New York in the spring of 1999 when the trees burst into leaf and filled with flowers. I was staying with my wife on the thirty-seventh floor of the Essex House Hotel on Central Park South. We were very high up, far higher than the Madonnina on top of Milan Cathedral, which is the highest point of that city. In New York, though, this is only medium height. From my window I could see many far taller buildings. It was a splendid sight, a forest of giants. Looking down at the people on the sidewalk they seemed to be ants, but powerful ants who were able to build these monsters that are stunning with glass walls that reflect the sky and seem to disappear. In front of me were two towers, one tall and narrow, the other wedge-shaped, and it seemed to penetrate the air with its black glass cladding.

It seems impossible that, being so tall, they don't unbalance and fall over to one side, pushed by the strong winds. One is built next to the Carnegie Concert Hall, where classical music is played, having taken advantage of the rights to air space that came with financing the restoration of one of the concert halls. From here I could see a good part of Manhattan, between one skyscraper and another, the Hudson River, and the harbor. I came here for the first time in 1954, many years ago. There were fewer large buildings but the city's character was already like this: an explosion of the will to power, not in order to be aggressive but to reach the sky, the Supreme Power. I came back a second time in 1960 when I had already bought many examples of American art: Kline, Rothko, and Rauschenberg. Since then I have returned once or twice almost every year. For the past ten years I have stayed there for a month every year. About half my collection was thought of, experienced, and created in this city, in the part to the south, the poorer district, in an area of just a few miles that I can take in at a glance. My mind, emotions, and thoughts have ideally existed together with the artists who have lived in this area. I was among the first to discover and love their work from thousands of others who have disappeared leaving little or no trace. I was perhaps the first to have loved so much what they thought and felt, and to want to have many of their works. Others, Americans, who live near to them have not done this even although they had everything necessary for doing so: a love of art, collecting, the necessary money. I lived some five thousand kilometers (3,107 miles) away, but just a little information was enough to discern the great things that were happening. Great but invisible things, hidden within the conscience of certain individuals who interpreted a situation hidden within the life of the city and visible in only a few tens of square centimeters, a tiny amount in comparison with the enormous reality. But, when it comes to it, there is a smallness that

never dies while great situations change and we don't know when this change will stop. Ideas are immortal, and to capture them has been the aim of my life.

Rothko, Kline, Lichtenstein, Flavin, Judd, Huebler, and Segal are dead, but their work continues to live and live again in us, in the living. When buying their work I appropriated a part of this city's soul, of the greatness it has produced and that will continue to exist.

I am certain that I have possessed, conserved, and transmitted a part of the art history of the twentieth century by giving it to museums. I believe I have carried out my duty, and now it is the task of these institutions that own the works to make them permanently visible.

I feel myself ideally a citizen of New York. If art and expression do not belong only to certain individuals but to the community, then I belong to it completely. Perhaps even more than others who live here passively without feeling the emotions and impulses it causes. This is a city where the air is cleansed by the ocean wind. From distant Europe came its best sons in order to create a new world. The atmosphere is electric and pervaded by an energy that woke up the mind and aroused the will to be totally alive. The artists whose work I have loved also experienced this situation, and their vision has been my vision. After some half a century a new generation has begun to be part of my life.

GIUSEPPE PONTIGGIA
COMO, ITALY, 1934–MILAN, ITALY, 2003

I am not a great reader. When I can, I reread the classics: *The Betrothed*, *The Brothers Karamazov*, *The Demons*, *The Idiot*, *Anna Karenina*, *Resurrection*, some tragedies by Shakespeare, pages from *The Divine Comedy*, Sophocles, and *Adonis* by Marino, an interesting Baroque poet from the seventeenth century. Most of these works I read between the ages of fourteen and twenty-two. I was an avid reader. The classics never disappoint and are always true, like the modern lyrics from Leopardi to Ungaretti and Montale. I knew these two poets personally, but superficially: a handshake and a few vague phrases. I became real friends with Pontiggia. I feel the need to talk about him as yesterday he suddenly died at the age of sixty-eight. We met when we both frequented the Rotary Club in the 'seventies. We had pleasant and interesting conversations about literature, which was the main reason for going to the meetings.

One morning I came across one of his books, *Il giocatore invisibile*, *The Invisible Player*, 1978, and I casually read a page and was struck by how it was written: brief, precise, exhaustive. It said everything in a few words, just like the kind of art I so loved and love.

I received advance copies of his books, which had dedications and which I keep like a treasure and which I read with endless interest and pleasure. His way of writing was just like the person himself: modest, simple, without pretensions, and with an incredible literary culture. He was certainly one of the greatest writers of the past fifty years. In the first book of his I read, *The Invisible Player*, there are all the indefinable aims of destiny that dominate everything and everyone, that cannot be seen, are not manifest, but which are in action. His end was like his philosophy: unpredictable. I wanted to show him some pages from this memoir, which I am finishing writing, in order to have his opinion whether it is something interesting enough to publish. I wanted to call him to ask if he had the time for a quick reading of it. Evidently the Invisible Player arrived before me. Stupidly I lost time when I could have asked him earlier. This would have been an occasion for talking to him, seeing him again. Then the Invisible Player interrupted and left us all embittered. Our admiration was reciprocal. Sometimes the Player is generous. We have had Pontiggia, we have lost some beautiful books, but all the same many have been left to us.

Intelligent and aware living beings are everything; if they didn't exist the whole universe would disappear since it would be completely useless: no one could look at it.

Men and women constitute the whole of history; it is made with and for them. We are inseparably united with them, even with those who do not understand anything because they have never given any thought but who will understand one day when they begin to think.

I write this at age eighty, and certainly I am not far from the end of a long life. I have met and known many people; those I remember mostly were all good and made a positive contribution to life; there are only a few who instead of creating, destroyed. In some people there is an inborn negative impulse that they cannot dominate. They do evil. But evil too is necessary for good. If good were easily obtained, then it would no longer be good but a natural requisite.

If the world goes ahead, it does so because goodness is greater than evil. I cannot remember all those who have been good to me, and anyway the list would be too long and go beyond the scope of this book, the aim of which is to document facts having a direct or indirect relation to my collection. We feel ourselves important, but in reality we are a momentary shadow on the long road of humanity; however, we are an important link even though we can be substituted. I am sad not to remember humble people who have fully undertaken their duty as human beings without ambitions and where loving others was a natural thing, a pleasure, something they did spontaneously. These are people dead a long time whom almost nobody remembers. Their silent departure from the world's stage is their greatness, their infinite greatness. They are the solid basis on which our world stands. Only if these silent presences continue to exist will the world have a future. Mothers are the greatest silent presence; they love without asking anything in exchange. Real love.

The Berlingieris are among the greatest collectors that I know. In fact, for a long time they have been among the two hundred most important collectors in the world, according to the list published by *ARTnews*. We have been friends since they began to collect, which was, I believe, at the end of the 'sixties. They often came to see us in Biumo. They wanted to know everything about what we were collecting. As my wife and I were some years older than them we had already gained quite a lot of experience in the field of art. It was a real pleasure to swap opinions, make comparisons with irresistible enthusiasm. I do not believe I have ever known any other people with such enthusiasm, and the result can be seen in the collection they have created, both for its quantity and, above all, for the quality of the choices they have made. I can see nothing mistaken. They too, like all real collectors who love beauty, buy without thinking where the works are going to go. A solution will always be found.

The Berlingieris are in privileged circumstances, being the descendants of an ancient family related to other ancient families. Every so often they inherit some ancient palace in Venice, Palermo, or Brescia. Their interest, though, is concentrated on a medieval castle in the Basilicata region, between Matera and Taranto, the San Basilio Castle, a fabulous place that outstretches the imagination. It really is a fairytale place both for its size and the ideas that such a mythical site can suggest. To restore a building as big as this must have cost a fortune, and in fact, they had to work for many long years.

My wife and I went to visit them during the wedding of a daughter of theirs. It was like something out of a dream, prepared with a refined stateliness in a splendid setting in which the works of art shone in all their beauty throughout a succession of large halls and many rooms in which Environmental works found their right setting.

I imagine that the rooms were so large in order to host the military garrison that defended the Basilicata coasts from frequent attacks by Arab pirates before the battle of Lepanto in 1571. There is a very tall tower in the center of the courtyard that served for looking out for pirate ships. In it there are many small rooms used for exhibiting the art that we too love and collect, a perfect fusion of the antique and the new, one that always works when the choices and the harmonization involve the best creative works of our time.

The first two parts of the collection, with purchases of Minimalist, Conceptual, and Environmental works, ended in 1976. To judge by events in 2003 these parts belong firmly to the past. These were almost all artists who forged the history of that period of our culture, which, together with the social, economic, and political events, changed the world for better or worse: personally I believe it was for the better. I believe that the years from 1950 to 1976 were a great period in Western history, comparable to the great periods of the past. It was a profoundly innovative time dominated by an urgent search for the new, determined by the will to deepen knowledge of the reasons for existing. This desire roots these artists firmly in the history of the art of all times.

The year 1976 marks the end of this desire, and after it Postmodern philosophy, the philosophy of disengagement, began to prevail: the refusal of choices, the idea that all ideologies are the same. The search for truth is difficult. History has disproved many ideologies (the wrong ones, I would add). The new generations now feel the weight of their Freudian father. The example of the preceding generation disorients them. They are afraid of comparisons and fear finding themselves in a condition of inferiority. Only a few have the will and the persistence to escape from this situation. Art exploring new areas of research and new ways of existing is the activity of a few, and these few are isolated, separated from a populous art world that is tired and does not want to be involved in an activity that is badly paid because there is little general assent to it. The aim of gaining money therefore becomes more important than research, a difficult and insufficiently paid activity. Widespread wealth, the lack of risks, the lack of need for decisions affecting the future are all situations that lead to a weakening of the personality.

A growing number of young people are attending art schools and academies. The academy in Milan, for example, had three hundred students in the 'fifties, but 3,600 in 2003. The number of valid artists, however, has not increased in proportion: they are always to be counted in tens in each generation throughout the whole world. During the Renaissance the population of Italy was far less than now, but the number of great artists has not grown. The new generations do not employ that self-criticism that can only be arrived at by studying the art of the past. This lack of self-control gives them false hopes that end up in disillusion. The years since 1976 have seen great changes: the end of Communism; greater efficiency in the market economy with limitations set on state controls; private activity seen as the best means

for diminishing misery; the Russian crisis; North America as the greatest world power. The development of electronics and communications. The slow integration of Europe. The economic progress of China. The crisis in Japan. Islamic Fundamentalism.

By 1976 the collection consisted of a great many works. The Minimal and Environmental sculptures needed large spaces, and those in Varese had been filled for some time. The first part of the collection was of artists who were famous by now and were in constant demand by museums. The conditions for placing them in a museum were right, above all for the first part. The time was ripe for looking for an interested museum.

I stopped buying in 1976 simply as a result of my financial situation. This would be the longest inactive period I would have as a result of such a situation. I only began to buy again in 1989. Thirteen long and unhappy years dominated by financial worries. I was too deeply involved in real estate investments in a period with very few requests. It was painful to rid myself of my obligations by paying off heavy debts to the bank. Even though I had many good-quality buildings to my credit, I remember them with such bitterness that I would prefer not to remember them at all.

I should have made the radical decision to sell everything and devote myself completely to collecting: this would have been the best solution, but when you are involved in an activity it is disagreeable to stop halfway through. The positive side to this period was that I could search for museums interested in having, either on loan or as purchases, part of the collection. The year 1989 was an important landmark because I finally managed to free myself of my debts and could think calmly about the collection. Today I can look back and ascertain that I have been extremely lucky. Over half the collection is in the hands of museums. In Italy I have had the possibility of using marvelous monumental buildings for long-term loans that, I hope, might become permanent. All the buildings hosting the collection are of the highest architectural quality. I am over eighty years of age, and in the days when I was young, I would have been considered a survivor who had outlived his contemporaries: and in fact this was how it has been for my parents, and my brother and sister. By now I have no future, or at least it will be very short, but I still hope to have the time and the possibility of doing something beautiful, though there is a question-mark over this. I have had five children who are all adults now, and with them too I have been lucky; I have seven grandchildren all clever: life continues. My wife and daughter are my consolers even though I have nothing to complain about. I consider myself, and I am, a happy man. My health is good even though in 2000 I had various problems: an operation for

an aneurysm and two heart attacks. These are things that could happen again without warning. Three times I have run the risk of dying but now am well, though who knows for how long? I faced up to these crises calmly, without useless fears, and I trusted and still trust in one thing: I believe in goodness and not evil; goodness is life and evil is death. Beauty is the image of goodness and will eventually win, even though only at the end. We cannot know what there will be after, but whoever believes in goodness does not despair but lives in hope. This is a hope that has nothing physical about it but is completely metaphysical.

I expect that my children will continue to be involved with the collection and will carry out the main aims relating to the public function of art: to do everything in order to make definitive the establishment of the collection in those Italian museums in which it is on loan.

From 1976 to 1989, when I purchased nothing, was a long empty period, but I do not think I lost much by buying nothing for so many years. In 1976 I saw the beginning of Postmodernism, which was an immediate success with the public. It represents a philosophy that is the exact opposite of my way of thinking and living. This is also why any purchase was impossible for me.

I have seen all the artists who later became famous when they had just started out and so cost little. I missed the occasion for earning money, but coherence with your own way of living and thinking is more important than money. I was able to buy those artists who reflect my ideas, even though I was only able to buy them later on. Because they are not part of a fashionable trend, they have been neglected and have only a small slice of the market. Things will change when people are tired of the art they are now buying, an inexorable and unstoppable change. It is just a question of time: we just have to have patience. I could write a book about these changes in the public mood and, over fifty years, of the reputations that have risen and fallen; it would certainly be an interesting book.

Fifty years are a long time: like the period from 1863 to 1912, from the beginnings of Impressionism to Abstraction: Manet, Monet, Renoir, Degas, Van Gogh, Gauguin, Seurat, Cézanne, Henri Rousseau, Toulouse-Lautrec, Matisse, Picasso, Boccioni, Balla, Modigliani, Segantini, Pelizza da Volpedo. Or else the birth of Abstraction in 1912 to Pop Art in 1962. This includes all the first half of the twentieth century, with Surrealism, German Expressionism, Informal Art. Mondrian, Kandinsky, Chagall, Duchamp, Matisse, Picasso, Otto Dix, Max Beckmann, Kirchner, Brancusi, Max Ernst, Dalì, Magritte, de Chirico, Sironi, Casorati, Carrà, Fautrier, Dubuffet, Burri, Kline, Rothko, Pollock, Lichtenstein, Oldenburg, Rosenquist, Rauschenberg, Tàpies, Still, Newman, Cornell, Calder, Wols, Johns, and Bacon. In the second half of the fifteenth century there were

great artistic events: Leonardo, Botticelli, Donatello, Michelangelo, Lotto, Filippo Lippi, Piero di Cosimo, Giovanni Bellini, Mantegna, Piero della Francesca, Dürer, Cosmè Tura, Memling, Jan Van Eyck, Petrus Christus. This is not a list but just the names that come to mind while I write.

In fifty years I have never seen dominant culture fall so low as after 1976. This is the measure of a deep moral malaise, of a loss of ideal values. This is a matter for serious worry about the future of the West. It is like the end of the Roman Empire when Christianity was repressed and the barbarians were at the gates: but now the only menace is Islamic Fundamentalism, which is dangerous but impotent. Sadly this miserable situation is given the seal of approval by critics and museums. But a small and vital minority always exists, one that believes in positive values. And as always it will be this that saves the world. When we look at the encyclopedias printed in the 'twenties we see that the Impressionists were not considered important, but other artists were, ones we have mostly forgotten, as is only right, even though today there is the attempt to recuperate so-called Pompier art that seduces not just the ignorant but also those who ought to know the difference.

This widely read French encyclopedia is representative of "official" culture at the end of the 'twenties. It is interesting to make some comparisons between the situation of contemporary and modern art then and in 2003. Some 1,300 images of modern and ancient art are reproduced. The works created between the second half of the nineteenth century and 1920 represent some 20 percent. There are about 260 reproductions of modern works: seven by Manet, two Renoirs, three by Degas, a Sisley, and nothing by Seurat, Van Gogh, Gauguin, or Cézanne. The entries refer to the Impressionists as masters; Gauguin is called a good decorative colorist. Matisse and Picasso are mentioned briefly, but whoever wrote these articles had not understood a thing: Picasso makes cubes with a decorative effect as does Matisse. Mondrian and Kandinsky, who by then had had careers of over twenty years, were not even mentioned, and the same went for Duchamp. The masters of modern art. The editors of the encyclopedia were eminent university professors, art critics, and artists. But there was no interest in the art we think of as important. On the other hand the following are mentioned and reproduced: Benouville, Lefeure, Baudry, Sauterre, Colin, Couder, Lethier, Yuon, Danloux, Cormon, Delaroche, Gerard, Tattegrain, Barrias, Scherffe, Leroux, and Burnand. There are over seventy artists reproduced whom I never have heard of, certainly because I am ignorant; but looking at the reproductions I do not find them interesting, and it is more than right that I do not know them. They have added nothing to culture and just repeat the same things with variations suggested by the same Positivist or Marxist ideology. Time has no mercy on useless things and eliminates them, and the same thing will happen to today's dominant art. This was an art without good ideas, pictures painted with photographic precision, though photography by then had substituted for painting as documentation.

The antique artists reproduced are: Rubens, with forty images, Poussin twenty-five, Raphael twenty-five, Ingres twenty-two, Delacroix nineteen, Rembrandt, Titian, and David eighteen each, Michelangelo fifteen, Velázquez thirteen, Murillo thirteen, Horace Vernet fifteen, Jordaens eleven, Laurens eleven, Gérard eleven, and Veronese ten. This was the classification, and Rubens was at the top. Laurens was completely unknown to me; a painter of historical subjects, who was born in 1838 and died in Paris in 1921. Gérard, another unknown artist, was born in Rome in 1770 and died in Paris in 1837: he was the portraitist of kings and emperors. Some great artists are given their due: Memling eight, Guido Reni nine, Mantegna seven, but Meissonier, a painter of

historical subjects, was also awarded seven; Guercino scored six. Some I consider great are included: Lotto one, El Greco two, Piero della Francesca two, Liotard one, Feti one, Piero di Cosimo one, Pontormo two, Zurbarán four, Leonardo eight, Fragonard eight. Dou, the seventeenth-century Dutch genre painter, is paid great attention with nine reproductions. Goya only seven, too few. Greuze eleven, Vermeer, certainly one of the greats, seven. It would take too much time to continue with this list, but it is evident that historical subjects were preferred, and this explains why so many artists without any quality were included. This kind of classification is dubious from any point of view, certainly from mine. Rubens is rated too highly, as are Greuze, David, Horace Vernet, Dou; and Meissionier, with seven reproductions, really is ridiculous. The importance of Rubens is certainly exaggerated when compared to Memling with his seven images. Fifteenth-century art was the complete opposite of the art fashionable in Paris in the early part of the century, pervaded as it was with Positivist ideology: the narrative prevailed over the image's ideal substance. An artist like Memling embodies the ideal vision of the fifteenth century: man in harmony with the Creator, and Creation with Eternity. In the 'eighties and 'nineties of the twentieth century something happened in Europe similar to what had occurred a hundred years before: the highest ideological values were abandoned by the greater part of society in favor of a utilitarian behavior that privileged aspects with little ideological value, and so in favor of the social, the politically correct, and the breakdown of moral values. Official culture in France in the 'twenties with its well-made rhetoric was something desolating. Real art was ignored.

We should not despair if today there is the triumph of an art that is not very artistic. One day there will be a reaction, and that art will be forgotten just like the seventy artists in the Larousse. Unmerited success is paid for later with oblivion, which is real, definitive death.

By 1976 the collection was huge. There were over seven hundred works, including many large Minimal sculptures and Environmental works examining perception, and all of them needed a room. The first part of the collection, bought in the 'fifties, was full of famous artists. Rothko, Kline, Rauschenberg, Tàpies, and Fautrier were in great request by many museums.

The German museums were very active and had a strong interest in American art, as was also the case in the Netherlands and Switzerland. There still had not appeared in Germany such Neo-expressionists as Baselitz, Penck, Lüpertz, and Kiefer who, a few years later, were to have great success in America with their use of Postmodern philosophy.

In a fairly small German city, Mönchengladbach, a short distance from Düsseldorf, there is a small museum run by an exceptional person, Dr. Johannes Cladders. I often went to visit him, since in the second half of the 'sixties he was among the first, if not the first, to show such artists as Beuys, Richard Long, Carl Andre, Hanne Darboven, and many others who are now famous but then were still unknown. Cladders exhibited the best American artists without ever going to the States, as the city would not give him the money for a trip there. His success in the field of culture merited a reward by the city administration, which decided to build a new and bigger museum. The director was adroit enough to influence the city in its choice of an excellent architect, Hans Hollein from Vienna. The city was less lucky in its choice of a building contractor, who went bankrupt halfway through the job; so, instead of in 1978 they finished in 1982. This delay caused an interruption in my relationships with the museum. I remember a visit to Biumo by representatives of the administration. I don't know how many of them understood the pictures by Rothko, Kline, Rauschenberg, Oldenburg, and Rosenquist. Cladders explained things to them and convinced them: they became enthusiastic, and when we went to the restaurant they began to sing. These were Germans of another kind. Their city is to the left of the Rhine, and there really is a difference. Sadly the postponed completion of the building was not just due to bankruptcy, but the overall financial situation was worsening, and this, too, delayed everything further. During this period of intermission and crisis I met Mr. Karl-Heinrich Mueller of Düsseldorf, a great collector who, some years later, created his own museum, the Insel Ombroich, consisting of numerous pavilions each devoted to a particular group of artists. He was a friend of the dealer Konrad Fischer from whom I had purchased many works of art by Andre, Darboven, Long, Ryman, and Charlton. He was the most intelligent

dealer in Germany and Europe, and sadly he died too soon. His widow continues his work in the gallery very professionally.

Mr. Mueller was a friend of Professor Werner Schmalenbach, the director of the north Rhineland and Westphalia regional museum. He was a person of great competence and intelligence who was building up a first-rate collection of modern art from the first fifty years of the twentieth century. He was being financed to the tune of two million marks a year, the equivalent of a million euros. His choices were very sharp: he only wanted masterpieces. Today this would be a very modest figure for collecting works chosen only from the best, but in the 'seventies it was still possible to buy, not just one, but various important pictures each year. The increase in values happened after 1983. The figure Schmalenbach could spend in a year was the same as I had spent in twenty years to buy seven hundred works that now, thirty years later, are considered central to a large part of the culture of the 'fifties and 'sixties.

Mr. Mueller knew the problems of Mönchengladbach and thought that the loan of my collection was no longer a possibility because of the building holdup, and perhaps it might be possible to contrive lending the works to Schmalenbach's museum. The director was interested in the idea and already knew which of the artists he considered most important.

Given that already in 1974 there was no longer any room in the Biumo house, and in consideration of a long-term loan to a museum, the pictures from the 'fifties had been moved abroad.

The 'seventies were certainly the worst period in Italian history since 1945. These were the "years of bullets": the kidnapping and murder of Aldo Moro, the head of the government; many kidnappings organized by the Red Brigades together with common criminals: some two hundred people were killed in order to create a climate of political tension. The abstention from government of the Socialist party had created a political void, and the government only held up because of a secret agreement with the Communist party, which insisted on passing laws it was favorable to.

One of these laws imposed the return to Italy of all the holdings of residents abroad, or else their sale and the reentry of the proceeds. I asked for this to be deferred since the pictures were on a long-term loan to a museum and that they would be returned afterward. The finance ministry's office of trade refused my request, and this was communicated to me when the terms for reentry had expired, leaving me in an illegal position: the law imposed penalties for defaulters. So my wife and I were in the same situation as delinquents who had to go to jail. Luckily preventative custody was not a possibility, and we waited for the court's sentence. As is well known, Italian justice is not the

quickest. We had to wait a great many years, and an infraction committed in 1976 was judged in 1982 by the Rome law courts competent for this violation. Finally a decision was made. We had to sit on the benches where thieves and murderers sit. The court sat in front of us: three black-robed judges and the public prosecutor, who had to explain what the crime was and then make the charges. Luckily he had understood what it was all about, having read all the documentation. Instead of asking for a conviction, as is usually the case, he asked for us to be exonerated. The trial was not over yet, and we had to wait for the decision of the judges who had gone into their chambers to discuss the problem. We waited twenty minutes, but it seemed an eternity. Finally they came back and read the sentence: we had been acquitted since what we had been accused of was not a crime. Ours was a cultural action without any financial aim. The trade office should have realized this earlier. Laws are made without taking into account the necessities of art. To run the risk of prison for having exhibited art in a museum was certainly something unusual.

Besides complying with the demands of the law, there was also a financial reason that forced me to sell the first part of the collection. In Italy this was a bad period for real estate development, which I had been too involved in, and I had debts to the banks that had become very heavy since I was not earning enough. I had bought a lot of art, and the accounts I held together with my brother were in the red due to the recession. It was a terrible decision for me to make, as I realized that if I could only wait another two or three years a better solution would have been available. Europe and America too were coming out of the slump. To sell would break my heart. Only my wife really believed in what we had accomplished, but the others thought that the moment of truth was at hand and that I would have had heavy losses as a result of my crazy passion for art. My first and only interest was to conserve the unity of all the eighty pictures I had bought between 1956 and 1962, and obviously only a museum could guarantee this unity over time.

MoCA

In 1980 during a conference at the CIMAM in Mexico City I had been invited by Pontus Hulten to be part of the committee of the new Museum of Contemporary Art (MoCA) in Los Angeles. It had only recently been formed under the direction of Pontus Hulten, and the deputy director was Richard Koshalek whom I had known and admired for some time. I had met Hulten in Biumo in 1963. He had wanted to put on a show of Pop Art and knew I had their pictures; this was while he was still director of the Stockholm Museum and long before he became the director of the Pompidou. I had met Koshalek when he

was working in the Fort Worth museum in Texas. There was a show by Robert Irwin, the Los Angeles artist I had begun to buy in 1968. Mrs. Dominique De Menil and Peter Ludwig had also been invited to sit on the committee together with various collectors from Los Angeles. The museum was beginning in ideal conditions for doing an excellent job.

I often went to Los Angeles in order to take part in the meetings. It was interesting to see the birth of a museum in a great city. One of the most influential members of the committee was Fred Nicholas, with whom I had always had a warm rapport.

My problems with Italian law were not yet over: even though I had been acquitted by the court the law still insisted that either the pictures or the proceeds of their sale reenter Italy.

For all these reasons I could no longer put off what was for me a painful decision. To detach a part of the collection was necessary, as it had gone beyond the size of a private collector's possibilities. The first part above all had all the qualities for entering a museum on a permanent basis. What hurt me most though was the timing, certainly the least favorable when the economic and cultural context was changing for the better. The Los Angeles museum was being started, but with the risk of remaining almost empty; there was no collection, and to put one together would have been difficult, costly, and would have taken many years. To buy on favorable conditions a collection of contemporary art, among the best existing, was an occasion not to be missed. The museum had an endowment fund, so there was enough money. The appraisals by Sotheby's and Christie's were very similar: the value of the eighty works was twelve million dollars. It is due to the president of the board, Eli Broad, that this was a necessary decision for the future of the museum and an unrepeatable occasion.

Finalizing the discussions took several months. In the meantime I asked for a delay in order to see if the region of Piedmont was able to make the purchase in order to show the works in Rivoli Castle, which was being restored and with which I had made a long-term loan of large-scale Minimal sculptures adapted to the castle's imposing spaces.

The eighty works had been offered to the regional administration for 7 million dollars instead of the 11 million for Los Angeles. Despite this huge discount the region could not find the money and so lost a holding that today is worth 200 million dollars. The seven Rothkos alone are worth between 10 and 14 million dollars. The negotiations with Los Angeles were long but rather vague, and when at a certain moment we arrived at a conclusion, it was a hurried affair without the consultancy of an expert in international law and American financial law. The consequence was that some important details were not

clarified, causing some misunderstandings that were finally sorted out. In the Getty Center there is a lot of documentation about the negotiations.

Then there was an incident. There was someone, more a businessman than a museum administrator, who wanted to sell some of the works acquired from the Panza Collection in order to cover their original purchase cost, which was not yet fully paid. When I read the minutes of a meeting that I had not been able to attend, and saw that the possibility of selling had been agreed to, I was really hurt. In order to react to such a big mistake I would have to use the most resourceful methods. I had the pleasure of knowing the art critics of the *New York Times*, the *Los Angeles Times*, and the *Washington Post*, the most important newspapers in America. They guaranteed they would help as soon as they received the documentation; in fact, the articles all appeared at the same time, condemning a decision that would have damaged some of the best examples of American culture from the 'fifties. The articles had been preceded by phone calls from the editorial offices asking for information. The museum administrators were extremely surprised and worried since they had not expected such a strong reaction. They defended themselves by saying that this was only a proposal, and no final decision had been made. I was worried that I might harm an institution that I should have been defending. Later on a very influential person from Los Angeles, the ex-president of the *Los Angeles Times*, Mr. Franklin Murphy, a very cultured man, confirmed that what I had done was extremely timely. Sadly, even in the best institutions there is always someone who only thinks of business. Some years later too the director Koshalek agreed that it had been a necessary action. The administrative council adopted a motion saying that there would be no sales of the works from the collection. The administrators too were forced to be more active in their search for financing the six yearly installments still to pay. The public response to the purchase of the collection was extremely positive. The newspapers published long articles about it, and people we did not know stopped us in the streets to thank us. The arrival of the collection in the museum was a much heralded event, even at an international level. In fact this fame began to create problems inside MoCA. Some people began to worry that it was about to become "the Panza Museum" and would overshadow the fame of other collections in Los Angeles. For this reason, for many years the pictures from the Panza Collection were rarely exhibited even though they were very important works. It is only quite recently that all the works are permanently on show, also the result of the death of some important collectors. In 1994 I gave MoCA seventy works of art by ten Los Angeles artists from the 'eighties and 'nineties: Therrien, Mahoney, Shelton, Carroll, Rudel, Griffin, Thurston, Greg Colson, Jeff Colson, and Lere. The first five artists in particular are of the

highest quality, though still little known since they are not fashionable. Even though dealing with a donation with the single condition of not selling the pictures for thirty years, the negotiations were lengthy, and it even seemed the museum did not want them, though they had recently accepted the donation of some really mediocre paintings. Someone on the board did not want an increase in the presence of Panza. I am sure that a part of this donation will be exhibited only in thirty years' time, when Postmodern influence has waned and when a certain other collector, who does not like to be compared to others, will no longer be here.

MoCA did something tremendous for me and my wife at the end of 1999 and the beginning of 2000: a great exhibition of all the 150 pictures in the collection; it filled the whole California Plaza building by Arata Isozaki. I must thank the director Jeremy Strick, the chief curator Paul Schimmel, and the curator Connie Butler, for having given me so much space, which I was able to use just as I wished. After so many years it was a great pleasure and emotion to see again artists and pictures that I loved exhibited in a way that enhanced their quality. I would have liked to continue and repeat this experience, but unfortunately the good things in life never last forever.

I am comforted by the thought that they will be shown in the future and that an ever greater number of people will also be able to love them. If they were still mine they would run the risk of being dispersed after my death. When I see a beautiful collection in a museum I feel a great sense of gratitude to the person who had given me this opportunity. When I see the marvelous pictures of the collectors Ivan Morozov and Sergei Shchukin in the Saint Petersburg Hermitage or the Pushkin in Moscow, I am infinitely thankful to them. Many artists in the first part of the collection are dead: Fautrier, Rothko, Kline, Lichtenstein, and Segal, but their works are more alive than ever. A hope for us mortals lies in the immortality of beauty and of ideas.

TURIN

After the negotiations for the eighty works ceded to MoCA, something surprising happened in Turin where I had stipulated a long-term loan for Rivoli Castle. But it might be interesting first to run through the history of my dealings with the Piedmont region.

Since the 'sixties I had done some research into Baroque architecture and had undertaken two journeys to Bavaria where there are some beautiful examples of Rococo abbeys, churches, and princely buildings. Another important center was Turin where in the seventeenth and eighteenth centuries Baroque architecture and town planning had had an interesting development. I made

these trips in August with some of my children in a large American car that we could load up with hampers for picnics in the country between the two cities. We had also been to Edinburgh, which in the eighteenth century had had a notable urban development. There were streets and squares outlined against the sky as in some metaphysical picture by de Chirico. But to complete my research I needed to visit Turin, the city that had become the capital of Piedmont at the end of the sixteenth century. It had been transformed from a small town with Roman origins to a new modern city built to the rational rules of Enlightenment culture. The streets were straight, leading into the countryside. It was an example of the great things accomplished by small Italian states. Our real civilization.

I planned my visits following the directions of books on Baroque architecture. One of the first monuments to visit was Rivoli Castle, which was easy to reach from Courmayeur where we had gone for our vacation. The mass of the castle could be seen from afar; it was abandoned and empty, in the upper rooms you could see the sky through great holes in the roof. It had been one of the Savoyard royal palaces added on to at various times: in the seventeenth century by Castellamonte and in the eighteenth by the great architect Juvara, but his project was interrupted and never completed. This was where Vittorio Amedeo II died in 1730. He had been interned there after his abdication by his son Carlo Emanuele III who wanted to assume control, and maybe it was for this reason that the building was never completed. Juvara had designed the elegant Baroque decorations that had been partly destroyed, not by war but by squatters who had used the doors, floors, and furnishings for firewood in the winter.

Turin had Communist and Socialist administrators. The Savoy family had been responsible for Fascism's and Mussolini's rise to power, so reminders of them had to be destroyed. Many of the monuments in Turin had been similarly neglected for the same reason. My wife and I were deeply impressed by the beauty of this building and its sad decadence. Once restored it could become a museum of Minimalist Art, something that we already had in mind. We had heard that the Piedmont region had plans for restoring the castle.

I knew an important person in Turin, Dr. Gian Luigi Gabetti, who was a fiduciary for the Agnelli family, the owners of the FIAT car firm. He was a member of the New York MoMA board, had seen the Panza Collection and admired my activity. I asked to see him to let him have my views on Rivoli Castle and also to ask for information. It was a friendly meeting, and our relationship has been of the best since then. He arranged a meeting with Gianni Agnelli one Saturday at his house in the hills above Turin, together with his brother, the architect Roberto Gabetti, one of the best architects in Italy. The meeting

was encouraging although we could not count on a contribution from FIAT, which was only just emerging from a critical period. Relations with the unions were strained, and the "years of bullets" were not yet over. Through the architect Gabetti, who knew the politicians of the Piedmont region, I met the president of the region, the attorney Viglione, a Socialist, and the city councilor for the territory, and the architect Rivalta, who was in charge of the restoration of Rivoli. They were favorable to the idea of using the castle for exhibiting international-quality works of art, otherwise the castle would remain empty when it was finished.

The architect Andrea Bruno, an expert in restoration, was in charge of the work and was authorized to keep in mind its future use as an exhibition space for the collection. It was a friendly collaboration, as the architect knew what to do and I never interfered with his decisions, which anyway were always right. I expressed my views about the lighting, always a difficult problem for museums. I often went to Rivoli, and it was a pleasure to follow the work, which lasted a long time, over four years. I think I did the Milan-Turin trip some seventy times. In the 'sixties and 'seventies, before the negotiations for Rivoli, I would go to Turin about once a month. My goal was always the Sperone Gallery, which had a high quality activity and showed new American artists, one of the first if not the first in Europe. These were artists who were still unknown in America, or at least known only by a very few experts and art lovers. When I went to the gallery to see the American works I often met the Arte Povera artists who Sperone exhibited: Kounellis, Paolini, Zorio, Fabro, and Merz. I saw their shows, appreciated their work, but I preferred to concentrate my limited resources on the Americans. For this reason my relationships with Turin were intense and particularly happy. Everything pointed to a glorious future.

In the summer of 1980 the president of the region called me urgently to Turin to sign the loan contract, together with the list of Minimal works that were to be lent to Rivoli at the completion of the restoration: Nauman, Serra, Flavin, Robert Morris, Judd, Richard Long, and Andre. In 1983, in view of the favorable consideration of the administrators, I decided to convert the loan into a donation of some hundred works by the above artists.

Recently, in 2002, a Nauman was sold at Sotheby's for nine million dollars and a Judd for four million seven hundred thousand dollars.

The sale of the eighty pictures from the 'fifties at seven million dollars was no longer possible. With this donation of Minimal Art the castle would have had a definitive systemization with the works best adapted to the extremely imposing character of the architecture. Before the administration changed its mind I had had some clues that things were being changed. The city coun-

cilor in charge of cultural affairs, Dr. Ferrero, asked me the addresses of the directors of foreign museums. I didn't understand why: the work was coming to a end and in a short while the sculptures could be put in place. Everything seemed to be going ahead perfectly, and in fact, I had fixed an appointment with the notary Marocco in Turin in order to sign the deed for the donation on the condition that the donated works would be exhibited permanently, knowing well that there might be heavy political pressure in favor of some protégé wishing to be placed in a prestigious position.

When I got to the meeting the cultural councilor told me that they could not accept the condition of permanent exhibition because of the castle's new multi-functional purpose. Exhibitions would have to change in rotation. Obviously I did not accept the rejection of this condition and so left the notary's office without signing the donation contract; in a way this was difficult to understand since Turin had lost an artistic patrimony. The building was not adapted to alternating shows: it did not have the air conditioning indispensable for obtaining important loans; the rooms on the first and second floors had extremely intrusive decorations that could not be covered, and there were no elevators for lifting large-scale art works to the upper floors.

There had been fairly convincing rumors that explained what had happened. Kounellis was doing the stage designs for a play directed by a Roman friend of his who had married the daughter of the secretary of the head of the Communist party, the member of parliament, Enrico Berlinguer, who in fact I consider to have been one of the best Italian postwar politicians. They said that artists from a capitalist power should not be allowed to take over a place that was the province of the artists from Turin who had always been faithful to the Party. This was why the Turin Communist party received the order to see to it that the Panza Collection would not arrive in Rivoli. I repeat that this was a rumor that can easily be denied.

For me this was a tremendous let down, but believing in the beauty of the works, I was trustful that some other solution might be possible, as in fact happened six years later. I think this was also a nasty surprise for the Communist administrators of the Piedmont region and of the Turin council who had always shown themselves to be enthusiastic about the project I had proposed. Enrico Berlinguer who, as I say, I admired, was a real democrat rather than a Communist. He died suddenly a few days after this episode.

VIGEVANO

Another project was being planned at the same time as the one for Rivoli. My friend Professor Carlo Bertelli had a few years earlier become the superinten-

dent of the Brera Museum, one of the most important Italian museums of ancient and modern art.

The castle of Vigevano, an imposing monumental group of buildings constructed by the Viscontis and the Sforzas, was being restored. It had been offered to the Brera for showing its reserve collection, but on a closer examination it was found not to be well adapted. It was a fortress that had been transformed into a house in the times of Ludovico il Moro and had additions by Bramante and Leonardo, who often stayed there. It was impossible to install air conditioning, and the walls were not straight, as the building had been a fortress. Professor Bertelli, besides being one of the greatest experts in medieval art, was also greatly interested in modern and contemporary art. He was familiar with the Panza Collection and its vast reserves awaiting installation. He was ready to suggest putting works from the collection in Vigevano on condition that I donated them to the State. There were about one hundred works, mostly Minimal sculptures, a part of the seven hundred I possessed.

This was in 1980. There were other corporate bodies interested in using the building, the stables, and the garrison barracks: the Vigevano city council for its archives, the librarians for the restoration of books, the archeological superintendence for storing its finds. There was space for them all. In order to coordinate the interventions the then minister, the Honorable Scotti, nominated a committee to make decisions. I believe the first decision was negative: a refusal to place contemporary art in the main building and to accept the Panza Collection. This was in 1982. Lombardy lost an opportunity. Now the works offered as a gift are to be found in New York, Bilbao, Berlin, and in all the museums of the world that ask for them on loan.

OTHER ATTEMPTED DONATIONS

My attempts and failures to donate conspicuous parts of my collection to Italian public bodies was not finished. I continued to try obstinately.

I don't even want to try to describe the attempts to donate the Biumo house and its contents to the Varese city council: all quite useless. A councilor who was more interested in wheeler-dealering than in culture treated me badly, but then he was dragged into the "Clean Hands" anticorruption trials.

Professor Giulio Carlo Argan, one of the most important and influential critics in Italy in the 'sixties and 'seventies, asked me to concern myself with an initiative that a university interested in contemporary art was developing, using a historic building. I was invited to a meeting with the person in charge. This was in 1982. He was involved in putting on shows and, in exchange, the artists would donate a picture, and in this way he was building up a collec-

tion for his museum. He showed the pictures he had been given. He greatly admired the Panza Collection even though he was of that group of intellectual protestors who thought that collectors should be put against a wall and shot. During our discussion on the works to choose for the future museum I pointed out that mine should be kept separate from those he had already been given. This irritated him a lot, and when he asked why, I explained that artists rarely gave away their best paintings. This statement made him explode in anger. He furiously told me to leave. Professor Argan had told me that the condition for exhibiting was a donation, and I had agreed to this; but I believe the real reason for his anger was not just my judgment on the works he had been given, but was above all the crumbling of an ideal that he had built his life on: the search for an alternative to bourgeois and capitalist collecting that had to be destroyed and substituted by the collective collecting by the viewers and artists together, freed from the restrictions of money. My negative comments on its results, which he probably agreed with as he had recognized the quality of my own selection, was the end of an ideal, a life, a religion. The most bitter delusion one can have. This was an experience similar to that experienced by many intellectuals who, after the fall of Socialist ideologies, found themselves in front of a void without knowing what to do.

This explains why many artists, after 1975, changed their way of working, and as was the case with many intellectuals, Postmodern philosophy, which rejects everything, became their ideal; but it was an ideal of death not of life and their great (mistaken) hopes were at an end.

They say, but it is only a rumor, that under the professorial chairs were hidden machine guns ready for an armed revolution that never came. The masses had no intention of taking part in one. The so-called proletariat had a FIAT 600 car and no longer used a bicycle. The Red Brigades remained isolated extremists without any kind of following. Their motivations were more Freudian than political.

In the same period another possibility was developing in Tuscany. My friend Giulano Gori was looking for a monumental building adapted to showing a part of the Panza Collection. In the marvelous villa in Poggio a Caiano, built by Giuliano da Sangallo for Lorenzo de' Medici, the great patron of art known as the Magnificent, there were the stables damaged by fire that were being restored by the Florentine superintendence. On the ground floor we could exhibit Environmental works by Nauman and Flavin, and on the first floor works by Irwin and Wheeler. These were long and wide galleries, ideal spaces for this kind of art that needs a lot. There were meetings with the president of the region of Tuscany and the various councilors concerned. Even the Honorable Scotti, the minister for culture, came to see. After many yeses, as no poli-

tician ever says no, nothing was concluded. But on that occasion I was able to see the Artimino Villa, a beautiful Medicean building by Buontalenti; it was curated by an outstanding person, Vittorio Dapelo from Genoa, who later on opened an excellent gallery where I bought works by Spalletti and Jan Vercruysse, though sadly it didn't last long. It is often the case that initiatives for good contemporary art, which is the most difficult kind to sell, meet up with too many difficulties and so do not last.

In the same period Giuliano Gori commissioned some large-scale sculptures for the spaces in the park surrounding the Villa Fattorie di Celle in Santomato in the hills between Prato and Pistoia. The best artists were invited to make site-specific works that could not then be moved. A generous gift to the environment: this Tuscan hill was among the most beautiful landscapes in Italy. When sculpture gardens are created with works taken from artists' studios and moved to a place that is extraneous to them they often become a mass of heterogeneous things that disturb each other. In Celle each sculpture was conceived for the space it occupies. You do not see the other sculptures, and there is complete harmony between art and nature, the greatest possible result. Some years ago I saw in a beautiful English setting near Leeds, among lightly rolling hills with the occasional majestic oak tree, many large sculptures by Henry Moore, a famous twentieth-century sculptor. Their limits were at once obvious: they could not stand up to the centuries-old oaks. Nature is an infinitely superior artist to man. In a secluded place was a modular sculpture by Sol LeWitt, made from blocks of cement that had become gray-green and harmonized perfectly with the environment. It did not have the overwhelming ambition of Henry Moore. Anyway, all art lovers should be grateful to Giuliano Gori, who created a great, permanent, unalienable thing.

There must exist somewhere in my subconscious a particular relationship with Turin, obviously due to the fact that the blood in my veins is 50 percent Piedmontese or, rather, from Monferrato, which is different from the rest of Piedmont. It is a hilly region where fine wine is produced, and there are no plains or mountains. So for these reasons my relationships did not end but continued, though evidently they were the relationships of unrequited love.

About halfway through the 'eighties the Agnelli family and FIAT initiated the creation of a center for cultural activities in Palazzo Grassi in Venice. At first the director was Pontus Hulten, who was a guarantee of the quality of the events. In fact the shows were always beautiful, with a great public following. I was asked to be part of the Friends of Palazzo Grassi who met twice a year; also, with the participation of people eminent in the fields of culture and finance, the meetings were always interesting. Pontus Hulten and

Dr. Gabetti thought this might be the occasion for creating a real museum with a foundation and collection.

This was why they asked me to propose some works from the 'sixties and 'seventies, something I did quickly and with much pleasure, suggesting values far lower than those of the market, given that the eventual buyer was a museum that was still being created. I don't remember exactly what the figure was, but it was certainly very low: some four or five million dollars. But Palazzo Grassi remained a place for temporary exhibitions with a program aimed at promoting the cultural image of FIAT.

Among all these negative events there was a positive one, in Turin in 1996. This was a small show in the art fair at the Lingotto factory. There were eight rooms with temporary walls, one for each of the artists of the 'eighties and 'nineties: Sims, Simpson, Spalletti, Vercruysse, Schütte, Carroll, Kiecol, and Davey. It was a good show lasting, like the fair, five days. During the fair I was invited to a dinner in Rivoli Castle. Present at it were the new authorities of the Piedmont region. The president and the councilor for cultural affairs invited me to renew our past contacts for a new collaboration. In fact after some time, the director of Rivoli, Ida Gianelli, whom I had known since 1970 when she worked with Germano Celant, asked me to meet her to study a proposal for collaboration. I suggested a three-year loan to exhibit some forty works, alternating for three-month periods three times a year on the first and second floors of the castle. Work was just beginning on the Manica Lunga, a nearby building used in the seventeenth century by Carlo Emanuele I to show his Flemish tapestries. Once the works had been finalized there would then be space for everything. The pieces I proposed were the new acquisitions from the 'eighties and 'nineties. The director thought the proposal interesting and asked for some time to obtain all the necessary permission from, above all, the museum board, and then the financing bodies: the Piedmont region, the Cassa di Risparmio of Turin, and FIAT. After some months she told me that at last it was possible to sign the loan contract. Instead, one morning I received a registered letter saying that the loan could not be accepted because it placed too many limits on the museum's use of the space.

I still do not understand what were the subterranean forces opposed to the Panza Collection in Rivoli. The situation with the Arte Povera artists had completely changed; they could no longer say they were the poor, oppressed by American imperialist power. In fact it was the American museums that were paying hundreds of thousands of dollars for Italian artists. In that period I had been for three years a member of the purchasing commission for the Pompidou Museum and had seen the high prices paid by the museum for works of Arte Povera. They were not any lower than the American artists

of the same generation. Mysteries! This obstacle was sprung only at the last moment, not earlier on as would have been logical: evidently there was a force that had to remain hidden. They say that Turin is a city of Spiritualism where there is a kind of initiation into mysterious forces. I never believed it myself, but perhaps there is some truth in this after all: I've experienced it.

Before closing this chapter on Turin, I must mention another episode. At the beginning of the 'eighties the region was very enthusiastic about using an internationally known collection for filling these Savoyard monuments. The Savoy family was one of mediocre collectors but of great builders of palaces and cities. What they achieved in Turin and Piedmont, above all in the seventeenth and eighteenth centuries during the Baroque period, is really grandiose. Near Turin, besides Rivoli, Moncalieri, Stupinigi, and Roccanigi, there was also Venaria Reale, an immense building for hunting, the preferred sport of gentlemen and nobles. This was an important occasion for keeping in contact with the important personages of the realm, and these were highly coveted invitations. It was built over various periods, and the last part, the best architecturally, was by Juvara at the beginning of the eighteenth century. Besides the building there was a village where the employees were housed, this too having a monumental town plan. It was kept in a disastrous condition and was about to fall down; it only resisted because it had been built without economizing, since it was intended to last forever. Tall trees emerged from the roofs of the stables. The situation was disastrous, but the superintendence and the regional administration had begun work, and some of the roofs had been repaired to save the buildings. It was possible to hope the works would be completed soon.

They asked me to make a project, which I finished after many visits to the site. This, I think, was in 1982. I imagine that my project did not please a certain lady professor specialized in Piedmontese Baroque studies and who did not appreciate the intrusion of contemporary art in a place she loved like a child. She had not understood that new art, when well chosen, harmonizes perfectly with the antique. I have been able to demonstrate this many times. In this case the refusal arrived quickly and openly.

My connections with Venaria Reale were not yet at an end. In 2000 the restoration was due to enter its final phase. The minister of culture, the Honorable Valter Veltroni had obtained substantial funding from the European Foundation for completing the restoration that had been begun twenty years earlier. The architect Gae Aulenti had been asked to plan part of the works, and I was interested to know what function was proposed for such a huge building.

I no longer had the large Minimalist sculptures by Serra, Nauman, Andre, Judd, and Morris, but it was possible to ask the Guggenheim for a long-term

loan that would of course have been granted on paying a rental fee for it, nothing much in comparison with the overall costs. The Citroniera by Juvara was the ideal place.

This would have been a perfect ensemble of art and architecture. Nothing better could be found to fill such an enormous gallery, some 200 meters long. The Venaria town council was one of the influential members of the commission that had to decide on the place's destination. I had a conversation with the person in charge who seemed interested in the idea. But I never heard any more. I have since heard mention of a plan to reconstruct the life of the Savoy court, though this seems a difficult project to undertake. I also recently heard that it might become a center for restoration, though if true I hope this will be in the stables and not in the monumental part and Juvara's Citroniera: it would spoil everything.

I believe my connections with Turin are by now over. My wife forbids me to even consider any new proposals coming from that particular city.

MILAN

The situation in Milan is completely different. I was born in Milan and lived there for seventy years. No one has asked me anything, and I have made no proposals, except for two instances during the collection's fifty years of existence, though this had nothing to do with me, and of course nothing came of it. Many years ago there was talk of restoring Palazzo Reale; this was at the end of the 'sixties, and now, in 2003, the work has not yet been completed, though it is at a good stage of development. It used to be thought the work would be completed in a short time. The director of the Milan museums asked me to see if I could make a long-term loan of important artists. I set about the project with American artists and had a positive reply. Someone who was familiar with the scene told me it would be better not to involve myself in it. Another case was around 1986 with the Milan Triennial. My friend Nathan Shapira, professor of design at the University of California at Los Angeles, wanted me to do a show there of Los Angeles Environmental artists. He knew the director of the Triennial, who enthusiastically backed a proposal that made use of the whole space. It would have been an interesting show. All the authorities involved were in agreement. It was to have cost 500 million lire, which the electricity company would finance since the works all functioned with light. The company was a dependency of the city council and had been promised a letter confirming the financing. This was at first late in arriving and then never arrived at all. These are my relations with Milan, the city where I was born, and I consider myself more than ever Milanese. But there is a little light

among all the shadows. For fifty years I have had good relationships with the Jesuits who do good work at the San Fedele cultural center where they run a small gallery that has often invited me to do shows by my artists. I warmly remember Father Favaro, Father Bruno, Father Saccardo, and Father Dall'Asta for their respect for me and my activity as a collector, and for giving me the opportunity of mounting shows in their gallery.

Every so often I am invited to some meeting for the future museum of modern art, which is always in the future; but I never take part as my presence would only create problems: *nemo profeta pro domo sua* ("no one is a prophet in his own land") is certainly true for Milan. But every cloud has a silver lining in Italy. After 1996 the situation was reversed, allowing marvelous possibilities, though not of course in Milan or Turin.

I forgot to mention another episode about Milan, one of the many failed attempts to find a space for Minimal Art, which really had need of space.

There are numerous barns that were used by the agricultural businesses in the suburbs and which had been made part of the green belt by the city planners and then purchased by the city council, causing great harm to the owners who lost any possibility of increasing their value. The aim was to create parks and green belts around the city, a commendable idea. As agriculture ran down, the barns fell into disuse and were in bad condition. The biggest was the Cascina Taverna, near the Forlanini park on the avenue leading to Linate Airport. The relevant councilor, the Socialist Polotti, thought it could be used as a museum of contemporary art. He knew I was looking for space for the collection. I took his proposal seriously. The buildings would have to be restructured. The plan was a rectangle with a big courtyard at the center, with the museum all around it. It would be a fine construction at a low cost. I also made a model that, though rough, was fairly faithful to the project. In order to go ahead with negotiations it was necessary to have the approval of the area where the Forlanini park was located. Two people were delegated to discuss the project: a (figurative) painter and another "art expert": two modest people in every sense of the word. On seeing photos of the works by Long, Flavin, and Morris they seemed thunderstruck: for them it was an incomprehensible language. I was also invited by the councilor to speak at a public meeting. I had the distinct impression that my words fell on deaf ears, and in fact that was the case.

I also forgot an additional episode that was even more interesting and another jewel in my crown of failures: Villa Scheibler in Quarto Oggiaro at the northern edge of the city. This was a fairly large building of goodish quality, built halfway through the nineteenth century in the sober Baroque form typical of the seventeenth century. It belonged to the city council and was in a

state of abandonment, though it could be restored. Originally it had a huge garden that had become a nursery for the trees destined for the streets of Milan. It was looked after by an intelligent, kind, and competent person, Italo Gregori, the administrative director of the Piccolo Teatro in Milan, one of the best theaters in the city and famous throughout Europe. There was also the interest of another excellent person, Dr. Antonio Iosa, president of the Perini Club, which had organized a good cultural activity in the area despite it's being a difficult one. In fact in the 'seventies he had been shot in the legs by the Red Brigade and could no longer walk normally. I made many plans for organizing the rooms in order to install art, but despite the help of such valid people, it all came to nothing.

VENICE

Interest in the collection was shown in Venice in the 'eighties. The foreign minister was Gianni De Michelis of the Socialist party. I knew him because I used to meet him in the house of a friend, Attilio Codognato, a busy collector forever involved in the promotion of contemporary art in Venice. In the 'seventies he had organized some beautiful shows in Palazzo Grassi before it became a vehicle for advertising FIAT. The minister had great ideas for Venice and wanted to create an international fair involving the various localities of the lagoon. He was interested in culture and art and also wanted to give a new lease on life to the ancient Venetian arsenal, which had made the warships for Venice when it still dominated commerce and the Mediterranean, from the middle ages until the eighteenth century. The arsenal was mostly unused but it still belonged to the Navy. There was an edifice built in the eighteenth century by an excellent Venetian architect, the Squadrattori building, which was on three floors and would have been ideal for the large-scale Minimal sculptures that might be installed there. I believe that to come to an agreement with the Navy is an endless process. So the space wasn't used.

When thinking of Venice and Palazzo Grassi I remember other interesting episodes. My connections with Palazzo Grassi date back a long way—they are almost ancient—and started in the 'sixties when it belonged to the Snia Viscosa firm and when the president of the company was Dr. Franco Marinotti, a special kind of person and a typical representative of Italian capitalism in the 'thirties. Snia Viscosa had developed rapidly during the 'thirties with the production of synthetic fibers and had the protection of the fascist regime's customs service to develop national industry. Marinotti's son Paolo was a good collector and knew the Panza Collection. Snia Viscosa wanted to use the building for exhibiting art. And this was curated by the son, who asked me

to lend him works by American artists, of whom he deeply admired Rothko. I remember the dinner after the opening of the show, presided over by the Marinotti father, who was able to dominate the other diners by his talk that showed his intelligence and insight into human relationships.

Palazzo Grassi then became FIAT's after a series of takeovers. Among other things, Snia Viscosa's fibers were no more competitive than those produced from petroleum-derived products.

BOLOGNA

Among all the negative things that happened in Italy in the 'seventies and 'eighties I must mention a positive episode that occurred in Bologna in 1976: an exhibition with American Minimal Art in the city's modern art gallery, one that was encouraged by Professor Renato Zangheri, the Communist mayor, a person of wide culture and a professor of economic history at Bologna University. It all came about because the curator of the show, Flavio Caroli, had convinced the mayor to make a courageous decision regarding culture. In 1976 Minimal Art really was contemporary and new, not like now, when it is already part of history. All this took place in a city that had always had close links with the Communist party, like the rest of the Emilia region, and America was considered the most capitalist country in the world. But Communist intellectuals were most receptive, and I had help and understanding from them, a better situation than when I had had to deal with the Right. In fact the Communist party in Emilia has always been tolerant and democratic, more concerned with real interests than ideology.

My collaboration with Flavio Caroli was perfect, and we made the best use of a difficult space. The architect had planned a large central room lit from the north as though it were the studio of an artist, but the side rooms were small. All the same it was a success. The mayor had had the courage to go against local interests, which are always hostile to new artists, especially if they come from abroad.

Flavio Caroli was at the beginning of his career as an art critic, though he was interested above all in antique art. His book on the complex psychology of the great Renaissance artist Lorenzo Lotto is still memorable.

BASLE

If the situation until 1996 was negative in Italy, the situation abroad was better.

In 1976 I had the possibility, with the help of a friend, Franz Meyer, director of the Kunstmuseum in Basle, of meeting Maja Hoffmann Sacher,

Emmanuel Hoffmann's widow who had then remarried the conductor Sacher. She was a particularly intelligent woman, an art lover who over the years had put together a first-class collection of contemporary art, most of it either donated or lent to the Kunstmuseum, works that are by now part of the history of the twentieth century. The Hoffmann family is the major shareholder of one of Europe's most important pharmaceutical companies. Mrs. Sacher wanted to create a new museum of contemporary art in Basle, run by the Kunstmuseum, in order to integrate the family collection with other works on loan.

She came to Biumo to see the artists she could exhibit. She became excited when she saw the works by Ryman, Marden, Mangold, Flavin, Judd, Nauman, Turrell, and Irwin: difficult art that she appreciated as though she were twenty-five years of age instead of eighty-five. The miracle of loving art is that it keeps you young even when you are old. I am eighty and hope that my love for art will keep me young for a few more years. I could still do some beautiful things. There are people who complain that by spending money on art we are not helping the poor, but they do not realize that if you do not love art you do not love life, you do not love others, you do not love nature, and life like this would be miserable.

After her visit to Biumo Mrs. Sacher took on the task of looking for land in Basle with the requisites for building a new museum. The solution she came up with was to enlarge an old building that originally had been a water mill for a paper works. It was in a beautiful position beside the Rhine in the old part of the city. The project was assigned to the excellent architects Wilfred and Katharina Steib. Mrs. Sacher very kindly asked me to follow the works since she had faith in my experience with art installations, which she had also seen at Biumo. I had an excellent rapport with the architects. They followed my suggestions about the lighting and many other important details that for a museum are fundamental. I had studied a system for using daylight for the top floor of the new wing. This permitted a diffused midday light without the alterations that occur when light enters from above through thick glass covers or semi-transparent filters used for hiding the skylights.

The architect consulted an expert for the illumination who, after many calculations, made a mistake and over-enlarged the skylights that I had suggested. Lighting experts do not have museum experience and also have no feeling for art; they are used to lighting offices and supermarkets, which is very easy, but to illuminate art is in itself an art and only secondarily a technique. In the other rooms the lighting was indirect with the use of halogen lamps. The technicians were convinced I was mistaken, and with their machines they checked the amount of light on the walls, which was 650 Lux, exactly the right amount for good viewing of pictures without the danger of damaging

the colors. The museum cost some 5 to 6 million Swiss francs, a modest figure for an exhibition space of about 3,000 square meters (9,843 square feet).

Someone regretted that an occasion had been lost for building a larger museum, using the family's financial resources. In Basle there is still a Calvinist culture that rejects the ostentation of riches, something I appreciate. Then I received a great gift: the possibility to use the whole space for showing a choice of works for some eleven months. There was a marvelous show of works of art from the 'sixties and 'seventies with pieces by Morris, Judd, Bell, Ryman, LeWitt, Kosuth, Mangold, Weiner, Long, Joseph, and Nauman, the first time they had been shown in a museum with such a large space. This occasion was important for the help I received from a dear friend Paul Jolles, a collector and art lover who helped Swiss art museums. He had an important job with the federal government, and afterward he became the president of Nestlé. I often met him and his wife to discuss art and museums.

In America too there were attempts to show the collection using abandoned buildings.

SAINT PAUL-MINNEAPOLIS

Another interesting thing happened at the end of the 'eighties, though I no longer remember exactly when. I don't have available the archives with the documentation of that period, which by now has been in the Getty Center for Art and Humanities for some ten years and so is not easy to consult.

In America MoCA's purchase of the first part of the collection had created general interest in the works of the 'fifties, which were on the point of becoming a record of the past, but it had also created interest in the artists I had collected later.

At the beginning of MoCA's activity in 1981 I had met a pleasant and intelligent person who was in charge of the museum's external relations, Robert L. Sain, who came from Saint Paul-Minneapolis in Minnesota.

Minneapolis is famous for its museums, the Institute of Art and the Walker Art Center, directed for many years by Martin Friedman, one of the most intelligent and competent people in America. Many of the museum's shows were done when the artists were still not well known. After some time Robert Sain went back to Minneapolis, I think in 1988. He sent me a proposal: the building that had housed the old train station in Saint Paul was now abandoned but in good condition and was architecturally of good quality. It could be used as a museum with works from the Panza Collection.

During one of my many journeys to Los Angeles I stopped off at Minneapolis. The building was in Saint Paul on the right side of the Mississippi while

Minneapolis was in front of it on the left side. Despite the fact that they are two separate cities—Minneapolis is more evolved and important, Saint Paul slightly less so—there was in fact no museum of modern art. The building selected was the Concourse, the old station ticket office, a single huge room, and here we could exhibit Minimalist sculpture. So this could be a solution. The good relationships that Bob Sain had with the city continued to function: the president of the most important bank, Bank One, which also had a collection of contemporary art, sponsored the advertising. The newspapers and television spread the news and there was a great deal of enthusiasm. I was interviewed by the television: when I saw it I was depressed by my ugliness though not by what I said, which seemed okay. My wife and I went back home to wait for good news that did not arrive. The prospective financers of the new museum had no intention of taking on further responsibilities than those of the existing museums.

Some years ago we saw Bob Sain in a totally unexpected and distant place: San Diego in California. He had become the director of the children's museum, a new building that he ran efficiently with new ideas. Ours was a happy and unexpected reunion, as happens when you see a dear friend after a long time. I really admire Bob Sain: he belongs to that small group of silent fighters for beauty and art. These are the heroes who uphold good against the assaults of the profiteers who are in search of success and their own well-being. Heroes work without asking anything in exchange, they only want to win for beauty's sake: a tough fight.

SAN DIEGO

I have had many connections with San Diego, and I often went there when I was in Los Angeles for the many meetings I had to attend at MoCA: I was part of its administrative committee. In La Jolla, a suburb of San Diego, there is a museum of contemporary art, and for many years it was directed by Hugh Davies, someone who always made excellent choices. I remember a beautiful show of works in plastic by Peter Shelton, some ten years ago when no one knew him.

The museum is on an excellent site by the ocean, which in San Diego is as blue as the Mediterranean. Though the rooms are beautiful the museum is small, but with a growing collection. They had to look for new spaces. At the San Diego port, at the end of a long bay, there are also the headquarters of the American naval fleet, with enormous warehouses built in the 'fifties and 'sixties for unloading merchandise in expectation of an increase in future commercial activity, something that didn't happen. Californian finance

became increasingly one of service industries and less of production: research, technology, medicine, computers, show business, finance, insurance, yes, but very little at all of bulk and weight. What is more, other kinds of merchandise travel in containers that are filled at the point where the merchandise is produced and emptied directly at its destination: a stop at the port's storehouses is no longer necessary. A revolution. The great San Diego storehouses, with their tens of thousands of square yards, are empty and obsolete, without any kind of useful future. They were well built in reinforced concrete with good midday sunlight. They might easily have been turned into a perfectly functional museum, although without any kind of eye-catching architecture. This would have been ideal for large-scale Minimal and Environmental sculptures by Los Angeles artists. The idea was not accepted by the port authorities: a great pity and a lost opportunity. The museum made up for it by using a small abandoned railroad station.

There was another reason for going to San Diego: James S. DeSilva and his wife Marne lived there, two very pleasant people, clever and generous collectors. James DeSilva had an excellent idea. There was a university campus with various schools scattered over a very large space. It was a state university with, unfortunately, not very good architecture. In America many universities are private and planned by the best architects, so they have some beautiful buildings. In San Diego or, to be more exact, in the suburb of La Jolla, the university had one thing going for it: a large open space that could be used as a big sculpture park. This was the generous idea of the DeSilvas who had a large hand in financing the works of art, all well chosen and by the best artists. I remember, among others, works by Irwin, Finlay, Fleischner, and Nauman. I was invited together with my friend Pierre Restany to be a member of the administrative council, but they had no need of our advice.

Mary Beebe was the director of the Stuart Foundation, a competent person whom I had come to know in the 'sixties when she mounted shows of Minimal sculpture before anyone else did, in the public spaces of Portland, Oregon. Sadly James DeSilva died some years ago at a time I could not travel after my heart attacks, and I am very sorry not to have seen him again. He did something beautiful though, and this will keep his name alive.

DÜSSELDORF

In September of the same year, 1980, there was another important event for the collection: a large exhibition of Minimal Art in Düsseldorf organized by the Kunsthalle, directed for many years by Jürgen Harten, a splendid person who shared many opinions about art with me; the city museum also took

part in the show. Nearby there was the Kunsthalle, an abandoned building used for trade fairs before the new edifice was built. It was a large space constructed in steel. It was not the best habitat for art but just right for the large-scale Minimal works by Donald Judd, Carl Andre, and Robert Morris, recently constructed in Italy following exactly the plans and directions laid down by the artists. They could be seen in all their imposing beauty.

MADRID

In 1988 there was another important event: the show in the new Reina Sofia Museum that was still under construction. It had been created by restoring a hospital built in 1788 during the reign of the Bourbon King Carlo III. It is a building with extremely beautiful spaces and an architectural vision similar to that of Minimal Art. This was the philosophy of the Enlightenment, a representation of the beauty of thought. The exhibition took place on the express wish of the exhibition's director, Carmen Giminez, a very proficient and knowledgeable person. I had come to know her some years earlier in Milan, and we had spoken vaguely of a show that had only now become possible. It took the whole floor of the museum, some 6,000 square meters. It was by far the best museum building before the Guggenheim opened in Bilbao in 1999. In the meantime the Jaca Book publishing house, managed by a person involved in culture like very few others, Sante Bagnoli, had published the catalog of the whole collection, which was printed and then reprinted with emendations in English, Spanish, and French. In my lifetime I have known many people who have devoted their whole existence to art, culture, and the good of others. These are the silent heroes who cause society to progress.

The Madrid show marked the triumph of Minimal sculpture in a setting that seemed to reflect exactly that of the philosophy of Minimalism itself: long rooms with heavy vaults rising from equally heavy walls. The long corridors were given rhythm by a series of imposing pilasters: a repetition of forms as can be seen in sculptures by Judd and Andre. There were also many rooms devoted to Flavin, and their colored light flooded the spaces, creating a powerful metaphysical beauty. Thomas Krens, who had just been named director of the Guggenheim, visited the show and, I believe, then thought of buying this Minimal collection to expand his museum.

The exhibition lasted a number of months, from spring to fall, with a large attendance and positive comments in the press. Carmen Giminez wanted the minister of culture to buy the works on show to form a basic collection for the museum. But the museum was still being formed and did not yet have a definitive statute; there was no kind of organization for making important

decisions for the future. I, though, would have been only too happy to see my works in that splendid setting. Spain has had an amazing cultural renaissance, and many contemporary art museums have been built in various cities: Valencia, Bilbao, Santiago, and others still are under construction, an admirable development after the civil war and the period of stagnation under Franco. A country in constant development Spain has made up for all the time it lost after the war and the damage it suffered under the dictatorship.

In Spain I have put together some beautiful shows, not just in Madrid and Bilbao, but also in Palma di Majorca in a splendid building, La Lonja: a room constructed at the end of the fifteenth century in the Gothic style with tall columns that supported the roof as in a church. In the distant past it was used for auctioning fabrics arriving from the Middle East. The room was large and so could be divided up by temporary walls. This was in 1997, and I chose artists of the 'nineties. It was a great experience: the building was beautiful and the comments by the local press were positive; also there was the help of Pedro Serra, a contemporary sculpture collector, who wanted to promote the idea of a new museum.

LOS ANGELES

In Los Angeles some years earlier I had been contacted by a dealer who wanted to introduce me to a lady, the wife of an important person, who wanted to create a museum and buy an equally important collection. She collected beautiful French Louis XV furniture and lived in an imposing villa in Bel Air, a very exclusive area of Los Angeles. The new museum was meant to complement the Los Angeles County Museum. I had a meeting with the director, Earl "Rusty" Powell, but without coming to any conclusion because no decisions had yet been taken. In the meantime he suggested that I sell some work to the value of a million dollars, but I said no as I had no intention of dividing up the collection.

Only later on did I understand why the project never got off the ground: the husband, a science enthusiast, wanted to finance an astronomical observatory, the W. M. Keck Observatory, constructed with the latest multi-mirror technology, something of great scientific use. Its high degree of resolution is contributing to new discoveries about the origins of the universe. Astronomy is a science that fascinates me, and on clear evenings I try to identify the stars. I feel a mysterious attraction to these distant worlds. I would like to know more. When I am in Arizona where the night sky is completely cloudless and you can see an enormous quantity of stars, I can stand for hours looking at them. It was right to relinquish a museum for a telescope.

THOMAS KRENS
NEW YORK, U.S.A., 1946–

I have known Thomas Krens since halfway through the 'eighties, though I don't remember on what occasion I met him. He was a professor at Williams College in the western part of Massachusetts, almost on the border with Vermont. Krens was also the director of the college's art museum. He had enlarged it in a postmodern, classical style designed by the architect Charles Moore. By carefully controlling expenses he had a positive result; the shows too were well chosen. Krens has always been someone with grand projects in mind. He can't stop at his first results but always has to have something bigger in mind, at a high personal risk and with very hard work. It is only in this way that the world goes ahead, because otherwise it would stay at the same point. Krens dreams of imposing architecture, but he has his feet on the ground. He is not only a graduate in art history but in business management and so knows how to study concrete possibilities to reach his aims. These possibilities for development are based on the influx of the public and the amount of money needed to execute large projects. The wider public tends to be more attracted by architecture than by contemporary art. Bilbao was a success but the crowds went to see the building by Frank Gehry—the art inside it was an extra.

Unfortunately, good contemporary art is an elite interest while bad art, which will disappear in time, is popular. Art history teaches us that this is how it has always been.

The price of a picture is the proof of its attraction for a wide public. The financial benchmark is 10 million dollars, and it is all the better if the values are three times greater, as happens with the Impressionists: Van Gogh, Cézanne, Matisse, and Picasso. This is why the Guggenheim collaborates with the Hermitage in Saint Petersburg and the Kunsthistorisches Museum in Vienna. Good contemporary art will be popular in fifty years' time, though it is more likely it will take one hundred years—as indeed happened with the Impressionists, who were rejected by the Louvre and by their contemporaries.

Krens's gift with words is fascinating, and those who listen to him also begin to dream of great art projects. As owners of sculptures and environmental works needing large spaces, my wife and I were interested in his projects.

Not far from Williamstown is North Adams, Massachusetts, where there is an industrial estate with fourteen buildings for processing wool dating back to the Civil War in 1863. These buildings were later used for producing electrical equipment, but recently that firm has moved elsewhere and created a pocket of unemployment in the city. There were, however, no other economic

alternatives. So the possibility of transforming industrial buildings into a low-cost art museum was a distinct possibility.

An important museum can create a great deal of tourism in a region where there already are a number of attractions and also create new areas of employment. The project had great possibilities, and so my wife and I would have happily made a legal transfer of works that could only with difficulty be placed in normal museums. The groundwork done by Krens with the help of Michael Govan was convincing and was supported by the local authorities. But it was also necessary to convince the State of Massachusetts, which would have to finance an area that was in difficulties. Michael Dukakis, the Democratic governor who was also running for the presidency, was favorable toward the plan. We had the pleasure of getting to know him in his office in Boston, in a very pleasant meeting with someone who demonstrated his intelligence and abilities for governing. The plan seemed on its way to a successful conclusion, but suddenly things became difficult. Dukakis was not elected president, and the next governor, a Republican, found he had a deficit instead of having assets, so there was no money for new investment. Krens felt himself too confined as director of the Williams College Museum, since in order to carry out his plans he needed a larger springboard. In America various museums needed a new director. And this was the situation at the Guggenheim.

Thomas Messer, the director, had done significant work over the years together with an excellent curator of contemporary art, Diane Waldman, but he was coming up to retirement age. It was necessary to better the museum's financial situation since its funds had been eroded by inflation, a difficult task though in common with all museums. The Guggenheim director and trustees were convinced by Krens's personality and the work he had achieved. I remember Tom Messer's opinion that he was the person best adapted to relaunching the Guggenheim. Its collection was one of the most important in the world, but Frank Lloyd Wright's exhibition space was insufficient; it needed restoration and the elimination of later accretions, and new spaces would have to be created for offices. The Guggenheim was the first American museum with a branch in Europe, in Venice, one with a collection of masterpieces brought together by Peggy Guggenheim and donated to the museum, after the City of Venice had refused the donation because it did not have enough money to pay the transfer taxes. It was necessary to build up the museum's finances and give it an international, rather than American, profile. The historic collection was almost completely of European art. Krens got down to work at once to resolve these problems and give the institution a new image. But at this point, in my view at least, he committed a psychological error. When he outlined his ideas he underlined the need to manage the museum like a busi-

ness. Cultural activity should be considered a productive activity and managed accordingly.

These statements were soundly criticized, even though in fact all museums, except for those with large funds at their disposal, had to do the same thing: chase after rich donors, discuss their conditions, search out businesses interested in financing shows for the sake of the publicity, with all the consequent compromises: these are all things that have to be done, but you mustn't say so. Art must be something sacred and above other interests. Krens's work capacity is really amazing: he is continually traveling around Europe, America, and the East; you need really good health and, above all, an iron will to stand up to such relentless work. His right-hand man, the young and extremely intelligent Michael Govan, a serious, balanced, and hard-working person, knew how to sort out problems and how to deal with people. It was a great loss when he left the museum to become the director of the Dia Art Foundation.

One of Krens's first worries was to bring the collection up to date. In the preceding thirty years the Guggenheim had done many beautiful shows by the best contemporary artists, but it had bought little, so the collection had gaps to be filled. The director had seen the show in Madrid, had been to Biumo, and knew the artists in the Panza Collection. He also knew that I was looking for a museum to exhibit them. For someone wanting to fill the gaps of the 'sixties and 'seventies there could have been nothing better.

The negotiations for the purchase were simple: the important things were discussed with Krens, the individual conditions in the contract with Govan, who was well acquainted with the relevant legislation, and there was also the help of various lawyers. Discussion about the basics was simple: two hundred pieces were chosen, the heart of the collection's works from the 'sixties and 'seventies, and these were then assessed by Sotheby's, an independent body. I had stated that I could give no more than a 50 percent discount, otherwise it would have been a donation, in which case my heirs could then annul the contract and ask for the works' return if it had infringed the laws regarding the rights of my heirs. Krens, who had studied business management theories, was unable to use the strategies indicated in the publications. It seemed an impossible situation to him, so this was the solution we arrived at. Usually discussions about costs are long and exhausting. The museum did not have ready cash, so in order to buy the works it sold three pictures, the most important being a very beautiful Kandinsky, and the profit was far higher than had been foreseen. This was the spring of 1990, the moment in which the market was at its highest: three months later things would have been difficult.

By selling three works the museum gained two hundred, all the best works produced in the previous twenty years. Two years later I donated a further

150, so the total arrived at 350, all of museum quality—a great bargain for the Guggenheim. These are all works that grow in importance and value, and this will be even more so in the future when the postmodern fashion passes. The bargain was seen straight away in the 50 percent discount. In this way I disposed of the second part of the collection in one of the most important museums in the world. The works required tens of thousands of square meters for them all to be shown, and the director's plans for expanding the exhibition space infused me with confidence in a positive outcome, even if in a distant future.

I have always worried about settling the collection in a definitive way in order to avoid the scattering that is a risk when you have many children, however well-disposed they are to the collection. Even if they do not dismember it during their own lifetime, then their own children will be obliged to. With the passing of time good quality works increase in value while capital diminishes as a result of inflation and taxes. Pictures do not satisfy hunger, so in order for one to eat they must be sold. Works of art can only be sold to museums if big discounts are given, but those who have created a collection feel the need to be generous to art, for it has given them so much. It is more difficult for their heirs to be so generous, especially when there are a lot of them, as in my case with five children and seven grandchildren. Once even a large cake is cut up into many slices, these slices become very small.

LUGANO

All the men in my family died before reaching seventy-five years of age, and as a result I had taken for granted that I would die when I reached the same age. I mistook my calculations, and now at eighty in 2003, I am still alive and kicking, even though in 2000 I had big problems due to an aneurysm and two heart attacks. This mistake led me to make others: I gave away almost six hundred works of art in too much of a hurry. Had I waited I would have been able to dispose of them better, but no one can predict their own health. The biggest error was to give two hundred works to the Lugano Cantonal Museum in 1994. In 1992 Manuela Kahn-Rossi, the director of the museum, asked me to install a show of recent works that took up all of the available 1,000 square meters. The Honorable Buffi, one of the most important politicians from the Ticino canton, said in public that the canton would buy the next-door building, which was for sale, and thus increase the exhibition area to 3,500 square meters, sufficient to show the two hundred works I had donated, even though on a rotational basis in order to give the museum more freedom. Unhappily, for various reasons the purchase did not take place. Even the Honorable

Buffi, who was a friend of the museum, sadly died suddenly from a heart attack. Now the director, Marco Franciolli, is working at a new program. In any case many years will be needed to bring things to a conclusion, and I hope I don't die first. If I had not made this donation I could have changed the legal transfers in Italy into permanent gifts. I have donated a considerable number of works of art, a quantity that can fill many museums. I have given to FAI not just paintings but also a museum: my house in Biumo, Varese, a Baroque building with fifty exhibition rooms. Italian law limits possible donations to a quarter of the total legacy. The remaining three quarters is by right the property of the children, and if this proportion is exceeded, the heirs have the right of restitution. I have gone just a little over the limit, but I am confident that my children will not ask for restitution. Morozov and Shchukin were, in their misfortune, quite fortunate: the two collections were appropriated by the communists and in this were preserved intact.

Tom Krens carried on with his tireless search for new space. The Punta della Dogana in Venice is an ideal place for being turned into a museum, and it is mostly empty. After complicated bureaucratic dealings the space is now completely empty, but is not yet a museum after fourteen years of work.

In 1992 I was with my wife at a conference on art in Santander, northern Spain, at the invitation of the Guggenheim. Krens had had talks with the administrators of the Basque region who wanted to create a museum with an international profile in order to prise Bilbao out of its cultural and political isolation. This didn't seem a very likely proposition to me, as Bilbao is a marginal industrial Spanish city built at the end of the nineteenth century, sad and without qualities. Krens too had his doubts. But the Basques made a considerable investment in order to have one of the most important and spectacular museums in the world. It was a great success, with an incredible attendance. In three years, entrance fees had repaid the huge investment of money. Everyone feels the need to go and visit it. The courage to make a great investment gives positive results. Half measures produce little.

I went to the building site in Bilbao a number of times, invited by Krens, and it was a great experience to see how the steel bearing structures were erected. This new development confirmed my trust in the Guggenheim program. The expansion program is still active, but its fulfillment is not as speedy as in the admittedly exceptional case of Bilbao. Theirs was a program begun in 1992 and, after only four years, was opened to the public in 1996. Mario Botta's plan for the museum in Rovereto is being completed now, at the end of 2002, after eighteen years. The Bilbao museum's space is very beautiful and perfect for the Minimal and Environmental works from the Panza Collection. In 2000 a show of the collection was put on in Bilbao, and it took up the whole build-

ing of some 11,000 square meters (7 square miles) with one hundred works, less than a third of the 350 from the collection that the museum owns. To exhibit them all would require three museums the size of Bilbao. I do not know when there will be other museums like Bilbao, only occasionally able to be filled with the Panza Collection.

The art of the 'sixties and 'seventies has to compete with that which was produced afterward, even if it is not of the same quality. It will be necessary to wait for 100 years in order to see them exhibited at least in part if not all together. It would be useful to rent homogenous groups of works for long periods to other museums that have the right amount of space. The art would be seen and the Guggenheim would gain an income. In matters of sales and donations the museum applies its "governing criteria" when works from the Panza Collection are exhibited. These are simple rules that are essential for good public fruition. These elementary rules are not always respected. Sometimes curators, art professionals who have studied so thoroughly in universities, do not have the sensitivity to understand how works, especially large-scale ones, should be exhibited.

They often lack an understanding of the setting and decide what to put on show before knowing if the pictures can be hung in the right way. I have heard talk about great plans for an enormous building in downtown Manhattan at an enormous cost. After the destruction of the Twin Towers, maybe it would be better to create a cultural alternative to new offices. I have also heard about projects in Brazil, but sadly this is a country with a nebulous future because of its difficult social situation. The two "Kunsthalle" in Las Vegas are spaces for shows, but not for the collection: this is an environment where art is the last thing to interest the tourists. There are big plans in Saint Petersburg, but the Hermitage has its reserve collections to take care of. There might be possibilities in China though we will have to wait another thirty years for the political situation to change.

Many museums are being built, but few with enough available empty space.

FRANCE

Another gorgeous show was the one in St. Etienne in 1989 in a new museum built like a factory with high, steel ceilings: a perfect space for Environmental works. The only drawback was that the lighting system was suspended too low. The director, Bernard Céysson, an outstanding man, and his staff gave me free rein. It was a very positive experience. The space was about 4,000 square meters (2.5 square miles). In Lyon at the same time there was also a show devoted to Dan Flavin's colored lights, held in the old Palais Saint Pierre,

before the museum was relocated to its new building planned by Renzo Piano. It was an evocative environment, and I had been invited by the director, Thierry Raspail, a very competent person. The following year there was another exhibition in the Paris City Museum that for some months occupied the whole building. I had known the director Susanne Pagé for some years. This too was a first-class collaboration, and I was able to choose without any interference the Environmental works best adapted to the architectural characteristics of an edifice built in 1937 for a World's Fair. The 1950s' prejudice against American art had by now disappeared. The Americans were no longer the dangerous enemies who were contending with Paris for the world art market. Critical and public approval was also positive. The wife of the mayor of Paris, Mme. Chirac, opened the show and I was presented with an award. During the presentation of the exhibition I referred to the French origins of my culture and to my relationship with Paris through my friendship with Pierre Restany.

In 1988 I had mounted a show in a space that was not adapted to it in the Rath Museum in Geneva. I had accepted out of friendship for the curator Charles Goerg who sadly was to die prematurely. I also have friends in Geneva who are great collectors of modern and African art and whom I admire a lot, Jean Paul and Monique Barbier-Mueller.

The space for the show was not very good, even though the choice of works was the best possible. The curator was in favor of it, until a friend of hers, an American Postmodernist painter, arrived a few days before the opening and became very angry with the curator, whom he considered was betraying him with an exhibition of work by his enemies. The outcome was that the show was sabotaged by its organizer, who printed an incomprehensible poster and increased the cost of the entrance ticket.

In the 'nineties too there was another negative episode. A ring-road had been built around Geneva, and the city council wanted to decorate it with works of art, and they had set aside a million Swiss francs to buy and install them. I was asked to be part of the commission for finding the artists and selecting the best proposal. After a great many meetings an acoustic work of an artist I had chosen, Michael Brewster, was selected to be placed in the longest tunnel. It had been tried out in Los Angeles with a positive result. The Doppler effect of the moving cars created beautiful sound effects. Brewster was chosen, but the work was never constructed and no justification was given. It had even been approved by the road safety office. Probably it was more interesting for the politicians to spend the million in another way, even at the cost of breaking an international agreement.

My relationship with France continued into the 'nineties. I was invited to be a member of the Pompidou purchasing commission for three years. It was

interesting to see how the choosing process worked in a large organization where decisions were made by a majority vote. Apart from the museum staff there were some external collaborators, Daniel Cordier, for example, who in 1960 had organized the first show in Europe of Rauschenberg. He was a pioneer of contemporary art and also generous to the museum, giving it his collection. I was invited to take part by Dominique Bozo, an exceptional person who died all too soon. It was interesting to see how choices were made at the request of the various curators. It is difficult to choose contemporary art, where everything is arguable, by a committee, even one consisting of qualified people. New art is a risk and takes years to become a certainty.

This risk must be the responsibility of a single person, if he or she has the necessary ability, something that is rare. There was also little attempt at bargaining: when an artist sells to a museum a reduction of 50 percent is made up for by the publicity that the institute gives to the artist.

THE CREX COLLECTION

The Crex Collection is the most important one of Minimal and Conceptual art in Europe. It has been directed by its initiator, Urs Raussmüller, since it began, and in fact all the choices have been made by him. Before beginning the collection he had been concerned with a foundation financed by the supermarket chain Migros, which had a gallery in Zurich.

The collection is on show in a very large, two-story industrial building in Schaffhausen. In it are almost all the artists I collected in the 'sixties: Judd, Andre, Nauman, Ryman, LeWitt, Weiner, Beuys, and others. It is a selection of works and artists worthy of an important museum, but one that important museums, at least in Europe, do not have. They will buy these artists when their prices go up, for this is the fate of real contemporary art: it is always difficult to overcome the wall of incomprehension and indifference, even at the highest levels.

I hope that the Crex Collection finds a permanent museum owned by a public institution, for it would be a sad loss if this doesn't happen.

The ownership of the collection is something of a mystery: we don't know who owns it, and the person does not want it to be known: reserve pushed to its very limits. Until now the anonymous owner has shown an understanding of the importance of the collection in the cultural context of Europe, and I hope this continues.

OTHER ATTEMPTS

An interesting project began in Zurich in the 'seventies. An intelligent and capable person, Dr. Christov Vitali, was involved with the city's cultural activities. The Zurich gasworks had by then fallen into disuse and was available, so this big building could be used for showing large-scale Minimal sculptures. Dr. Vitali invited me to come to Zurich and picked me up at the hotel in one of those old New York taxis that had disappeared years before, but were now used by the Zurich town council for occasional guests. The visit to the gasworks was interesting: not only were the industrial sheds large and well built, but all around them were cylinders, huge spheres, and long, horizontal, wide-bore pipes. This was an environment full of beautiful Minimalist sculptures—at least the result was similar—though designed by engineers rather than by artists. But then engineers construct things that earn money because they are useful to us: this is not so with works of art. It was a really interesting idea that Dr. Vitali had had and, I suggested various possibilities for using the gasworks for sculptures by Judd, Morris, Andre, and Nauman. Regrettably there was a problem at the very start. The terrain had been contaminated by the chemical residues of the gas. It was also in a dangerous location near the water tables that supplied the Zurich aqueducts.

There was a similar situation near Essen. I knew the director of the museum there, Dr. Felix Zdenek. Shortly before, I had gone with two famous photographers, the Beckers, to visit the steelworks between Essen and Dortmund, an unforgettable experience. I asked if there was any possibility of using such abandoned buildings.

In fact there was a mine complex that had been built in 1930 and not used since. The architecture of its main building was modern and of good quality, and it was very large. A request was made to the authority in charge but there was no answer. Probably there was some political factor involved, for these factories had supported two bloody world wars and two defeats. This was something better kept hidden. In recent years this attitude has disappeared, and I have since heard that the mine building is now used for exhibiting art.

ITALY

The year 1996 was one of great change in Italy. It was when the public administration changed its views about the collection. The starting point had been the donation of Biumo to FAI (*Fondo per l'Ambiente Italiano*): the endowment for preserving the Italian environment and heritage.

The negotiations with the president, Giulia Maria Mozzoni Crespi, were straightforward and friendly. I had prepared a detailed plan about what work was to be done in the house to make it possible to have in advance a good idea of the costs for opening it to the public. The CARIPLO Foundation and the Varese provincial government generously accepted financing the work. The CARIPLO adviser, Carlo Vimercati, and the president of the provincial government, Massimo Ferrario, were all-important in obtaining the finances.

FAI was begun some thirty years ago with the aim of safeguarding Italy's historic and monumental heredity, which is at risk of being destroyed as a result of financial and social changes. Italians now usually live far better than fifty years ago, but our monuments are in peril: the strange contradictions of well-being. FAI has made a great contribution to changing this dangerous situation, and it does its best to alter public opinion toward this problem. The courageous and resolute commitment by FAI's president, Giulia Maria Mozzoni Crespi, to safeguard thirty-five important monuments has been decisive. In this she is backed by a staff that works with real enthusiasm in order to operate an organization continually charged with the restoration, conservation, and diffusion of information about yet more monuments.

This is a thankless task that, year by year, becomes heavier and more demanding. For this reason it must continually adapt itself to a changing situation, and in doing so, it continues to gain respect.

Thirty years ago it seemed an over-ambitious program in a nation where culture has always been delivered from above: by dukes, kings, popes, aristocrats, but never by the whole of society. FAI has overturned this situation, thanks to its president and to a few willing helpers who believed in the need and importance of their mission. These few helpers are now a multitude that increases every year. As with all cultural activities that are not part of the administrative system of the state, regions, or city councils, they have to be financed by the generosity of private bodies, companies, and institutions; a difficult task that has to be confronted and continually resolved.

FAI was Villa Panza's salvation. The Varese city council was not interested in being donated the villa. The state, always lacking in funds, only just manages to maintain what it already has. Newly constituted bank funds, which in recent years have been of great help to many social and cultural activities, were not yet able to take on this burden.

After our death Villa Panza ran the risk of becoming a building for offices or divided up into apartments; the collection ran the risk of being shipped to a museum or abroad. FAI resolved this by conserving an inheritance for the joy of living and the increase in self-awareness of future generations.

Villa Panza is in the center of a rich and busy city. It would be financially very remunerative to find someone to buy a building with sixty rooms and some 6,000 square meters (3.7 square miles) of salable land. In today's world new museums are being built every year, any one of which would like a famous collection: the one in Villa Panza would present a very attractive proposition.

My wife and I are by now at the end of a long life dedicated to art and culture. Our five children will be the owners of our assets and our collection. By making donations we have deprived them of an important source of income that they had every right to expect. They have always been in agreement with this particular donation as well as with all the others we have made to museums over the years. They are in fact the real donors: those on the receiving end must always be thankful to our children who have never protested against our generosity, which, after all, was to their disadvantage.

The Biumo donation led to an unexpected and important political development. The center-left government had just come into office and the minister for arts was Valter Veltroni. His first public engagement was the donation ceremony at Biumo. During his speech he asked the government's pardon for his ministry's lack of attention to the Panza Collection. While visiting the house he told me in private that I would be receiving some requests. In fact some months later I had a visit from Dr. Caterina Bon Valsassina, director of the Gubbio Museum inside the Ducal Palace, who is interested in contemporary art. She wanted to rearrange a part of her building that at the time was provisionally housing frescoes taken from country churches hit by the earthquake and that had to be returned to their place of origin. We fixed an appointment for a meeting to see the quality of the rooms and to choose the best adapted works; before this visit we had met in Perugia where there was a small exhibition in the National Gallery with works by artists who used color. This had been organized together with Alfonso Fratteggiani, an expert musicologist and art lover who had not yet begun to make his monochrome paintings. I had met Fratteggiani through a mutual friend, the American artist Phil Sims, whose work I had been collecting for some years and who had also been invited to take part in the exhibition. It was interesting to see monochrome paintings next to works by Perugino and Piero della Francesca. The differences were not as marked as you might imagine.

We chose fifty works for the Ducal Palace in Gubbio, and Phil Sims decided to make three pictures for one of the rooms. The architecture's best point is the courtyard constructed by Francesco di Giorgio Martini in 1475. I often think of Duke Federico da Montefeltro, one of the most cultured patrons of the Renaissance, and the occasions he left Urbino to visit one of his other cities. A five-year legal transfer was stipulated with the fine arts superinten-

dent in Perugia; it seemed a long period then but I see now that the time is almost up.

Another interesting possibility was beginning to develop. The project for the new museum in Rovereto was about to be completed. Dr. Gabriella Belli needed collaboration from collectors to fill the spaces of the new building. She knew the collection and also what I wanted, so of course I was receptive to a long-term legal transfer. The plan of the museum was by Mario Botta, an architect I knew and admired, and I wanted to see my pictures in the spaces he had created. As a kind of introduction to a longer collaboration he asked me to create a show in the ancient Palazzo delle Albere, which had been built at the end of the sixteenth century by the Bishop-Prince of Trent. I have always been fascinated by the idea of using ancient buildings for showing new art. The edifice still had the remains of antique frescoes—in some rooms they were almost intact. It was a great pleasure to make the best choices for each room while respecting its history.

The exhibition was inaugurated in 1996 when the company was beginning excavations for the new museum. Dr. Belli's great merit was to have convinced the Trent provincial council to make a huge investment in an undertaking that could be compared to the best of those abroad. Such cities as Milan, Rome, and Turin still do not have a museum like the one in Rovereto, despite their possibilities being greater.

There is another important consideration: Dr. Belli appreciated the art from the 'nineties that I had chosen from my collection, an art that has nothing to do with the Postmodernist trends of today. You must be quite free of prejudices to make choices other than those that please other people, and have the courage to go ahead with them. In contemporary art those who have suffered most have the final victory. Whoever believes in immediate fame will come off worst. We made a transfer lasting six years, until 2006, with seventy works of the highest quality: thirty must always be on show, and seventy for three months every two years. The opening was on December 14, 2002. Six years pass in a flash, and I hope we can organize a longer loan, as long as the choice of works is to the museum's liking.

In 1999 I received a call from Dr. Filippo Trevisani, the superintendent in Modena, who invited me to visit the Ducal Palace of Sassuolo, built by Francesco I d'Este in 1640. My wife and I were deeply struck by this visit. It was a magical place where imagination created form and poetry. It must have been a delicious place for the prince, and it was still delicious, a sublimely delicious place. Every room had walls and ceilings with frescoes in a multitude of colors, and if colors are the manifestation of the pleasure of living, then the result here was fully achieved: color filled everything. Aristocrats' palaces

are often oppressive with too much gold in order to humiliate their subjects. But in Sassuolo the palace was created by the prince for the prince. In one wing of the building there were seven rooms called the *appartamento stuccato*, the stucco-decorated apartment, which were adorned with high-relief stucco-work like sculptures, all white and on a white background, with gilded decorations. These were the most elegant rooms, both rich yet sober. This was the apartment of the duchess. Dr. Trevisani wanted to put on a series of shows of contemporary art and also devote a part of the building to the Panza Collection, on a lasting long-term loan. Various solutions were studied, but I was not convinced by the idea of placing sculpture in the center of painted rooms. These were perfectly empty, and emptiness is also fullness: the colors of the walls and ceilings filled them. They have no need of anything nor should their magic be disturbed. Even at the time of Francesco I d'Este the furnishing was reduced to the essentials: a few tables, some chairs and armchairs.

In the stucco apartment there were empty stucco frames as part of the decorations of the rooms. In 1640 there had been pictures by Guercino, Salvator Rosa, Jean Boulanger, and the Cittadini brothers, all since dispersed because of the political vicissitudes of the Este family: wars against imperialists, the French, the Spanish, and finally the unification of Italy in 1861.

To fill the empty frames it was necessary to have works of exactly the same size, which of course did not exist. The only answer was to ask seven artists to make pictures in the right dimensions. This was a considerable undertaking: fifty-one pictures, and all of them large. Since this was all for a museum, the dealers representing the artists relinquished their percentage. The artists involved were Sims, for the *Stanza della pittura*, the Painting Room; Spalletti for the *Stanza della magia*, the Magic Room; Simpson for the *Stanza della musica*, the Music Room; Roeth for the *Stanza delle fontane*, the Room of Fountains; Litzmann for the *Stanza dei sogni*, the Room of Dreams; Anne Appleby for the *Stanza di Fetonte*, Phaeton's Room, and Carroll for the *Stanza dei cavalla*, the Room of Horses.

The result completely satisfied me. The monochrome colors of these artists harmonized perfectly with the gold and white Baroque decorations. The rooms preceding the stucco apartment were full of the same colors, a progression through four hundred years: beauty is always truth. And its truth is its eternal youth. The best creations can live together with the most diverse ones. The enchantment pervading the palace has not been interrupted in the seven rooms but continues in a more pure, a more complete form. Since 2001 this is not just my impression but is shared by other visitors. This was confirmed for me by Dr. Trevisani and the enthusiastic and competent curator of the restoration work, Dr. Laura Bedini.

Another beautiful possibility was maturing in Verona, a city with a history and monuments testifying to two thousand years of civilization. In Verona there is a gallery of contemporary art, directed by Hélène de Franchis, which is one of the best in existence and exhibits the artists I collected in the 'nineties. Hélène has good relationships with the city and knew Giampiero Beltotto, the mayor's assistant for external relations.

The mayor of the city was Professor Michela Sironi-Mariotti who had already been mayor twice running and was a person admired for her administrative abilities. She wanted to give her fellow citizens the possibility of seeing the best creations of modern art, and the occasion offered itself with the restoration of a beautiful and imposing building belonging to the city council that, at the back, had a new congress center excellently planned by the architect Luigi Calcagni. This building, the Palazzo della Gran Guardia, which stands in front of the Roman arena, was built in the seventeenth century by a nephew of Sanmicheli and finalized in 1830. It had been built for civil ceremonies. There are five rooms on the first floor with ceilings eleven meters high. The stairway, constructed later on, is of monumental dimensions.

The mayor wanted a prestigious and long-term solution. In 2001 a ten-year legal transfer was arranged. Before the final installation, in the summer of 2001, the building hosted a show of American Minimalist sculpture from the Panza Collection in the Guggenheim. For the long-term installation it was necessary to choose the right works to fill walls eleven meters (36 ft.) tall. An unusual height. I know of no museums with such high walls. When Sims and Carroll saw the rooms assigned to them they proposed making pictures that would harmonically fill these huge dimensions. I found their proposals interesting and so decided to take on the extra costs for improving the aesthetic function of the setting, which being quite exceptional called for an equally exceptional involvement. Sims's proposal was to create twelve new large-scale paintings. A considerable cost even after a big discount.

Sims made me a generous proposal: to replace the new pictures with five *Stable Paintings* I had bought in 1994 for installation in the Biumo stables. The artist took back the five pictures but promised to donate them to FAI on the condition that it exhibited them for three months every two years. In this way the marvelous *Stable Paintings* returned to their definitive home. They are alternated with another extremely beautiful large sculpture by Martin Puryear, given by me to FAI, and with the two shows organized every year.

I believe I did the utmost to create an environment worthy of the quality of the building. Even those who do not understand or love new art must recognize that just the decorative function of the colors and forms is unquestionable. There could equally well be hung large sixteenth-century Flemish

tapestries, perhaps even based on designs by Rubens, which, however, the city of Verona does not own and cannot purchase. I do not know what other living artists could create equally valid pictures from a decorative point of view, quite apart from any considerations of artistic quality. Schnabel and Kiefer have made large-scale pictures, but I don't think their decorative result is any better.

Unfortunately the installation was carried out in a period of transition, during the elections, with an outgoing city government that could not make decisions and a new one that didn't yet exist. Discussion for the assignment of administrative posts always takes a long time. Let's hope not too long. Now, in the month of August 2003, it still has not been opened to the public, thus completing the program for showing the collection in historical monuments in Italy. This is a marvelous occasion for those who, like me, believe that real art is part of the Whole, a superior order: beauty is the proof of its existence. I am grateful to the ministers Veltroni and Melandri, to the mayor of Verona, Professor Sironi Mariotti, to the superintendents, and to the other officials of the ministry of culture for the possibility of exhibiting the collection of works from the 'nineties in Italy. I hope that the loans installed in public buildings may become permanent.

As an Italian indissolubly linked to its centuries-long culture I feel the need for recent art, chosen from the best artists active today, to give a permanent contribution to the diffusion of culture.

A part of the collection featuring artists from the 'sixties up to the present day is placed permanently in my Biumo house donated to FAI: I also hope that the fifty-one works on loan in the seven stucco rooms in the Sassuolo Ducal Palace might become a permanent presence as the result of a donation.

Sadly the loan of the fifty works of art in the Gubbio Ducal Palace cannot be renewed. The town council wants to replace them with works it already owns. But as experience has shown, time works in favor of the artists in the Panza Collection. Names that were little known and therefore little appreciated have, over the years, become the protagonists of a period in the history of culture and are now in important museums, even though they are foreign ones.

I consider myself lucky that throughout my life I have always had the possibility to do things that take a long time, even though my life is near its end and I will never see the conclusion of this program. I am leaving this task to my children and am certain they will bring it about in the best possible way.

My relations with the Getty go back almost twenty years, long before the opening of the present imposing group of buildings devoted to visual art. I met the president, Harold Williams, about halfway through the 'eighties, having been introduced by the director of MoCA, Richard Koshalek. We had a friendly talk and, knowing fairly well the history of the collection, he said that the Getty would be interested in having the archive. He was about to begin construction of the new center, but the collecting of documents was already well underway. Thanks to my friend Popi Chiesa, the antiquarian dealing in renaissance books who had contacts with the Getty's chief librarian, I had the luck to meet a fine person and friend, Mel Edelstein, with whom I have always had excellent relations. He came to Milan on many occasions when the archive was still in Corso di Porta Romana, and his assistants carefully examined it. Thanks to the people who had kept it in order—my daughter Giuseppina, my daughter-in-law Francesca, and Cristiana Caccia—this examination of the documents was easy and quick.

At the start of the collection I had not given much thought to the papers: I bought artists who were more or less unknown but who my wife, myself, and a few others liked when it was impossible to know what their future would be. Luckily I soon realized things might change, even in the distant future, and the papers could be of interest, also because instinctively I tend to keep hold of past memories.

Unfortunately my friend Mel Edelstein retired, and shortly afterward he died—much too soon. He was a person of great learning and humanity. It was fascinating to go every so often to visit the center's building site, an imposing undertaking. I do not believe that ever in the history of culture was such a great capital investment made in such a short period. Mr. Getty must have been a very intelligent person, not only because he had made such a fortune, something that does not happen by chance, but also because he knew how to link his name to a program known throughout the world and for having given an important contribution to the spread of education. In order to have a good society it is necessary to have good citizens; goodness is absorbed together with the beautiful, which is goodness's visible image. Of course we must care for the ill and help the poor, but to help the spirit and contribute to the formation of conscience is far more important. I think that the money spent for education and art, which is its most accessible message, is the best way of using it. A contract was quickly arrived at. But when the time came to send it, something amazing happened in Italy. I didn't know the law on ar-

chives now subjected even contemporary ones to a veto on exportation, even if they were less than fifty years' old, as is the case for contemporary art.

When the exportation documents dealing with archives are presented to the customs they ask the advice of the relevant state superintendent who, in turn, asks the views of the ministry of culture in Rome who then asks the views of the ministerial commission for archives who then decides if the Panza Archive is to be considered of national interest and thus forbidden to be exported. For the commission it was of no significance that the archive was exclusively about American and foreign art that was to be found wholly in two American museums, the Los Angeles MoCA and the New York Guggenheim. All irrelevant conditions since the owner is resident in Italy, and so the law must be applied. A complete absurdity, but that is how Italian laws are: what counts is the form not the substance.

This was an event that deeply wounded me. It is an elementary right to dispose freely of your own memories by choosing the institution best adapted to conserving them and making them known. In that moment I decided to leave a country with such uncivil laws. You cannot repress freedom and cultural life. This was in the spring of 1991, and I began at once the documentation for a move to Switzerland where freedom is protected and is considered a basic right for society and the state. Obviously the notification about the archive had been considered a scandal by the Getty and by those museums that owned the works of art.

The Getty at once started a legal action against the ministry, but many people told me this was useless as the law could not be changed. But three years later the miracle occurred when a new ministerial committee took another look at the legislation. Respect for the heritage of American culture had been offended. The ministry repealed the law, and at last the archive left for America where, they tell me, it is being studied by many interested people. It was just as well that all this had occurred; I was forced to move to a free country together with my collection, which is no longer subject to a suffocating bureaucracy that slows down or stops transfers to foreign museums.

The Panza Archive is now in one of the buildings constructed by Richard Meier, a marvelous cultural acropolis that dominates Los Angeles from the top of a hill.

Twentieth-century art is characterized by a strong ideal involvement that becomes concrete in a different way from political ideology. The twentieth century has also been the century of opposed political ideologies, Fascist and Nazi nationalism, against Marxism, and democratic idealism against both. Art has always been above political ideologies, even when certain artists participate in them. Most of them have been democrats against any kind of dictatorship. The characteristic of the twentieth century is intense research activity that has led us to new possibilities for knowledge and personal expression. Modernism was the name coined for this behavior.

In order to understand Modernism we must understand its beginnings rooted in the second half of the nineteenth century, in 1863, when Manet and Monet painted the first Impressionist paintings. This was the discovery of color, a vision of the beauty of nature that is identified with color, the transformation of daily life into an effulgent living reality. This was the reverse of the dominant positivist philosophy of the time, which imprisoned any creative impulse within the limits of the visible and the useful. This was a period of unpredictable changes: the railroads were spreading all over the world, the discovery of microbes greatly reduced the death rate and increased the birthrate, the synthesizing of urea doubled agricultural production in a short time, science and its uses changed the world.

In the 'eighties of the nineteenth century Post-Impressionism opened the road to new expressive possibilities: Seurat broke light down into its component colors; Van Gogh used color to represent emotional violence in his desperate search for an unreachable happiness; Gauguin painted compact masses of color looking for the impossible purity of far-off exotic countries uncontaminated by Western culture; Cézanne created volumes in his search for a theoretical primordial form, thus beginning the breakdown of millennial expressive systems.

Cubism and Fauvism were the basis of a revolution and offered new freedom and new expressive possibilities by abandoning the usual representation of what we see. The abstract art of Mondrian and Kandinsky freed art from the imitation of what is visible in order to establish an immediate relationship between thought, emotion, and expression. This was the beginning of a new era with unlimited evolutionary possibilities. It was the beginning of a new history of art and culture that ran parallel to the discovery of the atom through the use of instruments that allowed an indirect knowledge of a universe that was too small to be seen. It was the search for the energies governing the universe, the creation of tools for changing life and information.

In the second decade of this century the Metaphysical art of de Chirico and later Surrealism allowed the possibility of knowing the unseen causes of our instincts, of exploring a reality that had been ignored. A parallel progress to philosophies that examined Being.

After 1945 American Abstract Expressionism articulated all the vital energy that lies at the heart of personality in a society wishing to build a different future.

European "Informal" art meditated on the collapse of so many philosophies as a result of the disasters of two world wars and searched for values that might permit a rebirth.

At the beginning of the 'sixties, Pop Art rejoiced in the end of the Atomic menace and the spread of the well-being resulting from an efficient economy. Immediately after, American Minimalism examined the primary structures of the power of thought and the beauty of the greatest asset nature has given to man. At the end of the 'sixties Conceptual Art examined the links between thought, expression, and representation by examining the philosophy of language. For the first time a philosophical idea was shown by images understandable intuitively. In the same period in Los Angeles Environmental Art was developed in which the elements are immaterial: light and space. The viewers become the protagonists and are forced to question themselves about just what they are. The deserts of western America are a setting in which a different dimension of existence can be experimented. Toward the end of the 'seventies the beginning of a new history for the West and for the world arrived: the implosion of Marxist systems in Russia and China. This was the most serious ideological crisis of the past two hundred years. The collapse of this system pulled down with it the Utopia that had fed, like a religion, the minds of so many people. It was a reason for existing that suddenly disappeared. The repercussions of this crisis have been widespread and devastating. A reference point for all those without solid hopes has vanished: one for all and all for one should be the basic principle of society. The New Testament asks it of us. Just as important is the principle that we, and only we, are responsible for our own choices and actions; we cannot delegate them to other authorities for that would repress individual conscience, but the abolition of agreement is repression. This is the contradiction in which we are obliged to live; it is something that cannot be resolved by law but only by our free understanding. Free agreement becomes difficult if we do not believe that a universally valid convergence point exists. If we lose this point of convergence then we fall into chaos, we do not know where to go and what is immediately useful, and personal interest becomes the only certainty. In the past the choice of what was immediately useful was the most widely made; now it has become

the choice even of those who once believed in the reverse. Most successful art today, an art also promoted by many museums, reflects this crisis.

Obviously all this has been a summary and I have not spoken of other movements such as Symbolism and the Magic Realism of the 'twenties. I have not mentioned the developments of Modernism in the 'nineties, the vital color and forms that are in complete contradiction to their opposite, what has been erroneously defined Post-Modernism. Its exact definition is Anti-Modernism. The dominant philosophy today is Weak Thought, which holds that it is useless to search for truth, but if you lose hold of truth you also lose art as an inevitable consequence. Time, as always, will be the implacable judge.

I have arrived at the age of eighty after almost fifty years of activity with art. This is certainly the time to conclude and make some reflections on the events of a, by now, very long life. I don't know how long it will last, certainly not for much longer.

Statistics say that we die between seventy-seven and eighty-two years of age, and I am more than halfway through that range. This is not something that bothers me: it is an inevitable event that must be faced with serenity, as happened some five years ago when the doctors discovered I was suffering from an abdominal aneurysm. Had they not operated straight away I would have died within four minutes. I am very lucky to be still alive and in good health, with a brain that still works today as I write these thoughts. Perhaps it will soon not be possible. Looking back may be necessary for someone who has always looked forward and never behind. Weighing up the past can be interesting, but nothing other than interesting: obviously the past cannot be changed and there is no future to make up for mistakes. What has happened has happened forever; time will make it disappear, and only a few things will be saved from the erosion of the years. And this is the big question: what will be saved? My wife and I have created five children and seven grandchildren who are growing up. The future is theirs, and they can pass it on in turn. Procreation and birth are a gift of nature, the most precious gift. How many of my actions, choices, and decisions, for all of which I alone am responsible, are worthy of continuing to exist after my death? I have always thought of the future when making my artistic choices, never of the present and not even of the future but, rather, of something distant in time and unpredictable, completely uncertain but to be hoped for. My wife and I were certain we made choices that were good, fully experienced, and loved. When we love without asking anything in exchange then it is difficult to make mistakes. The only unit of measure is the goodness, or otherwise, of our own actions and the judgment others make after thirty, forty, fifty years. The more that positive judgments are extended in time, the more probable it is that they might become permanent. This is not only a question of individual judgments but also of those bodies representing the community with regard to art.

The choices we made in the 'fifties and 'sixties are almost all permanently in museums. There will be periods of greater or less interest in this art. I think I have established that the culture these works represent is part of the twentieth century. The works of art we bought were rejected and despised, but now they are enjoyed by an ever greater number of people who love and understand the ideal message they embody. Even the larger part of the works from

the early 'seventies have a definitive public collocation. It is not yet possible to know what will happen for the works from the 'eighties and 'nineties, and this is only a question of personal faith and hope. The constant vision of art I have gained over the past fifty years feeds and renews this hope. Only a continuous relationship with each work of art renews and confirms it. Fifteen years are enough to develop an intimate certainty. An experience that has lasted fifty years is a confirmation of an ability to make judgments, confirmed by objectively valid proofs gained from widespread and qualified acknowledgment.

The 'eighties and 'nineties were a difficult period for an art corresponding to our ideal demands since it had to make its way against a hostile or indifferent background, and living, as we were, in a society that in part had aims opposed to ours. Despite this, we are sure that the search for good will prevail over that for destruction. A different understanding of our actions over the past fifteen years will be matured in time.

My wife and I believe that just as fifty, forty, and thirty years ago rejection was replaced by acceptance, so it will happen in the future, even though the evolution will be slower. The recent works need a long time to develop public interest. Evidently fifteen years are not enough; perhaps another twenty will be needed. We will not be here for much longer, and so we have handed on to our children the task of finding a way to make public the greater part of the collection. This is a distant objective and needs complete agreement to reach it, and to accept the necessary financial sacrifices, though without damaging their legitimate interests.

I trust in the good will of my successors and also that they will know how to involve their own families. My wife and I believe we have done what we could to accomplish aims going beyond our personal interests. We hope that the ideal values we have always believed in might continue to live on in them and their families. Likewise, their grandchildren and great-grandchildren will have this responsibility that, with the passing of time, could become very difficult. Those who put their faith in beauty will be generously repaid. This is how it has been for us, and how it will be for our descendents. All that is necessary is to wait in the hope that comes spontaneously when you love the things that merit being loved.

When reading over the interpretations I have written I realize that I see similarities between different artists. I do not think I have superimposed my ideas over those of the artists. I have always tried to avoid this danger. Perhaps there is another reason to be found in the artists, in their conscience. The interpreter's work is to understand what is implicit and hidden, not immediately visible. Much criticism is concerned with external facts, things that are added on. But only primary things are really important. There is a kind

of timidity about examining the real motive, which is not visible but hidden in the conscience of each individual. This invisible nucleus is the heart of art, the only thing that allows it to exist, and if it is not there then neither is art. Each nucleus is individual and different from the others. Given that it is basic it has common affinities. The principle of "less is more" is more than ever relevant here. Scientists are working ceaselessly to find some mathematical formula that can explain Everything: they never find it but they keep looking. The more knowledge they gain, the more the need for this research increases; the increase in knowledge gives the impression or illusion of arriving at the threshold of Everything, which ought to be the extreme limit of "less is more."

Science's way of proceeding is similar to artists' search for their own personality, which determines the birth of their art and which, by taking on a form, is enriched by other elements that then make it even more different from other personalities. I believe that a part of the critics' fear of getting to the heart of the question depends on their unwillingness to assume a precise ideological identity; this is always a commitment and imposes choices that force us to choose one side or another: it is difficult to hover halfway as the risk is then to remain on the surface. This refusal to make a choice then has to be covered with convoluted words in which it is difficult to discover the meaning. I believe in God and all that derives from this. This is why I am basically an optimist. Even though I can be pessimistic about some things I never am about the final destination, even if the reality everyone experiences seems to deny this.

I think these are the terms art should be considered in, as this is also the way to understand mankind. We may be more or less distant from this reality, but the distance inevitably weighs on our conscience. Experiencing distance creates pain, but this pain can be the source of great art. Many do not experience this distance: they are not alive and are not good artists.

I.
Villa Menafoglio Litta Panza, Varese, 1996
Rosa Giovanna and Giuseppe Panza di Biumo
Photograph: Giorgio Colombo, Milan

PHIL SIMS (1940–)
*Stable Paintings (cat. # 259, # 260, # 261, # 262,
263), 1995*
Oil on linen, 144 × 111 in. (3.7 × 2.8 m) each
FAI, Fondo per l'Ambiente Italiano; artist's
gift 2002

2. and 3.
Villa Menafoglio Litta Panza, Varese, 2001
FAI, Fondo per l'Ambiente Italiano
Photograph: Giorgio Colombo, Milan

4.
*The Legacy of a Collector: The Panza di Biumo
Collection at the Museum of Contemporary Art,*
MoCA, The Museum of Contemporary Art,
Los Angeles, December 12, 1999–April 30, 2000
Photograph: Brian Forrest, Los Angeles

ANTONI TÀPIES (1923–)
Grey with Red Sign, 1958
Mixed media on canvas, 57½ × 35 in.
(146 × 88.9 cm)
MoCA, The Museum of Contemporary Art,
Los Angeles; Panza Collection

Grey and Black Cross, 1955
Mixed media on canvas, 57½ × 44½ in.
(146 × 114.3 cm)
MoCA, The Museum of Contemporary Art,
Los Angeles; Panza Collection

Ochre-Sand, 1957
Mixed media on canvas, 76¾ × 51 in.
(195 × 129.5 cm)
MoCA, The Museum of Contemporary Art,
Los Angeles; Panza Collection

Blackish Ochre with Perforations, 1957
Mixed media on canvas, 57½ × 45 in.
(145.2 × 114.3 cm)
MoCA, The Museum of Contemporary Art,
Los Angeles; Panza Collection

All White, 1955
Mixed media on canvas, 57½ × 38 in.
(146 × 97 cm)
MoCA, The Museum of Contemporary Art,
Los Angeles; Panza Collection

5.
*The Legacy of a Collector: The Panza di Biumo
Collection at the Museum of Contemporary Art,*
MoCA, The Museum of Contemporary Art,
Los Angeles, December 12, 1999–April 30, 2000
Photograph: Brian Forrest, Los Angeles

FRANZ KLINE (1910–1962)
Monitor, 1956
Oil on canvas, 78¾ × 115¾ in. (200 × 294 cm)
MoCA, The Museum of Contemporary Art,
Los Angeles; Panza Collection

Black Iris, 1961
Oil on canvas, 108¼ × 79½ in.
(275 × 202 cm)
MoCA, The Museum of Contemporary Art,
Los Angeles; Panza Collection

6.
*The Legacy of a Collector: The Panza di Biumo
Collection at the Museum of Contemporary Art,*
MoCA, The Museum of Contemporary Art,
Los Angeles, December 12, 1999–April 30, 2000
Photograph: Brian Forrest, Los Angeles

MARK ROTHKO (1903–1970)
Purple Brown, 1957
Oil on canvas, 84 × 72¼ in. (213.3 × 182.8 cm)
MoCA, The Museum of Contemporary Art,
Los Angeles; Panza Collection

Violet and Yellow on Rose, 1954
Oil on canvas, 83½ × 67¾ in. (212 × 172 cm)
MoCA, The Museum of Contemporary Art,
Los Angeles; Panza Collection

Black and Dark Sienna on Purple, 1960
Oil on canvas, 119¼ × 105 in.
(302.9 × 266.7 cm)
MoCA, The Museum of Contemporary Art,
Los Angeles; Panza Collection

Red and Blue over Red, 1959
Oil on canvas, 93 × 82¼ in. (236.2 × 205.1 cm)
MoCA, The Museum of Contemporary Art,
Los Angeles; Panza Collection

7.
*The Legacy of a Collector: The Panza di Biumo
Collection at the Museum of Contemporary Art,*
MoCA, The Museum of Contemporary Art,
Los Angeles, December 12, 1999–April 30, 2000
Photograph: Brian Forrest, Los Angeles

ROY LICHTENSTEIN (1923–1997)
Desk Calendar, 1962
Oil on canvas, 48½ × 70 in. (123.1 × 172.7 cm)
MoCA, The Museum of Contemporary Art,
Los Angeles; Panza Collection

The Grip, 1962
Oil on canvas, 30 × 30¼ in. (76.2 × 76.8 cm)
MoCA, The Museum of Contemporary Art,
Los Angeles; Panza Collection

JEAN FAUTRIER (1898–1964)
Dépouille, 1946
Mixed media on paper mounted on linen,
45 × 57 in. (96 × 146 cm)
MoCA, The Museum of Contemporary Art,
Los Angeles; Panza Collection

Nu, 1943
Oil on paper, 21½ × 15 in. (55 × 38 cm)
MoCA, The Museum of Contemporary Art,
Los Angeles; Panza Collection

8.
*The Legacy of a Collector: The Panza di Biumo
Collection at the Museum of Contemporary Art,*
MoCA, The Museum of Contemporary Art,
Los Angeles, December 12, 1999–April 30, 2000
Photograph: Brian Forrest, Los Angeles

MARK ROTHKO (1903–1970)
Red and Blue over Red, 1959
Oil on canvas, 93 × 82¼ in. (236.2 × 205.1 cm)
MoCA, The Museum of Contemporary Art,
Los Angeles; Panza Collection

FRANZ KLINE (1910–1962)
Monitor, 1956
Oil on canvas, 78¾ × 115¾ in. (200 × 294 cm)

MoCA, The Museum of Contemporary Art,
Los Angeles; Panza Collection

9.
*The Legacy of a Collector: The Panza di Biumo
Collection at the Museum of Contemporary Art,*
MoCA, The Museum of Contemporary Art,
Los Angeles, December 12, 1999–April 30, 2000
Photograph: Brian Forrest, Los Angeles

ROBERT RAUSCHENBERG (1925–)
Kickback, 1959
Combine painting, 76½ × 33¼ in.
(190.5 × 81.2 cm)
MoCA, The Museum of Contemporary Art,
Los Angeles; Panza Collection

Untitled Combine, 1955
Combine painting, 86½ × 37 × 26¼ in.
(219.7 × 93.9 × 66.6 cm)
MoCA, The Museum of Contemporary Art,
Los Angeles; Panza Collection

Inlet, 1959
Combine painting, 84½ × 48 in.
(214.6 × 123.1 cm)
MoCA, The Museum of Contemporary Art,
Los Angeles; Panza Collection

10.
*The Legacy of a Collector: The Panza di Biumo
Collection at the Museum of Contemporary Art,*
MoCA, The Museum of Contemporary Art,
Los Angeles, December 12, 1999–April 30, 2000
Photograph: Brian Forrest, Los Angeles

CLAES OLDENBURG (1929–)
Tennis Shoes, 1962
Enamel on plaster, 24 × 24 × 10 in.
(61 × 61 × 25.4 cm)
MoCA, The Museum of Contemporary Art,
Los Angeles; Panza Collection

Fragment of Candies in a Box, 1961
Enamel on plaster, 44 × 32 × 6 in.
(112 × 81 × 15 cm)
MoCA, The Museum of Contemporary Art,
Los Angeles; Panza Collection

A Brown Shoe, 1961
Enamel on plaster, 23½ × 43¼ × 5 in.

(60 × 110 × 12.7 cm)
MoCA, The Museum of Contemporary Art,
Los Angeles; Panza Collection

Breakfast Table, 1962
Enamel on plaster and wood,
34½ × 35½ × 34½ in. (87.6 × 90 × 87.6 cm)
MoCA, The Museum of Contemporary Art,
Los Angeles; Panza Collection

Pentecostal Cross, 1961
Enamel on plaster, 52¾ × 40½ × 6 in.
(134 × 103 × 15 cm)
MoCA, The Museum of Contemporary Art,
Los Angeles; Panza Collection

11.
*The Legacy of a Collector: The Panza di Biumo
Collection at the Museum of Contemporary Art,*
MoCA, The Museum of Contemporary Art,
Los Angeles, December 12, 1999–April 30, 2000
Photograph: Brian Forrest, Los Angeles

JAMES ROSENQUIST (1933–)
A Lot to Like, 1962
Oil on canvas, 84 × 204 in. (2.4 × 5.2 m)
MoCA, The Museum of Contemporary Art,
Los Angeles; Panza Collection

Shave, 1964
Oil on canvas, 58 × 50 in. (148 × 128.2 cm)
MoCA, The Museum of Contemporary Art,
Los Angeles; Panza Collection

12.
*The Legacy of a Collector: The Panza di Biumo
Collection at the Museum of Contemporary Art,*
MoCA, The Museum of Contemporary Art,
Los Angeles, December 12, 1999–April 30, 2000
Photograph: Brian Forrest, Los Angeles

GEORGE SEGAL (1924–2000)
Man in the Armchair, 1969
Plaster and wood, 49½ × 30 × 31½ in.
(125.7 × 76.2 × 80 cm)
MoCA, The Museum of Contemporary Art,
Los Angeles; Panza Collection

Sunbathers on the Roof Top, 1963–67
Plaster and mixed media, 33 × 144 × 96 in.
(0.9 × 3.6 × 2.4 m)

MoCA, The Museum of Contemporary Art,
Los Angeles; Panza Collection

13.
Arte Minimal de la Colección Panza, Centro
de Arte Reina Sofia, Madrid, March 24–
December 31, 1988
Photograph: Giorgio Colombo, Milan

DAN FLAVIN (1933–1996)
*An Artificial Barrier of Blue, Red and Blue
Fluorescent Light (to Flavin Starbuck Judd),* 1968
Blue and red fluorescent light, two ft. and
four ft. fixtures, 27 × 555 × 12 in.
(0.6 × 14.1 × 0.3 m)
The Solomon R. Guggenheim Foundation,
New York; Panza Collection

14.
*The Guggenheim Museums and the Art of this
Century,* Museo Guggenheim, Bilbao,
October 19, 1997–June 1, 1998
Photograph: Erica Barahona, Bilbao

ROBERT MORRIS (1931–)
Philadelphia Labyrinth, 1974
Gray painted mdf plywood, 96 × 360 × 360 in.
(2.4 × 9.1 × 9.1 m)
The Solomon R. Guggenheim Foundation,
New York; Panza Collection

LAWRENCE WEINER (1942–)
Reduced, Cat. No. 102, 1970
Panza Collection

CARL ANDRE (1935–)
Reef, 1966
Eighty orange styrofoam planks lengthwise
from the wall, 21 × 801 × 108 in.
(0.5 × 20.3 × 2.7 m) overall
The Solomon R. Guggenheim Foundation,
New York; Panza Collection

RICHARD SERRA (1939–)
Snake, 1994–97
Three serpentine ribbons of hot-rolled steel,
site specific
Guggenheim Bilbao Collection

15.
La Percezione dello Spazio Arte Minimal della

Collezione Panza dal Guggenheim di New York,
Palazzo della Gran Guardia, Verona, June 29–
November 18, 2001
Photo: Giorgio Colombo, Milan

ROBERT MORRIS (1931–)
Untitled (16 steel boxes), 1967
Sixteen open top steel boxes, 36 × 36 × 36 in.
(91.4 × 91.4 × 91.4 cm) each, 36 × 252 × 252 in.
(0.9 × 6.4 × 6.4 m) overall
The Solomon R. Guggenheim Foundation,
New York; Panza Collection

16.
Arte Minimal de la Colección Panza, Centro
de Arte Reina Sofia, Madrid, March 24–
December 31, 1988
Photograph: Giorgio Colombo, Milan

DONALD JUDD (1928–1994)
Eight Hot Rolled Steel Boxes, 1974
Hot-rolled steel, eight units, 60 × 60 × 60 in.
(152.4 × 152.4 × 152.4 cm) each
The Solomon R. Guggenheim Foundation,
New York; Panza Collection

17.
Arte Minimal de la Colección Panza, Centro
de Arte Reina Sofia, Madrid, March 24–
December 31, 1988
Photograph: Giorgio Colombo, Milan

CARL ANDRE (1935–)
Copper Square, 1973
One hundred copper plates, 3/16 × 19¾ × 19¾ in.
(0.5 × 50 × 50 cm) each, 3/16 in. × 192 in. × 192 in.
(0.5 cm × 5 m × 5 m) overall
The Solomon R. Guggenheim Foundation,
New York; Panza Collection

18.
Villa Menafoglio Litta Panza, Varese, 1977
Photograph: Giorgio Colombo, Milan

BRUCE NAUMAN (1941–)
Live-Taped Video Corridor, 1969–70
Wallboard, camera, videotape and two moni-
tors, 12 × 32 × 1¾ in. (3.7 × 9.8 × 0.5 m)
The Solomon R. Guggenheim
Foundation, New York; Panza Collection,
gift 1992

Performance Corridor, 1968–70
Wallboard, 96 × 240 × 21 in. (2.4 × 6.1 × 0.5 m)
The Solomon R. Guggenheim Foundation,
New York; Panza Collection, gift 1992

ROBERT BARRY (1936–)
It Is and It Can Be, 1971–72
Eighty slides, forty with text and forty blank
Panza Collection

BRUCE NAUMAN (1941–)
Green Light Corridor, 1970
Wallboard and green fluorescent light,
120 × 480 × 12 in. (3 × 12.2 × 0.3 m)
The Solomon R. Guggenheim Foundation,
New York; Panza Collection, gift 1992

19.
*Percepciones en transformación La Colección Panza
del Museo Guggenheim,* Museo Guggenheim,
Bilbao, November 16, 2000–February 14,
2001
Photograph: Erica Barahona, Bilbao

RICHARD SERRA (1939–)
Strike (to Roberta and Rudy), 1969–71
Hot-rolled steel on edge, 96 × 288 × ⅝ in.
(2.4 m × 7.3 m × 1.5 cm)
The Solomon R. Guggenheim Foundation,
New York; Panza Collection

20.
*Minimal+Conceptual Art aus der Sammlung
Panza,* Museum für Gegenwartskunst, Basel,
November 9, 1980–June 28, 1981
Photograph: Giorgio Colombo, Milan

ROBERT RYMAN (1930–)
Standard Nos. 1-2-3-4-5-6-8-9-10-11-12-13, 1967
Enamel on steel, twelve panels, 48 × 48 in.
(121.9 × 121.9 cm) each
The Solomon R. Guggenheim Foundation,
New York; Panza Collection

Zenith, 1971
Oil on wood, 96 × 144 in. (2.4 × 3.7 m)
The Solomon R. Guggenheim Foundation,
New York; Panza Collection

Four Units, 1969
Enamelac on corrugated paper, 121 × 120 in.

(307.3 × 304.8 cm)
The Solomon R. Guggenheim Foundation,
New York; Panza Collection

Three Units (nos. 1-2-3), 1969
Enamelac on corrugated paper, three panels,
60 × 60 in. (152.4 × 152.4 cm) each
The Solomon R. Guggenheim Foundation,
New York; Panza Collection

Five Units (nos. 1-2-3-4-5), 1969
Enamelac on corrugated paper, five panels,
60 × 60 in. (152.4 × 152.4 cm) each
The Solomon R. Guggenheim Foundation,
New York; Panza Collection

21.
*Percepciones en transformación La Colección Panza
del Museo Guggenheim,* Museo Guggenheim,
Bilbao, November 16, 2000-February 14,
2001
Photograph: Erica Barahona, Bilbao

BRICE MARDEN (1938-)
To May Madness, 1972
Oil and wax on canvas, two panels, 72 × 72 in.
(182.9 × 182.9 cm) overall
Panza Collection

Untitled, 1973
Oil and wax on canvas, two panels, 72 × 72 in.
(182.9 × 183.2 cm) overall
The Solomon R. Guggenheim Foundation,
New York; Panza Collection

Passage, 1973-74
Oil and wax on canvas, three panels,
74 × 72 in. (188 × 182.9 cm) overall
Panza Collection

Private Title, 1966
Oil and wax on canvas, 48 × 96 in.
(121.3 × 243.2 cm)
The Solomon R. Guggenheim Foundation,
New York; Panza Collection

22.
*Minimal+Conceptual Art aus der Sammlung
Panza,* Museum für Gegenwartskunst, Basel,
November 9, 1980-June 28, 1981
Photograph: Giorgio Colombo, Milan

Robert Mangold (1937-)
Circle Painting 3 (Green-gray), 1973
Acrylic on canvas, 72 × 72 in. (182.8 × 182.8 cm)
The Solomon R. Guggenheim Foundation,
New York; Panza Collection

Circle Painting 1 (Yellow), 1972
Acrylic on canvas, 72 × 72 in. (182.8 × 182.8 cm)
The Solomon R. Guggenheim Foundation,
New York; Panza Collection

23.
Photograph: Giorgio Colombo, Milan, 2003

JOSEPH BEUYS (1921-1986)
Untitled, 1961
Plastic pail with mixed media, 10 × 8½ × 8½ in.
(25.5 × 21.5 × 21.5 cm)
Panza Collection

24.
Villa Menafoglio Litta Panza, Varese, 1981
Photograph: Giorgio Colombo, Milan

SOL LeWITT (1928-2007)
Wall Drawing no. 146, 1972
All two-part combination of blue arcs from
corners and sides and blue straight, not
straight, and broken lines, blue crayon
The Solomon R. Guggenheim Foundation,
New York; Panza Collection, gift 1992

25.
*Percepciones en transformación La Colección Panza
del Museo Guggenheim,* Museo Guggenheim,
Bilbao, November 16, 2000-February 14,
2001
Photograph: Erica Barahona, Bilbao

JOSEPH KOSUTH (1945-)
Titled (Art as Idea as Idea), 1966
Definition of paint in a set of eight parts
printed on paper on aluminum,
47½ × 47½ × ⅛ in. (120 × 120 × 0.2 cm) each
Panza Collection

Titled (Art as Idea as Idea), 1967
Definition of ultimate [English] printed
on paper on wood framed cardboard,
57 × 57 × 2½ in. (145 × 145 × 6 cm)
Panza Collection

Box, Cube, Empty, Clear, Glass—A Description, 1965
Five glass cubes with black lettering,
40 × 40 × 40 in. (101.6 × 101.6 × 101.6 cm) each
Panza Collection

26.
*La Percezione dello Spazio Arte Minimal della
Collezione Panza dal Guggenheim di New York*,
Palazzo della Gran Guardia, Verona,
June 29–November 18, 2001
Photo: Giorgio Colombo, Milan

ROBERT MORRIS (1931–)
Untitled (Aluminum I-beams), 1967
Aluminum, 66 × 306 × 402 in. (1.7 × 7.8 × 10.2 m)
The Solomon R. Guggenheim Foundation,
New York; Panza Collection

27.
*La Collezione Panza di Biumo Artisti degli Anni
'80–'90*, Soprintendenza per i Beni Ambientali
Architettonici Artistici e Storici dell'
Umbria, Museo del Palazzo Ducale di
Gubbio, December 5, 1998–December 4, 2003
Photograph: Giorgio Colombo, Milan

PHIL SIMS (1940–)
Gubbio Painting Blue (cat. # 317), 1997
Oil on linen, 144 × 84 in. (3.7 × 2.1 m)
Panza Collection

STUART ARENDS (1950–)
Untitled (Red), 1991
Oil, wax, wood, 3½ × 3½ × 3½ in.
(8.8 × 8.8 × 8.2 cm)
Panza Collection

Untitled (Yellow), 1991
Oil, wax, wood, 3½ × 3½ × 3½ in.
(8.8 × 8.8 × 8.2 cm)
Panza Collection

Untitled (Green), 1991
Oil, wax, wood, 3½ × 3½ × 3½ in.
(8.8 × 8.8 × 8.2 cm)
Panza Collection

Untitled (Blue), 1991
Oil, wax, wood, 3½ × 3½ × 3½ in.
(8.8 × 8.8 × 8.2 cm)
Panza Collection

28.
Villa Menafoglio Litta Panza, Varese, 2000
Photograph: Giorgio Colombo, Milan

PHIL SIMS (1940–)
Untitled (cat. # 143), 1993
Oil on linen, 100 × 100 in. (254 × 254 cm)
FAI, Fondo per l'Ambiente Italiano; Panza
Collection, gift 1996

29.
Villa Menafoglio Litta Panza, Varese, 1981
Photograph: Giorgio Colombo, Milan

LAWRENCE WEINER (1942–)
*Earth To Earth Ashes To Ashes Dust To Dust,
Cat. No. 151*, 1970
The Solomon R. Guggenheim Foundation,
New York; Panza Collection, gift 1992

30.
Villa Menafoglio Litta Panza, Varese, 1977
Photograph: Giorgio Colombo, Milan

DOUGLAS HUEBLER (1924–1997)
*Location Piece no. 1, New York – Los Angeles,
February 1969*, 1969
Statement [thirteen states airspace]:
16 × 13¼ × 1¼ in. (40.5 × 34 × 3 cm), map:
16 × 27½ × 1¼ in. (40.5 × 70 × 3 cm), thirteen
photographs: 12¼ × 14 × 1¼ in.
(31 × 36 × 3 cm) each
Panza Collection

Duration Piece no. 4, Paris, France, January 1970,
1970
Statement [one half previous time]:
16 × 13¼ × 1¼ in. (41 × 34 × 3 cm), twelve photo-
graphs: 12¼ × 14 × 1¼ in. (31 × 36 × 3 cm) each
The Solomon R. Guggenheim Foundation,
New York; Panza Collection, gift 1992

31.
*Percepciones en transformación La Colección Panza
del Museo Guggenheim*, Museo Guggenheim,
Bilbao, November 16, 2000–February 14, 2001
Photograph: Erica Barahona, Bilbao

HANNE DARBOVEN (1941–)
00→99=No 1→2K→20K, 1969–70
Pen on paper, 139 sheets, 11½ × 8¼ in.

(29.5 × 21 cm) each
Panza Collection

27K – No. 8 – No. 26, 1968–69
Typewritten on paper, 149 sheets, 11½ × 8¼ in.
(29.5 × 21 cm) each
Panza Collection

32.
Villa Menafoglio Litta Panza, Varese, 1977
Photograph: Giorgio Colombo, Milan

LARRY BELL (1939–)
Light Brown Box, 1968
Coated glass, 20 × 20 × 20 in. (51 × 51 × 51 cm)
Panza Collection

33.
Arte Minimal de la Colección Panza, Centro
de Arte Reina Sofia, Madrid, March 24–
December 31, 1988
Photograph: Giorgio Colombo, Milan

CARL ANDRE (1935–)
Steel Piece, 1967
One hundred hot-rolled steel plates,
3/16 × 19¾ × 19¾ in. (0.5 × 50 × 50 cm) each,
3/16 × 96 × 393 in. (0.5 cm × 2.5 m × 10 m) overall
The Solomon R. Guggenheim Foundation,
New York; Panza Collection

34.
Villa Menafoglio Litta Panza, Varese, 1989
Photograph: Giorgio Colombo, Milan

JAMES TURRELL (1943–)
Sky Window I, Varese, 1976
A vertical portal cut to outside sky and inter-
ior fill light, white neon light, room dimen-
sions: 222 × 96 × 585 in. (5.7 × 2.5 × 14.9 m)
The Solomon R. Guggenheim Foundation,
New York; Panza Collection, gift 1992; per-
manent loan to FAI, Fondo per l'Ambiente
Italiano

35.
Villa Menafoglio Litta Panza, Varese, 2001
Photograph: Giorgio Colombo, Milan

ROBERT IRWIN (1928–)
Varese Portal Room, 1973

Room dimensions: 138 × 177 × 438 in.
(3.5 × 4.5 × 11.1 m), aperture: 72 × 72 in.
(1.9 × 1.9 m)
The Solomon R. Guggenheim Foundation,
New York; Panza Collection, gift 1992; per-
manent loan to FAI, Fondo per l'Ambiente
Italiano

36.
Un Choix d'Art Minimal dans la Collection Panza,
Musée d'Art Moderne de la Ville de Paris,
Paris, July 12–November 4, 1990
Photograph: Giorgio Colombo, Milan

JAMES TURRELL (1943–)
Night Passage, 1987
Rectangular cut in partition wall, fluorescent
and tungsten lamps and fixtures, outer
room and entry: 135 × 810 × 123 in.
(3.4 × 20.6 × 9.2 m), sensing space:
135 × 117 × 363 in. (3.4 × 3 × 9.2 m), cut in
partition wall placed 39 in. (1 m) from
floor: 60 × 180 in. (1.5 × 4.6 m)
The Solomon R. Guggenheim Foundation,
New York; Panza Collection, gift 1992

37.
Villa Menafoglio Litta Panza, Varese, 1977
Photograph: Giorgio Colombo, Milan

ROBERT IRWIN (1928–)
Disc Coloured Pale Grey Green Pink Violet, 1967
Painted steel disc, four positioned lamps, disc
diameter: 60 in. (152.4 cm)
Panza Collection

38.
Percepciones en transformación La Colección
Panza del Museo Guggenheim, Museo
Guggenheim, Bilbao, November 16, 2000–
February 14, 2001
Photograph: Erica Barahona, Bilbao

DOUGLAS WHEELER (1939–)
Sa Mi Dw Sm 2 75 Continuum Atmospheric
Environment, 1975
The space is filled with quartz halogen and
UV light operating on a six-minute cycle,
ceiling height: approximately twice human
scale, depth and width: equal, and at least five
times man's reach

The Solomon R. Guggenheim Foundation,
New York; Panza Collection, gift 1992

39.
Villa Menafoglio Litta Panza, Varese, 1994
Photograph: Giorgio Colombo, Milan

JAMES TURRELL (1943–)
Sky Space I, Varese, 1976
An overhead portal cut to outside sky and
interior fill light, white neon light, room
dimensions: 249 × 141 × 141 in. (6.4 × 3.6 × 3.6 m)
The Solomon R. Guggenheim Foundation,
New York; Panza Collection, gift 1992; per-
manent loan to FAI, Fondo per l'Ambiente
Italiano

40.
Villa Menafoglio Litta Panza, Varese, 1994
Photograph: Giorgio Colombo, Milan

ETTORE SPALLETTI (1940–)
Fonte dei Passeri, 1989
Pigment and plaster on wood, height: 122 in.
(310 cm), diameters: 12 in. and 18 in.
(30 cm and 45 cm)
Museo Cantonale d'Arte, Lugano; Panza
Collection, gift 1994

41.
*Percepciones en transformación La Colección Panza
del Museo Guggenheim,* Museo Guggenheim,
Bilbao, November 16, 2000–February 14, 2001
Photograph: Erica Barahona, Bilbao

JENE HIGHSTEIN (1942–)
Human Scale Black, 1975
Steel armature, wire, and black cement,
height: 78 in. (198.1 cm), elliptical base
diameters: 660 in. and 600 in.
(16.8 m and 15.2 m)
Panza Collection

42.
*Percepciones en transformación La Colección Panza
del Museo Guggenheim,* Museo Guggenheim,
Bilbao, November 16, 2000–February 14, 2001
Photograph: Erica Barahona, Bilbao

JAN DIBBETS (1941–)
The Shortest Day of 1970 Photographed in My House

Every 6 Minutes, Amsterdam 1970
Eighty b/w photographs on aluminum, ten
panels, 6 × 561 in. (0.1 × 14.2 m) overall
Panza Collection

43.
Villa Menafoglio Litta Panza, Varese, 1995
Photograph: Giorgio Colombo, Milan

ALLAN GRAHAM (1943–)
Cave of Generation, First Refrain, 1991
Oil on canvas with pine steps, canvas:
90 × 168 × 3 in. (2.3 × 4.3 × 0.1 m), steps:
9 × 36 × 21½ in. (23 × 91.5 × 54.3 cm)
FAI, Fondo per l'Ambiente Italiano; Panza
Collection, gift 1996

Cave of Generation, Seventh Passage, 1991
Oil on canvas with pine steps, canvas:
90½ × 96 × 4¼ in. (229.5 × 243.8 × 11.4 cm),
steps: 9 × 36 × 21½ in. (23 × 91.5 × 54.3 cm)
FAI, Fondo per l'Ambiente Italiano; Panza
Collection, gift 1996

44.
*Percepciones en transformación La Colección Panza
del Museo Guggenheim,* Museo Guggenheim,
Bilbao, November 16, 2000–
February 14, 2001
Photograph: Erica Barahona, Bilbao

JOEL SHAPIRO (1941–)
Untitled (Coffin), 1971–73
Cast iron, 2½ × 11½ × 5 in.
(6.5 × 29.4 × 12.5 cm)
Panza Collection

Untitled (Chair), 1973–74
Cast iron, 3 × 1¼ × 1¼ in. (8 × 3.4 × 3.4 cm)
Panza Collection

Untitled (Table), 1974
Cast iron, 5⅜ × 6 × 4⅞ in. (14 × 17 × 12.4 cm)
Panza Collection

45.
*Percepciones en transformación La Colección Panza
del Museo Guggenheim,* Museo Guggenheim,
Bilbao, November 16, 2000–
February 14, 2001
Photograph: Erica Barahona, Bilbao

BRUCE NAUMAN (1941–)
Triangle Room, 1978–80
Wallboard and three yellow sodium vapor
lamps, cadmium red painted inside
144 × 360 × 159 in. (3.7 × 9.1 × 4 m)
The Solomon R. Guggenheim Foundation,
New York; Panza Collection

46.
Villa Menafoglio Litta Panza, Varese, 2001
Photograph: Giorgio Colombo, Milan

PHIL SIMS (1940–)
Untitled (cat. # 147), 1993
Oil on linen, 85 × 65 in. (215.9 × 165 cm)
FAI, Fondo per l'Ambiente Italiano; Panza
Collection, gift 1996

Untitled (cat. # 138), 1992
Oil on linen, 85 × 65 in. (215.9 × 165 cm)
FAI, Fondo per l'Ambiente Italiano; Panza
Collection, gift 1996

47.
*Percepciones en transformación La Colección Panza
del Museo Guggenheim,* Museo Guggenheim,
Bilbao, November 16, 2000–February 14, 2001
Photograph: Erica Barahona, Bilbao

RICHARD SERRA (1939–)
One Cut Bisected Corners, 1973
Two hot-rolled steel triangles on edge,
placed in opposite corners of room forming
parallelogram, 105 × 504 × 1¼ in.
(2.6 m × 12.8 m × 3.3 cm) each
The Solomon R. Guggenheim Foundation,
New York; Panza Collection

48.
Villa Menafoglio Litta Panza, Varese, 1981
Photograph: Giorgio Colombo, Milan

ALAN CHARLTON (1948–)
90 × 180 in., slit 156 in., August–November 1971
Acrylic on canvas, 90 × 180 in.
(228.6 × 457.2 cm)
The Solomon R. Guggenheim Foundation,
New York; Panza Collection, gift 1992

112 × 56 in., slit 100 in., March 1971
Acrylic on canvas, 112 × 56 in. (284.5 × 142.2 cm)

The Solomon R. Guggenheim Foundation,
New York; Panza Collection, gift 1992

*Outer piece 84 × 144 in., inner piece 68.5 × 128.5 in.,
channel 1,75 in.,* May–August 1972
Acrylic on canvas, 84 × 144 in. (2.1 × 3.7 m)
The Solomon R. Guggenheim Foundation,
New York; Panza Collection, gift 1992

49.
*Minimal+Conceptual Art aus der Sammlung
Panza,* Museum für Gegenwartskunst, Basel,
November 9, 1980–June 28, 1981
Photograph: Giorgio Colombo, Milan

PETER JOSEPH (1929–)
Untitled (Cream with brown border), February 1976
Acrylic on canvas, 76 × 54 in. (193 × 137.2 cm)
The Solomon R. Guggenheim Foundation,
New York; Panza Collection, gift 1992

Untitled (Cream colour with dark blue border), 1976
Acrylic on canvas, 76 × 61½ in. (193 × 156.2 cm)
The Solomon R. Guggenheim Foundation,
New York; Panza Collection, gift 1992

50.
*Percepciones en transformación La Colección Panza
del Museo Guggenheim,* Museo Guggenheim,
Bilbao, November 16, 2000–February 14, 2001
Photograph: Erica Barahona, Bilbao

RICHARD LONG (1945–)
Valle Pellice Stone Circle, 1989
Stones, diameter: 198 in. (5 m)
Panza Collection

Madrid Circle, 1986
stones, total diameter: 456 in. (11.6 m)
inside diameter: 228⅜ in. (580 cm)
Panza Collection

51.
*The Legacy of a Collector: The Panza di Biumo
Collection at the Museum of Contemporary Art,*
MoCA, The Museum of Contemporary Art,
Los Angeles, December 12, 1999–April 30, 2000
Photograph: Brian Forrest, Los Angeles

CLAES OLDENBURG (1929–)
Pepsi-Cola, 1961

Enamel on plaster, 58¼ × 46½ × 7½ in.
(148 × 118.1 × 19.1 cm)
MoCA, The Museum of Contemporary Art,
Los Angeles; Panza Collection

White Shirt on Chair, 1962
Enamel on plaster and mixed media,
39¾ × 30 × 25 in. (101 × 76.2 × 64.1 cm)
MoCA, The Museum of Contemporary Art,
Los Angeles; Panza Collection

Green Stocking, 1961
Enamel on plaster, 43¼ × 18 × 4 in.
(111.1 × 45.7 × 102 cm)
MoCA, The Museum of Contemporary Art,
Los Angeles; Panza Collection

Blue Pants on Chair, 1962
Enamel on plaster and wood, 37 × 17 × 26¾ in.
(94 × 43.2 × 68 cm)
MoCA, Museum of Contemporary Art, Los
Angeles; Panza Collection

Cigarettes Fragment, 1961
Enamel on plaster, 32¾ × 30¾ × 6¾ in.
(83.2 × 78.1 × 17.2 cm)
MoCA, The Museum of Contemporary Art,
Los Angeles; Panza Collection

Umbrella and Newspaper, 1962
Enamel on plaster and mixed media,
38½ × 19½ × 6 in. (97.8 × 49.5 × 15.2 cm)
MoCA, The Museum of Contemporary Art,
Los Angeles; Panza Collection

Mu Mu, 1961
Enamel on plaster, 63¼ × 41¼ × 4 in.
(162.6 × 105.4 × 10.2 cm)
MoCA, The Museum of Contemporary Art,
Los Angeles; Panza Collection

Hamburger, 1962
Enamel on plaster, 7 × 9 × 9 in.
(17.8 × 22.9 × 22.9 cm)
MoCA, The Museum of Contemporary Art,
Los Angeles; Panza Collection

Bride, 1961
Enamel on plaster, 61 × 37¾ × 36¾ in.
(154.9 × 95.3 × 90.2 cm)

MoCA, The Museum of Contemporary Art,
Los Angeles; Panza Collection

Pie à la mode, 1962
Enamel on plaster, 20 × 13 × 9 in.
(55.9 × 47 × 29.9 cm)
MoCA, The Museum of Contemporary Art,
Los Angeles; Panza Collection

Blue and Pink Panties, 1961
Enamel on plaster, 62¼ × 34¾ × 6 in.
(158.1 × 88.3 × 15.2 cm)
MoCA, The Museum of Contemporary Art,
Los Angeles; Panza Collection

Tennis Shoes, 1962
Enamel on plaster, 24 × 24 × 10 in.
(61 × 61 × 25.4 cm)
MoCA, The Museum of Contemporary Art,
Los Angeles; Panza Collection

Fragment of Candies in a Box, 1961
Enamel on plaster, 44 × 32 × 6 in.
(112 × 81 × 15 cm)
MoCA, The Museum of Contemporary Art,
Los Angeles; Panza Collection

A Brown Shoe, 1961
Enamel on plaster, 32½ × 43¼ × 5 in.
(60 × 110 × 12.7 cm)
MoCA, The Museum of Contemporary Art,
Los Angeles; Panza Collection

Breakfast Table, 1962
Enamel on plaster and wood,
34½ × 35½ × 34½ in.
(87.6 × 90 × 87.6 cm)
MoCA, The Museum of Contemporary Art,
Los Angeles; Panza Collection

Pentecostal Cross, 1961
Enamel on plaster, 52¾ × 40½ × 6 in.
(134 × 103 × 15 cm)
MoCA, The Museum of Contemporary Art,
Los Angeles; Panza Collection

52.
Villa Menafoglio Litta Panza, Varese, 2000
Photograph: Giorgio Colombo, Milan

RUTH ANN FREDENTHAL (1938–)
Untitled No. 130, 1987–89
Oil on oyster linen, 60 × 60 in. (152.4 × 152.4 cm)
FAI, Fondo per l'Ambiente Italiano; Panza
Collection, gift 1996

Untitled No. 121, August 1984–February 1985
Oil on oyster linen, 66 × 60 in.
(167.6 × 152.4 cm)
FAI, Fondo per l'Ambiente Italiano; Panza
Collection, gift 1996

53.
Villa Menafoglio Litta Panza, Varese, 2003
Photograph: Sergio Tenderini, Varese

MAX COLE (1937–)
Delta II, 1982
Acrylic on canvas, 69 × 162 in. (1.7 × 4.1 m)
FAI, Fondo per l'Ambiente Italiano; Panza
Collection, gift 1996

54.
Villa Menafoglio Litta Panza, Varese, 2000
Photograph: Giorgio Colombo, Milan

FORD BECKMAN (1952–)
Untitled (White Wall Painting), 1990
Acrylic, wax, industrial varnish on canvas on
plywood, 120 × 180 in. (3.1 × 4.6 m)
FAI, Fondo per l'Ambiente Italiano; Panza
Collection, gift 1996

Untitled (Black Wall Painting), 1989
Acrylic, wax, industrial varnish on canvas on
plywood, 88 × 70 in. (223.5 × 177.8 cm)
FAI, Fondo per l'Ambiente Italiano; Panza
Collection, gift 1996

55.
Villa Menafoglio Litta Panza, Varese, 2000
Photograph: Giorgio Colombo, Milan

STUART ARENDS (1950–)
O.S. 18, 1993
Oil on steel, 5 × 5 × 4½ in. (12.7 × 12.7 × 11.4 cm)
FAI, Fondo per l'Ambiente Italiano; Panza
Collection, gift 1996

O.S. 24, 1993
Oil on steel, 5 × 5 × 4½ in. (12.7 × 12.7 × 11.4 cm)

FAI, Fondo per l'Ambiente Italiano; Panza
Collection, gift 1996

56.
*Le Stanze dell'Arte—Figure e Immagini del XX
secolo,* MART, Museo d'Arte Moderna e
Contemporanea di Trento e Rovereto,
Rovereto, December 15, 2002–April 13, 2003
Photograph: Giorgio Colombo, Milan

BARRY X BALL (1955–)
One of Twelve Identical Units (bxb 88-07), 1987–88
Panel cable assembly, Ceylon ebony, maple,
dyed pearwood veneer, medium density fiber-
board, gesso, bole, 24 kt gold, black oxide
finished metal, 6 × 9 × 3 in. (15.5 × 22.8 × 8 cm)
Panza Collection; loan to MART, Museo
d'Arte Contemporanea di Trento e Rovereto

Tavola 11 (bxb 84-06), 1984
Composite construction, wood, linen, gesso,
bole, 22 kt gold, 7⅞ × 7⅞ in. (20 × 20 cm)
Panza Collection; loan to MART, Museo
d'Arte Contemporanea di Trento e Rovereto

57.
*The Legacy of a Collector: The Panza di Biumo
Collection at the Museum of Contemporary Art,*
MoCA, The Museum of Contemporary Art,
Los Angeles, December 12, 1999–April 30,
2000
Photograph: Brian Forrest, Los Angeles

LAWRENCE CARROLL (1954–)
As She Dressed, 1990–92
Oil, wax, canvas, wood, 120 × 54½ × 23½ in.
(304.8 × 138.4 × 59.6 cm)
MoCA, The Museum of Contemporary Art,
Los Angeles; Panza Collection, gift 1994

Untitled (triptych), 1992
Oil, wax, wood, 16½ × 23¼ × ¾ in.
(41.9 × 59 × 1.9 cm)
MoCA, The Museum of Contemporary Art,
Los Angeles; Panza Collection, gift 1994

Along the Ground, 1992
Oil, wax, canvas, wood, 120 × 60 × 36 in.
(304.8 × 152.4 × 91.4 cm)
MoCA, The Museum of Contemporary Art,
Los Angeles; Panza Collection, gift 1994

58.
MART, Museo d'Arte Moderna e
Contemporanea di Trento e Rovereto,
Rovereto, 2004
Photograph: Giorgio Colombo, Milan

RONI HORN (1955–)
Object of Constancy, 1980
Lead, 4 × 72 × 4 in. (10.1 × 183 × 10.1 cm)
Panza Collection; loan to MART, Museo
d'Arte Contemporanea di Trento e Rovereto

Limit of the Twilight, 1/3, 1991
Plastic and aluminum, 8½ × 8½ × 53 in.
(22.3 × 22.3 × 139.7 cm)
Panza Collection; loan to MART, Museo
d'Arte Contemporanea di Trento e Rovereto

Thicket No. 2, 2/3, 1989–90
Aluminum 7075 plate with plane finish,
inlaid and machined epoxy resin, two units,
4½ × 25¾ × 57½ in. (10.7 × 65.2 × 130.5 cm) each
Panza Collection; loan to MART, Museo
d'Arte Contemporanea di Trento e Rovereto

59.
*The Legacy of a Collector: The Panza di Biumo
Collection at the Museum of Contemporary Art,*
MoCA, The Museum of Contemporary Art,
Los Angeles, December 12, 1999–April 30,
2000
Photograph: Brian Forrest, Los Angeles

GREG COLSON (1956–)
Beaumont, 1990
Ink and enamel on metal and wood,
31 × 50 × 1½ in. (78.7 × 127 × 3.8 cm)
MoCA, The Museum of Contemporary Art,
Los Angeles; Panza Collection, gift 1994

Rambler (Tapemeasure), 1988
Metal and tape, 9¼ × 52½ × 18 in.
(20.9 × 132 × 48.2 cm)
MoCA, The Museum of Contemporary Art,
Los Angeles; Panza Collection, gift 1994

Stacked Hub, 1987
Plastic and metal, 9¾ × 9¾ × 9¾ in.
(24.7 × 24.7 × 24.7 cm)
MoCA, The Museum of Contemporary Art,
Los Angeles; Panza Collection, gift 1994

60.
*Minimal+Conceptual Art aus der Sammlung
Panza,* Museum für Gegenwartskunst, Basel,
November 9, 1980–June 28, 1981
Photograph: Giorgio Colombo, Milan

DONALD JUDD (1928–1994)
Untitled, 1973
Brass and blue Plexiglas, 33 × 48 × 68 in.
(83.8 × 121.9 × 172.7 cm)
The Solomon R. Guggenheim Foundation,
New York; Panza Collection

Untitled, 1972
Large round front progression, brass,
14 × 78 × 25½ in. (35.6 × 198.1 × 64.8 cm)
The Solomon R. Guggenheim Foundation,
New York; Panza Collection

Untitled, 1970
Round front progression, copper,
5 × 69 × 8½ in. (12.7 × 175.3 × 21.6 cm)
The Solomon R. Guggenheim Foundation,
New York; Panza Collection

Untitled, 1970
Fibonacci progression, clear and purple anodized aluminum, 3 × 252 × 3 in. (0.2 × 6.4 × 0.2 m)
The Solomon R. Guggenheim Foundation,
New York; Panza Collection

61.
Un Choix d'Art Minimal dans la Collection Panza,
Musée d'Art Moderne de la Ville de Paris,
Paris, July 12–November 4, 1990
Photograph: Giorgio Colombo, Milan

CARL ANDRE (1935–)
Reef, 1966
Eighty orange styrofoam planks lengthwise
from the wall, 21 × 801 × 10 in.
(0.5 × 20.3 × 2.7 m) overall
The Solomon R. Guggenheim Foundation,
New York; Panza Collection

62.
*The Legacy of a Collector: The Panza di Biumo
Collection at the Museum of Contemporary Art,*
MoCA, The Museum of Contemporary Art,
Los Angeles, December 12, 1999–April 30, 2000
Photograph: Brian Forrest, Los Angeles

GREGORY MAHONEY (1955–)
Sea Level/Bad Water, 1991
Weathered steel, cement, alkali, salt,
57½ × 13½ in. (146 × 34.2 cm)
MoCA, The Museum of Contemporary Art,
Los Angeles; Panza Collection, gift 1994

In the Pacific (Blue), 1992
Formed steel, oil, pumice, pigment,
31 × 31 × 4 in. (78.7 × 78.7 × 10 cm)
MoCA, The Museum of Contemporary Art,
Los Angeles; Panza Collection, gift 1994

Deconstructing Pacific, 1992
Rusted steel, cement, sediment, alkali, salt,
46½ × 95½ in. (118 × 242.5 cm)
MoCA, The Museum of Contemporary Art,
Los Angeles; Panza Collection, gift 1994

63.
*The Legacy of a Collector: The Panza di Biumo
Collection at the Museum of Contemporary Art,*
MoCA, The Museum of Contemporary Art,
Los Angeles, December 12, 1999–April 30, 2000
Photograph: Brian Forrest, Los Angeles

ROSS RUDEL (1960–)
Untitled No. 124, 1993
Stained wood, 7 × 7 × 20 in.
(17.8 × 17.8 × 50.8 cm)
MoCA, The Museum of Contemporary Art,
Los Angeles; Panza Collection, gift 1994

Untitled No. 132, 1993
Wood, nylon stockings, resin, steel rings, wire,
105 × 13 × 5 in. (266.7 × 33 × 12.7 cm)
MoCA, The Museum of Contemporary Art,
Los Angeles; Panza Collection, gift 1994

Untitled No. 129, 1993
Wood, nylon stockings, resin, adjustable steel
rod, 8 × 8 × 90 in. (20.3 × 20.3 × 228.6 cm)
MoCA, The Museum of Contemporary Art,
Los Angeles; Panza Collection, gift 1994

Untitled No. 108, 1992
Stained wood, 14 × 14 × 15 in.
(35.5 × 35.5 × 38 cm)
MoCA, The Museum of Contemporary Art,
Los Angeles; Panza Collection, gift 1994

Untitled No. 107, 1992
Enamel on wood, 13 × 10½ × 13 in.
(33 × 26.6 × 33 cm)
MoCA, The Museum of Contemporary Art,
Los Angeles; Panza Collection, gift 1994

64.
Villa Menafoglio Litta Panza, Varese, 2001
Photograph: Giorgio Colombo, Milan

MARTIN PURYEAR (1941–)
Desire, 1981
Pine, red cedar, poplar, Sitka spruce,
192 × 192 × 384 in. (4.9 × 4.9 × 9.8 cm)
FAI, Fondo per l'Ambiente Italiano; Panza
Collection, gift 1996

65.
Villa Menafoglio Litta Panza, Varese, 2001
Photograph: Giorgio Colombo, Milan

DAVID SIMPSON (1928–)
Dear to Saturn (Sapphire), 1994
Acrylic on canvas, 96 × 80 in. (243.8 × 203.2 cm)
FAI, Fondo per l'Ambiente Italiano; Panza
Collection, gift 1996

Quicksilver Shift, 1994
Acrylic on canvas, 96 × 80 in. (243.8 × 203.2 cm)
FAI, Fondo per l'Ambiente Italiano; Panza
Collection, gift 1996

66.
*La Collezione Panza di Biumo Artisti degli Anni
'80 e '90,* MART, Museo d'Arte Contemporanea
di Trento e Rovereto, Palazzo delle Albere,
Trento, September 12–December 8, 1996
Photograph: Giorgio Colombo, Milan

JONATHAN SELIGER (1955–)
Blue Cup, 1993
Alkyd, wax, acrylic, modeling paste on cotton,
11 × 5½ × 3½ in. (28.4 × 14 × 9 cm)
Panza Collection

Bouquet, 1994
Oil, alkyd, acrylic, modeling paste on cotton,
museum board, 12½ × 6½ × 6½ in.
(31.5 × 16.5 × 16.5 cm)
Panza Collection

Little Tod, 1994
Oil, alkyd, acrylic, modeling paste, epoxy on
canvas and cotton with museum board and
wood; lacquer on polyurethane resin; shoe
polish on steel with foam, velvet and wood,
21 × 9 × 7 in. (53.3 × 22.8 × 17.7 cm)
Panza Collection

A Pint, 1994
Oil, alkyd, acrylic, modeling paste, epoxy on
cotton, 11½ × 7 × 3 in. (24 × 17.7 × 7 cm)
Panza Collection

Small a Frame, 1993
Oil, alkyd, modeling paste, acrylic on
canvas with steel rods, 9 × 15¼ × 11¼ in.
(23 × 38.5 × 26.5 cm)
Panza Collection

Pink Cap, 1994
Acrylic, lacquer, modeling paste and wax on
cotton; acrylic on latex; shoe polish on steel
with velvet, foam, and wood, 18 × 10 × 10 in.
(45.7 × 25.4 × 25.4 cm)
Panza Collection

67.
Palazzo Ducale, Gubbio, 1999
Photograph: Giorgio Colombo, Milan

68.
*The Legacy of a Collector: The Panza di Biumo
Collection at the Museum of Contemporary Art,*
MoCA, The Museum of Contemporary Art,
Los Angeles, December 12, 1999–
April 30, 2000
Photograph: Brian Forrest, Los Angeles

PETER SHELTON (1951–)
B.mantle, 1987–89
Bronze, 37½ × 47½ × 5½ in.
(82.5 × 120.6 × 14 cm)
MoCA, The Museum of Contemporary
Art, Los Angeles; Panza Collection, gift 1994

Onelongsleeve, 1989
Cast copper, 28 × 47½ × 5½ in.
(71.1 × 120.6 × 20.3 cm)
MoCA, The Museum of Contemporary Art,
Los Angeles; Panza Collection, gift 1994

Curvedtubebentpipe, 1989
Cast bronze, two elements, 46½ × 90 × 20½ in.
(118.1 × 228.6 × 52 cm) overall
MoCA, The Museum of Contemporary Art,
Los Angeles; Panza Collection, gift 1994

Tubepipe, 1989
Cast iron and steel, two elements,
38 × 85 × 11 in. (96.5 × 215.9 × 27.9 cm) overall
MoCA, The Museum of Contemporary Art,
Los Angeles; Panza Collection, gift 1994

69.
*Panza di Biumo Gli Anni Ottanta e Novanta dalla
Collezione,* Museo Cantonale d'Arte, Lugano,
April 11–July 5, 1992
Photograph: Giorgio Colombo, Milan

FORD BECKMAN (1952–)
Untitled (Black Wall Painting), 1990
Acrylic, wax, industrial varnish on canvas on
wood, 72 × 72 in. (184 × 184 cm)
Museo Cantonale d'Arte, Lugano; Panza
Collection, gift 1994

Untitled (Black Wall Painting), 1989
Acrylic, wax, industrial varnish on canvas on
plywood, 48 × 144 in. (1.2 × 3.7 m)
Museo Cantonale d'Arte, Lugano; Panza
Collection, gift 1994

70.
Villa Menafoglio Litta Panza, Varese, 1981
Photograph: Giorgio Colombo, Milan

Jene Highstein (1942–)
Untitled, 1974, seamless steel pipe, 12 × 483 × 12 in.
(0.3 × 12.3 × 0.3 m)
The Solomon R. Guggenheim Foundation,
New York; Panza Collection, gift 1992; loan to
FAI, Fondo per l'Ambiente Italiano

71.
Palazzo Ducale, Sassuolo, 2001
Photograph: Giorgio Colombo, Milan

72.
Palazzo Ducale, Sassuolo, Appartamento
Stuccato, Camera delle Fontane, 2001
Photograph: Giorgio Colombo, Milan

WINSTON ROETH (1945–)
For wall b (opposite the window) # 1 (left), 2000
Tempera on panel, 60 × 74½ × 1½ in.
(152.5 × 188.5 × 3.5 cm)
Ministero per i Beni e le Attività Culturali;
Donazione Panza 2005

For wall b (opposite the window) # 2 (center), 2000
Tempera on panel, 26½ × 37½ × 1½ in.
(67.5 × 95.5 × 3.5 cm)
Ministero per i Beni e le Attività Culturali;
Donazione Panza 2005

For wall b (opposite the window) # 3 (right), 2000
Tempera on panel, 59½ × 69 × 1½ in.
(151.5 × 175 × 3.5 cm)
Ministero per i Beni e le Attività Culturali;
Donazione Panza 2005

73.
Villa Menafoglio Litta Panza, Varese, 2001
Photograph: Giorgio Colombo, Milan

ROBERT TIEMANN (1936–)
Untitled (Black bucket), 1992
Wood and enamel, 10½ × 10½ × 7 in.
(26.6 × 26.6 × 18 cm)
FAI, Fondo per l'Ambiente Italiano; Panza
Collection, gift 1996

Untitled, 1993
Screen, wood bowl, putty, ink, 12 × 12 × 5½ in.
(30.4 × 30.4 × 13.6 cm)
FAI, Fondo per l'Ambiente Italiano; Panza
Collection, gift 1996

Untitled, 1993
Wood with blue acrylic, 11¼ × 11¼ × 4½ in.
(28.7 × 28.7 × 11.2 cm)
FAI, Fondo per l'Ambiente Italiano; Panza
Collection, gift 1996

74.
*The Legacy of a Collector: The Panza di Biumo
Collection at the Museum of Contemporary Art*,
MoCA, The Museum of Contemporary Art,
Los Angeles, December 12, 1999–
April 30, 2000
Photograph: Brian Forrest, Los Angeles

ROBERT THERRIEN (1947–)
No Title (Black keystone sculpture) (RT 88-35), 1988
Bronze and mixed media, 20 × 47¼ × 37 in.
(50.8 × 120.1 × 94 cm)
MoCA, The Museum of Contemporary Art,
Los Angeles; Panza Collection, gift 1994

*No Title (Keystone, flat sides, white sculpture)
(RT 82-16)*, 1982
Oil and wax on wood, 61 × 23¾ × 24 in.
(155 × 58.4 × 61 cm)
MoCA, The Museum of Contemporary Art,
Los Angeles; Panza Collection, gift 1994

*No Title (Keystone, corniche, black sculpture)
(RT 88-11)*, 1988
Bronze and mixed media, 73 × 31¼ × 31¼ in.
(185.5 × 79.4 × 79.4 cm)
MoCA, The Museum of Contemporary Art,
Los Angeles; Panza Collection, gift 1994

No Title (Silver keystone sculpture) (RT 88-12), 1988
Silver on bronze, 89 × 40 × 40 in.
(226 × 101.6 × 101.6 cm)
MoCA, The Museum of Contemporary Art,
Los Angeles; Panza Collection, gift 1994

75.
*La Collezione Panza di Biumo Artisti degli Anni
'80 e '90*, MART, Museo d'Arte Contemporanea
di Trento e Rovereto, Palazzo delle Albere,
Trento, September 12–December 8, 1996
Photograph: Giorgio Colombo, Milan

LAWRENCE CARROLL (1954–)
For the Return, 1993
Oil, wax, canvas on wood, 23½ × 67 × 49 in.
(58.4 × 170 × 124.4 cm)
FAI, Fondo per l'Ambiente Italiano; Panza
Collection, gift 2005

76.
Villa Menafoglio Litta Panza, Varese, 2000
Photograph: Giorgio Colombo, Milan

ALLAN GRAHAM (1943–)
See of Dreams, 1988
Oil on canvas, 108 × 78 in. (274.3 × 198.1 cm)
FAI, Fondo per l'Ambiente Italiano; Panza
Collection, gift 1996

Sky Reins, 1990
Oil on canvas, seven panels, 96 × 96 in.
(243.8 × 243.9 cm) overall
FAI, Fondo per l'Ambiente Italiano; Panza
Collection, gift 1996

77.
Villa Menafoglio Litta Panza, Varese, 2001
Photograph: Giorgio Colombo, Milan

MEG WEBSTER (1944–)
Slipped Cone with Flat Top, 1993
Packed earth, 62 × 132 × 60 in.
(157.4 × 335.2 × 152.4 cm)
FAI, Fondo per l'Ambiente Italiano; Panza
Collection, gift 1996

78.
Palazzo Ducale, Sassuolo, Appartamento
Stuccato, Camera della Pittura, 2001
Photograph: Giorgio Colombo, Milan

PHIL SIMS (1940–)
Sassuolo Painting Yellow (cat. # 428), 2001
Oil on linen, 94½ × 65 in. (240 × 164.8 cm)
Ministero per i Beni e le Attività Culturali;
Donazione Panza 2005

Sassuolo Painting Blue (cat. # 430), 2001
Oil on linen, 93¾ × 72½ in. (238 × 184.6 cm)
Ministero per i Beni e le Attività Culturali;
Donazione Panza 2005

79.
Villa Menafoglio Litta Panza, Varese, 2001
Photograph: Giorgio Colombo, Milan

DAVID SIMPSON (1928–)
Alchemical Origins (First of tryptich), 1992
Silver Pearl (Second of tryptich), 1992
Lockdown – Stainless Steel (Third of tryptich), 1992
Acrylic on canvas, 72 × 72 in.
(182.8 × 182.8 cm) each
FAI, Fondo per l'Ambiente Italiano; Panza
Collection, gift 1996

Gold Violet Shift, 1992
Acrylic on canvas, 72 × 72 in.
(182.8 × 182.8 cm)
FAI, Fondo per l'Ambiente Italiano; Panza
Collection, gift 1996

80.
Palazzo Ducale, Sassuolo, Appartamento
Stuccato, Camera dei Sogni, 2001
Photograph: Giorgio Colombo, Milan

TIMOTHY LITZMANN (1963–)
Blue with Purple, 2000
Acrylic on acrylic, 47 × 47½ × 1¼ in.
(119.3 × 120.6 × 3 cm)
Ministero per i Beni e le Attività Culturali;
Donazione Panza 2005

Gray with Prism Violet, 2000
Acrylic on acrylic, 20 × 40½ × 1¼ in.
(51 × 103 × 3 cm)
Ministero per i Beni e le Attività Culturali;
Donazione Panza 2005

Blue with Deep Gray, 2000
Acrylic on acrylic, 47 × 62¾ × 1¼ in.
(119.3 × 159.3 × 3 cm)
Ministero per i Beni e le Attività Culturali;
Donazione Panza 2005

Blue Violet with Orange, 2000
Acrylic on acrylic, 47 × 56¼ × 1¼ in.
(119.2 × 142.7 × 3 cm)
Ministero per i Beni e le Attività Culturali;
Donazione Panza 2005

81.
Villa Menafoglio Litta Panza, Varese, 2000
Photograph: Giorgio Colombo, Milan

ETTORE SPALLETTI (1940–)
Vaso, 1988
Pigment and plaster on wood structure,
height: 53 in. (135 cm), diameters: 11 in. and
17¾ in. (28 cm and 44 cm)
FAI, Fondo per l'Ambiente Italiano; Panza
Collection, gift 1996

Tutto Tondo, 1989
Pigment and plaster on board, 79 × 118 in.
(200 × 300 cm)
FAI, Fondo per l'Ambiente Italiano; Panza
Collection, gift 1996

Vaso, 1992
Pigment and plaster on wood structure,
height: 36 in. (91 cm), diameters: 38 in. and

49½ in. (96 cm and 126 cm)
FAI, Fondo per l'Ambiente Italiano; Panza
Collection, gift 1996

82.
Villa Menafoglio Litta Panza, Varese, 2001
Photograph: Giorgio Colombo, Milan

HUBERT KIECOL (1950–)
Untitled (7/88), 1988
Concrete, 79 × 10¼ × 10¼ in. (201 × 26 × 26 cm)
FAI, Fondo per l'Ambiente Italiano; Panza
Collection, gift 1996

Untitled (8/89), 1989
Concrete, two parts, 102 × 10¼ × 10¼ in.
(260 × 26 × 26 cm) each
FAI, Fondo per l'Ambiente Italiano; Panza
Collection, gift 1996

83.
MART, Museo d'Arte Moderna e
Contemporanea di Trento e Rovereto,
Rovereto, 2004
Photograph: Giorgio Colombo, Milan

ANNE TRUITT (1921–2004)
Tribute, 1997
Acrylic on wood, 81 × 8 × 8 in.
(208 × 20.5 × 20.5 cm)
Panza Collection; loan to MART, Museo
d'Arte Contemporanea di Trento e Rovereto

Australian Solstice, 1983
Acrylic on wood, 96¼ × 9 × 9 in.
(245.5 × 23 × 23 cm)
Panza Collection; loan to MART, Museo
d'Arte Contemporanea di Trento e Rovereto

Wind, 1993
Acrylic on wood, 81 × 8 × 8 in.
(208 × 20.5 × 20.5 cm)
Panza Collection, loan to MART, Museo
d'Arte Contemporanea di Trento e Rovereto

84.
*Le Stanze dell'Arte—Figure e Immagini del
XX secolo,* MART, Museo d'Arte Moderna
e Contemporanea di Trento e Rovereto,
Rovereto, December 15, 2002–April 13, 2003
Photograph: Giorgio Colombo, Milan

GRENVILLE DAVEY (1961–)
Idiot Wind, 1991
Rusted steel and rivets, two parts,
89 × 51½ × 51½ in. (225.5 × 131 × 131 cm)
each
Panza Collection; loan to MART, Museo
d'Arte Contemporanea di Trento e
Rovereto

85.
Palazzo Ducale, Sassuolo, Appartamento
Stuccato, Camera dei Sogni, 2001
Photograph: Giorgio Colombo, Milan

DAVID SIMPSON (1928–)
Rosa Mystica No. 1, 2000
Acrylic on canvas, 105 × 79 in.
(267 × 201.5 cm)
Ministero per i Beni e le Attività Culturali;
Donazione Panza 2005

Rosa Mystica No. 2, 2000
Acrylic on canvas, 105 × 66 in.
(267 × 167.5 cm)
Ministero per i Beni e le Attività Culturali;
Donazione Panza 2005

86.
Villa Menafoglio Litta Panza, Varese, 1981
Photograph: Giorgio Colombo, Milan

DAN FLAVIN (1933–1996)
Ultraviolet Fluorescent Light Room, 1968
Fluorescent light fixtures with ultraviolet
lamps, room dimensions: 138 × 234 × 345 in.
(3.5 × 6 × 8.7 m)
The Solomon R. Guggenheim Foundation,
New York; Panza Collection, gift 1992; per-
manent loan to FAI, Fondo per l'Ambiente
Italiano

87.
*Minimal+Conceptual Art aus der Sammlung
Panza,* Museum für Gegenwartskunst, Basel,
November 9, 1980–June 28, 1981
Photograph: Giorgio Colombo, Milan

JOSEPH KOSUTH (1945–)
One and Eight—A Description (Red), 1965
Red neon tubing, length: 119¾ in. (303.5 cm)
Panza Collection

One and Eight—A Description (Green), 1965
Green neon tubing, length: 122 in.
(310 cm)
Panza Collection

One and Eight—A Description (Blue), 1965
Blue neon tubing, length: 120½ in. (306 cm)
Panza Collection

88.
Palazzo Ducale, Sassuolo, Appartamento
Stuccato, Camera di Fetonte, 2001
Photograph: Giorgio Colombo, Milan

ANNE APPLEBY (1954–)
For North Wall # 1 (left), 2000
Oil and wax on canvas, 56½ × 78 × 1¼ in.
(143.5 × 197.7 × 3 cm)
Ministero per i Beni e le Attività Culturali;
Donazione Panza 2005

For North Wall # 2 (center), 2000
Oil and wax on canvas, 36¼ × 52 × 1¼ in.
(92 × 132 × 3 cm)
Ministero per i Beni e le Attività Culturali;
Donazione Panza 2005

For North Wall # 3 (right), 2000
Oil and wax on canvas, 55½ × 69 × 1¼ in.
(141 × 174.5 × 3 cm)
Ministero per i Beni e le Attività Culturali;
Donazione Panza 2005

89.
MART, Museo d'Arte Moderna e
Contemporanea di Trento e Rovereto,
Rovereto, 2003
Photograph: Giorgio Colombo, Milan

ANNE APPLEBY (1954–)
Winter Landscape (Oregon), 1996
Oil and wax on canvas, three parts, 72 × 112 in.
(182 × 284.5 cm) overall
Panza Collection; loan to MART, Museo
d'Arte Contemporanea di Trento e Rovereto

Willow, 1997
Oil and wax on panel, three parts, 72 × 108 in.
(182.9 × 274.3 cm) overall
Panza Collection; loan to MART, Museo
d'Arte Contemporanea di Trento e Rovereto

90.
Villa Menafoglio Litta Panza, Varese, 2001
Photograph: Giorgio Colombo, Milan

ALFONSO FRATTEGGIANI BIANCHI
(1954–)
Senza Titolo Azzurro Ultramarino (46020 K-01),
2001
Pigment on stone [pietra serena],
22½ × 12 × ¾ in. (57 × 30 × 2 cm)
FAI, Fondo per l'Ambiente Italiano; Panza
Collection, gift 2001

91.
*Le Stanze dell'Arte—Figure e Immagini del
XX secolo,* MART, Museo d'Arte Moderna
e Contemporanea di Trento e Rovereto,
Rovereto, December 15, 2002–April 13, 2003
Photograph: Giorgio Colombo, Milan

JULIA MANGOLD (1966–)
Ohne Titel 6-10-97, 1997
Waxed steel, 79 × 19½ × 3 in.
(200 × 50 × 7.5 cm)
Panza Collection; loan to MART, Museo
d'Arte Contemporanea di Trento e Rovereto

Ohne Titel 15-12-97, 1997
Waxed steel, 49¼ × 6 × 19½ in.
(125 × 15 × 50 cm)
Panza Collection; loan to MART, Museo
d'Arte Contemporanea di Trento e Rovereto

Ohne Titel 31-05-97, 1997
Waxed and polished iron, 71 × 8¼ × 8 in.
(180 × 21 × 20 cm)
Panza Collection; loan to MART, Museo
d'Arte Contemporanea di Trento e Rovereto

92.
Arte Minimal de la Colección Panza, Centro
de Arte Reina Sofia, Madrid, March 24–
December 31, 1988
Photograph: Giorgio Colombo, Milan

DONALD JUDD (1928–1994)
Untitled, 1972
five plywood 26.5° open boxes, 72 × 72 × 42 in.
(182.9 × 182.9 × 106.7 cm) each
The Solomon R. Guggenheim Foundation,
New York; Panza Collection

Untitled, 1972
Six brass with red fluorescent Plexiglas
boxes, 34 × 34 × 34 in. (86.4 × 86.4 × 86.4 cm)
each, separated by 8 in. (20.3 cm),
33 × 243 × 33 in. (0.9 × 6.2 × 0.9 m) overall
The Solomon R. Guggenheim Foundation,
New York; Panza Collection

Untitled, 1973
Brass and blue Plexiglas, 33 × 48 × 68 in.
(83.8 × 121.9 × 172.2 cm)
The Solomon R. Guggenheim Foundation,
New York; Panza Collection

93.
Villa Menafoglio Litta Panza, Varese, 2002
Photograph: Giorgio Colombo, Milan

MICHAEL BREWSTER (1946–)
Aerosplane (An acoustic sculpture), 1993
Six minutes of sound in an interior room-
space, 135 × 231 × 393 in. (3.4 × 6 × 10 m)
FAI, Fondo per l'Ambiente Italiano; Panza
Collection, gift 1996

94.
*La Collezione Panza di Biumo Artisti degli Anni
'80 e '90,* MART, Museo d'Arte Contemporanea
di Trento e Rovereto, Palazzo delle Albere,
Trento, September 12–December 8, 1996
Photograph: Giorgio Colombo, Milan

ROBERT THERRIEN (1947–)
No Title (Silver pitcher sculpture) (RT 85-34), 1985
Tin on bronze, 60 × 29 × 29 in.
(152 × 73.6 × 73.6 cm)
Panza Collection

No Title (Yellow hat sculpture) (RT 86-31), 1986
Wood, bronze, and enamel paint,
50½ × 12½ × 3¾ in. (128.3 × 31.7 × 9.5 cm)
Panza Collection

95.
Palazzo Ducale, Sassuolo, Appartamento
Stuccato, Camera della Fama o dei Cavalli,
2001
Photograph: Giorgio Colombo, Milan

LAWRENCE CARROLL (1954–)
Family, 2001

Mixed media, eleven units, 13 × 55 × 39 in.
(33 × 139.7 × 99 cm) each, 143 × 55 × 39 in.
(363 × 139.7 × 99 cm) overall
Ministero per i Beni e le Attività Culturali;
Donazione Panza 2005

96.
Villa Menafoglio Litta Panza, Varese, 1981
Photograph: Giorgio Colombo, Milan

SOL LeWITT (1928–)
Wall drawing No. 265, 1975
A wall divided horizontally and vertically
into four equal parts, with lines in three
directions and three colors in each part, red,
yellow, blue pencil
The Solomon R. Guggenheim Foundation,
New York; Panza Collection, gift 1992

WALTER DE MARIA (1935–)
Ball Drop (Edition of 6), 1961
Plywood box with pencil wording and
wooden ball, 76 × 24 × 6⅜ in.
(193 × 61 × 16 cm)
The Solomon R. Guggenheim Foundation,
New York; Panza Collection, gift 1992

97.
Villa Menafoglio Litta Panza, Varese, 1981
Corridor with light arriving from rooms
containing other installations by Dan Flavin
Photograph: Giorgio Colombo, Milan

98.
*La Collezione Panza di Biumo Artisti degli Anni
'80 e '90,* MART, Museo d'Arte Contemporanea
di Trento e Rovereto, Palazzo delle Albere,
Trento, September 12–December 8, 1996
Photograph: Giorgio Colombo, Milan

RON GRIFFIN (1954–)
Untitled (Dish towel) (rgp 287-94), 1994
Acrylic and polyurethane on panel,
36¼ × 42½ × 3½ in. (92 × 107.9 × 8.9 cm)
Panza Collection

Untitled (Computer paper) (rgp 277-94), 1994
Acrylic and polyurethane on panel,
16¼ × 20⅛ × 1¾ in. (41.3 × 51.1 × 4.4 cm)
Panza Collection, now the collection of
the artist

Untitled (Bath towel) (rgp 286-94), 1994
Acrylic and polyurethane on panel,
36¼ × 36¼ × 3½ in. (92 × 92 × 8.9 cm)
Panza Collection

Untitled (Thesis paper) (rgp 283-94), 1994
Acrylic and varnish on panel,
16½ × 20¼ × 1¾ in. (41.2 × 51.4 × 4.4 cm)
Panza Collection

Untitled (Fabric swatch with tag) (rgp 291-94), 1994
Acrylic and varnish on panel,
12¼ × 14¼ × 1¾ in. (31.1 × 36.2 × 4.4 cm)
Panza Collection

Untitled (Fabric swatch) (rgp 288-94), 1994
Acrylic and polyurethane on panel,
8¼ × 10¼ × 1¾ in. (20.9 × 26 × 4.4 cm)
Panza Collection

99.
La Percezione dello Spazio Arte Minimal della Collezione Panza dal Guggenheim di New York (Cat # 276), Palazzo della Gran Guardia, Verona, June 29–November 18, 2001
Photo: Giorgio Colombo, Milan

PHIL SIMS (1940–)
Marienbad One cat. # 276, 1996
Oil on linen, 144 × 144 in. (3.7 × 3.7 m)
Panza Collection

LAWRENCE WEINER (1942–)
Over And Over Over And Over Over And Over Over And Over, Cat. No. 238, 1971
The Solomon R. Guggenheim Foundation, New York; Panza Collection, gift 1992

100.
Photograph: Sergio Tenderini, Varese, 2004

FRANCO VIMERCATI (1940–2000)
Senza Titolo (Tazza), 1/12, 1998
Photographic print 12¼ × 10 in. (31 × 25 cm)
Panza Collection

101.
Minimal+Conceptual Art aus der Sammlung Panza, Museum für Gegenwartskunst, Basel, November 9, 1980–June 28, 1981
Photograph: Giorgio Colombo, Milan

BRUCE NAUMAN (1941–)
Perfomance Parallelogram (Rolling), 1970
Plywood basement and two mirrors,
33 × 198 × 87 in. (0.8 × 5 × 2.2 m)
The Solomon R. Guggenheim Foundation, New York; Panza Collection

102.
Villa Menafoglio Litta Panza, Varese, 2001
Photograph: Giorgio Colombo, Milan

ETTORE SPALLETTI (1940–)
Ali, Grigio Neutro, 1988
Pigment and plaster on board, two panels,
79 × 60 × 1¼ in. (200 × 150 × 3 cm) each,
79 × 120 × 12 in. (200 × 305 × 30 cm) overall
FAI, Fondo per l'Ambiente Italiano; Panza Collection, gift 1996

Vaso, 1989
Sivec Czechoslovak white marble, height:
42½ in. (108 cm), diameters: 7 in. and 8½ in. (18 cm and 22 cm)
FAI, Fondo per l'Ambiente Italiano; Panza Collection, gift 1996

103.
The Legacy of a Collector: The Panza di Biumo Collection at the Museum of Contemporary Art, MoCA, The Museum of Contemporary Art, Los Angeles, December 12, 1999–April 30, 2000
Photograph: Brian Forrest, Los Angeles

MARK ROTHKO (1903–1970)
Brown, Blue, Brown on Blue, 1953
Acrylic on canvas, 115¾ × 91¼ in. (294 × 231.8 cm)
MoCA, The Museum of Contemporary Art, Los Angeles; Panza Collection

Black and Dark Sienna on Purple, 1960
Acrylic on canvas, 119¼ × 105 in. (302.9 × 266.7 cm)
MoCA, The Museum of Contemporary Art, Los Angeles; Panza Collection

104.
Villa Menafoglio Litta Panza, Varese, 1994
Photograph: Giorgio Colombo, Milan

MARTIN PURYEAR (1941–)
Shrine, 1985
Cypress, steel, kaolin, 126 × 126 × 108 in.
(320 × 320 × 274 cm)
FAI, Fondo per l'Ambiente Italiano; Panza
Collection, gift 1996

105.
Palazzo della Gran Guardia, Verona, 2002
Photograph: Giorgio Colombo, Milan

PHIL SIMS (1940–)
Verona Painting Red # 5 (cat. # 461), 2001
Oil on canvas, 108 × 108 in. (274.5 × 274.5 cm)
Panza Collection

Verona Painting Grey # 2 (cat. # 464), 2001
Oil on canvas, 108 × 108 in. (274.5 × 274.5 cm)
Comune di Verona; Panza Collection, 2006

Verona Painting Red # 2 (cat. # 458), 2001
Oil on canvas, 108 × 108 in. (274.5 × 274.5 cm)
Panza Collection

Verona Painting Grey # 1 (cat. # 463), 2001
Oil on canvas, 108 × 108 in. (274.5 × 274.5 cm)
Comune di Verona; Panza Collection, 2006

106.
Palazzo della Gran Guardia, Verona, 2002
Photograph: Giorgio Colombo, Milan

LAWRENCE CARROLL (1954–)
Untitled Verona, 2001
Oil, wax, canvas, Plexiglas on wood,
124 × 96 × 5½ in. (315 × 243.8 × 14 cm)
Panza Collection

Untitled Verona, 2001
Oil, wax, canvas, plastic flowers on wood,
131 × 96 × 2½ in. (332.7 × 243.8 × 6.4 cm)
Panza Collection

107.
Arte Minimal de la Colección Panza, Centro
de Arte Reina Sofia, Madrid, March 24–
December 31, 1988
Photograph: Giorgio Colombo, Milan

DONALD JUDD (1928–1994)
Straight Single Tube, 1974
Hot-rolled steel, 60 × 144 × 84 in.
(1.5 × 3.7 × 2.1 m)
The Solomon R. Guggenheim Foundation,
New York; Panza Collection

108.
Villa Menafoglio Litta Panza, Varese, 2001
Photograph: Giorgio Colombo, Milan

109.
Villa Menafoglio Litta Panza, Varese, 2000
Photograph: Giorgio Colombo, Milan

DAN FLAVIN (1933–1996)
Varese Corridor, 1976
Fluorescent light fixtures with green, pink
and yellow lamps, room dimensions:
219 × 1125 × 99 in. (5.6 × 28.6 × 2.5 m)
The Solomon R. Guggenheim Foundation,
New York; Panza Collection, gift 1992; per-
manent loan to FAI, Fondo per l'Ambiente
Italiano

INDEX OF NAMES

Entries and page numbers in *italics* indicate
a section devoted to that particular person.

EXHIBITIONS OF THE PANZA COLLECTION

SUBSECTIONS OF THE EXHIBITIONS:

Europa/America L'Astrazione Determinata 1960/1976
Galleria Comunale d'Arte Moderna, Bologna,
May 23–September 30, 1976
Catalog, *Europa/America L'Astrazione
Determinata 1960/1976,* Flavio Caroli, publ.
Comune di Bologna, 1976

*Carl Andre Donald Judd Robert Morris
Sculture Minimal*
Galleria Nazionale d'Arte Moderna, Roma,
January 16–March 2, 1980
Catalog, *Carl Andre Donald Judd Robert
Morris Sculture Minimal,* Ministero per i Beni
Culturali e Ambientali Soprintendenza
Speciale alla Galleria Nazionale d'Arte
Moderna e Contemporanea, Ida Panicelli,
pub. De Luca Editore Srl, 1979

Sammlung Panza
Kunstsammlung Nordrhein-Westfalen,
Kunsthalle, Düsseldorf, September 19–
November 2, 1980

*Minimal+Conceptual Art aus der Sammlung
Panza*
Museum für Gegenwartskunst, Basel,
November 9, 1980–June 28, 1981
Catalog, *Minimal+Conceptual Art aus der
Sammlung Panza,* Franz Meyer, pub.
Kunstmuseum Basel, 1980

*The First Show—Painting and Sculpture from Eight
Collections 1940–1980*
MoCA, The Museum of Contemporary Art,
Los Angeles, November 20, 1983–February 19,
1984
Catalog, *The First Show—Painting and Sculpture
from Eight Collections 1940–1980,* Julia Brown
and Bridget Johnson, pub. The Museum of
Contemporary Art, Los Angeles, 1983

*The Museum of Contemporary Art: The Panza
Collection*
MoCA, The Museum of Contemporary Art,
Los Angeles, February 13–September 29, 1985
Catalog, *The Museum of Contemporary
Art: The Panza Collection,* Julia Brown and

Kerry Brougher, pub. The Museum of
Contemporary Art, Los Angeles, 1985

Arte Minimal de la Colección Panza
Centro de Arte Reina Sofia, Madrid, March 24–
December 3, 1988
Catalog, *Arte Minimal de la Colección Panza,*
Guadalupe Echevarría and M. Rosa Garcia
Brage, pub. Ministero de Cultura, 1988

Minimal Art Dans la Collection Panza di Biumo
Musée Rath, Geneva, July 10–October 16, 1988
Catalog, *Minimal Art Dans la Collection Panza di
Biumo,* Hendel Teicher and Giuseppe Panza
di Biumo, pub. Musée d'Art e d'Histoire, 1988

Collection Panza—Dan Flavin
Musée Saint-Pierre d'Art Contemporaine,
Lyon, June 29–September 6, 1989

Collection Panza—Richard Long Bruce Nauman
Musée d'Art Moderne, Saint Etienne, June 26–
September 6, 1989

Un Choix d'Art Minimal dans la Collection Panza
Musée d'Art Moderne de la Ville de Paris,
Paris, July 12– November 4, 1990
Catalog, *Un Choix d'Art Minimal dans la
Collection Panza,* Suzanne Pagé, pub. Musée
d'Art Moderne de la Ville de Paris, 1990

*Panza di Biumo Gli Anni Ottanta e Novanta dalla
Collezione*
Museo Cantonale d'Arte, Lugano, April 11–
July 5, 1992
Catalog, *Panza di Biumo Gli Anni Ottanta e
Novanta dalla Collezione,* Manuela Kahn
Rossi and Marco Franciolli, pub. Umberto
Allemandi & C., 1992 (Italian and English
editions)

*Donazione Panza di Biumo. Arte Europea e
Americana '83–'93. Una prima scelta dalle cento opere*
Museo Cantonale d'Arte, Lugano, March 25–
April 30, 1995

*La Collezione Panza di Biumo Artisti degli Anni
'80 e '90*

MART, Museo d'Arte Moderna e Contemporanea di Trento e Rovereto Palazzo delle Albere, Trento, September 12–December 8, 1996
Catalog, *La Collezione Panza di Biumo Artisti degli Anni '80 e '90,* Gabriella Belli and Giuseppe Panza di Biumo, pub. Electa, 1996

Collezione Panza
Artissima 1996, Lingotto Fiere, Torino, September 26–29, 1996

Tra Post-Minimal e Concettuale: Opere Inedite dalla Donazione Panza di Biumo
Museo Cantonale d'Arte, Lugano, June 7–July 27, 1997

Colleció Panza di Biumo Anys 80 i 90
Llonja, Palma de Mallorca, August–September 1997
Catalog, *Colleció Panza di Biumo Anys 80 i 90,* pub. Govern Balear Conselleria d'Educació, Cultura i Sports, 1997

The Legacy of a Collector: The Panza di Biumo Collection at the Museum of Contemporary Art,
MoCA, The Museum of Contemporary Art, Los Angeles, December 12, 1999–April 30, 2000
Catalog, *The Legacy of a Collector: The Panza di Biumo Collection at the Museum of Contemporary Art, Los Angeles,* pub. The Museum of Contemporary Art, Los Angeles, 1999

La Collezione Panza di Biumo Artisti degli Anni '80–'90
Soprintendenza per i Beni Ambientali Architettonici Artistici e Storici dell' Umbria, Museo del Palazzo Ducale di Gubbio, December 5, 1998–December 4, 2003
Catalog, *La Collezione Panza di Biumo Artisti degli Anni '80–'90,* Caterina Bon Valsassina, pub. Edizioni De Luca, 1998

The Panza di Biumo Collection, Works from the '80s and '90s
American Academy in Rome, Roma, March 10–May 21, 2000
Catalog, *The Panza di Biumo Collection, Works from the '80s and '90s,* Marc Bowditch, pub. American Academy in Rome, 2000

Venice/Venezia California Art from the Panza Collection at the Guggenheim Museum
Peggy Guggenheim Collection, Venezia, September 2, 2000–January 7, 2001
Catalog, *Venice/Venezia California Art from the Panza Collection at the Guggenheim Museum,* pub. Guggenheim Museum, 2000 (Italian and English edition)

Percepciones en transformación La Colección Panza del Museo Guggenheim,
Museo Guggenheim, Bilbao, November 16, 2000–February 14, 2001
Catalog, *Percepciones en transformación La Colección Panza del Museo Guggenheim,* pub. The Solomon R. Guggenheim Foundation New York and Guggenheim Bilbao, 2000

La Percezione dello Spazio Arte Minimal della Collezione Panza dal Guggenheim di New York
Palazzo della Gran Guardia, Verona, June 29–November 18, 2001
Catalog, *La Percezione dello Spazio Arte Minimal della Collezione Panza dal Guggenheim di New York,* Giorgio Cortenova and Giuseppe Panza di Biumo, pub. Electa, 2001

Monochromatic Light Artisti Americani ed Europei dalla Collezione Panza
Progetto Contemporaneo 2001–2003, Soprintendenza per il Patrimonio Storico Artistico e Demoetnoantropologico di Modena e Reggio Emilia, Palazzo Ducale, Sassuolo, September 2001–September 2006
Catalog, *Monochromatic Light 2,* Filippo Trevisani, pub. Il Bulino Edizioni d'Arte, 2002

SUBSECTION OF WORKS ON LOAN FROM THE COLLECTION IN THE EXHIBITION:
In Viaggio con le Muse—Percorsi dell'arte del XX secolo nella Collezione permanente del museo
MART, Museo d'Arte Moderna e Contemporanea di Trento e Rovereto, Rovereto,
May 17–November 16, 2003

SUBSECTION OF WORKS ON LOAN FROM THE COLLECTION IN THE EXHIBITION:
Il Laboratorio delle Idee. Figure e Immagini del '900
MART, Museo d'Arte Moderna e

Contemporanea di Trento e Rovereto,
Rovereto, April 30, 2004–November 20, 2005

Dan Flavin Stanze di Luce tra Varese e New York
FAI, Villa Menafoglio Litta Panza, Varese,
September 30–December 12, 2004
Catalog, *Dan Flavin Stanze di luce tra Varese e
New York,* Angela Vettese, Giuseppe Panza and
Laura Mattioli Rossi, pub. Skira, 2004

Lawrence Carroll. Pitture attorno al bianco
FAI, Villa Menafoglio Litta Panza, Varese,
May 7–August 28, 2005
*La Collezione Panza Anne Appleby Stuart Arends
Anne Truitt Fotografie di Giorgio Colombo*
Galleria dell'Accademia—Accademia di
Architettura Università della Svizzera Italiana,
Mendrisio, October 27–November 20, 2005

*Really Really Simple Richard Long Opere dal 1978
al 2002*
FAI, Villa Menafoglio Litta Panza, Varese,
April 14–September 3, 2006

SUBSECTION OF WORKS ON LOAN FROM THE
COLLECTION IN THE EXHIBITION:
Scultura e Pittura Opere nella Collezione
permanente del MART
MART, Museo d'Arte Moderna e
Contemporanea di Trento e Rovereto,
Rovereto,
May 16–November 12, 2006

EXHIBITION IN PREPARATION:
*The Panza Collection: An Experience of Color and
Light*
Albright-Knox Art Gallery, Buffalo, November
16, 2007–February 24, 2008
Forty-four works from the Collection on loan
to the Comune di Verona:
Palazzo della Gran Guardia, Verona, March 8,
2002–July 13, 2006

SUBSECTION OF WORKS ON LOAN FROM THE
COLLECTION IN THE EXHIBITION:
Le Stanze dell'Arte—Figure e Immagini del XX secolo
MART, Museo d'Arte Moderna e
Contemporanea di Trento e Rovereto,
Rovereto, December 15, 2002–April 13, 2003
Catalog, *Le Stanze dell'Arte—Figure e Immagini
del XX secolo,* Gabriella Belli, pub. Skira, 2002

CATALOGS

Das Bild einer Geschichte 1955/1976—Die Sammlung Panza di Biumo,
Germano Celant, pub. Electa International, 1980

Arte Anni Sessanta Settanta Collezione Panza,
pub. Jaca Book, 1987 (Italian, French, Spanish, and English editions)

Donazione Panza di Biumo, Museo Cantonale d'Arte Lugano,
Marco Franciolli, pub. Skira Editore, 1997 (Italian and English editions)

L'Arte degli Anni '50, '60, '70 Collezione Panza,
pub. Jaca Book, 1999 (Italian and English editions)

La Collezione Panza—Villa Menafoglio Litta Panza Varese,
Giuseppe Panza di Biumo, pub. Skira Editore, 2002 (Italian and English editions)

PICTURE CREDITS

Our special thanks to the photographers acknowledged below, together with the organizers of the exhibitions where the photographs were taken, for their authorization to publish the images. Giuseppe Panza would, in particular, like to thank personally those who authorized the reproduction of their works on this volume: Anne Appleby, Stuart Arends, Barry X Ball, Ford Beckman, Michael Brewster, Lawrence Carroll, Max Cole, Greg Colson, Grenville Davey, Alfonso Fratteggiani Bianchi, Ruth Ann Fredenthal, Allan Graham, Ron Griffin, Jene Highstein, Robert Irwin, Timothy Litzman, Gregory Mahoney, Julia Mangold, Martin Puryear, Winston Roeth, Ross Rudel, Jonathan Seliger, Peter Shelton, David Simpson, Phil Sims, Ettore Spalletti, Robert Tiemann, Anne Truitt, Franco Vimercati, Meg Webster.

Our special thanks to the following photographers for their particularly helpful collaboration: Giorgio Colombo, Milano, Sergio Tenderini, Varese, Brian Forrest, Los Angeles, Erica Barahona, Bilbao; © by SIAE, 2006 for the reproduction of the works by the artists: Carl Andre, Joseph Beuys, Michael Brewster, Jan Dibbets, Jean Fautrier, Dan Flavin, Douglas Huebler, Robert Irwin, Donald Judd, Franz Kline, Joseph Kosuth, Sol Lewitt, Roy Lichtenstein, Robert Mangold, Brice Marden, Robert Morris, Bruce Nauman, Robert Rauschenberg, James Rosenquist, Mark Rothko, George Segal, Richard Serra, Joel Shapiro, Antoni Tàpies, Robert Therrien, Lawrence Weiner

Giuseppe Panza was born in Milan, in 1923, to a prominent family of Italian wine merchants. He studied law and eventually went into real estate, a move he later regretted since he accumulated far more resources for acquiring contemporary art, his genuine love, by devoting his time to collecting art, for himself and later for leading museums of the world. He credited an interior "thermometer" that enabled him to spot upcoming movements, artists, and works of art, and over a period of fifty years and hundreds of purchases he was rarely wrong.

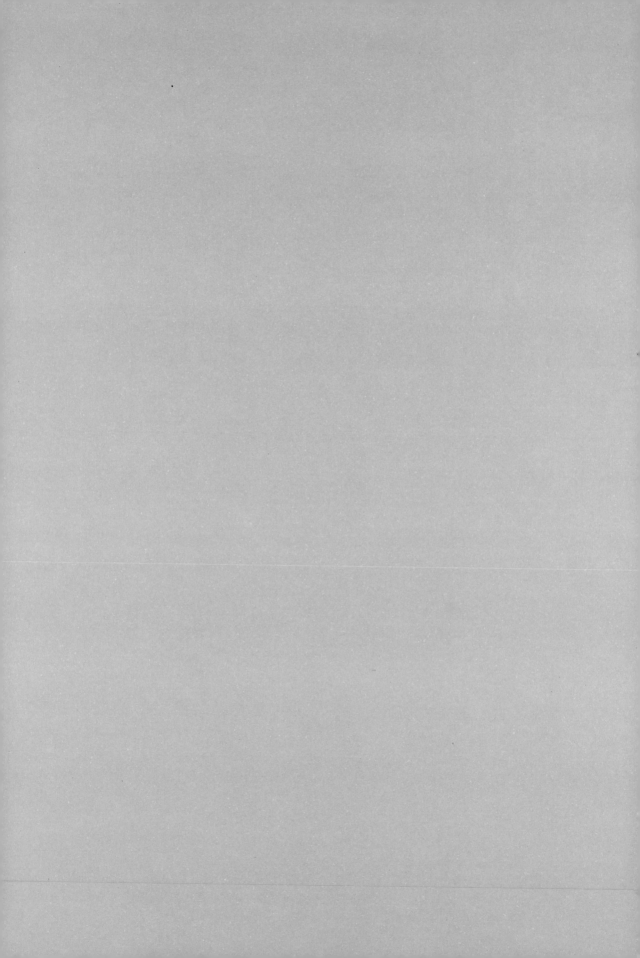